ART WITHOUT BORDERS

ART WITHOUT BORDERS

A PHILOSOPHICAL EXPLORATION
OF ART AND HUMANITY

BEN-AMI SCHARFSTEIN

THE UNIVERSITY OF CHICAGO PRESS Chicago and London

BEN-AMI SCHARFSTEIN is professor emeritus of philosophy at Tel-Aviv University. He is the recipient of the State of Israel's 2005 Israel Prize for Philosophy and is the author of numerous books, including *Mystical Experience, A Comparative History of World Philosophy and Religion, Ineffability: The Failure of Words in Philosophy and Religion*, and *Of Birds, Beasts, and Other Artists: An Essay on the Universality of Art*.

The University of Chicago Press, Chicago 60637
The University of Chicago Press, Ltd., London
© 2009 by The University of Chicago
All rights reserved. Published 2009
Printed in the United States of America

17 16 15 14 13 12 11 10 09 1 2 3 4 5

ISBN-13: 978-0-226-73609-9 (cloth)
ISBN-10: 0-226-73609-1 (cloth)

Library of Congress Cataloging-in-Publication Data

Scharfstein, Ben-Ami, 1919–
 Art without borders : a philosophical exploration of art and humanity /
Ben-Ami Scharfstein.
 p. cm.
 Includes bibliographical references and index.
 ISBN-13: 978-0-226-73609-9 (cloth : alk. paper)
 ISBN-10: 0-226-73609-1 (cloth : alk. paper) 1. Art, Comparative. 2. Art—
Philosophy. 3. Aesthetics. I. Title.
 N7428.5.S336 2009
 700.1—dc22
 2008028289

To Leonardo da Vinci,
because he wanted to know everything about everything,
and to Ghela, who alone knows why I chose her as well

CONTENTS

PREFACE

An extensive group of illustrations, especially in color, might create an illusion of visual adequacy to this book's themes. The few black-and-white pictures that do appear have a different, intellectually more stimulating aim, which is to illustrate the more-than-human extent of art and the interaction, throughout art, of likeness and difference. The first two pictures remind us that play and art are not confined to human beings. Then come two contrasting groups of pictures, each group expressing a likeness-in-difference of two traditions, which flank an image that symbolizes the unity of human beings with nature as a whole. The eighth image, of a ghost, as it happens, is an inadequate icon of the contemporary art of the so-called primitive peoples. With the final figure, I point once more to art's reach beyond the human.

In short, the book you hold in your hand is meant to be a self-sufficient text, and I prefer it to be visually austere. To my mind, its often detailed verbal descriptions of works of art arouse a sense of the works' nature better than would any but superlative illustrations. Illustrations would almost certainly be inadequate because of their small size, and, for practical reasons, too limited in number and variety. When I ask myself how, then, it might be possible to illustrate a text meant to interrelate the art of the whole world, I answer that, given the readi-

ness of the reader to collaborate with the author, a means is provided by the inexhaustible store of images on the Internet, which by now serves the needs of an image-hungry imagination almost too richly. Besides, when such images are enlarged on the screen, they glow with a life-giving luminosity.

The Internet's resources for images are bewilderingly many, and the responses of the general search engines can be staggering in their number and variety. As I have learned, it is often better to use specialized search engines, which make order among the responses of the general ones. I remind readers without much experience of the Internet that museums maintain Web sites. Of the museums whose sites I have visited, three show a systematic review of images to illustrate the art history of traditional cultures: the British Museum ("Explore World Cultures"); the Metropolitan Museum of Art ("Timeline of Art History"); and the Louvre (official Web site). Many galleries show (and price) their pictures on the Internet, and the large auction houses also have Web sites. Among the many useful sites I have found are Artcyclopaedia, Artseek, Virtual Art Library, and World Wide Arts Resources. I forbear to add more names and rely on the reader's own curiosity to extend the exploration I try to initiate and find a richer world art than is possible to contain, especially visually, in any one book.

ACKNOWLEDGMENTS

My first and main acknowledgment is to Wilfried van Damme, for the breadth of his interest in the subject of world art and his unwavering empathy and critical honesty. I also owe a debt of gratitude to my great old friend Hilary Putnam, now increasingly interested in art, for his willingness to read my manuscript and criticize it sympathetically. The artist and art historian Miriam Or has earned my gratitude by reading my texts with genuine appreciation (and by taking a strong interest in my paintings as well). I can say the same of my friend, the artist Dani Eshet, who seems by nature so well attuned to what I have written on art. Another friend, the neurosurgeon Hanoch Elran, helped me to understand the complicated relation between the right and left hemispheres of the brain.

To the careful reading of anthropologist Howard Morphy, I owe the strengthening of my sense of the ambivalence by which I veer from a universalizing standpoint to one more open to the art of individual peoples. Since Morphy is in my view the preeminent expert on Aboriginal art, I find it a great compliment that, save for a minor, controversial example, he did not criticize any of my frequent passages on this art. With another anthropologist, the late Rodney Needham, I conducted a long epistolary friendship that allowed me to take advantage

of his exceedingly wide learning, sharp mind, and lifetime of anthropological experience.

In chapter 4 in particular, I have often depended on the help of Ulli Beier, who, along with his wife, Georgina, has been a major force in the creation of nontraditional modern art among the Yoruba, the Papua New Guineans, and the Aborigines about whom I write. Without the help of the Beiers, my description of the art of these peoples would have been far less informed and trustworthy. Grazia Marchiano, whose views and publications show rich learning, an exceptionally empathic grasp of art, and eloquence to match, encouraged me by her interest in my work.

I thank my copyeditor, Carlisle Rex-Waller, who maintained a highly professional vigil against error, clumsiness, and redundancy, cut approachable paths through thickets of endnotes, and always showed an equal solicitude for reader and writer. In addition, I thank Laura Avey, the editorial assistant who, true to her title, gave me her unfailingly friendly technical assistance. As for my editor, T. David Brent, I mention him here not only because of the professional help he has given me, but because, even before we had worked together on this book, he remarked on how long he had been looking for a writer who, like him, had an equal interest in philosophy, anthropology, and the social sciences, and eliciting my answer to him that I had long been looking for an editor with equally broad and deep interests—two too rare literary birds who were happy to have discovered one another's existence.

I'm happy to have this chance to thank Siobhan Drummond for composing a good, full index, whose many revealingly analytical entries make it easier to sense the emphasis of the text and the direction in which it moves.

Finally, I thank my daughter, Doreet, a book designer, and my granddaughter, Efrat, an ardent student of art history, for their help with the illustrations.

NOTE ON TRANSLITERATION

The spelling of Chinese words and names has created something of a dilemma for me. The vast majority of books on China have made use of the Wade-Giles transliteration, named after Thomas Wade (1818–95) and Herbert Giles (1845–1935). Although this transliteration is rarely used in new books, some contemporary books on Chinese art still use it. One example is Wen Fong's *Beyond Representation*, published in 1992, which is based on the holdings of the Metropolitan Museum in New York City. Another is Wen Fong's and James Watt's *Possessing the Past*, published in 1996, which is based on the holdings of the National Palace Museum in Taipei. Yet almost all the new books on China, including those on art, have adopted Pinyin, meaning "phonetic spelling," which the People's Republic of China has made official. There are, however, two considerations that have stopped me from dropping Wade-Giles. The first is that among the books I use and quote, relatively few are in Pinyin; and Chinese terms and names in general reference books are still mostly in Wade-Giles. For example, I looked at two excellent new English dictionaries, one published in 1998 and the other in 1999, and found they have no entries for Dao and Daoism, the Pinyin forms of Tao and Taoism. The second consideration for keeping Wade-Giles is that Pinyin uses a number of consonants with pronunciations very different

from those given the letters in English. The pronunciation of Pinyin departs most from that of English in the following: an initial c is pronounced ts; q is pronounced $ch'i$, as in *chart*; an initial x is pronounced sh; and an initial z is pronounced dz, like the sound at the end of *adze*. If the book were all on Chinese art, the frequency of the use of these Pinyin transliterations would allow readers to get used to them, but here, China appears and disappears, and I'd not want the reader to have to keep looking up the equivalents or to have the uncomfortable feeling that the pronunciation of the transliterated words has something mysterious about it.

The outcome of my dilemma is that all Chinese names and terms appear in Wade-Giles, but the first time any one of them is used—in the index, as well—the Chinese name or term is accompanied by its Pinyin equivalent in parentheses. When the name or term in Wade-Giles and Pinyin are the same, only one form appears. There is, of course, at least one anomaly: although I use the Wade-Giles form Ch'an (Chan) Buddhism in reference to China, in non-Chinese contexts the term usually appears in its more familiar form, Zen.

For reasons like those I have given, but spelled out in more detail, the new *Columbia History of Chinese Literature*, edited by Victor H. Mair, New York, 2001, also prefers the Wade-Giles transliteration (slightly modified).

AN OPEN AESTHETICS

WHY THERE IS ART

Food and sex are more necessary than art, but except for bare sustenance, food needs to be made attractive by art, and sex, to go beyond mere coupling or coercion, needs the seductive attractions that evolution and art lend it. Such is the testimony of the songs, displays, and shimmering feathers of birds of paradise no less than that of the fashionable clothing, songs, and dances of human beings. This is because the brain, which interprets the world's signals for us, is a necessarily curious, susceptible organ. It needs its native curiosity to probe the world, and its curiosity needs imagination to reconnoiter all the world's interesting possibilities and yet avoid the inconvenience or danger of actually encountering them. Imagination, in turn, needs art, or, rather, takes the form of art, in order to make its imagined possibilities less fugitive, more tangible, and more accessible to exploration. If, lacking art, our imaginations would not cumulate or have art's tangible bodies to explore and recall, it would be harder for us to keep our interest alive by entertaining ourselves with any of art's many forms. Then whatever remained of our ways of playing or of entertaining ourselves would be much closer to those of other animals and lack the mark and substance of human culture. In that case, granted that we were still approximately human, it

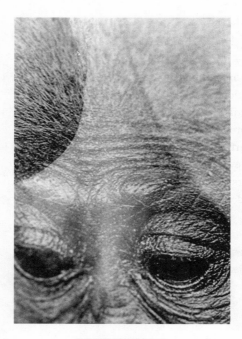

THE PERCEPTIVE GAZE.
PHOTO BY GHELA SCHARFSTEIN, 1990.

In this fused image, the ape looks right through the human. The photograph expands imaginatively on the fundamentals of evolution with which I begin this book, as does its companion picture of a chimpanzee painting in a human way. To make my point, I look back to the Chinese philosopher Hsün-tzu (Xunzi, c. 310–c. 210 BCE), a rationalist who thought that the forces of nature act together but are quite unconscious and quite unresponsive to human beings. According to Hsün-tzu, nature has endowed humans with emotions and faculties they can use to their own advantage, and the fully aware human, the sage, knows how to act in accord with nature. A sage completes the unconscious harmony of nature with his own conscious, natural, moderate understanding. Therefore the sage's eyes find greater enjoyment in the five colors, his ears in the five sounds, his mouth in the five tastes, and his mind in possession of everything.

We are now able to fill the evolutionary gaps in Hsün-tzu's thought because we know that our vision is inherited from the primates and their predecessors out of which we have evolved. As the fused ape-human in the photograph may suggest, our human curiosity, playfulness, emotion, and social needs originated in our nonhuman predecessors. In art, we make imaginative dramas of our experience and take pleasure in the conscious fruition of the seeds that nature implanted in our animal ancestors and, through them, in us. In our minds and art we complete nature by our awareness of it.

would be harder for us to escape boredom, and boredom would, as always, lapse easily into apathy, and apathy into depression, a disease that, in any case, too often afflicts us. Without art, which is to say, without the imagination that creates, appreciates, and embodies itself in art, human beings would be far sadder, duller approximations of what they in fact are.

In saying all this, I have of course been using my imagination, which is, I admit, a fallible prognosticator. But I am sure that human beings cannot remain human without art. How, otherwise, can we explain why art has existed among them at all times everywhere, why they have expended so much time, effort, and emotion in its pursuit, and why they are, with their senses, brains, and bodies, so often preoccupied with it? If I ask myself why art has existed everywhere among humans, I have a short and a long answer. The short one is: it is because art satisfies the inescapable human hunger for imagined experience in all of its imaginable variations. This hunger is our need to create, contemplate, possess, and repossess at least the shadow of what we do not have fully enough to satisfy us. Art is the instrument we use in order to give virtual presence to everything that interests us but is not effectively present enough to overcome the restlessness of an imagination too idle for its own comfort.

Think of the ways I have listed of responding to this need—first by creating, then by contemplating, and then by possessing and repossessing: We need to create art in order to respond to and exercise our imagination and our senses and by their means make the embodied equivalent, the embodied shadow, as I call it, of what we in any form want to experience, whether or not it has another, more literal existence. From the artist's standpoint, a person also needs to create art in order to undergo the effort of making something new or, if not new, made with the passion of renewal. The latter passion characterizes the artist-craftsman who is making a new example of something with an old, traditional form, but with a skill that cannot be taken for granted. The exercise of the skill is in itself exhilarating. When especially successful, it can culminate in the maker's feeling of astonishment and gratitude. How can one explain the birth of this object, this wonderful child, from this much less wonderful parent? As need not be said, except for their interest and ability in art, artists are likely to be more or less ordinary people, whose art depends on their imperfect nature, which they are characteristically hoping to transcend; and so the artist-maker, when bemused and exalted by the act of creation, can hardly escape a feeling of wondering parentage.

Usual as this metaphor of birth may be, I admit having been surprised to find it used by a traditional African carver. He had carved a mask for a ceremony of

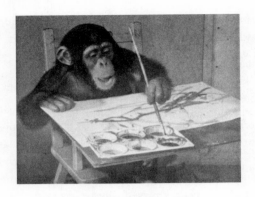

CONGO PAINTING WITH A BRUSH.
FROM DESMOND MORRIS, *THE BIOLOGY OF ART*, NEW YORK, 1962.

Among the many animals that engage in play, there is no obvious dividing line between the expression of biological needs, play, and what, in human life, is called art. Songbirds may well enjoy their singing. Cranes have spontaneous patterns of flight, beginning with a rapid bobbing of the head, that appear to human observers to express playfulness and pleasure and often spread from a single crane or pair of cranes to a whole flock. Elephants are affected by human music and have learned, with human help, to paint, that is, to engage in a form of play begun on human initiative and, at best, carried on to please elephants and humans alike. Much the same can be said of the painting primates, mostly chimpanzees, who in the twentieth century were initiated into art by human teachers, and who painted for the reward of human companionship or the pleasure of the act—not food—in a style that twentieth-century humans might call "lyrical expressionism."

The best known of these chimpanzee painters, shown here, was Congo, initiated into painting by the ethologist Desmond Morris, whose book The Biology of Art *chronicles the nature and development of Congo's paintings. As in the case of young children, among these "prehuman" artists, it is the act, not the result, that interests the painter. In the later twentieth century, when art and its tradition were put into complete question, there were artists who were impressed by the innocent integrity or, as the Austrian experimental painter Arnulf Rainer called it, the unadulterated mark or "sovereignty" of a chimpanzee's painting. Rainer, who had refused to study in art schools, was willing to regard a chimpanzee as his teacher, while, unbeknownst to himself, the chimpanzee reversed its role and became the teacher of a human. (Thierry Lenain,* Monkey Painting, *London, 1997, is comprehensive with respect to monkeys and apes. The only monograph I know that compares the art or "art" of human and nonhuman animals and describes the successful attempts of humans to encourage elephants and apes to engage in painting—and for elephants, music as well—is my own:* Birds, Elephants and Other Artists: An Essay in Interspecies Aesthetics, *Tel-Aviv, 2007. This book is in Hebrew; the English version is unpublished.)*

the women's secret society, but when he saw the mask emerging from the bush, it was now a proud man spirit, with many women running after it. He said:

> It is not possible to see anything more wonderful in this world. His face is shining, he looks this way and that, and all the people wonder about this beautiful and terrible thing. To me, it is like what I see when I am dreaming. I say to myself, this is what my neme [spirit] has brought into my mind. I have made this. How can a man make such a thing? It is a fearful thing that I can do. No other man can do it unless he has the right knowledge. No woman can do it. I feel that I have borne children.[1]

Having, like this carver, become a parent, an artist-maker is emotionally responsible for the object that, regardless of how it looks or sounds, must in some ways be a testimony to its maker's traits. Even when taken to be the fulfillment of a traditional task, every work of art therefore embodies signs of a more or less definite personality and carries some personal, even if unconscious, message, though its identity may soon grow obscure. But as I will emphasize later, the message is also impersonal, in the sense that it is meant to be delivered to anyone anywhere, a complete stranger no less than an intimate friend, with the same force.

As well as creating, we need to contemplate art in order to make our lives fuller and more focused. In its contemplation, we learn to demarcate ourselves more clearly and, at the same time, become both more individual and more social. This happens because the arts are like speech, itself an art, in that they help to join persons who regard one another as individuals into a kind of community. Individuals who seriously contemplate the same art weaken the barriers of strangeness that might otherwise separate them from one another. The contemplation of art helps us to respond to its impersonally personal messages by sensing the bond between its other real and possible viewers. Those who contemplate the same kind of art at least begin to enter into the same aesthetic community and, beyond the community, a whole similar aesthetic world. I anticipate that this idea will come to life as I describe the art, the artists, and the ideals of the great worlds of art.

Along with creation and contemplation of art, I have said, there is the need to possess and repossess it, which is the need to keep directly before our eyes whatever nourishes the perceptions we prefer to have. By having the art we prefer visibly before us, we feel we are fulfilling ourselves and, by means of our idiosyncratic choice, are becoming the individuals we have chosen to be. Each time that we take pleasure in or remember the art that we possess, our imagination acts

to possess it again. For this reason, the art that we possess asserts, enriches, and extends us: as individuals, we are (also) everything that, by need or hunger, we have made or acquired. Of course, the worth of the art we have assures us of our own worth; but along with the art, we acquire sensitivity to something other than ourselves, the messages that it conveys.[2]

As we know, the messages conveyed by visual (or other nonverbal) art, by which I mean mostly painting and sculpture, cannot be put into words without great loss. Visual messages can be fully conveyed only by means of their colors and shapes, which in turn arouse kinesthetic and synesthetic responses, for which there is hardly any vocabulary—how well can anyone describe the sensation of muscles as they tense or relax and joints as they move, or how well can a synesthetic person describe a color's sound or a sound's color or taste, which to the person are (often) absolutely real?[3][*] Whatever their medium, the messages resonate with often unnamable emotions and half-hidden memories. Even though we may not grasp these messages accurately, the desire to distinguish between them sensitizes us, and we improve at least the ability to discriminate between them. In this way, works of art become an individual form of aesthetic wealth, a resource for enriching our particular lives.

Everything I have said up till now will be developed, qualified, and documented. For the moment, I turn to another, more personal question, which is why I have undertaken to write this book, with its ambition to go beyond the ordinary limits of aesthetics. The answer is that I want to go beyond the extreme variety of art, which everyone notices, and instead to show how art's variety is qualified by its unity, and vice versa. Free of the weight of the art historian's obligations, it is easier for me to explore significant detail more fully than is possible in a history that takes in the art of the whole world. My aim of course opens me to the charge of rashness. In my defense, I can only say that I have been interested in comparative thought and art for long enough to feel confident that I

[*] Alexander Luria offers the following account of a synesthete he was examining. The subject recalled, "When I was about two or three years old I was taught the words of a Hebrew prayer. I didn't understand them, and what happened was that the words settled in my mind as puffs of steam or splashes." In a psychological experiment this synesthete was "presented with a tone pitched at 2,000 cycles per second and having amplitude of 113 decibels." He reported, "It looks something like fireworks tinged with a pink-red hue. The strip of color feels rough and unpleasant, and it has an ugly taste—rather like that of a briny pickle. . . . You could hurt your hand on this." (References for each footnote appear in its accompanying endnote; throughout, footnote citations are bracketed and follow citations that refer to the text proper.)

can carry out my project in an intellectually responsible way.[4] The attempt to go beyond the frontiers of our own time and culture leaves me especially dependent on narrower, more specialized studies. But my own aim, unlike theirs, is to keep both the whole and its details in at least successive views. The great museums of the world now gather art from everywhere in the world, and I want to guide myself and my reader through these testimonies of different cultures without losing either the varying contexts or the panhuman resemblances. Newspapers carry reports of art exhibitions and auctions across the globe, and I want to understand what unites all these examples of art, aside from their physical presence in certain museums and aside from the auction prices they command. That is, I want to create a more than superficial framework of aesthetic and social conceptions that can embrace the art of all cultures. The metaphors that come to mind are those of the airplane and the computer, which allow us to see things as a whole from a great physical or psychological distance and yet to zoom down to examine details at close range and then zoom up again to views at greater distance, shrinking and stretching the distances so that we can catch sight from above of the places we recall and their extraordinary buildings, and even, at a magical extreme, peer through their windows and catch a tantalizingly glimpse of the shrines and works of art inside them. For seeing the individual artists, we need no magic nor any faces but only, if they still exist, their works and their words.

Here the difficult final question will be, Are the standards of judgment of the different worlds of art irreducibly relative? I already know that I will contend that these standards, although developed in relative isolation in India, China, Europe, and elsewhere, are practically and aesthetically related to one another. As I will show, they are related by everything that is similar in human conception, perception, and action—to put it very simply, by how all human beings see, hear, move, make things, and, generally, live. But they are also related by an empathic kind of communication, which is the irresistible tendency to create and respond to the impersonally personal messages of art. This tendency expresses the communicative nature of all human beings and, for that matter, of all social animals.

THE AESTHETIC DIMENSION OF LIFE

The statement I made above, that art exists in order to satisfy the hunger for imagined experience, is not by itself adequate. One shortcoming is that it is easy to assume that I used the word "art" in its relatively new sense, that of "fine art," which, by excluding the kind of art the European tradition does not value highly, has become too confining for my purpose. A shortcoming that appears to me

more serious is the possible implication that art is something that can be accurately separated from non-art, that is, from the less imaginative, more prosaic part of life. I reject this implication because I am sure that all of our consciously experienced life has an aesthetic aspect or dimension and, as such, is the general precursor of art, or, better, the indispensable elementary material of which art is made. I know that you may have good reason to object to my view that we can react to anything and everything as possible art.[5] I therefore want to explain why, even if your view is justifiable, I prefer my own. To explain, I have to, first, make a point about choosing among conceptions of art, and then clarify the idea of the aesthetic aspect or dimension of life.

The dictionary of current English I am holding in my hand has nine definitions of art, some with subdefinitions, none of which it would make sense to dispute. If we aim the question "What is art?" broadly, beyond the Western tradition, we get as many different answers as there are cultures; and if we hope for an answer that is more than a set of successive descriptions, we seem destined to a generalizing superficiality or an honest failure. Failure to me would include any extremely relativistic conclusion. In fact, the difficulty is greater than it may at first seem, because when I say that we would get as many answers are there are cultures, I am oversimplifying—each culture has invented a variety of conceptions; and if I wanted to go on, still decently but with a subversive stubbornness, I would add that in all the great art cultures there have been many persons with individual conceptions of art, of which detailed histories of art have the obligation to take notice. Yet I am committed to formulating a view of aesthetics that is in principle relevant to all cultures.

It is because of this commitment that in the concluding chapter I try to find common ground among the most characteristic aesthetic conceptions of many of the art cultures with which I deal. These cultures include Europe, whose aesthetic is suffused with intimations of Neoplatonism; Africa, in which one of the two peoples I take up in detail require their art to show "goodness" and "clarity"; India, whose art theory, based on poetry and poetic drama, asks for aestheticized, depersonalized emotions; China, whose aesthetic is based on "reverberation of the life-breath," the force that animates everything; and Japan, where sensitivity to aesthetic beauty is tempered with regret for beauty's imminent end. I try, seriously, to find what all these forms have in common but, I must admit, with only very partial success, tempered with the idea that, despite their differences, they share a common universe of discourse. Obviously, then, any aesthetic theory I construct has to apply to all these different and, in some respects incompatible,

aesthetic theories without denaturing any of them and without surrendering to empty platitudes.

The way out is to recognize that an aesthetic view or theory is not a truth that can be denied only by spurning the revered tradition that discovered it, blinding oneself to the light of its self-evidence, or attacking the barricades that philosophers have built up to defend it. The way out is to regard a proposed aesthetic theory as neither more nor less than a tool meant to solve the problems that its author has set, for whatever reason. The problems I have set myself and my readers encompass an irreducible variety of cultures, so different from one another that even their broad similarities, when examined closely, show notable differences. For example, among the cultures I have enumerated, it is fairly usual to distinguish between artisans, who are ordinary workers, and artists, who, if successful, are regarded as inspired and are dignified with the highest praises. In pre-Hellenistic Greece, potters, painters, and sculptors might be admired or admire themselves for their skill, but they were, socially speaking, workers; only poets and their like could be honored as inspired creators. In ancient China, potters and sculptors were ordinary workers; true artists, as we would call them, had to be poets or calligraphers, or by relation at first to calligraphy, painters (but for a long time, not professional ones). In India, the inspired artists were the poets and poetic dramatists. In Africa, the notion of "artist" is sometimes applicable and sometimes not; and the position of sculptors might be either high or low. Japan may be unique in that it granted great dignity to artisans it recognized as superior transmitters of precious traditions. Today in the West, it is still usually true that the artistic status of a potter falls well below that of a sculptor, and the status of a weaver, textile designer, or graphic artist below that of a painter. A theory meant to encompass all these differences in status cannot commit itself to favoring any one of them. It must be flexible enough to be applied to all the arts and crafts that are essential to the great dance-dramas of Africa or Polynesia and Melanesia, even when the peoples involved distinguish mostly between what is well-made and ill-made and not between artisanship and art. Briefly, I do not contend that my conception of aesthetics is truer than any other, but only that it is the most useful I know for an aesthetics that means to be equally open to all the artistic traditions.

I return to the idea of the aesthetic aspect or dimension of life. As I use the term, the aesthetic is anything in experience that is other than the merely literal or practical. But the aesthetic and literal or practical I distinguish are inseparable, except verbally or imaginatively, from the acts, events, objects, or persons

of which they are, in the terminology I suggest, aspects or dimensions. How, then, can the aesthetic dimension be distinguished in words or imagination? The aesthetic dimension of experience is the free interest we take in our acts, our thoughts, and the functioning of our senses. It is in the mode of conscious experience, even when the consciousness is evasive and marginal; and it is in the mode of the consciousness of this consciousness; and in the mode of the imaginative response and the associative tie. It includes the small perceptual pleasures and exaltations of everyday life. It is the blueness we see as blue (and not just the sign of something else, maybe a bruise); it is the pain we feel, from a perceptual distance, as pain; the perception of another's smile as a smile; the changing geometrical relationships of the buildings as we pass them and the spatiality of the street and the sky; the stance of the neighbor's body standing before us; the wind as the wind-emotion's blowing; the sun as the imagination's response to its heat, light, motion, distance, and remote rule over the sky it lights. The feeling of the wind and seeing of the sun are touched with emotions and tinged with remnants of old memories. The seeing is most evidently aesthetic when it is colored with some exaltation, and when the feeling and seeing seem to be entering into us as if we were taking them in from our surroundings. This experience comes with the feeling that the world is in some way alive and full of vision. This, then, is an aesthetic aspect of the visible world taken in all at once by the simple act of opening our eyes.

The aesthetic aspect of ordinary experience plays a traditionally and, I think, emotionally fundamental role in each of the crafts and arts. The emotion is already there in the early love we all have for the feeling of our hands and mind when they work together to feel or change some object, as when they plunge together into water, mud, or sand, or together move, mark, bend, shape, cut, tear, or break anything. I say this out of experience that is common to us all, but the working together of hands and mind has an effect on the brain that can be roughly measured.[6*] In the crafts, this pleasure is refined into the cutting, gouging, smoothing, and decorating of a useful object, and into the pleasure taken in the object's shape, touch, and decorativeness. This pleasure emphasizes and

[*] Experiments showed that when part of a monkey's finger was stimulated many times in order to teach the monkey to discriminate between two vibrating stimuli, the area of the monkey's cortex that represented the stimulated part more than doubled. Similar stimulation of monkeys that were paying attention to something else had no such effect. It therefore seems that an animal's cortical map changes according to the animal's changing experience. Extrapolating from these experiments more generally, the active exercise of the mind is likely to enhance neural development in the brain of even mature persons.

is emphasized by the use to which the object is put, the affection in which it is held, and the value that is attributed to it.

The link between use, affection, and value is self-evident. I myself take pleasure in and even love the materials I hoard for use in drawing. The many pens I keep on my desk illustrate the value that accrues to anything I can write with. I used to attribute such value to a typewriter, which is now replaced by a computer. But the most striking examples of love derived from use are those of musicians' love for their instruments. Yehudi Menuhin describes his violin, part by part, as if it were a beloved woman and says, "I have always kissed the head of my violin before putting it back to sleep, as it were, in its case." The musicologist and pianist Charles Rosen says, "Pianists do not devote their lives to their instrument simply because they like music." They have to have a love for

> the mechanics and difficulties of playing, a physical need for the contact with the keyboard, a love and a need which may be connected with a love of music but are not by any means totally coincident with it. This inexplicable and almost fetishistic need for physical contact with the combination of metal, wood, and ivory (now often plastic) that make up the dinosaur that the concert piano has become is, indeed, conveyed to the audience and becomes necessarily part of the music. . . . The danger of the piano, and its glory, is that the pianist can feel the music with his whole body without having to listen to it.[7]

In sculpture, the pleasure of working includes the resistance and compliance of the clay to the fingers, the yielding of a particular piece of marble to a hand moving a specific chisel, and the flow of a certain metal into a particular mold—and so on, always in particular aesthetic responses. In painting, pleasure comes from the sticky thickness of the paint and the speed with which it goes on as it follows the motion of the arm that moves to the purpose that is set and reset by the mind. Arm and mind go into one another and become the same purpose and pleasure. In his poem, "To the Hand," Rafael Alberti says it this way:

> To you, tremor & steadiness, guide
> of the eyes' thread, mysterious line of sight
> which flows thence to the brush's underside?
> and sets it in a germinative light.[8]

The mere ability to work has made a painter cry with pleasure. Disabled by the collapse of a spinal artery, Chuck Close had to learn how to paint again. When he looked at the paintings by Petrus Christus and Hans Holbein in the Metropolitan Museum of Art, he realized, he says, that all that he loved in the history

of painting, especially portrait painting, is small and tight and the product of fine motor control, which he had lost. "I was depressed for days," he recalls, "but then I ended up with a cathartic experience because I found myself in my studio feeling so happy just to be working again that I was literally whistling while I painted and at the same time tears were streaming down my cheeks."[9] What brought him to that place was a rare kind of event, but in his struggle to create again, in any way, he touches on something true for all artist-makers.

I don't mean to imply that the work of arm and mind is either jointly or separately always and in every way a pleasure. It's dirty, the materials get perversely resistant, the mind goes numb. Each morning, as James Elkins tells us, the painter faces

> going into a room suffused with the penetrating sharp odor of turpentine and oil, standing at the same table, so covered with clotted paints that it no longer has a level spot for a coffee cup, looking at the same creaking easel spattered with all the same colors—that is the daily experience of all serious painters, and it is what tempts insanity.[10]

But sensuous and spattered materials apart, all of us are unknowingly artists. This conclusion emerges from the fact, to which almost no one pays attention, that we all spend a great deal of time every day in practicing what ought to be recognized as a complex and extraordinarily subtle art. I am referring to the art of speech. To begin to make the point, I quote the poet Robert Pinsky, who is struck by our surprising ability to identify poetry by the sound it makes:

> Because we have learned to deal with the sound patterns organically, for practical goals, from before we can remember, without reflection or instruction or conscious analysis, we all produce the sounds, and understand them, with great efficiency and subtle nuance. Because of that skill, acquired like the ability to walk or run, we already have finely developed powers that let us appreciate the sound of even an isolated single line of poetry—even if we have very little idea of the meaning—that someone might quote with appreciation.[11]

Speech is the most intensively learned, widely practiced, and sensitively employed of all the human arts. True, its instruments are parts of our bodies, but so are the singer's vocal cords and the artist's hand, while the dancer's instrument is the body as a whole. An ordinary person's control over the organs of speech is as delicate and nuanced as that of a musical instrument by a good musician—it involves the coordination of about a hundred muscles.[12] The con-

trol of the speaking voice must be as deeply inbred as the bowing, finger work, or breathing patterns of a musician who began to practice in early childhood.

The voice, the vehicle of speech, is probably the musical instrument—percussive instruments excepted—in relation to which all other musical instruments are innately measured. Every kind of emotional response elicits its own half-instinctive vocal contour, and every person has a vocal contour and quality that are characteristic of only that individual but that, all the same, do not obscure the meaning of the spoken words. The inherent musicality with which the voice composes speech is evidently necessary for human relations. The musicality of the voice also causes music of every other kind to carry intimations of speech. This makes it impossible for us to divide ourselves into purely musical and purely verbal, or purely aesthetic and purely utilitarian creatures. The utilitarian aspect of speech is as a rule so hard to divide from its aesthetic aspect because speech is the constantly improvised art by whose means we react to and control our everyday life. When its expressiveness is heightened by the motion of the arms, shifting of the body, and changing expressions of the face, speech has much of the quality of a contained but spontaneous dance.[13] In using the art of speech as its instrument, poetry, especially formal poetry, transforms one art into what is almost another; in sung music, the transformation goes further, though it leaves the words something of their word-nature.

There can be doubts. It is easy to define art so as to exclude ordinary speech. Ordinary speech is neither bought nor sold nor put on exhibition, and when recorded, loses its improvisatory quality. Besides, ordinary speech is not the defining activity of the specially trained persons who are designated as artists, likely to live in the company of other artists, to read art periodicals, to wear identifying artist clothing, and to hope that their work will be recognized enough to make them famous and rich. Here one and there another artist is great by any human standard. Ordinary speech is too usual for all that. If we sang our speech like the characters in an opera, talking would be much louder and take much longer, but it would still be too usual. We don't notice that speech is such a great skill because we all use it all the time. Like the air we breathe, we pay attention to it mainly when we lack it, when, for instance, we are in a country whose language we cannot speak.

The skill that speech requires and the natural pleasure that we take in using it are in themselves enough from my standpoint to justify calling it art. As I've said, considered along with facial expression and gesture, it is also a highly subtle medium for expressing emotion and for relating persons in act and in emotion.

If the measure of an art is the difficulty in putting its success into words, then, for me, speech is an art, and I would fail if I tried to write an accurate description of its shifting momentary nuances. The spoken moments that go by are indescribable and irrecoverable, except in memory, which keeps but also reshapes them.

Like every art, speech is unique, with its own inherent effects. Sometimes, at rare moments, like a large wave rising above smaller ones, speech can excite us with its spontaneity, inventiveness, and eloquence. As with the other arts, this sense of fulfillment arises out of our own skills, concerns, and pleasures. The philosopher Roman Ingarden (1893–1970) is said to have been a poet of objects and would talk about the role of everyday things in our lives with an extraordinarily infectious interest. One of his students remembers that

> one day, after he'd given one of his most inspired lectures on the life of objects (and when he talked he was really talking about our world), he took a fountain pen from his jacket's inner pocket, probably to jot down a few words, one of the little discoveries he'd made for us in the course of that unforgettable, endlessly generous hour. But we couldn't suppress a muffled sigh of rapture: that beautiful fountain pen, black and shining, suddenly struck us as an object from legend, from another species of beings, from a family in which its brother was the unicorn and its sister was the nymph Calpyso.[14]

Here I must add a word on the relation between ordinary speech and poetry. Although poetry can be regarded as an art that uses speech as its raw material, speech has certain advantages over poetry as we usually read it. The reason is that poetry in its printed form has been stilled, while speech—living speech—retains the charm of its unpredictability and the emotional warmth with which it connects us. Maybe that's why so many of us spend so much more time talking with one another than reading poetry. When I say this, I may be almost joking, for the flow of conversational intimacy is surely essential to our being. Does it follow, then, that the person who achieves conversational eloquence is equal to the poet? I think the question is interesting, but it makes sense not to answer it, because, for the imagination, conversation and poetry contain one another. They contain one another, all my argument has been saying, because imagination, which is poetic in a more than technical sense, is present everywhere, sometimes even in what may seem to be its absence or its opposite.

Having said this, I cannot find either in myself or in anyone else just what poetry is because poetry has as many aspiring essences as there are poets and occasions for poetry. To avoid this hesitation, I quote Robert Frost and Wallace

Stevens, both thoughtful poets, on the nature of poetry. Frost, venturing a few definitions, begins, "All poetry is a reproduction of the tones of actual speech." He ends his group of definitions by saying that a poem, which starts in a home-sickness or a lovesickness, "is a reaching out toward expression; an effort to find fulfillment. A complete poem is one where an emotion has found its thought and the thought has found the words."[15]

Speaking in a quite different voice, Wallace Stevens notes that reality has come to press on us so heavily that it is the poet's duty to press back. Therefore poetry now is "a violence from within that protects us from a violence without. It is the imagination pressing back against the pressure of reality. It seems, in the last analysis, to have something do with our self-preservation; and that, no doubt, is why the expression of it, the sound of its words, helps us to live our lives."[16]

That life always has an aesthetic dimension is something, as I have said, that can only be suggested, not proved. Even to call it a dimension is to divide it from its matrix, life as a whole, and give it a too separate existence. But there are advantages in thinking of life as always having an aesthetic dimension. If life is always also aesthetic, art can plausibly be explained as a heightened, more highly focused embodiment of ordinary pleasures and perceptions.

I'm sure that common and uncommon experience bear out what I'm say-ing, but let me confirm the relation between the impulses of ordinary life and devotion to art with the help of a psychological study of museum profession-als—curators, educators, directors of major collections of art, and the like. The psychologists who conducted the study, Mihalyi Csikszentmihalyi and Rick Rob-inson, summarize "a possible basic definition of the aesthetic experience" from their study of the museum professionals:

> On the analysis of what we have learned, we can define it as an intense involve-ment of attention in response to a visual stimulus, for no other reason than to sustain the interaction. The experiential consequences of such a deep and autotelic involvement [an involvement that has its end in itself] are an intense enjoyment characterized by feelings of personal wholeness, a sense of discov-ery, and a sense of human connectedness.[17]

If we take life in all its manifestations to be almost always also aesthetic, it is easier to explain why the arts have taken so many different forms and have nevertheless seemed to us to be so much alike, identifiable emotionally or imagi-natively as art in spite of their variety. And if we grant that all experience has an aesthetic dimension, it becomes easier to understand why contemporary art has no clear boundaries at all, not even academic or institutional ones. I think that

in becoming open to all the varieties of experience, contemporary art shows that it has tacitly adopted for itself the view for which I am arguing. That's why art today so often seems to be just an accentuation of some episode or characteristic of everyday life.

There is one more advantage to this idea of the aesthetic dimension. It has to do with the very concept of art. As I have said, what we now call art might not be singled out as such in other cultures. Does the ritual use of an object, which is shaped, decorated, and consecrated only to make it ritually effective, allow us to consider the object to be a work of art? The idea of the aesthetic dimension of normal human perceiving makes it possible to answer this question with a yes. The creators of such a ritual object took its artfulness for granted, or felt the artfulness to be only a way of marking the object to show how important or precious its use made it.

Of course, there are many possible relations between the use of an object and its character as art. For this variety, anthropologists are especially good witnesses. Thus, for example, Howard Morphy writes, "A Marquesan club . . . possesses many of the attributes of art—fine craftsmanship, aesthetic appeal, signs of status and religious symbolism—but it could also be used to crack someone's skull. Its functional attributes as a weapon have no necessary connection with its attributes as art." However, "its capacity to destroy may interact with aesthetic aspects of its form to give it particular connotations as an art object that it may not otherwise have had"[18]—like bows, swords, lances, and armor, and like lovingly crafted guns.

David Maybury-Lewis, another anthropologist, reads art into the whole life of the villagers he is observing, the Xavante, of the Mato Groso in Brazil. The Xavante, he explains, climax their important ceremonies with relay log-rolling races, which have an electrifying effect on everybody. Strangely from our standpoint, members of the side that is winning, maybe because they are rolling a lighter log or have more and therefore fresher runners, drop back to help the losing side and make the race more even. As the surprised anthropologist reports on the end of a log-race in which he has taken part:

> The two logs arrived in a virtual dead heat. Pandemonium. Everybody seemed to be speechifying or shouting or just yelling with glee. It was by common consent the most beautiful log race that had been celebrated for a long time. It was then that I understood. It was not a race at all, at least not in our sense. It was a ceremony, an aesthetic event. Xavante meant it when they asked if it was beau-

tiful. They were as nonplussed by notions of winning and losing as we might if a Xavante turned to us at the ballet, after watching the principal dancers leap athletically off the stage, and asked, "Who won?"

. . . The running of the logs expresses the dynamic tension between opposing principles. The purpose of the ceremony is to stress that these antitheses need not tear the world apart. . . . And what better symbol of equilibrium than two teams that exert themselves to the utmost and finish in a dead heat? At last I understood that this was the ideal, the most perfect outcome of a log-running, for it established the perfect synthesis.

Maybury-Lewis says that all Xavante activities of any importance are carried out by opposite social groups, moieties, which interact and reflect the search for harmony by alternation, interaction, and reconciliation, weaving every individual into the mesh of village relationships. He thinks of Xavante aesthetics as "concerned with this whole pattern of living. The beautiful things they produce—the mats, the baskets, the songs and dances—are merely contributions to their major art form, which is life itself."[19]

The broadening of the idea of art is justified because nothing made by human minds or hands, nor any human act, is without its aesthetic origin and aura. In this light, I agree with Joseph Beuys when he says that everyone is an artist. I add, in parallel, that everything we make is at least on the verge of art, an expression of its maker's characteristic skill, imagination, and aesthetic sensibility. Even when we ourselves make nothing but only look at what somebody else has made, we undergo the experience of being aware, of seeing, of remembering, and often of preferring.

I now take up these factors of experience—being aware, seeing, and remembering—one by one.

BEING AWARE

However much is still beyond the reach of science, it would be unreasonable to decide in advance that research into the abilities of the brain has nothing to contribute to aesthetics. Yet a survey of what is known about the brain, though fascinating, is also disappointing, as one expert says, because "the linking mechanisms between brain activity and subjective experience are unknown." Semir Zeki, whose field is the visual brain, is full of the desire to work out at least the outlines of a biologically based aesthetics, but he acknowledges that the explanation of how we see and why we feel about it as we do is still quite imperfect. He

says, I imagine with a sigh, it is "difficult to say much, if anything at all, about how and where the aesthetic experience that a work produces arises, nor yet about the neurology underlying the emotional experience that it arouses."[20]

What about consciousness, the eternal crux? If Zeki sighs, it is not because he is simply frustrated but also because he has come to see that consciousness is so divided and subdivided in space, time, and function that its unity in the perceiving person seems utterly remarkable. In his terminology the unified consciousness, the I of each of us, depends upon our macroconsciousnesses, which depend in turn on our mircroconsciousnesses. He gives macroconsciousnesses their name because they unite more than one attribute—more than one microconsciousness—for example, of color and motion, or color and sound. They need to be bound to one another not only because of their different sources—the different microconsciousnesses—but because these sources, each of which has a partial autonomy, perceive at a different speed: location is perceived before color, and color perceived before motion. The unity of the act of seeing something, which seems so elementary, is in fact the outcome of a whole hierarchy of processes.[21]

There are attractive hypotheses to explain the structure and function of consciousness, but consciousness has no accepted scientific explanation.[22*] This admitted ignorance does not deter the experts nor should it deter us from paying close attention to the variations in degree or kind of consciousness that play so great a role in our reactions to life and, of course, to art. When we reflect on our visual consciousness, we become aware of how mutable it is or, to put it

* In one hypothesis of consciousness, the neurological researcher Antonio Damasio distinguishes between three basic levels of self, two of which are levels of consciousness. First there is the "proto-self," which is unconscious. The proto-self is the temporary coherence at different brain levels of the neural patterns that represent the state of the organism. Then there is the "core consciousness" or "core self," by means of which you feel that you are the protagonist of the act of knowing. Generated and regenerated by whatever stimulates the proto-self, the pulses of core consciousness—none of them verbal—are like shadows that accompany the flow of images of the perceived objects. The sense of self arises again in each of the pulses that together create the sense of a continuous consciousness, none of which is verbal (Damasio's account of perception resembles the Buddhist theory of knowledge). The third level of self is the "autobiographical self" or "extended self." This self is based on the implicit memories that constitute the unchanging aspect of an individual's autobiography. "In extended consciousness, the sense of self arises in the consistent, reiterated display of some of our personal memories, the *objects of our personal past*, those that can easily substantiate our identity, moment by moment, and our personhood."

differently, how numerous its variations are. Take visual concentration, for example, without which no one can make a serious assessment of a work of art. Visual concentration requires that one's consciousness be fully alert and focused exactly on its object, which is lit up, speaking metaphorically, as consciousness shines its intense awareness on it. An art expert who works in a museum recalls how concentrated the observation of a work of art can be:

> There's nothing like it. I just get wrapped up in it. I mean, a bomb could fall next door and I'd be oblivious to it. I can get so wrapped up with an object, looking at the vase, painting, or studying the object, whatever it might be, that you're unaware of the phone ringing or people coming in the door, you just get so wrapped up. It's a total escape.[23]

When intent on the creation of something new, consciousness focuses on its unknown goal and shifts, searching, from one association—which comes, it seems, from nowhere—to another. In defiance of everyday logic, the effort draws together images, ideas, and memories in which the imagination can find even the slightest connection with one's experience, consciously remembered or not. Maybe some of these associations are, or arise from, random fluctuations of thought.[24] If they do, the ability to create something original is also the ability to draw productively on randomness—the Taoist says that something comes out of nothing—or, to change the emphasis, to draw on conceptually irrelevant acts or habits. If you ask for an example of such a conceptually irrelevant habit, I'll cite Bohumil Hrabal, a novelist imaginative enough to inspire himself by leaving periods out of his text. His character Bondy uses an even more out-of-the-way method to inspire himself to write poetry:

> When Bondy the poet came back pushing the baby buggy with his two offspring he told me in great confidence that he wrote poetry only in the toilet with a pastry board on his knees and a notebook on the pastry board, but now the babies have started walking and pounding on the door, it's enough to bring down a Goethe.[25]

Hrabal is trying, successfully enough, to make us laugh, but his Bondy inspires himself no less oddly than some flesh-and-blood writers, as the following account by Diane Ackerman suggests. The example of method at the end is as funny as Bondy's, but it implies, sadly, that one poet had to help herself by imagining her own death (which someone who disliked her seems not to have objected strongly to).

What a strange lot writers are, we questers after the perfect word, the glorious phrase that will somehow make the exquisite avalanche of consciousness sayable. We who live in mental barrios, where any roustabout idea may turn to honest labor, if only it gets the right incentive—a bit of drink, a light flogging, a delicate seduction. I was going to say that our heads are our offices or charnel houses, as if creativity lived in a small walk-up flat in Soho. We know the mind doesn't dwell in the brain alone, so the where of it is as much a mystery as the how. . . . Dame Edith Sitwell used to lie in an open coffin for a while before she began her day writing. When I mentioned this macabre bit of gossip to a poet friend, he said acidly, "If only someone had thought to shut it."[26]

I go on, less imaginatively: Consciousness has levels and kinds. Like scientific observation, personal experience teaches that when we divide our attention, consciousness splits and part of it grows almost automatic, that is, semiconscious.[27] A person driving a car and talking at the same time manages to pay attention to the other cars, the traffic lights, and so on, all close to automatically and is more attentive to the driving only when necessary. My wife, whose cooking is marvelous, sometimes cooks half automatically while she's deep in a telephone conversation, to which she has to be fully attentive, until something threatens to burn or—with the telephone held between her shoulder and ear—to slip from her hands.

Whatever the reasons, a good deal of our waking thought takes place with only a minimum of conscious awareness, which slips easily into unconsciousness and revives often without remembering that it has vanished for a while. Of course, tiredness, feverishness, drunkenness, and many other conditions lower the level of consciousness. More interestingly, conscious awareness slips into what can be called—in words that, taken too literally, are self-contradictory— unconscious awareness. This unconscious or highly selective awareness can be the finely tuned, subliminal awareness that wakes a mother when her child whimpers softly. Or it can be the veiled, narrowly focused awareness of someone under hypnosis, or the remnant of awareness of an anesthetized person who, otherwise unconscious, hears what the surgeon is saying.[28]

Evidently, consciousness or awareness is often only implicit. Implicit consciousness is implicit knowledge, and implicit knowledge is or implies implicit memory. For example, the implicit knowledge or memory we have of how to tie our shoelaces: long ago, when we were first learning how to tie them, we struggled some and had to be fully conscious, but now we tie them with no conscious memory of how we do it, and when we show a child how to go about tying

them, we're slower and clumsier than usual. Tragic examples of the loss of (only) explicit memory are given by those who suffer from imperfections, illnesses, or injuries of the brain.[29*]

I have recalled all this about degrees and kinds of awareness in order to make clear the varied possibilities of awarenesses in the light and the dark of which art is both made and appreciated. In chapter 2, I will take up some of the evidence that anthropologists have discovered that awareness is also culturally conditioned. The number of senses recognized is not always the same, and, as anthropologists have pointed out, senses or kinds of sensation may be emphasized and evaluated differently in different cultures.[30]

SEEING

To see, all we have to do is to open our eyes, but to understand what happens within us when we open them is anything but simple. This internal, wholly unconscious sequence develops rather like the process in which an artist creates a complicated work of visual art by fusing its simpler physical and imaginative elements. The seeing begins with an image on the retina, but the retinal image is only two-dimensional, and if it did not undergo visual processing it would be too ambiguous to make clear what in the world we were looking at. The rules of the processing that are already known reveal that they are rich, flexible, and coordinated enough to justify thinking of them together as an unconscious visual intelligence.[31] In order for objects to be recognized for what they are, the flickering, changing, two-dimensional images on our retinas have to be given stable, understandable, three-dimensional translations. That is, they have to be somehow recognized as the three-dimensional objects that we know because we have seen them before and have stored them in our memories as members of their particular classes of things. Since we recognize them generically as people, cups,

* Such cases are described by Antonio Damasio: "The foundational kind of consciousness, core consciousness, is disrupted in akinetic mutisms, absence seizures, and epileptic mutisms, persistent vegetative state, coma, deep sleep (dreamless), and deep anesthesia. . . . When core consciousness fails, extended consciousness fails as well. . . . When extended consciousness is disrupted, as exemplified by patients with profound disturbances of autobiographical memory, core consciousness remains intact. . . . It is possible to separate consciousness in general from functions such as wakefulness, low-level attention, working memory, conventional memory, language, and reasoning. . . . Patients with absence seizures or automatisms or akinetic mutisms are technically awake but not conscious. . . . Patients who lose wakefulness (the partial exception of REM sleep aside) can no longer be conscious."

apples, pictures, statues, or whatever, we know that they have to have been stored in memory in recognizable standard shapes.[32]* But, as we've seen, the neurology of visual perception is in fact much too complicated to fit any clear scheme so far devised. Color, form, and motion are not alone perceived separately but perceived at different speeds—within the limits of a second, color is perceived first; form, second; and motion, third. As Semir Zeki believes, "There is . . . a hierarchy of visual consciousnesses with the unified consciousness, that of myself as the perceiving person, sitting at the apex."[33]

How much of this evidence should we investigate in order to understand art better? The information appears to belong more to the general context of art than to art in and for itself. But art, which is never only in and for itself, depends on how things look, how the way they look changes, how they might look under other circumstances or be seen by other persons, and sometimes, how strangely they can and cannot look—by "cannot look" I am referring to strange visual lacks or kinds of blindness. In this, the conditions dealt with by the neurology of vision suggest or seem to mimic the varying emphases of art, especially modern art; and even when they do not, they lend the act of vision an extraordinary interest that can carry over into a sense of wonder at the pleasure we take in art, however abstract or far-out it may look to us.

We can understand this most easily in cases where something essential to ordinary vision is missing. Given an injury to a certain visual area of the brain, a person who sees objects but not their color loses the ability even to imagine colors and, in that very basic sense, to understand them. The corresponding kind of specialized consciousness—that is, microconsciousness—has simply disappeared (and yet, though not consciously conscious of the colors, the person who is unable to see them may to some extent remain able to match them). Or, given an injury in a different visual area, a person may lose the ability to see and, in

* According to the psychologist Irving Biedermann, everything we recognize by sight is constructed by our visual apparatus from combinations of twenty-four basic three-dimensional shapes, which he calls "geons." To make the shapes adequate for the construction, Biedermann further assumes that the geons have fifteen sizes and builds and can be joined in eighty-one possible ways. The resulting number of shapes is so great that it is easy to combine them into the objects that make up our visual world. But although the theory seems to be persuasive to those who have examined it in technical detail, it has its shortcomings. Its most serious lack appears to be that it does not explain how we are able to recognize the sometimes very different shapes of the same object seen from its potentially infinite number of angles of view.

an experiential sense, to understand motion, because, for that person, moving objects tend to disappear. This defect may even disturb the person's ability to hold a conversation because, when all movement is invisible, it is impossible to see the lip movements of whoever is talking. But someone with an injury that has the opposite effect is unable or almost unable to see objects, that is, to recognize or understand what they are, unless they are moving. Or the person will see motion but not what it is that is moving. But a person who is not able to distinguish a square from a long rectangle, or who mislocates objects in space, or who sees them without depth, does not lose all of the ability to see forms. Most strangely of all, a person who because of brain injury is totally blind may deny being blind (a condition named Anton's syndrome) and does not consciously experience the inability to see.[34]

Speaking for myself, to try to grasp the subjective experience of persons who suffer such visual difficulties is to make a near impossible attempt to reimagine the world, rather as we may find it hard at first to grasp what exceptional artists do when, with an imagination stranger or stronger than our own, they change the way the world looks. As I write this, I have especially in mind, the rare, dramatic illness of face blindness (in medical terminology, prosopagnosia). This blindness is the result of damage to the brain—usually, it seems, to the clusters of cells in the cortex that are dedicated to face recognition.[35] Face blindness must be a terribly disturbing illness: one looks at the faces of a father, mother, mate, and child—recognized by size, hairdo, voice, or clothing—but cannot recognize any of their faces. Imagine one day looking into the mirror and being unable to recognize your own face.

Such blindness is proof of the extreme specialization of the visual brain, which, in our present stage of knowledge, seems to be a mosaic of oddly divided abilities. But the image of a mosaic is so static and simple that I almost regret using it—even the attribution of a certain function to a certain brain area is misleadingly simple. Luckily, face blindness, though now found to be relatively common, is rare in its extreme form.[36] It is a sort of forced generalizing, a blindness to the individual members of a visible category. Someone afflicted by it may also have trouble recognizing individual members of other visual categories, for instance, particular makes or models of cars. Sometimes the face-blind person can recognize emotional expressions such as laughter and anger, and sometimes not. Now and then, every other perceptual ability seems to be normal. Every case, however, has its idiosyncrasies. There was the case of the farmer who could not recognize any human face but remained able to recognize the faces of his indi-

vidual sheep. And there was the face-blind person who saw all faces as flat white oval plates with dark eyes (this case reminds me of any number of modern paintings I've seen).

Oliver Sacks tells of the difficulties of a highly educated man with extraordinary musical ability. The man could recognize cartoons because they were stylized and had a minimum of individualizing detail, but he was blind to his own face and to the faces of his family, colleagues, and students. His problem with visual categories made it nearly impossible for him to recognize a glove as a glove. After he examined it with care, he defined it, with unusual skill, as "a continuous surface infolded on itself with, apparently, five outpouchings." Intellectually, the man was still very able. He had no trouble playing excellent mental chess.[37]

Since we will turn soon to the subject of memory, I add that it is suspected that in face blindness, the process of seeing as such is working normally, but the blind person is suffering from a memory disorder. The memory store of faces that are familiar has become separated from the memory stores for faces alone; that is, the integration between two different, strangely different, powers of memory has broken down.[38]

The ability to construct what we see by means of normal vision, along with the tendency of normal vision to create visual illusions when it is, so to speak, beyond its depth, and along with vision's potential deconstruction by injury, must be related to the ability of artists to construct and deconstruct the visual characteristics of the normal world. When European artists strove to be realistic, they learned with approximate success how to imitate the fully coordinated images that the visual system creates for us. But by the twentieth century, artists preferred the excitement that comes from altering the images' visual and psychological characteristics, and they taught themselves to break up the coordinated images into their visual elements, that is, their colors, angles, lines, planes, irregular shapes, motions, and anything else possible. Such aesthetic specialization, as it may be called, follows along the lines of specialization that are natural to the visual system. Neurologically speaking, the artists were pulling visual constructions apart into their elementary constituents and discovering how to fit the separate constituents to their new purposes. Semir Zeki, to whom art and neurology are by nature close, sees the whole tribe of artists as, in practice, students of neurology. He says, more generously than plausibly, "artists are neurologists, studying the organization of the visual brain with techniques unique to them." To me it seems enough to say that they are explorers of the possibilities that vision and imagination provide them.

What Zeki actually discovered about art is certainly interesting, but it does not translate easily into the answers for which ordinary aesthetics searches. Reporting on the results of brain scanning, he and Matthew Lamb, of University College, London, write that the scans show that naturally colored pictures of objects—of fruit, vegetables, animals, and landscapes—stimulate visual integration areas that unnaturally ("wrongly") colored ones do not. His experiments also show that the brain responds much more extensively when natural objects or scenes in their natural colors are viewed than when abstract paintings by Mondrian are viewed.[39]

As will become obvious, Zeki's work is a union of precise certainties, readily confessed doubts, and far-reaching aesthetic conclusions, in the present instance bearing on what he considers Mondrian's greatness. He is happy with Mondrian's art, like that of other artists he discusses, for the openly Platonic reason that Mondrian is not interested in fleeting appearances but in fixed, ideal constants, in Mondrian's case, straight vertical and horizontal lines that intersect to form squares and rectangles. These, says Zeki, reduce forms to their straight-line essence and, in their horizontality and verticality, create objective, universal beauty by reducing all forms to their constant elements, lines "that exist everywhere and dominate everything." Zeki is still fascinated by watching the cells in the visual cortex as they respond, time after time, with sensitivity to horizontal stimuli alone or vertical stimuli alone. He sees in Mondrian's insistence on vertical and horizontal an analogue to the orientation-selective cells that "are the physiological building blocks for the neural elaboration of forms" and allow the nervous system to represent more complex forms. "I find it difficult to believe," says Zeki, "that the relationship between the physiology of the visual cortex and the creation of artists is entirely fortuitous."

The results of these experiments by Zeki remain somewhat mysterious. He asks, but is unable to answer, why no memory area seems to be activated when we look at a Mondrian abstraction, or why the different parts of the frontal lobe are activated by naturally and unnaturally colored scenes. But whether the results are mysterious or not, Zeki contends that this experiment is, in a sense, "an important neurological vindication of the efforts of Mondrian and others to put on canvas the constant elements of all forms and colors."[40]*

*Zeki is sometimes but not invariably modest in discussing the accomplishments of what he and, following him, many others call neuroesthetics. He and his colleagues do their research at the Institute of Neuroesthetics of the Wellcome Laboratory of Neurobiology at University College, London. This research has the following five aims: "To further the

An interesting experiment by Richard Latto, which shows awareness of Zeki's views, is concerned with the reasons why there are some abstract shapes that are inherently attractive to us.[41] At the beginning of the twentieth century, Latto says in his introduction, artists, trying consciously to identify the primary features of aesthetically rewarding stimuli, made form completely dominant over narrative content, as it often is in music. The attractiveness of certain forms attests "that aesthetic pleasure is linked in some general way to neural activity, or more specifically that a form is effective because it relates to the processing properties of the human visual system." Such aesthetically primitive stimuli, he continues, were discovered by artists earlier than by scientists. In agreement with Zeki, Latto says that "particular forms are aesthetically moving not because they reflect the properties of the world but because they reflect the properties of visual systems that have evolved and developed to look at the world. We like looking at what we are good at seeing."

Latto then summarizes the scientific evidence that "observers with normal optics are best at perceiving, discriminating and manipulating horizontal and vertical lines." To test the aesthetic effectiveness of Mondrian's devotion to these two directions, Latto used eight of Mondrian's paintings, all consisting of hori-

study of the creative process as a manifestation of the functions and functioning of the brain; to study the biological foundations of aesthetics; to provide a forum for artists to keep abreast of recent developments in areas of visual research and technological developments that interest them; to instill among neurobiologists the virtues of using the products of art to study the organization of the brain; to promote the importance of learning more about the brain when approaching topics such as art, morality, religion, and law and public affairs in general, to as wide an audience as possible."

A recent critique by John Hyman contends that there is no support for the claims of Zeki and of the brain researcher V. S. Ramachandran that a neurological theory of art is in the process of creation. Ramachandran, Hyman points out, has gone so far as to claim that he has discovered the universal rule or deep structure that underlies all artistic experience. However, the technical evidence he cites, involving psychological "peak shift" (resulting from emphasis, like that of a caricaturist, on arousing features) is questionable, and his formulation of the rule, according to which the works of art we like activate the same neural mechanisms as those that are ordinarily activated by real objects, but more powerfully, does not seem exceptionally enlightening. Hyman admits that "neuroscience can explain some features of some paintings," but concludes "the idea that there is a neurological theory of art in prospect is utterly implausible." I think that Hyman takes his criticism too far when he says that Zeki does not distinguish between illustrations for his neuroesthetic theories and solid evidence in their favor. In my reading of Zeki, he is aware of how much he says is fact and how much is hope.

zontal and vertical lines alone. His object was to find out if the paintings' aesthetic effectiveness was changed when they were rotated clockwise and viewed at angles at most of which the lines were oblique. One of problems Latto had to deal with was the possible effect of the rotation of the frames rather than the lines of the pictures. Thirty undergraduates looked, one at a time, at the sixty-four projected slides and rated them for the aesthetic pleasure they gave. The result was that the original horizontal/vertical alignment was rated highest, though when the rotation was of ninety degrees and the lines looked horizontal and vertical, the superiority of the original position was not as great. Evidently, any rotation upset the balance of the pictures, but it was the obliqueness of the lines that detracted most from aesthetic pleasure. The experimenter's conclusion is that "Mondrian was right: we prefer horizontal and vertical lines because they are perceptually more powerful."

The experiment was carried out carefully, and the superiority of the horizontal/vertical orientation was shown to give more pleasure than the same pictures shown at oblique angles. But this need not be taken to prove that Mondrian's insistence on horizontal/vertical alone makes his paintings more powerful than those with different angles or entitles him to the superlative, to me extravagant, praise that Zeki and even Latto give him. After all, as Latto acknowledges, horizontality and verticality have always played dominant parts in human life, and after all, the right-angled crisscrossing of plaids and other designs preceded Mondrian's art. His art is, in its way bold, but it also signals his personal withdrawal, at least for a time, from a great deal of life. He hated not only diagonals, but also the green of nature.

Consider again Zeki's discovery that natural colors and representational styles stimulate the brain in more and in some sense "higher" visual centers than unnatural colors and Mondrian abstractions. This can be taken to show that natural colors and representational pictures have a more wide-ranging effect than abstract or unnaturally colored ones. We know that in the course of a child's development, prefigurative, abstract-looking drawings precede figurative ones. The fact that abstract or abstract-looking drawing comes earlier than figurative drawing makes it seem that abstract art or, more exactly, protoabstract art is more primitive in individual development than figurative art. Mondrian's thoroughgoing surrender to the power of the primitive directions of perception is also a return to a more rigorous version of the perception of early childhood. This does not mean, however, that the appearance together of horizontals, verticals, oblique lines, curves, verticals, and figures of all kinds in non-Mondrian-like art are a sign of such art's formal weakness or superficiality.

Mondrian, striking as he may be in the history of modern art, seems to me more an example of the stylized impoverishment of the resources of abstract art than of their intensification, a judgment that I would never make of Kandinsky or Miró. What I do, however, concede to Zeki and Latto is that recent art, by disassembling previous art into colors alone, shapes alone, and compositional elements alone, and by allowing all possible permutations and combinations of realism, abstraction, and sheer fantasy, has greatly intensified some of the powers of art (at the price of weakening or losing others).

REMEMBERING

Taken most simply, memory is the name we give to the cumulativeness in time of our awareness or, in other words, the connection of our awareness with our individual past. The particular memories or stretches of memory of which we are aware may be reconstituted from small shards, but our conscious awareness seems always to continue and contain the whole of experience, to be always "about bringing your entire history to bear on your next step, your next breath, your next moment."[42] And yet this, our whole continuous or continuous-seeming individual awareness, is a blend of fragments of our present and our past, our private fantasies, and of our emotions, from which many of our memories cannot be separated. No wonder, then, that when we create or observe works of art, we react personally and unpredictably, and no wonder that all those who remember works of art remember them quite differently.

This remark invites an account of two exhibits by the French artist Sophie Calle (b. 1953). One is "Ghosts," a "memory memorial" for absent paintings, made up of recollections by museum workers of the Museum of Modern Art, New York, who were asked to describe paintings that had been moved from their usual places. One person (surely not a curator) described Magritte's *The Menaced Assassin* as having "a lot of pink flesh, red blood, guys in black." Another (a framer?) remembered it as smooth and enigmatic, as, unfortunately, telling a story, as about five feet high and seven feet long, and as "framed in a plain, dark, walnut-stained molding." A third (who must be a film curator) said "it has a film noir sort of feel, a mystery novel look to it," and proceeded to describe it in visual detail, drawing on memories of the way Albert Finney was dressed in *Murder on the Orient Express*.[43]

Calle's exhibit "Last Seen . . ." has a more dramatic background story because it concerns the thirteen works stolen in 1990, by thieves dressed as policemen, from the Isabella Stewart Gardner Museum in Boston. To recall the stolen paintings, Calle exhibited large color photographs of them along with a text composed

of the memories of persons who worked at the museum. One person (probably a guard) remembered of Vermeer's *The Concert* only that the glare of the window struck the glass that protected it and made it invisible. Another person said of the figures, "I could hear them singing but it seemed very private, quiet, and pure. You felt like an intruder." Another, favorable memory is of something peaceful, to be looked at every morning before work. An unfavorable memory is of something disliked because not in the style the person preferred.[44]

I have not yet tried a formal, Calle-type experiment on my friends. But their informal comments, like the published comments of critics and descriptions by different art historians of the same works of art, suggest that it is not a great exaggeration to say that any one work of art is in effect as many works as there are persons who look at it.[45] As Calle demonstrates, the exaggeration becomes an almost literal truth when spectators are asked to describe the same work from memory. This variation of works of art in the memories of different individuals suggests that if each of us were allowed to look at a single painting once a year, each person's memory, being different, could serve the collective discussion of art during the year almost as if the discussion were of all the different pictures in the museum's collection.

Traditional art has of course depended on the memory of the community as a whole. Chinese painting, which was both a traditional and an individualistic art, was a knowing, subtle exercise in the recall of earlier kinds of brushstrokes, styles of composition, themes, and revered artists. These memories were open to anyone who had an adequate knowledge of Chinese art. But the memories that influence artists are also personal. These are surely hard for a stranger to disclose, but as everyone familiar with current art knows, it has become usual for artists to deliberately turn their personal memories into their art. Christian Boltanski (b. 1944), the French artist, can serve as a vivid reminder. In one interview he says that he has lied about his real childhood so often that he no longer has a real memory of it. Instead, like some traveling circus clown, he spins stories, pretenses about his childhood, which has become for him a kind of universal childhood. But "at the beginning of all the work," he says, "there is a kind of trauma. . . . I feel that there are some very important things that occurred at the beginning and only afterwards could I speak about them."

In another interview, Boltanski says of his art:

I had a score to settle with my childhood. The refusal to die was identified with the refusal to grow up, to become an adult. I wanted to show that situation as clearly as possible. Don't forget my artistic sensibility derives from my

personal mythology. . . . In 1969 I made my official artistic début by publishing a book of photos representing all the things that inhabited my childhood (sweaters, toys, etc.). This was a sort of search for a part of myself that had died away, an archeological inquiry into the deepest reaches of my memory. . . . What counts most in my work is not the medium, but the emotions and the images. My shadows are related to death. On the wall, one sees not the object itself, but its reflection.[46]

As Boltanski suggests, the memories that well up into a painting can have a traumatic origin. This is true of the black smoke and fire that have over and over invaded the paintings of the artist Melinda Stickney-Gibson, who went through a terrifying fire.[47] In contrast, ordinary emotion has been the usual source of the circles, spheres, ovals, and other shapes that present themselves, without conscious prompting, in the work of the American abstract painter Cheryl Warrick. In order to simulate and, at the same time, to create memories, Warrick paints one layer, which she sees as one day's emotional experiences, over another, and this over another, and over another, and over another. Then she scratches, erases, and scrapes to get back to the emotional past that is hidden within the lower layers of the painting. She says that this process of going down allows her to see how she has traveled through emotional space to become what she now is. Her images are described as emotionally powerful and as hazy and illogical as those in memories and dreams.[48]

. . .

The discussion of awareness, seeing, and remembering has aroused a general question that I feel obliged to ask and answer directly: Does an understanding of neurology change our aesthetic experience? Two main factors are involved in my question, the one, sensitivity, based, very often, on experience, and the other, information, mostly scientific. Sensitivity to the fluctuations of consciousness or to the interdependence of memories is essential to the aesthetic appreciation of many works of art, in particular, poems or films. Likewise, sensitivity to the qualities of pigments belongs by nature to the aesthetic appreciation of paintings, just as sensitivity to the qualities of stone or bronze belongs to that of sculptures. But does an understanding of the neurology of vision or of the geometric structures with which, the researcher supposes, we build the visual structures of the objects we see, change our aesthetic experience of the works of art we look at? What aesthetic advantage in viewing art can come from knowledge of the physics of light? What help do we get in the aesthetic appreciation of paintings from the study of the materials of pigments, or even of the way in which painters used

to grind their own paints? Assuming that memory can be explained in part by the chemistry of the interactions between synapses, does this knowledge make us better able to appreciate a book or a movie in which the memory of some event is crucial? Summarily, how much scientific knowledge is needed for the aesthetic appreciation of art? Isn't the ordinary ability to see, remember, think, and feel enough for all these purposes?

The best answer I can think of is that there is no good, that is, decisive answer to these questions—the reality is too fluid. Yet neurology, physics, materials science, and all the other kinds of scientific and unscientific information have a possible if usually vague effect on aesthetic appreciation. The sciences have their own forms of elegance or beauty, and this has motivated some of the great scientists, whose pleasure in the effort to understand might reach a near ecstatic culmination. This effort and experience are not alien to art. Certainly an architect who knows a good deal about building engineering can appreciate the aesthetic dovetailing of the art with the science. And certainly the person who invents or knows the equations for the evolution of an astonishingly beautiful series of color patterns in a computer is likely to have a more complex aesthetic-intellectual pleasure than someone who sees the evolving patterns without knowing anything about the process by which they are generated. The most famous set of such equations, the Mandelbrot set, "has provided an inspiration for artists, a source of wonder for schoolchildren, and a fertile ground for the science of nonlinear dynamics." The physicist Mario Markus, of the Max Planck Institute, is said to have an extraordinary aesthetic control over the set's "monstrously beautiful fractal images":

> The control Markus has over variables such as which equations to portray, which mathematical values to start with, what colors to assign to the values, what scaling and intensity level to use is, he says, like the control that the photographer exercises over his subject matter and is not just a mechanical pressing of the buttons on the computer. He argues, "The particular choices made by one person, as compared with those made by others, allow us to speak of a personal, recognizable style. Truly one can say that equations can be considered here as new types of painting brushes."[49]

Aesthetic appreciation always draws on the whole personality of the appreciator. It involves a complicated tangle of associations, among them, often enough, scientific ones. The person's associations lead waywardly in every direction. There is no formula for the relevance of associations, nor any doubt that their intricacy can enrich aesthetic responses. In this sense, the sciences, like any-

thing else that informs, may all be relevant. Anyone profoundly interested in an art, or for that matter, in any subject at all, is impelled by something between curiosity and love to search for more information of any kind, without asking whether or not it is formally relevant—the relevance is the hunger to know.

PREFERRING

Why do we prefer one work of art over another? To the extent that the answers to this complicated question are relative to culture or are expressed in terms of museum acquisitions or money, they will mostly be given in later chapters. It is needless to repeat that in art, as elsewhere, we prefer to escape boredom (though John Cage endorsed it, at least for those who listened to his music). What follows concentrates on preferences whose basis is either inborn or widespread enough to suggest that possibility. I begin with a discussion of a number of interesting recent experiments.[50*] These fit easily into the category of neuroesthetics. The first experiment, conducted by Semir Zeki and Hideaki Kawabata, has the aim of clarifying how the brain is involved in the choice between beauty and ugliness. The experiment makes use of functional MRI, which measures the rapid changes in the flow of blood that results from the need of active nerves for the oxygen carried by hemoglobin. The experimenters begin and end by asking themselves the same questions that Kant does in his *Critique of Aesthetic Judgment*. As they put it, the question is, "What are the conditions implied by the existence of the phenomenon of beauty (or its absence) and of consciousness (or its absence) and what are the presuppositions that give validity to our esthetic judgments?" To Kant's question they add their neurological assumption: "In esthetics the answers to both questions must be an activation of the brain's reward system with a certain intensity."[51] The answer they get is interest-

*In the immediately following pages, I summarize examples of both neurological and non-neurological research on aesthetic preference. For those who have had no experience in research, I feel it necessary to add that all research is subject to caution because it is in some ways imperfect and always turns out to be correctable. Surveys of research on a given subject are very helpful but are subject to a usual weakness: they are likely to put relatively poor research (research more poorly conceived or poorly executed) on a par with much better research. Even in capable, honest hands, there is a distinct tendency for the researcher to favor a favorite hypothesis. Even when it is practicable, double-blind research doesn't always overcome bias; about the triple-blind I'm not sure. Nothing replaces a careful, critical examination of the research on which one wants to depend seriously. For help in estimating a piece of research, it's best to turn to professional reviews, and best to read a few of them, because such reviews are apt to be skewed by professional rivalry.

ing because it shows that when their subjects—healthy, educated undergraduate and graduate students without special experience in painting or art theory—viewed paintings they felt were beautiful, ugly, or neutral, their choices were consistently reflected in the placement and intensity of reaction in a particular area of the brain. Each of the students had his or her own preferences among the many paintings—divided into groups of abstract paintings (having no recognizable subject), still life paintings, portraits, and landscapes—which the students were shown briefly on a computer monitor. Then, as they watched the same paintings, their order now randomly different, in the scanner, they each pressed one of three buttons to indicate whether the picture was beautiful, ugly, or neutral. Some of the results could be predicted. Whether judged beautiful or ugly, the portraits and landscapes showed up especially clearly in their usual brain regions specialized, respectively, for faces and places. What was unpredictable was that beautiful pictures produced the highest degree of activity in an area (the orbitofrontal cortex) known to be activated by rewarding stimuli, and the lowest degree in another area (the motor cortex); ugly pictures had the opposite effects in both areas. The beauty and ugliness of pictures are therefore shown to involve the same areas to opposite effect, creating a visual beauty and ugliness judgment continuum. This does not imply that these two areas alone determine the effect of pictures, or even anything connected with judgments of beauty and ugliness, because other areas are also activated by looking at pictures. Besides, both judgment areas are well connected with other regions of the cortex, one of which (the anterior cingulate), which reacted to the difference between beautiful and neutral, has been associated with the emotional states of romantic love, of the viewing of sexually arousing pictures, and of the pleasure of listening to music. Furthermore, the motor cortex, which is most sensitive to ugliness, is also activated by the conscious transgression of social norms, of fearful voices and faces, and of anger. The experimenters conclude that there is a linkage between the aesthetic sense and the emotions. They remain puzzled why the perception of the beautiful does not activate the motor system as much as that of the ugly. Finally, they concede that they have not been able to discover what constitutes beauty in neural terms.[52]*

*I allow myself only a brief note on analogous research on music, which seems to the experimenters themselves, while innovative and important, not as developed as they would like and not aesthetically sensitive or revealing enough. Tentatively, as experiments on animals, infants, and adults show, melodies that are consonant, in the usual sense, are preferred to those that are dissonant. Experiment also shows that there is some, though

Zeki relates the importance of this and similar neuroesthetic experiments to the primordial function of the brain to draw knowledge of the constant properties of objects and situations from the always changing flux of experience.[53] The visual brain helps to arrive at this knowledge by its functional specialization and processing. Its separate centers for the recognition of color, motion, objects, faces, and position in space are able to regulate the effects of stimuli—how, no one knows—so that they yield stable, useful information. When the same face is shown to each eye in different colors, the eye fuses them by disregarding the difference. Likewise there is temporal and spatial fusion of color, motion, and location even though these occur at different times and different locations. This unconscious visual processing carried on by specialized and subspecialized centers and cells is necessary for the construction of our basic concepts of objects and actions. That is, by innate, unconscious visual processes the brain constructs the concepts, categories, and norms needed for everyday life. We have a kind of subconscious lexicographer, or better, curator, who defines by pictorial ideal types what we consciously recognize when we see it. A cell in the primary visual cortex (area VI) is engaged in the process of abstracting in that it responds to, perhaps, verticality alone, without responding to what it is that is vertical, or a cell there responds to the color red alone, its sensitivity to red unchanged even when it is bathed in green light. The one cell is a largely innate verticality sensor and the other an exclusively red-color sensor, both of which would probably degenerate if they did not have enough visual stimulation early in life. Zeki writes:

often unclear, correspondence between particular music and particular emotions (sadness, fear, happiness, and so on); and that music calls up preferences (accompanied by measurable physiological changes) almost automatically. Music to which individuals have a response so intensely euphoric that it makes shivers go up their spines (as one experiment puts it) leads to measurable "pleasure" or "reward" responses in areas of the brain that respond to the pleasures of food, sex, and drugs such as heroin; unpleasantly dissonant music affects a different (parahippocampal) area; and merely pleasant music causes brain reactions different from those of either euphoria or displeasure. Evidently, music gives neural rewards and punishments. And, finally, there is the observation that "aesthetic listening," listening meant to evaluate certain musical cadences, affected the right, "musical," front-central brain more than purely descriptive judgments (judgments describing whether the same musical cadences, whether liked or disliked, ended with correct, ambiguous, or incorrect chords). The descriptive judgments affected both sides of the brain, that is, also its left, analytic side. The conclusion is that the neural mechanisms for the aesthetic judgment of music are different from those for descriptive or analytical listening to music.

By some neural mechanism of which we know little, a sort of idea of the object is built into the responses of single cells, so that their responses are no longer determined by a single view. . . . It is plausible to suppose that the result of this abstractive process is the creation of an "ideal" in which all the sensory experiences have been combined synthetically to generate a construct which, though dependent upon many particulars in its construction, is also independent of a given particular.[54]

Zeki goes a brave step further and speculates that the unconscious abstractive creation of perceptual norms or ideal types testifies to the power of the brain to generate complex personal ideals—bound together we do not know how—that depend on the individual's neurological machinery. If so, all ideals are brain concepts and, as ideals, may be realized not in life, but in art alone, in which their re-creation is a human refuge. This was true, Zeki points out, of the ideal love that motivated three of the greatest Western artists, Dante, Michelangelo, and Wagner. Their ideals were the result of their sensory lives, their inclinations, and their culture. "All three had formed an ideal of love in their brains that they never seemed to have attained in life and all three temporarily saw death as a possible relief from the struggle for attaining it." For them, art was the refuge that nothing else in life, not even actual love, could give them.[55]

· · ·

Many of the experiments on aesthetic preference use much simpler means than the neuroesthetic ones and at times reach conclusions that immediately seem plausible. This plausibility, though encouraging, is deceptive, because later experimenters usually (or is it always?) find flaws in their predecessors' work and propose alternative research strategies and different conclusions. This goes not so much to show their rivalry as to show that the experiments necessarily rob the behavior they test or replicate of its nuances and ambiguity. It is only by fault finding and slowly cumulative approximations that the experiments can become both clear and almost adequate.

I suppose these last sentences reflect the immoderate number of experiments and abstracts I have been reading and account for my decision not to try to represent them at all fully or systematically, but to take up only a few that seem to me representative or especially interesting.[56] I will skip over the experiments that show that, except for monotonous repetition, familiar art or music is preferred to the unfamiliar, and go on to those that distinguish between the reactions to art of right-handed as compared with left-handed persons.

Because the difference between right- and left-handed may explain some of

the most general preferences in visual art, I add some prefatory words on hand-edness and the brain: About 90 percent of all humans are right-handed, and of these, almost all but about 3 percent have their basic language and speech centers in the left hemisphere of the brain, where the areas for skilled hand-movement and for the articulation of speech adjoin one another. The life of the left, more analytical of the hemispheres, is the hierarchical, ordered flux of inter-acting neural systems that most clearly distinguishes the workings of human brains from those of other mammals. It is the hemisphere of grammar, seman-tics, and lexicography, which it uses to help fix the sequential logic of speech and thought. It uses this power to solve problems and, out of the need to solve them, gives everything an explanation, in this way generating answers, some true and some false, the false with the help, often, of false memories. Along with the logic of speech, it controls the right hand and fingers, with which it makes out spatial details—the curvature, smoothness, and so on, of objects by means of both sight and touch. It also processes the information of the right visual field of both eyes (right visual field because each hemisphere serves to process half of the visual field of both the right eye and the left eye).

Left-handers are much more variable than right-handers. Most often their speech center, like that of the right-handers, is in the left hemisphere of the brain; only about 25 percent have it in the right, close to an area for the left hand and fingers and the memory for shape (the two noninvasive ways of determin-ing the location of a left-hander's speech center is by means of fMRI or fTCD (functional transcranial Doppler sonography).[57] The right hemisphere is more concerned with orientation in space, with visual motor tasks (such as, in tests, assembling colored blocks to match a pattern), with emotions and with music, and with the recognition of objects and, notably, of faces. It is often thought to be the more holistic or global of the hemispheres. It has some language ability (in matching words with pictures, categorizing objects, intonation, and rhyming, and is more wide-ranging in its memory and recognition of alternative mean-ings of words). It governs the left hand and fingers, and it processes data from the left visual field. Its visual areas, except for the primary ones mapped as V1, are larger than the corresponding ones on the left side. Out of respect for the still bewildering complexity of the brain, I refrain from some of the usual sweeping distinctions between these like/unlike complementary halves.[58*]

*The hemispheres of the brain are joined by two neuronal bridges, of which the larger and much more richly connected is the corpus callosum. All or most of this connecting area has been severed to relieve epileptics of their otherwise untreatable seizures. Recent

There are also persons who are cross-handed, that is, who prefer one hand for some activities and the other hand for others—the mostly left-handed artist, Adolph von Menzel (1815–1905) said that he painted in oils always with his right hand but drew and painted in watercolors and gouache always with his left. A very few persons are genuinely ambidextrous, able to use either hand equally well for any activity.

Schemes have been worked out to describe left-brain-oriented and right-brain-oriented persons; but averaging personalities may make us forget that each person remains expressively individual. Something of the individuality and expressive variability of handedness in art is illustrated by the drawing, painting, and opinions of Leonardo da Vinci. As is well known, he was left-handed, probably by nature, and in the beginning both wrote and drew in a style that revealed his left-handedness. (Michelangelo, who was innately left-handed, trained himself when young to draw with his right hand.) Later in life, Leonardo's characteristic cross-hatching became more varied, not restricted by strokes whose direction is most natural to the use of the left hand, and its parallel strokes changed direction freely. Leonardo also had the ability, found among some left-handed artists, to reverse both writing and images, as if they were seen in a mirror, and he at times tried out ordinary compositions in mirror reversal as well. Often preoccupied with "the mystery of mirrors," he came to advise painters to compare objects they painted with mirror images of the objects, and to say that "the painter should be like a mirror which is transformed into as many colors as are placed before it, and in doing this he will seem to be a second nature."[59]

For visual art, what follows from the great preponderance of right-handed

evidence for the difference in function of the hemispheres comes from the study of such split brains, studies that began for humans in the early 1960s, and more recently, from studies using MRI and PET scans. Although the splitting apart of the two hemispheres by severing the whole corpus callosum leaves patients apparently normal, tests of the functioning of the separated halves shows that there are two separate centers of consciousness, unaware consciously of one another's thoughts and perceptions (in spite of some unconscious transfer of information). This is not the place to go into detail, but the relationship between the two hemispheres is more complicated and variable than appears in summary accounts or, for that matter, than is completely understood by anyone.

During the 1980s, the intolerable brain seizures from which some children suffered led to the discovery, which startled neurologists, that a whole hemisphere, either right or left, could be excised and yet allow the patient to live a remarkably normal life. Eyeglasses with prisms are used to shift a lost field of vision to the center of the eye, and the possible weakness of the limbs on one side of the body can be compensated for.

people is that, from the standpoint of both artists and spectators, the right side of pictures draws more attention than the left and is favored over it. For many of the left-handed people, the reverse is true. From its very beginnings, the history of art provides evidence that the human preference for the right hand is ancient, and that at least European painting has favored emphasis on the right side of pictures. The most ancient evidence for the predominance of right-handedness comes from the Upper Paleolithic practice of painting "negative hands" by holding a tube in one hand and blowing pigment through it toward the rock surface against which the other hand was held. Some 500 negative hands have been discovered in the Upper Paleolithic caves of France and Spain. Of these hands, painted 10,000 to 30,000 years ago, 343 have been surely identified as being of either the right or left hand. Of these, 264, or 77 percent, are of the left hand, that is, were painted by someone who held the tube for blowing pigment in the right hand. Aware of this evidence, two curious experimenters decided to see if negative hand painting now would give similar results. They assembled a group of 179 university students and began by determining their handedness by asking each of them to write and to throw a ball. Their handedness established, each subject got a pen that when blown in at one end projects ink at the other and was asked to paint a negative hand on a sheet of paper. No more than 8 percent of the students were left-handed, but because some of the right-handed ones held the tube in their left hands, it turned out that 138, or 77 percent, painted a left negative hand. This result makes it seem likely that the proportion of right- to left-handed persons was the same during Upper Paleolithic times as now.[60] Furthermore, there is historical evidence that most European paintings were probably made by right-handed painters. The evidence is provided by a survey that showed that 2,124 paintings made from the fourteenth to the twentieth century had the main subject matter on the right, the source of light on the left, and other directional cues going from left to right. Left-handed painters, Leonardo da Vinci and Hans Holbein among them, preferred the main subject matter on the opposite, left, side, and the source of light and other directional cues going from right to left. All of these left-handed painters must have read in the usual European direction, and almost all (Leonardo is the best-known exception) must also have written in the European, left to right direction. This shows that the cause for the preferred emphasis and direction of movement is the same left-hemisphere dominance that makes most people right-handed.[61*]

*Yet humans, we know, are hard to understand in any depth, and so it is not surprising that there have been experiments that show that the preference for the direction of

Other, comparable studies may give different explanations but reach the same basic conclusion, that it is the relationship between the two hemispheres of the brain that determines viewers' preference for emphasis and direction of motion. Such an explanation has been given for the findings of a study of Western European portraits, painted between the sixteenth and twentieth century, that show more of one side of the face than the other. The study contends that 62 percent of the men and 70 percent of the women painted revealed more of the left side or cheek than the right (this bias in favor of the left is close to that shown in Goya's portraits). To complicate the understanding of the preference for the left, another study—best ignored by those who want their conclusions clear— concludes that the preference for the left was very strong in the fifteenth century but diminished in time and had nearly disappeared by the twentieth. It can be argued that the left side was preferred for so long because right-handed artists find it easier to draw portraits facing left, but then the difference in left-cheek preference between men and women is left unexplained. It can be answered that women favored the left side more than men because, being more emotional, they favored the right, emotional hemisphere. But then it has to be assumed that, the preference of both sexes for the left having ended by now, women are no longer more emotional than men; and the answer leaves us without any explanation for the initial left-side bias for men as well as women, and without any explanation why normal viewers now tend to favor the right side (and left hemisphere). Having arrived at this dilemma, I have the feeling that the left, excuse-giving hemi-

motion in pictures is strongly influenced by the direction of reading and writing that one has learned. To investigate this possibility, persons, both right-handed and left-handed, whose mother tongue is Arabic or Hebrew, and who read and write from right to left, have been compared with persons whose mother tongue is Hindi, Russian, or English, who read and write from left to right, and with persons whose mother tongue is Urdu, which is bidirectional. These studies mostly show that there is a strong influence of the learned direction of reading and writing on, in one experiment, attention to expressed emotions: the left-to-right habit leads to the preference for a smile that shows in the left side of a face (the other side of which has a neutral expression); the right-to-left habit leads to the preference for a smile on the right; and the bidirectional habit leads to no preference for either. In another experiment, readers of Arabic and Hebrew preferred facial and bodily profiles that turned toward the right, while readers of Russian preferred the opposite. If one makes the neutral assumption that these experiments are as valid and revealing as those that demonstrate the effect of the difference between the effects of the two hemispheres of the brain, one concludes that different experimental conditions may account for the difference in results, and that further experiments are needed to reconcile the two kinds of experiments.

sphere has been working too hard, and that the changes involved may be based on misleading data, or if not, that they need a more plausible explanation. Or we might forget the assumed history of the change in preference and rest content with the opinion that because the right hemisphere is specialized to recognize faces, most people prefer the parts of faces that fall in their left visual field.[62] Take your choice!

Among the experiments on the differing reactions of the hemispheres, there is one that seems, in spite of its speculations and (inevitable) incompleteness, especially interesting. The reason is that careful research techniques lead to a conclusion that dramatically simplifies our understanding of the difference between realistic and unrealistic art. I therefore conclude the discussion of art and the hemispheres of the brain with an account of this experiment.[63] Central to it is the now standard method of projecting pictures separately to the right and left visual fields.

This is how it was done: A student in the experiment began by fixing his or her eyes on a small white cross in the center of a screen. Each of the pictures was then projected either to the right or left of the screen for a moment so brief that the viewer's eyes could not move significantly and involve the opposite visual field. The viewer then indicated his or her degree of pleasure by pressing one of five keys, graduated from "do not like" to "like very much." The brevity of the exposure contrasts sharply with the length of time we usually take when we want to look at a picture carefully, but the experimenters point out that the eyes can take in a great deal of information very quickly, as is shown by the brief glances that serve grandmasters to appraise positions on a chessboard.

In the experiment, forty well-known works of art were projected from each of the "schools," as the experimenters call them, Renaissance, baroque, impressionism, modernism (an especially vague category), expressionism, cubism, abstract, and pop. The result, in every case, was that viewing with the right field of vision was preferred more often. However, this right-field (and left-brain) preference was significant only for pop, abstraction, cubism, expressionism, and, rather less, for modernism. The difference in preference divided the "schools" into two clearly different groups. One was the older, more realistic group of pictures, almost equally preferred by both visual fields (and hemispheres). The other was the newer, unrealistic group, with figures expressively distorted, colors purer and more intense, and shapes often fully abstract, was preferred when viewed with the right visual field (and left hemisphere). It is not obvious which of the paintings' characteristics were the decisive ones—at any rate, the cause was not semantic meaning but visual pleasure. The contrasting emotional or

affective reactions of the two hemispheres were responsible for the choice. The contrast may be explained by the research that shows that the emotional resonance of the left hemisphere tends to be more optimistic and positive than that of the right—when one's gaze is directed to the right, photographs are judged more favorably than when it is directed to the left. Furthermore, the two hemispheres react differently to color.[64*] The older, more realistic group is truer to what we (our eyes and brains) identify with ease. It is more muted and graded in color, and is emotionally, too, more familiar. To such art, both hemispheres react symmetrically. Their reaction is asymmetrical only to the second, unrealistic or abstract group. This group is favored by the right field of vision and evidently evokes stronger reactions in the left hemisphere than does the realistic group; the unrealistic group is often more surprising, starker, and brighter, with larger areas of pure color. The paintings in this group are not only more arousing to the left hemisphere but, conversely, less arousing, that is, relatively more negative or repelling, to the right. Having learned to increase arousal by such means, artists are driven to continue the effort to outdo themselves by increasing art's vividness and strangeness. In continuing, the artists maintain the high degree of positive arousal of the one hemisphere and relatively negative arousal of the other. The newer art is simply more charged than the older.

Taken as a whole, the research I have summarized suggests that the viewing of art arouses opposing emotional responses in the brain's right and left hemispheres and so creates a dynamic tension between them. Maybe it is their opposition and their complementarity that makes the new art attractive. This pairing and tension between right and left suggest that if aesthetics has a heart (which I'm sure it deserves), it must beat with a somewhat complex symmetrical rhythm. The sense of "symmetry" as a regular, balanced, or measured relationship of the parts of a whole is expressed in aesthetic ideals that will be discussed in later chapters. But it does not take much daring to speculate that our usual preference for or sensitivity to symmetry—felt in perception as rest or order and contrasted with their opposites, motion or disorder—must have organic, even genetic causes. These causes are in our own bodies' (modified) bilateral symmetry and our need to perceive and live with the endlessly rich symmetries cre-

*As recent research on hemispheric processes has revealed: "The visual analyzers of the left hemisphere are turned to a higher band of spatial frequencies than those in the right. . . . It is therefore arguable that abstract paintings might have had a greater perceptual impact in the right visual field than in the left, which would lead to a greater cortical arousal in the left hemisphere following stimulus presentation."

ated by nature and, along with them, the symmetrical objects created by human beings. The symmetry that comes to expression in the ornamental forms of art can be taken to imply that artists have had an intuitive understanding of what has become a developed form of mathematics.[65]

Let me illustrate how the intuition and the mathematics may interact by describing the work of M. C. Escher (1898–1972), the Dutch graphic artist, and the effect on him of mathematicians, in particular of H. S. M. Coxeter, who was famous for his mastery of geometry.[66] After a trip to Spain, where the order and symmetry of the patterns of the tiles of the Alhambra fascinated him, Escher grew intrigued with "the problem," as he wrote, "of how to fit congruent figures together . . . particularly when the shape of such figures is meant to arouse within the viewer association with an object or natural form." Yet he felt himself to be in an enigmatic wilderness until he came "on the open gate of mathematics," where he found "well-trodden paths" leading everywhere, but especially for him, he discovered, to mathematics "on the analogy of crystal symmetry in the plane."[67] A geometrical shape, he learned, could be transformed, by sliding, reflecting, or pivoting it, so as to interlock with itself and cover a whole surface. Using diagrams, charts, and examples, he systematized what he could discover about such interlocking patterns. While the crystallographers and mathematicians wanted above all to analyze structures, Escher, beginning each time with a blank piece of paper, wanted above all to create new, original patterns, often with two motifs and two contrasting colors, and with forms molded to evoke associations with something familiar, such as some object or animal. The forms that came to interest him most were those that were not fixed but underwent a metamorphosis, changing shapes, interacting with one another, and even breaking or seeming to break free of their two-dimensional plane.

Living intensively on the border between geometry, crystallography, and graphic art, Escher used plane, projective, and finally non-Euclidean geometrical structures to teach himself to draw what he wanted, including paradoxical or "impossible" figures, space that changes directions or turns back into itself or, in every part, reflects every other part. Despite his mathematics, his understanding of its possibilities remained primarily visual and intuitive. When he met Coxeter at a mathematics conference, he asked if he could give him a simple explanation of how to construct a series of objects that grew smaller and smaller as they approached the periphery of a circle—he wanted a visually interesting way of representing infinity on a two-dimensional plane.

Mathematicians, said Escher, taught the theory that opened the gate to its domain and were interested mainly in the way it opened the gate, and so they

never entered the garden beyond. Characteristically, he wrote that it is absorbing that his realm and the realm of mathematics "touch each other but do not overlap. I regret that." Inspired by what he read in a book by Coxeter, he made many representations of hyperbolic space (one of two kinds of non-Euclidean space). Among these was the woodcut *Circle Limit III*, in which the fishes in the picture shrink progressively until those that reach the edge of the circle will have traversed a theoretically infinite space. Coxeter writes that *Circle Limit III* is an impressive display of Escher's "intuitive feeling for geometric perfection." The picture's structure, says Coxeter, appears to be based on "the elements of trigonometry and the arithmetic of the biquadratic field containing the square roots of 2 and 3; subjects of which [Escher] steadfastly claimed to be entirely ignorant." In 1995, well after Escher's death, Coxeter spent some three months finding out how he had been able to repeat exactly the same arc angles of intersection in *Circle Limits III*. After making trigonometric calculations, he found that if Escher had wanted to construct "his paintings from mathematical first principles, he would have used an arcane formula involving the cosine of an angle and the hyperbolic sine of a logarithmic function." Acknowledging he was astonished, Coxeter said: "He got it absolutely right to the millimetre, to the millimetre. . . . Unfortunately, he didn't live long enough to see my mathematical vindication."[68]

The story of Escher and Coxeter told (too briefly, I am afraid, to do it justice), I now return to the subject of symmetry. I tackle first the natural speculation that in patterns—groups of visual elements that form decorative, more or less symmetrical wholes—we for many purposes prefer those that incorporate departures from symmetry. We prefer patterns neither to bore us with their sameness nor discomfort us with their suggestion of rigidity or constraint, but we do not ordinarily want them to threaten to become formless or chaotic. The preference and the threat may arise because we are always finding our way, physically or conceptually, and we find our way with the greatest ease when our surroundings have a clear structure, a pattern that is differentiated enough to give us clues to where we are. If everything remains too much the same for too long a time, our eyes and minds grow tired, and we, bewildered. A simple example would be the sense of being lost in a forest with nothing we can distinguish to help us find our way out, or the feeling of confusion in a large building with long identical corridors. But if everything were unfamiliar and looked different from everything else, so that our eyes and minds could not help us to orient ourselves, we would also feel lost.[69] A painting, like a forest or building, may please us most when it combines clarity and variety, or when it resists easy perception without leav-

ing us to founder in ambiguity. Then—if there are no other, interfering conditions—we perceive it with the pleasure we call beauty.[70*]

The characteristic, often complicated designs that express the aesthetic individuality of different art cultures give pleasure for the same reasons as the simpler patterns but add the pleasure of grasping the more varied, detailed relations between their parts and their wholes. Later in this book we will see how these can embody and convey a culture's deeper perceptions.[71†]

[*] In a functional MRI study of neural reactions to aesthetic judgments, fifteen young right-handed men and women, all without professional training in the fine arts, made aesthetic judgments of twenty-seven black-and-white geometrical patterns, that is, they indicated the degree to which the patterns were symmetrical or not, harmonious or not, beautiful or not, and interesting or not. Abstract patterns were used in order to minimize or even rule out the influence of attitudes or memories related, for example, to the financial value of works of art or the attractiveness of faces. "As predicted, symmetry was found to be the most important stimulus property determining participants' aesthetic judgments. In general, participants showed agreement that symmetric and regular pictures were more beautiful than the others." For twelve of them, "a symmetric pattern was more beautiful. . . . Three participants considered a larger number of elements in a pattern more beautiful." To one participant "patterns with fewer elements were more beautiful." And one participant, whose judgment was based on shape, "found patterns with rhombuses more beautiful than other patterns." But "overall, pictures that contained more elements were considered more beautiful." The symmetry judgments elicited reactions in several visuospatial areas of the brain, while the aesthetic judgments (beautiful or not) elicited reactions in other areas, which overlapped in part with brain networks involved in social and moral judgments.

[†] The anthropologist Dorothy Washburn holds that such visual and other "metaphors draw on . . . shared experiences to communicate the knowledge necessary for the cohesiveness and continuity of their culture." She points out that in ancient and contemporary Pueblo pottery, almost every one of the varied designs has an underlying geometry "characterized by bifold rotation, a rigid motion that involved two 180 degree turns about a point axis in order for superposition to occur." Washburn proposes "that the interlocking of two equivalent parts (elements) in bifold rotational symmetry is a metaphor for the essential roles and responsibilities of Pueblo individuals in the perpetuation of life. . . . The specific interlocking of two parts expresses the way the Hopi conceptualizes the relationship of the married couple: two people have interlocked their lives to make new lives. . . . The *rotational* nature of the interlocked motifs recalls the Puebloan concept of life as a cycle" comprising conception, birth, growth, "pollination," conception, the birth of new lives, and then, "metaphorically conceived as a plant, the individual dies and becomes the foundation for a new life. . . . For every Hopi that passes on, another child is born and the cycle continues. In this way, bifold rotation symmetry visually replicates the quintessential essence of Pueblo life."

There is also another, intuitively plausible reason for the pleasure more complicated designs may give. It depends on the minimal synesthesia that all of us retain. In the case of more complicated designs, it is the synesthetic relation between their appearance and the motions they suggest. The motions I am referring to, of every sort and rhythm, are suggested by a direct and an indirect muscular cause. The direct cause is the motion of the eyes as they follow the design; the indirect one is the motion of the hands that, one feels, carried out the design or of the body that, one feels, is moving with it. The whole result is the sensed pleasure of a barely conscious virtuosity of the motion and the force with which, like a dance, the pattern draws the viewer into its rhythms. The motion makes the surface that it decorates come alive. Usually, the motion is held within borders; one can in imagination live a life filled with colorful incidents within the confines of a single Persian rug. The intricacy of the decorated surface may draw us in but, like a too complicated task or life, may also become exceedingly hard to imagine through to its end. As Alfred Gell explains,

> If we can see visual patterns as frozen traces of dance so we also can see dances as being half-way to music, which indeed normally accompanies them. . . . We may observe that a four-part canon reveals its structure (because it is easy to hear the four successive entries of the theme) but also conceals it, in that it is near impossible to hear all four parts simultaneously. . . . Drawing and music and dance tantalize our capacity to deal with wholes and parts, continuity and discontinuity, synchrony and succession.[72]

To go further with this last idea, the arts not only tantalize our ability to deal with and explain structural relationships, but also to explain the emotions that arise from them, the dance of the eyes that in art leads into the complex emotionality and intellectuality of our responses. The emotions and the intellectual responses call up and require one another. Emotions "call not just for satiation or pleasure, but for explication. . . . Visual art affords not only a meaningful, self-directed dance of the eyes, but also a meaningful dance of this emotional explicating process."[73]

The visual beauty we find in nature must include but go beyond the simpler kinds of pleasure in vision. Humans (and, I imagine, at least the animals that resemble them) take sensory pleasure in natural examples of balance and symmetry, and in the deviations that accentuate the norm from which they deviate. There is pleasure also in the lines, curves, angles, designs, and colors that we perceive in nature. These pleasures are contained within the pleasure we take in seeing trees, plants, flowers, birds, animals, and the other natural sights. If the

living things move, our eyes and mind repeat their swaying, fluttering, flying, dancing, scampering, and running.

Often the pleasure varies with the degree to which the sight we see approaches the norm by which we know it, that is, the extent to which it represents the others of its kind. Then the pleasure marks what we see as beautiful of its kind. Doesn't this reflect the way in which the visual areas of our brain, our memories, and our categorizing and imagining minds work? Which of the tulips we see in the garden is the most beautiful? None of them, we usually answer, that are weather-beaten, broken, faded, dried out. The most beautiful is the most tuliplike tulip, the one with the "petal glossiness, upright form, pale green color, broad leaves, etc." that we admire as a perfect example of its kind because it conforms most closely to its known or imagined prototype.[74] As creatures that order everything by categories, we for similar reasons take pleasure in identifying and looking at "perfect" examples of a style of art. To put the idea in somewhat more technical words, "Stimuli are processed via categorical mediation, meaning that the way people respond aesthetically to objects will be determined by the categories they have developed for understanding such objects. . . . In addition, the extent to which an object is typical—or prototypic—of the category determines affect," that is, the greater degree of pleasure that people take in an object that fits well into a predetermined category. "Termed 'preference-for-prototypes,' this hypothesis has been remarkably robust in predicting people's evaluations of a wide range of objects, from furniture, paintings, and buildings, to faces and colors." All the same, it has been disputed.[75] One reason for accepting it, with whatever reservations, is that it applies to the well-established conception of "prototypical" faces in the sense of the kind of faces that are constructed by averaging the appearance of many faces. The apparently universal attraction to symmetrical, averaged faces must be genetic, yet, as I will say, it is modified, sometimes drastically, by cultural habits. The moral is that the categories or prototypes we have been considering vary in the extent of their fixity from those whose origin is in the human genetic heritage, to those that are deeply embedded in a tradition or language, to those that depend on merely local habits of perception, and to those that are obviously temporary or tentative and quite open to change. Our dependence on prototypes coexists comfortably with our need for stimulation by change.

Human faces are natural designs of a kind that, beautiful or not, matter to us most. I take up this subject because I am convinced that the reaction to art cannot be divorced from the reaction to the objects it portrays (or fails to portray). Of these subjects, the closest and most important to us, the most minutely and emo-

tionally scrutinized, is the human face. Although its expressiveness is far less detailed, we of course scrutinize the human body, too, with unavoidable emotion. Faces and bodies: We will never understand figurative art deeply enough until we know how artistic conventions have conveyed or hidden what people have felt about the faces and bodies they actually knew. Nor will we understand how this art really influences us until we take into account how we ourselves react to real faces and real bodies.[76]

Alert as we are to faces, we read them easily into anything that looks like them, and then we easily read life into whatever we see as a face. But the life of an imagined face is weak and vague as compared with a real one. When we look at a real face

> we seem to gaze through it. It half-vanishes, like the pages of a book, so we view soul more than contour. Hence we often treat the face as the self.... The face is an uncanny semaphore. In life and in some fiction like *Jane Eyre,* it issues messages of startling depth and infinite hue. We rely on these signals constantly and willy-nilly, for almost none of us can define them. We are reading a language we cannot articulate and may not consciously notice.[77]

The research on faces that I am about to summarize is, as usual, subject to caution, most of which I disregard for the sake of brevity.[78] But if what I have been saying about the face is plausible, research into the nature of our preference for faces may be hardly less relevant to art than to our everyday lives. It is natural to ask, if the research is about our everyday lives, what can it teach us that we do not already know? With respect to attractive faces, relativism seems justified, especially in the light of anthropology. The history of art appears to teach the same relativistic lesson. Yet the research demonstrates that, in fact, there is general agreement on which faces are the most attractive. This appears to be true for every age and culture tested, and true cross-culturally as well: both children and adults choose the same children's and adults' faces as the most attractive. Babies less than a year old spend more time looking at the same faces that adults find attractive. Attractive and unattractive persons agree on the attractiveness of the same faces. So do men and women. Japanese and Europeans choose both the same Japanese and the same European faces. Tests of Taiwanese said to have been relatively uninfluenced by Western culture are said to have similar results.[79]*

*I had already written these words when I discovered the experiments, using a different technique, that at least appear to show that the relation of facial symmetry to facial attrac-

Two different conclusions suggest themselves. The one is that the basic standards of facial attractiveness (like facial expressions of emotion) are universal and, very probably, inborn, just as our attraction to flowers is possibly inborn. If so, the main cultural deviations from the universal ideal may be the result of passing fashion or the desire to display a trait—such as an elongated head—that for some reason has come to confer prestige or mark one's membership in a social group. The other, opposite conclusion, is that the influence of Western culture, with its television and motion pictures, has by now become universal.[80]

I will not try to choose between these two conclusions but instead go on to another that to me was at first even more surprising, though it fits what I have said, speaking of tulips, about ideal norms. This conclusion is based on a technique by which the photographs of many faces, all taken in similar poses and with similar expressions, are first scanned into a computer. Then, by a somewhat complicated process, the faces are joined into a single composite or average face. With respect to attractiveness, the result is always almost the same. The average (averaged) face is very attractive, and the greater the number of faces averaged, the more attractive the face that emerges. Furthermore, averaging a number of faces already made attractive by the process of averaging yields a face that is more attractive than one reached by averaging alone. Another way of arriving

tiveness is not strong, but weak. The main difference in technique is that instead of using photographs of faces that were "averaged" by a computer, experimenters used ordinary, unaveraged photographs, in some of their experiments creating perfectly symmetrical faces by joining two right or two left halves of the same photographs. The experiment I am summarizing here consisted of three parts, one in which a group of college students, both men and women, watched pictures of men's and women's faces exposed briefly on a computer screen. As they watched, the students pressed a key to record one of five degrees of attractiveness—very unattractive to very attractive. In the second part of the experiment, the faces were judged for their degree of appearance of health, and in the third, for one of three degrees of left-right symmetry. The results of the experiment showed that appearance of health was closely related to degree of attractiveness, but that there was almost no positive relation between symmetry and attractiveness. To explain these results, the investigators recall that among humans the brain is functionally and structurally asymmetrical, an asymmetry reflected in the subtle asymmetry of faces and facial expressions. My own explanation of the difference between these results and the results of those who averaged faces is very simple: a merely symmetrical face can easily be ugly, but an averaged face, which represents the very norm of what a human face looks like, cannot be seen (by anyone who does not dislike humans as such) as relatively ugly, and the averaged face is, of course, symmetrical.

at an especially preferred face is to begin the averaging with a group of faces already chosen to be unusually attractive.[81]

This attractiveness is not the result of the loss of facial blemishes (the averaging of line drawings leads to the same gain in attractiveness) and not the result of greater general familiarity (the attractiveness was confirmed cross-culturally). An explanation in the spirit of evolutionary psychology is that persons who are quite close to the average may be preferred because, being so average, they are not likely to carry genetic mutations, which are usually harmful. Alternatively, averaged, symmetrical faces tend to show freedom from parasites, which in some cultures have a serious influence on human development—in places where parasites are more troublesome, the physical attractiveness of a marriage partner is more stressed.[82] Another easy guess is that the attractive faces reflect (average together) both youthfulness and maturity. A certain degree of child-likeness in maturity proves to be attractive, probably because it suggests a just-achieved fertility. The preferred faces are also quite symmetrical, and correction for even more symmetry improves their attractiveness. Perfect symmetry may suggest perfect health (though, as usual, there are doubts). Experiments suggest an additional factor: symmetrical mates may be preferred because the symmetry of objects, whether peacocks' tails or human faces, makes them easier to recognize from different angles of view—in mathematical terms, because they are unchanged after transformation.

There are further amendments to the understanding of facial attractiveness. For instance, people rated by others for attractiveness become more attractive as they become more familiar; but, naturally, their voices and personalities affect the judgments of their attractiveness both for better and for worse. As one would expect, judgments of attractiveness based on photographs are changed when the same faces are shown in video.[83]

I close this discussion of faces by recalling those that were created by averaging a large, equal number of male and female faces. These faces—attractive, androgynous, symmetrical, somewhat vague because somewhat unindividual—bring to mind a number of Leonardo da Vinci's drawings and paintings, which are attractive, even beautiful, pensive-looking, mysterious, and sometimes androgynous, the pigment of their features graduated as smoothly and delicately as smoke. Raphael, Ingres, and others also painted such beautiful "averages," the characteristics of which they understood without statistical evidence. The truth is that they were quite familiar with a theory not unlike that verified by the averaging experimenters. This theory was derived from stories of ancient Greece. Its best-known form is the tale of the Greek sculptor Zeuxis, who tried to paint

the most beautiful possible Helen by combining the appearance of five beautiful virgins.[84] In Leonardo's own time, Alberti recalled the idea and suggested that, to arrive at human beauty, one should search for the beautiful parts of different beautiful bodies and find their mean or ideal by measurement. Raphael writes, in graceful disagreement, that because there are so few beautiful women and so few sound judges of their beauty, he resorts to an idea, an ideal, of beauty that comes into his head.[85]

In the name of recent research, not to say Zeuxis and Alberti, I have put the case for the universality of criteria for, at least, facial attractiveness. But even if the case proves to be generally true, it needs to be kept in empirical check. This is because the qualifications I mentioned above, the effect of fashion or of the desire to confer prestige or mark one's membership in a group, are serious and frequent. There always is a prevailing fashion, which passes but may well return; and the marks that confer prestige or signal membership are likely to become marks of beauty as well.

Out of an endless number of examples to qualify the idea that the standards of attractiveness are universal, I choose one, not of facial but of bodily beauty. I choose it because it is culturally important and because it seems to me beyond doubt. I am referring to the Chinese practice of footbinding. Tradition attributes this practice to the tenth-century Chinese ruler and poet Li Yü. According to the old story, he had a more than six-foot-high model of a lotus built for his favorite consort, Yao-niang. Then he "made her compress her feet with bands of cloth so that their pointed tips looked like the points of a moon sickle, and then had her execute his favorite dances on that lotus flower." Her bandaged feet are said to have influenced all the other ladies to imitate her.[86]

Europeans thought of footbinding as a strange mutilation undergone, for no obvious reason, by upper-class women in China and imitated by those of lower social rank, though not by peasant women, who had to work in the fields. The process by which a young girl's feet were bound was tormenting. Her toes were forced down and back by tight bandages until, in the course of time, as much of the foot as possible was pushed close to the ankle. The enlarged ankle was hidden by leggings, and the rest of the now tiny foot could be fitted into an equally tiny shoe. A woman with bound feet had to hobble (erotically) rather than walk in a normal way and must have found it hard to engage in many physical activities, including the respected art of dancing.[87]

The traditional story may be misleading, but none of the other suggested origins for the custom is convincing. It is clear, however, that small, bound feet, known by the euphemism "golden lotuses," were erotically charged. A lover

would take off a woman's tiny embroidered shoe and drink wine from it. Poets and novelists extolled the beauty of women's feet, the smaller the more beautiful. Having met a young woman to whom he feels greatly attracted, a love-struck character in *Chin P'ing Mei,* the most famous example of Chinese erotica, breaks into a poem in which he extols the seductiveness of the "upturned points of her tiny golden lotuses," the "raven-hued shoes, with high white satin heels" and "her red silk ankle leggings" that are "figured with orioles among the flowers."[88]

The key to a woman's sexuality in traditional China was her foot. A man who touched her foot was telling her that he wanted sex with her.

> Nearly every Ming and later erotic novel describes the advances in the same manner. When the prospective lover has succeeded in arranging a tête-à-tête with his lady, he never makes any attempt at physical contact for gauging her feelings, he is not even supposed to touch her sleeve, although there is no objection to his speaking to her suggestively. If he finds she reacts favorably to his verbal advances, he will let one of his chopsticks or a handkerchief drop to the floor, and when stooping to retrieve it, he will touch the lady's feet. This is the final test. If she does not get angry, the suit has been gained, and he can immediately proceed without restraint to all physical contact, clasping her in his arms, kissing her etc. While a man's touching a woman's breast or buttocks may be explained and accepted as an accidental mistake, no apology will be accepted for his touching her feet, and such a mistake invariably gives rise to the most serious complications.[89]

· · ·

Given all the traits that have been taken by different cultures to define physical beauty, it is evident that anyone who believes that human attractiveness is ruled by universal principles has a lot of explaining to do. But for the while, the studies I have summarized seem good enough to allow us to accept an approximate rule that says that, given explanations for the undoubted exceptions, highly average faces are on the average chosen everywhere as the most attractive.

The rule inspires me to ask a few, partly rhetorical questions. Can choice by averaging be extended to discover not only which faces but which works of art are the most attractive? Could persuasive evolutionary explanations be given for their attractiveness? Suppose that the averaging criterion is applied to works of art and to the traits that make them, on the average, most attractive. This could be done by means of a careful survey of the choices made by large numbers of all kinds of people (that is, a statistically representative group) who live in a wide variety of countries. And suppose, too, that, despite the variety of countries

involved, the average choice made everywhere proved to be fairly similar. What could we make of such results? Would they be enough to prove that, on the average, human responses to art are so similar that they may be, or may depend on, inborn inclinations? Or would the results prove only that, thanks to television, films, and the other means of communication, human culture is becoming aesthetically uniform? Or would the conclusion be that it is only popular culture that tends to be the same everywhere? And if popular, but only popular, culture turns out to be roughly the same, would this bear on any inclination we might have to separate the aesthetic populists among us from those who might be called, with or without invidious intentions, the aesthetic elitists?

I have said that these questions are just partly rhetorical, because, as you may know, a large-scale survey of the kind I have suggested was carried out years ago on the initiative of two émigré Russian artists, Vitaly Komar and Alexander Melamid.[90] Their object was to identify what qualities were the most attractive and least attractive in paintings. Once these characteristics were identified, they wanted to paint pictures that demonstrated the wanted qualities, and others that demonstrated the unwanted ones. To paint these images was a natural challenge to these aesthetic adventurers, but it was also meant as an ironical comment and conceptual joke, as I will explain.

With the help of a nonprofit foundation, Komar and Melamid hired a reputable public-opinion research firm to conduct a telephone survey to determine preferences. Public discussions were also held in various places. The poll itself was based on a statistically representative group of 1,001 Americans, each of whom was asked 102 questions. What sort of questions? Some are on most and least preferred colors. Some are on what art is preferred at home, and whether it is modern or traditional or some other kind of painting. Other questions tackle subject matter and style (realistic or not, bold or not, with angles or soft curves, geometric pattern or random). Further questions are on the preferred kinds of brushstrokes (visibly expressive or not), on textures (thick or smooth), on the separation or blending of colors, and so on and on.

The poll, which began in late 1993, was extended from the United States to China, Denmark, Finland, France, Iceland, Kenya, Russia, Turkey, and the Ukraine. The statistical analysis of the results was elaborate and seems, to my inexpert eye, to be on a high professional level.[91] On the assumption that the groups polled were in fact representative—a very crucial matter—Komar and Melamid claim that the result expresses the artistic opinions of close to two billion people, nearly a third of the world's population.

Taking a sample of responses across the survey, blue was most often chosen

as the favorite color (24%), followed by green (15%) and white (10%).[92]* With respect to style, 34 percent preferred traditional, 32 percent preferred modern, and 21 percent preferred mixed. With respect to morality, over 40 percent answered yes to the statement that paintings should teach a lesson, and over 40 percent answered no. Realism was preferred by 44 percent, "different" from realistic by 25 percent, and "both/depends" by 24 percent.

One of the puzzling aspects of the surveys is why in China, where the polling was conducted with great care, those polled were so hesitant to state what they preferred. The Chinese were not used to polling, and Melamid guesses that the people who were polled were afraid of making the wrong choices—wrong from the government's standpoint, or wrong in departing from American preferences, which were then especially important to the younger Chinese. Other, more general conundrums arise from the statistical results, which are often hard to interpret.[93]†

For each of the countries polled, Komar and Melamid made a "most wanted" and a "least wanted" painting. For instance, in the United States, the most

*Although Komar and Melamid's survey shows that blue is "the world's" favorite color, the fact that it was preferred by only 24 percent of those surveyed shows that most of them preferred other colors. In his book *Blue: The History of a Color*, Michel Pastoureau points out that, so far as the insufficient evidence shows, in ancient civilizations red seems to have been the dominant color, while blue dyes were used above all by the ancient peoples of the Middle East. In the Greek and Roman world, there was no clear, basic term for blue. In Europe, says Pastoureau, it was only in the eleventh and twelfth centuries that blue became a fashionable color, in the opinion of some, the most beautiful and noble of colors. During the romantic period, blue became the West's favorite color. "Color is a social phenomenon," says Pastoureau, not a neurobiologically fixed one. However, in the last chapter of this book, I take a less relativistic position.

†Take, for example, color preferences in the United States: Blue, which is by far the favorite color (of 44%), is most appealing to people in the central states. Among them, its appeal, which averaged 50 percent, varied only slightly (49% to 51%) among the different categories of those polled, categories including: persons between forty and forty-nine years of age; conservatives; whites; males; earners of $30,000–$39,000; persons unsure if they would take the art or its worth in money, and persons who don't go to museums at all. The appeal of blue decreases as the level of education increases: 48 percent of people with high school education or less like blue, as against 34 percent of postgraduates. The appeal of red—favored by 11 percent of Americans—increases with education level: 9 percent of those with a high school education or less like red, as against 14 percent of postgraduates. The people who visit museums most frequently prefer black far more than those who never visit museums. And although blacks prefer the color black as their first choice at about the same rate as nonblacks, they choose it far more often as their second-favorite color.

wanted painting, which unites all the characteristics that the highest percentage of Americans preferred, turns out to be large (defined as dishwasher-size), realistic, blue, with visible brushstrokes and blended colors, preferably in vibrant shades and with soft curves and playful designs. The season portrayed is the fall and the setting is a landscape with bodies of water. The preferred scene shows wild animals, in their natural setting and, as well, fully clothed persons, at leisure and in a group.[94]

In discussing their desire to find out what most people prefer, Melamid and Komar emphasize that they were brought up on the idea that art belongs to the people. "I truly believe," Melamid says, "that the people's art is better than aristocratic art, whatever it is." The aristocrats he is referring to are the rich collectors and patrons of museums. Speaking, he says, from experience, he insists that there is no reason to suppose that the artistic judgment of the rich is better than that of the poor. Very few among the collectors are smart, he says. They may have a passion for collecting, with no intrinsic relation to art. Others of the rich collect pictures in order to enjoy the prestigious social life that museums offer them—the real life of a museum becomes more evident when it closes its doors to the public and entertains its patrons. A museum, with its show and grandeur, is to its rich patron what a castle once was to the nobleman who stocked it with expensive art. Late modernism produced an often inhuman art, imposed on the people by those in power. The artist has no choice but to serve someone or other, maybe unconsciously. "So let's do it consciously," Melamid urges. "Let's serve the people."[95]

Melamid is especially impressed by the hundreds of people that he and his partner talked with who had a certain blue landscape in their heads, a landscape they could see in the smallest detail. Melamid guesses that the blue landscape, an inner paradise, is genetically imprinted on us. He says:

> We've now completed polls in many countries—China, Kenya, Iceland, and so on—and the results are strikingly similar. Can you believe it? Kenya and Iceland—what can be more different in the whole fucking world?—and they both want blue landscapes. So we think we hit on something here. A dream of modernism, you know, is to find a universal art. People believed that the square was what could unite people, that it is really, truly universal. But they were wrong. This blue landscape is what really universal, maybe to all humankind is.[96]

The idea that there is a blue universal landscape recalls the "savanna hypothesis" of evolutionary biologists. By this hypothesis, all humans have genetic

responses that fit the life they led where humans originated, on the African savanna. They still tend to favor or avoid whatever experience on the savanna once taught their ancestors—taught in the sense of favoring the survival of those best fitted to live in the savanna. Research is said to show that savanna-like environments are consistently favored over others, especially among children, in whom innate dispositions are easier to discover.[97] As in Komar and Melamid's ideal picture, the landscape supposed to be favored by inheritance is open, with the wild animals for which it is the natural habitat. Landscapes with bodies of water are favored because water is essential to survival. And groups of people are favored because humans have always been social animals and can hardly survive alone. I do not know what clothing, if any, was worn on the savanna, but something to cover the body would obviously protect it from the weather. By the hypothesis, blue may be the favorite color because the day was safer than the night and because the blue of the highly visible savanna sky signaled good weather. Green is a favorite color because it is the color of plant life. The black-white contrast is of great importance to the visual system; but I do not know if the savanna hypothesis can explain why white is a favored color, or why fall is the most favored of all seasons. But vibrant colors may be favored because strongly colored objects are easier to identify, because flowers signal the coming of spring, and because fruits are often brightly colored. (It's all a paradise for evolutionary biologists.)

I return to the comments of Melamid, who goes on:

> What we need is to create a real pop art, a real art of the people, like the music . . . the hip-hop, rock, that's the greatest thing in the world. . . . We're in a kind of dead end, the whole society. There's a crisis of ideas in art, which is felt by many, many people. . . . I have talked to many artists who feel this way—we have lost even our belief that we know the secret. We believed ten years ago, twenty years ago, that we knew the secret. Now we lost this belief. We are a minority with no power and no belief. . . . I've never seen artists so desperate as they are now, in this country.[98]

Komar remarks that his greatest surprise is that the polling produced no surprises. He raises the possibility that the method used was flawed. Maybe, he says, they should have worked with people individually. Or maybe they should have asked such questions as, "Do you want the painting to surprise you?"[99]

The philosopher-critic Arthur Danto, who contributed to the book in which Komar and Melamid's project is described, says that they misconceived what was wanted by the people who were questioned. He argues that the artists assumed,

mistakenly, that the people wanted all their preferred characteristics put together into a single strangely varied painting. Danto is off base here; the painters did not make this absurd mistake. Instead, it seems to me, Komar and Melamid's "most wanted" paintings were intended as proof of an odd kind of virtuosity by summation—instead of adding up numbers with astonishing speed, as arithmetic virtuosos do, they added together artistic subjects and aesthetic characteristics with surprising audacity and unsurprisingly mediocre results—none of their artificially assembled landscapes are up to the standards of the great idealizing landscapists, for example, of the Hudson River school. The paintings are meant to be ironic jokes, more on the artists themselves and their averaging passion, and maybe, as well, on the ubiquitously uniform standards that advertising encourages. There is no good reason to suppose that their populism was fake, or that they did not know that very few people would like a picture that summed up all of their preferences. I am quite sure that Komar and Melamid were aware that their "best loved" pictures would not in fact be loved, because, like most Russian schoolchildren of their time, they had read Serge Mikhalkov's fable about the elephant who, wanting to please all his animal friends, asked each of them what it would like to see in a picture. The hedgehog wanted shrubs and logs, the pig wanted a big mud puddle, the alligator wanted a clean blue sky, and so on. But when the elephant was finished with the painting and unveiled it before the eyes of the assembled animals, not one of them liked it. "How could he have taken everyone's desires, mixed them together, and ended up with something no one liked?"[100]

Danto's own ironic comment on Komar and Melamid's project is that they have given the art world a postmodern, humorous performance piece that is made up of the whole process of polling, painting, and publicizing.

> That work is probably a masterpiece. . . . It shows the truth that we are forever exiled from the aesthetic motherland where painting pretty pictures is the defining artistic imperative. It also shows how little distance our eyes will carry us in finding our way in the art world of postmodern times. But finally it shows how great the distance is between where art is today and where the population is so far as, until the mischief began, its taste is captured in America's Most Wanted.[101]

Danto's evaluation is sharp and apposite, but to my mind he sides, as is usual with him, with art that is new and taken to be museum-worthy. But as a philosopher he might have tried to take the long view and considered the possible justice in Komar and Melamid's praise of popular art, which seems quite sincere. What they say may be basically serious because, having thought about the ruling con-

ventions, they came to feel that they should resist the aggrandizing, intellectualizing temper of the art that Danto accepts and justifies. He accepts and justifies it because it rests on a web of associations open only to those in the know, and he takes it to be therefore right, in the sense of highly evocative, although inescapably distant from popular taste. Pop art was given its name because it made use of popular themes and objects. Its American originators seem to have thought of it as genuinely popular in intent. But I imagine that if confronted with actual examples, people without art training would reject most of it; they would all be puzzled by Warhol's *Brillo Boxes* and refuse it the name and value of art. Maybe, as Melamid says, "people don't understand that a car is art, but they buy on their aesthetic urge. They need to buy beauty. And, you know, it's mesmerizing, the shininess." So polishing your car and cutting your hedge "is a totally legitimate modernist action."[102]

Although regarded as opposites, "high art" and "low art" have always influenced one another. There's no a priori reason why they can't flourish together, even garner mutual respect. As we will see, there have been aesthetic critics who prefer the anonymity and unpretentiousness of folk art to what they see as the egotism and ostentation of high art. Komar and Melamid's "people's art" is surely not the same as "folk art," but it makes sense to fold their praise of popular art into that of folk art. I admire this praise because it accepts creativity as the natural heritage of every human being, and not the exclusive privilege of rare individuals. As folklore scholar Henry Glassie puts it:

> It is another message of folk art that creativity need not lead to the destruction of norms. It can be dedicated to the perfection of things as they stand. . . . Art is our birthright. We are stuck here. Alone, one by one, we are born and die. We are members of groups without which we could not survive our first day. From them we learn. To them we return our learning. And all the time beyond us flows and cracks, without question, a power not ours that we can bend but not master. Art is the way we come to grips with all this and make it visible, comprehensible. Born into this mumbo jumbo world, we have a right to make art, and I call conditions good that enable us to be artists, and I condemn conditions that steal art from us. Art is the way we achieve our humanity. The enemies of art are the enemies of humankind. If they say art is the privilege of a rare talented few or the possession of prosperous white men, I say they act criminally toward their kind.[103]

Glassie's words are so eloquent and forceful that it's a pity they can't help much. There must always and everywhere have been some gap between the

more and less aesthetically sophisticated or fashionable. Under current circumstances, the gap seems especially large and stubborn. But it is crossed, we see, in both directions, and after all, no one adopts the current (highbrow) aesthetics except in a selective, personal way. So it should be possible to value lowbrow art, folk art, marginal art, and so-called outsider art without fear of losing one's aesthetic standing.[104]

FORGETTING SELF

The creation of art in every form has its intimate rewards and punishments. I have already spoken of the rewards, but not of the research done by a group of psychologists into a particular rewarding state of consciousness they call "flow." The research included rock climbers, dancers, composers, surgeons, chess players, and writers, all of them persons whose activity challenged their best efforts. Its purpose was to discover exactly how they felt when things went especially well. This optimal state is described as the enjoyment of flow.[105] Those experiencing it are described as so absorbed in their activities that their actions follow smoothly from their thoughts. Flow needs clear goals, the psychologists say, and a clear understanding of how one gets to them. It also needs immediate feedback—hearing the notes just played, the musician knows what notes to play next. But the most important characteristic of flow is the balance that is maintained between the challenge that is being faced and the skill of the person who is meeting the challenge, including the challenge, I add, to understand a work of art.

That this last challenge is real is borne out by the experience of museum professionals who discover that the effort to understand a work can lead to aesthetic experience suffused with a sense of flow:

> Interviews with museum professionals provide support for the theory that aesthetic experience is a specific form of that more general enjoyment people report when they become deeply involved with opportunities for using their skills—be they sensory, intellectual, physical, or emotional in nature. Like other kinds of flow experiences, encounters with works of art present feasible goals which can be reached by using and refining perceptual skills, a wide range of knowledge, and emotional sensitivity.[106]

Whenever the balance of challenge and effort is disturbed, the person addressing a task grows restless or anxious. When it is undisturbed, action and awareness join and the work that is being done feels as if it is doing itself, just as the words that are now forming on my computer's screen feel as if they are generat-

ing the thoughts that are generating the words. As one's self-consciousness disappears, hours turn into subjective minutes. One does not want to emerge from such a self-consciousness-annulling activity because it is self-rewarding and so an end in itself, just as now I do not want to talk, eat, or rest, but only, stubbornly and self-forgetfully, keep on writing (the references, like the coming one, I put in only reluctantly).[107] Experimenters report that this state of unselfconsciousness is objectively better for those who experience it than is a state of self-consciousness. Mark Strand, an American poet, says of his own experience of flow:

> Well, when you're right in the work, you lose your sense of time, you're completely enraptured, you're completely caught up in what you're doing, and you're sort of swayed by the possibilities you see in this work. If that becomes too powerful, then you get up, because the excitement is too great. You can't continue to work or continue to see the end of the work because you're jumping ahead of yourself all the time. The idea is to be so . . . so saturated with it that there's no future or past, it's just an extended present in which you're, uh, making meaning.[108]

It strikes me as strange but true that activity that turns self-forgetful is both satisfying and stimulating. I can only guess why. Maybe the reason is that to be intently self-forgetful is to be in a state of undistracted harmony—the activity absorbs us so completely that we can think of nothing else and therefore of nothing better. Until it comes to an end, we are too absorbed to know even that we are happy. But remembering the experience makes us happy and tempts us, as it surely tempts artists, to repeat it as often as possible. If this is true of the artist, it is because artistic work is often wholly absorbing and makes one for a time psychologically indivisible. Of course, the quite abstract work of the mathematician can be just as absorbing, because, I suppose, to be mathematically effective, the mathematician has to withdraw consciousness from everything bodily and think and imagine nothing but still unknown mathematical objects and relations. All this—it will be seen—accords with Chinese and Japanese conceptions of artistic creativity and with the inclination of Indian aesthetics to situate the enjoyment of art on the border of mystical experience.[109*]

*The "flow" theory is analogous to what might be called the "processing fluency" theory of aesthetic pleasure. The authors of the processing fluency theory, Rolf Reber, Norbert Schwarz, and Piotr Winkielman, argue that "aesthetic pleasure is a function of the perceiver's processing dynamics: the more fluently the perceiver can process an object, the more positive is his or her aesthetic response." Fluent processing is facilitated by qualities

GRASPING

Now, close to the end of this introductory chapter, I return to the question with which it began and ask why there is art and what it is. My answer will be inadequate because the use of words to define all art insightfully is like the attempt to outline the exact edges of a current of water or a cloud. It is inadequate because words as abstractions have a quite different character from the art they relate to. Perceptual abstraction is possible only to symbols and words, but art, including "abstract" art, is sensuous, whether as vision, touch, motion, sound, taste, or odor. This difference is reason enough to go on and define art just because it resists definition. When a shortcoming in definition bothers us, instead of lazily blaming the nature of words, we ought to try to improve the definition or, because art has varying aspects that are hard to bring out clearly at once, to supplement the definition with another, and if there is need, with still another. Assuming that we care, we should take the trouble to sharpen our words on the whetstone of careful thought or free ourselves to search for better words in less common, even wild, verbal fields. This search is also to find ourselves. How can we know what even we ourselves think art may be if we don't make and repeat the attempt to express what we feel because it so often escapes us, or because it takes too much effort to find the words in which to put what has not yet taken verbal form?

I've made four attempts. Each uses the imagination, and each is aimed at different characteristics of art. The first, somewhat metaphorical attempt echoes the earlier ideas of this chapter but is reinforced by ideas that arose later: A work of art is the imagined and then created body that is meant to satisfy an inner demand or hunger for direct experience. The creating of this body is also the gratifying experience of the process of its own embodiment. This gratification is direct because it consists of the inherently pleasurable acts of the sensory, muscular, and imaginative process by which the embodiment is consummated. When the absorbing directness of the process is great enough, it makes the artist

of objects "like goodness of form, symmetry, and figure-ground contrast. . . . High fluency is subjectively experienced as positive, as indicated by psychophysiological findings" and "feeds into judgment of aesthetic appreciation. . . . Fluency has a particularly strong impact when its source is unknown and fluent processing comes as a surprise. . . . Beauty is in the processing experiences of the beholder, but these processing experiences are themselves, in part, a function of the perceiver's encounters with the stimulus properties and the history of the perceiver's encounters with the stimulus. Hence, beauty appears to be 'in the interactions' between the stimulus and the beholder's cognitive and affective processes." All this, while not the same as the flow theory, certainly does not contradict it, and its emphases strike me as true to experience.

momentarily whole. It does this by neutralizing or nullifying self-consciousness, which is by nature easily distracted, dissatisfied, split, or overattentive to the distracting circumstances of the moment.

My second, fully metaphorical attempt is this: A work of art is the ghost of a person yearning to be known by means of the material it inhabits. By "to be known" I mean that the person (now turned ghost) is to be appreciated for the self that is revealed within the work of art, and for the manner or style by which this inward self has been awakened, forced, lured, or seduced into inhabiting the material. If we accept this definition, we should ask of the work of art not, "What is that?" but "Who is that?" And if we can, we should answer with the detailed, empathic description of the imagined individual whose ghost is the work of art. A museum expert explains that in art she looks for a soul to communicate with. When successful, she says, she has "an experience of finding something that I can respond to at my most profound level, as a human being." This communication is most direct, she says, when, by luck, skill, intelligence, or a combination of these, this person has "managed to embed himself or herself into an object or a structure or work of art."[110]

My third attempt is only latently metaphorical: A work of art is an embodied aesthetic activity forceful enough to persist for an indefinitely long time. It persists by means of its continued aesthetic effect on the various levels of the viewers' various kinds of awareness, including those of sensation, perception, imagination, memory, and intellect. If the art has been given an outwardly static embodiment, its activity is its power to continue to activate its spectators. The work of art is an embodied aspiration and movement of thought that succeeds in influencing persons at large. Whatever its overt content, it is also the artist's aspiration for self-fulfillment by means of lasting human contact and esteem.[111]*

My fourth, partly metaphorical attempt is the following: Even when it is neither written nor spoken, a work of art is a message sent by a certain individual to other, mostly unknown individuals. Its written or visual language and the gen-

*This way of seeing art to some extent reflects the view of the anthropologist Alfred Gell. Gell looks on "primitive" art as an extension of the mind of a whole community. The example that he depends upon most is that of the Maori construction of meeting houses. The object of these houses was to exalt the community's ancestors. The building of a more sophisticated, innovative, and magnificent house would exalt the community's ancestors above those of a rival community and would crush the rival's aesthetic self-esteem. But all the houses, says Gell, were only the promise of still superior ones—the competition never ended. Gell's conclusion is that "the Maori meeting house (in its totalized form) is an object which we are able to trace as a movement of thought, a movement of memory

eral themes are drawn from the culture, place, and time to which the individual belongs. That is, the message inevitably draws on a particular collective memory and mode of life. But the individual artist—even the one whose culture minimizes individuality—is the final artist. The culture grinds the colors and prepares the set of stencils and preconceptions with all of which the artist composes a work that is a physical, aesthetic presence and a message that can be composed in no other way.

<p align="center">. . .</p>

Since all these characterizations of art are made by the same person, they have much in common. The stress is always on the aim of art and on art as an impersonally personal message. I of course do not mean to say that an intended or unintended message is always transmitted successfully. Julian Bell suggests that a spectator may enter into a mute dialogue with an absent painter and say, "Your painting expresses—for you; but it does not communicate to me. . . . You—this is the point—cannot determine how I go about my looking." Whatever the original intentions, they have turned into a residue of paint, something "indeterminate in meaning, just as a stone is. It has 'meaning,' insofar as we open our eyes to it and allow them to wander in fascination; but that 'meaning' is not an idea or an emotion, not a specific, unequivocal message. What we see is what we get: a product, not a process, lies on the wall."[112]

The objection that a work of art does not necessarily communicate is often relevant to contemporary art, which, in abandoning tradition, can become forbiddingly private if not accompanied by a verbal explanation. Yet Bell's objection takes the idea of "meaning" too simply: the message that is transmitted is not unequivocal—humans are not like that—and it is not or not only a clear idea or an easily nameable emotion. When we try to unravel the whole message of a work of art, it turns out to be hard to put into words. It has something of the verbally impenetrable quality of a person, any person, but a person who is both present and absent, so that there is always something unexpected that can be discovered in it. Even if one thinks that a work of art is poor or repelling, its particular character, which is its message, repays interest.

It is an often-proved fact that art of every kind shows us that there can be lifegiving exchanges of intimacy between persons who never meet. Pablo Neruda

reaching down into the past and a movement of aspiration. . . . Through the study of these artifacts, we are able to grasp 'mind' as an external (and eternal) disposition of public acts of objectification, and simultaneously as the evolving consciousness of a collectivity, transcending the individual *cogito* and the coordinates of any particular here and now."

regards his own experience of such intimacy as a possible explanation of why he is a poet. He has an unforgettable memory from his childhood: the tiny hand of a child he did not know pushing a toy, a marvelous white sheep with faded wool, through a hole in the fence that separated their houses. In return, Neruda took a pinecone he adored, full of odor and resin, and put it by the hole. Neruda and the child never met nor, after the one exchange, had anything to do with one another. Neruda speculates that that small, mysterious exchange of gifts remains inside him and gives his poetry its light. He feels, he says, that his life is fed by the love of those close to him,

> but to feel the affection that comes from those whom we do not know, from those unknown to us, who are watching over our sleep and solitude, over our dangers and weaknesses—that is something still greater and more beautiful because it widens out the boundaries of our being, and unites all living things. . . . Just as I once left the pinecone by the fence, I have since left my words on the door of so many people who were unknown to me, people in prison, or hunted, or alone.[113]

Neruda's story is as wonderful as the sheep he got, and so is his feeling that he gives poems away as if he were giving away his precious pinecone again. However, intimacy, in life or art, is not only the joint experience of love, but also of pain, despair, hate, and (as I've said) much else that escapes easy naming. But always, as I see it, the need to communicate some intimate selfhood or knowledge is essential to it.

If it is agreed that such communication is essential to art, it is natural to go on and ask how, that is, by what means, the message is received. Art everywhere demands of us that we modulate our actual selves by taking on something of the virtual selves of other, often-distant persons (and, with them, of often-distant forms of experience and culture). Such communication is the empathic, irresistible tendency to create and respond to the impersonally personal messages of art.

Before I continue, I want to repeat that art, taken in its most inclusive, disorderly sense, has no essence, no nature that is easy to distinguish from the nature of anything that is not art. Nor is there is a key concept that is able to concentrate in itself all the ways in which art is viewed and reacted to aesthetically. All the same, I have searched for a word to help me express what I mean by saying that art consists of aesthetic messages that are received as such by those who appreciate art. The concept of empathy, as my comments above indicate, will prove essential to my account. Empathy can now be assumed to have its physiological

basis in "mirror neurons." When aroused, such neurons are able to initiate the actions for which they are specialized. However, the neurons can also be aroused by the sight of someone else, who by performing the action stimulates the feeling of the action. By means of this ability, "the mirror system transforms visual representation into knowledge." In other words, "actions done by other individuals become messages that are understood by an observer without any cognitive representation."[114]*

The idea of a natural human ability to feel with or "in" others is old. Aristotle accepts something like it. Confucius tells a student that he understands the reactions of others by using himself as a gauge. Leonardo explains that when artists paint human figures, they are always painting themselves and their own gestures (is this empathy or its opposite?). "Empathy" is a translation of *Einfühlung*, meaning "feeling in," and its use in regard to art is attributed to Robert Vischer (1847–1933). According to Vischer, the object of visual art is experienced as if it has been "absorbed into one's personal subjectivity." I see, he says, in

> the present form of the phenomenon . . . a sort of duplicate of myself, the photographic image of my mood . . . and I speak for example of "the angry glare of the tempest." Attributing my own personal life to a non-living object, I feel myself into it, that is, I empathize with it. But the relation of viewer to the object is often that of an aware kind of "gazing." Gazing at something is like touching it delicately with the hand. With my eye muscles active, I allow my gaze to roam over the external contours of the phenomenon . . . ; at the same time my conscious second self, as it were, likewise roams along the periphery

* "A *mirror neuron* is a neuron which fires both when performing an action and when observing the same action performed by another (possibly conspecific) creature. That is, the neuron 'mirrors' the behavior of another animal, as though the observer were performing the action. These neurons have been observed in primates, some birds, and humans in Broca's area and the inferior parietal cortex of the brain. . . . These neurons may be important for understanding the actions of other people, and for learning new skills by imitation."

Mirror neurons were discovered in the 1980s and 1990s by two Italian researchers, Giacomo Fogssi and Vittorio Gallese, who were recording the reactions of a single neuron in the monkey brain when the monkey reached for pieces of food. As Rizolatti explains, the neurons were discovered by chance, he thinks "when Fogatti, standing next to a bowl of fruit and reached for a banana, when some of their neurons reacted. How could this happen, when the monkey did not move. At first we thought it to be a flaw in our measuring or maybe equipment failure, but everything checked out OK and the reactions were recorded as we repeated the movement."

of the object and thereby also takes a pleasure in the accomplished spontaneous movement of the eye itself.[115]

My difficulty with the idea of empathy is that it is natural to contrast it with intellectual responses. Besides, after I had learned a good deal of its history, I thought it heavily freighted with different, to me unhelpful, associations, and so I considered using the humble word "grasp," with its image of holding something with the hand, as a substitute. "Grasping" would serve me better than "empathy" if it were understood to express the activity by means of which art is most accurately and fully appreciated, or by which the message of art is most likely to be caught hold of. For the contagion of feeling that "empathy" expresses, I would prefer the contagion of understanding. By this I mean understanding of every kind and level: of awareness, conscious, semiconscious, and unconscious; of memory of every modality and intensity; of knowledge of any kind; and of any intellectual or nonintellectual response the preceding words may not have succeeded in catching hold of. Can so much be grasped all at once? What is composite in description is not necessarily so in experience. For someone with a good visual memory, a moment's view can take many words to describe. So my answer is that at especially perceptive moments art can be almost wholly grasped. This is what can happen, within human limits, when someone who is sensitive and knowledgeable concentrates fully on a work of art.

THEORIZING

When I reflect on what I have written in this chapter and what I address in later chapters, I see a basic consistency in the way I deal with the wider problems that I (and you, I assume) have chosen to face. As usual, such problems present themselves as dichotomies, opposites between which one has to decide in order to arrive at a clear position. Among the dichotomies that have already come up there is art as against non-art. Another basic dichotomy concerns the use of words—what can be expressed by reasoned words as against what cannot be expressed by them. A further dichotomy is between conscious or aware thought as against thought that is neither. There is also the dichotomy between absolute standards of judgment as against relative standards. Still another persistent dichotomy is between personal or individual expression in art as against the impersonal.

The consistency of my approach is the tendency to weaken dichotomies by adding intermediate possibilities and by denying, implicitly or not, that we are forced to choose between the opposite positions. "Yes and/or no," I'm likely

to say. This is because the sharp distinction into opposites that helps to make our thinking clear deprives us of the ability to perceive whatever it has a priori excluded from thought by omitting its possibility. Thinking that is too flagrantly dichotomous sets us at odds with ourselves, with others, and most seriously, with the reality whose elusiveness has provoked us into such thinking. (When faced by a rigidly logic-bound argument I'm apt to remember the words of the poet who said, "If only philosophers could learn a single thing from poets—how not to have opinions.")[116]

Now, when I want to summarize the ideas I have been expressing, I run into still another dichotomy, that of the view governed by theory—by explicit, consistent principles—as against the view that denies, ignores, or belittles the importance of theory outside of exact science. The title of this section is "Theorizing," but I am not aiming at a well-developed, rigorously defended theory, whatever "theory" may be taken to mean. The theorizing I do is only an attempt to put together the ideas raised here into coherent order. Its main goal is to construct a well-ordered position that is open to the art of every person and culture. I therefore begin with a leading question, one I return to in the last chapter: "Can there be a common measure—a common means of assessment or evaluation—of all art?" I soon come to a second leading question: "How does art communicate experience that is verbally or logically incommunicable?" To emphasize that the argument is only an outline, I put it into a series of, as it happens, thirty-one mostly brief paragraphs. I've discovered that, together, they've taken on a life of their own.

1. The question "Can there be a common measure for all art?" can be answered reasonably only if there is a conception of art in terms of which to answer it.

2. This question requires openness to the art of every person and culture. To satisfy the requirement, a conception has to be broad enough to include everything that has been seriously considered to be art, whether in our own, now relatively open culture, or in any other of which we know.

3. The broadest (to my mind, most plausible) such conception is that everything that we experience implies the possibility that it can become art because it has or can have an aesthetic aspect. The aesthetic aspect of an experience is everything in it that is other than merely useful or merely factual. For example, to say that a human hand has five fingers is to express a mere fact. To feel or imagine how the fingers feel or look or move or what one does with them is their aesthetic aspect and the source of innumerable metaphors and works of art. And to persons who are curious about numbers, the number five has an interesting

nature of its own and shares in the nature of the pentagon, a shape with many interesting associations.

4. The aesthetic aspect of experience, neither merely useful nor merely factual, tends to be reflexive. It is, so to speak, the self-conscious experience's experiencing of its own tonality, color, and interest. As such, it is wholly and immediately personal, and in this sense unique.

5. To understand experience so is to see a problem in the relation between experience as aesthetic and words in their ordinary, prosaic use. Prosaically used words can be fully adequate to convey what is practical, factual, and common to the people to whom they are addressed. They are much less adequate to express what is none of these.

6. Therefore, the extent to which something is unique in experience is the extent to which it cannot be fully expressed in words or, at the conscious limit, can barely be hinted at. The self-evident conclusion is that to the extent to which the unique in experience cannot be expressed in words, it is (verbally) incommunicable.

7. In saying this, I am not, of course, referring to works of verbal art. Such works, too, are unique, meaning, in this case, that they cannot be fully expressed in words other than their own. There are aesthetic experiences as well as recognized works of art that range from affecting memories to poems, songs, operas, dramas, and films that cannot be separated without aesthetic damage from the words that, in whole or part, make them up. Words in their rigid dictionary meanings are not fully adequate to express the aesthetic uniqueness of words in actual use, especially their use as verbal art.

8. Because all things done or made have aesthetic aspects, they can all be looked on as at least the raw material for art, or as art in a latent state. Anything done or made that in any way prolongs or accentuates its aesthetic aspects is art at least in a weak sense. As a term of praise, "art" is usually reserved for acts or works whose embodied aesthetic experience is especially concentrated, imaginative, or compelling.

9. There is no reason to suppose that such instances are confined to acts carried out or objects made in order to be exhibited or collected as art. Even if not explicitly identified as art, acts or objects are often an extraordinary part of the ordinary course of life, and are often memorable for the roles they play in secular or religious ceremonies.

10. Because a work of art, especially in the stronger sense of the term, is a concentrated embodiment of aesthetic experience, it is (insofar as aesthetic) fully

communicable only by means of its own presence (which can be suggested by a more or less faithful replica). Most often, the work's inherent quality and purpose is to communicate what can be fully communicated only by its presence.

11. Art has two basic functions. The first and most important is to strengthen the desire to live by enhancing the quality of life of those who experience it, whether by creating art or by enjoying it—and in some sense re-creating it—after it has been created.

12. Art strengthens the desire to live by countering boredom, lassitude, and depression. It does so by enriching experience or, in the simplest words, by making experience more interesting. More particularly, art enriches experience by using perception, emotion, memory, and association to create the embodied equivalent of whatever it is that we want to experience, whether or not it has a literal existence. Seen in this light, the function of art is to enhance the quality of life by satisfying the hunger for experience in all of its actual and imaginable variations.

13. The second basic function of art, which relies on the first, is to strengthen the sense of community by means of common works of art, works that all the people can all perceive or even, sometimes, engage in. That is, art supplies the common means by which otherwise incommunicable experiences are experienced together.

14. As a matter of psychological and social fact, art is often meant to be experienced by persons at large, who may know nothing or care nothing about the persons who created it or the circumstances of its creation. Art is in this sense impersonal.

15. But art also transmits or echoes the unique nature of the individual or individuals who created it. Its uniqueness is experienced as the residue or echo or ghost of the unique personality of its creator or creators and the unique circumstances under which it was created. Art is in this sense personal.

16. A work of art unites those who are interested in it by giving them the means to experience unique, largely incommunicable works of art either in themselves or in replica. While it is impossible to prove whether or not they are experienced similarly in different persons, the observable signs are that the experiences are in part the same, in part similar, and in part different. As a problem, genuine solipsism is a theoretical, not practical issue.

17. Even when art is not singled out as such by a special designation, it shows that it is intended to be art in the sense adopted here by following what we recognize to be local aesthetic conventions. These conventions prepare the art—under

whatever name—to be experienced as such. Those who know only other conventions may find it difficult to appreciate the local art for what it is meant to be and may have to fall back on their own, at least somewhat misleading, criteria.

18. Much of the effect of a work of art depends on the culture, place, and time to which the work belongs. Inevitably, the work draws on and enriches the collective memory and modes of life of the people among whom it is created.

19. But because art makes inevitable use of perceptual and emotional mechanisms common to all human beings, much of it can be appreciated intuitively as art by almost anyone. That is, almost anyone who takes the trouble to look at or hear it attentively can perceive that it embodies unusually concentrated aesthetic experience. Therefore the uniqueness of the experience and of the personality and circumstances embodied in the art can usually be intuited in partial independence of its own, local conventions.

20. To the extent that art uses means that are intuitively appreciable by almost any attentive person, art can be an effective means for communication between members of different times, places, and cultures. Of course, unfamiliar art is more easily, sensitively, or fully appreciated by those who are willing to make the effort to understand the conventions it uses.

21. Even in a time, place, or culture that does not emphasize an artist's individuality, this individuality is experienced in the aesthetic resemblance between the nature of the work and the nature of its maker.

22. The verbally incommunicable experience that is embodied in or constitutes a work of art cannot be accurately summed up in a clear idea or a nameable emotion. When we try to decipher the experience, that is, learn a work's message, we find that words can hint at its qualities and describe them in a general way but not sum them up without considerable loss. Our vocabularies are too poor and too general for the purpose, and our attempts to be exact in appreciating the works may be too personal to help much.[117]

23. Therefore a work of art has something of the verbally impenetrable quality of a person, one who is both present (because the art is inherently personal) and absent (because the art is also inherently impersonal). Its quality of verbal impenetrability is also that of the cultural influences it bears, which may prove too foreign to be grasped as intended.

24. The experience of a work of art involves a sharing of intimate experience between whoever creates it and whoever enjoys it. This shared, basically pleasurable experience is life enhancing, even though the sharing is usually in imagination alone.

25. So art shows that there can be life-enhancing exchanges of intimacy and pleasure even among persons who never meet and among times and cultures that are distant from one another.

26. Except for some comments I want to make on the whole of my argument, I've finished it, or rather, finished its outline. As I've said, it is meant to suggest a conception of art that is in itself plausible and is broad enough to allow a reasonable attempt to answer the question, "Is there a common measure to all art?" That is, does this conception make it reasonable to believe that art at all times and places has had characteristics common enough for us to enjoy it more or less as it was intended and to judge it by standards that are not radically foreign to it. I suspect that an attempt at a full answer would be a detailed, highly qualified "yes" or "yes, but."

27. One difficulty for my argument is that if it is persuasive, it may seem to be so at its own expense. This is because it is put in ordinary words, which I have confined, as best I can, to their rational, utilitarian use. But such words, my argument claims, are unable to communicate much of the uniqueness of art. This inability applies both to the uniqueness of the individual works of art and the uniqueness of art as a whole as compared with any other enterprise as a whole.

28. I have, however, already given my answer, which is that the difficulty is real but that, once understood, it does not matter very much. We live closely enough with our fellow humans to have learned that our private experiences are often not radically different from theirs, and that what is most different in them (surely in those that live culturally close to one another) is in a general way communicable as a variant of what we ourselves feel. We have learned this because, being social animals, we are able to sense or feel—with our usual admixture of words and silences, explicit declarations, shared habits, and intuitive apprehensions—what our fellow humans sense or feel. Our mutual understanding that our aesthetic and other experiences are hard and in some ways impossible to put fully into words is a challenge to us to share our intuitive experiences intuitively and, when it matters, to make a particular effort to find the least misleading, most carefully thought out words to say outright what is possible and, beyond what we can say, to hint at what we find hard to put into words. The incommunicability of aesthetic experience poses a standing challenge to minimize its apparent absoluteness.

29. The argument, with its outlined, miniature approximation to a theory, is finished. Is the theory convincing? If you take the points it makes one by one, you are likely to agree with, I hope, a large number, disagree with some, and feel neutral about the rest. But whether you agree, disagree, or are neutral,

many of the points my argument makes can be denied with at least a show of reason. This is because the points are not self-evidently correct, or are in some way unclear or inadequate. Nothing in my argument is logically compelling, and nothing is fully proved, logically (whatever that might mean), or empirically, or by the usual combination of logic and experience (though I do cite a good deal of scientific evidence, the fallibility of which I emphasize, and give and will continue to give a good deal of empirical evidence). This difficulty may of course be common to other views of aesthetics. Even if I forgo this ironical comment, honesty should compel us to acknowledge that such absence of compelling proof is common to free discourse. Only science technically worthy of the name escapes it more or less well by the rational means it adopts, and only art worthy of the name escapes it by the persuasion it exercises by its imaginatively compelling presence

30. If you take my position as a whole, it is, in any case, not reasonable to ask if it is right or wrong because it is a particular individual's way of looking at art and the world, and to be fair, it should be judged in the light of the problems to which it is relevant and the tradition-crossing attitudes it proposes. I would not object if the whole book this chapter introduces would be judged not only by its explicit arguments but, like the art it discusses, by its less-than-obvious tendencies and character.

31. Art or not, I am convinced that the views I express here are worth arguing out and arguing over. The desire to think through things clearly remains very strong. It is the desire to give the argument the bones of fact, the flesh of examples, and the nervous system of ideas, as well as the form that all these take as a whole.

· · ·

The desire to think things through clearly, not to say adequately and plausibly, is of course the point of this whole book, some of whose attitudes and arguments I have just now put into consecutive order. It remains to be seen to what degree these attitudes and arguments can persuade those in a field in which to disagree is the normal, creative way of expressing oneself. But I do not so much expect or want my readers to agree with me as to use what I say to renew or widen their views in ways that are compatible with their own natures and experiences. Each of us who prizes intellectual independence has to act as his or her own teacher. But a teacher of oneself, like any teacher, has the obligation to listen carefully to those who think otherwise, in order to grasp how different each of us is and yet how similarly dependent upon those we differ from. It's not easy to escape a narcissistic narrowness. It's also not easy to refuse to think honestly about

both evidence and counterevidence, but our independence as individual thinkers does not empower us to create the world that exists before, around, and after us. One of the great engines of productive thought is curiosity, which refuses easy solutions in a world it senses to conceal surprises at every turn. It is curiosity that keeps drawing us back to respect for evidence, respect that is the equivalent of honesty. So how, I ask, could anything be more interesting to us than this world we live in? This very world, having invented itself with such endless self-ordering complexity, is far more interesting and far more fantastic than the one that Alice experienced in Wonderland. And just as Lewis Carroll took his pleasure in making up the world he invented for Alice, so we can learn to take pleasure in sharpening our perceptions of this, our world we perpetually revise and reinvent in art, and bend our words until they say what we see, think, and imagine, reach almost as far as we would like them to, and express even more than we know we have put into them.

SELFLESS TRADITION

TRADITION, TRADITIONALISM

Tradition is based on pride in collective habit, on the conscience that approves the pride, and on the fear that if habit and conscience fail, the result will be social chaos, the fear of which is in turn based on a particularly low assessment of human nature. The assessment of humans as either depraved or not is balanced on a seesaw of memories that swings from low to high and high to low. To start with the low, the fear, there is Machiavelli's fear that if people are given freedom, it must be presupposed that they will always act "according to the wickedness of their spirits" and can be reliably influenced to be good only by laws that force goodness upon them. Move from Renaissance Italy to ancient India, and the fear takes the form of "the law of the fishes," by which the stronger fish devour the weaker or, in human terms, the stronger humans misrule, misuse, and dispossess the weaker. Move from ancient India to ancient China, and the fear, as expressed by the Confucian philosopher Hsün Tzu (Xunzi, c. 340–245 BCE) implicates the love for everything beautiful. "Man is born," he says "with the desires of the eyes and ears, with a fondness for beautiful sights and sounds. If he indulges these, they will lead him into license and wantonness, and all ritual principles and correct forms will be lost." For this reason, says the philosopher,

"any man who follows his human nature and indulges his emotions will inevitably become involved in wrangling and strife, and will end as a criminal."[1]

The seesaw's low, which is the misanthropic fear, is universal. So, however, is the high, which is the proud conscience according to which we maintain and love tradition because it is the accumulation of everything of value that human beings have gathered in the course of time. As will become apparent, there have always been reasons to accept both the misanthropic and philanthropic evaluations.

To speak neutrally, tradition is the name given to the whole body of transmitted culture. Or it is the name given to the spirit in the light of which a culture is conserved and transmitted. Tradition easily becomes "traditionalism," which is the name of the conscious desire to live in accord with the spirit and rules of the culture that has been transmitted. Traditionalism is therefore also the desire to live by the spirit and rules that may have almost vanished but are assumed to be the source of everything that is of value. In art, traditionalism is the partiality for the past that is likely to be expressed moderately in what we name "classicism" and more extremely in "archaism."

Traditionalists credit tradition with a superiority that is both practical and moral. The superiority is ascribed to the perfect wisdom of the founders of their tradition or, alternatively, to the great experience that the tradition has accumulated over the course of time. Except for moments of social disintegration, tradition is universal and proud of its origins and persistence. The oldest literary expression of traditionalism I have found (although I expect there are others as old or older) is in the Egyptian "Instruction of Ptahhotep," which goes back to about 2200 BCE (its precepts are like those at the start of Proverbs 4). The passage of the "Instruction" I refer to says that things go well with a son who has heard, that is, has learned to obey:

> When he is old, has reached veneration,
> He will speak likewise to his children,
> Renewing the teaching of his father.
> Every man teaches as he acts,
> He will speak to the children.
> So that they will speak to their children.

This ancient Egyptian example of reverence for an earlier, already traditional wisdom reminds me of the belief, expressed in the very oldest literature of India, that there has been a long preceding tradition. In India, the most ancient authoritative sources are the Vedic hymns. No one really knows their age, but a usual

(Western) scholarly guess would be that the collection of hymns known as the *Rig-Veda* goes back to about 1100 BCE. Yet it is not unusual for a poet of the *Rig-Veda* to speak of "our fathers," or of the old, "immortal generations."[2] A rather less ancient but no less sacred source, the *Brihad-Aranyaka Upanishad,* ends in two alternate lists of a succession of teachers, that is, transmitters of doctrine, one of fifty-two teachers and the other of forty-six. The first list begins, "The son of Pautimasi [taught] by the son of Katyayana, the son of Katyayana by the son of Gautami, the son of Gautami by the son of Bhradvaji," and so on. In India, obviously, the oldest existing sources claim to depend on much older ones.

I add a note on Confucius and a (not incongruous) reminder of Polynesian tradition: Confucius, the hero of Chinese tradition, is known as the editor of books that to him represented the revered past. A relatively modest person, he regarded himself as little more than the defender and would-be restorer of an already ancient tradition. Polynesian tradition, like the Indian for a long time, was wholly oral. It depended on "generations of specialists, saga-tellers highly trained in the art of memorizing as well as in their critical faculty," with the result that Polynesia had "one of the two finest oral historical literatures in the world."[3]

A word on the power of tradition in Africa, and then I turn to art. This reminder is based on the effort that African historians have made to recover their history by paying close attention to their oral traditions. One such historian says that the serious guardians of tradition are quite different from the minstrels who sing of the past, but do so mainly in order to entertain. Speaking of the Bambara (now usually called Bamana), of West Africa, especially Mali, A. Hampâté Bâ says:

> The public does not confuse the two. When Danfo Sine spoke, he was accompanied by two witnesses, whom he called upon to supervise and bear out what he had to say. It is the practice for traditionalists [guardians of tradition] to quote their sources by saying "I hold it from So-and-so, who held this from So-and-so," etc. They pay tribute to the historical or mythical originator of the tradition by crouching down and placing the tip of the elbow on the ground, with the forearm raised. . . . If the rules of transmission are not respected, a magical and sacramental current will not flow.[4]

Hampâté Bâ, who wrote the *History of the Fulani Empire of Macina in the Eighteenth Century,* says, "I discovered that the thread of the narrative recounted by the thousand or more informants to whom I listened was always the same. . . . The experience proved to me that oral tradition was perfectly valid from the scholarly

standpoint." In regard to art, he maintains: "The traditional crafts and trades are the great vectors of oral tradition. The craftsman's work is important because it is in the image of divine creation. Bambara tradition teaches that when Maa Ngala created the universe, he left things unfinished so that Man could complete them, alter them and finally perfect them."[5]

Slowly, as befits the evocation of tradition, we have come to tradition as it shows itself in art. Such tradition, too, relies on the transmission from master to disciple, a distinction in the absence of which a tradition could hardly maintain itself. The disciple must of course defer to the master, because the master, the disciple knows, is the agent of a timeless understanding and the transmitter of the skill by which this understanding is made exactly evident to spirit and body. Even the master is taken to be important only as the agent of the old, authoritative norms, forms, symbols, and skills, any of which it is wrong to change and destructive to abandon.

The dramatis personae of my argument concerning tradition in art are almost self-evident. Aside from ourselves, most of whom I assume (I hope mistakenly) are the heirs of the tradition stemming from the Greeks and Romans, they are mainly those called or, rather, miscalled "primitives," and the Indians, and the Chinese, Japanese, and Koreans, the last three most economically grasped as members of a single highly varied tradition.

To begin with, something general should be added of traditionalism. By nature and design, it is prescriptive. So far as I have been able to discover, it has an inclination toward the doctrine that the universe in all its variety is present in each of its fractions, forces, or manifestations. Each of the fractions or forces can influence all the rest. Their influence is expressed in the endless, changing tension between the poles of cosmic order and chaos and their sometimes catastrophic alternation. Order is equivalent to everything that is constructive and beneficent, but it is never enough to constitute the whole universal process because chaos, which never dies out, interferes. Chaos, then, drives everything toward destruction, even though, as part of the unending universal process, its ferment is essential to its creativity. Traditional priests and thinkers side with and try to fortify the order. But there are always those who, openly or secretly, identify themselves with the amoral whole of order/chaos, or of chaos alone (as they may be, rightly or wrongly, accused). It follows, according to the usual view of traditionalists, that human wisdom and goodness consist in performing the acts, individual and collective, that strengthen order and diminish chaos, because everything that is done, not done, or undone reverberates in the field of reality and has its ordering or disordering effects.

According to such a view, every form of human expression has an immediate or potential effect. If right, the word, the gesture, the tone of the voice or sound of the musical instrument, the movement, the mask, the costume, the role in the ceremony all express and strengthen the invisible power, which enfolds and protects those who serve it. But how the power should be served is not always clear, and the cause and effect of every object or event is augmented, so it is believed, by a secret meaning. The obscurity of ceremonial words the meaning of which has become obsolete is taken to prove their sacredness. The words may be explained to those who want and deserve to know them and have been initiated to receive them. Or the sacred revelation may be confined to the rare persons who are expected to pass it on from generation to generation. According to the ancient Indian tradition, for example, the deepest, more-than-verbal truths were intuited by sages, who were then able to interpret the puzzles within puzzles of existence. These sages knew how to pass on the intuited truths, or at least the ceremonial sounds and actions that resulted from understanding them, to lesser persons. These lesser persons, ascetics and priests, kept the truths alive by committing them exactly to memory, transmitting them from teacher to disciple in a great chain. The ancient Chinese, in contrast, believed in a small number of heroic creators of civilization, who taught humans everything essential for a civilized life, most especially the individual conduct and social relationships that mirror and support the order of the universe.

In spite of these embracing generalizations, and in spite of any impression I may make now or later, there is no formulaic way of all at once grasping whole cultures, each of which is enormously complicated. For this reason, when I take up India, China, and Japan, I will rely mostly on particular descriptions or on the context of a particular argument. In discussing the so-called primitives, I may not hesitate much in generalizing, but I will take care to draw on examples each of which I value in itself because it has taught me something I would otherwise never have known.

PROBLEMS ANTHROPOLOGISTS ENCOUNTER AND CREATE

Anthropologists are among the heroes and villains of the story I have to tell. Heirs of travelers and missionaries, the anthropologists in time developed a method for studying their exotic-appearing subjects as fully and objectively as possible. To be recognized as an anthropologist, one has to undergo the rite of fieldwork, usually in some "tribe," or now that "tribes" open to research are few, some plausible substitute. After the fieldwork comes the writing of a doctoral dissertation. The difficulties of an anthropologist in adjusting to life in the

field have been described in detail, and so, too, the reactions of the investigated peoples to the investigating anthropologists and of the anthropologists to the investigated people's reactions to them. This diversity of perspectives has made an anthropologist's life both difficult and revealing. Here is a humorous example from the monograph of James Fernandez, who took it upon himself to investigate "the religious imagination" of some small forest villages, home to the Fang people of West Africa. Toward the beginning of his book, where he writes miniature biographies of those who have a part in it, he describes himself in these words:

> The ethnographer, age 28. He and his wife share Ngema Mve's house. He asks too many questions and is always doing paper work. "What does he want, really?" . . . His number one wife, age 25, cooks in the kitchen with the other women, goes to the plantations and fishes and bathes down at the river. She is better loved than her nosy husband. "Was it true that her father had given money to her husband when he married her?"[6]

Fernandez, who has remained basically faithful to the ideal of objectivity, explains how hard it was to generalize his observations, because no matter how dogmatic, closed, and small the society, individual differences are always important to social change. He therefore used a method primarily "of intensity— repeated in-depth discussion with a limited number of knowledgeable informants, and, where possible, repeated observations of practices and collection of public statements and other texts." Fernandez says that if you imagine the activities of a Fang life as if it were a drama, with a beginning, middle, and end, you discover that "some Fang saw more of a drama than others but none an entire play."[7] But an incomplete understanding, along with ambiguity and ambivalence, are characteristic not only of the people studied but also of the anthropologists who study them. The anthropologists do not fit into the local, "primitive" life easily and need help because, in spite of their notable power, goods, and money, in local life they are naive and, in the most ordinary ways, laughably incompetent. Their ambivalence is now often acute because anthropologists have become terribly aware of the preconceptions held by their predecessors and, possibly, themselves, not to speak of the long, not conspicuously moral rule of the "civilized" peoples over the "primitive" ones.[8]*

* "Primitive" peoples who are studied are now likely to question an anthropologist's motives, just as the anthropologist may be troubled by the motives of the "primitive" informants. The payments the anthropologist makes for information raise the issue of who

Momentary disturbance apart, does the anthropologist do any real injury to the people studied? Precious, sometimes secret information the anthropologist assembles is set down first in field notes. If this is revealed, what effect may it have on those whose lives are described? Home from a probably too-brief period of observation, the anthropologist uses the notes taken in the field to construct a thesis. This construction is in itself no simple act of transcription and summary. In his book on the Achuar, an isolated people living in the Amazonian jungle of Ecuador, the French anthropologist Philippe Descola looks back on his sixteen years of intermittent work on his book and recalls the help to memory given by his field journal, his "initial wide-eyed naivety," his extremely slow advances in understanding, and his joy in feeling that he has suddenly fitted things together.

> But the man writing these pages is no longer quite the one who came upon the Achuar all these years ago, and fiction is also born of that slippage in time. . . .
> I have been unable to avoid superimposing upon the emotion and judgments that my journal delivered up to me in all their ingenuousness the feelings and ideas that happen to have stemmed from my subsequent existence.[9]

In spite of these words, Descola argues that the anthropologist is able to speak as a particular individual in relationship with other particular individuals and, all the same, give a careful, scholarly interpretation of an unknown culture. I sympathize with Descola's view but must go on with the prevailing doubts of other, American anthropologists, who have become their own most extreme judges.[10] They have obviously been influenced by the quasi-Marxist doctrine that all social relations and modes of thought express relations of power and the exploitation of the weak and poor by the strong and rich. Paradoxically, they often ally this doctrine with the idea that the points of view of all cultures are relative—the paradox is that extreme relativism makes good and evil relative, including the evil of which the anthropologists accuse themselves and their culture of having perpetrated.

At least in the anthropology of the United States as I know it, every culture has come to be regarded as if it were experienced by its members in a unique,

gets paid for giving information, how much the pay is, and whether or not the information is affected by the desire for payment. The anthropologist Clifford Geertz talks of "blunt demands for material help and personal services" and "a certain resignation toward the idea of being viewed, even by one's most reliable friends, as much as a source of income as a person."

barely translatable symbolic system or language. Conventionally, the anthropologist is supposed to be like a novelist trying to imagine the relationships of unfamiliar persons so that they seem to be understood and familiar. Such a construction, says the new, critical anthropologist (in harmony with Foucault or Derrida) is no more than a fiction. For a culture is read, so to speak, as a text is read and, like the text, has as many interpretations as it has readers: "As there is no canonical text, so there are no privileged readers."[11]

The American anthropologist Clifford Geertz, probably the most influential exponent of symbolic anthropology, explains that toward the turn of the century, the temperature of anthropologists rose, and he found himself in "howling debates . . . over such excited questions as whether the real is truly real," whether knowledge is possible, or objectivity a sham. "Is disinterestedness bad faith?" they asked, and "Is description domination?" The older anthropologists, Geertz says, felt that the unity of the field had been lost, along with "respect for the elders of the tribe" and mannerly discourse. Though sometimes held responsible, he says, he remains calm and unfazed because he is skeptical of the battle's very assumptions.[12]

I would not have described these problems of contemporary anthropology had I had not felt that its preoccupation with relativism, symbolic systems, power relationships, and social oppression makes its temper distinctly like that of current art criticism. Everything is called into question, all standards (except the self-evidently evil, "triumphal" or exploitative ones) become equal, and every object, motif, direction, or attitude can be given a symbolic justification. The world can be as easily seen upside down as right side up—the German painter Georg Baselitz (b. 1938) has thought it most revealing to paint it upside down. I've also said what I have about anthropology because this information is crucial to the discussion of the art of the peoples who have fallen within its scope. This art has for long been known as "primitive art" or, often, "tribal art." Everyone who knows anything seems either to abandon the first of these names, "primitive art," or to apologize, as I do, for using it, on the grounds that it has no good substitute. Let me explain why.

When the term "primitive art" is used, the most obviously relevant sense of "primitive" is "undeveloped because the work of a materially and culturally simple group." This sense goes well with the ideas of social evolution that describes the development of large civilized societies from small uncivilized ones. These smaller groupings are assumed to have developed into localized tribes consisting of a few enlarged families, which developed into centralized chiefdoms, which developed into complicated, internally differentiated states. However, good evi-

dence for the assumption that there was a particular kind of original primitive society has proved difficult to find, so that at least one historian of the idea of primitive society has called on anthropologists to liberate themselves from all the assumption's forms. However, what has discredited the anthropological use of "primitive" is not that it needs a questionable extrapolation to fit it to the supposed beginnings of human society, but the implication that those to whom it applies are of lesser human worth. Natural to colonial masters, this implication is as naturally rejected by those who have escaped or regretted their rule.[13]

What characteristics were (and sometimes may still be) assigned to the peoples called "primitive"? Living in small groups, they were innocent of writing and, of course, of exact, mathematized science and machine-based technology. Though their heirs and partisans have rejected their designation, going back to the time of their discovery, as primitive in the senses of "crude," "undeveloped," and "savage," they have often been inclined to accept such old, romantic, favorable senses as "primal," "natural," and "uncorrupted."[14] But whatever the sense of "primitive," the lack of writing cannot be taken to imply that "primitive" societies lack literature—which, like the most ancient literature of India, has been oral rather than written—or that they are insensitive to literary values. Some "primitives," such, as I have mentioned, the Polynesians, have had elaborate literary forms and compositions of epic length and complexity.

If we substitute "tribal art" for "primitive art," the more negative connotations vanish, but other difficulties remain. Why should the hundreds of groups of Bantus (meaning "people"), who are scattered over a third of Africa and speak languages that are mutually unintelligible, be considered to be a tribe or even a coherent people? And why should the name of "tribe" or "race" be given to the different foraging societies called Bushmen, whom the Dutch were eager to exterminate? Even when the name "tribe" is applied with reason, it is apt to give a misleading impression of separateness. Africans of different ancestral groups or tribes often lived together in villages, had dealings with people who lived in other, biologically unrelated villages or towns, and were loyal to the area's rulers, of whatever origin. All told, the notion of a "tribe" as an ancestrally related group with a common language, common tradition, and common territory is inadequate for many of the peoples and kinds of art to which it has been applied.[15]*

*Why should the peoples of a geographical region given the same name, for administrative purposes, by their colonial rulers be called "tribes"? And why should the word "tribe" be applied to black Africans such as the Yoruba, who live in most of southwestern Nigeria? Most of those who speak a Yoruba dialect and share the Yoruba myths have lived in

Besides, in and out of Africa, each people, village, or tribe is composed of individuals, each with an individual nature and history.

While it is impossible to erase all the contrasts between smaller, simpler societies and greater, more complex ones, the smaller ones have been judged unfairly. This unfairness has been justified by the absurd habit of comparing a "primitive" folk belief or practice not with a folk belief or practice of the anthropologist's own culture, but with the attitude of a positivistic scientist to science, or with an idealized account of the application of scientific method. Things look different when the comparisons are made of the ideas of ordinary with ordinary persons, of philosophical with philosophical persons, priests with priests, faith healers with faith healers, herders with herders, craftsmen with craftsmen, kings with kings, and so on.

Writing has of course given the cultures that have possessed it a cumulative complexity, a copresence and mutual dependence of texts and ideas, beyond that possible to the peoples who lacked writing (ancient India is a possible exception). Yet not every serious comparison is to the advantage of the "civilized." If we try to read the "primitives" symbolic self-expression in the same temper as we read our own texts, we can find it to be latently or even explicitly philosophical.[16] We continue to be intellectually self-enclosed. I have yet to come on an enthusi-

towns or cities that were military city-states at whose center lay the palace of the local king or *oba*. When such kingdoms were incorporated into the British empire, the kings of the city-states, which included conquered towns and varying ethnic groups, were referred to as chiefs and the city-dwellers as tribesmen; but these terms are surely misleading.

I omit the Mayas from consideration as either "primitive" or "tribal" because of their writing, which has now been deciphered, the hierarchical structure of their city-states, and their impressive architecture. As for the Aztecs, their art, too, resembles that of the ancient Egyptians in that its sequences are meant to be understood much as writing is understood. The Aztecs' actual writing, taken (inexactly) in a sense narrower than that of art, is made up of pictographic symbols (glyphs) interspersed with a few phonetic symbols to help with names. This writing, now "solved" as if it were a puzzle, is not at all sufficient for the Aztecs' historical records, orations, and sometimes extraordinarily expressive poetry (which are now known because they were set down in Latin letters by Aztecs in their own, Nahuatl language, or collected by missionaries, especially by the Franciscan Bernardino de Sahagun [1499–1590]). Further, as we are well aware, the Aztecs' architecture is impressively massive, their large population had a hierarchical structure and a strongly centralized government, and their union of city-states was the joint conqueror and exploiter of a large empire. The Mayas and Aztecs are therefore more reasonably compared with the ancient Mesopotamians, Egyptians, or ancient Greeks than with the peoples usually called "primitive" or "tribal."

ast for the Western intellectual tradition who has made a serious comparison of the early, searching, inconclusive Socratic dialogues with the sharp, inconclusive dilemma tales of the Africans, which engage the participants in extended discussion, or of these tales with Jesuit or Kantian casuistry or Zen koans. I have yet to see a serious comparison of Western existentialist views, whether those of Heidegger or anyone else, with those of Inuit shamans (I go back to the reports made by Knud Rasmussen [1879–1933], who learned as a child to talk with the Inuit in their own language). And in spite of some notable efforts, I do not know of any persuasive comparison of the views of God, destiny, or life that have been expressed by "simpler" peoples with the equivalent views that we adopt for ourselves.[17]

The balance has for some time been redressed, on occasions with a vengeful pride, by African, Afro-American, Native American, and Aboriginal writers and anthropologists who have assimilated Western culture well enough to attack it with its own instruments. Whatever we think of the ensuing discussion, it remains true that anthropologists have often compounded their shallow understanding of the peoples they studied with an insufficiently qualified understanding of their own people. It often used to be supposed that "primitives" think (mostly) mythically or magically, as compared with the "civilized," who think (mostly) rationally. This opinion, even odder for its view of the "civilized" than of the "primitive," is now held, if at all, with the caution born of long controversy.[18]

Consider what happened when a group of anthropologists investigated the !Kung, a San people of southern Africa, who live by hunting and gathering and whose speech, part of the Khoisan language family, is distinguished by its click consonants. The anthropologists discovered, rather to their surprise, that the !Kung were able to think along lines that Westerners identify with the "logico-deductive model" of science. Prolonged, careful discussions between !Kung hunters and the anthropologists, who enlisted the help of ethnologists, show how carefully !Kung hunters distinguish between hearsay and reliable data, that is, their own observations. The !Kung report new behavior, conduct skeptical discussions with one another, and admit ignorance readily. Such "animal seminars" impressed the anthropologists with the patient, accurate observation of the !Kung, their "breathtaking" volume of knowledge, and their elegant deduction from animal tracks.[19]

Against the notion that "primitives" are by nature or nurture emotionally childish, I offer the example of the Dogon, who inhabit cliff villages in West Africa, in Mali, in the central bend of the Niger River. I am able to offer them as a counterexample because they were once studied by a whole group of psycho-

analysts. The analysts were impressed by the ability of the Dogon to use their masked dances to sublimate and control their deep fears. Perhaps because the Dogon spend a long period close to their mothers, the analysts suggest, they are more self-assured, less troubled by doubt and disappointment, than ordinary Westerners. The Dogon, say the psychoanalysts, are neither childish nor primitive. "More exposed to external dangers than are Occidentals," they are less anxious. "More dependent on human company," they are less solitary, less pursued by their internal conflicts, and "get along better with their likes than we with ours."[20]

Against the idea that material poverty implies cultural poverty, I offer the example of the Australian Aboriginals, to whom I will often return. They were (as they are) very poor in a material sense.[21] They never wove nor made pottery, their shelters were of grass or bark, and before the coming of the white man, most wore no clothing. Yet they had a developed sense of craftsmanship and beauty, their memorized literature was rich, their ceremonial dancing was complicated and precise, and their religion was sensitive, imaginative, and not at all simple. They were and remain extraordinary trackers. They had and have a good sense of humor. There is no good reason to look down on them as persons or as artists.

The least moral to be drawn from the preceding examples is that we should be cautious in generalizing about materially poor peoples. If we hope to be exact in our questions, we have to ask to which peoples they refer, at what point of their existence, and in what respect. We should not think of such peoples as automatically conforming to old or new anthropological generalizations, nor should we forget to be grateful to the anthropologists, whose mistakes are far more than compensated for by their observations, which remain indispensable to our understanding.

THE ANTHROPOLOGY OF ART

A representative sample of human societies, published in 1981 in the *Atlas of World Cultures,* includes 563 distinct groupings, divided by region into African, Circum-Mediterranean, East Asian, Insular Pacific, North American, and South and Central American.[22] Reference to this atlas gives convincing evidence of the very many forms in which humans have learned to take notice of aesthetic experience. Does this evidence show anything of importance that is universal in art? I have given an answer at the end of the preceding chapter; at the end of the book I will give a more elaborate one. For the moment, I confine myself to three narrower questions and give summary hints of answers to them. I ask: Do the emotions that appear basic to us appear basic everywhere? Are the colors that appear

basic to us regarded as basic everywhere? Are the different senses—sight, hearing, smell, and so on—evaluated in the same way everywhere? In each case, neither the answer yes nor the answer no is adequate.

About emotions: Facial expressions for the basic emotions are much the same and for much the same reasons everywhere. Yet the research of the anthropologist C. A. Lutz has given her reason to contend that accurate descriptions of emotions are possible only with respect to a culture's particular, local life.[23]

About colors: A well-known study shows they are recognized and named everywhere as if they belonged in fixed positions in an embracing spectrum of colors, and there have been attempts to make a general map of color preferences.[24] But anthropologists and psychologists have shown that colors are recognized and classified differently in different societies and are assigned different symbolic meanings.

About the senses: they are classified, valued, and used in art in quite different ways. The Batak of peninsular Malaysia are said to classify almost everything in their environment by smell, including the sun and the moon. They say the sun has a bad smell, like raw meat, and the moon a good smell, like flowers.[25] To the Inuit, hearing and sound, the means of creation, have greater symbolic importance than sight. The same is true of the Hopi, in whose creation Spider Woman creates the Twins by chanting creation over them and commands them to send out sound everywhere. One Twin makes "all the vibratory centers along the earth's axis from pole to pole" resound with his call. "Thus he made the whole world an instrument of sound."[26]

Songs, say the Shipibo-Conibo Indians of eastern Peru, can be embodied, healing rituals. Sunk in a hallucinogenic healing ceremony, the shaman sees designs floating downward. When the designs reach the shaman's lips he sings them into songs. Sung again, the songs turn back into designs that penetrate and heal the patient. The power of these song-designs is said to reside in their "fragrance." The Shipibo-Conibo term *quiquin*, which means both "aesthetic" and "appropriate," refers equally to auditory, olfactory, and visual sensations.[27]

The varying use and importance of the senses is only a small part of the evidence given by anthropology of the variability of human culture. Anthropology makes it clear that a narrow definition of art makes it too hard to understand why humans have created so much with a care that goes so far beyond what is practically necessary.[28] Most of the art of the kind that anthropologists have studied has had a basically practical or ceremonial purpose. Yet much of the interest of the participants in ceremonies depends on the aesthetic effects of their chanting, singing, dancing, costuming, and acting.

The display of "primitive" art in fine-art museums, which dramatize its visual aspects, creates characteristic problems.[29] Implicitly, the curator reasons so: To be effective as fine art, the objects have to be put on effective display. To be worth being kept on display for a while and, in time, returned to display, the objects had best be durable (unlike ice or butter sculpture even when it has the look of "real" sculpture). How likely, then, is the curator to show the many Tibetan mandalas or Navaho sand paintings, which are made to be almost immediately destroyed and make no use of the kind of durable, precious materials, the gold, ivory, or precious stones that museums favor. And how willing or able will the curator be to show "primitive" art made in whole or part of flowers, woven palm-leaf offerings, baskets, bamboo, or bark cloth. It used to be the practice of art dealers to strip everything African of its soft and fibrous parts, a practice that gave the exhibits an abstract, modern appearance. It was a rare event when, in 1948, the Center for African Art in New York exhibited a reliquary figure from Gabon that, in the words of the catalog, retained the "complex texture of twisted leather thongs and basketry [which] gives the base a restless vitality and interest" and the "feather attached to the back of the head [which] further animates and complicates the figure's shape and texture."[30]

For all of the usually utilitarian attitude of "primitives" toward art, they, too, made art that was from the first intended for show, sometimes in institutions with rules on how the works should be displayed. "Such institutions are extremely widespread and vary from the courts of West African kingdoms through the mortuary displays of New Ireland and the Tiwi, to the 'cabinets of curiosity' of New Guinea cult groups and the galleries of Sepik men's houses."[31]

The strictly ethnographic and the strictly fine art approaches to "primitive" art are far from exhausting the ways in which it can be observed and enjoyed. The peoples who make and use masks for ceremonies see them in many different lights. The mask maker fashioning a not especially secret mask is likely to have an audience watching him work. This is the context of interest in the mask's making. The magical appearance of the mask out of what was earlier a log, and not long before that a tree trunk, is as interesting in its preliminary way as the appearance of the mask in the ceremony for which the sculptor is making it. Once carved (or knotted of fibers), the mask is appraised before and during the time when it actually plays its ceremonial role. Though an Igbo or Pende mask of a woman has been made for a role in a ceremony, there is nothing surprising in someone's admiration for the skill with which it was fashioned—the context is then that of appraisal of the skill of the mask's execution. Nor is it at all surprising if the Igbo or Pende spectator admires the mask for the womanly

beauty of its face—the context is then the appraisal of feminine beauty.[32]* Nor is it surprising if the mask is admired because its wearer acts its role cleverly or eloquently—the context is then that of dramatic criticism. The mask can also be admired for its suitability for its ceremonial role. This role, which is the mask's main function and context, of course overlaps with all its other functions and contexts.

How many are the ways a mask can be compared, in or out of museums? To begin with, masks are compared with living faces, or contrasted with them. Or they are compared or contrasted with other masks. Masks of wood are compared with other masks of wood, and with those of metal, of papier-mâché, of cloth, and so on. Masks are also compared for the techniques by which they are carved, cast, or otherwise formed, and compared for the carvings or shapes that decorate them. And masks are compared for their colors, and their colors are compared with one another for their effects. Masks are also compared for age, origin, use, and history. They have anthropological, sociological, theatrical, and more directly aesthetic categories or contexts of comparison. Like anything else, they can be compared and thought of in endlessly many ways.

Why multiply these possibilities of comparison? The answer is, to show how impoverished the simpler notions of context are, and how open and rich the possibilities of comparison, even only of masks. Even if we compare only works of art recognized as such with each other, we can compare them in any way the categorizing mind prefers. From a humanizing perspective, we can join the anthropologist Alfred Gell in saying that works of art "come in families, lineages, tribes, whole populations, just like people." From this perspective, "they have relations with one another as well as with the people who create and circulate them as individual objects. They marry, so to speak, and beget offspring, which bear the stamp of their antecedents."[33]

Having recognized works of art as related to one another like humans, we can recognize styles as bearing a hierarchy of individual and generic characteristics

*The art historian Z. S. Strother explains that although among the Central Pende "the features of the physiognomy remain true to an idealized representation of youthful feminine essence, the dance follows the fashions of the moment. Despite the little comedies with mirror and comb, the young female masks are always classed as *mbuya jia ginango*, 'masks of beauty.' The designation refers in part to the ideal of female physiognomy represented in the face but also to the component of fashion represented by the contemporaneity of dress, dance, and sometimes hairstyle." The clowns who danced along with the wearers of the "masks of beauty" made erotic advances to them with a freedom far beyond what was ordinarily allowed.

and meanings. How is the hierarchy structured? Begin with the most immediate, most local characteristics. A mask (or a poem) perceived as wholly individual has signs that can identify it by its exact time, place, and occasion. A particular mask maker carved it with a certain adze that had a small dent to the left of its blade, the wood of the mask had a somewhat peculiar grain and was darkened in a special way, and though the person who commissioned it was not too happy with the finished mask, it was worn at the ceremonial for which it was designed to the satisfaction of the onlookers.

Apart from these immediately local, temporal characteristics the mask bears of the occasion of its making, it also bears the style of a certain carver—everyone in the vicinity with an interest in masks can recognize that the shape, proportions, and features are in the style of a particular local sculptor. At a more general level, the mask is recognized as in the style of a particular, maybe small area of Africa; at the next level, recognized as African; at the next, as the carved mask of a human being; at the next, as a carving; and at the next, most general level, as a worked piece of wood. Even as just a worked piece of wood, it can be made with assurance or hesitation, in a mature or immature way, and so on. I mean that style, too, is perceived as individually or as generally as one chooses, at any level of abstraction, and from any angle of view or thought.

We are in fact always thinking in terms of such hierarchies, which lead in principle from the quantum to the universe. But as long as the created object is perceived at not too great a distance, as long as it still continues to speak for its exact moment and person, or just for its person or area and time, or even just for its continent—Africa, Asia, one of the Americas, and so on—or at least for its maskness, it bears the message of its external characteristics and its internal, imaginative characteristics, which can in principle be deciphered. This message can also in principle be correlated with the nature of its sender and its sender's culture. As a message, it testifies to the individual and can (with great possible error) have its changing thickness, loops, angles, joins, sizes, and so on, characterized in as surprising detail as handwriting.

This idea of identification can be extended of course from individual to culture. As an example of the unobvious but impressive inherence of culture in art, take a tentative analysis of Maori art, according to which its preoccupation with symmetry is associated with the culture's emphasis on sequences of competitive exchanges, including sequences of war and revenge. That is, to the Maoris, the complicated, difficult-to-read patterns they made on, for instance, the internal roof beams of their ceremonial buildings, were stylistic reverberations of the

extra-artistic pattern of Maori life in which sequences of reciprocal action, at various levels and degrees of intensity, were pervasive. Moreover, just as reciprocity in social life was never "perfect" but was always marginally unbalanced, giving rise to the onward momentum of competitive striving, so Maori bilateral symmetry is always marginally disturbed by contradictory elements of willful asymmetry. This trickiness in the juxtaposition of symmetry-conforming and symmetry-disrupting elements coincided with the Maori cultural presupposition that "nothing is what it seems."[34]

When we reconstitute what is possible of the context of a work of art, it stands to reason that the more accurate the reconstitution, the greater the likelihood that the aesthetic life of a society will be found to differ interestingly from every other. The more interestingly different, the more likely it is that it can be described as adequately as is possible only with the help of its own categories.

An anthropological example of this can be found in the culture of the Huichol, who live in northwest Mexico. Huichol art alludes constantly to the occult world of essences that helps the individual "to identify the network of obligations that bind one to the deities."[35] The Huichol seek and praise the special "clarity" that arises from their untiring perception of the well-loved features of their sierra landscapes and of the deities whose nature is read in these features. "The initiate knows, in effect sees, by the nature of the landscape, that Tatei Rapaviyeme, the southern rain mother, dwells on the shores of Lake Chapala in southern Jalisco. She lives by an ancient fig tree (rapa), which has luxuriant green foliage, covered by a moist, translucent sheen of dew which continuously drips from its leaves." The initiate also knows that the lightning sky serpents of the Huichol are the rain mothers that cross the sky to fertilize the land. "Clouds are much admired, and the many names given to different formations were traditionally used as women's names," for beauty and goodness are joined.[36] The sacred plants, too, are admired. The Huichol shaman chants that the peyote and the toto, the little white flower that grows by the maize, mark the world in which his gods sing. "In the world of these divine flowers, all is wisdom, counsel, example and song. . . . Oh, beautiful flower, flower of the gods, you will never again be deserted." A symbol of perfection and wholeness, the white flower serves as a frequent, varied motif in the textiles the Huichol weave.[37] The designs of bowls and textiles often represent sexual metaphors that are also connotations of beauty.

The point I am making is that what is important to the Huichol in art cannot be summed up in laws of symmetry or other visual relationships. Their aesthetics is too involved in maintaining their system of ethics, given, they know, by the

gods. As will become evident, there is some parallel with Indian and Chinese notions that make ethics and art dependent on one another. If we stress only this interdependence, then the Huichol are not altogether distant from the medieval scholastics. "For the Huichol, art makes explicit the immanence of intransmutable essences underlying the appearance of the world."[38]

Like the Huichol, the Yolngu, Australian Aborigines of Arnhem Land, have a view of their art that does not refer directly to its formal or material characteristics but to the enduring power of their ancestors.[39] That is, they believe that most of the designs they make originated in events connected with their ancestral beings. In their songs, dances, paintings, sacred objects, and ritual incantations, the Yolngu identify themselves with the essential power of their ancestors and re-create or re-express ancestral events, of the kind that the Aborigines believe formed their landscape. The same ancestral design may be made

> as a sand sculpture, as a design in string, or in painted form as a body painting, bark painting or painting on a ceremonial post. . . . Firstly, the designs are ones that originally appeared on the body of the ancestral being they represent, and were designated by that ancestral being as part of the sacred law (or property) of the groups of human beings who subsequently occupied the land with which the design is associated. Secondly, paintings encode meanings that refer to the events of the ancestral past that resulted in the creation of the landscape, including, of course, the events that led to the creation of the design itself. Finally, designs are ancestral in that they are thought to contain the power of the ancestral being concerned and provide a source of ancestral power of use in ritual.[40]

To the Yolngu, a painting must be accepted as a correct representation of the ancestral design. To be correct it needs the cross-hatching that defines its parts clearly and gives it what the Yolngu see as its brilliance, "the sensation of light one gets and carries away in one's mind's eye." This brilliance or scintillation is projected from the fineness of the cross-hatching that covers the painting's surface and relates it to the ancestral past and power. Since the ancestral power is associated with a particular ancestral being or group of beings, the visible brilliance, the *bir'yun*, of a painting is never pure appearance. The brilliance has a symbolic or iconographic aspect and an emotional aspect, which is the association of the brilliance with joy or happiness.[41]

The examples of the Huichol and Yolngu show how the use of abstract, external, or foreign categories may hinder the ability to appreciate the art of a particular people. It may nonetheless be true that the concentration on an individu-

alized, terrain-bound tradition has kept the Huichol and Yolngu from needing or developing conceptual tools for purely aesthetic analysis. There have been so many human cultures that I may easily be wrong when I say that only two of them, both technologically advanced, have created detailed, fully abstract concepts for the analysis of visual art. The two are the Chinese (along with the Japanese and Koreans) and the Europeans. The analysis of compositional structures was perhaps more highly or subtly developed among the Chinese. So was the analysis of directional relationships and of what may be called the velocities and weights of lines and masses. This latter ability testifies to the intense interest of the Chinese in calligraphy (an interest shared by the Muslims), and the ability of the Chinese to abstract the verbal meaning of the writing from its calligraphic qualities.* These are matters I will go into later.

It is evident that the idea that abstract aesthetic analyses miss the uniqueness of a culture's art needs to be supplemented by the understanding of what is missed by the refusal to see beyond the uniqueness. Abstract visual analyses do miss the intimate, nonvisual aspects of a culture, but they are an indispensable instrument of aesthetic generalization and perception. The ability to make abstract aesthetic analyses allows one to see, clearly if not completely, beyond the lightning sky serpents of the Huichol and the ancestral shaping of the Yolngu landscape and all their vividly personal but purely local commentary.

CEREMONIAL CELEBRATIONS OF LIFE

When tradition is strong, its strength is derived from the willing participation it evokes. In saying this, I am thinking mainly of the ceremonies in which a large number of participants commemorate their culture's primal history by means of dancing, singing, costume making, and acting. Ceremonies of course play an indispensable role in every tradition, but I find it easier to use "primitive" ceremonials to illustrate the likeness between them and art understood in a broad sense. My illustrations are the ceremonials of the Elema, who live around Orokolo Bay at the head of the Gulf of Papua, of the Suyá of southwestern Bra-

*The Chinese had a much weaker sense than the Renaissance Europeans of one-point spatial convergence in perspective (as compared with their own, usually "moving" perspective). And the Chinese, as far as I know, did not have a conscious equivalent to the European interest in the golden section, nor a conscious desire to compose and analyze by its means. In architecture, the interest in compositional structure was strong, certainly in practical fact, among the architects of India and the cultures related to it. As for the abstract analysis of literary structures, it was highly developed among Chinese, Indians, and Europeans alike, and, maybe, among the Polynesians.

zil, and of the Dogon of Mali. Each illustration is quite different, but each shows how a people takes part in retaining its life by repeating or re-creating the events on which its tradition is based.

According to one early study (1940), individual freedom among the Elema was more respected than in Western culture. Among them, no one, not even a child, was ordered about. When Elema asked about someone who wasn't present, the answer was, "His desire; he himself." No person spoke for another. The chief did not expect nor exact obedience, but simply voiced group decisions. This habit of mind is of interest because it implies that their participation in ceremonies was completely voluntary. Indeed, the individual freedom of the Elema makes their ability to conduct their long ceremonial cycles the more surprising. A seven-year cycle was considered quick. Some cycles remained incomplete after twenty years, and no one's lifetime could be expected to encompass more than three cycles.[42]

An Elema ceremony cycle is too complicated to describe here, but its program was as elaborate as the years of its production were long. Of its many colorful and dramatic situations, the climactic one was the coming of the Magic People. After some twenty years of confinement, they came to fulfill their existence in dancing and merrymaking, led by "a tall fantastic figure, silvery white, its colored patterns in the atmosphere of the dawn appearing pale and very delicate."[43]

This ceremony cycle, which may be the longest dramatic performance ever given, contained everything: the fellowship of rehearsal, brilliant spectacles, solemnity, tragedy, humor, and blissful dancing. Although it was believed to placate certain spirits, it was not primarily religious, at least not by the time Europeans observed it. It was undertaken because of its great dramatic interest, its enlistment of every Elema ability, its uniting of the Elema in pride, and because, as the Elema said, it was "the fashion of our ancestors."[44]

The Suyá, a Brazilian people whose ceremonies I next recall, live in a small circular village on a riverbank in the Xingu Indigenous Park. Their tiny community lives from hunting, fishing, gardening, and trading. When they grow bored with the old ceremonial sequences of song/dances, they make up new ones to add to them. Following the anthropologist who is my source, I write "song/dance" and "song/dance/ceremony" because to the Suyá these to us separate activities are joined in the concept for which they have only a single word, *ngere*. When they sing/dance, they are euphoric, they say, and they eat a lot of food, because food is integral to the song/dance/ceremony. When they sing/dance, in ways that correspond with the participants' sex, age, and ceremonial group, the Suyá say that they are beautiful and good. This is because they reach a eupho-

ria that joins the senses, the mind, and (to bend the word oddly) the conscience. In the grasp of this euphoria, the pleasure and self-approval of each person creates collective pleasure and self-approval, for everyone has played the role that fits his or her person, and has played the role correctly and therefore been given the reward of this euphoria. If ever they stop their singing/dancing, the Suyá say, they will be finished. The community, with the tradition it depends upon and the fellow feeling and cooperation it needs for survival, will have ended.[45]

The Dogon of Mali also perform a prolonged ceremony, called the Sigi, repeated in each Dogon village once every sixty years. During the Sigi, the Great Mask (the Mother of Masks) has to be renewed and is therefore carved again. The French anthropologist Marcel Griaule (1898–1956), who described the ceremony in detail in *Masques Dogons,* did not survive to witness it. However, the description he drew from his informants proved to be correct when, in 1967, the ceremony was actually performed. A film of the ceremony made by Jean Rouch and Germaine Dieterlin was released two years later under the title *The Cavern of Bongo (La Caverne de Bongo).*[46]

The Great Mask represents a flat serpent whose long body, topped by a rectangular head pierced by two eyes, when raised may extend thirty to fifty feet into the air. Far too large for anyone to wear, the mask is hidden in a cliff cave known to only a very few authorized persons. The ceremony reenacts the primal disobedience and the consequent first death, replicating the process by which reparation was made so that the life force, *nyama,* could once again prevail.[47] The mythology presupposed is intricate and recalled partly in a language that is unintelligible to most people. But the ceremony involves everyone, and it gives everyone the feeling that he or she is integrated into the same half-sensed, half-understood universe. The rules of the ceremony, and the cosmetics, sculpture, painting, poetry, and choreography that it requires, makes the ruling Society of Masks into a kind of regional government. The ceremony is more than art in its usual sense because it is both the expression and the mainstay of social and individual life. The instructions for the ceremony are given by knowledgeable elders, whom the mask maker has to satisfy. Yet some woman-masks are carved and worn mainly because they are beautiful. Some masks of new, untraditional subjects are made. The members of the Society of Masks are eager to show themselves to be clever and elegant, and mask or costume makers recognize and take pleasure in their own and others' work.[48] Tradition, group, individual, obedience, and egoism, all are integrated and, in principle, reconciled.

As the descriptions of the Elema, the Suyá, and the Dogon show, their ceremonial traditions are in practice flexible. This flexibility can be surprising to

anyone who thinks of tradition as always rigidly fixed.[49]* And in this flexibility, the three traditions have room to celebrate life in ceremonies that encompass its deepest needs—by the song/dance euphoria of beauty in goodness and goodness in beauty; by the prolonged, kaleidoscopic dramatization of the legendary past; and by the dramatic reinstatement of the permission to live in spite of sin.

MEMORY PRESERVED

Tradition creates for itself a memory utopia, the lost dignity and splendor of which support its demanding hopes. I begin my account of social memory in art with examples from Africa, in whose kingdoms, as in others, the memories essential to the maintenance of ancestral and royal authority were many. The splendor of the king's memorial art was a sign that the kingdom was rich and stable.[50] In Benin, impressive ancestral heads and plaques were cast in bronze or, more often, in brass. Many are attributed to the fifteenth and sixteenth centuries CE. Ewuare, the warrior-king of the mid-fifteenth century who transformed Benin, is said to have instituted an annual ceremonial cycle to honor the royal ancestors and strengthen the mystical powers of the *oba* (king)—in African kingdoms the king was usually regarded as responsible for his subjects' health and good fortune and might be accused and replaced if things went badly.[51]

One popular story about Oba Ewuare relates that when he had grown old he asked the members of the casters' and carvers' guilds to make an image of him. The casters depicted him as he appeared in the prime of life, but the carv-

* As we will discuss in more detail below, Yoruba traditions have also been found to be constantly dynamic. The same god gets different names, new gods appear, and every place and person gives the received tradition a new form. Even in a single town and even among the apprentices of a single master carver, traditional sculpture shows diversities that are both subtle and rich. But tradition rules in that significant departures from the customary must be known to be justified by the nonhuman power, the *ashe*, that maintains the beneficent order of human life and prevents the intrusion of chaos.

The flexibility and integrative power of "primitive" tradition should not obscure the fact that ceremonial art has often been used to compel obedience, and that rites of passage very often enlist pain and fear to drive home the lesson of obedience. Among the Mano of Liberia, groups of boys isolated and taught in the forest learned a lifelong awe of the spirits that dwelled in the masks and spoke through them in human voices. The owner of the Great Mask could walk into a turbulent session of the secret Poro society and with a word, backed by the threat of death, make everyone prostrate himself until touched with the bundle of small sticks the mask owner held. The masks and their power could be passed on to new owners, but tradition kept their power within the old bounds.

ers showed him as he was at the time of the commission, in his old age. Oba Ewuare was furious with the carvers and demoted them, proclaiming that they would never again be as important as the brass-workers.[52]

A study of the Luba, who live in present-day southeastern Zaire, shows the use of art by the leaders of an African kingdom to perpetuate its memory, which is to say, its historical consciousness and traditional way of life.[53] The royal history of the Luba was held in memory with the help of special visual devices. The devices and the memories they recalled were kept under the guard of an association called Mbudye. Mbudye historians were trained specialists in memory, who could recite genealogies, lists of the kings, and the episodes by which the kingship was established. "They traveled with kings, danced in celebration of their deeds, and spread propaganda to outlying areas about the prestige and sanctity of Luba kingship" and as a group might have the power to dethrone a ruler.

The main memory device of the Luba has been a flat wooden object, the *lukasa,* covered in decorative beads and pins or bas-relief ideograms. A *lukasa* is used during rituals to teach the sacred lore of the Mbudye. The colors and arrangements of the beads and ideograms of a *lukasa* are meant to recall the appearance, qualities, and exploits of the kings.

> For example, Nkongolo Mwamba, the tyrannical antihero of the Luba character, is always represented by a red bead, for he is the red-skinned rainbow serpent associated with bloody violence. . . . Significant events, relationships, and the paths of Luba migration are indicated by lines and clusters of beads. Chiefs and their counselors, sacred enclosures, and defined places are shown by circles of beads. . . . Beads constitute a kind of alphabet that articulates a vocabulary for Luba royalty. Their plurality of forms, colors, and sizes provide a perfect vehicle for the "cognitive cuing structures" of mnemonics.[54]

According to Marcel Griaule and his associates, the Dogon were able to keep in mind and memory an elaborate double scheme of exoteric and esoteric myths, the former available and common to most of the people and the latter entrusted only to certain elders. Instead of writing, the Dogon had a reliable system of signs or ideograms, which served to recall a systematic correlation of concepts that Griaule considered to be a philosophy, that is, a cosmology and metaphysics. (Though impressive for its richness, the system, I interpolate, was not supported by any explicit arguments. In this sense, it was a complicated group of interlocking symbols and myths, a symbolic map of the world rather than a set of coherent philosophical arguments.) According to Griaule, the Dogon believe that a

"sign" or symbol is interchangeable with what it symbolizes, and that everything is locked into a great system of correspondences.

> This conceptual structure, when studied, reveals an internal coherence, a secret wisdom, and an apprehension of ultimate realities equal to that which we Europeans conceive ourselves to have attained. The Dogon, in this system of myths and symbols, are able to express a correspondence between their social organization and the world order as they conceive it. For them social life reflects the working of the universe and, conversely, the world order depends on the proper ordering of society. Furthermore, the social order is projected in the individual, the indivisible cell which, on the one hand, is a microcosm of the whole. . . . Because he is the representative of the whole, the individual affects the cosmic order which he also displays.[55]

This complex worldview, though it astonished the French and other anthropologists, fits in well (critics say, too well) with the structure of what I have called traditionalism. It parallels early Indian and Chinese thought and has some general affinity with the amalgam of Aristotelian and Neoplatonic thought that was so powerful an influence in the philosophy and theology of the medieval Jews, Christians, and Muslims.

Griaule ascribed the deepest, most secret knowledge he gained to the blind old Ogotemmêli, who in 1947 was authorized by the village elders to impart the secrets of the Dogon to the French anthropologists, especially Griaule. Griaule, who mourned Ogotemmêli after his death, says that he helped because he was one of the Dogon who understood the importance of European research.[56]

So far, so surprising and so good. But before I leave my account of the way in which the Dogon maintain their tribal memory, I have to add a cautionary word on the controversy surrounding Griaule's later work. It concerns, first, the possible contamination of anthropological accounts by even the unconscious intervention of the researchers, and second, the possible dependence of small societies' deepest, most esoteric doctrines on the memory of a few individuals, with whose death the memory, the secret, and a fraction of the societies' culture may vanish. Which of the two alternatives holds true in the present case depends on the position one takes on the controversy.[57]

Griaule had long been criticized for depending on translators, for confining his interest to a few informants who might not represent most villagers, and for idealizing and oversystematizing Dogon views. On his own testimony, he is said to have seen himself in the role of detective or examining magistrate and to have used tactics that "have in common an active, aggressive posture."[58] For to Gri-

aule, the ethnographer acts many roles: an affable companion cross-examining his informant, "a distant friend, a severe stranger, a compassionate father, a concerned patron, a patron paying for revelations one by one, a listener affecting distraction before the open gates of the most dangerous mysteries, an obliging friend showing lively interest for the most insipid family stories."[59]*

Griaule's collaborator and daughter, Geneviève Calame-Griaule, herself a researcher into the Dogon view of language, answers his chief critic, Walter E. A. van Beek: "Having sought without success to reconstruct (or shall we say deconstruct?) that enormous edifice" of anthropological research built by a group of researchers, [Van] Beek ingenuously concludes "that because he had not found it, none of it existed." Van Beek's sort of detective work could only have been distrusted by the Dogon. Not all the Dogon shared in the secret knowledge, and many of the elders who did share in it "have died without having passed their legacy of 'words' on to their descendants, who are no longer concerned with it and only want to be modern, that is, Muslim. Such has been the fate of some of Griaule's main informants, for example, the venerable patriarch Ongnonlou. . . . Whatever role one wishes to assign myth in culture, one can no longer, since Griaule's work, ignore African myth or reduce it to insignificant fragments."[60]

*The most detailed and damaging criticism of Griaule was made in 1991 by the Dutch anthropologist Walter E. A. van Beek, who for many years studied the Dogon in the same area as Griaule. Van Beek accepts the accuracy of Griaule's earlier work, which includes his thesis on Dogon masks, but argues at length that his conversations with Ogotemmêli must in effect have been a joint invention of the two, "the product of a complex interaction between a strong-willed researcher, a colonial situation, an intelligent and creative body of informants, and a culture with a courtesy bias and a strong tendency to incorporate foreign elements." Van Beek says, "It is hard to understand how someone who warned so eloquently against inventive informants remained naïve about what was happening between him and his informants." It is impressive that three anthropologists with long field experience with the Dogon agree that they had not come across any trace of the disputed doctrines among the Dogon.

On the other hand, Marcel Griaule speaks of Ogotemmêli with respect and gratitude, and though he was a demanding questioner, I see no sufficient reason to accuse him of conscious misrepresentation. Yet he was a less than morally exemplary collector. I am referring to his role as leader of the Dakar-Djibuti Mission in 1932, which collected some 3,500 objects for the Trocadero museum, later the Musée de l'Homme. The "secretary-archivist" of the expedition, Michel Leiris, reports in his journal how Griaule used threats to get hold of the masks that the African village chiefs were unwilling to give up. Leiris tells how Griaule got him to participate in the stealing of a tempting mask and a figure, and how, against the horrified protests of villagers, who were afraid they were losing "the life of their land," the anthropologists took away several rain-producing statuettes.

It would be absurd for an outsider to take sides in this controversy. If what Ogotemmêli revealed in the end was his own invention, based on Dogon thought but stimulated by Griaule's systematic questions, the old Dogon can be looked upon as a theologian who systematized the symbolic thought of his people and, in this sense, resembled many other creative theologians. In an ironic fantasy, I see a future in which Dogon develop a traditionalist nostalgia and use Griaule's *Conversations with Ogotemmêli* to restore the old doctrines of their forefathers, or of Dogon ideas deepened by Ogotemmêli under Griaule's persistent questioning, but in either case, no longer secret. If the conversations really do reflect an ancient mystery, its disappearance demonstrates the fragility of traditions. It is said that of the three hundred or so original Native American languages, about half have vanished and some are spoken only by a small number of old people.[61] The same must be true of a special artistic skill or a local style. Or, as seems to have been the case with the symbolic system discovered by Griaule, the symbolic meaning attributed to works of art may be diluted or vanish even when the works themselves survive. Works of art always draw their depth from the networks of their associations, but the networks themselves can become thin, tear apart, and be replaced by associations of another kind.

AUTHENTICITY

The doubts concerning Griaule's late work make a good introduction to the subject of authenticity. I take "authenticity" in three senses, all related to the meaning of "genuineness." One sense is "worthy to be considered art" or "real art." The second sense is "living up to its own cultural assumptions or pretensions," meaning, really representative of a given culture, style, or the like. The third sense is "original" in the sense of "not forged."

There are poetically and philosophically embarrassing questions that might precede the distinction between the different senses of authenticity: Are some works of art, like some persons, more authentic, more deeply sincere, than others? If they are, is it the absence in them of pretension, that is, of striving for effect that makes them authentic? If so, are children more truly themselves than are adults, who have learned how and why to be devious? Is this why so many modern artists have been influenced by the art of children? Are these artists right in thinking that more spontaneous works of art are more authentic, more revealing of their makers' true selves, than carefully planned works of art? Did the surrealistic search for unconscious reactions, like the search of shamans for the guidance of the spirits, reveal what was truly authentic? Did the art of the

insane and other "outsiders" influence modern artists because it was so strange or because it was taken to be authentic self-expression rather than an attempt to earn recognition or money?

Since I deal with these questions elsewhere, here I will take up a number of other, deceptively simple ones. They include the harsh lessons to be learned from authenticity as understood by the early collectors of so-called primitive art. Other lessons that teach a cautionary ambivalence will be learned from the nature of authenticity and forgery in Chinese and Indian art. I avoid the problem of the authentication of Western works of art because they are well known and have been addressed in the study of the corpus of every important artist.

The authenticity of "primitive art" is now the subject of a number of books.[62] As one of them points out, since the mid-1980s, there has been an open attack on the very idea of "authentic primitive art." For the art market, however, it is more important that the supply of "authentic primitive art" is declining because the societies that used to produce it are becoming part of the economic system of the world as a whole.[63]

The most realistic way of entering into the subject of such authenticity is to describe how the art it refers to was first collected. When explorers or travelers first met "primitives," they mostly regarded them and their handiwork as "curious," "singular," or the like, meaning, in the case of the handiwork, that it aroused their curiosity but did not command their respect, aesthetic or other. Captain Cook's journals record many such reactions. In the account of his second voyage (1772–75), for example, he noncommittally describes a Marquesan head ornament as "a curious fillet of shell work decorated with feathers &c." Johan Reinhold Forster, who accompanied Cook, describes Maori wooden axes only as "commonly curiously carved."[64]

The early collectors of African art were interested less in art than in missionary activity, trade, or the systematic description of African culture. By the late nineteenth and early twentieth century, much of central Africa—the basin of the Congo—had fallen to the control of the Belgians, and the collectors of art moved within it with little fear. As Europeans, they saw themselves as the righteous masters of this Africa (but some carved images the collectors found made fun of Europeans and the Africans who served them). After 1908, when the territory of Congo was transferred to civilian rule, it was easier, whatever the motive, to collect "the harvests of everything from ivory to souls to art."[65]

Curios and trophies had long been collected, but now expeditions were organized for the scientific study of the continent and its inhabitants, and art collection

became a viable business. Literally thousands of objects were collected for museums—the total number taken then is hard to calculate, but "between 70,000 and perhaps as many as 100,000 objects may have been removed before World War I." The Africans soon learned to make artistic use of the cloth, glass beads, and other materials the traders brought them, but on the grounds of authenticity, collectors would often reject art that made use of imported materials. While the objects that Africans made for themselves "often incorporated acrylic paint, plastic, and imported cloth . . . a lively market emerged in faked authentic objects using only 'natural' materials—most wood, raffia, hide, copper, and feathers—that met Western consumer expectations."[66]

The manner and the goals of early collecting influenced the ways in which the objects were organized, exhibited, and understood. "The notion of 'one tribe/one style,'" though repeatedly faulted by scholars, tends to persist because of the way the art was first categorized.[67] The reasons for this situation can be illustrated by the efforts of the American anthropologist Frederick Starr (1858–1933). In 1905, without help from any institution, he and his friend, a photographer, left for Africa with the missionary-explorer Samuel Verner. In 1911, Starr sold the collection of about 4,000 objects (mostly bought by Verner) to the American Museum of Natural History. Starr provided the museum with no more than a list of the objects, a label for each of them, such a "mask," "fetish," or "basket," and the name of the tribe or place from which the object was collected. He would reject a native informant's explanation of an object or custom whenever it differed from his preconceived view of native backwardness.[68]

While living at Verner's camp, Starr and his friend would be visited by chiefs who wanted to trade. Starr bartered for pieces he thought might interest museums and paid for them in salt, cloth, iron bars, tobacco, cowries, and beads. If an object looked old and used but not overused, he would be attracted to it, but evidence of European influence on the object decreased its charm for him and the price he was willing to pay. Though he depended on the middlemen who brought him objects from the surrounding villages, he distrusted them; he seems sometimes to have understood that he was buying objects made, from his standpoint faked, to meet his specifications. Faking was in fact encouraged by his endless appetite for masks and fetishes.[69] Ironically, the authenticity hunger that developed during the early twentieth century "was met by Africans who began forging authentic-looking objects. Europeans made African-style objects for sale to Africans that were sold back to European collectors of ethnographic artifacts. A few times Starr was about to buy well-made African-looking knives only to discover that they had been manufactured in Europe for sale in Africa."[70] Some of the

masks that he supposed inferior because they looked too new were part of the collection he sold the American Museum of Natural History. "In museum storage, these masks still look today as if they were made yesterday, despite the fact that they are some of the oldest documented examples of art from the Congo." They are important to scholars "because in the details of their iconography they show how Africans chose to represent themselves to Westerners in 1905–06."[71]

Musical and verbal performances presented Starr with a special difficulty because he believed that they should be fully traditional and therefore had to have a fixed, authentic form. "On one occasion he asked a man to recite the words of a song so he could write them down. The singer kept changing the words. . . . In his view the man simply 'couldn't get it right.'"[72]

So much for Starr and his influence. The reality was more complicated than he understood. In African eyes a mask's or figure's age was not necessarily a criterion of its value. For instance, among the Igbo, who live in Nigeria, it is considered wrong to reverence an object because of its age. If age were to determine authenticity, the Igbo believe, the impulse to create such objects would be weakened—in any case, the objects will probably soon decay or be eaten by termites. What the Igbo value most is not the traditional object but the process of creating it in a traditional way.[73]

The attitudes of dancers among the Central Pende of Zaire (now the Democratic Republic of the Congo) show how amusingly hard it is apply the usual criteria of authenticity to their masks:

> Dancers in a hurry may purchase headpieces intended for the foreign trade. . . . Performers usually keep headpieces they admire in pristine condition (away from smoke and termites). Consequently, a cherished ten-year-old piece will look brand new. Cognizant of Western tastes, dancers (or middlemen) will "age" these treasured pieces only when they are released for the foreign market, through the application of acidic berry juices and exposure to smoke and termites. Most curious of all, dancers in search of a gimmick have inserted certain . . . "fakes" into the masquerading milieu at Nyoka-Munene and Kinguba, capitalizing on their novelty.[74]*

*It is not only the authenticity of a "primitive" work of art that can pose a problem, but also what person is entitled to the status of an authentic "primitive." Such a decision can turn into a practical problem for judges and legislators, for instance in the case of Native American art, for which criteria of authenticity have been legislated. In a 1990 dissertation "Tradition on Trial," Deirdre Evans-Pritchard "argues that the major issue and most vexing problem in defining authentic Indian art is deciding who is an Indian." She points

Analogous problems of authenticity arise outside of Africa. Natives of New Guinea are ready to perform their approximately traditional dance for tourists. "But when the tourists are gone, these same people work for wages, run their own government and businesses, and study their homework." Likewise, there are Native Americans who "welcome tourists to their powwows, in which traditional and modern dances are performed not only for themselves but for the tourists' edification and cash."[75] Writing on the virtuosity of the canoe-prow carvers of the Trobriands, the anthropologist Alfred Gell notes that the carvers of primitive art he discusses are not primitive at all but "educated, literate in various languages, and familiar with contemporary technology. They continue to fabricate primitive art because it is a feature of an ethnically exclusive prestige economy which they have rational motives for wishing to preserve."[76]

One final point on the authenticity of "primitive" art. The conditions under which the great early collections were formed concealed the fact that the works of art had identifiable creators, so the works were regarded as anonymous expressions of the "tribe" to which they were attributed, and the individuals who made them were assumed to be the selfless instrument of tribal tradition. Bill Holm, the Northwest Coast Indian artist and art critic, complains that those who go to a museum to look at the art of (Canadian) Northwest Coast masks, or at any art from an "exotic" culture, are seldom helped by museum labels to personalize the faceless "primitive artist."

> The idea that each object represents the creative activity of a specific human
> personality who lived and worked at a particular time and place, whose artistic career had a beginning, a development, and an end, and whose work influenced and was influenced by the work of other artists is not at all likely to come to mind.[77]

A tentative moral regarding the authenticity of a work of art can already be drawn. It is not that the term "authenticity" should be discarded as too subjective or too dependent on questionable criteria. To discard it on such grounds would require us to discard its synonyms and antonyms as well—opposite meanings always need one another—and soon we'd reduce ourselves to speechlessness. Rather, the moral is that it's important for us to consider just what we're say-

out that "buyers' reasons for purchasing particular Indian art pieces have many permutations. For instance, Indian art may be evaluated as a cultural symbol, an investment, a souvenir, a fashion accessory, and/or an expression of personal taste. However, almost everyone who buys Indian art is influenced by the fact that it is Indian."

ing when we use such an evaluative word. The deceptiveness of the word arises from the assumption that underlies it psychologically, which is that artisans, artists, and works of art have or ought to have identifiable essences and that we are cheated when this turns out not to be true.

. . .

I now turn to the authenticity of art in China and India. I will keep using "authenticity" in the three senses I have specified—worthy to be considered art, living up to cultural standards, and not forged. Here, I confine my discussion of Chinese art's authenticity to two related matters, for which Chinese tradition provides unusually good documentation.[78] The first matter is the use of workshop methods and substitute artists. Because Chinese tradition lays emphasis on the visibility of the artist's nature in the brush strokes the artist makes, it might be supposed that the touch of another's hand on a painting would be accounted a misrepresentation, an attempt to lie. The second matter is forgery, which, like connoisseurship, the Chinese developed to an extraordinary level. In both matters the Chinese developed more tolerance than one might in the abstract expect.

To understand this tolerance, we must have a feeling for what the Chinese valued most in art. Drawing and brushwork were considered to be expressively essential and necessarily personal, but the coloring of a picture was considered an inessential way of adding decoration to it. (There is some parallel here with the seventeenth-century academic doctrine in Europe that the value of a painting lies in its drawing or "line," which appeals to reason, and not its color, which, appealing only to the senses, should be regarded as subordinate.)

Consider the case of the artist Ch'en Hung-shou (Chen Hongshou), an archaist of the first half of the seventeenth century. He was an extremely busy painter, with more commissions (in polite scholar language, more requests for paintings) than he could fill. On one well-known painting, he adds to his signature a note saying that the picture has been colored by his son. On at least two versions of his painting *Female Immortals in the Palace Museum,* he names an assistant as the colorer. The likeness between the several versions makes them seem as if this proudly individual painter had hit on an attractive subject that he decided to repeat a number of times, without taking it very seriously either for selling or for giving. Such copying of oneself is easy to understand, and it is also easy to understand why Ch'en, like other Chinese (and European and Indian) painters, might divide the work on a picture among different specialists. In Chen's case, there is a portrait scroll in which he made the figures—most of his work consists of paintings of highly mannered figures—a disciple made the

setting of trees and rocks, and a portrait specialist, it seems, made the person who is portrayed. As can be guessed, a portrait of someone in a landscape was likely to call for the joint efforts of a portraitist and a landscape painter.[79]

There were also unacknowledged participants in the creation of art, that is, assistants or substitutes. The Emperor Hui-tsung (Huizong, 1082–1135), a great patron of the arts and himself a considerable calligrapher, painter, and poet, had what amounted to an academy of painting. The very large number of pictures he is said to have made, the bundles of paintings and calligraphies he gave away at a party, and the painstaking quality of some of his paintings arouses the suspicion that, as emperors find easy to arrange, he was credited with work done by his court painters.[80]

This suspicion leads to the subject of the use of a "substitute brush" (*tai-pi, dai bi*), aptly translated "ghostpainter." Busy Chinese painters found unacknowledged substitutes very convenient. Tung Ch'i-ch'ang (Dong Qichang,), the great sixteenth-century painter I will cite as an example of a creative copier, was sardonically aware of how many forgers traded on his name. Not caring, he said he left the authenticity of the fakes ascribed to him for future persons to solve. Out of the desire to keep for himself the paintings he made and treasured, he got other artists to ghostpaint for him and then signed their work. He is said to have been so unconcerned about forgeries that he happily signed his name to pictures he recognized as such. To get a picture that was certainly painted by him, it might be necessary to use guile—"those who bought his genuine paintings often got them from his concubines," who kept silk on which they would persuade him to paint.[81]

The well-known eighteenth-century painter Chin Nung used a number of ghostpainters, one of whom wrote of him without excessive sympathy, "The old man loved money, but would not lift his brush. Therefore, I compliantly painted nonstop. As long as I signed the old man's name in his peculiar lacquer-brush style after I had finished, people would express their admiration and great joy."[82]

To understand the Chinese practice of forging calligraphy and painting, one has to understand the depth of the Chinese artist's need to embed himself (or, rarely, herself) in tradition by means of copying.[83] The Chinese divide copies into two basic types, free copies, which will be discussed later, and exact copies. The most usual method of making an exact copy is simply by tracing it on a thin piece of paper or silk. Another, more elaborate method is to trace the outlines of the shapes of the strokes of the brush and then fill in the outlines with very small, very careful strokes. When used by a virtuoso, the result can be aston-

ishingly faithful. A third method is to rub a traced white outline onto the silk or paper on which the copy is to be made.

The disciple of a Chinese master traditionally teaches himself by the repeated faithful copying of his master's work. And the master himself is likely to keep making close copies of the traditional masters he most admires.

> Chinese artists and connoisseurs will spend days over an antique painting, absorbing its every detail; this is called *ta-huai* "to read a painting." Their visual memory is so remarkably developed that after having studied a given picture for an hour or so they can often afterwards paint a good copy of it from memory.[84]

A copyist may note on a calligraphic work or painting that it is a copy. Copyists who do not do so are likely to copy the signature, inscriptions, and seals of the original, because to preserve the work is to reproduce as much of it as possible for the edification and pleasure of everyone who wants to live within the tradition. A really good copy is a treasure to be cherished almost as much as the original. Different good copies relate to their original in rather different ways. But all of them point toward it and individually and collectively keep its spirit alive even when, as has often happened, it no longer exists. No wonder that it is often so hard to distinguish copy from original, or that it is so subtle an exercise to try to glimpse the original through its different copies. In calligraphy, the calligrapher's sensitive correction of a mistake adds to the connoisseur's pleasure in following, that is, reliving, the process by which the writing was set down. The good copyist relives the moment of correction by faithfully copying both the mistake and its correction.[85] Good copies derive their authenticity from their ability to assimilate the very special spirit of their originals.

Given artists with so much practice in copying, forgery can be expected to be frequent and expert, and to nourish itself on all the criteria by which the connoisseur determines whether or not a work of art is authentic.[86] Aside from the copy, free or faithful, and aside from forged inscriptions or colophons, the Chinese forger has at his disposal two further techniques. The more usual, attested to as far back as the fourteenth century, is to take a good but heavily damaged picture and cut it up into smaller, well-balanced, self-sufficient pictures, which together will sell for a much higher price than the damaged original. Seals and inscriptions are added as necessary—the seals may even be genuine. A trickier technique is to assemble a picture out of old, approximately matching fragments. The joins are concealed with grime and, if discovered, are ascribed to the repair of the badly damaged scroll.[87]

We may be disconcerted by the relative tolerance of traditional Chinese paint-ers and connoisseurs for forged art, to which good painters or calligraphers might turn their hand. Superlative forgery was the mark of superlative technique and understanding. It was supposed, too, that you did not need to be told what you were not able to see, because it was considered bad form to disillusion the owner of an obvious forgery. The insensitivity or ignorance the owner exhibited was con-sidered punishment enough. I have already mentioned the tolerance of some art-ists for forgery of their work. Two artists, at least, resembled Picasso in that they were reportedly willing to help sympathetic, needy forgers or owners of forgeries. These artists, Shen Chou (Shen Zhou, 1427–1509) and his pupil Wen Cheng-ming (Wen Zhengming, 1470–1559), "put their signature and seals on imitations of their works. . . . Their justification was that the sellers were poor, the buyers rich."[88]

. . .

Unlike Chinese art, there is very little on forgery that is of interest to a discussion of the authenticity of Indian art.[89] One of the few accounts I have come upon begins in 1951, when a corroded but beautiful old statue of Shiva Nataraja, the Dancing Shiva, was dug up by some laborers. The statue was eventually turned over to the nearby temple in Shivapuram in Tamilnad, where it was returned to worship. Because it had been badly corroded, it was decided to send it for res-toration to a bronze maker. The bronze maker returned a copy he cast to the temple and sold the original, for which, eventually, in 1973, the Norton Simon Foundation paid a million dollars. As it happened, a researcher working on simi-lar bronze images discovered that what had been returned to the temple was a modern fake. The Indian police then uncovered the trail of the statue all the way from Shivapuram to its American owner. Then the Indian government sued to recover the original, intending to return it, the government said, to its home. A compromise was reached, by which the original was to be returned to the Indian government after a ten-year tour of American museums.[90]

This report leads me to another issue concerning the authenticity of Indian sculpture, an issue defined by a contest between two forms of reality or value. The problem is that of "authenticity" in a purely aesthetic, art-historical sense as against authenticity in a traditional religious sense. It involves bronzes made in South India from the middle of the ninth to the thirteenth century (to be exact, the Chola period). The bronzes of this period "have been appreciated for their technically superb solid casting, harmonious proportions, dignity, and grace." Like other Indian sculptures of gods, these bronzes were "awakened," given ritual life, by means of an eye-opening ceremony. As a traditional manual requires, in detail I do not repeat, after an eye-opening ceremony, the god is shown pleasing,

auspicious sights and then bathed, beautifully dressed, perfumed, ornamented, and carried around the temple to the sound of music. In the case of the bronzes in question, centuries of daily worship—water baths and liquid offerings and ritual unguents—wore down their facial features, including the eyelids and the outlines of the eyes. To remedy this, a metalworker would either reincise the outlines or carve away the metal around the eyes. Such repaired eyes were rarely in the same style as the original or as carefully made. But to worshippers, this aesthetic loss did not matter because the renewal of the statues' eyes re-evoked the statues' lives and renewed their religious purpose. That the god was awake again was important, that he looked worse was not.[91]

As the need to repair the god's eyes shows, in Indian tradition, the image of a god can become so worn that it has to be restored. If the image has to be replaced, the new image is made—embodied—and the old one is buried. An image that becomes inadequate (for example, by failing to attract worshippers) or that is injured is likely to lose its divine force in proportion to its inadequacy or to the injury done it. When an impure person handles an image, the image can be ritually purified. But an injury can be so great (for instance, when the god can no longer be recognized for what it is) that the image is no longer fit to support the god's presence. In such cases of unfitness, "clay images are thrown into the water, metal images are melted down, and wooden ones are cremated in fire, much as human corpses are consigned to flames on the funeral pyre."[92]

The life and death of Indian religious images leads me to a story, which I quote in a summary form, that shows how an Indian image, like a primitive or medieval European one, may vacillate—one might say vacillate ontologically—between religious existence, as a powerful object of worship, and aesthetic existence, as an object to be collected or looked at in a museum. This also involves a twelfth-century bronze image of Shiva Nataraja, dug up by some laborers at Pathur, in Tamilnad.

The Pathur Nataraja was taken out of its temple in a small village in Tamilnad and buried long ago, accidentally dug up in 1976, sold and resold several times in India, smuggled abroad, sold again, and seized by London police as a stolen object. It became the object of a legal dispute between [the] Government of India, which sought to repatriate the image to its village shrine, and the chief executive of a Canadian oil corporation, which sought to retain it for museum display. When the bronze image finally returned to Tamilnad in 1991, the chief minister and other dignitaries hailed it as a new symbol for the successful protection of India's cultural heritage.[93]

Ironically, because of the fear that it would be stolen again, this Shiva was not restored to its temple, as was intended, but along with other valuable images was put for safekeeping in a strong-walled, double-locked Icon Center, with an armed police guard, to which the public was not admitted. Once a week a priest made a ceremonial offering for all the images. According to a newspaper report, "priests and officials of several small rural temples in Thanjavur District felt that their gods were in jail, held without freedom to leave the Icon Center."[94] The Pathur Nataraja had again changed its status. Once an authentic object of religious worship, it had lost its religious being and become an authentic object for museum display, and having lost that status too, it had become an authentic, heavily guarded object of national pride. How many different kinds of lives can a statue authentically have? Which life is the real one, or are all the lives unreal, or both or neither real nor unreal?[95]*

These questions cannot be so much answered as extended in the light of the drastically changing reputation of Indian sculpture as art, its reputation, that is, among Westerners. The change was not unlike that undergone by "primitive" art. Because it concerns India when governed by Great Britain, the story starts with the acts and opinions of the British. Between 1771 and 1785, when Warren Hastings was the first governor-general of India, he and others in his circle collected Indian miniatures and manuscripts. It was quite unusual, however, to collect so-called idols. The only person to make an extensive collection of them was a British army officer, Charles Stuart, who rose to the rank of major general. Stuart, whose wife was Indian and who was himself unenthusiastic about Christianity, was rumored to participate in Hindu rituals. During some fifty years in India, he built up an enormous collection of objects, including hundreds of statues, many of them large and many ancient. A stubbornly persistent collector, he

*According to the Native American Graves Protection and Repatriation Act passed in the United States in 1990, every museum and federal agency must notify an existing tribe of any Native American human remains, funerary or sacred objects, and "objects of cultural patrimony" that appears to belong to that tribe's tradition. If the tribe requests the remains or objects, they must be returned to the tribe if it can prove its lineal descent from the tribe from which the remains or objects first came. Something returned under this provision can cause an outburst of collective emotion. When the carved beaver head from a war canoe of a Tlingit Indian clan of Alaska was returned to the clan in 1999, after more than a century, by the American Museum of Natural History in New York, a clan member recalls, "The day it came back was something you couldn't even imagine. The whole village was at the dock. People were crying and weeping." However, apparently many tribes have begun to agree that "museums display cultural artifacts better than anyone else."

was the cause of an elderly Brahmin's question to a missionary, "How is it that your countrymen steal our gods?" Stuart was later cited as the most prominent of those who had taken statues or cut away inscribed slabs from the remarkable temples of Bhubanesvar, in Orissa. To exhibit his collection, Stuart made his home almost into a museum. Much of his collection is now exhibited in the British Museum.[96]

I do not follow in detail the slow subsequent growth of interest in what we now know as Indian art. But as might be expected, there were negative and positive cultural way stations. Hegel's philosophy of art is a negative station. He thinks of Indian art as a confused, unresolved mingling of the infinite or absolute with the finite. In his eyes, this is a wild, fantastic world, "steeped with poetic fantasies" but containing not "one work of genuine art."[97] John Ruskin, the great art critic, is also, for the most part, negative. He at one point admits that Indian art "is delicate and refined" and praises the Indians (and Chinese) for their superior sense of color, even though they are, as a whole, he says, only semicivilized. But Indian architecture, he says, is idolatrous and empty of thought. He is especially put off by what he takes to be the absence in Indian art of any close study of nature. To him, Indian art is opposed "to all facts and forms of nature." It "*never represents a natural fact,*" he emphasizes. In his not unusual rhetorical intoxication, he goes on:

It will not draw a man, but an eight-armed monster; it will not draw a flower, but only a spiral or a zig-zag. It thus indicates that the people who practice it are cut off from all possible sources of healthy knowledge or natural delight; that they have willfully sealed up and put aside the entire volume of the world. . . . For them the creatures of field and forest do not live. They lie bound in the dungeon of their own corruption, encompassed only by doleful phantoms, or by spectral vacancy.[98]

William Morris, who shared Ruskin's dislike of industrial society and his idealization of the European Middle Ages, was much more sympathetic to Indian art. But Indian sculpture did not begin to be socially transformed into art worthy of the name until the twentieth century, at a time when India itself had become a symbol of Eastern spirituality that contrasted with Western materialism. The first person to have a strong influence on the transformation of Indian sculpture and painting into art was probably the art historian Ernest Havell. In his *Indian Sculpture and Painting* and *The Ideals of Indian Painting*, published, respectively in 1908 and 1911, Havell argues that Indian art should be appreciated in terms of its own standards. These standards go back, he says, to the Vedic period, even

though this period left little if any evidence of nonverbal art. According to him, the Vedic idea became sculpture in later India, when Indian sectarianism was overcome. In accord with the Vedic philosophy, Havell writes, what is central to Indian art is "the Divine Idea within nature," "the Noumenon within the phenomenon."[99]

To go on with dramatic (and somewhat misleading) exactness, there are two dates that in the West mark the accession of Indian art to the status of authentic art: January 13 and February 28, 1910. On January 13, Havell delivered a lecture to the Royal Society of Arts in London in which he defended Indian art as art and argued that it could not be understood without reference to the ideas of its creators, which were idealistic, mystical, symbolic, and transcendental. This praise of Indian art aroused the chairman of the society, George Birdwood, an expert on India well known for his book on its applied arts, to make a rebuttal. The sculpture and painting of India are not at all fine arts, said Birdwood. Pointing at the photograph of a Javanese Buddha, he exclaimed in sarcasm, "This senseless similitude, in its immemorial fixed pose, is nothing more than an uninspired brazen image, vacuously squinting down its nose to its thumbs, and knees, and toes. A boiled suet pudding would serve equally well as a symbol of passionless purity and serenity of soul!"[100]

On February 8, less than a month later, a group of thirteen artists, critics, and students of art, as they described themselves, sent a letter to the *Times* in rebuttal of Birdwood's rebuttal of Havell. The group wrote that they, the undersigned,

> find in the best art of India a lofty and adequate expression of the religious emotion of the people and of their deepest thoughts on the subject of the divine. We recognize in the Buddha type of sacred figure one of the great artistic inspirations of the world. We hold that the existence of a distinct, a potent, and a living tradition of art is a possession of priceless value to the Indian people, and one which they, and all who admire and respect their achievements in this field ought to regard with the utmost reverence and love.

Then, addressing their Indian confreres, the group added:

> Confident that we here speak for a very large body of qualified European opinion, we wish to assure our brother craftsmen and students in India that the school of national art in that country, which is still showing its vitality and its capacity of the interpretation of Indian life and thought, will never fail to command our admiration and sympathy so long as it remains true to itself.[101]

Another influential, early-twentieth-century defender of Indian art was Ananda Coomaraswamy. His learned, passionate, mystical criticism of art and life, Indian and European, still carries weight. The appeal of the thirteen partisans of Indian art to Indian artists did in fact encourage Indian artists; and the views and educational work of Havell and the philosophical aesthetics of Coomaraswamy had a practical effect among Indian artists, especially on the Bengali painter, Abanindranath Tagore. In both the nineteenth and the twentieth century, it was not unusual for attempts to revive tradition in a contemporary context to be colored by nationalistic fervor, and if at all successful, to be regarded in retrospect with self-congratulatory emotion, as this passage by Balraj Khanna and Aziz Kurtha testifies:

> Aided by the remarkable Englishman, E. B. Havell (principal of the Calcutta School of Art from 1896 to 1908 and the first Briton to condemn English art education as unsuitable for Indians), and also assisted in his efforts by India's greatest art critic, Ananda Coomaraswamy and the gifted painter Nandalal Bose [1882–1966], Abindranath tried to breathe new life into Indian art from the dawn of the new century. Instead of looking towards the all-powerful West, he and the Revivalists turned to India's own glorious past, to the riches of its great epics and the wisdom of its transcendental philosophy. Inspired by the frescoes of Ajanta and by Mughal-Rajput paintings, they attempted to create a new voice for India's long-dormant artistic psyche.[102*]

EPHEBISM

The classical Greek style, revived in the Renaissance, and revived again in neo-classicism, had a vision of human beauty that has been called "ephebism" in honor of the youth, vigor, and attractiveness of the Greek ephebes, the young men of Athens who, from the age of eighteen to twenty, underwent military training.[103] This ideal was an expression of the Greek reverence for well-built

[*] Abanindranath Tagore (1871–1951), who was "the first major artistic figure of Modern Indian Art, evolved a 'national' style and school of painting, The Bengal School, not just by using national themes but, in his early works, fusing Rajput and Pahari miniature traditions with his training in European paintings, especially pre-Renaissance Florentine influence, and his Western academic ideas of portraiture and watercolor landscapes. Also, works such as: *Last Days of Shah Jahan* (Oil on board, 1902), announced the arrival, of a new direction in Indian modern paintings, where the 'treatment of *bhava*, feeling, becomes the leitmotiv of his work' arousing a 'nostalgic evocation of history.'"

human beings, athletes in particular, and of the Greek opinion that physical and spiritual beauty implied and echoed one another. In the eyes of the Greeks, there was no contradiction in representing gods with bodies that looked like those of superlative human beings.

I do not know if ephebism marks every culture that may reasonably be thought traditional. It must be related to the practice of making portraits, especially of those singled out as model humans, more as they would look improved beyond their best than as they actually did. At least the warts and signs of excessive age were removed. This practice, which was quite conscious among the ancient Chinese and Romans, can be assumed to have recommended itself to portraitists and patrons everywhere.[104] An ephebic kind of representation of humans occurs often enough to show that it is natural for a tradition to use art to visualize and repeat what it most hopes to retain, including life at its prime. Take the Egyptians, for example. If you compare their art with that of the Mesopotamians, you are likely to agree with the analysis of the German Egyptologist Heinrich Schäfer:

> Egyptians were probably the first to be aware of the nobility inherent in the human form and to express it as art. One can sense the pleasure that the Egyptians must have taken in the balance of the shoulders and the delicate way in which they contrast with the aspiring shape of the rest of the body. . . . We should not imagine that the fact that human figures in Egyptian art "have stiff figures and erect backs, with their heads held high, and set squarely on their bodies, to be a sign of incompetence." Rather "the awareness grew that this attitude expresses vitality and confidence in real life. . . ." Among these pictures, apart from a few exceptions determined by their contexts, only youthful, firm, and well-formed bodies are to be seen. . . . With faces we can see clearly how each period developed and then cultivated its own ideal of beauty.[105]

The Egyptians, we know, made great efforts to prepare for their afterlives, which they planned to experience while they, or some soul-fractions of themselves, inhabited their tomb images. So their sculptured and painted tomb figures were as they imagined themselves alive in eternity. When the figures meant to contain them eternally were finished, they were brought to life in a special ceremony. This was a priest's "opening of the mouth" ceremony, meant to allow the souls of the figures' perishable flesh-and-blood originals to enter and leave, in the form of birdlike spirits.[106] Given the Egyptians' hope to preserve

their images for their future existence, we can understand why their portraits and other images of human beings are simplified and idealized—besides, the frequent hardness of the stone they sculptured favored the making of simple shapes. But none of this should be taken to have neutralized their aesthetic impulses. To choose an example from the first half of the Fourth Dynasty, the sensitivity with which certain so-called reserve heads are sculptured is evidence that their function

> must have been other than to serve as a surrogate body with which to receive ritual offerings in the mortuary cult. . . . It is fascinating to observe the tensions between idealization and realism in individual works. Those showing the furthest development toward individualization . . . are astonishing and it can be assumed that they had something of the character of a portrait. An idealistic trait is, on the other hand, that it shows the figure in a completely neutral state, having neither emotions nor ages, as was necessary for claiming a place in eternity.[107]

The idealizing impulse of the Egyptians is most easily evident in Fourth Dynasty representations of the pharaoh, who is shown in the full prime of life, healthy, alert, and confident, with his face unlined and free of any disfigurement. The faces of the reigning pharaohs of the Twelfth Dynasty may reflect age or disillusionment, but even their faces show no sign of ill health or deformity. The ephebic ideal is not consistently applied to captives and not at all to the occasional crippled or starving figures, who are mostly either peasants or serfs. The revolt against the ephebic ideal by Akhenaten, who reigned from 1352 to 1336 BCE, was consistent with his religious revolt and his stress on the truth, even, it seems, in the distorted-looking sculptures of his own perhaps really distorted face and figure. But his example was not followed.

Traditional India had its own kind of ephebism. In art one encounters what the Indians believe to be a creative force that gives life to all living things. The sensuously curving lines and volumes of so much Indian art are the subtler counterparts of the symbols of fertility that the Indians worship. In the traditional art of India, there are (almost) no old people, and only few who suffer from disease or deformity. Artists and patrons wanted well-made, fresh, responsive youth. "Our gods and goddesses," says an Indian scholar, "are all young, the latter always and eternally sixteen, and they are supposed never to grow old, since youthful freshness, litheness, flexibility and vibrancy are what constitute life at its best and fullest."[108] For traditional reasons, elderly persons or dwarfs

may be portrayed; but threatening, bloody, morbid images are the historically late results of the prominence of Tantric doctrines.

Ephebism is visible in "primitive" sculpture as well. What African ruler would agree to be represented as other than physically perfect?

> With their smooth shiny surface, calm demeanor, and full-fleshed features, African royal portraits such as those of Dahomey, Kuba, and Benin often show the king as the epitome of bodily perfection and beauty, neither too old nor too young, too heavy nor too thin. They convey an image of the king as someone who never ages, gets ill, or succumbs to the strains of office. . . . And if portraits of African kings generally show them to be strikingly handsome, it is partly because physical perfection was one of the many prerequisites of rule.[109]

Ephebism is characteristic of a good deal of the sculpture of the Yoruba. They make rough, glaring, monstrous masks to harass enemies; and criminals, fools, and foreigners may also be represented as ugly by Yoruba standards. But the Yoruba ideal is neither realistic, nor expressionistic, nor abstract, but rather neutral and somewhat symbolic.[110] A sculptor who would show his patron's warts or infirmity would risk the displeasure of the patron and his family. Yet, to the Yoruba, a human being is not to be sculptured as something else, and a particular human being should retain something of his particularity. Age itself can be symbolized by dress, hairstyle, or ornaments, but it may not appear in the features themselves, whose ugliness might be transmitted to the next-born of the family's children. This human agelessness agrees with an aesthetic or, more broadly, a whole philosophy, of equilibrium. An image should strike the mean between abstraction and resemblance, between childhood and old age, between faint and overconspicuous carving, and between light and shade. In keeping with the ideal of the mean, the Yoruba prefer a statue to be shiningly, but not excessively, smooth, that is, to have an only moderate polish and to be partly crosshatched or otherwise cut into.[111] They also prefer judicious proportions, proper roundness and angularity, and overall symmetry.

African tradition generally appears to favor no more than an approximate realism. The Bassa, who live in the interior of Liberia, tell the traditional story of a carver so infatuated with his wife that he secluded her and carved a mask with her exact likeness. When the mask was revealed in order to perform its ceremonial function, the elders were outraged that the carver had lost his equilibrium to the point of subjecting the clan symbol to merely human emotion. They punished the carver and "retired" his mask from use.[112]

FOUR SYMBOLIC IMAGES

Apart from long and intimate experience, there is no way to enter far into the webs of connotation that traditional art has woven. All the same, it is possible to get a feeling for the webs' variety and density. For this reason, I offer four quite different examples, each developed enough to hint at the depth that a tradition in time accumulates. My first example, a "primitive" one, is that of the Rainbow Snake of the Australian Aboriginals' Dreamtime. The second, which illustrates Indian tradition, is that of Shiva as the Lord of the Dance. My third example, for China, is that of old trees and rocks as portraits of their painters. My fourth, for the Western tradition, is that of the nude standing male that, in its earliest beginnings, has been called by the name of Apollo.

. . .

Any description of Aboriginal art, or even of the being called the Rainbow Snake, is complicated by the Aboriginals' diversity. Before Australia was colonized by Europeans, there were by one estimate some five hundred "tribal" units. The members of each such unit lived and moved together and spoke a language or dialect that they recognized as their own. Living in a self-contained group of biologically related or supposedly related persons, they might be critical of the oddness of those who lived in other, alien groups. They believed (and still believe) that a certain territory belonged to them as a group, in the sense that it is their right to hunt its animals and gather its food. Their clan traditions described how this right was granted them by the sanction of the preternatural beings that created the features of the landscape.[113]

To understand the Rainbow Snake, one must go back to the primordial time when, as the Aboriginals say, the earth was all a flat, unmarked plain. Some, however, say that there was water, or a soft and jellylike something, along with some natural species and spirits and monstrous creatures.[114]* The forerunners of the original human beings, who came from the unknown or the sky or the earth,

*A number of the sources I provide on Dreamtime and the Rainbow Snake identify the teller of each tale they repeat. In their collection, Ronald and Catherine Berndt thank the Aboriginals who told them the myths and stories and praise "the enthusiasm they displayed, and their recognition that such material should not be lost to them and to others. . . . Many of the Aboriginal men and women were outstanding raconteurs, having a tremendous aptitude for dramatic effect. Many, too, went to great pains to ensure that we understood the myths and stories—*almost* as well as they did themselves. . . . This is, essentially, a collaborative work between the many Aboriginal story-tellers and ourselves."

were still only latent, still asleep, or still not self-created. When these ancestors awoke to the work of creation, each one sang and created particular rocks, hills, springs, rivers, waterholes, cave entrances, or other landmarks. Each one sang and created, and could at will be a particular animal or object, though free of its ordinary limitations—one ancestor might be a tree that could walk, another, a rock that could run, still another, a beehive with its honey, and so on. Or the ancestor could sing and be an animal, such as a kangaroo or emu, or a human being, or it could give birth to human beings, or simply put humans into the territory they were to occupy.

In its particular way, each ancestor constitutes the being and life of whatever it once created as it sang. Where the ancestors died in battle with one another, their bodies might become hills, or the pools of their blood, lakes.[115] Or, as in an account by the Dieri people of the Lake Eyre District, in South Australia, "At the beginning of time the earth opened at Perigundi Lake and incomplete creatures emerged. They lay on the nearby sandhills and were strengthened by the sun. Eventually they were able to stand up 'as human beings,' and then spread out 'in all directions.'"[116] Or, as the Aboriginal poet Oodgeroo (Kath Walker, of the Noonuccal tribe) writes, in a syntax that suggests the structure of her native language, "In the time of *Alcheringa* [great power], the land lay flat and cold. The world, she empty. The Rainbow Serpent, she asleep under the ground with all the animal tribes in her belly waiting to be born. When it her time, she push up."[117]

This time of power, which most of the Aboriginals think of as "belonging to dreams," has come to be called Dreamtime, or the Dreaming. If an Aboriginal objects to the use of this term, it is because the word "dream," with its implication of unreality, does not do justice to the persisting reality of a time different from though still underlying the time of ordinary human life. To the Aboriginal, the nature of such time explains the powers that affected and, though now hidden, continue to affect life. It explains the beginnings of things, especially the features of the land and the relationship with that land of every being hidden within it, and it explains the mutual relations of the people, animals, and objects that have inhabited that land. It is a time of differentiating powers and relationships that continue to influence the cycle of seasons, the rules of social life, and the change-in-stability of the present. This is the time when the Law, sprung from itself, binds everything and everyone together into a world.[118]

Some of the characters of the Dreaming leave behind them a sign which is a part of themselves. This is particularly the case with Akurra, the Dreamtime Serpent, whose eggs (as stones), mane and teeth (as plants), fat (as talc) and

feces (as a mountain) are encountered. It is quite common for Dreamtime Spirits to leave behind them their feces and urine, the former generally in the form of rock, the latter in the form of waterholes. Blood is left behind in the form of red ground. When both the birds Marnbi and Yuduyudulya leave their feathers behind, it is in the form of white quartz, and when the eagle leaves his feathers behind, it is in the form of flintstone.[119]

The work of creation finished, each ancestor sank back into sleep or, more accurately, "into a cyclical, constantly-recurring, essentially repetitive process which ensures their survival through time."[120] But even while "asleep," the ancestor must be appealed to by the creation songs the ancestor once sang and the designs the ancestor revealed and continues to reveal in dreams, so as to renew the forms of life that issue from this particular ancestral being. The vitality of each design depends on the vitality of the song that accompanies it, and the vitality of design and song together can be heightened by dancing or dramatization. Properly sustained, the design's vitality can keep children healthy, attract lovers, and make plants and animals fertile. Drawn on a human being's body, a design draws that person more deeply into the cosmic and communal web of vitality.[121]

Individual Aboriginals, clans, and "tribes" develop particular relationships with particular primal beings. As Pat Mamanyjun Torres, a contemporary Aboriginal teacher, writer, and storyteller, says:

Before an indigenous Australian child is physically born to its mother, sometimes the parents or relatives have a dream of a spirit child playing with an animal, plant or weather element like wind, rain, clouds etc. When this happens the child is said to "belong" to that plant, animal, or thing. . . . In my case, I was given the "spirit of the rainbow serpent or *bulany*" of my elders when I was sick to help me get strong. This spirit of the rainbow serpent is very important for Yawuru people's way of life and can help to protect a person from danger or illness as well as giving the person the "special gift" of being able to dream the old songs, know how to sing the songs, and to know how to bring rain and to make rain go away.[122]

Each Aboriginal myth that is told as a "dreaming history" or "a telling of the land" is an individual's variation, believed by its teller to be basically true, of a particular tradition, so ideally the "tribal" or clan source of everything I say about the Rainbow Snake would be identified. I am not always so careful, however, because the Aboriginal belief in great, creative, fearsome ancestral snakes is extremely widespread. In one guise or under one name or another, every great

ancestral snake is most often known as the Rainbow Snake. Such a snake first appears, it seems, in rock paintings estimated to be three to six thousand years old, its long body combining a snake with, maybe, a head or other feature or attribute of a different animal. I have said "it," but the Rainbow Snake is male or female, a great father, great mother, or both. It is the great totemic ancestor who created and still lives under the rock pools, waterholes, and other deep waters. The lightning is the Rainbow Snake's shining body. So, too, is the rainbow, which arches so strikingly over the desert plain. The signs of the Rainbow Snake are everything that glitters, from the quartz crystals, which magicians use, to mother-of-pearl shell, used for rainmaking and other magic, and to the drops of water that hang over a waterfall. If the Rainbow Snake's rules are not respected, the result is flood, disease, or infertility.[123]

Sometimes the Rainbow Snake has hornlike projections from its head or, if male, has "whiskers," and its eyes may emit a dazzling light. Mostly, though,

> it is the sound of the snake's approach, rather than the sight, that is mentioned in stories. The victims are so overcome by what is happening to them that they have only a vague vision of "who" might be doing it. Apart from the sight and the feel of rising water, trees falling and their belongings being washed away, they hear the noise of rushing flood-streams or tides, and the roar of the wind like the combined "voices" of many bees, or like a huge bush-fire speeding toward them. That noise is sometimes contrasted, in myths, with the stillness and quietness later on when all is over, when the bones have turned into rocks.[124]

Everything creative and destructive that has to do with water, especially with rain, gives evidence of the great snake's power. This is the power not only of rain, but also of regeneration and reproduction, of swallowing and regurgitating young boys and in this way giving them a symbolic rebirth. Among some of the Yolngu (Aboriginal People) of southeastern Arnhem Land, a great act of swallowing revealed the powerful anger of the snake at the two incestuous Wagilag Sisters. The angry snake sucks up the water of his lagoon and spits out the clouds of the first monsoon. When the sisters try to avert a deluge by singing and dancing, he swallows them and their children and regurgitates the rain that engulfs and regenerates the earth. Then, sick and penitent at swallowing people with an ancestral relation to him, he falls hard into the earth, imprinting it with his snake's image, vomits out the women and children, and creates a wind to drive the flood away. Then he swallows the women and children again and regurgitates the women as two large, still visible rocks.[125]

One more Dreamtime story, this time related in the translated words of Anne Coulthard, the storyteller herself. It is a simple story, which explains how the local landscape, a creek system with waterholes, was produced by the huge Akurra, a water snake with beard, mane, scales, sharp fangs, and stubbornly immovable ticks on the back of his neck. Able to make more selves out of himself, he is in many places at the same time, is also female, and is both alive and, at dried-up waterholes, also dead (though formidable even then). A long time ago, as the story tells, he was so thirsty that he drank a whole salt-water lake dry. His bloated, heavy body carved out a great, still visible gorge, in which he made many waterholes, including a number of large ones.

> He kept on coming up, gouging out the gorge, until he came to Nuldanuldanha. He camped here and made another big waterhole. From here he went on to Valivalinha, and made another waterhole. After that the next important waterhole that he made was Adiyu Vundhu Awi.
>
> From here he went up into the Mainwater Pound. He kept on climbing until he arrived at Yaki Awi, and there he stopped. This is where he came to stay for the rest of his life, and he is still there today.
>
> He often comes up out of the waterhole at Yaki and makes rumbling noises. He lies there sunbaking and while the sun makes him warm, he makes loud rumbling noises in his belly. You can hear that big rumbling noise from a long way away.[126]

Speaking of the Dreamtime stories of the Flinders Ranges, among which Anne Coulthard's story belongs, her translator, Dorothy Tunbridge, explains that they are at once Aboriginal histories, geographies, and practical maps. Although my account has not shown this, the stories also explain the laws and customs of the Aboriginals, incorporate warnings to those who do not observe them, and help preserve the social history of the past. They record the memory of plants and animals—scrub wallabies, bandicoots, possums, stick-nest rats, and others—that have vanished from the Flinders Ranges. Usually, they incorporate a hopeful attitude toward severe problems like drought by stories about rainmaking or moving camp. These stories of course also entertain. Taken as a whole, they define an Aboriginal people's existence as a particular community on a given stretch of land.

> In the Flinders Ranges region they traditionally bound together in some social unity many different camps of people whose language was mutually intelligible. . . . The function of stories to provide a sense of community identity is

**AN ARCHAIC ROCK PAINTING OF THE RAINBOW SNAKE FROM DEAF ADDER VALLEY,
NORTHERN TERRITORY, AUSTRALIA, SITE 6.**
FROM E. J. BRANDL, *AUSTRALIAN ABORIGINAL PAINTING*, CANBERRA, 1973.

today enhanced. The stories are uniquely Adnyamathanha and are a part of the peoples' heritage that they can hold onto in a social situation in which there remains little that is tangible from traditional life. . . . They answer the questions as to who are the Adnyamathanha.[127]

To the extent that the Aboriginals are attached to their old culture, it is important to them to show their respect for the sites of their Dreamtime ancestors, of which they may see themselves as curators. I read, for example, in Dacre Stubbs' classic study *Prehistoric Art of Australia* (1974), of

> the celebrated rainbow-serpent of the Walbiri [Walpiri] nation of central Australia, which is painted along the side of a large rock mass overlooked a corroboree or ceremonial area. Every year about Christmas messages are dispatched to the widely spread Walbiri people and the different groups and families muster for the celebrations and rituals before the great rainbow serpent, their "patron" spirit. . . . This particular great snake painting is nearly twenty meters long and its image is flanked with innumerable child spirit symbols [a series of inverted U's]. The painting is outlined in red ochre and then filled in with pipe clay. The "U's" are painted in red and surrounded with white.[128]

Australia was populated over 40,000 years ago. Red ochre pigment, which is associated with burial, goes back some 20,000 years or more. Motifs common

THE RAINBOW SNAKE OF THE WALBIRI PEOPLE, ROCK PAINTING, AUSTRALIA.
UNATTRIBUTED PHOTOGRAPH ON P. 41 OF DACRE STUBBS, *PREHISTORIC ART OF AUSTRALIA*, NEW YORK, 1974.

in the Aboriginal art of historical times are found engraved in rocks as early or earlier: Concentric arcs go back, as cation-ratio tests show, over 30,000 years; one circle within another and "bird tracks" (trident-shaped marks) go back about 25,000 years; there are ancient sets of dots; and so on. Rock paintings appear about 18,000 years ago in Western Arnhem, where the "x-ray art," still characteristic of Aboriginals, begins to appear about 7,000 years ago.[129] These dates are only approximate, controversial, and subject to error, but they are enough to show that the motifs of Aboriginal art are ancient. The same motifs, attributed to their sacred ancestral beings, have been inseparable from the cultural practice of Aboriginals as far back in the nineteenth century as there are surviving records. Since the practice of the Aboriginal tradition, though abandoned, revived, or renovated by many Aboriginals, has been continuously practiced by others, it is plausible to regard Aboriginal art as the oldest continuously produced art in the world.

. . .

The Indian god Shiva (Śiva) is enormously powerful in all of his, to humans, contradictory manifestations.[130] He symbolizes a world that obeys no consistent rules but those of the universal cycle of creation and destruction, and his divinely irrational complexity mimics the darkness and equivocation of human beings, whose lord he is. As the power of generation, he is the phallus, and his spouse, his female counterpart, is the energy of the world; but he is also the universal celibate yogin, a haunter of graveyards, and a dancing beggar.

In this account Shiva appears in the symbolic guise of Nataraja, Lord of Dance. He is not simply the Lord of Dance but the incarnation of dance and its inseparable counterpart, music; he is their indwelling energies, expressive forms, and constructive and destructive powers. Put in a theologically schematic way, his dance is fivefold: a dance of world creation, of world preservation, of world destruction, of illusive veiling (or incarnation), and of release (or salvation).[131] His dancing is given sometimes baroquely eloquent descriptions—how else can one even begin to describe the universe itself pirouetting and dancing? His great traditional performances include his dance as the world-activating Lord of Yogins; his superlatively erotic dance in the Pine Forest; his awesome cosmic dance; and his dance at the end of time, when he tosses mountains into the air, causes the oceans to rise, disperses the stars, and dances the world out of existence, yet scatters the ashes and emits the rivers by which the world is reconstituted.[132] The ancient poet Somanathaprasasti writes of the hurricane stirred up by the terrible, magnificent god's "whirling, dancing arms" as he dances his twilight dance, by the force of which "the serried ranks of mountains fly from earth again."[133] The Indian scholar Calambur Śivaramamurti admiringly calls his relation to the universe impossible. The concept of the Lord of Dance is of a god, both container and contained, who envelops the universe impossibly completely. To adore him in temple ritual through dance and music is therefore, the scholar repeats, as absurdly inadequate as worshipping the sun by waving a lamp before it.[134]

In the Shiva-doctrine of Kashmir, on which I will draw in discussing Indian aesthetics, Shiva is the dance of bliss in the hall of consciousness, the human heart.[135] A seer, able to see inwardly, he savors perfection when he witnesses and experiences this dance, for there, in the heart, Shiva dances and undances the cosmos. His raised leg is liberation, his raised drum sounds creation, his flame is the flickering of destruction, and his foot on the ground suppresses the demon and shows the god to be the cosmic axis. The circle of flames that may surround his head is his sun-flame that burns away ignorance, the flickering of his *maya* that in dancing transforms everything by its energy, which is his endless playfulness of creation and destruction.[136] The different forms of Shiva and

SHIVA NATARAJA, THE DANCING SHIVA.

SHIVA NATARAJA, A TWELFTH-CENTURY BRONZE, FROM THE ASIA SOCIETY GALLERIES, JOHN D. ROCKEFELLER III
COLLECTION, ACQUISITION NUMBER 1979.29; AS REPRODUCED IN J. MASSELOS, J. MENZIES, AND P. PAL, EDS.,
DANCING TO THE FLUTE: MUSIC AND DANCE IN INDIAN ART, SYDNEY, AUSTRALIA, 1997, P. 4.

their iconography are too complicated to be described at length here. Although
its representations in art become numerous only during what is called the medi-
eval period of Indian history, the idea of his dance is very old.

I end what I have been able to say about Shiva Nataraja with the words of
Śivaramamurti, whom I have already quoted. He has studied the literature that
speaks of the dancing god and the art in which the god appears with reverent devo-
tion. I do not know how exactly to defend the generalization he makes, but feel,
with him, that Nataraja has been embodied in many extraordinary works of art. In
Śivaramamurti's words, "The Indian *śilpi* [craftsman] who conceived and fashioned
the form of Nataraja has undoubtedly created the greatest masterpiece of Indian
art. Nataraja almost sums up the perfection of aesthetic appreciation in India."[137]

. . .

In China, the old tree was a symbol of freedom and long life.[138] The Chinese rhapsodist of freedom Chuang Tzu (Zhuangzi) must have helped make it so by the answer he gives his critic, the sophist Hui Shih (Hui Shi), when the latter attacks him for talking big but uselessly and compares his talk to a huge tree with a trunk too gnarled to be marked for cutting and with branches too curled and crooked for a compass or square to be applied to them. If the tree were by a road, says Hui Shih, a carpenter wouldn't turn to look at it. Chuang Tzu, who joins logic with irreverent fantasy, answers that if Hui Shih had a huge tree and were troubled by its uselessness, he should try planting it in the village of Not Anything or the field of Vast Boundless, stay close to it doing nothing, or lie under it, sleeping easily. Its life never shortened by the ax, says Chuang Tzu, there would be nothing, there *is* nothing, to harm it. If it's useless (or if you're useless), what can trouble it? (or what can trouble you?)[139]

To the conscience-bound, pleasure-loving, often disappointed or endangered Chinese literati, this was memorably hopeful advice. Recalling it, a Confucian poet of the late eighth and early ninth century writes that an old tree without leaves or twigs is immune to the wind and frost but still has the ability to support fire. A Ch'an (Chan, Zen) poet of the same period sees in his mind's eye a tree, older than the forest itself, that is laughed at for its shoddy exterior but that is fine-grained inside and remains neither more nor less than the core of truth. Both the Confucian and the Buddhist make the old tree the image of human integrity and endurance.[140] Given this meaning, the old tree becomes a picture of the human being that matches its qualities, or more intimately, a self-portrait that artists could paint without exposing themselves completely. "The tree," says a student of Chinese art, "was the first motif to emerge in convincingly realistic pictorial form from the vast repertory of nature and was also the first to acquire affective overtones and to serve as a mirror of human sentiment."[141]

To begin with, the human or near-human tree was most often the pine. A tenth-century text on the art of painting by the landscapist and essayist Ching Hao (Jing Hao) explains "the true nature of a pine tree":

It may grow curved, but never appear deformed and crooked. It looks sometimes dense and sometimes sparse, and neither blue nor green. Even as a sapling it stands upright and aims to grow high, thus already showing its posture of independence and nobility. Even when its branches grow low, sideways or downwards, it never falls to the ground. In the forest the horizontal layers of its branches appear to be piled one upon the other. Thus appearing as a breeze blowing gently over the sawing grass, they are like the breeze of the virtuous

which passes over the bowed heads of the humbly respectful. Sometimes a pine tree is painted as a flying or coiling dragon, with its branches and leaves growing in maddening disarray. It does not represent the *spirit-resonance* of pine trees [that is, it is misleading to represent pine trees, whose nature is noble and orderly, in maddening disarray].[142]

The pine was very often depicted with a rock or rocks. As the preceding quotation shows, the pine was chosen because it was regarded as the king of trees and the symbol of upstanding strength, towering above other creatures like a dragon. The rocks, the pines' natural companions, were regarded as the bones of the earth and, in poetry and painting, as symbols of strength and stony endurance. By the eighth and ninth centuries, the painting of a pine and rock became, in effect, the painting of a human condition or person, and by extension of the artist who painted them. The metaphor of the desolate, wintry tree or forest, the literary roots of which go back at least to Confucius, became prominent in the tenth and eleventh centuries, along with the idea that the season portrayed is the equivalent of the human mood that is natural to it. First in Chinese poetry and then in painting, wintry trees represented sorrow, hardship, and old age, and the snow that lodged on them, their purity of spirit. By the eleventh and twelfth centuries, the bamboo joined the old tree and rock.[143] The tree of the tree-rock-bamboo grouping was usually leafless, that is, wintry. The rock lent its immovable strength to the group, while the bamboo lent its strength in pliancy, which human beings need no less than do bamboos. Made with a few deft strokes of the brush, the bamboos were also good for displaying their painter's virtuosity.

I end my account of the old-tree theme with the memorable tree portraits of Wen Cheng-ming, mentioned above in connection the tradition of copying in Chinese art.[144] To Wen, it is said, nothing in life came easily. Born in the late fifteenth century, he was a traditional, conservative Confucian, who had been taught by his difficult life to guard his independence from politics, and by his pride to reject commissions offered by merchants. His company therefore became restricted to scholars, artists, and their like-minded friends. In art, he was a devoted student of the past, who in every stroke was said to follow one of the old masters.[145]

Toward the end of his life—he died at the age of eighty-eight—he became more and more preoccupied with old trees and rocks, the trees often twisted, lonely, and tangled in one another. In 1532, he painted his most famous version of the picture called *The Seven Junipers of Ch'ang-shu*. I have read a deprecating comment on the picture but have not seen even a reproduction of the version

said to be its superior, and I remain impressed by its somberness and graphic daring.[146] In his inscription on the painting, which I quote only in part, Wen writes with rhetorical intensity of his seven trees:

> Dry lichen binds their bone knots. Now the boughs trail and now they soar, swirling in a gyre or suddenly dropping. Now martial as spears, now supine and flat. Now the boughs writhe like the arms of apes, grasping at some shifting prize. Now, like the necks of haughty cranes, they bend as if to preen themselves. Wrinkles crack as though struck by axes. The russet bark bursts asunder, pierced through by tiny leaves. The branches sweep the lonely night like brooms. By day a sound of roaring waves echoes in the hollows of the trunks. Like creaking ropes the junipers dance to the wail of the wind, conjuring up a thousand images: split horns and blunted claws, the wrestling of dragons with the tiger, great whales rolling in the deep, and giant birds who swoop down on their prey. And now, like ghosts, they vanish, now reappear, vast entangled forms.

The inscription ends with a humorous simile, an ambitious hope, and a dedication: "My portrait of these junipers is like the admiration of a northerner for an orange tree, and yet, may I attain, inscribed in granite, a touch of immortality! In the summer of the year 1532, Cheng-ming painted and wrote this for Wang Shih-men."[147]*

And so the old tree, upright and twisted, leafy and barren, represents the Chinese artist, his rectitude, his endurance, his pain, his refusal to betray his faith to an alien government, his premonition of death, and his sense of his existence within a nature that encompasses everything.

· · ·

The Rainbow Snake, the Dancing Shiva, and the old tree would be easy to compare with some motif taken from Christian tradition, a motif with perhaps pre-Christian origins. However, I have chosen a vaguer figure, the actual mythology

*In her book *Wen Cheng-ming*, Anne Clapp says that the text above is not by the artist but is a poem by Huan Yün. Richard Edwards, who has Clapp's book in his bibliography, says, all the same, that it is an inscription written by the artist. In Clapp's interpretation, Wen is inspired by the poet, Huan. She writes that the poet's "spectacular figures of speech seemed to have impressed themselves on the artist's mind and he searches for congruent form in various tree species, especially in pine and juniper, that lend themselves naturally to assimilation with sentient creatures. . . . Wen's tortured animal images waver on the margin between the real and the unreal, infusing a still greater intensity of life into the

of which soon lost its ability to convince. I have chosen this figure because of its great age, its innumerable variants, and its penetration, too hard for us to make out consciously, into our habits of perception. I am referring to the standing male nude, which in the form in which it first appeared, in Archaic Greece, was in modern times named "Apollo."

None of the "Apollos," the figure of a Greek youth, or *kouros* (a late-nineteenth-century name for such a figure), is a cult statue, and none is certainly a god.[148] Because many *kouroi* are from sanctuaries of Apollo, they may represent the god's devotees. As grave markers or memorial figures, they call up the dead man in his youth and vigor. Just why these figures are naked no one knows, but their nakedness seems to have been taken for granted, no doubt because the practice of naked running had spread from Crete and Sparta and was usual in the gymnasia (from Greek *gymnasion*, "naked-training" place). As these figures grow more realistic in the sixth century, they look as if they are related to the prevailing, though ambivalent, pederasty, which ascribed bravery in warfare to the desire of male lovers to prove themselves worthy of one another.[149] These are heroes, but as the figures grow smoother and more pliant we also begin to feel the devotion of the ancient Greeks to the beautiful human body, especially of the male, and recall that among the contests the Greeks held there were also male-beauty contests (the details of which are unknown). The male body is given ideal proportions by Polyclitus; it makes its appearance as the figure of the athlete; and Phidias makes of it a great, beautiful, serene Apollo. In the earlier Middle Ages, there is hardly any Apollo. He appears again, as strength, in Nicola Pisano; and nakedly beautiful, as Donatello's *David;* and then, upstanding, stalwart, and brave, as Michelangelo's *David.*

Between the standing male nudes of the Greeks and the Renaissance sculptors there is a subtle difference. The Greek nudes suggest concern with manly strength, with pederasty, and with the ideal of the harmony of mind and body. The Renaissance nudes that draw on those of the Greeks tend to a spirituality with a Christian, Neoplatonic tinge. And so the resurrected ancient nudes, with whose help the human body is once again made flexible, given a clear articulation, and endowed with an inner structure as well as an outward presence, show

wild posturing of the juniper branches. With them comes a new subjective content which Sirén rightly labels expressionism. In the Honolulu scroll the expressionistic features may seem a little calculated and rhetorical, but in later pictures they will be more subtly integrated with no loss of their original power."

the artist how the human body can be a privileged object, the instrument of the soul, and the harmonious reciprocal of the universal harmony. "The philosophic love for boys" is reinvigorated for the sake of the aristocratic culture of the Medici period, and the nude figure, especially of the male, comes increasingly to interest the Florentine ateliers.[150] The adolescent nude of Donatello evolves into a sexually indeterminate adolescent that Botticelli, Leonardo, and others can associate with angels, a form that is seen as an ideal combination of human perfection and delicate asexuality. For their historical importance, I mention the Renaissance discovery of the Apollo Belvedere and recall the reaction of Johann Winckelmann (1717–68), who in its presence felt himself pass from admiration to ecstasy, and urged the spectator to let his spirit "penetrate into the kingdom of incorporeal beauties . . . for there is nothing mortal here, nothing which human necessities require."[151]

I need not follow the history of the European male nude any further, neither to the suppleness and sensuality of Bernini, nor to nineteenth-century academicism, romanticism, or realism, nor to Cézanne's bathers, nor elsewhere. Whoever the artist, the Western tradition has been such that every standing male nude has been experienced by anyone with knowledge of the tradition as a variant of a figure going back to the Greek *kouros,* and perhaps to its Egyptian predecessor. It is natural to question this statement: Doesn't an evolution toward realism lead inevitably to the kind of standing nudes we find in Renaissance and later European art? What does the Greek style at the beginning of the evolution have to do with its end? The answer is that there is always a recognizably European stylistic influence, which stems, to begin with, from Greece. To test this statement, one might compare paintings and sculptures of the male nude with the closest equivalents one can find in the art of other cultures. (Since realism is more developed in European art, one might make the comparison easier by including clothed non-European figures.) In chapter 3, I will refer to the sometimes surprising realism we find in art to which realism is supposed to be alien. If I am not mistaken, the test will show that the non-European and the usual European realism are stylistically distinguishable. There are likely to be many reasons for the differences, but the Greek heritage is certainly one of them. While I am not sure how the Apollo-experience influences our reactions to the art of other traditions, I think it has been bred into our bones for so long that it has become part of our visual nature. This remains true in spite of the passionate Western artistic revolt against tradition, because the passion of the revolt is still a kind of dependence.

FROM APPRENTICES TO MASTERS

Traditionalism, with its stress on continuity from generation to generation and its love for reverent orderliness, may diminish or even erase the line we have learned to draw between the crafts and the fine arts. In accord with fixed standards, work is organized so as to protect its well-understood quality and its old forms, and rule out cheating, rebelliousness, and unfair competition, names used, as likely as not, to attack a menacingly competitive stranger. Whole specialized communities or organizations may be set up, often resembling the medieval guilds of Europe enough to be called "guilds" without serious misrepresentation. Apprenticeship is inculcated by ceremony, accentuated by personal service, and recalled by a gratitude that lasts in theory throughout life. Guild tradition is often extended backward in time to ancient founders or sponsor gods.

Take as an example the nature or natures of apprenticeship in Africa. There, the relationship of apprentice to master and to tradition shows that the possibilities range from quite strict to relaxed and informal. Among the Dan and Kran peoples of West Africa, the apprentice carver learns by simple imitation. After two or three years, when the apprentice has learned enough, his master frees him to go back to his home town; but the new master continues to bring his teacher gifts and consider him his superior. When a master dies, his inheritor, usually his son, steps across the corpse four times, and makes motions symbolizing the taking over of the dead man's skills, saying, as he does so, "Give me your skill in carving."[152] Together with the skill of the master, he inherits the skill embodied in the master's tools.

In some African tribes, the process seems more fixed and the person of the craftsman more stringently regulated. Such may be the case among the Senufo, another West African people, whose craft practitioners live in their own craft village and do the work that is passed on to them by their chief.[153] African kingdoms have a relatively complicated organization. In the kingdom of Benin, much of the carving (in wood and ivory), forging, casting, weaving, and embroidering has been done by members of court guilds, who live in their own quarters, close to the palace, where they have areas in which they work and store their work. When members of the carvers' guild invoke their patron god and their ancestors, they ask not only for prosperity but also that the patterns they make should not be forgotten. "Don't let our children forget them," they ask.[154] There are also many artists outside of the guilds, either individuals believed to be divinely chosen as artists or simply persons who live and work in a craft village. All the artists believe that their designs come from the supernatural world, whose gods they petition to guide them and protect them against accidents and the malice of witches.

There are no "artists" as a general category but there are weavers, potters, casters and so forth, all of whom have expertise in artistic production; they are skilled creators . . . knowledgeable in technique, form and pattern. Done properly, their creations can be called *mosee,* which means "beautiful," but has the connotations of "proportionate," "appropriate" and "morally good." Aesthetic criticism is part of the creative process: artists are evaluated and guided not just by their fellow artists but also by the ancestors or gods, who come to them in dreams.[155]

Among the Pende, of eastern Zaire (the Democratic Republic of the Congo), some sculptors undergo full formal training as apprentices, some have short, relatively lax apprenticeships, and now and then an artist learns the craft by trial and error, by no more than his "own force," as the Pende say. "Sheer talent takes one a long way. This is as true today as in the past." The present demand for sculptures makes art a profitable enough occupation to attract relatively many men to it.[156]

In India, as in Africa, a craftsman often inherits his craft from his father, and, as often in Africa, he must be reverent to his teacher, his guru, and to his tools and materials, or rather, to the powers that lodge in them.[157] He memorizes the traditional craft rules, put into rhymed form, learns the relevant craft mythology, absorbs his teacher's craft formulas and perhaps secrets, and participates in the many ceremonies of consecration. If he lives in the usual variegated village, he exchanges his services for those of others and continues to do some farming, as he must in order to have enough to live by. In the larger cities there may be life-encompassing guilds, which lay down conditions of work and standards of quality, and which may also have their own houses of assembly, temples, pools, gardens, and monuments.[158] Such guilds help members in need, convene their own courts, and expel undisciplined members.

In writing the last paragraph I was unsure, as I have often been, to what extent I might still use the present tense. The great traditional work seems all to have been done in the past. To judge from the building records of a thirteenth-century temple in Konarek, complex work was organized like that on the great medieval cathedrals of Europe, though perhaps more fully.[159] Not only were there distinctions between ordinary stonecutters, assemblers of stone into architectural forms, sculptors, and architects, but there were also doctors, barbers, waiters, torch replenishers for night work, officials to maintain order, and Brahmans to perform the numerous and indispensable ceremonies.

In China, some of the craftsmen or craftsmen-artists (whose control over

materials sometimes verged on the unbelievable) were bound to their work in imperial workshops. Guilds, with functions like those in India and Europe, seem to have been confined to towns and cities. Japanese craft guilds, organized in family-centered schools, developed in the thirteenth and fourteenth centuries.[160] Each constituted a world in itself, with careful genealogies recording the succession of masters and the subschools with their successions of masters, and with their own instructional manuals, craft secrets, and philosophical or religious precepts.

With the organization of Western craftsmen, we can glance first at ancient Greece, where crafts often ran in families.[161] Much of what we know about the continuity of tradition from master to student in medieval and Renaissance Europe comes from evidence relating to sculptors. It appears that freemen apprentices were bound by agreements drawn up between masters and the apprentices' parents. In the Middle Ages, building workers were exceptions, because they moved from site to site, and masons were often free to make their own terms.[162] The guilds, which were more concerned with the master's than the journeyman's advantage, established a full framework for the lives of their members, regulated the quality of work, and controlled competition. The fourteenth-century Regius manuscript, written in late octosyllabic Middle English, is filled with the craftsman's pious ethic. The master mason is required to be loyal to his brotherhood, never to demand of his companions more than he can do, to be the honest boss, and not criticize the work of another.

He should make everything known
of the art whose slightest detail
he has consented to reveal.
The pupil will make this his store of knowledge . . .
Every mason swears the oath with great respect,
to his Lord, to be faithful to all
aspects of the traditions, rules, and Law,
which everyone in his profession reveres,
companions, Master, in the name of the King.[163]

From the second half of the thirteenth century, demonstrations of skill, masterpieces, began to be demanded as a sign of full competence.[164] The exact skills to be taught were likely to be listed in formal agreements. In a rather unusual contract drawn up in Sienna in 1467 between two painters, Francesco Squacione of Padua (Andrea Mantegna's teacher) promises to teach the son of Guzone the painter

the way to make a *piano lineato* or pavement, well drawn in my manner; and to place figures on that pavement here and there in different places, and to place things on it such as chairs, benches, houses; and he is to understand how to do these things on the said pavement. And he must teach him how to foreshorten a man's head by isometry, that is of a perfect square underneath in foreshortening, and to teach the method for making a nude body, measured both from the back and from the front, and to place eyes, nose, and mouth in the head of a man in their correctly measured place. . . . And I want the usual gifts, on All Saints' Day, a goose or a pair of chickens. . . . And if he [the apprentice] damages any of my drawings, Guzone is obliged to pay me for them at my discretion.[165]

The demand for masterpieces was made not only of painters and sculptors, but also of tailors, locksmiths, rope makers, cooks, and philosophers, the philosopher's test being the defense of his master's thesis. In 1516, the painters' guild of Strasbourg even demanded originality. This sounds like a sign of changing times, the recognition that originality, some measure of which could never be escaped, was now becoming an explicit criterion of the quality of art:

The candidate shall make his masterpiece an independently designed one, without using any model pattern and skill, but rather out of his own intelligence and skill; for such a one as makes the masterpiece in this way is one who can also make others after it, which may then be proper to him.[166]

EXACTING RULES

Traditionalism requires that everything should be constructed in accord with rules. After a word on Dogon architecture, I will go on to well-known rules of construction in traditional China, traditional India, and Europe, including, for India and Europe, the rules for making sculptures of human figures. The point is not to review the rules, numbers, and instances in detail, which would be dismaying, but only to show something of the similarity and difference of the building rules and figure-making rules traditional in different cultures. Everywhere, traditionalism implies the rule of rules. I suspect, though, that the rules themselves have been less important than the extent to which their supporting rationalizations have embedded themselves in their respective cultures. Practical reasons aside, the main force behind the rules is the tendency, hard to resist, to think in imaginatively plausible correlations, mainly macrocosmic-microcosmic ones, between human structures and those of the universe at large, or between the human body and the universe imagined as a living organism.[167]

So-called primitive architecture is far too varied and unexplored for its exact rules of construction to be explored here.[168] But I can give an example of cosmological anthropomorphism as it is reflected in the practice of building. Because it is convenient, I take the example from the Dogon. In the ordinary Dogon house, according to Marcel Griaule,

> The soil of the ground floor . . . is the symbol of the earth and of Lebé [the ancestor who, after dying, was resurrected as a snake], restored to life. The flat roof . . . represents heaven, and the ceiling which separates the upper story from the ground floor represents the space lying between heaven and earth. . . . The vestibule, which belongs to the master of the house, represents the male partner of the couple, the outside door being his sexual organ. The big central room is the domain and the symbol of the woman, the two store-rooms to each side are her arms, and the communicating door her sexual parts. . . . The four upright poles (feminine number) are the couple's arms, those of the woman supporting the man who rests his own on the ground. . . . The earthen platform that serves as a bed lies north and south and the couple sleep on it with their heads to the north, like the house itself, the front wall of which it is its face.[169]

From very early times, buildings in China (like the ordinary Dogon house) were usually arranged symmetrically, along a north-south axis; with doors opened to the south.[170] The orientation of buildings is based on the Chinese symbolism of the cardinal directions. The Chinese sensitivity to space, especially the contrast and aesthetic balance between emptiness and fullness, seems related mostly to Taoism (metaphysically, Taoism favors emptiness, in the sense of potentiality, as the mother of all things).

There is more, however, that is believed to govern buildings and the fortune of the humans who inhabit them. Both depend on harmony with the forces of nature, or more exactly, on a harmonious balance of the yin and yang components of the universal breath-force (*ch'i* or *qi*). To achieve this balance, buildings of all kinds—all the residences of the living and all the residences, the graves, of the dead—are placed, oriented, and sometimes in part designed, according to Feng Shui (Wind and Water) principles. These are complicated systems of geomancy, which make use of correspondences between heavenly objects, such as planets, and earthly ones. To put it simply, they combine astrological influences with an assessment of the effects of the various topographical features of a building site, especially the shapes of hills or mountains and the directions of flow of streams or rivers. Along with its demand for harmony with the environment in

place and time, Feng Shui seems to imply Chinese aesthetic attitudes, as is suggested by its preference for winding paths over straight ones.[171] Its practice was often criticized, for instance, when it led to the postponement of a funeral, in defiance of the time-honored duty of children not to delay the burial of their dead parents. The Feng Shui tradition, whose keepers were the geomancers, here clashed with the Confucian tradition, whose keepers were reluctant to suffer or accept what for them were injurious delays or beliefs.

Building in China was essentially in wood. "No Chinese house could be a proper dwelling for the living, or a proper place for the worship of the gods, unless it was built in wood and roofed with tile."[172] The modular system of traditional building in China may have first suggested itself because of the complex carpentry necessary to support a Chinese roof, with its curves and its clusters of brackets. A modular system, in the sense of repeated units of space, whether filled or empty, has remained characteristic of Chinese building, not to say, aesthetics. The module that came into use for the actual construction of buildings was a relative proportion defined as the width of the joint of the wooden block put on top of a column to support the structural members above it.[173] This standard proportion made building simpler and quicker and made it possible to assemble several buildings at the same time. In a summary of some of the directions it gives, the late eleventh-century *Treatise on Architectural Methods* explains:

> Thus the height and depth of the roof, the length, curvature and trueness of the members, and the ratios of column and post heights (in the structural cross-section adopted for any particular ground-plan), together with the right use of square and compass, plumbing and ink-box—all proportion and rule depends on the system of standard timber dimensions and the standard divisions of these.[174*]

*The parallel perspective (perspective having no true vanishing point) of the Chinese helped them to make clear constructional (working) drawings, such as those in the *Treatise on Architectural Methods*. As Joseph Needham explains, "Engineers of our own time are often inclined to wonder why the technical drawings of ancient and medieval times were so extremely bad; what remains from the Hellenistic world is so distorted as to need much interpretation, and the machine drawings of the Arabs are notoriously obscure. The medieval builders of European cathedrals were no better draughtsmen; even Leonardo himself produced little that was clearer than sketches, brilliant though these sometimes were. We must face the fact that Euclidean geometry had no power to give Europe precedence over China in the appearance of good working drawings, at least in building construction. Indeed, the very reverse was true."

Building in India may have been subject to even more rules than in China.[175] An astrologer was consulted and, if all was well, a date for the ritual beginning was set; at later important stages of construction, other rituals were performed. At least for an important building such as a temple, a Brahman architect had to determine the building's correct place and orientation, for which its purpose and the caste of its users had to be taken into account. Groves, rivers, mountains, springs, and "towns with pleasure gardens" made good sites because they were known to please the gods. The earth on which the building was to be erected had to be fertile, and its consistency, taste, smell, and color had to be propitious.[176]

If it seems unnecessary to repeat the building rules themselves, it is only to recall that the science of architecture was assumed to be a holy emanation from the gods. The master builder or architect was considered the earthly equivalent of the universal constructor-god, Vishvakarma.[177] Each one of his four faces, tradition said, had given birth to another kind of architectural specialist: the master builder, the drawer or tracer, the painter, and the carpenter or assembler. For each of these aspects, minute obedience to the rules promised good fortune and neglect of the rules fitting punishment. If the staircases, for example, were of the wrong size, "the master would be crippled, without any doubt."[178]

An Indian temple has a plan, generally a square mandala, which symbolizes the universe or the world of the gods. Before the erection of the temple begins, this mandala is actually drawn on the ground, as accurately as possible. The temple's inmost room, the center of its force, is also based on a square mandala. It fits the mountain-shaped (or even mountain-range-shaped) temple to be the habitation of a god (who may contain all the gods). For the temple is the place in which and by which the god shows himself. As a whole and in all of its parts, the temple has to be well proportioned. Its perfection sustains the perfection of the universe. This requires a geometrical organization. The geometry has its symbolic meaning determined by often ancient, highly detailed, sometimes-mysterious texts. "Yet Hindu architecture is outstanding for its organization, its extreme accuracy and rigorous planning and for its geometrical perfection."[179*]

*Take the inner room, the sanctuary, for instance: "The plan of the sanctuary is based on the square, but subdivided into a series of small square areas, each derived from whole number. Thus the side of the quadrilateral will be divided into 3, 4, 5, 6, 7, 8 or 9 parts. Its surface will thus be 9 (3^2), 16 (4^2) 25 (5^2), 36 (6^2) 49 (7^2), 64 (8^2), or 81 (9^2) small identical squares. In this way the Brahmanic mathematician decides which scale the building is to be governed by, the scale literally informs the building structure. . . . In Hindu theological speculation, a correspondence was often sought between the squares of the *mandala* and the gods of the Hindu pantheon. Each square, therefore, has a sacred value."

Holy images, which were objects of veneration, supports for meditation, and complete microcosms, were also subjected to many rules, designed to make them inviting to the god who was meant to enter them. One unit of measurement to fix proportions was the middle segment of the bent forefinger; the next chief unit was the palm of the hand, taken to be equal to the length of the face from scalp to chin.[180] It should be understood that the Indian rules allowed the sculptor some latitude. One researcher claims that the study of one form of the sculptures of Vishnu—the boar incarnation—leads him to believe that there is not "a single case of full coincidence between textual injunction and the work of art in question"[181] Another researcher says that in South India the patron of an image was bound to the image by the use as units of measurement of his fist, of the middle segment of his middle finger, and of the palm of his hand.[182]

In any case, the rules were all subject to a paradox: despite the categorical wording of each text, there was in fact no universal canon, because Indian tradition is made up of many local traditions. It has been said, plausibly, that religious sculptures that were part of an architectural context had to be varied to suit their place. For instance, a sculpture might be deliberately distorted when it was meant to be viewed from below.[183] Under such circumstances, it is hard to distinguish between conformity to an unknown local canon and deviation from it. The application of the rules for temple building also varied greatly. Temple symbolism seems never to have conformed exactly to the rules we know and, despite what I have quoted about the exactness of Indian temple architecture, actual measurement shows that practice varied considerably even from the canon supposed to have been applied to particular temples.[184]

In Greece, there was a similar distance between rule and practice. The more mathematical ideas of consonance and beauty had what we may think of as a Pythagorean background. That is, numbers were associated with the intervals of music and with geometrical shapes—1 is the point, 2 is the line, 3 is the plane, and 4 is the solid. In this sense, number, geometry, and objects could be thought of as the same, except that the numbers, unlike objects, had an absolutely unchanging, essential nature. Musical harmonies are heavenly ones; for example, in the sacred number 10, in which the tetrad, "the group of four" are arranged so as to represent the decad and the universe. As Aristotle understood the Pythagoreans,

> they supposed the elements of numbers to be the elements of all things, and the whole heaven to be an attunement and a number. And all the properties of numbers and attunements they could show to agree with the attributes and

parts and the whole arrangement of the heavens, they collected and fitted into their scheme; and if they find a gap anywhere, they readily made additions so as to make their whole theory coherent.[185]

If nature obeys or, rather, *is* numbers and their relationships, then architects and artists who care for the essential search for the harmony and beauty they yield. It must have been in something of this spirit that the Roman architect Vitruvius projected his modular building method far back into Greek history, even though the ruins of every Greek temple we know have different measurements from every other.[186] Vitruvius claimed that the proportions of the columns were based on those of the human body, and he agreed, as the Indians did, that the proportions of buildings should be based on those of humans:

> Since nature has designed the human body so that its members are duly proportioned to the frame as a whole, it appears that the ancients had good reason for their rule, that in perfect building the different members must be in exact symmetrical relations to the whole scheme.[187]

The discovery of the building plans for the Temple of Apollo at Didyma show that the plans, drawn full size directly on the stone, were geometrically accurate, but that the master builder purposely deviated from them. "The interacting considerations of stringent rules and dauntless whim forced the master builder to engage in an architectural balancing act between the two opposites. . . . At each stage of construction the plans for a building were constantly elaborated and refined."[188] It is interesting that the conception of *symmetria,* the "commensurability of parts" or harmonious proportion that characterized classical art, seems to become increasingly subject to optical refinement. That is, the appearance of pleasing proportions is preferred to the strictly measured reality. It was only by the late Hellenistic period that convenience taught Greek architects to use a true, encompassing modular system.[189]

Impressed by Vitruvius's ideal, Renaissance architects measured classical buildings to discover the proportions that underlay their beauty; and they supplemented the ideal of human proportions with that of musical ratios, also supposed to reflect the harmony of the universe.[190] Doubts expressed by eighteenth-century thinkers were no more effective than the equivalent reservations of seventeenth-century Chinese thinkers. The doubts did not prevent the rise of neoclassical architecture. In more recent architecture, the ideal of human proportions continues to exist, for example, in the modular system of Le Corbusier.[191]

Although ancient Greece served as the theoretical foundation of these ideal-ized proportions, the Greek sculptural canon has been shown, after a good deal of controversy, to have been at first based upon a modular Egyptian canon, the influence of which was extended, through the Greeks, to the Renaissance and beyond.[192] As every art history repeats from Galen's treatise *On the Doctrine of Hippocrates and Plato,* Polyclitus (active c. 460–410 BCE) constructed a statue, the *Canon,* and wrote his own treatise by that name to recommend "symmetry,"

> the harmonious proportion [or "commensurability"] of the parts—the propor-tion of one finger to another, of all the fingers to the rest of the hand, the rest of the hand to the wrist, and of these to the forearm, and of the forearm to the whole arm, and, in short, of everything to everything else, as described in the *Canon* of Polyclitus. Polyclitus it was who demonstrated these proportions with a work of art, by making a statue according to his treatise, and calling it by the same title, the Canon.[193]

Clear as this description sounds, it turns out to be enigmatic because no one has been able to translate it convincingly into numerical proportions—at what exact points of the body is the measuring supposed to start?—or show that it fits the copies, which differ from one another, of Polyclitus's statue known as the Doryphoros (Spearbearer). The Spearbearer, which may or may not be identical with the *Canon,* "is generally considered," in the words of Pliny's *Natural History,* "to be the most perfect work of art in existence." It also demonstrates Polyclitus's division of muscles into tense and relaxed, the lowered right arm, straight shoul-ders, taut right foot, and slightly thrust-out right hip being balanced against the raised left arm and relaxed, bent-kneed left foot. The whole body is therefore counterpoised into a slight S-shaped curve.

The Spearbearer was criticized in antiquity for being "virtually stereotyped," as might be expected of a sculptor who believed that "perfection arises little by little through many numbers" (another phrase hard to interpret exactly).[194] But the Spearbearer's reputation and its many ancient copies show how widely it was admired and how effectively it exemplified the ideal of the athlete who is the warrior, or better, the athlete and warrior who is in everything, even the way he stands, proportionate and harmonious. As Andrew Stewart puts it,

> the Doryphoros's balancing act between whole and part, realized through its strict division of the muscles into major and minor, active and passive, tense and relaxed, and their proportionally based integration into the whole, created a visual hierarchy of forms that was intended to appeal to both eye and mind.

Essentially, the statue was perfect anatomy and perfect geometry combined. It strove to balance and satisfy both the sensual requirements of the glance, which seeks to scrutinize (*theasthai*) movement, detail, and texture, and the mind's eye (*theoria*), which takes sight's atemporal sense of simultaneity to privilege being over becoming, speculation over observation, abstraction over mere flesh.[195]

Stewart's praise is a good statement of the Greek classical ideal of strength in balance and of change conceived in eternally stable harmony. The statue that provoked these reactions makes me think of a warrior-aristocrat, petrified somehow, who has come from Plato's impossible republic: a lover of the state when tested with pleasure and pain; sober, brave, and lofty of soul; an athlete of war, so to speak, and a guardian; and a mirror of these abilities in the visible health of his body and the harmony of his appearance.[196]

Later artists are said by Pliny to have followed Polyclitus's work like a law.[197] For a time, the Greek sense of human beauty tended more toward the ideal human than the actual one. This idealizing is aptly illustrated by Cicero's report that when Zeuxis decided to paint a superlative Helen, he compounded his painting from the appearance of five beautiful virgins, "for he did not believe that it was possible to find in one body all the things he looked for in beauty, since nature had not refined to perfection any single object in all its parts."[198] I need not remind you that what Zeuxis did, or is said to have done, fits the conclusions of the research I earlier reported on beauty achieved by averaging.

Like Renaissance architects, Renaissance sculptors, for whom "the proverbial Name of the Artist par excellence was Polyclitus," measured the surviving works of classical art and devised canons.[199] The most interesting of the canon devisers were Leonardo, who investigated how human dimensions changed in the course of movement, and Dürer. The old analogy between musical harmonies and visual proportions received endless rhetorical embellishments and was extended by virtue of the new doctrines of perspective. The art academies that soon developed made the canon of proportions an integral part of their teaching, as was experienced by many generations of art students.

CLASSICISM AND ARCHAISM

So far tradition has been considered as if it were an unbroken though flexible devotion to old forms and ideals, mostly of measure and harmony. Dissatisfied, however, with the present, traditionalists may teach the need to return to what they regard as the true tradition. The result is a self-conscious classicism, mean-

ing, a neoclassicism or archaism. Such teaching is clearly visible in both the literature and art of ancient Egypt. It is needless to say that if terms like "classicism," "neoclassicism," "archaism," and "canon" are applied to Egypt, their likeness to the same terms applied to China or to Europe can be only approximate.

The Egyptians felt they had to validate their present way of living by reference to their past and did so with the help of their mythological history, their armory of ancient spells and medicines, their wisdom crystallized by sages in cautious apothegms, and their rituals designed to stabilize life in the present and guarantee life later, after death. Evidently, ancient Egypt was by nature traditional. During the Middle Kingdom, the Eleventh through the Fourteenth Dynasty (2040–1674 BCE), Egyptian culture may be said to become classical. That is, it creates an accepted canon of the older literature, and it repeats the past, with a considered moderation that is also a part of the European notion of classicism.[200]

Later, during the New Kingdom, from the Eighteenth to the Twentieth Dynasty (1550–1069 BCE), the Egyptian language comes to change. When it turns literary, it grows more distant than before from ordinary speech, while literature grows more individual. A long history has given the Egyptians a sharper historical consciousness, and one senses a tension between respect for the ancients, whose now memorable names are cited, and an active interest in newer forms. The tension shows itself in the rhetorical question, "Where have all the classics gone?" a question that implies that the past, with all its achievements, is now in effect dead.[201] This death is implied in a well-known literary complaint in which a skeptical scribe says—remarkably for an Egyptian—that books and books alone are immortal, and that only they can immortalize their authors. "Instructions are their [immortalizing] tombs," he says, "the reed pen is their child, the stone surface is their wife." Then he enumerates the great old authors, the sages whose ability or insight no one can any longer equal:

Is there anyone here like Hardedef?
Is there another like Imhotep?
None of our kin is like Neferti,
Or Khety, the foremost among them.
I give you the name of Ptah-emdjehuty,
Of Khakheperre-sonb.
Is there another like Ptahhotep,
Or the equal of Kaires?[202]

In Egyptian art, as in Egyptian literature, classicism or archaism is likely to prevail at the same time as does novelty. In what seem to be attempts to associ-

ate themselves with the great old times, artists of the dynasties of the Late Period (747–525 BCE) go back to earlier, Old Kingdom styles. Literary style and the style of painting or sculpture is something the artist has become conscious of and draws on as a quotation from old, recognizable sources. In Egypt of this period, "allusion to a classic literary work would create the same reaction as allusion to a biblical or Latin author in Eighteenth Century Europe."[203] The Egyptologist John Wilson speaks of a "deliberate archaism" in art, by which he means the faithful copying of ancient models. He states that the artists usually went back for their inspiration to the most vigorous ages, those of the Old and Middle Kingdoms.

> At its best this copying was remarkably successful, so that it is often difficult to distinguish a statue of the Twenty-Fifth or early Twenty-Sixth Dynasty from a statue of the Sixth or Twelfth Dynasty. For some reason, the earlier stages of this renaissance were more effective, with a successful capture of form and vitality. When, however, the movement settled down to mere slavish copying, any attempt at creative recapture was lost, and the work became dull and lifeless. . . . The walls of many tombs were filled with slavish copies of those Pyramid Texts which had been inscribed in royal tombs seventeen hundred years earlier.[204]

. . .

Chinese classicism, like Chinese thought in general, is moralistic. To Confucius, the study of the lyrics contained in the *Book of Songs* not only stimulates the mind, trains one in social intercourse, and teaches one to complain if necessary, but also teaches obedience to the immediate father and to the distant father, the ruler.[205] As the Great Preface to the *Book of Songs* says, "To uphold what is just, to correct what is wrong, to move heaven and earth, to reach the gods and spirits, nothing comes close to poetry." To orthodox Confucians, this evaluation embodies an eternal principle, and they take the *Book of Songs* and the other Confucian classics to be the source of all morally effective literary forms, the only forms they are willing to accept.[206]

Such moralism was not necessarily to the liking of poets. During the late fifth to seventh centuries, Chinese court poetry is an elegant diversion, not a sermon nor, for that matter, an emotional outburst.[207] Bowing under the weight of the literary past, the court poets, like those of the European Renaissance, try to achieve what grace they can within the accepted rules of rhetoric and decorum. They are sad, awed, led to wonder, celebrate the beauties of beautiful women, and they extemporize quickly and wittily, all within the limits of aristocratic rules of behavior.

The opposition to such "frivolity," which lapses, from the standpoint of the moralistic critic, into "decadence" and "lasciviousness," can be summarized in the words of the great critic Liu Hsieh (Liu Xie, c. 465–520 CE). Liu lived, it should be noted, just when the "decadent" poetry had begun to flourish.

> As times grew remote from those of Confucius, literary forms decayed. Rhetoricians loved the unusual and valued the frivolous and bizarre; they decorated feathers merely for the love of painting and embroidered patterns on leather bags. They have gone too far from what is fundamental in pursuit of the false and superfluous.[208]

The debate on the need to pay allegiance to the past and its forms, and always to decorum, never ends in Chinese literature. Japanese literature feels similar warring impulses, and the terms "classicism" and "neoclassicism" have been used to characterize its changing relations to its past. The social chaos from the twelfth to the mid-fourteenth century highlights the literature that has become classical for the Japanese and stimulates its, so to speak, neoclassical evaluation.[209] The classics of Japanese literature are then not only Japanese but also Chinese, or written by Japanese in Chinese. The Chinese literature accepted as classical gives the chaotic world some stability. As for their own literature, the Japanese learn to look back to some one hundred years between, roughly, 900 and 1000 CE as the central period of a great literary era. As Jin'ichi Konishi, a historian of Japanese literature, sums up:

> Thirteenth-century and later neoclassical writers modeled their work on the best literature produced during this glorious century. The models remained unchanged up to the middle of the nineteenth century and are still emulated today. . . . Twelfth-century aristocrats longed for the glorious century or two . . . because that period marked the apogee of elegant aristocratic life.[210]

Early Chinese writers on painting are as moralistic as those on literature.[211] Hsieh Ho, writing in the fifth century, is sure that pictures all illustrate some exhortation or warning, or show the causes for a dynasty's rise or fall. The ninth-century *Record of All the Famous Painters of All the Dynasties,* by the T'ang scholar Chang Yen-yüan (Zhang Yenyuan) says that painting "perfects the civilized teachings" of the sages and helps maintain social relationships, and that "it proceeds from nature itself and not from human invention."[212] This way of expressing the role of painting plays on its close relationship, evident through the use of the brush, with writing. Because the prestige of writing is taken for granted, painting too is asserted to be important because it displays good in order

to warn against evil and displays evil in order to make men long for wisdom. Yet I have the impression that in painting, as in writing, the identification of art with morality did not nullify the sensitivity of Confucian critics to aesthetic criteria. The contrary was more nearly true: a good calligraphic hand or style of painting was evidence of a good character, while a poor calligraphic hand or painting style was evidence, in spite of possible appearances, that the calligrapher's or painter's character must also be poor. Certainly it becomes conventional to believe that to survey a person's calligraphy is to "perceive the aim and spirit of his whole life, as if we were meeting him face to face."[213]

The clash between an old, moralistic, magical, and cosmogonic view of painting with a more commonsense one is visible in *A Record of All the Famous Painters of All the Dynasties,* finished in 847 CE. Putting his words quoted above in context, we see how Chang Yen-yüan begins his explanation of the origins of painting:

> Now painting is a thing which perfects the civilizing teachings of the Sages and helps to maintain the social relationships [that is, painting has the same power over the objects pictured that names do over the objects named]. It penetrates the divine permutations of Nature [benign or calamitous] and fathoms recondite and subtle things [in its magical, revelatory way]. Its merit is equal to that of any of the Six Arts of Antiquity [Ceremonial, Music, Archery, Charioteering, Writing, and Reckoning]. Originating with language, it has the same high status as the civilizing arts taught the royal and noble sons of the ancient Chou [(Zhou) Dynasty] and it moves side by side with the Four Seasons [in the sense that to participate in and enhance the season's nature] one should paint a scene in keeping with the prevailing season]. It proceeds from Nature itself and not from human invention.[214]

Chang adds that outstandingly moral, valiant, and public-spirited men "were preserved in shape and appearance in order to illustrate instances of brimming moral power," as can be done best in drawings and paintings. Anyone who sees the pictures of the great civilizing emperors looks at them in reverence, while anyone who sees paintings of the extremely degenerate rulers of early history is moved to sadness. The sight of a usurping minister provokes anger, and of a licentious husband or jealous wife, aversion. Also, the sight of a vassal dying for the sake of principle hardens one's resolve. The sight of a banished minister or persecuted son inspires a sigh of sympathy, and of a virtuous consort or obedient queen, of praise. "Paintings are the means by which events are preserved in a state in which they serve as models for the virtuous and warning to the evil."

For this reason, says Chang, he is indignant at the skepticism of the philosopher Wang Ch'ung (Wang Chong), of the first century CE, who argued that it is absurd to suppose that looking at paintings on walls of virtuous ancients has the effect of contemplating their words and actions.[215]

To move to a later age and a different attitude, sometime in the twelfth century there began a classicistic scholarly painting, discovered more easily at first in painters' exhortations than in paintings themselves. Among those responsible for establishing classical or neoclassical attitudes, Chao Meng-fu (Zhao Mengfu. 1254–1322) stands out.[216] This statesman and man of all talents, including painting, was as inspired by the China of the T'ang (Tang) Dynasty (618–c. 906) as Renaissance artists were by classical Greece and Rome. He was a partisan of the ideal, so powerful in the history of Chinese art, of neoclassicism or, as the Chinese term *fu ku* is translated, a "return to the archaic." This ideal, which was preceded and paralleled by its equivalent in calligraphy, took as its goal the analysis and synthesis of the traditional methods, those of the great archaic artists, and concentrated on the expressiveness of brushwork rather than on the objects represented.

Chao himself was consciously retrospective rather than imitative, and the past he recalls is intended to nullify the personality of the artist living in the present. He is quoted as having written on one of his paintings that an artist can be skillful and get a good likeness but lack the spirit of antiquity, without which skill goes to waste. He says that people in his own time who know to draw at a fine scale and lay on rich, brilliant colors think themselves competent. But, as he complains,

> they quite ignore the fact that a lack of the spirit of antiquity will create so many faults that the result will not be worth looking at. My own paintings will seem to be quite simply and carelessly done, but connoisseurs will realize that they are superior because of their closeness to the past.[217]

This is the point in time, of which more will be said, when the growing technical ability of Chinese painters is put into question and resonance of spirit preferred not only to likeness of form but also to sensuous beauty. From this point on, a new movement in art is likely to be a variety of classicism or archaism, each variety turning to its preferred ancient period and paradigmatic old masters.

CHINESE CONNOISSEUR, ARCHAIST, COLLECTOR

Few Chinese had access to the collections in which the old masterpieces of art were kept. Their closest contact with them was by means of copies, the exactness

of which they could only rarely judge. These copies became all the more important when their originals had faded or decayed, or when, as was all too usual, they were destroyed by fire, flood, or war. Given the difficulty of access to famous originals and their not unusual disappearance or destruction, the mislabeling of works of art was frequent and forgery an always present though usually tolerated danger. The connoisseur, along with the archaist and collector, therefore filled an especially critical role in the continuity of the Chinese artistic tradition. The connoisseur I introduce to this discussion is Mi Fu, the archaist is Ch'en Hung-shou (Chen Hongshou), and the collectors I will name when I reach them.

Mi Fu (1052–1107/8) belongs here because of the passion with which he studied Chinese art. This passion makes him the paradigmatic connoisseur and expresses his Confucian desire to "return to antiquity." His fame was such that the grounds of his old studio and the buildings there were often restored and added to. Those who came to pay their respects found copies—reminiscences they may be called—of his calligraphy on engraved stones and wooden plaques.[218]

Mi Fu was a well-known calligrapher by his thirties. I will not dwell on his calligraphy, except to repeat that, by his own account, he was not able to establish a personal style. Instead, he said, "I chose the strengths of the various early masters, combined and synthesized them. As I grew old I finally established my own style, and when people now look at my calligraphy they have no idea from what sources it developed." In time, Mi became an expert in the materials and processes of art, expounding on calligraphy, painting, paper, inkstones, the mounting of scrolls, and the use and identification of seals.[219] As a government official, he had to travel extensively, and wherever he was, he took the trouble to visit every important collection of which he got wind, especially of calligraphy. Around 1101, he spent much of his time sailing with his collection of scrolls in a houseboat. Atop the boat (which is famous in Chinese literature) he hung the sign, "The Mi Family Riverboat of Calligraphy and Painting."[220]*

Mi's criteria for the authenticity of a work of art started with its pedigree—

*Compare Mi's expeditions to the boat trip on Lake Garda in 1464 by Andrea Mantegna and three friends. As related by Frances Ames-Lewis from a contemporary account by one of Mantegna's companions, the four "'circled Lake Garda . . . in a skiff properly packed with carpets and all kind of comforts, which [they] strewed with laurels and other noble leaves, while [their] ruler Samuele played the zither, and celebrated all the while.' Ostensibly the trip had the predictable antiquarian purpose of recording classical inscriptions. But the account suggests that it also became an attempt at an archeological reconstruction of the life-style of the classical figures whom the four friends sought to emulate. The episode highlights not only Mantegna's aspiration towards humanist learning but also his Paduan

in what collection it was to be found and who had owned it early, as far back as it could be traced. The typical Chinese way of tracing this history was by means of the colophons written on a scroll by its previous owners, by its mention in literature, and by the seals collectors impressed on the art that had passed into their hands—seals were harder to forge, Mi thought, than paintings and calligraphies. His writing about the individual objects he examines is described as exact, logically argued, vivid, and based on extensive knowledge.[221]

Mi Fu is said to have examined art styles so intensively that it became impossible thereafter to paint in a new manner without a justification drawn from the history of art. He was obsessively careful with the paintings he collected and altogether obsessively clean. It is recorded that when he was preparing for a ceremony at the Imperial Ancestral Temple, "he scrubbed his official gowns so vigorously that the fire-and-watergrass patterned embroidery came undone," for which he "was demoted in punishment for his transgression." With what degree of seriousness we can only guess, he was known as "Crazy Mi"; relevant anecdotes were collected in such books as the late-fifteenth-century *Minor [Unofficial] History of Mad M.*[222] Among the anecdotes on his passion for art, there are the following glimpses of his single-mindedness: "Once, disappointed in his efforts to acquire a work attributed to the Eastern Tsin calligrapher Hsieh An (320–385), Mi vomited blood and fainted." On another occasion, Mi visited a boat whose owner had an extraordinary calligraphic scroll. Mi offered to trade it for some paintings, but the owner refused. Mi then said that unless the owner agreed, there would be no reason for him, Mi, to go on living, and he threatened to drown himself in the river. "He then let out a loud shout and grabbed at the hull of the boat as if to go over." The owner quickly gave him the scroll. Once Mi was even successful in extorting an imperial inkstone from the emperor, who, luckily for Mi, was amused. Given the inkstone as a gift, Mi jigged in happiness, looking utterly gleeful even though he spilled ink over his clothes.[223]

The quality of care that Mi took with the works of art he collected can be suggested by his description of how to clean old works of calligraphy, the soft-sized paper of which, he had discovered, could be washed in water, then dried, and in the process gain in strength. Mi wrote:

antiquarian friends' acceptance of his equal intellectual status." But Mantegna, like Mi, was also looking for the historical and aesthetic past he had learned to respect so much. Some enemy of pleasant stories is said to have doubted whether the boat trip really took place, "but even as fiction Felciano's account is suggestive of an archeologically motivated approach to the past with which Mantegna sympathized," as, I add, would have Mi.

Every time I obtain an antique autograph, I immediately take two sheets of good paper. One I lay over the original, the other I spread under it. Then, starting from one side, I moisten the scroll with a thin decoction from *tsao-chiao* pods till it is well soaked, and till the water has penetrated till the bottom sheet. Then, with the flat of my hand, I softly press and rub the paper on top: in this way all the dirt and grease will disappear together with the water. Turning over the sheets I repeat the process, and then wash the scroll six or seven times with clean water. Then it will be found that while the paper and the ink of the autograph have not been affected, all the dust and dirt have disappeared. Finally I take off the sheet on top, and let the scroll dry, blotting it with a sheet of good paper.[224]*

Connoisseurship as intense as Mi's might have developed of itself, but it was fostered by the growing sophistication of forgers, who perfected their methods and, as I have described above, did their often talented best to re-create the spontaneity of the original while preserving its corrections or shifts in style. A master calligrapher, Mi often copied works to enable him to study them at leisure. His copies, he proudly writes, were sometimes taken for originals, as one old story about him confirms:

Old Mi had a mighty appetite for calligraphy and painting. One time he borrowed an ancient painting and made an exact copy. When the copy was finished he returned the genuine along with the fake to the owner so that he would have to choose between them. The owner couldn't tell which was the original. Mi Fu was clever and bold at stealing and thus acquired a large collection.[225]

As Mi writes humorously of himself in a poem, referring to his less than scrupulous covetousness and his compulsive carefulness:

*Here are further comments on connoisseurship and scrolls, from "A Discussion of Painting," composed by T'ang Hou (Tang Hou) between about 1320 and 1330: "When people of today collect paintings, they always want to adorn them with gold and jade, unaware that gold and jade are incitements to stealing. . . . One should not look at paintings under the lamplight, nor with wine by one's side after drinking to excess. Furthermore, do not show paintings to people without taste. To unroll a painting in an inappropriate manner is extremely harmful to it. As for the ignorant and deceitful, they insist upon looking at paintings and thoughtlessly criticizing their quality and style. They basically lack understanding of these works and carelessly judge their genuineness or spuriousness. This causes one to become short-tempered."

To trade a fake for the real thing you must be "in the know."
Though already cracked and bleached from scrubbing I wash my hands some
 more,
When it comes to keeping a scroll from smudging, who can compete
 with Mi?[226]*

Mi was most apt, by his own account, at forging the works of the calligrapher he knew best and admired most, Wang Hsien-chih (Wang Xianzhi, 344–388CE). "Wang Hsien-chih's natural perfection," he said, is transcendent and untrammeled. To Mi Fu, "natural perfection," like "plain tranquility," was the expression of an unstudied spontaneity, while he took the word "untrammeled," to mean "beyond all the usual rules." "In studying calligraphy," says Mi,

> one has to observe well the handling of the brush; that is to say, the brush is to be held with ease, and the palm should curve spontaneously. The movements should come swiftly with a natural perfection and emerge unintentionally. This is the reason why in the calligraphy of the old masters identical characters never resemble one another. When they are all alike, it is the writing of slaves.[227]†

* Smudging wasn't the only problem with scrolls. Mi, like other connoisseurs, was aware that the more valuable a scroll, the less often it should be viewed, as Robert van Gulik elaborates: "The frequent rolling and unrolling is liable to cause wrinkles in the paper or silk, make fragments of the surface peel off, loosen the borders of the mounting or otherwise damage the scroll. Thus not seldom it happens that an antique scroll that had the good fortune to remain during many centuries in one and the same family or always was transmitted from one connoisseur directly to another, looks as new as if it has been painted yesterday although it dates from the Yüan period."

† In his capacity as an expert, Mi established Wang Hsien-chih's authentic oeuvre, which he used as the basis for his own calligraphic style. But Mi had only three works that he thought were originals. The most reliably identified work is quite different in style from the two others attributed to Wang. Mi mentions three copies he made of Wang's work, but he doesn't say which of the supposed originals he copied. It is therefore likely enough that the Wang Hsien-chih known to art history is a partial creation of Mi Fu. Mi's success in authenticating the art of the past seems to have encouraged him to change it at a critical point. (There is a not dissimilar Muslim example of the forgery of tradition. Much of Muslim calligraphy is based on the cursive script invented by the tenth-century calligrapher Muhammed ibn Muqlah, but the examples attributed to him are in most and perhaps all cases forgeries, so that the tradition has been more influenced by the forgeries than by their celebrated model.)

It is hard to overemphasize the regard in which connoisseurs like Mi were held and how important the appearance of connoisseurship was in Chinese society. As is still true, a fine art collection might furnish the measure of the one's social standing. Specialists helped collectors, as they have done in the West, to build up their collections. We hear of a seventeenth-century dealer, Wu Ch'i-ch'en (Wu Chichen), who advises merchant families what it is best to buy. This dealer declares that the difference between a refined and vulgar family "depended on whether or not they owned antiquities." The dealer

> tells us of a certain Mr. Wang, a rich official in Yangchou, who notices "that it is a fashion to enjoy collecting curios and antiques." Because Wang himself is ignorant of how to do it, he commissions Wu Ch'i-ch'en to select for him, saying, "I intend to build up a great collection. Without you I cannot outrun other people," and agreeing to pay any prices that Wu recommends. "His reputation in connoisseurship," Wu concludes, apparently without irony, "became known in both south and north."[228]

. . .

In considering the Chinese reverence for the past, I turn next to the archaist Ch'en Hung-shou (Chen Hongshou, 1598–1652), an ambivalent and unhappy figure. Over the course of his life, Ch'en becomes filled with regrets, regrets at failure in his official examinations, at the death of his first wife, and at his failure to take effective part in reform politics. There is, as well, his disappointment that he can make a living only by selling his paintings and by making illustrations for plays, novels, and playing cards for drinking parties, all of these printed by woodblock. To have to make his living by his art makes him, in the eyes of society, an artisan, a mere entertainer, and not an artist, someone who creates out of spiritual need.[229] This is what he writes toward the end of his life in a poem that prefaces a series of woodblock playing cards:

> My family numbers twenty,
> And I lack the power to support them.
> I beg for food, obligating myself to people,
> Making myself like garbage in the ditch,
> I publish these cards for my livelihood,
> And to escape people's importuning.[230]

Ch'en's reputation as a painter grew and he was offered a position as a court painter, which, however, he refused (it was a lesser position than that of a

scholar-official). Then there came what was for him and many others the disaster of invasion by the Manchus and the fall of the native Ming dynasty in 1644. He drank and wept and cried out, to the point, it seemed, of madness—he had friends who committed suicide or suffered execution rather than live under alien rule. Ch'en grieved but survived to make most of the paintings for which he is now famous. During his last years, Ch'en participated in long drinking parties and indulged in the women, without whom, it is said, he could not eat or sleep. His paintings were in great demand, and he painted rapidly to fill the orders. [231]

What is Ch'en in terms of tradition? [232] Like classicists, he aims to return to the past, though to styles regarded by some as vulgarly illustrative. For centuries, Chinese figurative painting had remained a minor subject of art, which favored landscape, the mountains and water that reflected the prevailing Chinese interest in the rhythms of nature. The artists of Ch'en's period, who for a time restored figurative painting to the level of serious art, fell back for guidance on the distant past. Original, therefore, as their paintings may be, they have the archaic look of their models. [233]

All told, Ch'en deserves to be called an archaist rather than a classicist or neo-classicist because his figures are self-consciously primitive, that is, schematic, two-dimensional, and distorted, as if he were unable to draw them more conventionally. The figures' robes flow along their own archaically curved, calligraphic lines rather than the lines of the bodies under them. [234] Using an archaic "iron-wire" line, he invents a mock-archaic style that appears both serious and ironic. The fluently drawn figures always have something grotesque, almost cartoonlike, about them, and it looks as if he meant his style also to amuse and interest his contemporaries with its allusive, clearly and beautifully drawn, half-grotesques. His "schematic archaism" is more a subtle retreat into his own ironic resources than a re-creation of the earlier painting that he quotes in his style and motifs. But for China, his portraits are exceptionally realistic. For China, his portrait of himself drunk—a portrait more of his mood, it seems, than of his person—has an unusual expressionistic force. He looks real, and his sadness looks right out at us. [235]

As a whole, Ch'en's style is an odd, complex, knowing amalgam. As James Cahill tells us:

> In Ch'en Hung-shou's works the brush mannerisms and distortions of form that had come to afflict imitation or forgeries of antique styles are played on in a knowing way and thus made compatible with the aesthetically upper-class aims of the archaists. . . . Typically, his paintings are bitter-sweet evocations of old themes, themes that prove to be as moving as ever, even while Ch'en

regards them a bit distantly and ironically. . . . It is the flavor one finds, perhaps, in some of the music of Ravel and Poulenc that plays similarly on rococo or romantic styles, evoking feelings in the old way while establishing an emotional distance from them with astringent twists on familiar harmonies.[236]

In his "Essay on Painting," Ch'en attacks the ambitious but ignorant amateur artists who "ridicule and criticize other, older and accomplished artists." To professional artists he gives the advice that they join the virtues of the different early styles. "If you temper the stiffness of Sung with the harmoniousness of T'ang," he writes, "and realize the qualities of Yüan through the order [or rightness] of Sung, then you will have achieved the Great Synthesis." This kind of advice, to learn in an analytically differentiated way from the whole of tradition, is common to the other Chinese classicists. Ch'en ends his essay in disappointment because he feels that the tradition he reveres has not really been restored: "I, Old Lotus, am now fifty-four. My hometown [Ch'ien-t'ang] lacks any artist who can revive the study of painting. I wipe my eyes and wait."[237]

. . .

Connoisseur and archaist are likely to be themselves collectors and, if not, are the collectors' natural advisers and companions. The most powerful of all collectors was, of course, the emperor. Far back in Chinese history, it was already the custom to keep important records in the imperial collection. In time, the imperial collection began to include art as well. It is known that the Secret Pavilion set up by the Han emperor Wu-ti (Wudi, r. 141–87 BCE) had pictures and writings. During the Han dynasty there was a gallery in the emperor's palace where pictures of former rulers were exhibited. But a true imperial art gallery, one in which art was exhibited for its aesthetic qualities, was set up only later. By the fifth century CE, there were emperors who collected art avidly, much of it, an old source says, forged. Exercising an emperor's privilege, Ming-ti (Mingdi, r. 465–472) recovered calligraphy earlier stolen from the palace and, for good measure, appropriated new art from aristocratic collectors. Within a few months he had a large collection, whose curator arranged its scrolls by type of script and by quality. The collected, authenticated work of the important calligraphers known as the Two Wangs was recorded in the catalog in the following style:

Calligraphy of silk with coral knobs: 24 scrolls in two wrappers.
Calligraphy on paper with golden roller knobs: 24 scrolls in five wrappers.
Calligraphy on paper with hawksbill roller knobs: fifty scrolls in five wrappers.
All scrolls in the wrappers are equipped with labels written in gold, rollers
 made of jade, and a woven band.[238]

But even beyond the imperial collections, reverence for the past and the reverence for art were so closely entwined that the time and place at which art was being most vigorously created were likely to be the time and place at which collecting of old art, too, was most vigorously pursued.[239] The height to which a collector's passion could rise is described by Chang Yen-yüan in the *Record of All the Famous Painters of All the Dynasties*. Chang says that he sells his clothes and economizes on his food in order to pay for a valuable scroll, and that he has had to suffer the derision of his wife, children, and servants. He tells them, "If one does not do useless things, how can one enjoy this limited life?" His love for scrolls has grown to be a true passion: "Among all those outer things that bother us there is none that possesses real value; there are only these antique scrolls that never pall on me. Completely absorbed by them I forget speech, I go on looking at them in a mood of perfect serenity."[240]

The collector's extreme passion is recalled and resisted in a prose poem written by the great scholar-artist Su Shih (Su Shi, 1036–1101). In this poem Su Shih warns of the calamity brought on by an excessive fondness for calligraphy and painting, which has caused people to endanger their health, dig the dead from their graves, and estrange ruler from subject. Art treasures, he says, have even been taken along on military expeditions in specially made boats or stored away in secret rooms. But he himself has exchanged his mania for a near equanimity and has come to see art treasures

> as if they were clouds that pass before the eye or the song of birds coming to the ear; one loves those things while one perceives them, but once they are gone one does not long for them. Thus my treasured autographs and paintings are now for me a constant source of joy while they have lost their power to cause me sorrow. . . . Written on the 22nd day of the 7th moon of the year 1077.[241]

I conclude with one more, to me irresistible, testimony to the passion of collectors, this time Chou Liang-kung (Zhou Liang-gong, 1612–72):

> I have been crazy about seals for the last 30 years. I am proud of having traced their origins and evolutions and the changes in this art. In the whole country there is no one like me. I have loved seals all my life. When I see seals from the Qin and Han and seals carved by famous masters, I fondle them with love and appreciation all day. I refuse to let them leave my hands. To satisfy my desire I even forget to eat and to sleep. They are to me just like the flowers of the seasons and beautiful ladies.[242]

CREATIVE COPYING FROM THE CHINESE PAST

Judged by common consent and by influence, the greatest of the creative copiers of the Chinese tradition was the artist Tung Ch'i-ch'ang (1555–1636). It is to him that I devote this whole section.[243] His surviving paintings, along with the others that we have information about, are judged to make up a coherent, impressive body of works, which reveal a powerful intellect interacting with richly creative if narrowly focused visual imagination.[244]

The term "creative copying" in the title above is the equivalent of the Chinese word *fang*, which can be more modestly translated as "free copying" or "working in the style of."[245] Though it is a term necessary to the Chinese form of classicism, it implies a conception of art quite different from the idealized realism and cool harmony of European classicism. In the view of the Chinese classicists, this conception implies the use of the methods of a certain group of old masters and the avoidance of the methods of a certain group of others. It opposes and minimizes the value of art that is primarily decorative, that is decoratively colored, or that is primarily representational or documentary—Tung himself goes so far as to avoid human figures in his landscapes, which he jokingly says he doesn't know how to draw. This conception of classicism also requires that brushwork should be of certain historically defined types, and the compositions and themes of a conventionally "harmonious" kind. Altogether, it implies the social status and mindset of a model scholar-official, who paints simply because he wants to, without thought of any but a spiritual reward. Such a person, who has spent so much of his life poring over classical texts, finds it natural that art should be based on the study of its own history.

Are Tung's free imitations like those we know from European art? Are they at all, as has been suggested, like Picasso's variations on the paintings of Grünewald, Poussin, Cranach, Claude, El Greco, Delacroix, Velasquez, and Manet?[246] Maybe in their deformation or re-formation of their subjects, but very little, if at all, in any other way. Picasso's choice of artists does not pretend to be based on any canon, because his variations take account only of basic composition and subject matter, not of handling of the brush or manner of drawing, and because his variations do not combine several distinct styles into a single free synthesis. Is there some parallel, as has been suggested, with the neoclassical music of Stravinsky, which is a cool-tempered, technically expert remaking of earlier music? Or is there some parallel between Tung's homage to past masters and the homage poems of Ezra Pound, who aims to create original poems that absorb something of the style, manner, and substance of other poets?[247] To Stravinsky, I think,

there is a slight parallel, but to Pound, none worth speaking of. My reasons can be understood from what follows.

Of Tung's official and unofficial life I will repeat only that he was a man with an intense ambition to win official honors. In an environment in which success invited jealousy and jealousy invited danger, Tung had his ups and downs, but he did win the honors he coveted. Under Chinese conditions, his knowledge of art, which grew very extensive, had to be based on his ability to gain entry into private collections. Helped by friends from the political world, and later, when he was retired, by scholar-artists and merchant collectors, he saw more of the works of the ancient masters than anyone else of his time.

> The prestige he commanded as Minister of Rites endowed his critical pronouncements with an aura of authority that perhaps even his prodigious talents could not have secured for him on their own ... As a collector and connoisseur, recording his views and attributions on a large proportion of the almost innumerable paintings and calligraphies that passed beneath his eye, Tung stamped an impression on the history of Chinese painting and calligraphy so indelible that its effects must still be reckoned with today. More than any other artist he can be said to have changed the face of Chinese painting and its history.[248]

Like many of his predecessors, Tung advocates learning from each ancient painter that element in which the ancient painter was most skillful. "Willow trees should be made after Chao Po-chü," he says, "pine trees after Mo Ho-chih, and old trees after Li Ch'eng. These are traditional and cannot be altered."[249] But an isolated sentence of this kind makes his view seem much simpler than it really is. This is because to Tung and those who thought like him, it was essential to investigate and master the inner law or logic (*fa*) of whatever was being portrayed.[250] True, they said, even a great master has to begin by conforming or imitating. But when undertaken in the proper spirit, this conformity or imitation leads to virtuosity, and virtuosity leads to individual variation and spontaneity, in which the true old method and the individual variation become indistinguishable.

Tung could not accept imitation as such because it negated his basic convictions. When young he had studied Ch'an Buddhism, which taught the doctrine that enlightenment comes suddenly. He also admired and became friendly with the radically individualistic philosopher Li Chih. And he was friendly as well with the three Yüan brothers, the leading opponents of literary classicism, who detested imitation and rejected all fixed formulas and the authority of the past.

They insisted instead on sincerity and on the perfection of the innocent "child-mind" they believed was inherent in every person.

There was still another, not unrelated contemporary intellectual influence on Tung. It was that of the prominent school of Neo-Confucianism of Wang Yang-ming (Wang Yangming, 1472–1529). To this school, which in the sense of European philosophy was idealistic, the universe exists in the mind alone. The writer or painter can therefore argue that, if undertaken in the rightly intuitive spirit, a return to the past or to the old masters is not imitation but a return to one's own true self.[251] Though living in a cultural context so different from that of Leonardo da Vinci, Tung felt some of the same sense of an ability to re-create the world thorough himself. "The Way of painting," he says, "is to be found in the painter who controls the universe in his own hands. Wherever he looks he sees life, or the motivation for life." Then, very unlike Leonardo, he adds that "those who meticulously and carefully delineate, they can only be the slaves of nature."[252]

This last remark is a key to Tung's compromise between the classicists, that is, the revivers of the past, and their opponents. To him, rules need to be modified by change, and intuition needs the support of method. Close imitation kills the spirit of the imitated model. In Tung's own words, "If one imitates the models too closely one is often further removed from them."[253] That is, the methods of the old masters must be learned so deeply, in such consonance with the spirit of the old masters themselves, that the methods can be imitated, combined, altered, and discarded. Only then can painting attain its necessary concentration of "breath-momentum," which is, in another term, "directional force" or, simply, "momentum" (shih).[254] Only then will form, mind, and hand be in total accord. But because the knowledge of form comes from study, it is essential to know the methods practiced by the ancients, and to know them with analytical exactness, and, as well, to know for what purpose each method is best suited. Tung says, "Painting must be formed through ancient methods. Whenever the brush is applied to paper, every stroke shows its different source and tradition."[255]

As it turns out in Tung's thought and practice, this knowledge of sources requires what we see as purely formal analysis. Given such analysis, Tung says, painting can attain what he calls "scholarly breadth," so that the painter, like a fish escaping a net, can escape the bondage of mere craftsmanship and merely literal appearances. To Tung, who believes in the creative power of nature, real scenery is stranger than human art can create, but art freed from the constraints of realism has power beyond that of the scenery. As he says, "If one thinks of strange scenery, then painting is not the equal of real landscape; but if one considers the wonders of brush and ink, the landscape can never equal painting."

Tung does not think that this superiority frees the painter from the study of nature. Rather, the painter has to "read ten thousand books" and also "travel ten thousand miles."[256] However, a study of Tung's works makes it appear that he was more interested in reconstructing nature formally than in studying it. The old masters he did, of course, study, but it is easy to imagine that none of them would be happy with what he made of them, especially not with his combinations of their styles—he is said to mark each turn of a mountain with a shift in his pictorial language—just as calligraphers had already combined different historic styles in the same composition.[257] Tung uses this idea of simultaneous borrowing and changing as a compromise between his desire to be as innocently new as a child and yet to remain aware of the tradition he is using for the sake of enlightenment. His solution is suggested by what an earlier, twelfth-century calligrapher describes as "grabbing the fetus" and "changing the bones" when making use of the old masters.

One historian of Chinese art, James Cahill, has argued that Tung lacked the technical ability to make close imitations of the past styles he favored. His solution, the argument goes, was to consider his lack to be the virtue of the "transformation," which proves its higher conformity to a master's style by its differences from it.[258] Tung's pictures seem meant to reveal nature not as something conventionally beautiful but as a structure made of intersecting, force-bearing volumes. He builds his landscapes of large separate units, each made up of smaller units, the force of each balanced by that of its neighboring units. Large and small, all the units are subjected to the pervasive lines of force that the Chinese call "dragon veins" and are pushed together and pulled together. As in Cézanne and Van Gogh, individual brushstrokes tend to have a uniform, expressive direction, which strengthens the force of the masses' directions.[259] Tung is careful to integrate heavily moist inking with dry inking and with texture-strokes and washes. That is, everywhere by every means he aims at the typical Chinese balance of opposites. But in his work the units he balances may seem mismatched in weight, misjoined in angle, and equilibrated by aesthetic will rather than by nature. "In painting," Tung says, aptly characterizing his own work, "one of the wonderful things is interruption without being interrupted, and continuity without being continuous." Speaking of the equilibrium he aims at, he says:

> In painting landscapes, one must understand the principle of opening and closing. The opening [i.e., dividing] brushstrokes mark the principal outlines. There are divisions within the whole composition, and division within each

individual section. When one has understood all the subtleties in this respect, one will have grasped the large half of the Tao of paintings.[260]

An evaluation of Tung by Wai-kam Ho and Dawn Ho Delbanco makes him out to be an unwilling but effective revolutionary. There are historians, they say (referring to James Cahill and Max Loehr), who regard him as a studied painter whose paintings are aesthetic structures with only a distant relation to nature. This new kind of abstract imagery, the aesthetic reworking of old styles, was the art-historical aspect of Tung's style that interested the later orthodox painters in his art. But, say Ho and Delbanco, the individualist painters (discussed in chapter 3) would not have responded to Tung's art if his was only a response to earlier art, or only a formalist exercise. What the Individualists responded to was the expressive tension of his painting, its imitative, individualistic, abstract, analytical, quite human nature, a precarious walk between unresolved, conflicting modes that work against one another. The resulting awkwardness can be interpreted as the birth pangs of a new modernism. Tung Ch'i-ch'ang can legitimately be designated the first modernist Chinese painter. Unlike the twentieth-century Chinese modernists, his modernist tendencies, with their rawness and ambiguity, were all derived from the Chinese tradition that they serve to undermine.

> Like the early modernists in the West, Tung had no intention of making a break with the past. . . . Tung's painting, like Picasso's, is both classical and anticlassical. . . . Tung does not use the past elegiacally or archaistically; he turns the past into the future. . . . Tung was the first painter to erase iconographic necessity from his painting by endowing brush and ink with an independent life beyond their traditional descriptive and expressive functions. In his painting, brush and ink no longer function as the intermediary between artist and subject; rather, they become the subject. The distance between signifier and signified is eliminated and they are merged as one.)[261]

CLASSICISM IN EUROPEAN ART

In the European tradition it is usual to refer to the art and literature of Greece of the fifth and fourth century BCE and Rome of the first century BCE as "classical" or, to emphasize that the term refers exclusively to Greece and Rome, as "Classical." The use of the term "classicism" to refer to the conscious imitation of the art of an ideal period "derives from M. Cornelius Fronto's use of *classicus* (lit. "belonging to the highest class of citizens') to denote those ancient writers

whose linguistic practice is authoritative for imitators."[262]* In Greek literature, the incomparable, often echoed classic was Homer. Hesiod played a distant second. Then came the duly ranked poets, iambic and lyric. All these, together with the great dramatists, were the inspiration of the Alexandrian poets and scholars, who with their grammars, glossaries, synonym collections, and every other scholarly aid did their best to preserve the precious old writers. These writers are the great figures, said Longinus, who were "presented to us as objects of emulation and, as it were, shining before our gaze."[263]

The attempts of the Alexandrian Greeks to revive the old language were paralleled by those of the Romans to return to their primitive virtues, including the linguistic ones. By a process I have hardly even hinted at, the Greeks and Romans adopted their old literature as classic, and Greek and Roman literature became entwined in one another and equally classical in the eyes of Petrarch and his Renaissance friends. Then, in the early Renaissance, precious manuscripts were discovered, annotated, and in an age when books were scarce, memorized as far as possible.[264] Niccolò Niccoli, who was close to the elder Cosimo de' Medici, spent all his fortune on books, but the Medici gave him money to go on buying. Petrarch himself, who is now remembered as a poet, was more famous among his contemporaries as a living encyclopedia of antiquity, the rare person who could guide those who wanted to relive it.[265] To him and the other Renaissance lovers of antiquity

*Some of the overlapping connotations of the words "classic" and "classical" are made explicit in the following quotation from the *Oxford English Dictionary*: Aulus Gellius, of the second century CE, "has 'classicus scriptor, non proletarius,' where the word means 'high-class,' as opposed to 'low'" (c.f. *proletarius sermo*, Plautus), and this is the main sense of *classique* in Cotgrave [the compiler, in 1611, of the first French-English dictionary], as well as in our earliest examples. Littré however takes as his first sense of *classique* 'Used in or belonging to the classes of colleges or schools'; and it is probable that this notion has influenced the word in its extension to the ancient authors generally, as studied in school or college, together with the associated languages, literature, history, geography, mythology, art, etc. It is probable, also, that the transference of the epithet from the first-class or standard writers in Greek or Latin to these languages themselves has been partly owing to the notion that the latter are intrinsically excellent or of the first order, in comparison with the modern tongues. But the extension has probably been in the main unthinking and unanalysed: the Greek and Roman authors read in school were actually the classical writers in these languages, and thus 'classic' became practically synonymous with 'ancient Greek or Roman.' [Cf. also the modern L. *locus classicus*, the passage of first-rate authority or importance.]"

the appeal of the authors the middle ages had read but not really heard—Plato, Aristotle, Virgil, Cicero, and Ovid—became stronger than ever, and they were joined by a host of others. The impact of so many minds on men who read them not merely with admiration for their learning or their particular expertise, but as models from whom to learn about statecraft, the waging of war, the creation of works of art and the more important art of bearing up under adversity: this impact made the study of the ancient world into a cultural force. It was not simply the perusal of neglected manuscripts but purposeful communication with a race of illustrious forebears.[266]

And so the classical literature, art, and attitudes toward life that were repossessed or reassessed became the background, the source of memory, allusion, quotation, theme, and style, altogether the touchstone of worth for the new literatures and renewed art of a Europe some learned fragment of which felt itself reborn.

· · ·

The history of European classicism or archaism in sculpture might begin with a Greek sculptor like Alcamenes, the favorite pupil of Phidias, who gave his otherwise classical figures "archaistic" traits—coiffure, for example, or drapery—to lend them an ancient, holy air. Later, Athenian nostalgia for its old glory led to what may be called "neoclassical" statuary, often designed for sale to Romans. In fact, much of the Greek art we now have we owe to the acquisitiveness of the Roman collectors.[267] Roman generals looted Greek sanctuaries, and Roman rulers took whatever pleased their fancy. Sulla went so far as to pay his troops in coins made from melted Greek statues. Such behavior was, notoriously, the case with Gaius Verres, who was successfully prosecuted by Cicero in 70 BCE for failing to observe the custom by which he should have given the state part of his loot.

> When Verres descended on Aspendos in Pamphylia, not a single statue escaped his greedy trawl. In addition to the Samian Hereaion, Chios, Erythrai and Halicarnassus were also plundered. As for his governorship in Sicily, it left many cities and private individuals short of their cherished possessions. The great danger of inviting Verres to dinner was that his henchmen would be around the next day to carry off the silver dinner service.[268]

As the Romans grew more familiar with Greek art, they grew less inclined to criticize it as effeminate and readier to use it to embellish their city and their gardens. More martial Romans might feel that, just as it was their business to

conquer and rule, it was the business of the Greeks to create the art the Romans collected. Rich Romans bought statues they especially coveted, probably copies or versions of "great works," *nobilia opera,* as they called them, for extremely high prices; when unsure of their own expertise, they employed connoisseurs to advise them. "The Roman villa," it has been said, was the aristocrat's "palace of Hellenism, and Greek statues were one of its essential components."[269] The statues, made mostly by Greek sculptors, often look as if they are free adaptations. When there are a number of copies of the same famous originals, the differences between the copies naturally stand out. As I've mentioned, the copies of Polyclitus's Spearbearer, of which there are twenty-five, are too different to allow the reconstruction of the original from them.[270] Copying by means of the so-called pointing process seems not to have been especially accurate. However that may be, the number of stone figures in Rome became large enough to rival that of the human figures who inhabited Rome along with them.

Some of the ancient art of Rome survived during the Middle Ages, but many bronze statues were melted down then, and marble ones were heated to make them into lime for cement. A living classical art becomes visible again in the thirteenth-century statues of Reims Cathedral, some of them with the flowing drapes and relaxed, bent-knee posture of the old Greek statuary. But I begin with the collection established by Pope Julius II, soon after 1503, in the statue court of the Vatican's Belvedere (the palace "beautiful to look at"). This collection, which took away the breath of those who first visited it, was a dramatic confrontation with a past known mainly by literary testimonies. It contained a great Apollo and a great Laocoön, both restored with the archeological insouciance of the time. Above all, it contained the great Belvedere Torso, which embodied in its broken and unrestored stone the pathos of a vanished past and a vanishing present.[271] Donatello's sculptures had already assumed the classical spirit, and now Michelangelo, who in his youth had forged an antique sleeping Cupid, set himself with all his enormous ambition to emulate the classic past.

From the sixteenth century on, the antique past came to dominate the education and, to a varying extent, the imagination of European artists.[272] Sometimes the figures in paintings, of Nicolas Poussin (1594–1665) for example, look like antique statues, their faces with the same masklike inexpressiveness of those of classical, pre-Hellenistic Greece. The philosophical justification for dependence on antique models is stated very effectively by Giovanni Pietro Bellori in a lecture in 1664 called "The Idea of the Painter, Sculptor and Architect, Superior to Nature by Selection from Natural Beauties."[273] Bellori speaks in opposition to artists he accuses of being either too literal, that is, naturalistic, or, in con-

trast, too independent of nature. The naturalistic ones, he says, having no idea in their minds, swear by their chance models, and reproduce the ugliness that surrounds humans. Those who suffer from the opposite fault, err by copying from other painters, swearing by their masters' brushstrokes, and corrupting nature with manner.

What, then, does Bellori think is right? Reasoning in a basically Neoplatonic way, Bellori says that the author of nature, looking deeply into himself, constituted the first forms of every species "in such a way that each species was expressed by that original Idea." However, as Neoplatonists had long argued, the various species, which are in themselves perfect essences, were joined with variable, sublunary matter. The visible result is that "human beauty is especially disarranged."

> For this reason the noble Painters and Sculptors, imitating that first maker, also form in their minds an example of superior beauty, and in beholding it they emend nature with faultless color or line.

> Thus the Idea constitutes the perfection of natural beauty and unites the truth with the verisimilitude of what appears to the eye, thereby not emulating but making itself superior to nature, revealing to us elegant and perfect works, which nature does not usually show us as perfect in every part.

> The Idea is not one beauty; its forms are various—strong, noble, joyful, delicate, of any age and both sexes.[274]

Common people, says Bellori, find it natural to praise things painted to look natural, as they see them, but do not appreciate beautiful forms. They "tire of elegance and approve of novelty; disdain reason, follow opinion, and walk away from the truth in art."

> It remains to be said that since the Sculptors of Antiquity used the marvelous Idea, as we have indicated, a study of the most perfect antique Sculptures is therefore necessary to guide us to the amended beauties of nature and with the same purpose direct our eyes to contemplate the other outstanding, masters.[275]

It is very much in this spirit that Johann Winckelmann (1717–68) writes his *History of the Art of Antiquity*, published in 1764.[276] In its preface, he states:

> *The History of Art* is intended to show the origin, progress, change, and downfall of art, together with the different styles of nations, periods, and artists. . . .

From my youth upward, a love for art has been my strongest passion. . . . All the pictures and statues, as well as engraved gems and coins, which I have adduced as proofs, I have myself seen, and seen frequently, and have been able to study.

Winckelmann explains not only what he takes to be the course of the development of art, but also the reasons for its different development in different countries, especially the differences in climate. For him, the context is that of human history in general, from Egypt, which he takes to be aesthetically lifeless, to Phoenicia and Persia, Etruria, and Greece, in which art is finally and fully mature. He ascribes the superiority of the art of the Greeks to the ideal balance of their climate between winter and summer, to their political constitution, with its prevailing freedom, and to their appreciation of art and artists, not to speak of their gymnasia, where the artist saw the beauty of structure of the forms of the beautiful youths who exercised there, forms that became his own and were always present in his mind.[277] Roman art, as Winckelmann sees it, is wholly derived from Greek art, the downfall of which, in the late empire, he mourns. Now, there is nothing left of the object of our wishes but the shadowy remains it has left behind.

Written with an infectious love for the classical literature and art of Greece, Winckelmann's history was received everywhere in Europe with great enthusiasm—so much so that the Europe of the second half of the eighteenth century is said to have looked at classical art, especially sculpture, through Winckelmann's eyes. What his poetic, rhapsodic eyes saw and his mind grasped led him to conclude that "the only way for us to become great or, if this be possible, inimitable is to imitate the ancients." We have to become as familiar with the works of the ancients, he said, especially the Greeks, "as with a friend in order to find their statue of Laocoön just as inimitable as Homer." For "these are the eyes," Winckelmann says, "with which Michelangelo, Raphael, and Poussin see the works of the ancients. They partook of good taste at its source, and Raphael did this in the very land where it had begun." Look at the great soul in the face, "and not the face alone," of Laocoön. The muscles and sinews of his body are contracted violently, yet despite his violent suffering, his pain is expressed not in rage but in no more than an anxious sighing. "The physical pain and nobility of soul are distributed with equal strength over the entire body and are, as it were, held in balance with one another. . . . The artist had to feel the strength of this spirit in himself and then impart it to his marble."[278]

The very different Apollo Belvedere impressed Winckelmann as a wholly

ideal statue, the greatest of the works of antiquity to escape destruction. Loving in imaginative retrospect the nude, noble bodies of ancient Greek youths (as, in the present, he loved German and Italian boys), he rhapsodized erotically about the Apollo's limbs, the contour of his body, and his soft hair playing about his divine head.[279]

Winckelmann's mentor in Rome, the painter Anton Mengs, accepted Winckelmann's theories and wanted to translate them into rules for a student's education in an academy. The mere aping of nature or study of human models cannot be enough, he said. The beginning has to be an unquestioning imitation of beautiful paintings. Only later, after his eye has been trained, should the student begin to question and differentiate, gather beauty, as the bees do honey, from many sources. The ancients will give him the taste for beauty; Raphael, for expression; Correggio, for grace or harmony; and Titian, for truth or color.

The classicism of the eighteenth century—neoclassicism as it later came to be called—was rather different from the classicism (or classicisms) of the Renaissance and the seventeenth century and the earlier academies.[280] I will not go into these differences, which are the ordinary substance of art history, except to say a word on a change in its favored subject matter. The change can be followed in the career of Poussin, whose attitudes and practice had so great an influence on French academic, that is, official, painting. His earlier poetic and mythological themes often give way to solemnly dramatic ones drawn from the Old and New Testaments and classical writers, such as Livy and Plutarch, whose works lent themselves to a conventional moral interpretation. His last paintings are of still another character, but all I want to point out is the increasing emphasis on moral lessons drawn from history. "Painting," he is reported as saying, "is simply the imitation of human actions, which, properly speaking, are the only actions worthy of being imitated."[281] The justification for this emphasis on pictorial actions is put by the classical painter Joshua Reynolds in a more sharply moral light when he says that the great men whose actions history records are the "exemplars of humanity, generosity, grandeur, courage, disdain for danger and even for life itself, or passionate zeal for the honor and safety of the country."[282]

I recall the primacy of such painting in neoclassical art not only because of the constant issue of the relation of art to morality, but also because it brings ancient China clearly to mind. The morality is different and the exemplars are different, but the principle that art should teach morality by historical example and the implicit presence of the spirit of great men is clearly the same.

As in China, so too in Europe, the traditional desire to depend on past models was formalized in lists of paradigmatic artists and works of art. In the sev-

enteenth century, Roger de Piles graded artists for composition, drawing, color, and expression. Perfection in all categories is unattainable by any artist, he said; but in the High Renaissance, Raphael fares best in Roger's grading, Leonardo (whose color is less than great) comes next, and Michelangelo (who is relatively deficient in composition, expression, and particularly in color) comes third. For a later period, Rubens is first (his total score equals that of Raphael), Rembrandt (who is relatively low in drawing) is second, and Teniers is third.[283]

. . .

Although I have not spoken of the institutions, notably the imperial court, by which Chinese art was controlled to a varying extent, I hope to be forgiven the asymmetry of a brief description of European academic training. The old guilds of artists held on for a time, sometimes pertinaciously, but the academies that competed with them were likely to have the advantage of government recognition, subsidies, and official exhibitions.[284] The first official, state-supported academy of art, the Accademia del Disegno, was set up in Florence in 1563, with the artist and painter Giorgio Vasari and the sculptor Vincenzo Danti among its founding members. At first an extension of the ducal court, it was a response to the demand for a new kind of artist, and so it included geometry, perspective, drapery, astronomy, and geography among the subjects it taught; figure-drawing classes were added only later.

I concentrate, however, on the French Academy of Painting and Sculpture, which was set up in 1648. Its curriculum resembled that of the academies in Florence and Rome, but it was more fully distinguished from the guilds and their practices. Its twelve founding members, each of whom took over life-drawing for a month of the year, called themselves *anciens,* "seniors." When fully institutionalized, the Academy had a strict hierarchical structure, at the top of which was a director and at the bottom of which were academicians and elected members. Soon, all painters given court patronage were required to join, and the giving of royal commissions became a function of the Academy. The professional members of the Academy, who earned their entrance by the acceptance of an "admission piece," were given biannual public exhibitions, called "Salons," in the Louvre's *salon carré* (square room). The official purpose of a Salon was to demonstrate the culture and munificence of the king and to promote the glory of the state. Among the artists who studied in the Academy were Géricault, Delacroix, Fragonard, Ingres, Moreau, Degas, Monet, Renoir, and Sisley.

The Academy's most coveted gift to students was the Prix de Rome, initiated in 1666. It was given for winning a rigorous yearly competition. The winner, theoretically unknown to the judges, whose vote was secret, got a four-year sub-

sidy to study and work in Rome, as one of twelve "pensionaries." The tradition of these contests continued for all of 320 years. Simon Lee's book on the career of the painter Jacques-Louis David (1748–1825) describes the process of competing. Lee says nothing of cheating, which did sometimes occur, and only a little of the rigor of the examinee's near imprisonment. Both the temptation to cheat and the rigor of the testing standards remind me of what, in the examination life of Chinese scholar-officials, has been called "the Chinese examination hell." As Lee says, "The goal of practically every Academy student was to win the great student prize: The Grand Prix, or Prix de Rome." At the annual history painting competition, a student, working in a tiny studio cell, had ten weeks in which to make a painting on a set subject. The winner

> spent between three and five years at the French Academy in Rome. Study in the Eternal City was thought essential to complete a young artist's education, and the attraction of doing so at the government's expense meant that the Prix de Rome was the subject of intense competition. But David was neither a brilliant nor a precocious student, and it took him five attempts to win the coveted prize. At each failure he became increasingly frustrated with the Academy for denying him the prize, and this dissatisfaction sowed the seeds of a long-standing grudge against the institution.[285]

The Academy's official style was at first essentially that of Nicolas Poussin (1594–1665) and in a later period that, essentially and perhaps ironically, of David himself. As luck would have it, David's teacher was Joseph-Marie Viens, who was appointed director of the French Academy in Rome and took David to Rome with him. The discipline that David endured then must explain why, when the French Revolution broke out, he was more than ready to lead a revolt against the Academy, though not against the style, his own style, that it had made its official standard.[286]* To the students' dismay, I assume, Viens, the new director,

* As his biographer Simon Lee explains, "David the politician was a highly complex and volatile mixture of personal grudges, private insecurities, artistic ambition and democratic righteousness. He was said to be in a state of near delirium as he tackled his duties with the vigorous intensity of a zealous convert. . . . The Revolution seems to have brought out the best and the worst in him. On the one hand he was generous, anxious to help the unfortunate, and capable of tolerance and leniency. Yet he could also be a fanatic, an inflexible patriot and able to ignore pleas for help. . . . He is reported to have drawn a sketch of the king at the guillotine, his head severed, with the inscription, 'The head of the tyrant will soon fall like this.'"

designed a course of studies meant to counter the slackness he attributed to the past. Under his regime

> students were to rise at five in the summer and draw the life model from six until eight, when the light was at its best, and in the winter work in the evening under artificial light. A rigorous programme of drawing and making copies in the Vatican museum, in churches and in palaces also existed, and paintings of the students' own composition had to be sent back to Paris for assessment. The students' social life was also regulated: they had to be back inside the Academy by 10 pm in the winter and by 11 pm in the summer. Viens even proposed that they be made to wear a uniform, but this was not adopted for fear of antagonizing the people of Rome.[287]

The aesthetic theory of the Academy was basically that of Renaissance classicism, which it attempted to work out in systematic and practical detail. By applying the known rules, which stressed proportion, perspective, and composition, one was remaining faithful to nature but, at the same time, reducing its disorder to the order of art. Keeping to these rules had a more than aesthetic or even moral usefulness, for a member of the Academy was favored by the patrons on whom the career of an artist depended.[288]

Since, as I have said, entrance to the Academy was by examination, it was only reasonable for a student to choose an official examiner as a teacher. The training given by an École master, the painstaking inculcation of a conservative technique and way of seeing, was the fulfillment of the process by which European academicism had kept itself alive. As in China, there was much copying and the piecemeal study of fragments meant to be finally integrated.[289] In Europe, however, the emphasis was primarily on the human body. One learned the body by first copying engravings or prints, then plaster casts, then paintings, and only then live models, whose unfamiliarity and unexpected tendency to move made them very difficult subjects to master. Eyes, noses, and lips were learned separately and later combined into profiles and front views; and chins and ears were learned separately, by the same method of copying. The whole head followed, after which came separate studies of hands, feet, legs, and finally of entire figures. Modeling, the representation of light and shade, was something additional, to be learned separately.

Students also sketched the masterpieces in the Louvre. Some teachers, among them Delacroix, advised the students to make quick painted sketches as well as finished copies; but sketches were regarded as mere preliminaries, and

artists who exhibited sketchy work were rebuked.[290] Ingres declared that the artist's touch, no matter how skillful, ought not to be apparent. Only a charlatan, he said, would draw attention to himself by this device. "It shows us the method instead of the object, the hand instead of the brain. Where do you see the touch in nature?" Toward the end of his training, the student was encouraged to study the old masters who most appealed to him and to combine the best features of each of them. It was understood that an artist could achieve a respectable style of his own only as the result of the analysis of the styles of old masters. The advice that Ingres (1780–1867) gave his pupils was, "Go to the old masters, talk to them—they are still alive and will reply to you. They are your instructors. I am only an assistant in their school."[291]

CREATIVE COPYING FROM THE EUROPEAN PAST

Classical Europe, like China, used copying as a primary method of absorbing tradition. But in Europe, copying was not thought of as a way of keeping great but fragile pictures alive in near duplicates. Europeans therefore never developed the deep aesthetic respect of the Chinese for a good copy, nor did they develop as full an armory of methods of copying. But European classicism, too, was fixed on the ideal, not of copying as such, but of the creative use of copying, or, in the phrase of the scholar Leonid Barkan, "original imitation."[292]

We can begin to appreciate what this means by recalling an insult that Michelangelo paid a sculptor he hated, the expert but malicious and litigious Baccio Bandinelli (1488–1560). Unlike most insults, this one needs an introduction: On the urging of a Medici who wanted to give a gift to the king of France, Baccio, a confirmed classicist, not only agreed to make a copy of the Laocoön but, according to Vasari, boasted that he could even surpass the original in perfection. Baccio began his work by making a much-praised wax model of the Laocoön, from which he went on to a full-scale drawing and then a marble copy of the larger boy. "All those who were good judges were satisfied" with this copy of the boy, "because between his work and the ancient one there was scarcely any difference to be seen." Baccio also made a convincing restoration of the ancient Laocoön's broken, lost right arm (for some unknown reason another restoration was made and attached, by Montorsoli, in 1532). In 1525, Baccio finished the copy of the Laocoön, which brought him "great fame," Vasari says. It was valued so highly that it was not sent, as intended, to the king of France, who was given "other ancient statues." Instead, it was kept "at the head of the second court in the Palace of the Medici" in Florence.[293]

Michelangelo's insult, reported by Vasari, was this:

> Being asked by a friend what he thought of one who had counterfeited in marble some of the most celebrated antique figures, and boasted that in his imitations he had surpassed the antiques by a great measure, Michelagnolo [sic] replied: "He who goes behind others can never go in front of them, and he who is not able to work well for himself cannot make good use of the works of others."[294]

Michelangelo himself seems to have got something of his early reputation by the talent he exhibited in the forgery of an ancient Greek statue. When young, he made a life-sized sleeping Cupid, which he treated and perhaps buried to fool people, as it did for a while, into thinking that it was ancient. The success of the forgery "brought so much reputation to Michelagnolo, that he was straightway summoned to Rome and engaged by Cardinal San Giorgio."[295] This story is paralleled by another, that Michelangelo's *Bacchus* was a work made by him "for the purpose of fooling the Romans and the pope with its antique style." There are stories, too, "in which Michelangelo declares the [Belvedere] *Torso* his chief teacher, in which he is discovered kneeling before it, in which he asserts that 'questa è l'opera d'un uomo che ha saputo della natura' ('this is the work of a man who knew more than nature'), and in which he produces a beautiful wax model after it."[296]

Michelangelo's insult does not imply any lack of reverence for Greek sculpture nor any scorn for copying it, but was based, just as it says, on his conviction that the really good use of the work of others depended on the ability to "work well" for oneself. In the context of Michelangelo's training and Neoplatonic yearnings, working well for oneself means, unsurprisingly, that one must not only have mastered the craft of sculpture but, with the help of inspiration, be able to go beyond craftsmanship, however masterly. This conviction reflects the creatively imitative use that Michelangelo made of ancient Greek sculpture. It is more than enough to cite his use of two famous statues I have named, the Belvedere Torso and the Laocoön—the Laocoön that Michelangelo and other excited spectators had started to draw and discuss in a vineyard just as soon as a hole had been widened enough to pull the statue out.[297]*

*As Francesco da Sangalla, who was present when the statue was dug up, later recalled: "Since Michelangelo Buonarroti was always to be found at our house, my father having summoned him and having assigned him the commission of the pope's tomb, my father wanted him to come along, too. I joined up with my father and off we went. We climbed

The Belvedere Torso had not attracted much attention when it was first dug up, in the early fifteenth century. But in time it became a favorite subject for drawings, the careful realism of which emphasized the unfinished, broken nature of the old torso. In Michelangelo's case, the influence of the Torso is first apparent in the figure of the *ignudo* that is placed above and to the right of Jeremiah in the Sistine ceiling frescoes. The Torso's influence is visible again in the sculpture *Day* in the Medici tombs and in two figures in the *Last Judgment*, the one, Christ, who dominates the whole scene, and the other, Saint Bartholomew, who is holding his own flayed skin.[298]

Michelangelo's intense interest in the Torso and his repeated use of it in his art lead Leonid Barkan to an interesting speculation on his tendency to leave his works unfinished:

> If the *Torso Belvedere* is the paradigm of ancient sculpture and Michelangelo is the tragic hero of the fragment, that is because he based his career in part on what could be imagined and not seen or because he appeared too often to be unable to produce statues more complete than the fragments that inspired him. Yet . . . the unfinished works of Michelangelo are not really deficient at all. Rather we should say that they are open; in other words, they admit the historical imagination as a genuinely collaborative force.[299]

As for the Laocoön, Michelangelo uses it again and again. Its twisting, muscular torso and protruding knee can be detected in the statue of Saint Matthew and in some of the *ignudi* on the Sistine ceiling, as they can be detected, gone limp, in the Florentine *Pietà* and in the drawings of the crucified Christ he made for Vittoria Colonna.[300] It is above all the Laocoön that stimulates Michelangelo to use the muscular tension of twisting bodies and moving limbs to express a

down to where the statues were when immediately my father said, 'That is the Laocoon, which Pliny mentions.' Then they dug the hole wider so that they could pull the statue out. As soon as it was visible everyone started to draw, all the while discoursing on ancient things, chatting as well about the ones in Florence."

The antiquity of the unearthed Laocoön has recently been challenged by the idea that it is a forgery by Michelangelo. The main bit of evidence cited by Lynn Catterson, the exponent of the charge, is a drawing made by Michelangelo in 1501, five years before the statue's supposed discovery. The drawing can be superimposed almost perfectly, says Catterson, on a photograph of the back of the statue, except that the left arm of the drawing is raised, instead of the right arm of the statue. "This is the sort of compositional revision," she says, "that a sculptor would make in order to make the best use of the marble at hand, as well as for the overall balance in the finished group."

physical struggle that is also a spiritual one. This is a struggle in which his own and his subjects' energies are exerted against whatever limits, oppresses, or punishes them. As Barkan continues, "The great sculptural forms that he creates out of this inspiration are not imitations but responses to a set of qualities in the *Laocoön* that he himself defined. In turn, his status canonizes the vision while rendering it almost inimitable."[301]

. . .

In using Michelangelo and Tung Ch'i-ch'ang as my main examples of creative copiers, I have implied a likeness between them. They both made extensive, conscious use of imitation in order to express their own great creative power, but I can make no more than a general, distant comparison of the mountain landscapes of Tung with the frescoes, the human landscapes, of Michelangelo. Nevertheless, the two were both bold, forceful persons, so it is unlikely to be an accident that Tung's mountains and mountain ranges are in their bulges, thrusts, and forceful organization not unlike Michelangelo's figures' bulging muscles, thrusting movements, and forceful organization. In both cases, what one sees is an aware, knowledgeable, creative, passionate reworking of tradition.

THE IDEAL OF THE ANONYMOUS CRAFTSMAN

To end this discussion of traditional art, I review the arguments of several of its more interesting defenders. Each argues in favor of the anonymous craftsman, but the last is more openly intellectual and more defiantly mystical. These defenses are indebted to the succession of moralists, including Carlyle and Burckhardt, who warned of the growth of materialism and the decline of intellect, virtue, and taste. The nineteenth-century moralist who applied this warning most eloquently to art was John Ruskin (1819–1900), who said, "No human face is exactly the same in its lines on each side, no leaf perfect in its lobes, no branch in its symmetry. All admit irregularity as they imply change; and to banish imperfection is to destroy expression, to check exertion, to paralyze vitality."[302] Unfortunately, he went on, the growing skill of the late medieval carver led him to defy the nature of the stone he worked, and his virtuosity, indulged in for its own sake, led to the demand for technical perfection. This demand came to prevent the draftsman from being natural and individual. Art was then led to perfection, and from perfection to the inhumanity, luxury, and vice that accompany it.[303]

Such views led to the Arts and Crafts Movement, which looked back fondly on medieval and folk art, and on Japanese art as well.[304] For some reason, potters seem to have had a special affinity for the movement. Among these potters

(left) **DETAIL FROM TUNG CH'I-CH'ANG'S PAINTING**
THE CH'ING PURE MOUNTAIN IN THE MANNER OF TUNG YÜAN, 1617.
FROM *THE CENTURY OF TUNG CH'I CH'ANG, 1555–1636*, VOL. 1,
ED. WAI-KAM HO, KANSAS CITY AND SEATTLE, 1992.

(right) **THE BACK OF THE FIGURE GIORNO (DAY),**
FROM THE MEDICI CHAPEL, COMPLETED, LIKE THE OTHER
STATUES IN THE CHAPEL, BETWEEN 1530 AND 1535.
FROM *MICHELANGELO: THE COMPLETE SCULPTURES*, ED. FREDERICK
HARTT, NEW YORK, 1968. PHOTO CREDIT, ALINARI ARCHIVES, FLORENCE.

Tung's landscape and Michelangelo's statue both owe a great, willingly acknowledged debt to their respective classical traditions, but each artist displays his original, strikingly forceful organization of spatial masses. Tung has his many smaller geometrical mountain masses organized into lines of force, while Michelangelo's anatomical masses are constrained by Day's strongly thrusting shoulder and twisted arm.

there were the Englishman Bernard Leach (1887–1979) and his Japanese friend Shoji Hamada (1894–1978).[305] These two seductive exponents of the craft-ideal were close to one another, and I take the liberty of representing their position in Hamada's more Buddhist version.

A confirmed opponent of egoism, Hamada refused to sign any pot he made or stamp it with his seal. He refused, that is, to draw attention to himself as an

individual artist. Offended by the egocentricity common to artists, he preferred that the buyer of a pot buy it for what it was and not for its potter's name. In his opinion, an unknown craftsman deserves to be put on a level with the best of artists, "provided that humility and life are given expression." He acknowledged that it was not possible to go back to anonymity, and yet he saw modesty as the salvation of art. According to him, the craftsmen of the East were unconcerned with natural flaws and irregularity. They were careful, but nonchalantly so, careful while also free. Perfection's very smoothness, he said, makes us yearn for the imperfection that signals life, which goes beyond all arts and artists.[306]

This defense of modesty, life-enhancing imperfection, and traditional craftsmanship was completed and given a more philosophical turn by the arguments of Leach's and Hamada's friend Soetsu Yanagi (1889–1961). Yanagi was an admirer of Rembrandt and Cézanne, and, later in his life, of Blake and Whitman. But he also had a consuming love of Koreans and Korean art, especially the pottery of the Yi dynasty (1392–1910). Leach remembers that once, when he went to see Yanagi, he "found him in a reverie, slowly moving from pot to pot, gently stroking each in turn." When Leach asked him what he was doing, the answer was, "I am visiting my Korean friends."[307] Leach insists that it was Yanagi who discovered both Korean and Japanese folk art, because he was the first to look at it with real appreciation. He became the best-known exponent of the folk crafts or folk arts of Korea and Japan—the word he coined for "folk crafts," *mingei,* embodied in the name of the Japanese Craft Association, the Mingei-kai, and the Folk Craft Museum, both of which he founded.

Having embraced the spirit of Zen, Yanagi tried to move beyond beauty, ugliness, and form itself. He had an especially strong admiration for Chinese Sung ware, which, he said, was mostly painted by illiterate boys. "No famous painters of the day were hired to work for the kilns. The job was performed by boys around the age of ten, children of poor families, many of whom no doubt disliked the work."[308] How does it happen, he asks, that these boys were able to draw so superbly? His answer is that because each boy had to draw the same picture hundreds of times a day, the result was an easily moving brush, a bold composition, and a miraculous quickness of hand, all testimony to the absence of anxiety and ambition. Illiterate children as they were, it was by means of the power of tradition and their own undividedness that they were able to produce astonishingly good pottery. Working with complete disengagement, they forgot themselves, forgot that they were drawing and, having forgotten, were liberated from distinction between dexterity and clumsiness though not at all from the distinction between beauty and ugliness. In their unhesitating unawareness,

they exceeded the artist who supplied them with the design they painted. (I am reminded that the fashion designer Paul Poiret, who worked with Dufy, reportedly "sold materials and objects designed or hand-painted by teenage girls especially chosen for their lack of formal artistic training.")[309]

Yanagi's craftsman ideal requires beauty that is identified with and born of use, but not in the sense that separates mind from matter. According to Yanagi, the true craftsman, who uses natural materials and processes and works with an accepting heart, is saved, not by himself, for he does not have the power to save himself, but by nature. In the works of the true, humble craftsman, there is nothing false.[310] Today, in the absence of such artisans, Yanagi says, we have to be satisfied with the artist-craftsman, who, though an artist, may copy himself until awareness of the original dies away and the design becomes far more beautiful.

As if by providence, Yanagi's ideal was put to an empirical test, a test explained in Brian Moeran's study of Sarayama, a village community of potters. This two-hundred-and-fifty-year-old community is located in the mountains to the north of the town of Hita, Japan. It was Yanagi's admiration for a black teapot made in Sarayama that led him to pay a visit to the community. Its oldest men remember his visit very well, because no one from the outside world had ever taken the trouble to find out about their wares. Yanagi's admiration was passed on to other *mingei* connoisseurs, to such effect that hundreds of thousands of visitors have since come to savor the nature of the folk-art ideal embodied in the rural community of fourteen households, ten of which make pottery, which the other four sell. The members of each household work together, worship at a common ancestral shrine, and regard one another as mutually responsible.[311]

The people who have bought pottery made in Sarayama believe that it is good because natural materials are used there in a simple, natural, cooperative spirit. The Sarayama pottery and way of life seem to demonstrate the authenticity, at once moral and aesthetic, that Ruskin, Leach, Hamada, and Yanagi believed in. "Leaders of the *Mingei* movement have praised Sarayama because they see the potters living in a kind of ecological equilibrium, in harmony with nature and with themselves." Their purity of character is said to "give them a warmth that is reflected in the beauty of their pots."[312]

Such appreciation is especially natural to the Japanese, with their reverence for Zen-like intuition and simplicity, their choice of craftsmen as national treasures, and their recurrent exhibitions of traditional craftwork. Of course, the commercial success of the potters, the public exhibitions that were held of their work and its public ranking, and the promotion of individual potters' names have all disturbed the old equilibrium of the community. The most interesting

tests of Yanagi's ideal are the attitudes held by the potters and their dealers after their success became assured. Of the fifteen working potters—all there were when the study I am referring to was made—five had never read a word Yanagi wrote, eight had only glanced at his articles on their work, and two had read the first volume of his selected works and thought it rewarding. The potters read little if anything of current *mingei* literature and expressed no interest in the views of the best-known expert in *mingei*.[313]

Nothing I have said so far puts the *mingei* ideal in question. But in contradiction to Leach, Hamada, and Yanagi, both potters and dealers tended to deny that there were persons who have the ability to rank pots by direct perception—ironically, the choices made by Yanagi's son were rejected by a panel of Tokyo critics. Yet all of the potters, regardless of the degree of their economic success, agreed that the more a craftsman was interested in making money, the lower the quality of his work. The accent should be put on "interested," because none agreed that the money they had gained had made their work any worse. As for the link between the cooperation of the community and the beauty of the pots, about half of the potters agreed, but for their own work, not necessarily for that of others. Maybe they believed in the effectiveness of the ideal in their own cases because they had been praised, as they were aware, for their mutual cooperation.[314]

What of the influence of "closeness to nature"? This question is the more interesting because Sarayama is very nearly unique in Japan for its dependence on natural materials and simple processes. Many of the potters did in fact feel that their environment affected their work, but they could not always agree that their work was good just because they used natural materials and simple equipment, say, a kick wheel rather than an "unnatural" electric wheel. They themselves were not able to tell the difference in quality, they said. But all but one of the dealers were certain that the potters' work was better because they used natural materials. "There was a close association in almost every dealer's mind between people's spiritual attitude, the nature of the environment in which they lived, and the quality of the work they produced." Did the potters think of themselves as artists or as craftsmen? The answer is unequivocal. Even though some of them were becoming well known, all refused the title of "artist" for themselves and the title of "art" for their work. "They made 'pottery' (*yakimono*), not 'ceramics' (*toki*)" for "art was for city, not for country, people."[315]

They were also unhappy about Yanagi's idea that craftsmen should remain uncultivated and unlearned. They argued that, in view of the amount of time

critics had spent telling them how they should be making pottery, it was impossible for them to throw pots "unconsciously" any more. Potters said that they had learned to see their pots differently [i.e., they had been "educated"] and were now more conscious of their work; it was not surprising that people said it had got worse [the flower vases, tea bowls, and coffee cups, which the potters made because they sold, were regarded by folk-craft leaders as less, I should say, authentic because they were not traditional].[316]

Is this evidence enough for a verdict on the truth or viability of Yanagi's ideal? The quotation above shows what we in any case know, that when a craftsman is taught to value the virtues of an ignorant dependence on tradition, the ignorance evaporates and, with it, whatever special virtues it may have possessed. Simple means and simple methods have a usually visible attraction of their own, but given the possibility of using other, more efficient or impressive means, the simple ones will usually be displaced, and not necessarily for the aesthetic worse. Yanagi depends on a form of mystically assured intuition that more modest critics do not attribute to themselves. The social ideal he favors has been brought to life in artists' cooperatives or utopias that have now and then been created or revived in different forms. Unlike traditional guilds or craft villages, however, they usually break down before long. Spontaneity of the kind he praises comes to natural life in lyric poetry or painting, or in Chinese or Japanese calligraphy. For this, the evidence is endless. Yet there is something deeply unpersuasive in his ideal, which is the combination of a purely repetitive, unthinking spontaneity with an uninformed reliance on tradition. This seems, as I repeat it now, a poor, even shabby ideal. In a moment of idle curiosity I asked myself what Michelangelo would think of it, or Velasquez, or Gauguin, or Dali, or Picasso, or Andy Warhol—or Jeff Koons. I didn't answer even for one.

A more attractive defense of the authenticity of a nameless craftsman's or folk artist's work, such as a pot, is that the pot fits into and belongs among a set of similar ones, and therefore, because it is "an emblem of a culture's continuing search for its own soul (and not the product of trivial, fickle fashion), we name it traditional. At the same time, though fitting its set, every song or pot worthy of the qualifier 'folk' will be precisely like no other. It will have fathered into itself something of its creator's freedom."[317]

THE METAPHYSICAL IDEAL

The views of Ananda Coomaraswamy, whose interest in Indian art has been pointed out on an earlier page, provide an avenue to other intellectual defenses

of traditionalism in art. I choose him because he is the most interesting and forceful of his philosophical kind that I have come upon.

Some words on Coomaraswamy's life and personality will illuminate at least the intensity with which he held his views. They were certainly affected by his emotional makeup, which is describable as a disharmonious, restless, ambitious striving toward unity, calm, and self-abnegation.[318]* The son of an Englishwoman and a learned, politically active Ceylonese who died when his child was two, Coomaraswamy returned to Ceylon, the country of his birth, with the purpose of writing a book.[319] His *Medieval Sinhalese Art,* published in England in 1908, is a learned hymn to traditional craftsmanship, to its reverential attitudes, its training methods, and its authenticity.

Coomaraswamy settled in the United States, where he made his reputation as a scholar, mostly of Indian art, and as the compiler of the catalog of the Indian collection at the Boston Museum. "He was a central figure in world scholarship, with an erudition and keenness that required no alteration."[320] Coomaraswamy's attitudes were influenced by William Blake, a representative, along with Walt Whitman and Friedrich Nietzsche, of what he called idealistic individualism, which he for a time hoped would be the new philosophy of the West. Later, Coomaraswamy was strongly influenced by the views of René Guenon, who proclaimed that Europe had been decaying materially and spiritually since the thirteenth century. Two neoscholastics, Etienne Gilson and Jacques Maritain, gave him a lasting interest in the Christian Middle Ages, especially in the mysticism of Meister Eckhart.[321] A further influence was Carl Jung, whose writings he began to follow in the 1930s.

The contrary aspects of Coomaraswamy's nature may help to explain why his scholarship was put at the service of an unrealistic, half-mythical reading of

*Coomaraswamy was an unrelenting moralist, but the moral discipline that he demanded of everyone must in some way have been a counter to his own undisciplined appetites, especially for sex. It was only in his later years that he managed to live in a way that even approached the ideals of the mystical traditionalism he preached with all the resources of his learning and eloquence. Roger Lipsey, a sympathetic friend and himself a considerable scholar, says of Coomaraswamy, "His marital career was inappropriate to a man who wrote of marriage as a sacrament, and some of his financial dealings seem no less inappropriate and incongruous with the view of right livelihood which he expounded." Yet "he lived habitually in his intellect in a much higher degree of concentration than other men. As that was perfected, other things fell away. This made the personality exciting and memorable, and edifying in a sense which the character, the whole psychic complex was not."

Indian history and character.[322] In pursuit of the truth and of his own heritage, he made an intensive study of Indian iconography and philology, as well as of the Vedas. His interest, which had shifted from the history of art to iconography, shifted once more, to the metaphysical meanings transmitted by the visual symbolism of art. (Book learning apart, his devotion to a complex, all-embracing symbolism reminds me somehow of Ogotemmêli.)

Coomaraswamy believed in a fixed, universal, perennial metaphysics. In an essay called "The Philosophy of Medieval and Oriental Art," he pictures himself as a complete and therefore basically unoriginal traditionalist:

> Throughout this essay, I shall be using the very words of the Middle Ages. I have nothing new to propound; for such as I am, the truth about art, as well other things, is not a truth that remains to be discovered, but a truth that remains for every man to understand. I shall not have a word to say for which I could not quote you chapter and verse. These pages are littered with quotation marks. Many of the quotations are from the *Summa* of St. Thomas; many from Augustine, Bonaventura, and Eckhart; Oriental sources are both too many and too unfamiliar to be listed here.[323]

Sometimes Coomaraswamy made lists of the cultures he considered to be traditional, which included the "Indian, Egyptian, early Greek, medieval Christian, Chinese, Maori, or American Indian."[324] India he took as the epitome of traditional civilization, and he used his knowledge of Indian art and thought as a touchstone for the study of other traditional civilizations. In his mind, the perennial philosophy was such that "as long as the tradition is transmitted without deviation, as long in other words as the chain of teachers and disciples remains unbroken, neither inconsistency nor error is possible. On the other hand, an understanding of the doctrine must be perpetually renewed; it is not a matter of words."[325]

It was important to Coomaraswamy to stress that the formal element in art represents a purely mental activity for which India had developed a highly specialized technique of vision.[326] The maker of an icon, he says, uses the technique of yoga to eliminate anything distracting and egotistical, then visualizes the form of the sacred image according to the received canon and draws the form to himself as if from a great distance. It is only after he has realized a complete self-identification with the image he is to make, in other words, has known the image in an act of nondifferentiation, that the imager can go on to translate it into stone, pigment, or other material. All this, says Coomaraswamy, is a process in which worship is paid to a mental image, which is conceived not by mere empir-

ical observation but by true knowledge.[327]* To drive this lesson home, Coomaraswamy quotes Dante's pithy words, "He who would paint a figure, if he cannot be it, cannot paint it."[328] To drive the lesson home still more firmly, he quotes Plotinus's statement that in contemplative vision the thinker makes himself over into the matter that is shaped and takes ideal form under the influence of his vision, although potentially he remains himself all the while.

According to Coomaraswamy, Indian tradition implies the existence of types or archetypes. These are not Platonic absolutes external to the universe in which they are reflected, but types "of sentient activity or functional utility conceivable only in a contingent world." Coomaraswamy criticizes democracy as a form of life that condemns each man to the exhibition of his own imperfections and to the vanity that we describe, with uncomprehending complacency, as self-expression. He prefers by far the traditional, immanent culture that endows every individual with the grace or typological perfection that only very rare beings can achieve by their own efforts. Only in a traditional culture, he claims, does art reach its true aim, for "heaven and earth are united in the analogy of art, which is an ordering of sensation to intelligibility and tends toward an ultimate perfection in which the seer perceives all things imaged in himself."[329]

I will not enter into a criticism of Coomaraswamy's views, which, the reader knows, are far from my own. I will, however, mention the resistance of two Indian scholars I have read. One of these scholars, Partha Mitter, on whom I have depended in this chapter, argues that Coomaraswamy's metaphysical generalizations, largely drawn from Plato and from nineteenth-century romantic aesthetic thought, rest on the assumption that art is an "uncaused spiritual activity." Coomaraswamy's generalizations reduce art criticism "to the level of irrational mysticism." Mitter suggests that

*Alfred Gell provides a description of Trobriand carving that is useful for comparison. The carver, working on the prow of a canoe, has to visualize the design that he mentally follows in the act of carving, like a musician trying to give a perfect performance of a certain memorized score. "The carver is supposed by his audience, and himself, to follow an ideal template for a canoe-board, the most magically efficacious one, the one belonging to his school of carving and its associated magical spells and rites. The Trobriand carver does not set out to create a new type of canoe-board, but a new token of an existing type; so he is not seeking to be original, but, on the other hand, he does not approach the task of carving as merely a challenge to his skill with the materials, seeing it, instead, primarily as a challenge to his mental powers."

a more effective and fruitful way of studying the nature and quality of Indian art and the entire relations between art and religion would be in concrete and human terms and not by presenting collective notions or metaphysical generalization. This may be done by seeking to restore the religious, cultural, and social contexts of Indian art. In the process we shall have to make a conscious effort to learn what actual standards of art criticism were in operation among those Indians who had created these works and among those for whom they were created, and not to depend on the classical tradition whether to affirm its principles or to deny [them].[330]

The learned and sensible Niharranjan Ray argues not dissimilarly. He acknowledges how great Coomaraswamy's influence has been on Indian and Western writers on Indian art, including Ray himself. Yet Coomaraswamy's basic assumption, he says,

> led him inevitably to an undue and not unoften irrelevant emphasis on the literary, religious, symbolical and metaphysical content of Indian art at the expense of important imaginative and aesthetic questions, problems of artistic form and its evolution and the human and social context of art . . . more closely related to life and actual living and hence more humanistic, not just scholastic and priestly.[331]

. . .

At this point I will draw no moral nor suggest any conclusion except to say that neither the Zen-like paradigm of Yanagi nor the more intellectualized mysticism of Coomaraswamy nor any other prescriptive ideal of which I know is adequate to the richness of the history of art. Art is not a single problem, nor does it have a single solution, rational or mystical.

As for tradition and traditionalism, they are, as they seem to be, analogous to individual memory. I mean, to begin with, that tradition displays social analogies to the various kinds or qualities of memory. To recall the most obvious kinds: There is implicit or unconscious memory, which includes the habit memory that is of such practical importance to our lives. Then there is explicit, conscious memory, both short-term and long-term, which is essential to the autobiographical memory that is the center, the gist, of every person's conscious identity. What are the analogies between individual and social memory? Surely the confirmed, often more or less unconscious, habits of social action are like the individual's habit memory. The conscious preservation of the past, which is unique to every culture and subculture, is like the individual's autobiographical memory. But

though it is helpful to keep these analogies in mind, they are much too simple. Individual habits of action do not simply sum themselves up in collective habits of action, nor conscious memories in collective memories, nor individual autobiographies in collective ones. To use too lax a metaphor, the collective organism, with such numerous heads, hearts, and memories, is such an extraordinarily multiple beast-beyond-imaginable-beasts that I'll leave it to itself for now and attend instead to the art that bears witness to its natures.[332]

Still, having spent so many words on the idea of the classical, it seems unfair to end by saying only that it is human, like us, and, like us, not at all simple to understand. I'd rather end with praise for the eloquent balance that classical art has so often demonstrated. The words I borrow from Kierkegaard—reminding himself that it was Mozart who helped him to grasp Greek art as a happy, idealizing, classical union of content with form:

> From the moment my soul was first astounded by Mozart's music and humbly bowed in admiration, it has often been a favorite and refreshing occupation for me to deliberate on the way that happy Greek view of the world that calls the world a cosmos because it manifests itself as a well-organized whole, as an elegant, transparent adornment for the spirit that acts upon and operates throughout it, the way that happy view lets itself be repeated in a higher order of things, in the world of ideals, the way there is here again a ruling wisdom especially wonderful in ruling what belongs together.[333]

But though Kierkegaard has a profound love for the balance of content and form in art, he also has a deep-seated need to walk on and over the margins of rationality and even of reasonableness and hence of classicism. In the guise of the aesthete, he listens to music, like Schopenhauer, as the supreme because quite bodiless art. In the text I have cited, he goes on to lead the reader from classicism into romanticism, and closer to the spirit of the artists who are the subject of the following chapter.

EGOCENTRIC INNOVATION

EGOCENTRICITY AGAINST TRADITION

It is in the nature of human relations that a tradition is always under some challenge, internal or external, mild or brazen. The challenges that I concentrate on here are those made by the kinds of artists who are unwilling to suffer any yoke but the yoke they set on their own shoulders. Yet the way in which the yoke is worn or cast off can be deceptive, because the way a tradition actually works cannot be grasped from its principles alone. All the easy, monochromatic judgments turn out to be misleading. Sometimes the members of a tribe, a social group, or a whole culture have been described as living in a state of traditional self-abnegation that is suggested by the name of the preceding chapter, "Selfless Tradition." Such self-abnegation has been ascribed to the Zuni Indians, to traditional Hindus and Chinese, to Christians of one century or another, or, to take a sharply focused example, to Ch'an (Zen) monks. But every time that someone probes more deeply, the devil will out. The Zuni Indian will be seen to compete in how uncompetitive it is possible to be. The exquisitely deferential Chinese will compete before a superior in expressing the depth of his self-abnegation, will modulate his deference into even derision when facing an equal in rank,

and (like a Hindu) modulate it into possible harshness when facing a woman or other social inferior. The Ch'an monk will break off his training, be dismissed from it, go mad with it, or show by his actions that his professed ideals hide a personality incompatible with them.[1] The perfectly traditional society, in which everyone accepts an assigned function whole-heartedly and fulfills it reverentially, has never existed as more than an ideal, however powerful.

Because the situation in fact is so complicated, I will simplify it by setting up an antithesis between tradition and egocentricity. Beginning with the notion of an existing tradition, I will picture basically egocentric artists trying to bend it to their own purposes, or attempting to contradict or destroy it. I will not describe as egocentric the organizers of work projects, given names such as "master of the works" or "architect," who were indispensable to the more developed traditional societies. Their social importance and pride in creation might combine to make them resemble egocentric or romantic artists. In fact, the social position of the architect was high in ancient Egypt, ancient India, imperial Rome, medieval Europe, and at times in Islamic culture.[2] But even when they might fit into an egocentric or romantic mold, such architects were not normally intruders into their social traditions. Instead, they were among the individuals who literally formed the material shapes that the traditions took.

INSPIRATION, HEROISM, AND UNIQUENESS

The persons I take to be intruders into art tradition are apt to share two beliefs about themselves. The first is that they are inspired, and the second that they are performing uniquely important, even heroic acts. This inspired heroism is sometimes imagined to be as much physical as spiritual and artistic. Imagination easily embodies it in an ideal person who is at once fearless, inspired, and spontaneously expressive. In China, the idea of inspired heroism was adopted especially by the Taoists, who described the perfect man in extravagant cosmic imagery. Their ideal was so poetic, so engagingly impossible, and so often related to the ideal of the artist that I choose it as the metaphor with which to begin the discussion of heroic or would-be heroic artists.

This perfect or ultimate man is, above all else, completely spontaneous. At his level, to be completely spontaneous is to be so fully attuned to nature, so much himself a natural force, that he is immune to care, desire, and suffering. In direct contradiction to traditional demands, Chinese or not, this immunity also applies to all moral imperatives.[3] Because a natural phenomenon such as himself has nothing to fear of nature, he is, like a spirit, immune to fire, cold, and fear. Mountain-splitting thunderbolts or sea-shaking gales cannot frighten

him. As the Taoist philosopher Chuang Tzu (Zhuangzi) says in the collection of stories and parables that bears his name, "Such being the case, he rides the clouds, mounts the sun and moon, and wanders beyond the five seas. Since not even life and death have any transforming effect upon him, how much less do [human] benefit and harm."[4]

Extravagant as such words sound, there were Taoists who aspired to become like the ultimate person they imagined, at least in carefree immortality, which they tried to attain by methods of natural magic, for example, by refining their diet until it consisted mainly of air.[5] Perhaps I should qualify this summary. The Chinese artist knew only too well that he (and sometimes she) could not be immune to all ills, but he did see himself as in some sense a natural force. That is, he believed, art was created by a natural force acting through and by means of the artist's traditionally deployed and yet spontaneous responses. So because there could be no true art in the absence of natural spontaneity, to be truly effective, an artist had no choice except to be inspired. Given this conviction, the more adventurous Chinese artists concluded that an inspired spontaneity in art was most likely in a life that was wholly spontaneous. This is the point of the story, well known to the Chinese, in the Chuang Tzu text: Lord Yüan of Sung wanted some pictures made and, among all the "court clerks" anxious to fulfill the lord's demand he chose the one who, unlike the others, had gone back to his own quarters. Those sent to see what he was doing found "that he had taken off his robes, stretched out his legs, and was sitting there naked. 'Very good,' said the ruler. 'This is a true artist.'"[6]

The spontaneity an artist hoped to attain was not necessarily by way of such trust-inspiring nakedness. A different, deeper kind of immersion in nature is described by Chuang Tzu in a story about the woodcarver Ch'ing (Ching). Ch'ing carves a bellstand so amazing that it seems to be the work of a more-than-human being. When he's asked by what art he carved it, he answers that he's only a craftsman and has no special art. But before he makes a bellstand he conserves his energy by fasting and stilling his mind. After fasting for seven days, Ch'ing says, he's forgotten everything that usually concerns him. He's forgotten about rank, rewards, praise, and skill and clumsiness. Then he forgets even that he has four limbs and a body. He forgets that there is a ruler and a court. All distractions fade away. Then he goes into the mountain forest and examines the heavenly nature of the trees till he finds one with ultimate form and sees the form of the bellstand (in the tree trunk, I assume) and goes on to carve the bellstand. Unless all this happens, he gives up. This is matching my own inward nature, he says, with the inward nature of the tree, in his words, matching "heaven"—that

is, nature—with "heaven." That's why, he says, people wonder so much at the apparently more-than-human results of his carving.[7]

The poet Juan Chi (Ruan Ji) (210–63 CE), who was so careless of the Chinese rules of propriety that he ate meat and drank wine on the day of his mother's funeral, wrote a long prose poem in which he imagined a Master Great Man. This Master Great Man interacts with all kinds of lesser persons. Among them, he meets a woodgatherer, who sighs and sings, "We melt away or coalesce like clouds or mist." His hair flying loose on his shoulders and temples, Master Great Man answers (his grandiose outburst confined to a few sentences):

> Spirit is the root of Spontaneity. . . . You must transcend the world and break from the crowd, leave the vulgar and go off alone, climbing up beyond the Great Beginning, gazing upon the commencement of Chaos, your thoughts flowing throughout "that which has nothing outside it," your will immense and free, as you soar in the four seasons, flying and swooping in the eight cardinal points. The desires have full rein to roam at will, throughout the vast expanses of the universe without hindrance. You should not be blamed for neglecting the small rules of conduct, nor praised for being a saint or sage. . . . Embrace the entire universe and take it as your humble cottage. . . . Unite with that which is above [heaven] with what which is below [earth] to rule them together; differ from both the ancients and the moderns in your acts.[8]

As Juan Chi's text suggests, the Chinese idea that an artist ought to live a spontaneous life was nourished by stories of artistic abandon in which conventional morality was sacrificed for the sake of a life so fully natural that it expressed itself in fully inspired art. These stories make the point that impulse and intuition go far beyond anything that can be formally learned. The stories are an indispensable part of a tradition of anti-traditional abandon or, if not abandon, of disregard of conventional appearances and behavior. Understanding the advantages and not indifferent to the pleasures of letting go, poets and artists tried to gain all at once by drinking large enough quantities of wine.[9]

Among the many Chinese examples, it is hard to forget the mostly professional Chinese artists of the fifteenth and sixteenth centuries CE who were called and called themselves "crazy" ("crazy-stupid") or "wild," "wild" having the positive meaning of "impetuous" as opposed to "timid" or "merely conventional."[10] I'll not explain further here, and I'll not more than mention these artists' use, for spontaneity's sake, of "scribbling" (not lifting the brush between strokes) or "splashing" (use of ink so wet that the brushstrokes are obscured). They were, as they meant to be, picturesque characters. Even among them, Shih Chung (Shi

Zhong) (1438–c.1517) stood out, beginning with his reported inability to talk until he was seventeen. Afterward, he learned very quickly and revealed his many talents. As a biographer says, Shih was a man "of irrepressible nature, who rode around on a buffalo, his feet bare, wearing Taoist robes, with yellow flowers tied to his waist."[11]

Not only did the "crazy," "wild" artists produce art that was sometimes only barely controlled, but they might exhibit, or be reputed to exhibit, boldness in both manner and act, sustained by physical strength, skill in the martial arts, and great pride. Scholars might disdain the wild artists for being professionals, that is, artisans in the sense that they worked on order and for payment, but they were celebrated for their willful, powerful selves. The politically mighty, the socially grand, and the merely rich were happy to be their patrons. Those who admired boldly unconventional painters, even if they were professionals, were likely to praise their style for its "heroic spirit" or its "heroic, powerful spirit." Such painting, says the critic R. Barnhart, "has a force that sweeps all else before it. There is nothing here of the bitterness of self-restriction or measured ink, but only the purity of Natural Creation not availing of human strength."[12]

. . .

The theme of the artist's inspiration and heroic individualism having been sounded, I will develop it first by recalling how such traits were expressed in the two civilizations for which we have the fullest historical records, those of Europe and China. By an often-exercised license, I begin the account of European or Western culture with Egypt.

Is there anything in Egyptian art that is relevant to the theme of the importance of the individual? To answer, it is convenient to begin with the king's image, because the Egyptians had the habit of giving something of his generalized features to the other heads sculptured during his reign. During the period of the New Kingdom (1550–1069 BCE), the king's will to be recognized as a particular individual seems to grow stronger, and there is more evidence of artistic freedom.[13] The most spectacular evidence is given by the change in style and subject matter during the reign of Akhenaten (1352–1336 BCE), and the most spectacular of the changes is in the appearance of the king himself. His sculptor Bak (or Bek) insists that it is from the king that he has learned his art. What Bak seems to mean is that the king looks as he told Bak he wanted to look. Otherwise neither Bak nor anyone else would have been allowed to depict the king with such a strange appearance.[14]

At first, when he still bears the name of Amenhotep IV, this king is represented in a conventional Egyptian style, like that of his father, Amenhotep III.

But soon he is depicted very differently, with a long face, thick lips, a long chin, a thin and long neck, breasts almost as full as a woman's, a rounded belly, womanish hips, and extremely thin legs, The statues of the king's intimates tend to take on his appearance; his sculptor Bak is represented, for instance, with, for an Egyptian, an unusually bulging belly.

No one of the king's own time explains, so we are left with a choice between a number of unverified hypotheses. The change in appearance comes along with a change in the king's allegiance to a new form of the sun god, Aten (Sundisc). The king now adopts the name Akhenaten, meaning, "Aten's effective agent" or "Aten's creative manifestation," and regards himself as Aten's child and coregent. One explanation for this new appearance is that as a creator god Aten was androgynous, so the king may have wanted his own image to be one of fecundity, with both male and female traits.[15] A second explanation rests on Akhenaten's repeated statement that he is "someone who lives on—consumes—truth [maat]."Making use of the word maat in what for the Egyptians would be an extended sense, Akhenaton may be insisting that his image be true to his appearance.[16] But maat also continues to mean what it did earlier, which is "rightness," and "a true, just balance," rather than "real-looking." Thus, the explanation for the strange images of Akhenaten may be that they were accentuations of a new style and a new religious emphasis, both of which began during his father's reign. The images were daring expressions of Akhenaten's hope that nature's vitality, concentrated in the sun's rays, might be drawn on more effectively for the sake of human welfare.[17]

The last in my series of explanations is the simplest. It is that Akhenaten really did look strange and used his kingly privilege to insist that this was the way he wanted to be represented. His statues and reliefs reflect his appearance, exaggerated maybe by the sculptor's effort to go beyond the conventions he was accustomed to. The king—the sun disc, the mother "who gives birth to everything"—wanted to make his own image the official one and, in the Egyptian way, to affect the images of those who wanted to be like him.[18] However, if he really did look like his colossal statue by (it seems) Bak, he may have been malformed as the result of a glandular disorder, probably of his pituitary gland. If he did suffer from such a disorder, it was not severe enough to affect his potency—he had six daughters and, as art convincingly records, a happy family life.[19]

Regardless of which explanation is adopted, the art associated with Akhenaten's rule shows a will to expression that has been compared at its most pronounced with twentieth-century European expressionism.[20] There were many typical changes. In relief and painting, the figures' hands become longer and

more dramatically expressive. The king's children are represented in a more childlike way—the relief that shows him and Nefertiti, his queen, dandling their children on their knees is said to be the first example by anyone in Egyptian art of such open familial affection. Although faces remain stiff even in such new, more human art, emotional ties are indicated by gestures. These gestures are not of the hands alone. Courtiers raise their eyes to their king and queen, as the king and queen raise theirs to Aten, the power of whom is concentrated in the sun's disc and its extended, life-giving rays.[21]

What can we say about the pride or individuality of the Egyptian artists? A good deal is known about them from the reliefs they carved and painted of their own activity. Additional information comes from excavations, such as of the workers' village of Deir el-Medina (most active in the Ramessid period, 1295–1186 BCE). The workers who lived there were charged with the building and decoration of the royal tombs and mortuary temples nearby.[22] The necessarily modest tombs they prepared for themselves show their social status, self-respect, and individuality. At Deir el-Medina, the decoration of the tombs is unusually skillful and lively. While the motifs are conventional, the colors are bright and the drawing is relatively free. "The unusual attraction of these paintings lies in the generous handling of the flowing lines largely without correction, the sketchy details often indicated merely by a few strokes of the brush, and the application of paint that in places resembles that of watercolor."[23]

The joint tomb-chapel of the sculptors Ipuky and Nebamun, situated on the hill of Khoka, is a good example of artistic individuality. Its paintings contain hints, rare in Egyptian art, of open emotion: some of the mouths of the mourning women are distorted by sorrow; and the emotional isolation of the widow who faces the coffin of her husband is accentuated by her physical isolation from the other mourners.[24] There is more here than a traditional pattern of images to be read for its abstract meaning like a succession of hieroglyphics.

A word here about the standing of Egyptian craftsmen: We find Egyptian temple-craftsmen being addressed by their superior with a peremptory "Get busy" to finish the monuments in honor of the god Amun. But King Ramesses II (1279–1212 BCE) set up a column in a temple declaring his gratitude to his temple builders. They "work for the love of me," he says, "who am strengthened by your greetings."[25] In the tomb of one Amenemhat of Thebes we come on a rare artist-oriented picture: The host, Amenemhat, is inviting four seated men to share in a rich banquet. One of the men is the artist, Ahmosé, who drew the scene, and another, whose name has vanished, is a sculptor.

During the reign of Ramesses IX (1126–1108 BCE), we find that an official,

Setaou, First Prophet of the goddess Nekhabit, has given over the decoration of his tomb to the artist Mery-Re, whom he praises as no copyist. "His inspiration comes from his heart. No master gives him a model to copy, for he is a scribe of dexterous fingers and of good understanding in all things."[26] Another artist, Houy, who had the titles of "prince" and "scribe," paints himself prominently on a tomb wall in Deir el-Medina. We still see him there as he squats and, with his long hair falling over his shoulders, paints two statues, one of a king and one of the king's mother.[27]

Finally—I'm willing to say, inevitably—there is also the Middle Kingdom artist who on his stele informs posterity of his greatness. After boasting of his knowledge of divine words and magic, he goes on:

> Moreover I am an artist that excels in my art, a man above the common herd in knowledge. I know the proper attitude for a statue [of a man]. I know how a woman holds herself . . . , the way a man poses to strike with the harpoon, the look in an eye at its moment [in its fleeting glance], the bewildered stare of a man roused from sleep, the way a spearman lifts his arm, the tilt of a runner's body. I know the secret of making inlays that fire cannot melt or water dissolve. There is no man famous for this knowledge other than I myself and my eldest son.[28]

Egyptian art has been described as unchanging, and its artists are said to have been no more than ordinary workmen. But if we view it in its whole range, says scholar Claude Vandersleyen, we see how wrong it is to repeat the complaint that Egyptian artists had no sensibility of their own. Instead, he says,

> Egyptian art, which seems to the uninitiated so similar, often even monotonous, amazes even the connoisseur by the constant variability of its forms of expression. It must therefore be concluded that the "craftsmen" of this distant past were not less sensitive and creative than the artists of the last centuries.[29]

. . .

At first sight, the Greek potters, painters, and sculptors appear, like their Egyptian counterparts, to be no more than unpretentious craftsmen, on a level with craftsmen of any other sort.[30] In the Greek city-states, the aristocrats were usually landowners, who looked down on artisans and denied them the privileges of citizenship. To do continuous physical work was itself supposed by Aristotle to be degrading. But many of the Athenians who painted or made pots (or owned workshops in which the pots were made) signed their work, which sometimes has strikingly individual characteristics. Certainly, there is evidence among them

of pride in what they have created. In Athens, toward the end of the sixth century BCE, the so-called pioneers would make the usual overall black and leave the figures on the pot outlined on its red ground. Then, instead of finishing the figures as usual by incising lines inside them, they finished them with thin brushes dipped in black paint. This substitution of a brush-painted line for an incised one allowed them to draw with greater suppleness, virtuosity, and naturalism. All "consummate artists," together they had the coherence of a group. In the words of Nigel Spivey, "It is as though, for the first time in the history of Western art, we can here discern a conscious movement, a camaraderie of artists," who admire the same handsome youngsters and sometimes address one another on their vases.[31] These painters

> not only signed their names—Euphronius, Euthydemes, Smikros, Phintias—
> but drew caricatures of each other, cracked in-house jokes on the surfaces of
> their pots, and openly contested their respective abilities at drawing. On one
> wine jar Euthydemes drew three drinkers getting merry. . . . The central figure,
> shown moving sidewise but also looking backwards, is a particularly virtu-
> oso example of the degree of difficulty posed by the three-quarters view. . . .
> Euthydemes not only judged these lines perfectly, he knew it too, and in his
> signature on the work—"Euthydemes, son of Polias, drew this"—he could not
> resist adding, "as never Euphronios."[32]

Although the Greek artists were classified as craftsmen, there were some among them who were widely respected. In Xenophon's *Memoirs of Socrates* there is a point at which Socrates begins to persuade his interlocutor, Little Aristodemus, that the world is governed by an intelligent God, whose creations are the result not of chance but of design. In the course of the conversation, Socrates, looking for examples of the superiority of creation by design, thinks of artists. He asks Aristodemus if he has ever admired any persons for their artistry. Aristodemus answers, "Well, in epic poetry the man I have most admired is Homer, and in dithyrambic Melanippus, and in tragedy Sophocles, and in sculpture Polyclitus, and in painting Zeuxis." Aristodemus then agrees that all these were admirable because, by design and not by chance, all of the persons he had named "created things that are alive and intelligent and active."[33]

Polyclitus (active mid-fifth century BCE) was especially well known, as I have said, for his bronze Spearbearer, which was taken to demonstrate his rule for perfecting human figures by relating their parts mathematically to one another. A well-known anecdote about Zeuxis (active in the late fifth and early fourth century BCE) is that he painted grapes so realistic that birds flew up to them,

but that his rival, Parrhasius, painted a curtain so realistic that Zeuxis asked him to draw it aside and show the picture behind it. This drew the admiring comment from Zeuxis that while he, Zeuxis, had deceived birds, "Parrhasius had deceived him, an artist."[34] An anecdote told about Zeuxis (and in another place about Apollodorus) says that the painter wrote the words, "Easier to criticize than imitate" on one of his works. Zeuxis is said to have become too wealthy to go on selling his paintings—saying they were priceless, he gave them away. He is also said to have had his name woven on his cloak in golden letters and to have issued the following challenge to other artists, "If any man says that he has reached the boundaries of our art, let him show it and defeat me." His equally proud rival Parrhasius is said to have written on a painting, "The limits of art have been discovered by my hand," though with the addition, dictated either by a remnant of modesty or the fear of divine anger at his presumption, "but nothing done by humans escapes criticism."[35]

The sculptor most respected by the ancient Greek and Roman critics was Phidias (active c. 465–425 BCE). He was above all famous for his two huge gold and ivory statues, Athena in Athens, and Zeus in Olympia. He was also famous for his role in (most probably) supervising the making of the sculpture that decorated the outside of the Parthenon, and for his intimacy with Pericles. Among painters, the most famous seems to have been Apelles, the hero of many old anecdotes. An intimate of Alexander the Great (r. 336–323 BCE), he was the only artist allowed to paint him. "When in Apelles' Studio, Alexander talked often about painting although he had no specialist knowledge, and Apelles used to advise him politely to keep quiet, saying that the lads who ground the colors were laughing at him."[36] There is even a romantic-sounding story involving the artist, Alexander, and one of Alexander's mistresses, named Pancaste. On Alexander's request, Apelles painted the beautiful Pancaste in the nude and, like Praxiteles before him, fell in love with his model. Magnanimously, the king parted with her in favor of his painter.[37]

Apelles was famous for his "completely lifelike" portraits; his self-portrait seems to be the first one in Greece of which we know. In Greek eyes, he was a fabulously inventive portraitist, as he showed when he painted a portrait of King Antigonous, who had lost one eye:

> He was the first artist to devise a way of hiding the defect: he drew the portrait in three-quarters view, so that the missing eye would not appear in the portrait, and he showed only that part of the king's face that he could present intact.

Among his works there are people on their deathbeds. It is, however, difficult to say which paintings are the most celebrated.[38]

There is no way of verifying the anecdotes I've repeated. It would not be surprising if the later ones were embellished or invented to satisfy collectors of Greek art. But such anecdotes had their social importance and, even when exaggerated or false, created the public image of artists, whose original work grew scarce in time—of the works of the famous painters not even a verifiable scrap is left. Toward the end of the fourth century BCE, there was already enough interest in the lives of artists for Duris of Samos to write an anecdotal (mostly lost) *Lives of Painters and Sculptors*. By the first and second centuries of the common era, rhetoricians such as Quintilian, Dio Chrysostom, and Cicero were ready to compare the inspiration of the painter or sculptor with the inspiration of the poet. Quintilian writes of the different artists' distinctive kinds of excellence—the precision of Polyclitus, for example, and the majesty of Phidias's two great statues, which "added something to traditional religion." Dio Chrysostom believes that Phidias's images have helped humankind to grasp the divine nature. In an imaginary conversation, he has Phidias say that he had a harder time than Homer because he had to keep the vision of the divine in his mind all during the time he made the statue. Cicero, who points out that the arts mature slowly, finds the sculptures of Myron to be fairly close to nature and "beautiful," but those of Polyclitus "more beautiful" and even "quite perfect."[39]

Such favorable estimates of artists never became dominant. There were still echoes of Plato's and Aristotle's contempt for the artisan. An amusing imaginary conversation in *The Dream*, by Lucian of Samosata (c. 160 CE) shows how ambivalent about artists literate people might be. Lucian reports that as a child he used to scrape the wax from his writing tablets and use it to make models of oxen, horses, or people. When the time came for him to make his living, his father apprenticed him to his uncle, a sculptor. When he picked up a chisel and broke a slab of marble, his uncle lost his temper and beat him with a stick. He ran home sobbing and, still tearful, he fell asleep at night and dreamed that two women were fighting noisily over him. One woman, Sculpture, was rough, dirty, masculine looking, and, like his uncle at work, covered with dust. The other, attractive and neatly dressed, was Paideia, Education. Sculpture promises Lucian good food, sturdy shoulders, and a life lived comfortably at home. If he is successful, she says, then, like Phidias, Polyclitus, Myron, and Praxiteles, who were worshipped along with the gods they sculpted, he will become famous,

make his father everyone's envy, and make his native city famous. When it's the turn of Education, she says to Lucian, if you become a sculptor, you'll be only a workman,

> toiling with your body, earning a meager and mean income . . . one of the common mob, cringing before the distinguished, courting the articulate, living a dog's life at the mercy of your superiors. Even if you should turn out a Phidias or a Polyclitus and complete many wonderful works, though everyone will praise your craftsmanship, nobody who sees you, if he had any sense, would want to be like you. For regardless of your qualities, you'll be considered a working class artisan who lives by manual labor.[40]

It is obvious that Lucian took the way recommended by Education and became a writer, but his writing shows how knowledgeable he is about the famous masters of sculpture; and painting, in which his interest is stronger, engages more detailed attention. He says that "the great Zeuxis" was always trying to innovate and, having chosen an unusual subject, would use it to demonstrate his skill. After he saw a copy of a lost painting of Zeuxis of a mare centaur suckling two tiny centaur foals, he is able to describe it from memory in some detail. I'm no artist, he says, "but I well remember having seen it in a painter's house in Athens and the immense admiration for the painter's skill I showed at the time may perhaps help me in my efforts to depict it more vividly."[41]

In spite of the cultural dilemma described by Lucian, Greek and Roman collectors hungry for classical works of art must have found it unnatural to hold in contempt the artists who had created the works. Emperors such as Nero (r. 54–68 CE) and Hadrian (r. 117–38 CE) took up painting and sculpture, and in an age enthralled by the virtuoso performer, neither decent emperors nor wicked ones could resist the temptation to sing or to play a musical instrument. The dignity of the imperial office may have led Severus Alexander (r. 222–35 CE) to abandon the trumpet, but he continued with his lyre, pipes, and organ.[42]

From the perspective of attitudes toward art and artists, the great change was the increasing tendency to regard artists as visionaries, who by the penetrating quality of their insight could reveal what was hidden from ordinary mortals. The changes in the connotations of the Greek term *phantasia* form a record of this change. The term originally meant "appearance" and, psychologically (as in Aristotle), the soul's faculty that retains the images given to it by sensation. This meaning of *phantasia*, namely, the ability to visualize, remember, or imagine the likenesses of things became by a natural extension

roughly equivalent to our "imagination" and then also to "creative imagination" or "intuition."[43]*

The older sources of this extension of meaning include the dialogues of Plato. As a rule, Plato looks on poets as inspired madmen who, along with artists, mislead humans by their fictions or shadowy misrepresentations of reality. But Plato also suggests (in the *Timaeus* 28a–b) that when the maker of anything looks at what is always unchanging, not relative, and uses a model of it in making the form and quality of his work, everything he accomplishes in this way must be good.[44] Plotinus (205–69/70 CE), in his own eyes a faithful expositor of Plato, speaks, like Plato, disparagingly of art. "It makes only dim and weak imitations," he says in the *Fourth Ennead*, "bringing in many devices to help it in producing an image of nature." But in his *Fifth Ennead*, Plotinus develops Plato's favorable judgment and gives an eloquent account of art as an earthly representation that draws its beauty from a transcendental source. Plotinus draws out his argument over several pages, which, in spite of a certain repetitiousness, I cut short reluctantly:

> Let us suppose, if you like, two great lumps of stone lying side by side, one shapeless and untouched by art, the other turned into a statue of a god or of a man, of a Grace or one of the Muses, and if of a man not just of any man but of one whom art has made up of every sort of human beauty. . . . Now the material did not have this form, but it was in the man who had it in his mind even before it came into the stone . . . because he had some share of art. . . . The art does not simply imitate what they see, but they run back up to the forming principles from which nature derives; then also . . . since they possess beauty, they make up what is defective in things. For Phidias too did not make his Zeus from any model perceived by the senses, but understood what Zeus would like if he wanted to make himself visible.[45]

. . .

* *Phantasia* is one of three related ancient terms of praise. The second is the Greek *charis* (*gratia* in Latin) in the sense of "grace" or "charm." The third term is the Latin *ingenium*, meaning literally, "that which is born in one." It therefore means "natural ability," "talent," "inventiveness," and even "genius." Sometimes it appears to be the translation of a Greek term, but it is not clear which. It may carry the connotation, like *phantasia*, of "creative imagination." Like "genius," it belongs to a family of words related to procreation or origin by birth.

Like the ancient Egyptians and the ancient Greeks, medieval Europeans looked on painters and sculptors as craftsmen, not to be compared with aristocrats or those who practiced the liberal arts and made use of their intellects. As I have said, I will not deal here with the initiators of medieval building projects, or the masters of medieval works, or the architects, who were all indispensable to the great communal enterprises of the period, as the following quotation suggests:

> Over all these buildings hovers the shadow of exceptional men: some were bishops, such as Fulbert of Chartres at the beginning the eleventh or Maurice de Sully at Paris in 1161; some were abbots, such as William of Volpiano at St-Bénigne at Dijon, and Notre-Dame at Bernay at the beginning of the eleventh century; some were kings such as Philip Augustus in the twelfth century, or Frederick II in the thirteenth century; some were great lords such as Fulk Nerra, count of Anjou; some were urban communities, such as Florence, Milan and Siena. . . . Without their strength of purpose, cathedrals, castles, town halls and bridges would never have come into being. Their construction was an architectural manifestation of piety indispensable to the life of society, to its flowering and its happiness. Building was also a display of temporal power.[46]

It was not unusual for persons of lower social standing, such as the sculptors, illuminators, and goldsmiths, to show their pride openly. For the most part, it is a sign of their importance in their own or others' eyes that medieval artists sometimes signed their work and occasionally inscribed a few words in praise of themselves. Now and then there are a name and self-portrait on a stained-glass window or other work of art, to show who made it or who donated it. An example is the monastery window portraying Moses and the burning bush, with, below it, a portrait of the painter holding a brush in one hand and a pot of paint in the other. The inscription above the self-portrait reads, "O illustrious King of Kings, be favorable to Gerlachus."[47]

Unlike modern works of art, medieval ones do not seem to have been signed in order to prove their authenticity. In the case of larger, more complicated works, the signatures seem to be those of the supervising master artist, who may be represented together with an assistant. Some artists who signed their works seem to have been soliciting prayers in their behalf. Or it may have happened that an artist's employers wanted him to sign in order to show that they had called on someone known for his skill. But the explanation must also include the pride of the artist himself or herself—there were some women artists, for instance the nun who painted herself inside an initial of a twelfth-century German manu-

script, along with the words "Gulda, the sinful woman, wrote and illuminated this book."[48]* Examples of artists' pride were exceptions for their time. Even so, there was enough conscious innovation to have aroused Bishop Luke of Tuy to attack those who supported innovation, whom he accused of saying, "In order to avoid the dullness of accustomed formulas, the artist needs freedom to devise unusual motifs and to invent new ideas . . . to deepen love for Christ through the emotions they arouse."[49]

ISLAMIC HERO-ARTISTS

I place the Islamic artists, who were geographically both Eastern and Western, both non-European and European, between the artists of medieval and Renaissance Europe. The Muslims had an intense love for beautiful books, in which they invested great effort and large sums of money.[50] Since my general theme here is antitraditionalism in art, it would be too distracting to detail the painstaking training that a Muslim artist underwent, or the way in which a whole group of craftsmen and artists worked together in the royal workshops, where the greatest of the illuminated manuscripts were produced. Unless for such training and organization, how could one explain the manuscripts' superb assurance, complicated design, and masterly decoration? Or explain their finely drawn, ingeniously composed, brilliantly colored, glittering, lovingly polished miniatures?[51]

Now that we have come to medieval miniatures, something should be said about the traditional Muslim opposition to images of living things—living things with souls, that is, which plants are taken to lack. There are no representations of living things in mosques and no figurative illustrations in the Koran. A few Koranic passages directed against idols, as their context shows, use a word

*During the Middle Ages, the signing of works of art was sporadic and accompanied by little if any information. Signatures on French Gothic sculptures, unlike those on the Italian, are rare, and the illuminators of France and Germany in the tenth and eleventh centuries signed much less frequently than their Spanish colleagues. No reason is known for these differences, which we can attribute, without understanding them any the better, to different social habits. Yet the names of thousands of medieval artisan-artists are known. In the twelfth century, there is more evidence of artists' self-satisfaction. The facade of Modena Cathedral bears an inscription reading, "How worthy you are of honor, Wiligelmus, to be famed among sculptors for your sculpture." In the same century a sculptor named Natalis inscribed on a carving, "God has created everything. Man has remade everything. Natalis made me." And in the Canterbury Psalter, the scribe Eadwine identifies himself triply, by means of his name, his full-page self-portrait, and his description of himself as "the prince of scribes."

for idol that means "statue" as well. The Koran also has passages praising the omnipotence of God, such as, "God is the Creator of everything, and he is the Guardian over everything." This thought leads to the traditional doctrine that says that whoever makes pictures of living beings shows a presumptuous desire to imitate God and deserves to be punished. Therefore "those who make these pictures will be punished on the Day of Judgment by being told: 'Make alive what you have created.'"[52]

Some of the earlier interpreters of the tradition held that only whatever cast a shadow, that is, a statue, is outlawed.[53*] But it was not until later periods of Islamic history that the prohibition against images of living things became generally effective in secular life. One of the arguments used to counter the reluctance to make images of living things was the "theory of the two pens," according to which the Koranic approval of the calligrapher's reed applied to the artist's brush just as well.[54]

By way of introduction, I add a further word, on the aesthetics of Persian, that is, Iranian painting, first on its colors, and then on its rhythmic organization. I draw without shame on the words of those who know this art by long, acute observation. As Stuart Cary Welch explains:

> In Iranian miniatures the palette not only forms a visual "chord," like a cluster of musical notes, but it also can be enjoyed bit by bit. It is a great pleasure, for example, to look at a miniature for the pattern of blues, reds, or whites alone. Perhaps the most characteristic element in Iranian painting is its use of arabesque, the rhythmic design based upon flowering vines that invigorate most Islamic art. Like a pulse, the reciprocal rhythms of this ornamental system suffuse and unify all Iranian compositions. Without it, these paintings would

[*] A summarizing account by the thirteenth-century jurist al-Nawawi reads in part: "The great authorities of our school and others hold that the painting of an image of any and all animate beings is strictly forbidden and constitutes one of the capital sins because it is threatened by all the punishments cited above as mentioned in the traditions, and this is regardless of whether it be for a domestic use or not, Thus, such fabrication is forbidden in any and all circumstances because it implies a copy of the creational activity of God . . . ; on the other hand, the painting of a tree or a camel saddle or other objects without life is not forbidden. . . . Certain later authorities have applied the interdiction only to objects casting a shadow and see no evil in objects lacking in such a shadow. But this point of view is entirely false, because the curtain that the Prophet pronounced against was certainly condemned, and yet the image it bore on it threw no shadow."

be as unthinkable as an orchestra playing a Bach suite without rhythm. With it, they are the visual equivalent of poetic verse.[55]*

In miniatures, such color and design are used to create a rich library of princely dreams. In these dreams, the main characters are all beautifully dressed, all appear in beautiful surroundings, and all are as immaterial as those in a shadow play. As Oleg Grabar describes, in the dreams, "a whole art of representation is created that is two times removed from any possible reality: bodiless people play at creating an illusion of events. . . . One transforms everything into a game of theater."[56] There is also the immaterializing presence of decorative borders, burnished gold, blackening silver, beautiful color-flecked paper, and precise, inherently beautiful calligraphy. It all becomes a familiar kind of show, because the human figures are mostly conventional types and, for the most part, are set in typical postures and grouped in typical ways.

For example, the old woman who comes to complain to Sultan Sanjar always appears in the same manner, in profile, bent over and toothless, or the warriors of the epics and the lovers of the romantic poems are shown in the same standard poses and with the same absence of expression only barely illuminated by simple gestures. But whatever the variations, it is only in some of Bezhad's paintings and in the great *Book of Kings* of Shah Tahmasp—and also, of course, in the mysterious Black Pen of the albums—that human figures escape in part from the traditional conventions of a theater of forms.[57]

Yet dematerialized as they are, these characters are likely to be humanly connected, like the Egyptian figures of Akhenaten's time, by the directions of their gaze and by a vocabulary of gestures, to us often unintelligible. The overriding conscious or unconscious aim is to reflect the universal harmony of everything with everything, in a cosmos that is incessantly renewed by Allah's crea-

* According to Alexandre Papadopoulo, "The Muslim artists were highly sensitive to the densities of color areas, and this constituted one of the chief variables in the autonomous world of their compositions. The consequence was what we can call a logic of densities. Each fabric pictured in a miniature makes up a patch of solid color without internal modulation but filled with decorative motifs—'atoms' if you will—that are unvaried within any particular patch of color and constitute a 'group' or 'ensemble' in the mathematical sense of those terms. . . . All the various surfaces or color areas in a picture are involved in never-ending dialogues with each other and all others, and these are determined by their respective densities as well as by their typological relationships to each other and within the whole."

tive power. This is the harmony that is so deeply embedded in Islamic theology, mysticism, and, often, science and literature. It is safe to assume that something at least of the mystical attitudes of Islam finds its colorful correspondence in the miniatures. But in the absence of compelling evidence, it is more plausible to assume that the mysticism adds an indefinite aura to an art that is loved for its own colors, sights, and stories, for the pleasure it gives, not for an esoteric doctrine it embodies.

The rulers and artists I will describe are conscious and conspicuous violators of the prohibition against images of animate beings. This violation is most open among the Mughals (Moguls), who ruled most of India from the sixteenth to the nineteenth century. The most attractive of them, Akbar, who ruled India from 1556 to 1605, was endlessly curious and open to every idea and every religion. He appreciated, organized, and rewarded his painters, whose work he reviewed every week. As described by Abu'l Fazl, a contemporary historian, the result was that "the minuteness in details, the general finish, the boldness of execution, etc., now observed in pictures, are incomparable; even inanimate objects look as if they had life."[58]

Akbar wanted the natural world recorded, and realistic portraits made. He was interested in the European pictures, mostly engravings, that reached his court and did not at all object to their influence on his own painters. He favored portraits, individual and collective. Abu'l Fazl writes that "His Majesty himself sat for his likeness, and also ordered to have the likenesses taken of all grandees of the realm. An immense album was thus formed: those that have passed away have received a new life and those who are still alive have immortality promised to them."[59] Abu'l Fazl says that in his time more than a hundred painters had become famous as masters. The Hindus among them, he says, are especially masterful, and he briefly describes four of the Hindus of Akbar's workshop who especially won the emperor's favor. The third of these, whom I recall for his brilliance and for the possible reflection of his disturbance in the character of his art, was Daswanth (or Dasvanth or Dasvanta). "Urged by a natural desire," this son of a palanquin bearer who served the workshop,

> used to draw images and designs on walls. One day the far-reaching glance of His Majesty fell on those things and, in its penetrating manner, discerned the spirit of a master working in them. Consequently, His Majesty entrusted him to the Khwaja [Abd as-Samad]. In just a short time he became matchless in his time and the most excellent, but the darkness of insanity enshrouded the brilliance of his mind and he died, a suicide. He left several masterpieces.[60]

Few of Daswanth's works survive. What I have to say about him is on the strength of a description of the illustration he made to a Persian translation, commissioned by Akbar, of the Hindu epic, the *Mahabharata*. The illustrated manuscript, called the *Razmnana (Great India)*, was finished in 1586. Akbar ordered his chief nobles to have copies made so that this Hindu classic would become familiar throughout his empire. The description makes it seem that only an artist with an extraordinary ability to call up ominous fantasies could have designed such a "visually irrational" illustration of an assault by night on one of the combatant armies:

> *A Night Assault on the Pandava Camp*, designed by Daswanth, shows the ghoul-ish Kal-ratri emanating from a corpse and drinking the blood of battle vic-tims. A vision related to Tibetan and Tantric imagery, it possesses extraordi-nary power and directness. The demoness wears a necklace of freshly severed heads, and the skins of flayed animals. These are iconographic traits, however; it is the style that creates the impact. Here there is no defined or definable space, but neither is it flat. Kal-ratri hovers suspended, and even the surround-ing encampment does not anchor the scene. At every point where a horizon-tal or vertical might create stability, overlapping forms instead cause spatial ambivalence. It is a perfectly conceived presentation of an otherworldly being, and its technical and aesthetic complexity defines the highest level of imperial painting at the time.[61]

The emperor Akbar, who underwent a mystical experience and grew disillu-sioned with Islam, came to invent a monotheistic religion of his own, the Divine Faith, as he called it, which drew on Islam, Hinduism, Zoroastrianism, and Christianity. Independent and curious, he was not troubled by the violation of Islamic tradition implied in his love for images of all kinds. The grounds for his violation were the reverse of those on which the prohibition against images was based. His chronicler records his words:

> There are many that hate paintings; but such men I dislike. It appears to me as if a painter had quite peculiar means of recognizing God; for a painter in sketching anything that has life and in devising his limbs, one after the other, must come to feel that he cannot bestow individuality upon his work and is thus forced to think of God, the giver of life and will thus increase in knowl-edge.[62]

The emperor Jahangir, Akbar's son, who reigned from 1605 to 1627, inher-ited his father's curiosity and love for art and artists. Though his workshops of

artists and craftsmen were much smaller than Akbar's, his demands, too, helped to forge the new, Mughal style of painting among the artists of different origins who served him. Less interested than his father in illustrated narratives, he collected individual paintings on every subject that struck his fancy.[63] He wanted the real world, animal and human, captured in his gorgeous albums, in any current style, European no less than Persian, Hindu, or Turkish. But realism of any style apart, he appreciated the individuality of his artists and prided himself on his ability to distinguish the work of each of them, so it can be assumed that Jahangir's artists took their individual traits as seriously as did their patron. Jahangir writes in his chronicle:

> My liking for painting and my practice in judging it have arrived at such a point that when any work is brought before me, either of deceased artists or of those of the present day, without the names being told me I say on the spur of the moment that it is the work of such and such a man. And if there be a picture containing many portraits, and each face be the work of a different master, I can discover which face is the work of each of them. If any other person has put in the eye and eyebrow of a face, I can perceive whose work the original face is, and who has painted the eye and eyebrow.[64]

It is Jahangir's appreciation of artists' individuality and his curiosity about the world that justify the attention given to him here. His curiosity, taken to an extreme, is responsible for the drawing called *The Dying Inayat Khan* and the painting based on it, which are portraits of one of his intimates. A few days before the portraits were made, Inayat Khan had petitioned Jahangir for permission to go back home. When Jahangir learned that Khan had grown sick and weak, his reaction, as he tells the story, was this:

> I ordered him to come into my presence and obtain leave. They put him in a palanquin and brought him. He appeared so low and weak I was astonished. . . . Though painters have striven much in drawing an emaciated face, yet I have never seen anything like this, or even approaching to it. Good God, can a son of man come to such a shape and fashion?
>
> As it was a very extraordinary case I directed painters to take his portrait. . . . Next day he traveled the road of non-existence.[65]

I return now from India to Iran, and from royal patrons—the Akbars, Jahangirs, and Iranian kings—to a few great Iranian artists. I neglect the Iranian calligraphers, whose art requires a more technical exposition, in favor of the painters of miniatures. But I cannot resist beginning with an example of how

the desire to be a calligrapher can generate the kind of consuming passion that we associate with Western romantic conceptions of the artist. The calligrapher is Maulana Sultan-'Ali. I quote from the verse "Epistle" he wrote in 1514, when he was seventy-four years old. Looking back on his youth, Maulana recalls that his love for calligraphy led him to forget food and sleep and spend day and night practicing. But the effort did not earn him the recognition he desperately needed, and at the age of twenty he lapsed into depression. Speaking to himself, he said, as the old Maulana remembers it:

> Oh my heart! It is better to say "farewell" to writing
> And to wash the traces of script off the tablets of my heart,
> Or to write in a way that people should talk of it
> And entreat me for every letter.[66]

In a renewed access of zeal, Maulana withdrew from all human company and perfected his art, which at last earned him fame. As far as the story goes, this is a happy ending in the romantic style.

Even though Iranian painters had to serve their patrons, some of them became increasingly and self-consciously individual. To show how their individualism developed, I begin with the best known of the fifteenth-century painters, Bizhad (or Bezhad). His greatness is acknowledged by his contemporaries, though in terms that are more rhetorical than informative. Many of the manuscript illustrations attributed to him do not bear his name (if a name does appear, it is often a name added not by the illustrator but by the calligrapher who wrote the manuscript's text). Convention did not yet demand that an artist sign his work. But though Bizhad is clearly working according to a convention, the skill with which he evokes it is extraordinary. The humans who appear in his paintings are not the usual illustrator's puppets. Like everything he painted, they are closely observed, in a style that is exact, rich, balanced, and poetic.

> Even when he was absorbed in technical innovation, and built up pigments to suggest rough textures so thickly that they have cracked and flaked, he never weakened his poetic vision by virtuosity. . . . The settings with their exquisite arabesques are elaborate, the colors rich, the costumes detailed, the characterization of people and animals psychologically penetrating, none of the elements outweighs the others. In these miniatures Bizhad's work is always harmoniously balanced—mind and body, intellect and intuition, are fully integrated.[67]

Bizhad succeeds in developing the convention in which he works to the height of its perfection, to a moment of balance without excess or exaggeration. Of him

personally we know very little, so presumably he was not eccentric in any obvious way. For this reason he makes a good foil for the more openly individualistic artists of a later period, beginning in the last quarter of the sixteenth century. During this time and during the following century, paintings and drawings are signed more often—artists want their work to be known as theirs. In Iran and Mughal India, the artists themselves and the paintings they make become more openly individual. The pictures kept in albums are now almost freed from the texts to which they were once quite subservient. Artists' careers are now more often and more fully recorded, and it is apparent that individuality and temperament have become more closely identified with the occupation of the artist. We read of temperamental, neurotic, and even psychotic artists, and see the suspicion beginning to arise that such traits are characteristic of anyone who becomes an artist.

This suspicion is nourished by the sixteenth-century artist Sadiqi (1533–1610), also called Sadiqi Bek or Sadiqi Bey. Sadiqi, who rose to a high position, wrote two works on art and artists in a self-revealing and not especially modest way. He was convinced that to be an artist is to be an unusual person, one who follows a remarkable, sometimes noble career, even an eccentric one. Records of his time do, in fact, report on artists who are at best temperamental. We read that Hasan Baghdadi was dangerous, malevolent, and treacherous, and that 'Abd al-Aziz and 'Ali Asghar abducted a favorite catamite of the shah and forged the shah's seal.[68] We learn much more, however, from the work and character of well-known artists like Sadiqi, and along with him Riza (c. 1565–c. 1635), who is also called, to the confusion of later historians, Aga Riza and Riza-i Abbasi.

To begin with the art of these men, we are told (and can attempt to see in reproductions) that Sadiqi's illustrations to books are relatively original. They are described by Oleg Grabar as having

> clear and rigid separations between segments of the landscape, with rocks into cubist masses, personages uneasy in spaces too small for them, sometimes imitations of former styles that are almost pastiche. By contrast the manuscripts illustrated by Riza-i Abbasi have flatter colors and more animated human figures in varied poses and gesticulations.

Both artists made pen drawings and brilliantly colored paintings. There are many subjects, all heavily stylized, but most of the pictures are of anonymous standing figures of a man or woman, usually young, richly dressed, and, with the artist's help, strongly curved, The pictures look like idealized portraits, but the faces are expressionless and the stylization is so strong that it verges on caricature. There

are also pensive, bearded old men "lost in thought that is hard to think of as profound." These figures are very easy for us to read graphically but hard to interpret in a social sense because we know nothing of them as persons and the pictures reveal little emotion. "Maybe, like caricatures, they are intended to be social criticism, but the visual evidence is too unclear to make this certain."[69]

Qazi Ahmad, a contemporary of Riza who wrote a history of calligraphers and painters, believes that Riza almost willed himself to be unhappy. He says that Riza "became the marvel of the age in the art of painting and unequaled in portraying single figures." But delicate as Riza's touch is, Ahmad complains, he engages constantly "in athletic practices and wrestling" and associates with "low persons" instead of men of talent. Though he has repented to a certain degree, "he has become ill-tempered, peevish, and unsociable. But the truth is that there is a certain strain of independence in his character." In spite of all the shah's help and consideration, "on account of his evil ways he has not taken warning and consequently is always poor and in distress."[70]

Sadiqi was well born enough to associate with the elite of Iran. For a time, he studied with Mir San'i, an ascetic, subtle calligrapher and poet, whom he met at a time when San'i had fallen into a burning, consuming passion for a young man. Sadiqi tells of himself how he too "was seized with love" for a boy named Badr, but finally "the flame of my affection cooled, and my affection changed into indifference." Sadiqi was thirty-five then, and the time arrived when he came to feel an overpowering impulse to sacrifice everything for the sake of art:

> Due to an innate inclination for higher things, my inner self at times could hear a voice which said: "You should renounce the companionship and the customs of these sultans; you should forgo covetousness and their dalliance; mark my final words and never forget them. Your true vocation is art; search for it unflaggingly for the rest of your life. Follow it relentlessly and hold onto it forcefully. For life without art is bleak."[71]

Sadiqi gave in to the impulse. His heart, he says, "experienced nothing but thoughts of pure joy." The quest for his true profession, art, "grew steadily more passionate," and he was drawn on by "only one real aspiration—to be inspired by a touch of the Bizhad." Luckily, he met "a savior" who could transmit this inspiring touch. This was Muzaffar, a forbearing, righteous man and an incomparable teacher who had been an apprentice and then a "beneficiary" of Bizhad himself.[72]

I will not go on with the detailed, adventurous life of Sadiqi except to describe its sad end. Sadiqi became familiar with the shah's court and is described by

someone who knew him there as a very good poet, a man who regards himself highly, and a painter who "brought the harmony of colors, portraiture, and details to such perfection that men of clear vision are amazed in contemplating his work."[73] For a brief while, in 1576, Sadiqi was close to Isma'il II, the talented, suspicious, drug-ridden shah. A terrible head of government but a sincere, enthusiastic patron of the arts, the shah was poisoned before long, leaving the throne to a successor far less interested in art.

Art having lost its luster, and his power and position gone, Sadiqi, dressed as a dervish, left the court and traveled in western Iran until he came on the governor of Hamadan, who admired him enough to become his patron. Sadiqi taught both painting and poetry, and when his patron moved to Tabriz, Sadiqi moved to another city and found another patron; but politics made him move on again and again. About 1585, the new shah appointed him to the enviable post of head of the royal library. This appointment put him in charge of the production of manuscripts. By then, Sadiqi had a reputation for a bad temper and is described as disagreeable, jealous, suspicious, self-seeking, and extremely impolite to his friends and associates, but he managed to keep his post for ten stormy years. At the age of sixty, as he shows in the colophon to a new manuscript, he still thought of himself as "the rare man of the time, the second Mani and Bizhad of the Age."[74]

Then his rival 'Ali Riza, who was becoming celebrated, somehow got Sadiqi removed from his post. Sadiqi's difficult personality may have caused his fall, but there is likely to be another reason for his disgrace: as described in the memoirs of the Mughal emperor Jahangir, Sadiqi stole and sold an old, well-known, and precious painting that belonged to the shah, representing

> the fight of Sahib Qiran [Timur] with the Tuqtamish Khan, and the likeness of him and his glorious children and the great Amirs who had the good fortune to be with him in that fight, and near each figure was written whose portrait it was. In this picture there were 240 figures. . . . The work was very complete and grand, and resembled greatly the paint-brush of Ustad Bizhad[75]

Although Sadiqi was allowed by the shah to keep his title and salary, he lost the power of his office to Riza.[76] Until the time of his death, he remained active as a court artist, but his power was gone and his bitterness was no doubt finally justified by the downfall he had brought on himself.

HERO-ARTISTS OF THE EUROPEAN RENAISSANCE

In his *Lives of the Painters, Sculptors, and Architects,* the first edition of which was published in 1550, Giorgio Vasari gives many examples of artists' eccentricity,

pride, and extraordinary devotion to work.[77] These examples foster the image that was in time to become that of the romantic artists. From Vasari and other Renaissance writers, we learn that Masaccio's passion for art made him careless in everything else; that the same passion for art kept Christofano Gherardi from noticing that his shoes were mismatched or his cloak was worn wrong side out; that Bartolomeo studied anatomy with the help of fragments of corpses strewn around his room; and (to change countries) that Jan Lys would forget to eat or sleep for days on end. Speaking of the passion of artists to go on with their work, a witness, Matteo Bandinelli, remembers that

> Leonardo had the habit—I have seen and observed him many a time—of going early in the morning and mounting the scaffolding, since the Last Supper is rather high off the ground, and staying there without putting down his brush from dawn to dusk, forgetting to eat and drink, painting all the time. Then, for two, three, or four days he would not touch it and yet he would stay there, sometimes one hour, sometimes two a day, wrapped in contemplation, considering, examining, and judging his own figures.[78]

Like some of the Chinese painters I will soon describe, Pontormo would often work only "when and for whom he pleased." He refused even noblemen, even "the excellent Ottaviano de' Medici," but "would go and do anything in the world for some low and common fellow at a miserable price."[79] Vasari also tells of one Jaccone, who drew with bold skill but would lose himself in jesting, "going off into cogitations, feasting, and speaking evil of all and sundry." He and the "gang of friends" he belonged to simply negated the ideal image of the artist that Vasari so wanted to draw. They never washed, he says, or swept their houses, or made their beds except once in two months or so.

> They laid their tables with the cartoons for their pictures, and they drank only from the flask or the jug; and this miserable existence of theirs, living, as the saying goes, from hand to mouth, was held by them to be the finest life in the world. But since the outer man is wont to be a guide to the inner, and to reveal what our minds are, I believe, as has been said before, that they were as filthy and brutish in mind as their outward appearance suggested.[80]

Everything considered, even Vasari's mistakes, it's lucky for us that he was so fond of a good story—the reader, like the historian, needs some compensation for an endless procession of facts. The better the story is, the more stubbornly it takes root in memory and the more likely it is to color one's perception of the Renaissance. Yet a careful analysis of Vasari's work shows that his

main aim was not to emphasize the picturesque, eccentric, or (in our terminology) the neurotic. It was, instead, to demonstrate that artists were cultured and worthy of much more respect than ordinary craftsmen. He himself had gained respect, success, and wealth as an artist. "He achieved this not by being temperamental and unpredictable, but through being reliable, efficient, and willing to serve. Ironically, the virtues that he extolled are not the ones for which the *Lives* are now read."[81]

The image that Vasari preferred, of the artist as a true, cultivated gentleman, was in the process of formation. Well-known examples are Titian, Mantegna, and the learned, graceful, princely Raphael. Bernini was famous for his conviviality, his brilliant conversation, and his aristocratic manner, which could be leavened by an aristocratic wrath. Rubens, man and painter, was a phenomenon.[82] His will to paint was tremendous, and his paintings, composed like torrents intertwined, were viscerally profuse and fleshly. Yet he lived an equable, orderly life, and he was tolerant, learned, acute, and charming enough to make him an aristocrat aware of his own worth, as well as a valued diplomat. In the seventeenth and eighteenth centuries, Italian artists not infrequently became members of aristocratic households and lived on the salaries their patrons gave them. The artists' self-portraits show them as men of the cultured world, serene and maybe complacent.[83] The unserene exception was Salvator Rosa (1615–73), who craved artistic independence and fame. A prospective patron was turned away with the words, "I do not paint to enrich myself, but purely for my own satisfaction. I must allow myself to be carried away by the transports of enthusiasm and use my brushes only when I feel rapt."[84]

Though it is exceptionally easy to remember stories about artists' strangeness or gentility, what impresses the memory even more, it seems to me, are the stories or the vision of the artist as an omnicompetent human being, metaphorically comparable to God himself. To put this vision in terms of the paradigmatic persons in whom it appeared to be realized, we need only recall Leon Battista Alberti (1404–72), Leonardo da Vinci (1452–1519), and Michelangelo Buonarroti (1475–1564).

Scholars now are divided over Alberti's importance as an architect and the influence his writings had on painters and architects. His treatises on art had no immediate successors, and the humanistic writers of his time were more likely to be interested in "the poetics of praise."[85] Yet Alberti continues to represent a Renaissance ideal, eloquently expressed in Burckhardt's *Civilization of the Renaissance in Italy*. Omitting most of the pains and doubts expressed by Alberti in his anonymous autobiography, Burckhardt sings a paean of astonished praise.

"In all by which praise is won," he begins, "Leon Battista was from his childhood the first." He explains that "the deepest spring of his nature" was "the sympathetic intensity with which he entered into the whole life around him," and he ends by acknowledging an even greater, more astonishing human being, Leonardo, who, he says, "was to Alberti as the finisher to the beginner, as the master to the dilettante."[86]* Vasari does not hesitate to say that Leonardo was one of the individuals in whom "celestial influences" had united measureless "beauty, grace, and talent":

> This was seen by all mankind in Leonardo da Vinci, in whom, besides a beauty of body never sufficiently extolled, there was an infinite grace in all his actions; and so great was his genius, and such its growth, that to whatever difficulties he turned his mind, he solved them with ease. In him was great bodily strength, joined to dexterity, with a spirit and courage ever royal and magnanimous; and the fame of his name so increased, that not only in his lifetime was he held in esteem, but his reputation became even greater among posterity after his death.[87]

Yet praise Leonardo as he does, Vasari is able to raise the pitch of his rhetoric somewhat higher when he comes to Michelangelo. Vasari counts it among his greatest blessings to have been born at a time when Michelangelo was alive and to have had him as a master, friend, and intimate. While "noble and industrious" spirits, he says, were trying in vain to use their art to imitate Nature's grandeur, God, having seen "the infinite vanity of their labors," decided "to send down to earth a spirit with universal ability in every art and every profession, who might be able, working by himself alone," to show what perfection is in painting, sculp-

*The scholar Anthony Grafton, summarizes Alberti as he was at the end of his career, in the following words: "The Alberti of 1472, like the Alberti of the 1430s, was still a master builder. . . . He still hoped for glory. . . . A prophet of individualism and the cult of glory, a tightrope performer of self-creation, Alberti knew, as he always had, that if he lost his audience, the lights would be extinguished, the curtain would fall, and he would find himself alone and lost in the dark, unable to move his audience. In the last years of his wonderfully productive life, he kept busy, as he always had. He thereby avoided the lethargy and depression that had always threatened him. But he did more as well. He made his life, until the end, a conscious performance and a continuous act of reflection on the problems that had gripped him since his troubled, isolated youth. Nothing that he built of stone expressed Alberti's ideals more fully than his lifelong effort to create a rich and responsive social world: to make, out of the rhetoric he prized so deeply, not only an art of composition, but a model for all forms of intellectual and artistic community."

ture, and architecture. Forgetting for the moment how difficult a man Michelangelo could be, Vasari goes on:

> He was pleased, in addition, to endow him with the true moral philosophy and with the ornament of sweet poesy, to the end that the world might choose him and admire him as its highest exemplar in the life, works, saintliness of character, and every action of human creatures, and that he might be acclaimed by us as a being rather divine than human. . . . He chose to give him Florence, as worthy beyond all other cities, for his country, in order to bring all the talents to their highest perfection in her, as was her due, in the person of one of her citizens.[88]

This panegyric is a Christian, Renaissance variation on praise of the kind we have heard earlier in this chapter. That the true artist has a special relation to God was a familiar idea to both Leonardo and Michelangelo. Leonardo, who thought that the artist was engaged in re-creating God's original creation of the universe, wrote in his notebooks:

> He who despises painting loves neither philosophy nor nature. If you despise painting, which is the sole imitator of all the visible works of nature, you certainly will be despising a subtle invention which brings philosophy and subtle speculation to bear on the nature of all forms—sea and land, plants and animals, grasses and flowers, which are enveloped in shade and light. Truly painting is a science, the true-born child of nature, for painting is born of nature, but to be more correct we should call it the grandchild of nature; since all visible things were brought forth by nature and these her children have given birth to painting. Therefore we may justly speak of it as the grandchild of nature and as related to God [see Dante's *Inferno* 11.105, "Si che vostr' arte a Dio quas è nepote"].[89]

"GENIUS"

Throughout the period we know as the Renaissance, the old word *genius*, meaning "guiding spirit," was undergoing a marked change. It never quite lost its original meaning but accumulated others, which came to dominate.[90] By degrees it was applied to one's nature or character, or one's particular gift. Ancient nuances helped to make the word usable to express a person's spontaneity or spontaneous inventiveness, as contrasted with reason. In the later seventeenth and eighteenth centuries, this belief in genius and disbelief in imitation and academic study

found support in such great "natural" geniuses as Homer and Shakespeare, though for Germans, it was Goethe who became the most cited example.[91]

A particularly influential argument for original genius, Edward Young's *Conjectures on Original Composition* was published in 1759 and immediately translated into German, in which it was extremely successful. Young's praise for Shakespeare is briefly qualified by a remark on his "faults," but his praise for originality as against learning and imitation is filled with strong rhetorical antitheses, the spontaneous good being balanced against the ineffective, imitative bad. "An original may be said to be of a vegetable nature," Young says, and goes on, "it rises spontaneously from the vital root of Genius; it grows, it is not made." In contrast, "Imitations are often a spirit of manufacture wrought up by those Mechanics, Art and Labour, out of pre-existent materials not their own."[92]

That one has or is a genius, says Young, may take one unawares:

> That a Man may be scarce less ignorant of his own powers, than the Oyster of its pearl, or a Rock of its diamond; that he may possess dormant, unsuspected abilities, till awakened by loud calls, or stung up by striking emergencies; is evident from the sudden eruption of some men, out of perfect obscurity, into publick admiration, on the strong impulse of some animating occasion, not more to the world's great surprise, than their own.[93]

Young's moral is not merely that natural genius is essentially creative and therefore deserves far more respect than imitation or learning, but that everyone should search oneself for signs of hidden native genius. "Delve deep into thy bosom," Young exhorts,

> learn the depth, extent, biass, and full fort of thy mind, contract full intimacy with the Stranger within thee; excite, and cherish every spark of Intellectual light and heat, however smothered under former negligence, or scattered through the dull, dark mass of common thoughts, and collecting them into a body, let thy Genius rise (if a Genius thou hast) as the sun from Chaos; and if I should then say, like an Indian, worship it, (though too bold) yet I should say little more than my second rule enjoins, (viz.) Reverence thyself.[94]

Among the many fervent examples of praise of the genius, I choose a few for their eloquence or importance. It is hard to skip the short, pointed sentence that appears in a book by William Duff published in 1770: "A man of Genius is really a kind of different being from the rest of his species."[95] I'd feel it wrong not to recall, if only in a sentence, the voice in which William Blake spoke in

favor of Imagination, Genius, and Infinity.[96] I'd also feel it wrong not to bring up a remarkable knot of (sometimes estranged) friends, all Germans, each important in his own right: Wilhelm von Humboldt (1767–1835), Johann Gottfried von Herder (1744–1803), Johann Wolfgang von Goethe (1749–1832), Friedrich von Schiller (1759–1805), and Immanuel Kant (1724–1804). I call them a knot (though I cannot aim to unravel it here) because these thinkers were acquainted with and influenced one another, and also because in them one sees how the two themes of the inevitable dependence of art on rules and of the unintelligible, ruleless creativity of genius become knotted together.

Humboldt revels in an emotional exaltation of the artist. When surveying the path taken by any poet or artist, he says, "We are overwhelmed by the realization with what a simple aim he starts and what incomprehensible heights he reaches as he executes that aim." The poet or artist makes the world around him "a completely individual, living, harmonious," self-sufficient whole and by this transformation transforms "his own inmost and best nature into a creation with which he can then completely sympathize." The artist, says Humboldt, "makes nature (by which we mean everything that can have reality for us) into an object of the imagination." For this reason "we may call art *the objectification of nature by the imagination.*" Humboldt believes that, in a way that cannot be fully proved, investigated, or even wholly thought, the great poet or artist is taken up as a great spirit by contemporaries and handed down as a heritage to later generations.[97]

Herder agrees with Young's view of natural genius. He interprets Young to mean that to draw on the power of original, spontaneous genius is to be yourself not only as an individual, but also as a member of the culture into which you are born. To be yourself, he says, means to abandon imitation as such and also to abandon the imitation of the literature and art of other, alien cultures. Herder's views converted Goethe to the profession of writer. Having met Goethe when the latter was a young law-student, "Herder opened Goethe's ears to the power of folk poetry, encouraged him to look in Homer, Shakespeare and the Bible for instances of powerful, apparently unsophisticated expression of intense experience." Goethe's adoption of Herder's view of original genius inspired him to find this genius in himself.[98] At the beginning of his literary life, Goethe denounced the general principles and traditions of art, which "shackle every power of knowledge and activity." Art that is "whole and vital," he then said, is unconcerned with anything that is foreign to itself and relies on "intense, unique, individual, spontaneous, feeling."[99] In one of Goethe's early poems, the artist, who is talking with the connoisseur, compares the artist's ability to form things with a man's

sexual ability. In the poem, he asks how, with godly sense and human hand, he, the artist, can form things in the way that, like an animal, he can and must form them with his woman. In another early poem, the "Wanderer's Storm-Song," he appeals to the Spirit to lift him "with wings of fire" above the path of mud below, to deck him "with guardian pinions," so he can float among the Muses. Various images of cosmic victory and creativity enter the wanderer's mind, till, in the decrescendo of the poem's end, he becomes humble and asks the Heavenly Power to glow just enough for him to wade his way to his cabin.[100]

Goethe came to regret his early seduction by the ideal of the unfettered genius preached by Herder and by his own alter ego, the hero of his book the *Sorrows of Young Werther.* He had grown convinced of the need to draw on the collective accomplishments of tradition, because genius, too, has to be embedded in a tradition. The belief in original genius alone, he said (attacking Diderot, whom he had earlier praised), is a vacuous fantasy.[101*] He now believed, as he wrote in a letter to Humboldt, that "the sooner one realizes that there is such a thing as a craft, an art, which assists the orderly development of natural disposition, the happier one is; no matter what is received from outside it does no damage to innate individuality."[102]

The great philosopher in this knot of friends was, of course, Kant. *The Critique of Judgment,* published in 1790, which expresses his mature view of art and genius, was read attentively by them all—Goethe, having studied it carefully, ventured that it was the most important of all Kant's books.[103] Kant makes the point that genius cannot be learned because it is "a *talent* for producing for which no definite rules can be given." Its main property, he says, is originality, so it is not art that gives the rule to genius but genius that gives the rule to art. But since nonsense, too, can be original, the originality of genius must be such that it produces models, that is, standards or rules for others (could Kant have thought of Lewis Carroll as a genius?). The rules it gives them cannot be

*Goethe was reacting to the first two chapters of Diderot's "Essays on Painting." In the French *Encyclopédie,* which Diderot edited, there is a famous article in Diderot's spirit and often wrongly attributed to him. Geniuses, the article says, are always the glory of their nations and the benefactors of mankind. The author of the article, Jean-François Saint-Lambert, finds genius to be mysteriously beyond judgment and beyond even imagination. He praises "extravagance" and the possibly creative virtues of inattentiveness, distraction, excessiveness, extravagant comparison, and the ability to spin out fictions, in short, the "enthusiasm" that "if not madness is close to it."

explained scientifically. The genius himself does not know how the idea for what he invented (Kant uses the masculine) entered his mind, nor is he able to arouse his power at will, nor teach it nor communicate it to others. But the ideas the artist has are able to arouse similar ones in other more or less creative persons. "For this reason the models of fine art are the only means of handing down this art to posterity."[104] Elsewhere Kant uses the metaphor of an explosive flash:

> *Genius* is a talent for *discovering* that cannot be taught or learned. . . . Genius, then, flashes as a momentary phenomenon, appearing at intervals and then disappearing again. It is not a light that can be turned on at will and continues to burn as long as we choose, but an explosive flash that the spirit, by a happy impulse, wrests from productive imagination.[105]

Difficulties arise when one tries to work out the logic of Kant's aesthetic doctrine in a way consistent with itself and with his whole position on skepticism and belief, according to which humans have a basic need to believe in what, as they should know, they cannot prove. Such necessary but unprovable beliefs include belief in limitless perfection (like that assigned to God), in our souls, and in our essential freedom from the laws of nature. This freedom is akin to our sense of beauty. Something is beautiful, says Kant, when, though lacking a purpose, a practical end, it has the form of something that *is* purposeful, meaning, made to realize a particular end.[106] In this sense, beauty is analogous to a good, moral will, a will that motivates acts that have no end beyond their own morality. Beauty, like something with an ordinary purpose, shows coherence; and its purposeless coherence is a harmony that gives disinterested pleasure. In the human imagination, the beauty of art and, especially, of nature arouses responses that hint at reality-in-itself, in which we cannot help believing, even though we are in no way able to get beyond the limits of the time, space, and categories of thought by means of which we know the world. To keep ourselves from self-delusion, Kant says, we must avoid building metaphysical castles in the air; but to keep our humanity, we have to think that we ourselves are free and think that perfection is real, even though—while we feel it within ourselves—it is entirely beyond our direct experience. Briefly, "though I cannot *know,* I can yet *think* freedom."[107]

This is what Kant in his most characteristic philosophical mood insists on, in a long, often difficult argument. Yet it seems to me that he walks on so thin an intellectual borderline that he cannot avoid stepping over it. He cannot or does not avoid implying that by means of imagination, especially as exhibited in genius, humans are able to come into contact with the final reality, the "noumenon." To the extent that he really does imply this ability, he supports

the position of the thinkers he opposes for believing more than he thinks they should.[108*]

Friedrich Schiller, who regards himself as a Kantian, tries to improve on Kant.[109] His general direction of thought is clear, but, lacking Kant's philosophical power, he expresses it to more poetic than philosophical effect. Schiller's key is freedom, self-determination out of inner need and not external influence. To Schiller, the deep emotion that great art arouses is related to the moral consciousness that is the center of human being. "In the work of art man becomes objective to himself, since his essence is freedom."[110]

Schiller's most important work on aesthetics is his *Letters on the Aesthetic Education of Man*, published in 1795. Kant, though he walks, as I have said, on the thin borderline between skepticism and belief, tends to split the human into a mundane being, defined by humans' sensory and intellectual limits, and a free, disinterested spirit that experiences intimations of immortality, freedom, and perfection. Schiller believes that this human duality can be resolved by the impulse to play, which is the same as aesthetic experience. In play, as he explains in the Fifteenth Letter, humans fuse the sensory, material life with form and, joining the two, arrive at "living form," which is beauty.[111]

> With beauty man shall *only play,* and it is *with beauty only* that he shall play. For . . . man only plays when he is in the fullest sense of the word a human being, and *he is only fully a human being when he plays.* . . . This proposition . . . will, I promise you, prove capable of bearing the whole edifice of the art of the beautiful, and of the still more difficult art of living. But it is, after all, only in philosophy that the proposition is unexpected; it was long ago alive and operative in the art and in the feeling of the Greeks.[112]

Humans can be fully human, Schiller believes, when they understand that they are joining what nature has separated, or conversely, when they have separated what nature has joined. By separating form from substance, man gives

*I excuse myself from justifying what I have just said by quoting John Zammito, a careful student of the *Critique of Judgment*, who reaches the same conclusion. He cites a passage (section 49) of the *Critique* in which, he says, Kant "is unquestionably talking about the noumenal freedom of the subject. . . . That is, he presses a metaphysical interpretation of genius, instead of the natural one. . . . All Kant's efforts to connect aesthetics with ethics, when he speaks of 'perfection' and the 'ideal of beauty,' make perfect sense with a breathtakingly metaphysical revision of the whole project: art offers symbolic access to the ultimate. . . . Art therefore assumes a central place in culture. Art is the vehicle through which the supersensible gives tokens of its real presence."

form autonomy, extends the realms of beauty, and preserves the frontiers of truth. For, as Schiller elaborates in his Twenty-sixth Letter,

> it is in the *world of semblance* alone that he possesses this sovereign right, in the insubstantial realm of the imagination; and he possesses it there only as long as he scrupulously refrains from predicating the real existence of it in theory, and as long as he renounces all idea of imparting real existence through it in practice.[113]

Having unified the Kantian human being, or having unified the two opposite human drives by means of the play drive, Schiller nevertheless shows that he retains much of Kant's philosophical caution. The poet of freedom, as he has been called, who tries to return us to the full humanity he finds in the ancient Greeks, believes that the artist is "only" playing and can make no valid claim to capture reality. The artist, playing, creates art for the sake of playing. While playing, says Schiller, the artist, disinterested and contemplative, is fully human. This thought links the doctrine of genius or inspiration with that of art for its own sake.[114]

The relation between the two doctrines rests on the assumption that because a genius experiences in the "play" of art what is most fully, imaginatively, and intensely human, art can be regarded as the highest purpose of life. Life is then for the sake of art, and art's uselessness, in the ordinary sense, becomes its recommendation. This kind of aestheticism takes religious and hedonistic forms. The form I call religious tends toward the basically Neoplatonic equation of the beautiful and the good. In keeping with these forms, life for the sake of art is understood to mean material or biological life for the sake of the beauty that is the good, or the good that is the beautiful.

The hedonistic form is given an almost commonsense expression by Théophile Gautier in his well-known preface, dated 1834, to his novel, *Mademoiselle de Maupin*. The question that provoked the preface was the simple "What use is this book?" Gautier's answer is that the use of the book is that it puts a few thousand francs in its author's pocket, gets the publisher a handsome horse and cabriolet, and, for the paper merchant, means still another factory that's likely to ruin the landscape, and so on. But a novel isn't a pair of boots and you can't wear a literary comparison like a slipper. But what is absolutely useful in this world? he asks. And what's so useful about our being alive, except, for publishers, to provide the people who buy the journals they put out? Useful things express man's pitiful, ignoble needs—"the most useful place in the house is the latrine." However, says Gautier, "I would happily give up my right as a French-

man and citizen for the sight of an authentic Raphael or a beautiful woman naked—the Princess Borghese, for example, when she posed for Canova." Gautier continues:

> I should prefer to bestow, like that great and misunderstood philosopher Sardanapalus, a large sum on anyone who could invent a new pleasure; for pleasure seems to be the goal of life, and the only useful thing in the world. God willed it so, He who made women, perfumes, light, beautiful flowers, fine wine, mettlesome horses, greyhounds and Persian cats. . . . He accorded to ourselves alone the glorious privilege of drinking without thirst, striking a light, and making love all year round, things which distinguish us from brute beasts much better than the use of newspapers and the production of legal documents.[115]

The English writer Walter Pater offers another influential expression of an aestheticized hedonism. But the name "hedonism" for his view is misleading because, by his description, the beauty he aims to experience verges on mystical exaltation. It aims at what Baudelaire calls the "evocative magic" that pure "unphilosophical" art should create. As Pater writes in 1868, he wants to be alert to the strange, perpetual weaving and unweaving of the experiences of the self. The goal, he believes, is "not the fruits of experience, but experience itself," the ability to pass swiftly from point to point of life's pulses and yet to remain at the focus where most of the "vital forces unite in their purest energy." Using a metaphor that became famous, he writes,

> To burn always with this hard, gemlike flame, to maintain this ecstasy, is success in life. . . . While all melts under our feet, we may well grasp at any exquisite passion, or any contribution to knowledge that seems by a lifted horizon to set the spirit free for a moment, or any stirring of the senses, strange dyes, strange colors, and curious odors, or work of the hands, or the face of one's friend. . . . With this sense of the splendor of our experience and of its awful brevity, gathering all we can into one desperate effort to see and touch, we shall hardly have time to make theories about the things we see and touch.[116*]

*Though not at the moment dealing with China or Japan, I'd like to add as an aside that I sense something like the doctrine of art for art's sake in the "pure talk" of the third to sixth century Taoists. Their witty badinage is a similar protest against the measurement of everything by its social utility. The theoretical goal, "emptiness" or "nonactuality," resembles the goal pursued by the French poet Stéphane Mallarmé (1842–98), though Mallarmé has such a different cultural basis for his view.

Oscar Wilde's dialogue *The Decay of Lying*, published in 1889, refers to Pater but, in expressing the doctrine of art for art's sake, shows his own pattern of acceptance and rejection. For Wilde, unlike Pater, I see no need to qualify the term "aestheticized hedonism." "Art," says Wilde, "never expresses anything but itself."

> The highest art rejects the burden of the human spirit, and gains more from a new medium than she does from any enthusiasm for art, or from any lofty passion, or from any great awakening of the human consciousness. She develops purely on her own lines. She is not symbolic of any age. . . . All bad art comes from returning to Life and Nature, and elevating them into ideals. . . . The moment Art surrenders its imaginative medium it surrenders everything. . . . The only beautiful things are the things that do not concern us. . . . The final revelation is that Lying, the telling of beautiful untrue things, is the proper aim of art.[117]

In spite of such words, morality, life, and nature were not and could not be excluded from art, nor could art be kept from assuming the nature of a sacred mission. From the late eighteenth century on, we find artists who experience art as a personal need that is also a moral obligation, to themselves and to humanity. We recognize such an understanding of art in a letter written by Asmus Jacob Carstens in 1876. It was addressed to the Prussian minister who had notified him that his stipend was being withdrawn, and that he had to return to the Academy money he had borrowed from it. Carstens (whose style was not romantic but meticulously neoclassical) stood his ground and answered that he was not, as assumed, a court functionary painting for royal approval. He has never had obligations to the Academy, he writes. "I must inform your Excellency that I do not belong to the Berlin Academy but to humanity." Then he adds:

> I can only develop as an artist here in Rome, among the greatest works of art in the world, and, as far as my strength allows, I will seek to justify myself to the world through my art. In order to remain true to my duty and calling as an artist I am prepared to relinquish all the privileges of the Academy and to choose instead poverty, an uncertain future and perhaps, considering my already weak condition, an invalid and helpless old age. . . . If need be, I will declare this truth publicly in order to justify myself to the world as I am justified to myself.[118]

In a similar spirit, the artist Hans von Marées, writing in 1882, expresses a sacrificial, idealizing view of art and artist. A born artist, he writes, is someone

in whose soul nature has set an ideal, in which he believes unconditionally, that stands for truth.

> It becomes the life's task of the artist to attain the purest awareness of this ideal so that he can bring it to the perception of others. . . . That he is human, this is what makes it so difficult to be an artist; and yet it is only in virtue of being human that we can become artists at all. For this reason, the artist can never escape the task of becoming a complete, and when possible, a purified human being.[119]

The change in artists' self-appraisal is evident in their self-portraits. In Italy, the first surviving, unquestionable self-portrait of an artist is Benozzo Gozzoli's, painted about 1460. It is hard for a painter to paint a self-portrait without betraying by its stare that it is the painter who is the subject of the portrait. Gozzoli's questioning stare detaches him from the crowd in which he is placed—only toward the end of the century did Italian artists become separate subjects of their pictures. Lorenzo Ghiberti, who wrote what was, in Europe, the first autobiography of an artist, portrays himself painting with a lively, ironical expression. Eighteenth-century painters are likely to depict themselves formally, decorated, maybe, with their noble patrons' awards to them. But romantic artists, whose self-appraisal is more affected by thoughts of immortality and less by the formal marks of status, are apt to paint themselves dressed with Byronic negligence, in an easy, informal pose, and with a hint of dreaming melancholy in their faces.[120]

The importance attributed by artists and others to the artist's role was reflected in public adulation of a sort that had been reserved in ancient Rome or baroque Italy for musicians and other virtuosos of performance. A list of the great heroes of European romanticism might begin with Beethoven as a stubbornly individualistic prototype and continue with Byron, Delacroix, Chopin, and Liszt. Byron became the object of a cult as wide as the literature of Europe. Altogether, European thinkers, especially Germans, took to romanticism no less naturally than Japanese cranes still take to their dances.[121] The adulation of these heroes could go to extraordinary extremes, as in the case of the adoring ladies who snipped off bits of Liszt's hair, collected his cigar butts, and gathered the dregs of his coffee in glass phials.[122]

GENIUS, MELANCHOLY, MADNESS

In the European tradition, the connection between madness and inspiration goes back to the Dionysian religion of the ancient Greeks. Plato, who accepts this connection, believes that the poetry of the possessed, the mad, is by nature immea-

surably superior to that of the sane. Plato has Socrates say in the *Phaedrus* that "in reality, the greatest blessings come by way of madness, indeed of madness that is heaven-sent." Socrates later adds, "Let us not be disturbed by an argument that seeks to scare us into preferring the friendship of the sane to that of the passionate." Socrates enumerates four forms of madness or possession. The third, which is relevant here, is the form "of which the Muses are the source," and which seizes and stimulates "a tender, virgin soul" to rapt expression. "But if any man come to the gates of poetry," Socrates says, "without the madness of the Muses, persuaded that skill alone will make him a good poet, then shall he and his works of sanity with him be brought to naught by the poetry of madness, and behold, their place is nowhere to be found."[123]

The connection of madness and inspiration with melancholia is made in a text attributed to Aristotle. According to the speculations of *Problemata* 30.2, great men, madmen, and imbeciles share a melancholic nature. All great men, the text says, are likely to be subject to depression or its opposite, excessive excitement, and poets are sometimes the better for their madness. But the accomplishment of great men and poets is usually the result of their success in causing their anomaly to express itself "in a well-balanced and beautiful way." The text begins with the question, "Why is it that all those who have become eminent in philosophy or politics or poetry or the arts are clearly melancholics, and some of them to such an extent as to be affected by diseases caused by black bile?" In heroic mythology, the text goes on,

> Heracles is an example. And among the heroes many others evidently suffered in the same way, and among men of recent times Empedocles, Plato, and Socrates, and numerous other well-known men, and also most of the poets. For many such people have bodily disease as the result of this kind of temperament (*krasis*); some of them have only a clear constitutional tendency (*physis*) toward such afflictions, but, to put it briefly, all of them are, as has been said before, melancholic by constitution.[124]

In the eyes of the Neoplatonists of Florence, these speculations gave Plato's belief its medical, scientific basis. The leading thinker among them, Marsilio Ficino (1433–99), added that melancholics, the only persons capable of the divine mania, were "saturnine," that is, born under the ambivalent planet Saturn.[125] Ficino learned to contend with the melancholy from which he himself suffered by exercising, living carefully, and listening to music, but the Greek view of melancholia led him to see his affliction as an advantage. Artists, who

believed themselves the writers' peers, appropriated the association accepted by Ficino for men of letters. The association having been triply confirmed, by philosophy, medicine, and astrology, great artists, even the amorous, equable Raphael, were described as melancholic. And so the improbable truth that poets, heroes, and other great men are all melancholics was converted, not without protest, into the certain falsehood that melancholics are great.

> Even moderately gifted men were categorized as saturnine and, conversely, no outstanding intellectual or artistic achievement was believed possible unless its author was melancholic. . . . In the sixteenth century, a veritable wave of "melancholic" behavior swept across Europe. Temperamental qualities associated with melancholy such as sensitivity, moodiness, solitariness, and eccentricity were called for, and their display acquired a certain snob value, comparable to the *Weltschmerz* of the Romantics or the bitterness of our own Angry Young Men.[126]

Dürer's great engraving *Melancolia* illustrates the theme in Renaissance symbolic style, though it seems likely that it refers to himself as well.[127] Melancholy as a fashion can be hard to distinguish from genuine depression, but depression does make an unmistakable appearance in the lives of many artists during the sixteenth, seventeenth, and eighteenth centuries.[128] Romanticism, we know, renewed the theme of the artist's sensitivity and possible closeness to insanity. One can recall Charles Lamb and Gérard de Nerval, but I feel no need to add extended analysis of real or hoped-for madness, not even the example of Rimbaud, who proposes to derange his senses so as to become the suffering all-experiencing seer and so, by his more than human omnipresence, become one with the universe from which he feels radically disjoined.

In novels, Honoré de Balzac and Victor Hugo dealt with the relation between insight and insanity. Balzac, who had both realistic and mystical inclinations, gives the protagonist of *Louis Lambert* an exactly described schizophrenia along with the ability to see into hidden things.[129] Victor Hugo, who was deeply moved by the real insanity of his brother Eugène, chooses Hamlet as a symbol of the creative discomfort of the soul in a life unsuited to it. He adds, with a measure of self-portraiture, that the life of the artist, a Hamlet, is interwoven of reality and dreams, a combination that, for all its strangeness, is after all the reality in which we exist. According to Hugo, one might almost consider Hamlet's brain to be a formation made of different layers, one of suffering, one of thought, and one of dreams: "It is through this layer of dreams that he feels, comprehends, learns,

perceives, drinks, eats, frets, mocks, weeps, and reasons. There is between him and life a transparency—the wall of dreams; one sees beyond it, but one cannot step over it."[130]

. . .

So far, a possibility and a problem have been presented, but no attempt to resolve the problem has been made. Platonic philosophy, humoral psychology, astrology, cultural fashion, and picturesque examples drawn from poets or novelists are not enough to demonstrate a likely connection between genius, melancholy, and madness. The simplest reason is that mental disturbance is so widespread that all the examples I've given and might have given of disturbed artists do not in themselves prove a particular connection between creative ability and mental disturbance. This holds true even though the connection between genius and mental illness was in time widely accepted not only by laymen, artists, and writers, but by psychiatrists as well. Among the well-known early psychiatrists who accepted it were Cesare Lombroso (1836–1909) and Ernst Kretschmer (1888–1964). I remember being impressed by an unexpected reversal of their view by the psychiatrist W. Lange-Eichbaum. In a once well-known study, he compiled an extensive list of creative "geniuses," each of them subjected to a "pathography" and diagnosis. He argued that what leads to the application of the term "genius" is not some superlative capacity but the combination of being well known and mentally disturbed. As he saw it, it is enough for somebody to look and act like a genius to be defined as one.[131] The list that he compiled was taken by him to be evidence of the circularity of a socially preestablished definition, a variant of the claim that an artist's biography tends to fall into the stereotype of what "the artist" is supposed to be.

In the course of the last century or more, the psychological traits of "genius" have been spelled out, and every obvious position on the genius's physical and psychological health has been seriously maintained. The most extreme position, widespread in the late nineteenth century, is that the genius is not only mad or close to mad, but in a medical and possibly moral sense, degenerate. As Lombroso sees it, the genius suffers from "degenerate psychosis," probably, he says, of the group of such psychoses associated with epilepsy, and since body and mind are inseparable, the genius is also likely to be physically degenerate. Genius, Lombroso says, is usual among lunatics, and madness among men of genius. As he sees it, geniuses show "poor integration of personality traits, oversensitivity, over emotionality, extreme forgetfulness, perseveration, and alternation between excessive energy and excessive fatigue."[132]

A less extreme position, which will soon be illustrated, is that highly creative

persons (including geniuses, however defined) suffer far more often from mental illness than do others. A contrary position is that highly creative persons are on the whole both mentally and physically healthier than others when, in the words of psychologist A. H. Maslow, the persons are creative and courageous enough to find "the path to the fullest self-actualization."[133] A moderate, commonsense position is that there is no special relation between mental health and creative ability. According to one version of this position, the suffering of creative persons, when it occurs, is the result of the unfortunate conditions under which they live, not of their great ability. This is the belief of the renowned psychologist Mihaly Csikszentmihalyi, who, reflecting on his observation of a group of highly creative persons, says:

> After several years of intensive listening and reading, I have come to the conclusion that the reigning stereotype of the tortured genius is to a large extent a myth created by Romantic ideology and supported by evidence from isolates and—one hopes—atypical historical periods. In other words, if Dostoyevsky and Tolstoy showed more than their share of pathology it was due less to the requirements of their creative work than to the personal sufferings caused by the unhealthful conditions of a Russian society nearing collapse. If so many American playwrights and poets committed suicide or ended up addicted to drugs and alcohol, it was not their creativity that did it but an artistic scene that promised much, gave few rewards, and left nine out of ten artists neglected if not ignored.[134]

Much as I respect Csikszentmihalyi's work, the examples he gives are not convincing. To make his case for Dostoyevsky, he would point out, I am sure, that Dostoyevsky was forced to experience the preliminaries to what he believed was his own execution and then had to serve four years in a Siberian prison and four in the army, after which, until close to his death, the secret police kept opening his letters. But his psychological problems were not solely determined by these very difficult experiences. All his life he suffered from the psychological effects of a terribly violent father. He also suffered from epilepsy and an irresistible compulsion to gamble. As for Tolstoy, Russia accepted neither his pacifism nor his Christianity and was not as a whole deeply influenced by his respect for and imitation of his peasants. But all this has nothing obvious to do with his self-accusations in his confessional diary, or anything to do with the uncontrollable sexual desires that left him with such a sense of guilt (or of his temperamental inability to read Dostoyevsky's novels).[135] Csikszentmihalyi's explanation of the psychological difficulties of the two Russian writers in terms of social condi-

tions alone is too simple. As for American poets, if he means to include, as he should, such poets as Robert Lowell, John Berryman, Randall Jarrell, Theodore Roethke, Sylvia Plath, and Anne Sexton, his argument is quite implausible. If he were to choose the example of the social conditions under which the great black American jazz musicians lived, his argument would be more plausible, but how could the argument be generalized to all other psychologically troubled artists?

So many positions, so many problems.[136] To do research on the mental health of geniuses, whether artists or not, one has to figure out how to decide who the geniuses are. If one uses published biographies, one has to decide if the biographers are open, knowledgeable, and reliable enough. If the researcher aims at statistically valid conclusions, how is such validity to be decided? Is it enough to follow the widespread practice of relying on questionnaires or must there be adequate face-to-face meetings with the individuals investigated? And how much should investigator understand of the geniuses' work?

These not easily answerable questions can be heightened and complicated by taking note of the research that shows that injury to the brain can evoke artistic ability where none existed before or influence an existing ability for the better. Consider the surprising ability awakened in a fifty-one-year-old, right-handed man who suffered a brain hemorrhage. According to the neurological report on his case, he recovered well, but underwent a change in personality and complained that he felt his mind had been split. About two weeks after the operation that followed his hemorrhage, he "began to fill several notebooks with poems and verse." During the months that followed "he drew hundreds of sketches, mainly of faces, all of them asymmetric. This was followed by large-scale drawings on the walls of his house, sometimes covering whole rooms. He claims the brain injury left him obsessed with making art and he now spends most of his day painting and sculpting." It is pointed out that this man's burst of creativity seems related to his left-hemisphere injury, which relaxed his verbal inhibitions. However, he speaks easily and writes poems freely, so the brain injury seems not to have damaged a speech area. "Things he sees and hears seem to trigger a stream of associations he can find difficult to inhibit. . . . This stream of images and thoughts . . . may well be a source of his creativity, at the same time that this process of expression through the artwork may help him to make sense of it."[137]

Another victim of a left-hemisphere injury was a right-handed, seventy-one-year-old painter, who became ambidextrous after a stroke. His style evolved from an impressionistic manner to one described as more joyous, geometric, and simplistic (I think that "simplistic" here means no more than "simple"). He reported

to researchers that he used his left hand to paint with the brighter, more vivid colors, and the right for the others.[138]

Among artists stricken by Alzheimer's disease, the loss of ability to paint realistically has sometimes led to an increased interest in color or a shift of style in the direction of surrealism. Researchers have found the results interesting, even beautiful.[139] Persons who suffer from a certain form of dementia (DLB, "dementia with Lewy bodies") usually lose the ability to copy even simple figures, but their complex hallucinations, visual and auditory, can stimulate them to try to represent their visions. Such an effort accounts for the hallucinatory sketches and poetry of the novelist, illustrator, and poet Melvyn Peake.[140]

Sufferers from a different form of dementia (FTD, "frontotemporal dementia") lose their linguistic but not their visual ability. When this dementia affects the left hemisphere of the brain, it may trigger "spontaneous bursts of visual creativity." Relatively many of those who suffer from this dementia turn to art, which is most often realistic or impressionistic. "Patients often repeat and perfect the same picture. . . . Often the colors used are startling combinations of purple, yellow or blue." One stockbroker, whose language and memory deteriorated severely, turned spontaneously to art and painted the images he experienced with increasing exactness and detail, well enough to win awards at a few art shows. In another instance, the work of a highly trained artist suffering from a variant of FTD "became progressively wilder and freer, with sexually provocative topics. In this instance the freer style suggested a release from prior inhibitions, generating a highly successful series of paintings."[141]

My excursion into the possibly favorable effects of brain damage on artistic creativity leads me back to the central question, which is whether or not there is a link between creativity and mental illness.[142]* The variety of existing opinion

*The scholar Charlotte Waddell asks this question in her essay, "Creativity and Mental Illness: Is There a Link?" This essay, a careful effort to review existing research impartially, ends in the conclusion that the link has not been proved. However, the evidence she takes account of (along with evidence she does not discuss) shows not that there is no link but only, as might be expected, that the link is uncertain. Waddell's ideal, which only more recent studies have generally come close to, includes the use of comparison or control groups, random or blind assessment of subjects, standardized or reproducible definitions of mental illness and creativity, and the use of data that do not depend on memory alone and therefore invite memory's biases. In her critical review of the empirical studies, Waddell finds that most of the twenty-nine empirical studies she examined have methodological flaws, and, significantly, that most do not support the association between creativity and mental illness. However, regardless of the state of the evidence, many of the

must in part be the result of differences in the subjects or conditions of research, or in the attitudes of the researchers, and it seems unlikely that the conclusions can be both simple and plausible. For one thing, the abilities that establish genius are of quite different kinds. Musical and mathematical abilities seem separate from the others. The abilities that made Velasquez a wonderful painter may be different from those that make Jasper Johns a great painter (and, if he is one, a great painter in the same sense as Velasquez). Even when kinds of geniuses and abilities have been sorted out well enough for a particular study to be made, how is it possible to summarize all the other studies, each of which was set up and pursued by different researchers using somewhat different methods in relation to often quite different subjects? Should one conceal these differences under the smooth uniformity of the numbers of an array of statistical tables?

To these difficulties there must be added the difficulty of psychiatric diagnosis, not only of the distant dead but also of the still living, a difficulty made the greater by the overlapping symptoms of psychiatric illnesses that are at present defined as different from one another.[143]* A further difficulty is the statisti-

thirty-four review articles on creativity and mental illness Waddell examined supported the association. "What explains this contradiction?" she asks, and she answers, "One possibility is that the eloquence of creative or gifted people who comment on their own mental health problems attracts attention and compels us to spuriously connect their creativity with their problems." Waddell wants larger, more varied, methodologically better studies, with creativity as well as mental illness defined and rated by standardized measures. I cannot avoid noticing that Waddell's review of the evidence, as she is surely aware, is quite far from complete—there is little coincidence between her bibliography and the mostly standard sources I provide. (Sometimes, too, her judgment is questionable. Why does she think that it is at all relevant that "'Lucas and Stringer's 1972 study of 84 architecture students in London found only 1 was 'severely disturbed'"?)

*There are two authoritative diagnostic manuals, the DSM, the *Diagnostic and Statistical Manual of Mental Disorders*, of the American Psychiatric Association, now in its fourth edition, and the ICD, the *International Classification of Diseases*, of the World Health Organization, now in its tenth edition. In spite of these elaborate classifications, there is still only a shallow understanding of the major psychiatric illnesses. Individual cases can be hard to classify, and the classifications themselves are always subject to revision. The chair of the DSM committee on schizophrenia, Dr. Nancy C. Andreasen, has said, "The DSM definition may have distracted us from the real illness by overemphasizing symptoms and even the wrong ones." The overlap of symptoms between schizophrenia, schizoaffective disorder, and bipolar affective disorder (manic-depression) has led to the view that they all express the same basic disorder. Some researchers now take what is called a dimensional view of personality and distinguish between underlying personality and cognitive traits, which can be put to either normal or insane use.

cal assessment of the psychological health of the ordinary population with which the creative individuals are compared.[144] Here, I want to do no more than give a brief answer, for the sake of which I paraphrase and quote from contemporary research that deals with artists' creative traits and with the relation of these traits to their mental health.

If we confine ourselves to Western culture, where most of the research has been done, it is helpful to begin the answer with a summary of the traits ascribed to the persons we classify as geniuses: Creative geniuses have great enthusiasm and are deeply committed to their work. Creative geniuses tend to have wide interests, which open them to a wide range of stimuli and allow unusual associations between apparently unrelated fields. Creative geniuses are able, so to speak, to defocus their attention and see how to connect previously unconnected trains of thought. Creative geniuses are introverted, because problem solving requires solitary thought. And, finally, creative geniuses are independent, often to the point of iconoclasm.[145]

In themselves these traits can fit a broad conception of psychological health. Yet the link or, better, affinity between genius and mental disturbance remains plausible, and between genius and madness possible and at times virtually certain. The fact is that most research has shown that persons with great creative ability are more likely to show signs of mental illness than does the population at large. If we allow ourselves to judge from the study of the 1,005 twentieth-century biographies in Arnold Ludwig's *The Price of Greatness,* only businessmen and public officials are relatively little disturbed. Among the creators whose biographies Ludwig includes, famous scientists are much less disturbed than famous composers, who are less disturbed than visual artists, who are less disturbed than playwrights, who are less disturbed than writers of fiction, who are less disturbed than poets. The percentages of the psychologically disturbed rises in this list from 28 percent for the scientists, 60 percent for the composers, 73 percent for the visual artists, 74 percent for the playwrights, 77 percent for the writers of fiction, to an astonishing 87 percent for the poets. Ludwig also finds that among painters with a formal style, only 22 percent show mental disturbance, as compared with 52 percent for those who paint in a symbolic style, and 75 percent for those who paint in an emotive style. But "although creative geniuses seem to exhibit above-average levels of psychopathological symptoms, these levels are seldom so high as to translate into total mental and emotional deterioration. . . . So creative individuals tend to exhibit symptoms midway between the normal and abnormal."[146]

The relative tendencies toward illness reported by Ludwig seem to conform to

our preconceptions, but I would be more convinced by his statistics if we could compile and compare equivalent statistics from the biographies of 1,005 ordinary, randomly chosen persons, whose psychological disturbances would be described with unsparing attention. But even if "ordinary" persons proved to be more prone to psychological difficulties than supposed, this would not account for the different levels of susceptibility of scientists and artists—unless scientists and their biographers, especially during the earlier part of the century, thought that it was not of any public interest to reveal a scientist's psychological problems.[147] Yet even if scientists' psychological disturbances have gone unreported, this would not account for the different levels of disturbance of the different kinds of artists.

It is interesting to investigate the psychological makeup of a relatively coherent group of artists. Take, for example, the abstract expressionists, the members of what is known as the New York school. Stylistically they were split roughly into two groups, one, to which Willem de Kooning and Jackson Pollock were central, that painted gesturally, and another, to which Barnett Newman and Mark Rothko were central, that painted in often large fields, that is, areas, of color. The two groups are considered to make up a single school because during the years when the artists in both were trying to gain recognition they lived within walking distance of one another, met often, had common artistic interests, and respected the same critics. I have read full biographies of only a few, but if I add their public statements and descriptions of their meetings, I would describe them collectively as highly articulate, highly competitive, highly ambitious, rhetorically grandiose, heavily womanizing, freely brawling, hard-drinking creators. They favored psychoanalysis and looked on their gestural paintings as immediate records of the unconscious processes of their lives. For a while, they savored the critical and social victory for which they had worked, but before many years had passed, they saw themselves, with incredulous dismay, being relegated to the artistic past by pop artists and others.

To the question of whether the abstract expressionists had any psychological characteristics or problems in common, a partial answer can be found in a study devoted to fifteen of them published in the *American Journal of Psychiatry*: "Mind and Mood in Modern Art: Depressive Disorders, Spirituality, and Early Deaths in the Abstract Expressionist Artists of the New York School." The fifteen artists studied were William Baziotes, James Brooks, Arshile Gorky, Adolph Gottlieb, Philip Guston, Franz Kline, Willem de Kooning, Robert Motherwell, Barnet Newman, Jackson Pollock, Ad Reinhardt, Mark Rothko, David Smith, Clyfford Still, and Bradley Walker Tomlin. Over half of the fifteen artists suffered from psychological illness, mainly depression or manic-depression, compounded by

excessive drinking and with preoccupation with death. In the dry language of the abstract of the study: "At least 40% sought treatment and 20% were hospitalized for psychiatric problems. Two committed suicide; two died in single-vehicle accidents while driving; and two others had fathers who killed themselves. Many of these artists died early deaths, and close to 50% of the group (seven of 15) were dead before the age of 60."[148] This is a sad summary, which prompts one to question whether it is typical of all modern artists, of only contemporary artists, or only of a particular group of artists, some of them psychologically problematic to begin with, living under unusual tension.

Other studies show less extreme results but point to similar general conclusions. The psychiatrist Kay Jamison studied a group of forty-seven distinguished British poets, playwrights, novelists, biographers, sculptors, and painters, all of them winners of at least one prestigious prize or award—nine of the eighteen poets were already included in *The Oxford Book of Twentieth-Century Verse*. Jamison discovered, she says, that of the writers 38 percent

> had been treated for a mood disorder. Of those treated, three-fourths had been given antidepressants or lithium or had been hospitalized. Poets were the most likely to have required medication for their depression (33 percent) and were the only ones to have required medical intervention (hospitalization, electroconvulsive therapy, lithium) for mania. Fully one-half of the poets had been treated with drugs, psychotherapy, and/or hospitalization for mood disorders [but their suicide rate was only a quarter of that reported by Ludwig].[149]

From all she has learned about manic-depression, Jamison concludes that a certain level of manic mood is typical of the intensity with which artists generally create. The excited, invigorating optimism or elation of a manic state makes it easy to work intensively for long hours and stimulates rapidly shifting, deeply charged emotions. The manic state also increases the fluency of one's thinking and stimulates free play with language. A slight degree of manic-depression falls with the usual limits of normality, she says, but a high degree is, of course, a misfortune. "In a sense," she says, "depression is a view of the world through a dark glass, and mania is that seen through a kaleidoscope—often brilliant but fractured" and ending, all too often, in a chaos of jostling thoughts, until, as Jamison says of her own experience, "your brain splinters."[150]

By now there is a great deal of evidence of all kinds, gathered and judged with varying levels of technical competence and sharpness of analysis and leading, of course, to different conclusions. But, all considered, I think it is fair to accept the modest conclusion of the researcher who says, "The genius-madness link may

be more than a myth." To this conclusion I would add another, equally modest, which is that the sane artist, too, is more than a myth.[151]* The good artist who, art apart, lives an ordinary life is real, and the great artist who is quite sane and social is not wholly unfamiliar to history.

I suspect that the genius-madness link may also hold for bygone China, the only civilization (as I've said) with biographical records good and extensive enough to compare in detail with those of the West. But for the while, I will only remind the reader that Chinese poetry and Chinese painting exhibit a great deal of sadness. In China, those who wrote poetry or painted were troubled by what troubles us, the precariousness and brevity of life; but the situation of most Chinese literati and, among them, of poets, calligraphers, and painters, was different from that of most of their Western counterparts. They were often officials sent by government policy far from their homes, and then, like Western diplomats, repeatedly shifted. As a rule, their lives were governed by the hope of official success and the fear of official disgrace. A good deal of drinking was indulged in. The strain of such lives must have increased the oppressiveness of the feeling that life was too brief. There were those who failed to get government posts or avoided them out of hatred for an alien or immoral government. It would be surprising if the sensitivity, failure, and alienation common among these poets and artists did not lead to psychological difficulties like those we have come upon among contemporary Western poets and artists. Remember, the Chinese are said to have expected poets and artists to be odd, "mad," or wild, and to have tolerated their strangeness. I assume, too, that the sometimes tyrannical but also protective families of traditional China could give troubled individuals more effective emotional support than does a modern city anywhere.

THE ROMANTIC/EGOCENTRIC ARTIST

The basic myth of the hero, any hero, begins with the portent by which it is known that a hero is about to be or has just been born. Then in the myth there comes the first evidence of the hero's ability, hardly to be measured by the usual

*The analytical yet intuitive pianist Alfred Brendel says, or complains: "I have not been a child prodigy. I do not have a photographic memory; neither do I play faster than other people. I am not a good sight reader. I need eight hour sleep. I do not cancel concerts on principle, only when I am really sick. My career was so slow and gradual that I feel something is either wrong with me or with almost everybody else in the profession. . . . Literature—reading and writing—as well as looking at art have taken up quite a bit of my time. When and how I should have learned all those pieces that I have played, besides being a less than perfect husband and father, I am at a loss to explain."

human standards. This ability, depending on the hero or the hero's culture, is granted (or should one say "infused") by a spirit or god that acts as the hero's patron; or by one of many natural if also mysterious potencies; or by the creative force of Nature or changing conjunction of complementary natural forces; or by the gods or God. Then comes the series of the hero's great, probably magical feats, which include the overcoming of great obstacles, including inhuman monsters and human enemies. This ancient story acts as an underlying social memory or expectation that plays a role in the way that reality is conceived, because, by expecting the typical or stereotypical, we are able to preordain its occurrence.

I know of only one undoubtedly historical artist, neither a painter nor a sculptor but a poet, whose life story, as it became known, was a full magical-moral variant of the basic myth. This is not surprising when one considers that this great poet was also a great Tibetan Buddhist saint. I am referring to Milarepa (or Mila Ras-pa, 1040–1123 CE).[152]* Mila so loved to sing that he would answer questions—converse—in songs that, to judge by the form in which they have come down, were composed in meters and with a parallelism usual in Tibetan poetry. But it is not his "hundred thousand" songs with which we are concerned, but his mythically enhanced, heroic life. This life is an epic that begins with the vengeance he takes by magic, goes on to his search for a guru, on to his future guru's prophetic dream, on to his trials by humiliation and senseless tasks, on to the dream and fact of his mother's death, on to meditation for eleven lonely years, and, only then, on to enlightenment. Mila acquires the ability to subdue demons and the elements. Evildoers would have died in the great snowstorm that engulfed him, but having lived through it easily, he celebrates his heroism:

Struggled in the desolation of icy peaks
The falling snow I conquered, melted it into streams
And the great roaring wind I still back to its source—
My cotton cloth blazing like fire.[153]

*Tibetan art may appear totally anonymous to us. However, artists' names often appear on temple frescoes, sometimes with praise for their skill. In literature, artists are sometimes named as especially gifted. An example is the many-sided Mikyo Dorje, in the sixteenth century, who carved a self-portrait out of stone. Another example is Chöying Gyatsho, whom the Fifth Dalai Lama considered "the supreme painter." It is also relevant to our theme that Tibet has had groups of "mad" bards, who have sung, danced, and clowned, to everyone's amusement, but often in protest against the establishment, including the religious orders.

Myths of this degree of heroism have been succeeded by less overtly super-human biography. Yet it seems not unlikely that biographies of the familiar art-ists of Greece, Rome, and the Italian Renaissance retain stereotyped features the point of which is to play up the heroism or supreme talent of the artist.[154] Biographical stereotypes are hard to distinguish from reality because they re-semble it enough to remain possibly true. Let me refer to a kind of story that is often placed at the beginning of the myth or stereotype of the artist-hero's life, the revelation in childhood of the artist-hero's special, untaught gift, which, hav-ing luckily been discovered, is the start of the hero's career. For example, when Giotto was ten years old, Vasari says, he would graze the sheep of his father, a simple tiller of the soil. "Impelled by a natural inclination to the art of design," Giotto "was for ever drawing, on stones, on the ground, or on sand, something from nature, or in truth anything that came into his fancy." One day, the artist Cimabue accidentally came on Giotto, who was using a pointed stone to draw "a sheep from nature on a flat and polished slab" and, deeply impressed, induced Giotto to live with him and become his apprentice.[155]

Except that Cimabue is assumed to be Giotto's teacher—because of the hard-to-resist desire to join great, historically adjacent names—Giotto's story, with no source but oral tradition, might be true. So might the similar stories Vasari tells about other, later artists. Domenico Beccafumi, he says, was guarding sheep when a nobleman found him "drawing various things with a pointed stick on the sand of a small stream." The sculptor Andrea Sansovino also found an aris-tocratic patron when he was discovered intently drawing on the sand or model-ing some of the sheep in clay as he looked after his flocks. Similarly, Andrea del Castagno, a herdsman whose passion for art had been aroused when he saw a painter working on a shrine, began to scratch surprising, masterly "drawings of animals and figures on walls and stones with pieces of charcoal or with the point of his knife." When a "Florentine gentleman" heard of this, he took the boy to Florence to study art.[156]

Even in this incomplete list, there are implausibly many discoveries of sponta-neously drawing herders. But the stereotype becomes provably misleading when applied to Goya. Inspired, it seems, by the fact that Goya was born in a small vil-lage, the story was told that he was a peasant whose talent was discovered when he put down the sack of wheat he was carrying and, as a surprised friar saw, drew a pig, surely a wonderful pig, on a wall. But Goya's father was in fact not a peas-ant but a master gilder and the story can be nothing but a wholly invented vari-ant of the stereotype.

A story stereotype, which, from its beginning, is implausible takes as its

theme the extraordinary realism of certain paintings. One instance of the story, which I have brought up before, is that in which Zeuxis paints grapes that look so real that birds peck at them. But this is only one of a number of similar Greek stories, such as the story of the painted quail to which real quails fly, of the twittering of birds silenced by a painted snake, and of the painted mare that a real stallion tries to mount. Among similar Italian stories there is the one about the fly that Giotto paints on a picture by Cimabue, a fly so realistic that Cimabue tries to brush it away; of the painted lamb to which a mother ewe bleats; of the portrait of Dürer that Dürer's dog mistakes for him; and of the portrait of Leo X by Raphael to which a cardinal hands pen and ink in order to get the pope's signature. Among similar Victorian stories, there is one of how bees settle on John Everett Millais's picture, set on a sunlit easel, of spring flowers. Similar stories are told in Chinese, Japanese, and Indian literature.[157]

That a work of art can not only look alive but actually *be* alive is a theme that occurs in Egypt, India, China, and Europe. Egyptian funerary statues and Indian statues of gods underwent ceremonies that gave them life in the senses suggested by their respective religions—in Egypt and India, as in China, the putting in of the pupils of the eyes was crucial to the giving of life. There is also the not unusual kind of story in which a work of art or a figure in a work of art comes to life. In one Chinese story, a painted figure comes to life and leaves the painting in which it is set. In an Indian story, a boy dies and the god Brahma replaces him by giving life to a painting of the boy.[158] And men fall in love with statues of women, which sometimes respond by coming to life.

. . .

When I think about the myth of the heroic, romantic, egocentric artist and about the individuals in whom it comes closest to fulfillment, it seems to me that it has a central narcissistic element. If the artist is to succeed, Freud says, he has to modify his dreams by removing from them whatever repels strangers. By doing so, the artist makes it possible for the strangers to share his dreams.[159] The artist who succeeds in getting his dreams shared, says Freud, wins the honor, power, and love that he had at first won in his imagination alone. This explanation, which I take to be incomplete but not very far from the truth, is accentuated in modern egocentric art in ways that Freud himself did not approve and was unlikely to have foreseen. Modern egocentric art has by now proved to be, in Freud's sense, more personal and more often ugly or repulsive than his view allows. Instead of discouraging the artist's open egocentricity, spectators often admire it, and by their admiration encourage its development. When this happens, the artist becomes the bearer of the success that is attained by means of

open, intense self-cultivation, which is inseparable from self-interest. Such self-interest is related both to the inward difficulties the egocentric artist experiences and the gratifications the artist enjoys. The heroic/egocentric/romantic artist's importance to himself, herself, or others lies largely in the artist's effectively expressed self-interest and, in a sometimes tortuous sense, self-gratification. This need for self-gratification in order to gratify others excuses both extreme bohemianism and great indifference to the feelings or rights of others.

In this light, it is tempting for the artist to adopt a way of life as free as possible of repressions or obligations. The logic is that it is just this freedom that provides the gratification that admirers gain from their hero, gratification they feel it impossible to enjoy except by proxy. But to live so as to gratify admirers by gratifying oneself, an artist has to live in accord with fantasies that are by nature as unpleasant as pleasant, as frightening as appeasing. By tempting the artist to forbidden acts, these fantasies are even genuinely dangerous.[160] That is, the artist awakens always-present pathological potentialities. In learning to shed inhibitions, the artist gives expression to traits that, whatever power they add to art, are pathological and, at their worst, likely to frighten the artist into self-punishment, silence, or suicide.

If all this talk of self-engendering pathology sounds exaggerated, I remind the reader of the observation of art therapists that to encourage the expression of a psychotic's insane fantasies can make recovery more difficult. I also suggest reading the biography and some of the works of August Strindberg, who exploited his pathology to the point of amplifying its symptoms. He also authenticated the inflated symptoms by entering them into his diary as if he had really experienced them. Sometimes, the pictures and words of Edvard Munch suggest such a potentially dangerous exploitation of fantasies. I remember, too, that the surrealists abandoned experiments in automatism because they appeared to encourage psychosis or suicide. Maybe the intensive attention to themselves of some of the New York school artists was of the psychologically harmful kind I have described. I say none of this in condemnation, but only in (possibly overgeneralized) explanation. I do not pretend to know how or when the cultivation of a symptom can exacerbate the illness it expresses, or if or how acts of emotional release can be cultivated as causes of illness. But I think that an act of supposed catharsis might work as a perilous incitement to oneself or others.

As the kind of studies I have cited show, a usual condition for artistic or other creation is loneliness, which is expressed and overcome by art that makes use of one's body, imagination, or intellect. This is a use by means of which one turns oneself into the company that one misses. Such absorption in one's own com-

pany becomes necessary to the artist in order to come into satisfying communication with others. But constant absorption in one's own company makes it hard for the absorbed, egocentric artist to pay genuinely sympathetic attention to the experience of others. I mean that such artists are lonely not when alone but when their communication with the self is blocked, when they cannot be deeply enough themselves to be original and accepted as original by others. They are lonely when others stop reacting to their experiences or stop admiring them or their work. And they may even be lonely when they are reduced to paying much serious attention to others, most of all if the others give them nothing that supports their self-interest. Failure of interest in an artist's work suggests that the artist has grown impotent and has lost any social reason for existence.

To give what I have been saying a more empirical expression, I summarize a study of the life of young artists, beginning with the years they spend in art school. Much has changed in the life of artists since it was published in 1976. But *The Creative Vision*, by Jacob Getzels and Mihaly Csikszentmihalyi, still gives a psychologically valid picture of young artists preparing to engage the world by first exploring themselves. As one of the students said, "I want to know what I am doing, trying to express myself emotionally. I want to draw what is in me, not what there is." Another said, "I know the feelings I want to convey, but not the real reasons. All my works are related in the sense that they are areas of myself, facets of my personality."[161]

To judge by this study, there is still a good deal of truth in the stereotyped picture already present, though not dominant, in Vasari, of the artist as someone "withdrawn, introspective, independent, imaginative, unpredictable, and alienated from community expectations."[162] Getzels and Csikszentmihalyi show that bohemian life appealed to the young artists not because it promised dissipation, but because it promised the freedom to work as the artists wanted, and the chance to gain the great intrinsic rewards provided by art.[163] Put abstractly, the main themes of the artists' work were rebellion, loneliness, and jealousy. But even when the artists were able to put these themes into clear words, the themes seemed to yield their meaning, acquire their form, or approach their solution much more effectively in the media of art. The work required the artists to be sensitive to their inner states and to that extent narcissistic. As the authors make clear, the emotional and cognitive equilibrium the artists were searching for was a continuation and substitution for childhood play.[164] This equilibrium depended less on intelligence, conventionally defined, than on sensitivity, self-sufficiency, intuition, and the like.

Getzels and Csikszentmihalyi found that most of the artists felt alienated

from the work they produced. All of the artists were dissatisfied with their paintings. One of the most successful students found his own and those of his friends to be "hideously ritualistic," and contemporary art to be mostly "distressing." An abstract style appeared to him too easy, impersonal, and empty, an art as a whole too bound up in itself. "Artists," he said, "are not inspired by art any longer but only by one another."[165]

Furthermore, the teachers in art school "rewarded students who were highly original, reclusive, abrasive, unconcerned about material rewards and success." But after graduation, these were the students who "antagonized the 'field' of critics, gallery owners, and collectors, and pretty soon found themselves without contacts or commissions" and who therefore took up other occupations. "The young artists who left their mark on the world of art tended to be those who in addition to originality also had the ability to communicate their vision to the public, often resorting to public relations tactics that would have been abhorrent in the pure atmosphere of the art school."[166]

Even granted the findings I summarize, my interpretation of the self-concern of the artists I have been calling egocentric is of course subjective. But it explains why their narcissism pleases their votaries, who adopt it as a second, greater self, and displeases less fervent admirers, who feel, despite its attractiveness, that there is no room in it for anyone other than the artist. This is the displeasure voiced by William Hazlitt, the English essayist, when he complains that, whatever the variety of Byron's experiences, the art in which they are expressed allows nothing and no one to breathe in it freely except for Byron himself:

> He hangs the cloud, the film of his existence over all outward things—sits in the center of his thoughts and enjoys dark night, bright day, the glitter and gloom "in cell monastic"—we see the mournful pall, the crucifix, the death's heads, the faded chaplet of flowers, the gleaming tapers, the agonized growl of genius, the wasted form of beauty—but we are still imprisoned in a dungeon, a curtain intercepts our view, we do not breathe freely the air of nature or of our own thoughts.[167]

CHINESE ROMANTIC/EGOCENTRIC AMATEURS

In chapter 2 I touched on some of the cardinal differences between the development of art in the West and in China.[168] In the West, art was from the beginning centered on the human body, which it divinized, eroticized, imitated realistically, or distorted expressively. Western art also came in time to demand knowledge of anatomy and mathematically conceived perspective. In China, as I have shown by

example, the ability of art to express or incarnate human states of being is related less to figure painting and portraiture than to the rendering of trees, rocks, bamboos, and landscape in general. For this reason, when landscape painting grew dominant over figure painting, a painted landscape was regarded as infused with the nature of the painter and, in this sense, as a portrait. While it did not make a literal portrait superfluous, it was likely to be a more sensitive representation.

Another cardinal difference between the development of Chinese and Western art is the theoretical and actual dynamism in China of calligraphy and painting, the actual dynamics being recorded in the brushstrokes. As pointed out earlier, in the ninth-century *Record of All the Famous Painters of All the Dynasties,* Chang Yen-yüan explains that painting originated in the same pictographs as writing. Because painting is made of the same substance as writing, Chang says, and is made by the same use of the brush, it deserves the same traditional respect.[169] Influenced by experience, or by Taoist precepts, or by his conception of the breath of life, or by all of these, Chang says that the genuine artist is successful only when he is not conscious of the mechanics of his art—the greater the conscious effort, the less successful it is:

> Now if one revolves one's thoughts and wields one's brush consciously thinking of oneself, then (the more one tries) the less success one will have in painting. But if one revolves one's thoughts and wields one's brush without being conscious of (the act of painting), then as a result one will have success in painting. When the hand does not stiffen, the mind does not freeze up, and the painting becomes what it becomes without one's realizing how it becomes so.[170]

Though it is not possible to be sure how to interpret the ideas of Chang and other early writers on art, the life that they believe can enter into a work of art is cosmic life. A calligrapher or painter draws it in by innate "spirit consonance," not by technical cleverness or close application. "What it depends on is had from the motive force of Heaven itself, and proceeds from the depths of the soul."[171] The cosmic vitality the painter draws (the pun is exact) is not personified, yet it bears the character of the heart of the particular artist who has summoned it up or been possessed by it—the summoning and the possession are the same.

At first, the vitality of spirit-consonance (*ch'i-yün, chi yun*) that gives life to art was supposed to be confined in painting to representations of men, demons, and divinities. However, by the eleventh century, landscape paintings, too, were regarded as possible to animate. Chang attributes this ability to animate landscapes to at least three painters, who are, he says, so wonderfully perceptive "that they have reached the level of divine understanding."[172] When it was accepted

that a really good landscape painting was one that had life transmitted to it by its painter, it was easy to conclude that the landscape's literal accuracy was relatively unimportant.

One of the persons most responsible for the change in favor of landscape and inwardness is the eleventh-century poet, calligrapher, painter, and politician Su Shih, introduced in chapter 2. Quick-witted, sharp-tongued, and outspoken against tyranny, Su was often unfortunate in politics. He rejected the tyranny of political reformers just as he rejected the tyranny of objects and events over his inner life—he insisted on being just what he naturally was. This double rejection corresponds with his Buddhism, a Buddhism relaxed enough to allow him to enjoy his pleasure in ordinary life, his unconventional Taoist ideas, and his Confucian sense of the moral obligations that an official owes to the people he governs. As a poet and thinker, he is thoughtful, humane, impatient, sometimes dense, often eloquent, and toward the end, when he lives in exile, distinctly philosophical. Nature and everything in it is to him a set of mutually patterned lives within lives. Consider the bamboo, what it is and how it grows—Su often thinks bamboo and is the bamboo he thinks. He and his friends feel that in painting bamboos they are painting themselves. It is not only the bamboo's grace and flexibility that matter to them, but the astonishing immanence of the whole bamboo, joint and leaves, in the one-inch sprout in which it starts its life.

> Therefore, to paint bamboo one must first obtain a complete one in one's breast. One grasps the brush and looks thoroughly. Then when one sees what one wants to paint, one rises rapidly to follow it, moving the brush in direct pursuit in order to close in on what one has seen. It is like a rabbit starting as a hawk dives. . . . Now when one knows in one's mind that something is thus but cannot make it thus, the inner and the outer are not one. The mind and the hand are not mutually responsive.[173]

When Su sees the work of his cousin, the painter Wen Tong, he is sure that Wen has "obtained the inherent patterns of bamboo, rocks, and barren trees." Su writes:

> When [Wen Tong] paints bamboo,
> He sees the bamboo and does not notice people.
> He not only does not notice *people*.
> Oblivious, he leaves behind his corporeal self.
> His body transforms into the bamboo,
> Inexhaustibly bringing forth pure and new forms.[174]

On a friend's wall, Su writes a poem saying that when he drinks, his intestines sprout and fork out, and his liver and lungs shoot rocks and bamboos onto the friend's snow-white wall. In another poem, Su writes that "to judge a painting by its verisimilitude shows the mental level of a child." Whoever judges so has as little understanding as someone who wants a poem composed according to a preconceived plan. "Natural genius and originality" are the essential things.[175]

Su Shih usually praises artists by likening them to poets. But once he uses the admiring phrase "scholars' painting," and contrasts it with "artisans' painting." He makes this contrast in an inscription on a painting by Sung Tzu-fang, a friend's nephew:

> Looking at scholars' painting is like judging the best horse of the empire, one sees how spirit has been brought out; but when it comes to artisan painters, one usually gets just whip and skin, stable and fodder, without a speck of superior achievement. After looking for a few feet or so [of a scroll] one is tired. Sung's . . . is truly scholar painting (*shih-jen hua*) [*shi ren hua*].[176]

Su believes that only a "superior man of outstanding talent" can grasp the *li*— the inherent form, or "way of being," or "rightness"—of any particular thing and intuitively understand how it expresses nature's harmony-in-transformation.[177] Su also accepts the criterion of pure self-expression, that is, expression for expression's sake, with no ulterior purpose. He praises a poet-landscapist for not wanting to do anything with art but articulate his ideas. Though this poet and landscape painter writes well, Su says, he does not use his writing to pass the civil service exams, and though he's good at painting, he doesn't try to sell his paintings. Such opinions seem to have been common in Su's time, at least among those who in repeating them were claiming to be superior.[178]

It was Su Shih who "established the image of the artist-literatus who combined the romantic conception of genius with that of the courageous man of conviction."[179] For reasons that were at once political, social, and aesthetic, the trend of thought that Su expressed so eloquently was in time successful. The change it brought about was as fateful for Chinese art, it has been said, as the Renaissance was for European art.[180] It was the revolution in painting during the Yüan period (1276–1322) that led to the success of the amateur scholar-official painting style over the previously dominant professional painters. "Done by men of a different social class with different backgrounds, ideals, and motivations, produced under different conditions for a different audience, painting could not help but change in fundamental and far-reaching ways."[181]

A word in explanation: The Mongol conquerors who set up the Yüan dynasty needed the help of Chinese scholar-officials but preferred to keep them in positions of minor importance. Scholars who did get the chance to serve the conquerors were often afraid that they would be regarded as traitors by those loyal to the old, native Chinese regime.[182] But for those without family or land wealth, refusing to serve, for whatever reason, made it hard to make a living. The poetry and painting of the literati of the time reflect these dilemmas and attempts to escape them. Maybe their political and social difficulties explain why the educated elite cultivated art so earnestly and, adopting Su Shih's views, preferred to weaken the traditional tie between the faithfulness of paintings to appearance and the paintings' emotional, imaginative, and kinesthetic qualities. The use of calligraphic "wrinkles," *ts'un* (*cun*), helped to make painting into a form of writing, in the sense that the painters used the "wrinkles" to spread a varying calligraphic intensity, a brush-touching both personal and intense, over the surfaces of their paintings.[183] To justify themselves, to band together more effectively in isolation from a government whose legitimacy they denied, and to encourage themselves to experiment aesthetically, the scholar-artists made their own choice of exemplary painters and calligraphers from their cultural past. They could then regard themselves as members of an old tradition, the rather extreme principles of which they undertook to express.

A central principle of scholar-amateur painting is clearly egocentric in the sense I have proposed: an artist's expression is individual, so the style of a painting mirrors the artist's nature and measures the greatness of his spirit. The artists' aesthetic radicalism lay especially in their consciously ascetic attitude. This required them to avoid the qualities of art that make it showy and external— the evidence that it was made carefully, that is, its decorative colors, its showily expert brushwork, everything that suggested virtuosity. Virtuosity must be avoided in favor of more inward, personal, sketchy, "awkward," authentic, genuinely expressive qualities. And so professionalism, with its showiness, shallowness, and surrender to mercenary values, must be given up.[184]

This amateur-professional distinction runs through the whole of later Chinese art. The pioneering scholar-amateurs were convinced that working for the sake of money was ignoble because to work for money was to subject oneself to the taste of whoever paid them, and to lose the authenticity that makes art more than craft. It therefore became important to the amateur painters not to sell their art. But giving art away, in particular to those fit to appreciate it, was taken to be blameless. If a friend or relative who got a picture as a gift gave a spontaneous gift in return or decided to sell the picture, this was not taken to reflect on the

integrity of the artist. Although theoretical amateurs might in fact sell their art, the more fastidious among them adhered to the convention of an exchange of gifts.[185] The result was that a great deal of art was freed from the direct pressure of patrons and marketplaces, and the artists were free, in theory and often in fact, to express themselves in perfect accord with their own nature. More nearly professional "amateurs" could, like the professionals, resort to "ghost painters" or "substitute brushes," whose work they signed. Ironically, the noncommercial convention of amateur art could increase its monetary value.[186]

The contrast with Western artists is sharp. Although the prouder Western artists learned to regard themselves as inherently individual and aesthetically free, almost all of them remained subject to the demands of the marketplace, as they remain today. Cézanne did not need to sell his pictures and Van Gogh could not, but almost all serious painters and sculptors were and are frankly professional— a teacher of art remains a professional. Modern poets, for all their need to publish, may fit the Chinese notion of amateurism more easily. I suspect that a resurrected Chinese scholar-artist would look down on Western artists, even the radical ones, as essentially mercenary. The fact that the usual scholar-artist made his living from his salary as a government official or the income from his land did not change the theoretical purity of his art. However, the purity of motive, surely adhered to by its determined or fanatical believers, was not followed consistently by many of the artists. Face, pretension, or social sensibility could easily become more important than the presence or absence of material reward.

The "pure," the "amateurs," came from a different, prouder kind of family than the professionals.[187] Their teachers were others of their kind, and their practical experience depended, as I have pointed out, on their study and copying of old, not necessarily authentic masterpieces. The professionals were likely to be the sons of professionals. Their training was that of an apprentice in a regional workshop, which followed a regional tradition and produced whatever illustrations or portraits buyers asked for.[188] The professionals often seem to have suffered from the repetitious nature of their work and a lack of sensitivity or ambition. In contrast, the amateurs often seem to have suffered, as the surviving evidence is said to show, from ordinary amateurishness, for which their rhetoric, nobility of purpose, and family ties gave no adequate remedy.

Having made this generalization, I feel the need to qualify it. During the middle of the Ming period, there were many very popular professional painters, some of them famous for the "wildness" and eccentricity I have described. They liked to paint on large areas of silk, which need skillfully controlled washes and clear, hard lines quite unlike the calligraphic strokes on absorbent paper

that the scholars were used to. "Often celebrated at court, patronized grandly by poets, scholars, merchants, and lords, acclaimed in popular song, drama, and fiction, they lived on the skill or genius of their art and the fascination of their diverse personalities—despite the disdain of some scholars." One of the professionals, Chang Lu, who was often attacked by literary critics, gave the obvious answer: just as it's impossible for people who can't read to appreciate literature or calligraphy, it's impossible for those who don't know how to paint to understand anything about painting.[189] Yet in the late sixteenth and into the seventeenth century, when the court had stopped its patronage of professionals and the attack of scholars on professionalism had come to dominate criticism, even professionals, it seems, were attracted to the spontaneity of the scholar painting. In the past, "wild," spontaneous painting had been meant to demonstrate how freedom could transcend the extreme of skill that made the freedom possible. But the spontaneity of the kind a scholar-amateur demanded and a professional might now try to exercise was in principle free of skill. For the professionals, "there was no longer a community, and no longer the sustained, hereditary continuity of craft and artisanry" that the traditional skills required. Skill, skill in the virtuosic Chinese sense, tended to disappear from the art of painting. No professional wanted to be called "capable," meaning that he had learned the traditional techniques. The more interesting among the professionals reacted by becoming, as they were called, "heterodox." Some painted simple, humorous, apparently careless pictures. Often these professionals seem to be commenting ironically on the traditions they are leaving behind, and expecting their patrons to approve. It looks as if they are caricaturing traditions by reducing them to hypersimple forms.[190] Their attitude reminds me of our own, Western, contemporary art.

As I've said, the eccentric artist was a culturally familiar figure in traditional China, and, if talented, was respected by his cultural peers. The three artists I have chosen as the heroes of this section on Chinese amateur art, Ni Tsan (Ni Zan), Kung Hsien (Gong Xian), and Tao-chi (Daoji), were all eccentrics and all artists who remained defiantly themselves. They were, in the Chinese sense, amateurs. To all of them external resemblance in a painting was less important than vitality, quality of brushwork, and structure. In choosing these three, I neglect the history of art that leads from the Yüan dynasty to those of the Ming (1368–1644) and the Ch'ing (1644–1911), a period of hundreds of years, during which scholar painting had a rich, variable history and constructed a semihistorical tradition to which to ascribe itself. Tung Ch'i-ch'ang , the scholar whose innovative art I described in chapter 2 as an example of creative copying, was the most influential exponent of a two-tradition classification of Chinese paint-

ing. In his terminology, a Northern school was set against a Southern school, the Southern being that of the scholars, the literati.[191] I neglect this tradition building as well because I want to concentrate on the three amateur painters as individuals.

Ni Tsan (Ni Zan, 1301–74) suffered from the loneliness that follows on the death of too many close members of one's family.[192] He was three when his father died, and a series of other deaths left him at about the age of twenty-two harried by grief and in charge of the affairs of his rich family. His melancholy, he wrote in a poem, drove him to degrading habits; and he had to spend his time bowing humiliatingly to government clerks. "In the old days I bathed in the glow of parental love / but now I am as a weak seedling in the bitter snow."[193]

Until early middle age, Ni lived among the indulgences that only a rich Chinese aesthete could afford: ancient jades, bronze cauldrons, paintings, specimens of calligraphy, musical instruments, and very many books; and, outside, pavilions, ornamental trees, flowers, and the strangely pitted rocks that the Chinese revered. The wealth that made all this possible allowed Ni to express his great, sometimes spontaneous generosity. How such spontaneity fitted in with his compulsiveness I do not know, but he was obsessively clean, maybe as a reaction to the extreme emotional pain he had undergone. He perfumed everything he wore, washed himself till, I imagine, his skin was stiff and sore, washed the tiles between his potted plants, had his trees washed, and had the seats of less fastidious visitors washed as soon as they left. But when he was about forty, all this luxury had to be abandoned. The nature of the rule and probably the taxes of the "barbarian" Mongol government led him to sell or disperse his property, and he spent most of the latter part of his life—he died at seventy-three—traveling around China in a houseboat filled with books, scrolls, and implements for teamaking and painting.[194] Sometimes he left the boat to live with friends or in a Buddhist monastery. During his late years, after his wife had died, he was a reclusive roamer of lakes and mountains. Even during his lifetime, everybody wanted his paintings, which had become famous enough to enhance the status of their owners and invite the flattering but troublesome attention of forgers. In later China, his art, his amateurism, his detachment, and his unbending refusal to come to terms with illegitimate or brutal authority—I have told very little of this—made of him a hero in more than art.[195]

Among Ni's surviving pictures, *The Jung-hsi [Ronxi] Studio*, painted in 1372, is considered to be outstanding. It has the same basic composition as so many of his other landscapes, the same mountain background cut off by a river from a foreground with trees and rocks, and the same sparse, pale brushwork. All is

skillfully and unobtrusively bound together, as the art historian and critic James Cahill explains:

> The fabric of the forms, now entirely without washes, reaches the point of thinness, transparence, weightlessness, that is the quality Ni Tsan was forever working toward. It is as though, like some Taoist Transcendent, he has refined away all that is mundane and material, all the grossness that he found so repellent in the real world around him. . . . Ni's achievement here, which his imitators were never to equal, is in reconciling that transparence and weightlessness with a satisfying substantiality given to the masses through drawing which, however lax it may at first appear, functions volumetrically in describing three-dimensional structure.[196]

This landscape, like the others that Ni painted, is in the style that the scholar-painters had come to designate with the old term *i*, "untrammeled," now not in the sense of "wild" but in the sense of "disengaged" and therefore also "independent." Asked why there were no people in his landscapes, Ni answered that he did not know that there was anyone around in the world, meaning that his landscapes were all his subjective experience, which did not need anyone but his only self inside it. A true amateur, he gave away his pictures to hosts or to his carefully chosen friends. But when a general sent him painting-silk, money, and a request for a painting, Ni answered angrily, "I have never been a painting teacher at the beck and call of the lords and princes."[197]

When he first studied painting, as Ni writes in a poem, he painted the likeness of everything he saw.[198] Despite his words, his painting always remained representational, but in a style that I would call minimalistic perfectionism, or in a Chinese term with a different resonance, an "unembellished naturalness" (*p'ing-tan, ping dan*). Ni wants to paint "without likeness" in the sense of "beyond likeness."[199] What he calls painting, he says, is nothing more than sketching with a few unforced brushstrokes, and he does not aim at likeness but only at "amusing" himself. When he comes to town, and people ask him to paint in a particular way (I think he means, to paint in color and to represent all the details), they insult him or worse. It's not fair, Ni says, any more than to scold a eunuch for not growing a beard. He remembers that his friend Chang always likes his bamboo paintings. He does bamboo, he says, simply to express his own, independent spirit. Why should anybody argue whether his bamboo looks real or not? Often after he's daubed and rubbed for a while, others take what he's done to be hemp or rushes. He can't bring himself to argue that it's really bamboo, so what are the onlookers to make of it? He simply doesn't know what it is that Chang is seeing.[200]

The second eccentric, individualistic painter I want to describe is Kung Hsien (Gong Xian, 1618–1689).[201] Born of a poor family, he remained poor because of pride and patriotism, his pride preventing him from kowtowing to protectors and his patriotism from making his peace with the non-native, Manchu government. Searching for true culture, he and his friends wanted to study the classics, revive the old forms of writing, and prove themselves the worthy heirs of antiquity. Eventually he settled in the suburbs of Nanking (Nanjing), where he lived by teaching and selling paintings. Limiting himself to his hut and garden, he avoided the marketplace. In the words of a contemporary, he dreaded people, hid his footsteps, and was grateful to the goodwill of only tigers and wolves. Always poor, he wrote, "Even in my old age I still scheme at getting a living."[202] When he died, his family was too poor to pay for his coffin. A friend who happened to be passing through the city at the time settled his affairs, collected his writings, and adopted his orphaned children.

At first, Kung accepted Tung Ch'i-ch'ang's view that a painter should make a personal synthesis of earlier approved styles, but he grew to aim at a sharper, more extreme style, one that comes from facing nature directly and makes the experience of a painting the same as the experience of nature. He was critical of both professionals and scholar-painters. The professionals, he thought, were artistically dull, and the scholars practiced a vacillating eclecticism. What he aimed at was an art in which originality and stability, that is, strangeness and calm, would interpenetrate and constitute one another.[203] The landscapes he paints are correspondingly plausible but are meant to be strange enough, as he writes in an inscription to a painting, "to lead one off on journeys of the imagination." In another inscription he writes, "Anything that exists in the minds of artists also exists in the world." This desire to paint a real-seeming visionary landscape is reminiscent of Piranesi's etchings of Rome and of imaginary prisons; it is in fact not unlikely that Kung saw and was affected by the European prints by then known to Chinese artists.[204] To make another comparison, when Kung simplifies nature and subjects it to a deep overriding rhythm, the force with which he rules the landscape reminds me of Van Gogh, but unlike Van Gogh and like Ni Tsan, Kung leaves people out. Some of his paintings have a somber intensity that comes from the application of as many as seven varying layers of ink.[205] In Chinese painting, his density and depth are extraordinary.

Kung Hsien's whole method of working with light and dark instead of with arrangements of discrete, delineated forms encourages . . . ambiguities, and, because it was extremely uncommon in Chinese painting, was in itself some-

what unsettling. Objects and spaces are often defined only by light and shadow, and by areas of uniform texture that reduce diversity of substance to homogeneity. Forms are rendered, that is, as they might be perceived by the contemplating nonanalytical eye, not as they would be felt by the hand or understood by the mind.[206]

We know from Kung's sketchbooks that his approach to art was analytic, and we know that he composed illustrated teaching aids for students of art, and so it makes historic sense that the first-published section of the famous analytical textbook *The Mustard Seed Garden Repertory of Painting* was compiled by one of his students. Kung was, as he wanted, both systematic and proudly original. He wrote of himself as a poet, "He spits out his heart and digs out his marrow before he is finished; only afraid that one word might fall into someone else's path." Once he recommended himself with the words, "There has been nobody before me and there will be nobody after me."[207] Although he had students, his prophecy was accurate, and no one we know of continued his art.

The third of the individualists I would like to describe is Tao-chi, also called Shih-t'ao (Shitao, 1641–1710?), who was born into the imperial family not long before the Manchus invaded and conquered China.[208] After the Manchu triumph, the emperor committed suicide. Tao-chi's father tried to take over the throne but was captured and executed by a rival. Tao-chi, then a little boy, was saved by a servant, who fled with him to a Buddhist monastery. There, like many others, they escaped capture by becoming new persons, that is, by shaving their heads, adopting Buddhist names, and becoming monks. Tao-chi is one of the artist's Buddhist names; the Chinese usually refer to him as Shih-t'ao, meaning "Stone Waves."

When Tao-chi was about nine, he and his friend left the monastery and for ten years wandered by foot and by boat over a large part of China. To judge by his own words, he turned to painting in order to develop his self-reliance. In a colophon probably of 1679, he wrote:

> Being by nature lazy, and so often ill, I almost felt like burying my brushes and burning my inkstone, since no amount of "carving and skinning" the forms gave me what I wanted. Then quietly, and all by myself, I walked by the Chuchai studio and saw some original works by Ni Tsan, Huang Kung-wang, Shen Chou, and Tung Ch'i-ch'ang. As my eyes passed over the paintings, my soul followed. For several days afterward, I could sleep well and eat with interest again.[209]

Tao-chi was able to make his living only by painting. This was no longer a matter for a scholar to be much ashamed of, yet Tao-chi felt anxious and somewhat demeaned. He writes on an album leaf that professionalism might become his downfall. Although he prefers to paint on fine old paper and hates to paint on silk or make large hanging scrolls, he feels he had no choice. As Marilyn and Shen Fu elaborate:

> In one letter he apologizes to a client that his style is not suitable for decorative screens, but he accepts the commission, he writes, because he needs the money. In other letters he discusses fees or laments his ill health; he complains that his energies and mental powers are failing because of old age and that he often cannot stand the strain of stretching the large panels over frames or climbing up and down footladders to execute them. The tone and content of such letters offer a glimpse of the human side of the man which his poetry and painting often disguise. In spite of these hardships, Tao-chi in his late years was still able to maintain the core of self-esteem vital to any artist.[210]

Tao-chi thought that contemporary scholars could not grasp the spirit of the old masters they copied, or thought they copied—what his contemporaries have copied, he says, "are all forgeries, or if they happen to see any genuine one, they are unable to understand what they see."[211] Exact fidelity to an ancient model struck him as nothing in comparison with the ability to penetrate its spirit. He wanted to rise above both eclecticism and conflict between schools and be simply, freely himself. These were the reasons, I assume, that he writes that for him there is no style, a point I will pick up again in the final chapter. I think he also means (as did de Kooning in a similar remark) that there had been so many styles that style had disappeared or should disappear from painting.

In chapter 4, I will summarize Tao-chi's artistic creed, which is a declaration of artistic independence. It leads him to say, "Following old rules is death to mind and eye." After these words, so grating on conservative Chinese ears, he writes, with the kind of poetic flourish we have already met, "For the immortals ride on the wind, and flesh and bone compel the appearance of divine spirit."[212] His "no method" has been described as a factor in the decline of the originality and power of Chinese painting. His late paintings are weak, James Cahill suggests, because Tao-chi was by then ill, overworked, and beyond his prime. But it was his doctrine of no method that "drove him at last into an ultimately destructive renunciation of the very disciplines that had sustained Chinese painting through the centuries." Like Tao-chi in the end, many of the best of the eighteenth-century

professionals fell into a loose, amateur's spontaneity, while many of the amateur scholar-painters grew rigidly academic in style. The freedom granted by Tao-chi's theoretical emancipation from the past weakened the old, productive Chinese symbiosis of criticism and practice. This weakening, says Cahill, "marks the end of . . . the most intensely self-conscious time of this most reflective of artistic traditions."[213] Emancipation from tradition always has a price.

INDIAN ROMANTIC/EGOCENTRIC ARTISTS

There is an early-seventeenth-century history of Buddhism in India that includes a short section on "image-makers." It begins in a mythical style that fits in well with the artist-hero myth:

> In the ancient period the human artists possessed miraculous power and their artistic reactions were astounding. In the Vinaya-vastu [rules for monastic discipline], etc, it is clearly said that the statues made and pictures drawn by them created the illusion of being the real objects. For about a hundred years after the *parinirvana* of the Teacher, there were many artists like them. As afterwards there was none of them any more, the celestial artists appeared in human guise and made eight wonderful images for worship in Magadha [the kingdom in which Buddhism originated].

During the early period of Buddhist history, the account goes on, there were many images made by supernatural creatures, images that "created the illusion of the real objects for many years," but in the later period "there remained practically none with the knowledge of the technique concerned." The tradition of image making lost its uniformity and depended on the talents of the individual artists. No uniform tradition remained. But later, "during the period of king Buddhapaksha [fifth century CE?] there lived an artist called Bimbasara, who produced the most wonderful architectural sculptures and paintings," comparable "to those of the celestial artists of the earlier period. Numerous artists became his followers."[214]

It seems that celestial skill did not desert all human artists, as we see also when we turn from Buddhist to non-Buddhist India. There, too, of course, there are mythical origins. Vishvakarma, whose name means "all-creator," is the sculptor, jeweler, armorer, and architect of the gods. In order to entice and destroy two invincible demons, he takes a grain of everything beautiful in the world and creates a transcendently beautiful woman. As the originator of the arts and the crafts—the distinction between them is not Indian—he is the patron of all the

craftsmen and artists of India. The all-knowing god Vishnu is also credited with creating the arts, including painting.[215]

Sanskrit literature has many references to art and artists, some of whom are named and praised for their skill. Dasoja, openly proud, describes himself as the "smiter of the crowd of titled sculptors," and his son Chavanna is described as a veritable Shiva, a sculptor-god. Chikka Hampa, a king's sculptor, is "champion over rival sculptors." And Malliyana, who serves a king, is "a tiger among sculptors" and is, as he calls himself, a "thunderbolt to the mountains, rival of titled sculptors."[216] One literary source describes how amazed a king is at the skill of a sculptor in restoring a beautiful statue; another tells of the enthusiasm with which an art-loving king receives the announcement of the arrival of an extraordinary painter.[217]

The spirit of competition in ancient India was highly developed, from the very beginnings for which there is literary evidence. Artists were rated as better and worse in order "to create an emulative spirit in them and the desire to excel" in art. There is an account of a painter who moves from court to court in order to prove his superiority over other painters. At least some itinerant painters would arrive at court and "announce a challenge at the palace gate of any king by planting a banner with the words of the challenge painted on it and calling on those who desired to compete with him to pull it down. In any competition, the successful one was rewarded by the king. If, however, no one competed, the challenging painter was the recipient of honors."[218]

When the artistic ability of kings and princes is described, it is hard to distinguish between the truth and the hyperbole that is due their rank. But there were kings who were celebrated for their learning and creative ability. King Bhoja, an encyclopedic spirit of the eleventh century, is reputed to have been an architect; and King Someshvara, of the same century, wrote a detailed discussion of architecture, iconography, painting, literary criticism, and so on.[219]

It would be easy to add names, but even if I did, the list would remain miscellaneous and, to the extent that it would be based on literary references, it would not help us much to visualize the art in our mind's eyes. Yet the references show the variety of artists, the esteem in which they could be held, and the competitiveness and pride of some of them—the earlier Indian artists were not invariably anonymous or necessarily modest.

I have already discussed the artists who served the Mughal rulers, who for centuries dominated most of India. During the same centuries, the native Rajput rulers, too, were patrons of art.[220] These patrons are written about more

than the artists who served them, but artists could become well-known locally, and research has uncovered a considerable number of names and the styles attached to them. This is true, to give an instance, of the Kangra court, whose art, beginning toward the end of the eighteenth century, is a lyrical celebration of the ideal of love and beauty.[221] The ideal woman is always Radha, the ideal god-man, Krishna.

The writers of India, who are more often named than its sculptors and painters, have left some autobiographical fragments. From such fragments we learn that the novelist-poet Bana, of the early seventh century, lost his mother when he was very young and his father when he was fourteen. After mourning his father for a while, he tells us, he led a dissipated life, but learned calm, regained his prestige at court, and finally returned to home and tranquility. Dandin, who lived about a century later, also tells us that he lost his parents early in life. As was traditional among young writers, he wandered abroad for years and was able to study in foreign countries. We can sense these writers as individuals. The tenth-century poet Pushpadanta, who, lacking everything but ability and "a noble mind," is humiliated at the first court at which he serves and withdraws to the life of a wandering ascetic. His luck takes a turn for the better when "his wanderings bring him to the outskirts of a city . . . where he stays in a park, sleeping under the trees. Two passers-by invite him to visit the city, but he objects that he would rather eat grass on the mountains than see the faces of wicked and contemptible kings. However, they manage to persuade him to visit a minister who is a great patron of literature."[222]

To us, deaf to its original sound, the translated rhetoric of Sanskrit poetry may easily seem fulsome. This is certainly true when Indian poets praise themselves or one another. Writing some time about the beginning of the tenth century, the poet Abhinanda gathers up superlatives and praises the poet Rajeshekhara as a source of companionship, as a storehouse of conversation, as master of charm for winning the hearts of women, and as lover of fine speech. The translation of his evocative greeting of the poet can only hint at the beauty of the original:

> Sole abode of beauty, repertoire of gentle song,
> sea of firmness, tree upon the hill of justice,
> Rajeshekhara, my friend!
> Now I have seen you, I depart well blessed![223]

In India, writers sometimes complain, as writers do everywhere, about the reaction of the public to their work. Dharmakirti complains that though he

weighs word and sense alike, the public sneers and scorns his poems. The eighth-century poet-playwright Bhavbhuti says sarcastically that those who scorn him must be especially wise, so his writings are not for them. But "time is endless and the world is wide," he muses, and he consoles himself with the idea that some day someone will be born "whose nature is the same as mine." Dharmakirti also complains, or maybe boasts, that his artistic integrity has left him isolated. He is now alone, he says and goes on, "Ah yes, I see, the path which the ancients opened up by now is overgrown / and the other, that broad and easy road, I've surely left."[224]

When Indian aesthetes like Abhinavagupta (whose views I will take up later) say that the poet is capable of the mystic's numinous experience, they are not far from the stereotype of the mad artist.[225] There is at least one passage in Indian aesthetics in which the connection between poetic inspiration and madness is made. Poetry has little to do with sanity, the passage says. The heart of the poet is like an immeasurably deep lake of aesthetic emotion. When it is filled, the poet "becomes as if possessed by a planet, as if mad, and finally he pours out poetry, and turns the listener, the sensitive reader, into the same sort of madman as he has become."[226]

"PRIMITIVE" ROMANTIC/EGOCENTRIC ARTISTS

Given the great variety of "primitive" societies, I cannot pretend to know to what extent egocentricity or "heroism" is usual in their art. It does obviously occur, however, and seems, in one way or another, not to be rare. I will give three examples, one each from Australia, Polynesia, and New Guinea, and then go on to Africa, where I have found more and better developed examples.

The Australian Aboriginals recognize the Songman as a key figure in the transmission of their stories. The Songman inherits his position from his father or uncle and has a heritage of songs, the rights to which belong to him. This matter of rights needs to be explained. Among the Aboriginals, a song, a story, and a dance all recall one another as expressions of the same event in Dreamtime, and painting, singing, and dancing may very well go together in a ceremonial. Each design is associated with a particular Dreaming, and a song may be explained with the help of a painted design that belongs to the same site and Dreaming. There are different customs in different Aboriginal groups, but it is common for individuals to inherit artistic rights over paintings, songs, and dances, or to gain ownership rights over them by demonstrating deeper, more effective knowledge of their natures. Among the Yolngu, who live in northeast Arnhem Land, a

senior man who has the strongest right to the knowledge of his mother's group is considered to be the manager ("mother's owner") of a given ceremony. It is he who voices the dance calls that direct the singers. This man

> always dances with energy and passion and his performance often outshines the others. The jumping is higher, the movements more dramatic, the interpretation theatrical and emotional. Being a virtuoso is his right and duty. By means of his virtuosity, he displays his legitimate claim to the knowledge of his mother's group and fulfills his rights and responsibilities. It should be noted that such claims made through performance are brought into and displayed within the public arena, usually in front of a large seated audience whose members observe, comment on, acknowledge, or ridicule the performer's danced statements.[227]

The manager of a ceremony and the owner of a song sung in its course are likely to be different persons. But without the Songman's permission, which must be recompensed, no one can sing any of his heritage of songs or the songs that he himself has created. He remains a model of individuality and originality.[228] His social importance is evident, and though he is not the Chinese, Indian, or European kind of rebel-hero, he can be Aboriginal to a heroic degree, in the sense of a dramatic, self-consciously original creator, who can create, as he recognizes, only with the help of ancestral forces. He is, then, a traditional, ancestrally driven originator (who might as well have appeared in the preceding chapter, on tradition). As David Mowaljarli explains his heritage, in the beginning, when all the animals and birds were humans, everyone was lawless, but the animals, the ancestors, created ideas, the first of which was song, the basic principle of sharing. The animals who created ideas

> started ceremony, song, and the *wunman* (exchange system) which gives us our marriage system and a network for sharing our resources to all the different clans in our country. . . . A composer, *banman,* gets songs from these animals. The spirits start teaching him songs from the Wunggurr (rainbow serpent), the source of our lives. . . . Sometimes a male and female wunggurr will mate inside the body of the *banman* in order to give him power. This power is easily lost and many people have seen the snake leave their body and can point out the marks on their skin where the snake left their body. After this a person will lose the power to be a *banman*. . . . The wunggurr is a blind snake . . . but when it opens its eyes inside the body of the composer-doctor then he or she [the host] is given clear vision and a shining eye and is able to look into the

spirit realm. . . . The art of the great *banman* is being lost to us now. There are only very few left.[229]

The importance of particular people in the transmission of the aesthetic life of a culture can be seen as well in the example of the Arioi, a professional cult of worshippers of the Polynesian god Oro.[230] The Arioi traveled from place to place in the service of their god, performing their ceremonials and entertaining their hosts. To become an Arioi "novice"—the first of a number of ranks—one had to be handsome, physically perfect, and show talent in singing, dancing, and other relevant skills. Active members were not allowed to have children. Abortion and infanticide were used to enforce this rule; if a child did survive, the offending parent was confined to the cult's less important activities. The origin of this custom is unknown, but because they were childless, the full members of the cult were able to devote themselves more completely to their profession as entertainers.

Before arriving at any destination, which was usually the house of the chief of the host community, the Arioi

> dressed in their lavish cult costumes and approached their destination (most often in canoes) with great clamor . . . paid their respect to their tutelary, and then settled down to a few days of dancing, theater-performances, feasting, and—according to some European observers—sampling the sexual wares of their hostesses and hosts (there having been female Arioi as well as male).[231]

Each Arioi performance, whether concerned with mythology, history, or love, began with songs and dances and ended with a dance. While Polynesians were ordinarily very careful to show respect for their rulers, the Arioi, who also performed satirical farces, could mock their ruler-hosts with impunity. The performers gave welcome pleasure to the crowds that watched them and were applauded everywhere. Their songs and dances were sexually very explicit, and the victors in an Arioi contest of theatrical ability would choose the most attractive of the women spectators as their private rewards. Different as the social context may be, I can't help connecting the activity of the Arioi with the romantic artist-myth that Westerners (and not they alone) know so well.

From New Guinea I take the example of the woodcarvers of the Asmat region.[232] Each woodcarver is in most ways an ordinary villager, and like his fellows, he prepares sago, hunts, fishes, and makes wooden implements for everyday use. But though he has had no formal training in woodcarving, he is considered a "wood-carving person" (*wow-ipits*), who is related in spirit to the cul-

ture hero of the Asmat—a great creator, the first drummer, the first woodcarver, and the great headhunter. In every village there are some people with a connoisseur's attitude to woodcarving, and they are able to evaluate the local carver and name the more important carvers of neighboring villages. Good craftsmanship is always an important criterion, but some of the carvers are clearly distinguished by their daring and imagination. Yet I take this example of the heroic artist to be a relatively weak one, so I abandon it without further explanation and turn now to Africa.

AFRICAN ARTISTS' CREATIVE EGOCENTRICITY

My African examples begin, briefly, with storytelling and music. I haven't gone into the special nature of storytellers, but I think it is relevant to repeat what an investigator found in a study carried out in Benin. D. Ben-Amos determined that storytellers there, whose performance is believed to attract "witches" and "spirits of the night," are socially isolated, have troubled lives, and are mostly introverted.[233]

For music, I point to the Bala, who live in what is now the Democratic Republic of Congo, and the Tiv, who live in Nigeria. Among the Bala, musicians neither work in the fields nor do the other work expected of ordinary men. Since musicians are regarded as weak, eccentric, and impractical, parents do not want their children to take up that profession. The musicians themselves usually agree that their profession is not a desirable one, and yet they are said to be born to it and, because they want and need to make music, are unable to resist its call. Often they fulfill what people expect of them by becoming drinkers and spendthrifts.[234]

Among the Tiv, who are known as warriors and singers and dancers, most songs are regarded as the creation of a particular individual. The composers of songs are assumed to be meditative and slow moving. Some of them become musicians because they were born blind or lame, and others seem to have decided to become musicians as the result of some personal misfortune.[235] One Tiv composer generalizes and says that composers are different because they praise people in order to get money from them, but they are also never at rest, because "their minds are always working like a clock to bring about a new song, always restless." Another composer reports that women who love certain composers' songs leave their homes to follow them. A third, who confirms the sexual attractiveness of songs, says that praise is very important to him, but that he is most pleased by the marriage his songs have awarded him. This is because, he explains, he was at first too alone, but "now it seems that the world wants me

again." Still another composer, defining what makes a composer, believes that that "if he can convert the hearts of the people to experience the same situation that he has experienced, then he is a good composer."[236]

To do some justice to the richness of African life and sculpture, I have drawn my examples of the more subjective or egocentric kinds of carvers from a number of different peoples: from the Sisala of northwest Ghana; from the Bangwa of west Cameroon; and from the Dan, Kran, and Gola, all of Liberia. Thanks to more recent, especially helpful literature, I can also report on the Baule, who live mostly in the central Ivory Coast (Côte d'Ivoire), and, to end with, on the Yoruba, most of whom live in Nigeria. Although these examples are all meant to make the same general point, their number is justified by the variety of the evidence they provide.

I begin with a Sisala sculptor named Ntowie (c. 1910–57), whose career has been documented at length by J. Nunley. Having recognized early on his identity as "first carver," and having that identity confirmed by others, his growing reputation inspired imitators and disciples. He stood out as a model of nonconformist success. As a boy, he was described as lazy, preferring to hide and carve instead of farming. Once, after having been severely punished, he ran away for a while, and then he came back with human figures so beautifully carved that the elders of his lineage assumed that the bush spirits had inspired him. From then on, he was never ridiculed but encouraged to go on carving. He was so well regarded that persons from other clans commissioned sculptures from him: his work was found in many villages, and a surprising number (fourteen) of his sculptures remained for Nunley to see. Nunley comments that this was remarkable "considering the public's minimal demand for wood sculpture."[237]

Among the Bangwa, there are hardly any typical artists. Some of them do conventional work, and some are original, some are well integrated into society, and some are wastrels and philanderers such as fit an egocentric stereotype. One of those who does fit is Atem, a person equally devoted to carving and to drink.[238] The money he earns from carving a mask goes into drink, which he shares with his friends. Unlike most Bangwa men, he does not care for status or material comfort, and he belongs among the Bangwa carvers who are remembered for their wit and their self-willed way of life.

In Liberia, in the Dan and Kran area, the greatest sculptor known for two generations was Zra.[239] Though he was old and sick when the German anthropologist H. Himmelheber visited him in the 1950s, he got up immediately and said, "If anyone calls here, it can only be for me." As his explanation shows, he had no doubts about his creative power:

I am called Zra. Zra means "God." People gave me this name because I am able, like God, to create such beautiful things with my own hands. If you see a particularly beautiful carving anywhere in the land, whether a mask or a rice-spoon, and another carver claims it, it is a lie. All the beautiful pieces were made by me. I was born with this ability. No one showed me how to carve. No, no one in my family knew how to carve.[240]

Zra told Himmelheber that he had been so famous that even the chiefs of hostile tribes had invited him to come and carve for them. When he got such an invitation, he would send a message asking his hosts to build him a fine hut in the bush where he could work. When the hut was finished, he would move there with his favorite wife and an apprentice. "From what I earned with my carving," he remembered, "I bought many women. . . . I gave them to my sons and nephews, who in turn worked my farms with these women."[241]

Tompieme, a carver who lived in a neighboring area, loved carving and spent most of his time at it, and he also composed and sang.[242] The story he told Himmelheber was that he had been inspired to become a carver by the request of his dead brother, who appeared in a dream and asked him to work, as he had taught him, at the smithy. Tompieme then prepared to become a carver by buying an adze. The following night his brother came again in a dream and commanded him to carve a Kagle mask, and from that day he kept on carving.[243] He took up blacksmith's work too. Before he began a piece, he would look at the chosen block of wood, he said, and could see the carving in it. He declared proudly, "I do not carve to earn something, but mainly for my fame. My name will not be lost when I die. My apprentice Ge will also tell of me when I am dead."[244]

The Baule, who live in the central Ivory Coast, are in certain ways quite like and in others very unlike ourselves in their attitudes to art. Their experience of art is to them emotionally and intellectually of great importance. The artists who make the Baule's valued works of art are respected professionals. Although it was hard for them to make a living from carving alone before their sculptures became valuable in the outside world, they worked on individual objects, then as now, with great care, always attentive to the objects' appearance. The aesthetic merits of these works were and continue to be discussed, and the works themselves have often been protected for generations.[245] Yet the Baule have no category for "art" as such because they are too deeply concerned with the great powers of the objects for good or ill. One's fate can easily be determined by a created object. A portrait, for example, is a spiritual double. To reveal a powerful object, which protects one's well-being, to a stranger or to a jealous or hostile neighbor

is to court misfortune, or as the Baule have recently learned, to attract thieves. For these reasons, the most important of the sculptures are usually hidden. Even the masks for dances meant to entertain are put away carefully after a performance and are seen by few people apart from their appearance as part of a costume worn by a dancer. "The more important Baule sculpture is, the less it is displayed, just as in public debates the most senior and respected people speak the least."[246]

What in Baule character and art allows Baule artists to join the others classified as individualistic, as "heroes" or even "egocentrics"? Part of the answer is that all Baule learn, from childhood on, that they have power over their own lives. Unhappy children and unhappy wives can easily move to the home of a relative, or even to another village, without fear of coercion. The refusal to conform is accepted with great tolerance, and as Susan Vogel explains, the Baule are no more conformists in art than in life.[247]

> Baule individuals like to present themselves as striking, idiosyncratic, and highly independent—traits that are mirrored in Baule art, which includes many highly particular one-of-a-kind objects. Peculiar or flamboyant behavior is nobody's business; people notice it but barely talk about it. Just as Baule society tolerates a wide latitude of eccentric behavior, there is no sharp orthodoxy in the forms of Baule art. Both art forms and individual behavior can be determined by the personal desires of individuals—old and young, male and female—who manage to assert their needs and attract the attention of others. More than birth, rank, gender, or even age, the main requisites for special treatment are presence, conviction, eloquence, and personal charisma that even a child can possess.[248]

In Baule art and life, individual desires, individual possession, and the competition between individuals is the rule. Most art objects are the property of individuals, who alone have the right to use them. The individuality of the objects helps to establish the individuality of its maker or owner. Art has no demanding orthodoxy or fixed iconography, and so Baule art is, in its own terms, bold, idiosyncratic, and widely varied. Competition is strong and natural in music, dance, costuming, and carving. Successful competitors are usually rewarded by praise, fame, money, and other gifts.

> The rewards for power, status, skill, and beauty, and the public competition among the mask wearers, carvers, musicians, and soloists, are more or less overt and explicit, and in this they mirror the society of which they are a

part. . . . In fact many kinds of objects ultimately owe their existence to this spirit of competitiveness and independence, which is part of the impulse for their creation.[249]

The last African artists I want to dwell on are those of the Yoruba, of Nigeria. Western historians' view of Yoruba art has become increasingly influenced by Nigerian scholars and artists, and as a consequence the Yoruba sculptors of premodern times have been getting their names and their aesthetic identities back. Early researchers assumed that Yoruba works of art often lacked signatures because it was unimportant to the Yoruba who made them. One well-known scholar, Roland Abiodun, claims that this was a serious mistake. To the Yoruba, he says, it has always been important that persons acknowledge one another's individual identity. Yet the Yoruba are very careful in their use of names—under ordinary circumstances, Yoruba children think that it is seriously disrespectful to address parents by their given names. This is because the Yoruba believe that their names are, so to speak, their spiritual essences. Traditional artists, who felt themselves especially vulnerable to malevolent forces, only rarely revealed their names to strangers and, it is reasonable to suppose, rarely signed their works.[250]* But whether or not this explanation is sufficient, we know that Yoruba sculptors might sometimes be given and must often have relished great, at times extravagant praise. The testimony can be found in their praise poems, *oríkì*.[251]† The

*Contradicting this view, my friend Ulli Beier, who spent many years in close contact with Nigerians, especially artists, comments in a letter of September 9, 2005: "I don't think that artists feel more vulnerable when they reveal their name. They may be referred to by any of their names or any of their Oriki [praise-poem names]. If they did not 'sign' their name, it was simply because they did not write! Nor did they mark their carvings with a small incised image that identified the work as theirs! (This was later introduced by Yoruba women who made indigo batiks.) They had a distinctive symbol, but they were so modest you had to undo the seam to discover it!" I explain the discrepancy between the views of the two authorities by the different experiences they underwent—Nigeria is a large, variable country.

†The Yoruba have a concept, *alujanun*, that has a range of meanings like that of the European "genius," genius in the sense of great inborn ability to know more, to be more perceptive, and to act to greater effect than ordinary people. As one Yoruba informant said, "The persons we call '*alujanun*' are those who can do extraordinary things. . . . Whenever we would see something mysterious or marvelous in the olden days, we would refer to it as the work of *alujanun*." The character of such innately gifted people can be good or bad. "Some of them are bad, because there are no persons with extra powers who [on some occasions during their lifetimes] are not cruel. . . . They can do good things and bad things

praise poem is usually sung by a close woman relative during the subject's life and, later, in the subject's memory. A good example is the praise poem for the sculptor Olowe of Ise, who died in 1938. He is considered the most important Yoruba sculptor of the twentieth century—a pair of his carved palace doors are in the British Museum. The Yoruba ruler for whom they were carved refused to sell them to the museum but agreed (when the British Museum refused to return them) to trade them for a British-made throne. Olowe later made new palace doors for the ruler. His style is easy to recognize, one of its characteristics being more dynamic figures than those of other Yoruba sculptors. On one of the palace doors in the British Museum, for example, all the figures are active and the illusion of motion is created. Compared "with other Yoruba carvers, Olowe was an innovator," his work Yoruba in style, but unique, with "large-scale, elongated, often angular forms, illusion of movement, exceedingly high relief, polychromy, and richly textured surfaces."[252]

In 1988, Olowe's praise poem was recorded as recited by his fourth wife, Oloju-ifun Olowe. It begins "I am Oloju-ifun Olowe / Olowe, my excellent husband / Outstanding leader in war / One with a mighty sword" and contains, among the rest, the following lines:

I shall always adore you, Olowe.
Olowe, who carves *iroko* wood.
The master carver.
He went to the palace of Ogoga
And spent four years there.
He was carving there.
If you visit the Ogoga's palace
And the one at Owo,
The work of my husband is there.
If you go to Ikare,
The work of my husband is there . . .
Olowe also worked at Ogotun.
There was a carved lion
That was taken to England.
With his hands he made it.[253]

as well. The same as with ordinary persons." It is not clear from the account I am quoting if the concept of *alujanun* was in fact used to characterize art, for instance, extraordinary sculptures, or the extraordinary ability to carve sculptures.

Among the Yoruba carvers, Taiwo (c. 1855–1935) of Ore's compound, is also well remembered. I quote a few of the lines from his long praise poem, which emphasizes his skill as a carver:

He carved the wood, and it was perfect.
The wood had eyes, a mouth, and a powerful chest.
It also had a capped [circumcised] penis.
This carving was perfect, perfect in the eyes,
Perfect in the mouth, perfect in the broad chest.
To crown it, he depicted perfectly the penis with its cap.
The father [king] then spoke with authority:
"Let the appropriate sacrifice be made for *orisa* and Ore [Taiwo's family
 compound].
Future generations shall be known for their carving skills,
And they shall continue to prosper for generations."[254]

The last of the celebrated Yoruba sculptors whose praise poems I will quote is the most distant in time and the closest to a legendary figure. He is Lagbayi, the itinerant sculptor of Ojowon, who lived toward the close of the eighteenth century. No sculpture made by him has been identified. According to the praise poem, Legbayi made characteristic, delicate textural markings on his carvings, which were as naturalistic "as a picture," that is, as a literal description. "His carvings were tall and robust human figures. . . . Even small carvings appeared queen-like, that is, had monumental qualities."[255] The praise poem boasts that the other sculptors in Legbayi's ancestral home carved shapeless wooden objects.

But whenever my father did his own carving, it looked robust and
 beautiful.
The itinerant carver, who changed a wooden object into a human being.
You, my father, inscribed beautiful and delicate *kéké* facial marks on a
 wooden object.
You inscribed broad *abaja* marks on a wooden object in the city of Owon.
Lagbayi, the itinerant artist who carved wooden objects
resembling real persons during the reign of Abiodun.
On the day Lagbayi, the itinerant artist, was returning
from one of his carving expeditions,
The *apa* trees collided with one another in trepidation. The *iroko* trees
 collided with the palm trees in great fear.

They wondered where next Lagbayi would place his load of carving
implements.
Short people in the crowd stood on their toes,
While very tall spectators stooped down [to catch a glimpse of him].
They all exclaimed, "Kujenra, whose other name is Agbosokun,
Where are you going?
On which road are you going to tread? I wish I knew where you were
going,
I would have gone with you."[256]

Perhaps the most striking report tying African carvers to the egocentric or heroic tradition concerns the Gola of western Liberia.[257] The traits described by the anthropologist W. L. d'Azevedo may be the result of modern conditions; but because the historical background is not well enough known, we can see no further than the time he made his observations. D'Azevedo reported that the sculptors themselves emphasize that they want to become known for the masterpieces they carve. Like skilled musicians and dancers, expert Gola carvers are as much distrusted as admired.[258] This ambivalent attitude is nourished by their independence, because, to the discomfort of ordinary tribesmen, they have become relatively free of their families and communities.

Famous Gola artists—singers, dancers, storytellers—compete for attention at ceremonies and festivals. Some have become legendary because of their ability to create songs, because of their well-known lovers, or because of the supernatural inspiration they claim. Singers, who are often childless, claim that it is their tutelary spirits who have made them barren. The carvers who believe that their ideas come from dreams inspired by a spirit-friend claim that their work is superior to that of nondreaming carvers. Professional carvers questioned by the d'Azevedo usually said that they had chosen carving against the will of their families, such talent being supposed to weaken family loyalty. One carver reported that his father had destroyed the tools he had made for himself. Others reported that they had run away to tolerant relatives or had become apprentices in secret. Their urge to carve, they claimed, could not be resisted, and it was a competitive urge, to carve so as to excel any rival. Even when the carver was a relative conformist, there was a consistent expression of "the theme of misunderstanding and the lonely pursuit of a beloved craft."[259]

Masks are essential to the ceremonies of the women's secret associations, so the women may court a famous carver with money and if necessary, stories say, with a specially chosen seductress. A carver is said to be by nature generous to

children and women friends. Like his person, his work appears both heroic and eccentric. "As the child of society his work is a kind of eternal 'play' but his play-things are more-than-lifelike symbols which awaken disturbing thoughts and values which lie for the most part dormant in culture."[260]

I cannot abandon the subject of African egocentricity without reporting on an apparently rather new art form of the Ibo (or Igbo) of eastern Nigeria. This art, which honors the dramatic festival of regeneration, the Mbari, requires the building of an Mbari house with clay sculptures of animals, men, gods, and monsters. As H. E. Cole explains, the moving spirit in the process of construc-tion, "the person of skill," combines the qualities of architect, sculptor, and even priest. Although Mbari artists are guided by the work of their predecessors, they and their clients prize originality and agree that each artist works according to the dictates of his own will. Artists of the same generation are fiercely competi-tive. "No man admits to a superior; few acknowledge equals." As one of the art-ists says, "The thing that spurs me on is my willingness to make my work more beautiful than that of any other artist." However, Cole wryly observes, that if one takes the Mbari-artists at their word, most of them are more interested in finan-cial reward than in self-expression.[261]*

ALL ALIKE, ALL DIFFERENT

My conclusions on creative egocentricity and innovation are not without reserva-tion. Doubt arises because the cases I have described may illustrate the exception rather than the rule, or may reflect recent social attitudes rather than older, more traditional ones. The "inspired" or "mad" artist was often regarded as an excep-

* Ulli Beier takes issue with this view. Beier, who studied Mbari houses well before Cole, argues that Cole is certainly wrong in ascribing money as a motive of the Mbari house builders. In his experience, the actual builders were teenagers, fed by the community, who did not ask for or receive money. Perhaps, he adds, the motives of the artists or build-ers later "became corrupted." The creation of a Mbari house was first and foremost a way of serving Ala, the Igbo creator-goddess. "The High Priest would select two boys and two girls from a certain age group in each compound. These would live in total seclusion for about a year and create the mud building and hundreds of mud sculptures. The building would then be abandoned to wind and rain and it would crumble and collapse within five to eight years. Then it was time for the next age group to go through the creative process. For the Ibos the constant renewal of the Mbari house was necessary for the survival of the village and the survival of the crops!" The conspicuous desire to be original therefore had a practical motive like that of other African ceremonials, notably their dance-dramas (I quote Beier's letter of August 23, 2005).

tion, although, for example, the same statistical evidence that shows that recent Western artists were relatively disturbed shows that many, perhaps most, were not. Furthermore, in estimating the plausibility of the statistics, it is hard to get clear of issues of choice of examples, ways of categorizing them, and other problems of statistical adequacy. All the same, the scope of the examples is impressive enough to justify the application of the categories of "hero-artist" or "romantic/egocentric" artist to world art in general, and the overall impression remains: the artist who stretches tradition to the breaking point or rebels against it, who is impulsive and alternately elated and depressed, who is regarded by himself, herself, or others as a kind of hero, who is by nature or design willing to sacrifice anything and everything for success in art, is not unusual in human culture. This type of artist is neither a mere legend nor a mere creation of the modern European imagination.[262]*

If I had emphasized how often that artists I've spoken of in this chapter were in the end subordinate to patrons, the impression of "heroism" or rebelliousness might well have been weakened. A full rebellion against the artist-patron tradition must have been quite rare. True, there have been artists or writers, like Bhavbhuti, who, disappointed by their lack of success, anticipated that they would be understood only in the indefinite future. The socially best-developed independence among artists was that of the Chinese amateurs, the antiprofessionals who, for all their compromises, tried to keep their distance from proficiency in and for itself, and from the restrictions imposed on artistic freedom by payment and patronage. Our own immediate present strikes me as hard to judge from such a standpoint. The attitude of some contemporary artists may even be that the social and aesthetic good they bestow upon society is so great that it is the duty of society to support them.

Surely, "heroic" or "romantic" kinds of artists come into being naturally enough for their absence at any given time and place to need just as careful an explanation as their presence. But wherever the heroic or romantic or rebellious

*As Z. S. Strother argues, "The issue of creativity has become a difficult one. Modernism constructed a world marked by obsessive concern with questions of origin and originality. . . . The avant-garde held that 'tradition' was for those left behind. They constantly opposed themselves to imaginary 'primitives' caught in time. African art specialists responded to the interest of the period by emphasizing the social and communal.

"Today it is necessary to steer a course between the two extremes. On the one hand, we do not want to paste onto Africa romantic eulogies of 'the genius,' who can create independently from all society. On the other, we must break out of the mold of primitivism to open up room for the creative participation of the individual in society."

artistic persona exists, it gives evidence not only of the likenesses but also of the incessant variety in which it shows itself. This variety is certainly not less worth noticing than the similarity. Because art exists only in imagination-suffused sensuous bodies, the sensuous uniqueness of its examples exposes the inadequacy of the generalization that states that they are alike, or, for that matter, that they are different. If worked out, the examples are precious because, in illustrating the generalization, they show how, as sensuous, imaginative presences, they go beyond it. The generalization has an abstract meaning that ordinarily leads thought, like a road, in a narrowly defined direction. In contrast, a well-described example leads in many directions at once. Everything can be looked at very closely or very distantly, with indefinitely many degrees of attention, from an endless number of literal or figurative points of view, and with any of an indefinitely large number of purposes. It is the general similarity between different works of art that makes it easy to see the differences in their interest, style, background, and effect: what is similar is also always different, and what is different, also always similar.

Here is an example: At the beginning of this chapter I quoted some of the extravagant cosmic imagery by which the ancient Chinese made a creative hero into a perfect, omnicompetent human being. Not, to my mind, surprisingly, this tendency reappears in Yoruba praise poetry. Take the poem from which I earlier quoted in praise of the master carver Olowe of Isa. He was, the praise poem recalls, not only a carver to whom the hardest wood was as soft as a calabash—a standard compliment for a Yoruba sculptor—but an "outstanding leader in war / One with a mighty sword." Also, he was "Handsome among his friends / Outstanding among his peers." And, to speak in near cosmic terms, he was "a great man, who, like a mighty river, flows beneath rocks / Forming tributaries / Killing the fish as it flows." And Bamidele, son of Dada, is said in his praise poem to be a veritable "wizard" among carvers, "whose axe is like the thunderbolt of Sanga," the god who shows his power in thunder and lightning.[263]

Remember the woodcarver Ch'ing and the amazing bellstand he was able to carve because he would fast, forget himself, and everything else and go into the mountain forest and look for the tree whose heavenly nature would match his own and be essentially right for the sculpture into which he intended to transform it. In some ways, Ch'ing calls to mind Legbayi of Ojowon, the itinerant Yoruba sculptor who had the marvelous ability to change a wooden object into a human being. Unlike Ch'ing, who matched his nature to a tree's, Legbayi was assumed to frighten the trees he approached so that they would fall victim to his axe. But like Ch'ing, he preferred to carve in the deep forest. He carved there

because, a Yoruba, he believed that sacred tasks should be carried out where the spirits and supernatural beings live. And he chose the forest to carve in because there he was close to the best trees for his work, and, even more, because, far from his family and community, he could be alone and "gain the much-needed inspiration, tranquility, and quiet composure of mind and body to carry out his creative task." How like Ch'ing and how different.[264]

INTERSECTING WORLDS AND IDENTITIES

CREATIVE CHAOS

This chapter takes up the ways in which Western and non-Western artists have rejected their traditions and, in doing so, have made art extraordinarily free, fertile, and problematic. The result has been what is called postmodern art, in which there is no dominant influence or direction, but a kind of chaos, governed more, I suspect, by rules of economics than aesthetics. Some of the senses of "chaos" serve as interesting metaphors for this art, so I'll play with them briefly to see where they lead. But I devote most of the chapter to the mutual influence of Western and non-Western art. The extent to which the different traditions have recently influenced one another testifies to the power of modern communications and, no less, to the human lust to know, fathom, buy, sell, and exhibit art of every kind. In the confusion that has resulted, artists have been sometimes caught painfully between cultures. The artists of the Western tradition have proved able to assimilate influences from everywhere, while those of the non-Western traditions have also been engaged, as I show, in affirming, revising, confusing, disputing, and complicating their identities.

A word first on the chaotic element in art history. Modern Western art, with its volatile changes, unexpected successions of schools, and often surprising rise

and fall of individual artists, is chaotic in the sense that few if any of its changes could have been predicted or be shown in retrospect to have fallen into a pattern that accords with causes of the kind to which we usually attribute them. The chaos I mean is not the true randomness of "chaos theory," which teaches that whatever happens, although causally determined, may be the outcome of causes whose influence was too quickly and unexpectedly effective for their outcome to have been predicted. But applied by way of analogy, with neither mathematics nor determinism, to the history of art, the theory implies that art's historic changes might have resulted from small, unpredictable causes that, by multiplying quickly, had great, unpredictable results. Unpredictably, a few insects imported from no one knows where might have multiplied quickly and ruined a crop; the failure of the crop might have triggered an already latent revolution; and the revolution, perhaps like the French Revolution, would have caused a far-reaching change in the nature of the country's art. Likewise, Van Gogh's intermittent attacks of madness, which occurred for reasons he did not understand (and which are still uncertain), were, of course, extremely frightening to him and made him fear that they would affect his pictures for the worse. Yet his madness and suicide helped to make him a hero in the eyes of some of the German expressionists, who were inspired to exploit their own strangeness so they could become, they hoped, more like Van Gogh in genius and reputation. Who could have predicted this effect of Van Gogh's misfortune? And who could have guessed the eventually enormous effect on contemporary art of the ironical joke that Duchamp once played on the other organizers of an open exhibition when he submitted the upside-down urinal signed Mr. Mutt and, in the little magazine he edited, defended its submission on the grounds that the urinal had been transformed by its new title, *Fountain,* and its choice by one Mr. Mutt?

A less than orthodox history of twentieth-century art could be based on the transforming power of small, unexpected events. In such a history, art's unpredicted changes might be assumed to be fateful deviations from the patterns that reason suggests and history now and then validates. These patterns (analogous to chaos theory's "strange attractors") could be any of the persistent social forces that affect art. Such forces, dwelt on in current histories of art, might be supposed to express the effects of relatively lasting class differences, such as those described by the French sociologist Pierre Bourdieu.[1] But an exponent of the chaos-theory analogy would prefer to show how personal factors, as insiders know them—love affairs, bribes, favors, avarice, envy, illness, and other accidents of human relationship or nature—have deflected the history of art. Such random factors have made it impossible to give any but very tentative explana-

tions of art's changing fashions. I use the word "impossible" ironically, because explanations are always given, but not until the unpredictable changes, having already taken place, have their more dignified causes assembled into explanations by experts after the fact.

Chaos of some sort has certainly characterized recent art, and it seems to me natural to explore the analogies with senses of "chaos" that are associated with the process of creation. The sense that comes to mind immediately is that found in the cosmologies in which the origin of everything, being wholly indefinite, is the potentiality to become anything that can take on existence. "Chaos" is then equivalent to "primal potentiality." In both Jewish and Mesopotamian mythology, what preceded the world was a watery chaos. The idea that everything that is anything emerged from primal potentiality is the message of a famous hymn of the Vedas (*Rig-Veda* 10.129), which relates how in the beginning there was neither existence nor nonexistence but only a nameless unknown, maybe bottomless water, a darkness hidden by darkness, and, somehow, a heat, a life force, and desire, so the world could begin to create itself out of its potentiality.

China has a more interesting conception of chaos, the Tao (Dao). In the book attributed to Lao-tzu (Laozi), the *Tao-te Ching* (*Daode Jing*), the Tao is a mysterious something, amorphous, complete, and everywhere active, that is the nameless mother of everything that has a name and form. The earliest commentator on Lao-tzu explains that "everything that exists arises from emptiness, and action arises from quietude."[2] But the Taoist belief I like best as metaphor for the death and rebirth of art is the one in accord with which the adept grows an embryo inside himself in order to rejuvenate or displace his aged self. This process isn't easy to undergo. The adept has to live morally and meditate on the Light of the One, that is, visualize a powerful succession of colors that will illuminate him internally. There's also a complicated hygiene to nourish the vital principle, assure tranquility, and teach embryo-like breathing.[3] I find a sad charm in imagining a stiff, anxious old man trying to be reborn by relaxing, directing himself to be like Chaos, and trying to return to his embryonic state. And the Taoist process of embryogenesis, however it works for the old man, makes a stimulating, if odd, metaphor for the birth of a new art in the twentieth century. In my mind's eye, I see the metaphorical process begin with art in the person of an academic painter who, unhappy to remain bound by rules, takes the trouble to become childlike in art. By practicing the innocent simplicity of childhood, the artist gets to feels free, natural, and authentic. This attempt explains the effort of European painters such as Klee, Matisse, and Miró to rejuvenate themselves and their art by drawing on the art of children.

If we accept the metaphor of art that is born, grows old, is reborn, grows old again, and needs to be reborn again, then the European art we are most familiar with is that of Greece and Rome. Its first death was in the early Middle Ages; its rebirth and adolescence took place in the late Middle Ages and Renaissance; and its growth into adulthood and (in some eyes) old age took place from the Renaissance until about the beginning of the twentieth century. But as I imagine it, the chaos and rejuvenation would not have occurred if not for the appearance of a new, magical instrument, the equivalent of the Taoist's mind-mutating, light-creating alchemical hygiene. I mean that the beginnings of the chaos or creative indeterminacy of painting were mostly the effect of the light-capturing mechanism we know as the camera. In terms of the embryo metaphor, the old art died for the artists who declared that the paintings they had just made were the last possible, because painting or art altogether was on the verge of death or (their paintings having already been painted) had already died. The chaotic, embryonic indeterminacy of art that ensued was that signaled by monochromes, blank canvases, empty frames, readymades, and empty spaces (exhibited by Yves Klein and others). This can be seen as the transformation of an old, dying art into a lustily howling, attention-demanding childhood.

THE CAMERA'S LIBERATING LIGHT

Photography served painting by being faithful, after its fashion, to appearances, but it also subverted some of art's uses and conventions. The European passion to see better had been growing. In Italian Renaissance art, it was the passion to see in a way both scientific and ennobling. In Dutch art of the seventeenth-century, it was the passion to see in ways at once intensive, extensive, and lovingly factual. This accurate seeing was encouraged by the telescope, microscope, camera obscura, and the new maps that exploration encouraged. All these innovations increased the range and accuracy of the eye and aroused the appetite to know the world accurately and as a whole.[4]

Then the eye got the camera as its increasingly effective agent, although the testimony of eye and camera was not and could not be identical.[5] The relation between the two and between them and what the painter set down is extremely interesting. Comparison is hindered by our ignorance of the workings of the visual brain, but even so, we know that perception by the eye and the camera is different in perspective, degrees and areas of sharpness, degrees and areas of distortion, color, and other qualities that cannot be summarily named. Unlike the camera lens, the perceiving eye has to dance around continuously in order to keep on seeing. But granted all these differences, the similarity between what

the eye sees and the camera records remains striking. The gross truth is that it is possible in photography for the world to show itself with a previously unknown independence of the artist's interpretive will. A painter begins with a completely blank surface, a photographer with an image chosen within an already existing field of view.[6] A photograph can still affect us as if it represents brute fact rather than nature mediated by human intentions.

Historically, reactions to photography were varied. Baudelaire denounced the new industry and the ideal of the exact reproduction of nature. He was afraid that if the "results of a material science" were accepted as the model of beauty, the ability to judge and feel the immaterial qualities of art and life would be sadly diminished. But Delacroix, Baudelaire's model of the true contemporary artist, used photographs freely to help with drawing and painting. Although he learned soon enough that the camera could falsify, he felt that if a man of genius used the daguerreotype as he should, he would raise himself to unknown heights; he himself, he wrote, might have had a fuller career had photography been discovered a generation earlier. As Delacroix said, photography corrected errors of vision, showed nuances of tonal recession, and, all told, initiated the painter into "the secrets of nature."[7]

In spite of painters who emulated the realism of photographs, the prevailing view came to be that photography and painting were not and should not be rivals because the nature of the one was to capture objective reality and of the other, subjective reality. At first this distinction was interpreted in a conservative way, but it contributed to the radicalization of art. In the eyes of André Derain, fauvism was likely to have been a reaction against anything that looked like a photograph, because, he said, "The idea that everything could be lifted above the real was marvelous in its pristine freshness. The great thing about our experiment was that it freed painting from all imitative or conventional contexts." A futurist manifesto of 1918 declared, "Given the existence of photography and of the cinema, the pictorial representation of the truth does not and cannot interest anyone." An expressionist manifesto read, "Today photography takes over exact representation. Thus painting, relieved from this task, gains its former freedom of action." André Breton said, likewise, "The invention of photography has dealt a mortal blow to the old modes of expression, in painting as well as in poetry." Most succinct of all is Picasso's statement that now, after the invention of photography, "we know at least everything that painting is not."[8]

For many, the sharp splitting of photography from painting was enough to change the course of both. But this view took no account of the ability of photography to inspire painters by its explorations, which add so much to the ordi-

narily visible world. In spite of their denials, the futurists' paintings of motion depended upon photographs, as did Duchamp's. Even such a highly imaginative painter as Francis Bacon was inspired by photographs.[9] But the least anticipated gift of photography was the richness of visual information that it gives, of sights too small, too distant, or too concealed from ordinary vision to be seen with the unaided eye: the paths of subatomic particles as they move, collide, and swerve; strange microscopic plants; polarized light making newly seen patterns glow with color; patterns of heat, sound, and vibration made visible; and exotically false-colored images arrived at by computer processing.[10] All these, and the sights I have not recalled, have inspired painters, for whom Klee spoke when he said that the artist should acquaint himself with the fantastic images of the microscope and should concern himself, as well, with history and paleontology, "to free his thoughts and to develop a cosmic consciousness."[11]

Of course, photography also made possible reproductions of works of art whose echoes, degraded but increasingly accurate, gives them universal currency and are mainly responsible for the growing assimilation of all human art into a single history. Yet the greatest gift of photography is one that we forget because photographs and reproductions made with their aid have become so integral a part of our lives that we are not aware of the extent to which they make our visual resources greater than those of our ancestors. Our private and our collective memories have been enormously enhanced, and the visual testimony open to researchers, artists, and the simply curious were unimagined and unimaginable before the invention of the photograph.

To the aesthetic questions that photography raises in relation to painting, further sharpened by the intervention of computers, there is no categorical answer. In the present context, there is, however, the inescapable conclusion that photography set painting free from its ancient function as the recorder of everything visual that humans want especially to remember, and that photography has surrounded us with a great pictorial field into which our eyes are always straying.

HISTORICAL RELATIVITY

Another, often subtle, agent of change in art has been the progress of art history. I mean by this the sheer quantity, precision, and detail of the information that art historians have made available. It is true that there are art historians, like historians of other sorts, who have been more interested in establishing facts than in anything else. Maybe the neglect of many art historians to raise the more searching aesthetic questions is based on a latent fear that the questions have no satisfactory answer. The easiest historian's response to this fear is to submit to

whatever just happens to happen and then, after the fact, to explain why it was inevitable. However, the stubborn curiosity of art historians has revealed how distorted our usual understanding of art history has been.

From my present standpoint, the historians' ability to reconstruct the contexts of art is of crucial importance because, when the reconstructions accumulate, they heighten the sense of the never-ending changes that evaluation undergoes. The successive evaluations teach that over a long period of time all evaluations are probably indeterminate, that is, impossible to verify or falsify except for a historic moment. If the evaluations always change, they must always be relative, and, if so, they must always be right for the time and the persons who make them and afterward must be wrong, unless and until they are revived. But if they are revived, they are always revived with a difference, and the indetermination, with the necessity of which I will later struggle and almost deny, always insinuates itself.

To see how art history teaches relativity, consider the period in Europe between roughly 1790 and 1870, which the historian Francis Haskell contends was the scene of "the most extreme reversal of which we know in the history of art after the Renaissance." The most radical change in appreciation was of a group of statues that represented the art of Greece and Rome. I have described their effect on the art of the Renaissance. Yet this change in esteem was not at all fixed. Goethe, who recalled how the Apollo Belvedere had swept him off his feet, represents the phase of ecstatic praise. But Ruskin, who had expressed great respect for the Apollo, came in 1846 to describe it as "unspiritual." Ten years later it had become "a public nuisance" in his eyes. It took no more than a single generation for the artistic greatness of Greek and Roman art to become questionable.[12] This implies that the judgments of such artists as Michelangelo, Titian, Bernini, and Canova, not to mention Goethe, had been a mere aberration of taste. Furthermore, the art lovers of the mid-nineteenth century "rediscovered" old master after old master. Eighteenth-century art as a whole was rediscovered by Edmond de Goncourt; Le Nain was rediscovered by Champfleury; and early Italian art and Tintoretto were rediscovered by Ruskin.[13] But none of these rediscoverers anticipated the rediscovery, in the mid-twentieth century, of Caravaggio and his followers. History teaches us that there is every reason to believe that our own evaluations of artists will be subjected to reevaluation.

Not surprisingly, the prevalence of a given fashion influences the choice of exemplary works from the past. When the curves of Jugendstil were favored, so were those of Botticelli; when the more angular compositions of Cézanne were favored, Botticelli's curves fell out of favor; and once geometrical structure had

come into fashion, regard for Piero della Francesca went up, while appreciation for Raphael and, even more, Murillo went down.[14] A comparison of what an art museum exhibits with the contents of its storage rooms is always instructive. The truth, as a Congolese proverb says, is that "those who are absent are always wrong," and so it is the present that always wins, for itself. Yet this constant victory of the present leaves disturbing inconsistencies. If Michelangelo is the great sculptor we still take him to be, on what grounds can we fault his judgment of such sculptures as the Apollo Belvedere or the Laocoön, which Michelangelo not only praised but internalized and emulated?

THE ENCOMPASSING INFLUENCE OF JAPAN

I have already described the almost lawlike course according to which Westerners come to appreciate the art of any particular non-Western culture: First there is ignorant curiosity, countered here and there by persons with the courage of their own intuitions. Then comes a sometimes slow, sometimes spasmodic, gathering of information, and then the interest of a few ignites a passion for the exotic, born of revolt or weariness with the past; and then, at long last, there comes the ability to see things in context, almost as they were seen in their own time and place. But there never seems to be a definitive judgment, only a competition of individual or group preferences and perhaps, for a time, a near consensus.

Persons with the courage of their own intuitions include artists such as Dürer, who marveled at the wonderful Aztec art brought to Europe, and Rembrandt, who owned and copied Mughal miniatures.[15] I have earlier recalled a number of both disparagers and praisers of "exotic" art. But I have not yet mentioned the sudden enthusiasms of fashionable or rebellious Europeans, such as the wild enthusiasm of bourgeois and upper classes for porcelain, or of Louis XIV and his courtiers and then all France for Chinese lacquer work and silk hangings, or of German, French, English, and American writers for the poetry and wisdom of India.

Japanese prints were the first non-Western art to exert a strong and general influence on modern European art. Beginning in France, which fell in love with everything Japanese, including kimonos, erotic prints, and food, the influence spread in every direction.[16] Everything about the prints attracted the French painters who found their own tradition no longer sufficient. They were attracted by the affectionately simplified episodes of daily life, the rocks jutting out of the ocean, the rounded bridges and straight waterfalls, the delicately bold flowers, the heroically enlarged sexual organs, the bright, hardly modulated colors, the decorative patterns on kimonos, the freely undulating curves, and the waves

made of imaginatively varied linear undulations. The French also appreciated the long, narrow Japanese formats, the compositions made up of diptychs and triptychs, the silhouetted foreground masses, the dramatic diagonals from one corner to another corner, and the dramatic truncations, especially of foreground figures. Both the diagonals and the truncations were similar to those observed in photographs, Japan and Europe converging in this instance as if by providence.

The first well-known French artists to feel the influence of the prints were Théodore Rousseau (1812–67) and Jean-François Millet (1814–75). Rousseau, a sensitive landscapist, was moved by the prints to adopt a bolder, more sudden, more Japanese gradation of depth. Millet learned from them that he could defy the anthropocentrism native to European art and relegate a human figure to one side of a composition.[17] Of the older impressionists, Edgar Degas (1834–1917) and Claude Monet (1840–1926) showed the deepest influence. Both of them loved and bought the prints, which were cheap, both had access to large collections, and both looked to the prints for new subjects, compositions, and points of view.[18] Degas's women bathing, drying themselves, combing their hair, and being combed are borrowed from Kiyonaga, whose diptych of women bathing hung in his bedroom, from Hokusai, and perhaps from Utamaro. The near-parodic nudes Degas drew in monotype also recall the Japanese. From Japanese artists and from photography he learned to break the time-honored centrality of human figures and cut them off at the frame, show them from behind, from above, from below, at close range, and reduced to shadows; and from both sources he learned to create depth by means of sharply opposed diagonals. Monet, like Degas, adopted the Japanese downward- or upward-viewing, and he cut boats off at the frame and extended boats over more than one leaf of a print. It was maybe from Hokusai's series *Thirty-six Views of Mount Fuji* that he learned to paint things— poplars, haystacks, water lilies, cathedrals—in series. His masses of water lilies growing in a pond are composed in Japanese asymmetry. However, the most profound of the influences or parallels was the dissolution of man and nature in one another experienced as the intermingling of cosmic forces.

It is hard to know to what extent Gauguin, Van Gogh, Toulouse-Lautrec, and the rest of the new generation of French artists got their Japanese qualities from Degas or Monet or directly from Japanese prints. Gauguin borrowed figures quite literally from Kuniyoshi and Hokusai. Van Gogh, who at one time planned to go into business with his brother selling Japanese prints, copied three paintings and many themes from them. Attentive to the Japanese space-filling techniques, such as Hokusai's dot-and-stroke method, he used them when he drew with reed pens on absorbent paper. "I envy the Japanese," he wrote, "the extreme

clearness which everything has in their work. Their work is as simple as breathing."[19] Van Gogh preferred to live in the south of France because he saw a "second Japan" in its sunlight, color, and simple inhabitants; and he dreamed of a community of artists who would refresh their spirits and humanity by returning periodically from the city to live in what he called Japanese fellowship. Like Van Gogh, Toulouse-Lautrec found in the Japanese a dream-ideal.[20] His portraits of actors and his erotic scenes, not to speak of his style and mode of composition, are reminiscent of the Japanese. Hokusaï's *Manga* stimulated him to portray momentary and yet typical gestures, precarious equilibriums, and people stretching, lying, and lolling, in every pose.

I must at least mention Bonnard, Vuillard, and Cassatt, and though I cannot go on with the influence of Japanese prints on French art, it remained powerful for almost fifty years.[21] This explains the judgment that between 1860 and 1905 Japanese prints played a role comparable to that played by Greek and Roman antiquities in the creation of Renaissance art. Yet by 1905 the turn of Africa and of "primitive" art had come.

GAUGUIN AND OTHER SAVAGES

It was the Universal Exposition of 1889 that introduced Gauguin to "primitive" art. Thanks to European empire building, antitraditional artists were coming into easy contact with this art, and the reaction of Gauguin shows how dramatic the results could be. Because he was the first important European artist to live among "primitives," in whose company he hoped to find something between ecstasy and calm, I will examine his life, views, and art in relative detail and show how in his case, as happened with other, later artists, enticing adventures merged with personal problems, social ideals, and artistic ambitions.[22]

As one sees in his pictures, Paul Gauguin (1848–1903) was a partisan of primitivism. His primitivism was a protest against European civilization and what he believed was its deadening spiritual effect. But Gauguin also wanted to be a primitive in order to escape his obligations to his family, to find easygoing sex, and, mostly, to become recognized as a great painter by the French artists and critics he respected. To understand him it is necessary to take into account that his life instilled in him the feeling that he had always lacked something extremely important that was, all the same, within his reach. That is, his life bred in him a feeling of exile, a sense of a paradise somewhat beyond the horizon, a feeling of exhilaration in aesthetic and social danger and, in suffering, a sense of Christlikeness. He had the desire, too, to make himself into someone important in his own right.

On psychological grounds, we can assume that Gauguin's suffering began with the death of his father when he was only a year old. This loss must have been reinforced when, at the age of seven and a half, he had to leave Peru, where he had been happy, and return to France and to surroundings and a language he did not know. In adulthood, the sense of lack was reinforced when he quarreled over money, friends, and art with his fearless Danish wife—both were spend-thrifts—and increasingly lived apart from her and their five children. His first occupation, as a sailor, had been compatible with his rootlessness. His later work as a stockbroker, obtained with the help of a mentor, was merely a way to make a living. His third occupation, as artist, led him to hope he could overcome his psychological drifting as part of a colony of like-minded persons. He tried to escape his dissatisfaction by settling for a time in Tahiti, then by leaving Tahiti and returning to France, and then finally by settling in the Marquesas Islands. In neither Tahiti nor the Marquesas did Gauguin want to live either like the usual French settler or exactly like a Polynesian. The success he craved was not to be a true Polynesian but to be a successful French artist. He was always frustratingly dependent on others because of his chronic lack of money, a lack so bitter that at one time, he says, he was driven to an unsuccessful attempt to kill himself. Further suffering was caused by syphilis and by the heart trouble of which he died at the age of fifty-four.

However and wherever he lived, Gauguin could not endure a prosaic or imposed routine. Instead, he expressed his rootlessness, restlessness, and love for life in a synthesizing art. His art is synthesizing in that it combines motifs and ideas taken from many sources. He puts together an imagined world made up of all the nonmodern worlds that attract him. When analyzed, many of his paintings can seem almost to be made of bits and ideas taken by chance from different sources and put together like crossword puzzles.

The distant art worlds that attracted Gauguin were surprisingly many and various. They included, to begin with, the world of pre-Columbian Peru as represented mainly by its pottery and small metal figures, and the world of preindustrial rural France. They also included the world of Italian Gothic and Quattrocento art; the world of ancient Buddhist Cambodia as represented by its statuary and reliefs; the world of ancient Egypt as viewed in tomb friezes or paintings; the world of classical Greece as represented by Greek pottery and the Parthenon frieze; the world of Japan as expressed in its pottery and woodcuts; and the world of Polynesia in its art, religion, and, most fundamentally, its natural, creative way of life.

Of all these worlds, Gauguin's deepest attachment was to Peru, not only

because he had lived there as a child, but also because he thought, maybe rightly, that there were native Peruvians among his ancestors. He therefore considered himself to be both a European and an "Indian," a "savage," or an "Inkan." He wrote to his wife, Mette, in February of 1888, "You must remember that two natures dwell within me: The Indian and the sensitive man. The sensitive being has disappeared and the Indian now goes straight ahead."[23] Gauguin also says in his memoirs that he has a remarkable visual memory and recalls his early life in Peru, his house there, and very many things that happened there. His mother owned Peruvian vases and Peruvian silver figures—her collection was burned in France in 1871—and he no doubt remembered them.[24]

Around the time of this letter to Mette, Gauguin had begun to make small sculptures and carvings to help support himself. Soon he began to decorate and then to make pottery, built up by hand like Peruvian pottery, from coils of clay. The sixty or so of Gauguin's surviving ceramic objects have strange sculptured shapes, unusual handles, joined pots, and human and animal faces. Many of the objects are inspired by the art of the northern coast of the ancient Andes, which Gauguin mistakenly considered to be of Inca origin.[25]

There is a striking example of the way in which Gauguin joined his experience of Peruvian pottery with his artistic creed, Symbolism, and with his difficult personal history. I refer to his ceramic self-portrait of early 1889. The pot's backward tilt, its handle, its neck-base, and its profile with its projecting nose looks as a whole like a Peruvian (Moche) pot, one that he might have seen in the collection of Jean-Dominique Arosa, who had been his guardian after his mother's death. The critic Félix Fénéon said in praise that Gauguin's ceramic self-portrait was something "altogether Japanese by a savage from Peru."[26]*

· · ·

For the creation of his art, Gauguin depended on what he called "an entire world of friends," his collection of photographs, postcards, and reproductions. He took

*Fénéon's comment must refer to the colors of the pot's glazing. On the red-glazed pot Gauguin's eyes are closed and his ears are absent or hidden underneath the flowing red glaze. These traits reflect his experience. Some months before he made this self-portrait, Van Gogh had rushed at him, Gauguin reported, with an open razor in his hand. Disturbed, Gauguin spent the night at a hotel, where he hardly slept. Next morning, December 24, 1888, Gauguin saw a crowd around Van Gogh's door. Inside he found Van Gogh with his head heavily bandaged. Van Gogh had cut off part of his left ear to be given to the shy young prostitute, Rachel, whom he liked. Just four days later, Gauguin was present at the guillotining of an assassin. Maybe the blood-colored, probably earless figure represents Van Gogh's threat to him, or his identification with Van Gogh. Or maybe the

this printed world with him when he traveled. Since he lacked academic training, his collection was likely to be useful when he wanted to paint a difficult body position. But Gauguin also used his collection as a storehouse of the varied images, stemming from different cultures, to whose expressive power he responded. Some of these images went back to the time when his mentor, Arosa (whose collection of paintings gave Gauguin his first education in modern art), began to publish photolithographs. Arosa's first major photolithographic publication was a series of twenty-two pictures called *The Friezes of the Parthenon by Phidias*. From this series Gauguin chose the pictures he particularly liked. When he was in Tahiti and the Marquesas, these pictures were his Greece. In 1892, when Gauguin made paintings that included the image of a new friend, a young Tahitian woodcutter, he set this friend repeatedly in the posture of a Greek ephebe from the Parthenon frieze.[27] The central subject of Gauguin's famous White Horse, painted in Tahiti in 1898, is a riderless horse fairly literally copied from the Parthenon. Likewise, figures taken from Borobudur, in central Java, and from Egyptian tombs were incorporated by Gauguin into his images of Polynesia.

Gauguin's method and ideas can be illustrated by the famous painting whose name is made of three successive questions, *Where Do We Come From? What Are We? Where Are We Going?* By the time he painted it he had become more reflective, more committed to transcending his own time and place. Writing in 1898 to a Symbolist friend, he explains the picture's rather complicated content. He writes that he has "finished a philosophical work on a theme comparable to that of the gospel." He dreamed much of this, he writes, in front of his hut "along with the whole of nature that reigns over our primitive soul, the imaginary consolation for our sufferings insofar as these are vague and misunderstood in relation to the mystery of our origin and our future." He asks himself in the end "Where do we come from, what are we, where do we go?" But "the

figure represents his continuing competition with Van Gogh, whose self-portrait with a bandaged ear he had probably seen when he visited Theo van Gogh in Paris. Does Gauguin's bodiless head represent Van Gogh, or himself, or the artist martyred by indifferent contemporaries, or Christ bloodied by thorns (a theme natural to Gauguin)? We have no sure way of answering these questions, though all the answers that suggest themselves are compatible with Gauguin's symbolist cast of mind. I should add that to Gauguin the heat with which ceramics are fired had the transforming power, he said, of a passage through hell. The heat, he said, released the material's beauty and harmony of colors. However it is explained, Gauguin was convinced that his ceramic self-portrait was a success. It was the first of his works to find a place in a museum collection.

reflection is no longer part of the picture and is therefore set out separately in language, on the surface around it—not so much a title as a signature."[28]

Apart from what Gauguin himself tells us, what can we reasonably find in his philosophical painting? The landscape as a whole is based on that of his Tahitian home and the studio he built next to it. Like many religious pictures, *Where Do We Come From?* expresses its symbolic nature by means of symmetry. A woman with a sleeping baby in the right foreground resembles a somewhat earlier painting that Gauguin called *The Dream (Te rerioa)*. This dream appears to reflect his life then with Pau'ura and their daughter, who died at birth—the child who turned out to be only a dream. The child in the middle sucking on a fruit repeats a similar though stranger child in a picture called *Delightful Day (Nave nave mahana)*. Maybe this is the child that Gauguin had hoped to have. The resigned old woman at the very left is like figures that recur in other pictures by Gauguin, all derived from a Peruvian mummy on view in the 1880s in the old ethnographic museum in Paris, later the Musée de l'Homme, which Gauguin often visited. A mummy, in the crouched or fetal position usual in Peruvian burial, is a symbol of the cycle from life to death, a cycle that is prominent in the iconography of ancient Peru.[29]

The main figure of Gauguin's painting resembles an Eve plucking forbidden fruit in Paradise. But this figure, its pose borrowed from a painting of Rembrandt's school, is either a man or a sexless person. Given Gauguin's views, it is probable that Gauguin took the figure to stand for the inquisitiveness that makes it impossible for humans to remain in a paradise of innocence. There is much more to Gauguin's *Where Do We Come From?* than I have described, but enough has been said to allow me to ask if it has a claim to being a great work of art—which is not the same as asking if Gauguin is a great painter.[*]

*Thadée Natanson, one of Gauguin's contemporaries and editor of the literary and artistic journal *Revue Blanche*, found Gauguin's Tahitian paintings less innovative than the artist maintained, seeing in them the influence of well-known European art. To the canvas *Where Do We Come From?* Natanson reacted by saying that it had profound and charming qualities, but its separate motifs were each self-sufficient and more gratifying than the whole, because the whole, which needed comment in order to justify itself, was too obscure for its meaning to unify it. As I see it, the problem is that in the case of a Buddhist or Christian painting, there is a reliance on detailed traditional myths and symbols, so there is likely to be only a minimal distance between the artist's symbolism and the spectator's explicit understanding of it. Both painter and spectator know the references involved, and the aesthetic issue is the expressiveness (of whatever kind) with which the artist has endowed the traditional account. But without a good deal of biographical expla-

I will not go on assessing Gauguin's painting except to ask bluntly whether he—or any artist with a similar ideal—was in fact justified in searching for a better life among peoples he thought were living more naturally than the Europeans of his time. Did Tahitians live the kind of innocent life of which Gauguin dreamed? Along with Van Gogh, Gauguin had become enthusiastic about Tahitian life as the result of the novel *The Marriage of Loti* by Pierre Loti (a pseudonym), whose British hero finds that his romance with a young Tahitian, Rarahu, is doomed to failure because of the racial difference between them. The novel makes Tahiti into "a stereotypical realm of sensual liberty and epicurean delight." In 1890, in a not especially kind letter to his wife, Gauguin reflected on his own financial and marital troubles and Loti's romanticism by writing that he hoped to find a South Sea island where he would live "in ecstasy, in peace and for art." Then, with a new family, and "far from this European struggle for money," he would listen to the music of his heart, "beating in amorous harmony with the mysterious beings" of his environment. However, when Gauguin got to Tahiti, he found only something of what he had hoped for, which was the possibility of personal, especially sexual, freedom.[30]*

Indeed, what especially pleased Gauguin about pre-European Tahiti was the Tahitians' appreciation of physical beauty and the unashamed pleasure they took

nation, Gauguin's picture is simply an assemblage of different figures in what looks like a rather too crowded paradise. None of the meanings he attributes to the figures are obvious in themselves, except that the old woman on the left is clearly pensive or sad. Why should a spectator assume that the white bird with a lizard in its claws stands for the futility of words, or that the two figures near what Gauguin calls "the tree of science" are anguished because of science?

* But it is now easy for us to see that there was much in pre-European Tahitian life that could not have pleased Gauguin. The old Tahitian social structure and Tahitian human relations did not display a childlike naturalness or a simple human equality. Everyone in a Tahitian kin group was ranked in terms of ritual and duties. People were ranked as well by the degree of divinity they were thought to inherit as members of the upper, middle, or lower class. It seemed inherently right to the Tahitians that people should be unequal. A chief was likely to want power over as many people as possible, and so warfare was frequent. In *Noa Noa* Gauguin recalls something of the harshness of Tahitian life in the past. To explain why the Maoris sacrificed their children, he argues that if the number of children had increased too much, they would have risked famine. Gauguin adds that the constant spectacle of death taught the warriors to despise pain, saved the whole "nation" from idleness, and gave it its vitality. So although he was happy that life in Tahiti released him from civilization, simplified his thought, and taught him to love his neighbors, he was ready at times to accept the fact of social dominance and the need for killing.

in sex from childhood on. They practiced sexual relations with extreme and open interest and artistry, and gave free expression to this interest in conversation, entertainment, and mythology. With great interest, Gauguin had read about the Arioi cult, which the missionaries hated and destroyed. I have described how troupes of the Arioi, worshippers of the god Oro, traveled from place to place, entertaining. It is easy to imagine that Gauguin would not have objected to being reborn as a member of the Arioi cult, which represented the kind of life he loved in the Tahiti he imagined. But the price the younger Arioi paid for their uninhibited sex and their creativity was their subjection to a ban against the bringing up of children. Gauguin, it may be recalled, abandoned his own children, French and Polynesian alike, but wherever he went "he always placed photographs of his [French] children on the walls of his room, arranged in strict order of age and height," and the death of his favorite among them, his daughter, Aline, caused him overwhelming sorrow.[31]

EUROPEAN BORROWING

Gauguin leads us back to the influence of the "primitive" on Western art. The early Western contacts with African art by travelers, traders, and anthropologists have already been described, but little has been said about the effect of this art on Western artists. Each kind of "primitive" art was discovered by artists in its own right, and African art was taken up as creatively stimulating during the first years of the twentieth century. It seems to have been recognized first by the Belgian artist James Ensor about 1900, and by the German artist Ernst Kirchner (who, preferring to be first, predated his own epiphany). The French artist Maurice de Vlaminck became aware of African art in 1905 or 1906 and passed on his enthusiasm—along with the African mask he had bought—to André Derain, who showed the mask to Matisse and to Picasso, each of whom reacted in his own way. Not long afterward, the shape of the Fang mask shows up in the paintings of all three artists. Picasso, who is reported to have said of an African sculpture, "It is more beautiful than the Venus de Milo," collected African statues and masks enthusiastically.[32] His surviving paintings from 1906 to 1908 show borrowings. It has been argued that some or all of the similarities are accidental "affinities" with sculptures that he could not have seen. But by now it seems very likely that Picasso did in fact see the African statues and masks and that the borrowings were quite intentional. Picasso's friend Max Jacob insisted that the geometry of African sculpture helped Picasso to move from naturalistic to cubist art.[33] Much later, Picasso told André Malraux that to Matisse and Derain, African sculpture had been sculpture, nothing more; but to him, viewing it at the Tro-

cadero (the predecessor of the Musée de l'Homme), it had consisted of magical objects, made to ward off unknown, threatening spirits. The old Trocadero was a disgusting, smelly flea market, Picasso said, but he understood that something was happening to him, and he stayed and stayed until he understood that the sculptures were magic weapons to help people "against unknown, threatening spirits. . . . I too believe," he said, "that everything is unknown, that everything is an enemy! . . . I understood why I was a painter. . . . Les Demoiselles d'Avignon must have come to me that very day; but not because of the forms; because it was my first exorcism painting—yes absolutely!" [34]

Unlike Picasso and his friends, the German expressionists wanted to follow the example of Gauguin and return to the authentic life of "primitives."[35] Emil Nolde actually accompanied an anthropological expedition to the South Seas. Moved by the "absolute originality" and intense expression of life he found, he was ready by 1920 to declare that "primitive" art was superior in value to the art of the Greeks or of Raphael.[36] That same year, the English artist and critic Roger Fry wrote that some "primitive" art was greater than anything produced in medieval Europe. He was especially taken by the ability of Africans to conceive form in three dimensions. Neither then nor later, however, did he see much in Oceanic or pre-Columbian art.[37] Oceanic art was the province of the surrealists, who found in it the same free reflection of the subconscious mind for which they were striving.[38]

African art proved to have a more radical influence on Western artists than had Japanese art, which accentuated tendencies that were already clearly present in the European tradition. In contrast, African art drew out more hidden, even alien attitudes, antagonistic to naturalism and to European notions of beauty or grandeur. Picasso had been prepared by his interest in Egyptian sculpture and by his so-called Iberian style, but no one knows what would have happened in European art in the absence of the African influence. It therefore makes good dramatic sense to date the beginning of the end of the European tradition at about 1910, with the influence of African sculpture on Picasso. Picasso did genuinely admire "primitive" art. Once, in 1920, he wrote a letter to Malawan, a successful Aboriginal painter, hunter, and warrior, saying that he envied him the ability he showed in his bark paintings.[39] I find it moving that this great European artist should regard himself as in the same world of artistic discourse as the Aboriginal and should want to congratulate him.

African sculpture, with its simplified, symbolically proportioned shapes and often sharp adz-cut planes, was a factor in the invention of cubism. Cubism, it hardly need be said, departed from the modern European tradition of art in

a way far more profound and disruptive than any artistic change that had pre-ceded it. All things seemed to have been broken up—could you hear them being cracked apart to make them over in painted angles?—and reassembled with a new, dull-colored angularity. Cubism treated appearances with what looked like inexplicable, outrageous violence.[40] Because it was created jointly by two indi-viduals, Georges Braque and Picasso, it might seem easy to understand how and why it came to be. Picasso himself refused to consider it in any way a response to "mathematics, trigonometry, chemistry, psychoanalysis, music, and whatnot."[41]* To him, though not to some later cubists, all such explanations were "pure lit-erature, not to say nonsense, blinding people with theories." As for Braque, his renewed passion for Cézanne had led him to feel that scientific perspective was only a bad, illusionistic trick, which had taken four centuries to redress, first by Cézanne and then by Picasso and himself. Scientific perspective, said Braque, "makes it impossible for an artist to convey a full experience of space, since it forces the objects in a picture plane to disappear away from the beholder instead of keeping them within his reach, as painting should."[42] Both Braque and Picasso insisted that they did not want to invent anything, but only to express what was in them. As Braque explained,

> Traditional perspective gives no satisfaction. It is too mechanical to allow one to take full possession of things. It has its origins in a single viewpoint and never gets away from it. But the viewpoint is of little importance. It is as if someone spent his life drawing profiles and believed that man was one-eyed. Once we arrived at this conclusion, everything changed, you had no idea how much.[43]

Picasso was in part reacting to Monet's huge paintings of water lilies set in multicolored, shapeless spaces and, even more, to Bonnard's "potpourri of inde-cision" that made things melt together.[44] He wanted, instead, to make strong,

*The mathematical physicist and philosopher Henri Poincaré (1854–1912) argued that space as humans sense it is a projection of the way they sense the world. By their con-vergence, our two eyes, for example, make us sense space as three-dimensional. Though one geometry of space may be more convenient than another, Poincaré said, none is true in itself. "By at least 1909 Maurice Princet, an insurance actuary . . . had enthusiastically conveyed his knowledge of the writings of Poincaré and other mathematicians to Picasso, Salmon and Apollinaire, the latter two key writers on Cubism. Leo Stein remembered: 'There was a friend of the Montmartre crowd, interested in mathematics, who talked about infinities and fourth dimensions. Picasso began to have opinions on what was and what was not real.'"

"ballsy" paintings, to take possession of things by fragmenting, faceting, flattening, massing, and illuminating them from everywhere, and by rebuilding and exhibiting them like an architect who had bent or cut them into their angled shapes. To explain the origin of cubism, Picasso uses words we will see echoed by the Russian avant-gardist Kazimir Malevich. Picasso explains:

> I saw that everything had been done. One had to break to make one's revolution and start at zero. I made myself go towards the new movement. The problem is not to pass, to go around the object, and give plastic expression to the result. . . . All of this [he said looking around] is my struggle to break with the two-dimensional aspect.[45]

· · ·

In examining the process by which European artists became aware of other traditions and began to accept them, value them, incorporate aspects of them, and, especially in cubism, be inspired by them to make a radical change, it is important to remember that there is nothing new in the fact of artistic change itself nor in art's acceptance of influence from the outside. I do not know of a single art tradition that has been genuinely static for a long period, not even the Egyptian or, on a shorter time scale, the Tibetan, and certainly not the Indian or Chinese. Our own modern art is no different from the art of any other time or place, by virtue of the fact that it has changed in the past and keeps on changing all the time. Nor is our own art different in reflecting the influence of what might be supposed an alien culture. In the distant past, Scythian art came to terms with Greek art; Greek art had its early, orientalizing phase; Egyptian art was in the end almost overwhelmed by Greek art; Buddhist art was affected by Greco-Roman sculpture; the purposeful simplicity and roughness of Japanese tea-ware reflects Korean qualities; Chinese pottery designs in blue may reflect Persian influences; Persian miniatures certainly show Chinese influences; eighteenth-century Japanese prints are affected by European perspective; and so on. In the past, however, influences were fewer in number and more limited by the nature of the receiving culture. We in the West are exceptionally receptive because we have, for the purposes of creation, demoted our own tradition and been attracted to other, alternative traditions. Once the old borders have been erased and so much of so many places and times has acquired legitimacy, the field of choice becomes a borderless, indefinable miscellany.

An example of what I am saying about influences can be found in the almanac *The Blue Rider,* published by Franz Marc and Wassily Kandinsky in 1912 and taking its name from the movement of which they were founding members.[46]

To help revitalize European art, which they thought moribund, the contributing artists drew illustrations from children's drawings; Russian folk art; Bavarian votive pictures and glass paintings; medieval ivories, tapestries, mosaics, and paintings; Japanese paintings and prints; Chinese paintings and masks; African masks; pre-Columbian sculpture and textiles; Egyptian shadow-play figures; Malaysian and Easter Island sculpture; and El Greco, Cézanne, Van Gogh, Matisse, and German contemporaries. I picture an eager young artist hovering over the illustrations with the question, "Which of these, alone or in combination, can serve me best in the development of my own art?" Maybe the artist would respond like the editor Marc, who was to write in a preface to a planned second volume that this repudiation of the European tradition in favor of every other might show that it was time "to cut loose from the old world." Or maybe the artist, faced by such a dazzling variety, would find it paralyzingly rich.

. . .

Since the time of Marc and Kandinsky, we have grown more knowledgeable in art history, and our ability to discriminate between different cultures and different stages of the same culture has increased the number of possibilities even more. To make the point economically, I will limit myself to the work of the sculptor Henry Moore (1898–1986), who has written in convincing detail on the art that influenced him.

Early in his life as an artist, Moore tells us, he was strongly impressed by Roger Fry's book *Vision and Design*. Fry opened his eyes to the "three-dimensional realization" and "truth to material" of African art. Fry's book led Moore to other artists and to the British Museum. Moore recalls that his first year at the Royal College of Art passed in a dream of excitement—not because of the school, but because every room in the British Museum revealed a new world to the twenty-one-year-old student.[47] With everything before him, he says, he was free to find his own way and, after a while, to discover what especially appealed to him.

At first, Moore was most impressed by the monumentality of Egyptian sculpture, which was closest to familiar Greek and Renaissance ideals; but the hieratic stylization, academic obviousness, and "rather stupid love of the colossal" ended by alienating him from much of the Egyptian. Other rooms remained attractive: the archaic Greek, with life-size female figures, "grand and full like Handel's music"; the Sumerian, with its bull-monsters and contained sculptural energy; the prehistoric and Stone Age, with the free but very human richness of its female figures (and its tender, thumbnail-sized carving of a girl's head); the African, its figures statically patient, resigned to unknown powers, vertical and

rooted in the earth like the trees they were made from (and its Sudanese figure, as deliberate and, to the sculptor who made it, as pleasurable an achievement as the writing of a poem); the Mexican, its figures tremendously powerful and yet sensitive, astonishingly fertile in form-invention and notably three-dimensional; and the Oceanic, more two-dimensional and pattern-conscious than the African, but in its New Ireland examples with a unique, bird-in-a-cage form.[48]

Moore says that early Mexican art made the deepest impression on him, although the Romanesque or early Norman also spoke deeply. His assimilation of these influences, however, was far from peaceful. He underwent an aesthetic crisis, the result of a six-month trip during

> which he was exposed to the masterpieces of European art. He could not shake off the new impressions without denying everything he had believed in before, and he found himself helpless and unable to work. Only gradually did he begin to feel his way out of his quandary, the way out leading back toward ancient Mexican art. Of his tension then he writes, "It seems to me that this conflict between the excitement and great impression I got from Mexican sculpture and love and sympathy I felt for Italian art represents two opposing sides in me, the 'tough' and the 'tender,' and that many artists have had the same conflicting sides in their nature."[49]

Moore did not admire all non-European art. He was not moved by perfectionist art, such as he took Chinese painting to be, and he saw it, compared with painting like that of Rembrandt, as more craft than art. Yet he was glad that the sculptors of Greece no longer blind us to the sculptural achievements of the rest of mankind. When he adventured in a museum, he might happen on a non-European sculpture he would like to but could not, he felt, equal. Of the Egyptian head of a woman he discovered in Florence, in the Archaeological Museum, he said that he would give anything if he could get into his sculpture as much "humanity and seriousness, nobility and experience, acceptance of life, distinction and aristocracy. With absolutely no tricks, no affectation, no self-consciousness, looking straight ahead, no movement, but more alive than a real person."[50]

JAPANESE AND CHINESE BORROWING

To be practical, I restrict my account of Eastern borrowings from the West to Japan and China.[51] In Japan, the influence of Western art was first felt in the second half of the sixteenth century, when things Portuguese—diet, clothing, words—came into fashion among both merchants and warriors. Whether or

not converted to Christianity, a fashionable Japanese might wear a driftwood rosary, a crucifix, or the like.[52] But this fashion was cut short, the Christians were subjected to persecution, and Japan remained isolated until the seventeenth century, when it was opened to Europe again, and when Western knowledge, under the name Dutch studies, was taken up with enthusiasm. The resulting influence of the West was felt in particular by science-oriented scholars and by some painters.

The "Dutch Scholar" Shiba Kokan (1738–1818) was a devoted partisan of all things Western, including art.[53] He was a successful artist in the Japanese style, but curiosity and reforming zeal led him to rediscover forgotten European methods of engraving and etching and then to turn to Western oil painting. His complete conversion from his well-mastered Japanese style did not lead to a full mastery of the Western style, even though he did achieve an attractive serenity in his compositions. With the fervor of the converted, Shiba Kokan was adamant that art must represent reality just as our eyes grasp it, and as only Western techniques could show it. "If pictures do not portray objects accurately," he said, "they are neither admirable nor useful." He contended that, compared with Western painting, Japanese painting was child's play. Although in the end he gave up what was called Dutch scholarship and reverted to Taoism and Zen, it is for his adoption of Westernism and his Western-style art that he is remembered.[54]

Just as Shiba Kokan represents the partisan of the West, Maruyama Okyo, a painter in the Kano style, represents the attempt at a compromise. His pictures, favorites with some of the early admirers of Japanese art, may now appear sentimental. His compromise seems to me to denature his Japanese heritage, and his adopted Europeanism to lack the vigor possible to hybrids. I make this criticism somewhat hesitantly, because Okyo's pictures reflect his pleasure in life, while his insistence on observing the living things he painted animated the painting of his time and led to many charming descendants.[55]

In contrast with Kokan and Okyo, Hokusai (1760–1849) exemplifies the undeniably creative borrower from another culture. Full of curiosity, he took whatever he wanted from wherever he found it. His desire was to grasp the living quality of everything he drew, which for him included the grasp of "the bone structure of birds, fish, animals, and insects." When young he experimented with European projection and perspective, and he educated himself to understand both European and Sino-Japanese shading, which are, he wrote, "as different as front and back" and equally important. To judge by Hokusai's own standard of the creation of "life and death in everything one paints," his fusion was quite successful.[56]

The influence of European on Chinese art is also perceptible.[57] Christian missionaries to China in the late sixteenth and seventeenth centuries came equipped with religious paintings. Some of the missionaries were themselves painters. A few of them served as such in the emperor's studio, and now and then they had converts who were or learned to be painters. It is reasonable to suppose that it was the influence of this European art that caused portraiture, long consigned to artisans, to be taken up again by persons who looked on themselves as true artists. The artist Tseng Ching (Zeng Jing, 1568–1650) was not only a portraitist, but an extraordinarily realistic one by Chinese standards. A contemporary source praises his portraits as "like images reflected in a mirror" and explains that the faces "would glare and gaze, knit their brows or smile, in a manner alarmingly like real people. . . . When one stood looking at such a face one forgot both the man and oneself in a moment of spiritual comprehension." Tseng's technique of adding "tens" of washes on washes was also an attempt to gain a European intensity of color. But it is interesting that the praise of realism I have quoted is justified, in Chinese fashion, by its ability to induce self-forgetfulness and spiritual comprehension.[58]

Tseng is said to have had many followers.[59] Unfortunately, of the two styles attributed to him, heavy and light, only examples of the light survive, and they are executed in a predominantly Chinese manner. Later, in the Ch'ing (Qing), or Manchu, dynasty, not only did more evidently European-type portraits appear, but also European-influenced landscapes. We learn of such landscapes from the description of a painter who served in the imperial studio toward the end of the seventeenth century, at a time when the emperor favored missionaries as painters and astronomers. I am referring to Chia Ping-ch'en (Jia ping-chen), who was reportedly versed in topography and astronomical measurement, knowledge that must have helped him to achieve his striking effects of depth—mountain ranges showing enormous distances—daylight, and mist. The description of Chia's painting continues with praise for "the Western method" he employed, which excels in rendering shades:

> It dissects the picture into minute parts to distinguish yin from yang, front and back, slanting and upstanding, long and short, and applies colors either light or heavy, bright or dark, according to the distribution of shades. Therefore, viewed from a distance, figures, animals, plants and houses, all seem to stand out and look rounded.[60]

The mutual criticism of the Chinese and the Europeans naturally reflected their traditional values. The painter Wu Li, though converted to Christianity, was

not impressed by the Europeans' ability to represent distances by special rules of light and shade, or by their brushwork or their painstaking attempts at realism.[61] The European criticism of Chinese painting was usually that it lacked perspective, shadows, and knowledge of human anatomy. Yet it was a Jesuit missionary and a painter, Giuseppe Castiglione, who wrote that the paintings in the imperial palace had "a great deal to teach our painting as to the way to treat a landscape, to paint flowers, to render a dream palpable, to express passions, etc." The emperor himself considered Castiglione as the equal of the great Chinese painters, in particular, without a rival as a painter of horses.[62]

When Christianity fell into disfavor in China, so did European painting. The attitude toward the paintings was also affected by the very reluctant compromise the missionary painters had been forced to make with native standards, and their mixed, European-Chinese style, thought foreign and vulgar by Chinese connoisseurs, was ridiculed by Europeans as well. Yet it appears that there was a pronounced European influence on certain able Chinese painters who nevertheless remained distinctively Chinese. These painters lived in or near Nanking (Nanjing) in the early seventeenth century. One of them, Wu Pin (Wu Bin, active 1576–1616), became a court artist and is likely to have seen the European paintings and illustrated books presented to the emperor in 1601. His style may have been derived from Chinese sources, but a near contemporary writes that "he never followed old models, but always depicted real scenery."[63] His landscapes struck viewers with amazement. Extraordinarily for China, the claim was made that he had painted them directly from nature. The angles from which he viewed the landscapes, the way he cut off structures and trees, his use of reflections in water, and his rainy or cloudy skies, sunsets, and chiaroscuro, all suggest European influence.[64]

Other painters of about the same time also show characteristics that are likely to have stemmed from or been accentuated by European pictures they encountered. I have already described the work of Kung Hsien (Gong Xian), whose very forceful landscapes have been taken to argue an acquaintance with European engravings. A similar acquaintance is likely to have helped Chang Hung (Zhang Hung, 1577–c.1652) to make landscapes that were thought mysteriously natural. They do have a fresh, unusually empirical quality, displaying an attempt to paint from a European kind of perspective, dominated by a single viewpoint, and new ways of dotting to represent forms. His departures from Chinese tradition, which influenced Chinese critics to rank him low, do not deter a European historian of Chinese art from ranking him high.[65]

I skip many intervening years and reach two recent painters, Zao Wou-ki and

Tsing-fang Chen, whose lives tell not only of the influence of Western on Eastern art, but also of the emotional price it may exact, in their cases, luckily, only temporary. Zao Wou-ki was born in Beijing in 1921 (Zao is the French version of Tsao).[66*] His family, which prided itself on an ancestor who was an emperor's brother, cherished two ancient paintings, one of which, by Mi Fei, fascinated and continued to fascinate Zao. His grandfather taught him calligraphy, and from the age of ten and he never stopped drawing and painting. Despite the opposition of his mother, who wanted him to become a doctor, his father, a banker and an able amateur painter, encouraged Zao to take up painting. He entered the Fine Arts School of Hangchou (Hangzhou) in 1935, when he was fourteen, and studied there for six years, after which he was appointed a lecturer. He learned both traditional Chinese painting and calligraphy and the Western academic method of drawing first from plaster casts, then drawing from a model, and finally painting in oils. But he felt neither happy nor successful. "You cannot imagine the degree of backwardness and conservatism of Chinese painting at that time," he recalled in an interview in the *Free China Weekly* in February 1983. "I was very unhappy about that." Influenced by reproductions of Cézanne, Picasso, and especially Matisse, Zao painted in the contemporary French manner, and when critics ridiculed his work, he reacted defiantly.[67†] The great tradition of Chinese painting

*In the context of modern East-West influences, I mention here only in passing the influence of Eastern art on Mark Tobey, and only glance at Morris Graves and Isamu Noguchi. Noguchi had an American mother, Japanese father, and a belated but deep experience of Japan. Mark Tobey, almost entirely self-taught, was initiated by a Chinese friend into calligraphy, which he took up briefly in China and later in a Zen monastery in Tokyo. In the monastery, he was disturbed by his inability to meditate and felt himself all the more Western. But when he returned to England, the calligraphic impulse he had absorbed inspired him to paint in his "white writing," to try to make space penetrate form and dematerialize it. At a time when he was trying to make rapid sumi-ink pictures, he wrote to a friend, "Standing as I am here between East and West cultures, I sometimes get dizzy as I find I can't always make a synthesis and also that I admire both paths which should and will, I suppose, merge." Looking back in 1971, it seemed to Tobey that all he was able to assimilate from Japan was rhythmic power, because it was the only thing that, as an American, he could take.

†Later Zao paid tribute to Matisse's 1914 *French Window at Coullioure* (*Porte-fenêtre à Coullioure*)—almost all of it six vertical stripes, the widest, of black, in the center—as for him the most important painting of the twentieth century, "at once constructed and inspired, filled with perceptible intelligence and at the same time marked by modesty, like when one bears in oneself something spiritual that one never shows. It is a perfect painting because it has both a diabolical depth and the simplicity of supreme refinement. They say in China that *French Window I* is a magical painting, because in front of this

ought not, he felt, be suffocated at the hands of the conservatives. In reaction, he and his first wife, Lan-Lan, moved to Paris in 1948. He spent the afternoon of the day he arrived at the Louvre.

The art Zao found in the Louvre flooded him with joy; but though he lingered over the classical paintings, he was most drawn to avant-garde abstraction. Excited and torn by conflict, ashamed to display what he had painted in China, he stopped painting for a whole year. His first exhibition, in a mixed Chinese-French style, aroused little interest. He tried turning completely French but discovered, guiltily, that he kept on using traditional Chinese colors. But when on a visit to the United States he saw Franz Kline's paintings with their Chinese air, he was convinced that he ought to penetrate intuitively the essences of both culture, Chinese and Western. To penetrate Chinese art, he studied the ancient painter and calligrapher Mi Fei, his childhood favorite, *The Book of Changes,* and Lao-tse; and to penetrate Western art, he toured the museums and ancient sites of Italy and Spain. Yet the exhibition of his works in 1952 led to a renewed agony of self-examination. "My paintings have become unidentifiable," he mourned. "No more flowers bloom in them."[68] It took some four years for Zao to overcome this renewed spell of anxiety. The paintings that followed showed the influence of ancient Chinese stone rubbings, engraved Chinese characters, oracle-bone writing, and Chinese calligraphy. Since then, his paintings have become more nearly realistic. They are often large landscape-like vistas, generally seen from above, in colors that suggest both Monet and Turner.

Zao, who can paint only in isolation, comes to work in his studio and its adjoining garden. He reads the poems of Li Po (Li Bo), Tu Fu (Du Fu), Wang Wei, and the other Chinese authors, ancient and modern, in his collection. Though he has been on the whole very successful, his encounters with critics have taught him, he says, not to pay much attention to them.[69] I follow his career no further and will not attempt to describe his colorful, often huge paintings but say only that he has won considerable honor and that exhibitions of his work have been held in many countries, including Japan, Taiwan, and China.

The last of my examples of the influence of Western on Eastern art, Tsing-fang Chen, again shows an artist in a crisis of choice between traditions and between *conceptions* of art. Born in Taiwan, under Chinese rule, in 1936, Chen was educated in Chinese and, perforce, in Japanese.[70] Attracted to the West, he

door, empty and full at the same time, there is life, dust, the air one breathes, but behind it what goes on? It is an immense black hope. For all of us it is a door that opens on true painting."

got a scholarship from the French government and simultaneously attended the Sorbonne and the École des Beaux-Arts. The ruling style in Paris of the 1960s was lyrical abstraction. Prominent artists, such as Pierre Soulages, Hans Hartung, Henri Michaux, and Zao Wou-ki, showed the influence of oriental calligraphy and Zen, and so Chen, while in the process of adopting Western attitudes and techniques, was driven as well to reevaluate his own tradition. He remembers the traditions quarreling and then making up:

> East and West lived side by side in me like two sisters but I couldn't get along with both of them. Dispute and quarrel, confrontation and conflict between them caused me to fall into a profound crisis which reflected itself in my painting. One day, my work would look like Matisse, tomorrow, like that of Cézanne, the third day I tried doing abstraction. Chinese archaic characters and Formosan folklorics also served alternately to my changing mood.[71]

As Chen explains, he was freed by the revelation that contemporary painting was right in trying to fuse all the different sources of art. Suddenly he realized that he belonged to the generation toward which all traditions were converging. Neither Eastern nor Western, he belonged at once to both traditions and to their union. Released from his crisis, he began to paint in a new style, neoiconography, which is an attempt to synthesize "East and West, past and present, by organizing and combining familiar 'icons' in unfamiliar ways." That is, he combines fairly literal copies or variants of figures from paintings or prints made by different artists, for instance a Japanese printmaker, Ingres, and Picasso. The reproductions I have seen of these strange but pleasant composites are not enough to allow me to assess the quality of the originals, but the crises of cultural identification that Chen underwent and the visual universalism he has since practiced are enough to make him relevant here.

THE EXCESSIVE PAST OF CHINESE AND WESTERN ART

During the course of the sixteenth century the Chinese tradition, by then extraordinarily well documented and scrutinized, began to appear overwhelming and even oppressive to many artists. It is easy to picture how the great collections of calligraphy, painting, and bronzes—the region of Suchow (Suzhou) was especially famous for its collections—increased the pleasure of artists and gave more substance to their connoisseurship, but also confronted them with a problem of competition with this extraordinarily fertile past.[72] The problem was compounded by scholars and critics, all themselves probably artists, and their increasingly elaborate efforts to classify, evaluate, and authenticate works of art.

Each artist or writer felt it necessary to find a place within or on the margins of the tradition: what an artist made was consciously for the sake of being placed somewhere within or, at times, in a relative sense, outside of history. Maybe the most usual result was a deliberate eclecticism of the kind I have discussed, that is, the study of many different styles in order to make each painting or kind of object in the style best fitted to it.[73] For this reason, it can be quite hard to determine the oeuvre of a master-eclectic of the seventeenth or eighteenth century. Even when there is little doubt whether pictures are the artist's or not, what exactly of the styles can be attributed to him personally? Does the artist have, submerged within these styles, a style that is his alone?

As we have seen, another response to the richness of tradition was a proud egalitarianism according to which artists of the present could be as spontaneous, forceful, and essentially creative as those of the past, so that similarity to a past artist was not taken to diminish the originality of the present one.[74] Still another possible response was a conscious eccentricity—the artist would stress some quality to the point that he might be named an "eccentric," a category that might or might not be the same as "individualist."[75] Though the two-thousand-year-old discipline of the brush continued to guide the artist's hand, eccentricity or individualism could prompt the artist to relax or vary the discipline conspicuously. The trouble for those who wanted to be original was that "everything that could be done with the brush had already been done."[76]

This surfeit of the old explains the successful eccentricity of Kao Ch'i-p'ei (Gao Qipei, 1660–1734), who became famous for painting with his fingers. There had been a few scattered artists who had made finger paintings before him. He must have known of the most famous, Shun Chih (Shunzhi), the first emperor of the Ch'ing dynasty, who ruled China from 1651 to 1661. Kao Ch'i-p'ei says nothing of this predecessor but tells the following story, which there is no special reason to doubt, in an inscription on one of his paintings:

In my youth I was fond of painting in a meticulous style; it would take me several months to finish a painting. I would be totally exhausted, but did not care. Later, I wished to express the idea in painting, but could not vie with the ancients, which made me most unhappy. One afternoon while I was asleep, an old man led me to a room with mud walls on all four sides. He spat water at them, and all kinds of shapes appeared, exquisitely painted, surpassing by far anything that a man could hope to reach in his wildest dreams. I traced them with my finger and succeeded quite well in comprehending their mystery. When I woke up I sought myriad visions everywhere, painting every single one

of them. I abandoned the brush and have not wielded it since then, more than thirty years ago. In the course of time my paintings have filled many albums; the paper bears their cloud-like traces. Is this not what the ancients called "... turning, changing, penetrating everything?" I have painted two men gazing into the distance, as an expression of my samadhi (secret).[77]

Kao learned that when his hand was finding its way by itself, it was able to achieve effects impossible by moving it deliberately or by using the brush conventionally. It's more natural, he as much as says, to be able to abandon oneself when using one's fingers, and only someone who is able to forget convention and its brushes is able to express the idea, the essence.[78] Kao's grandson, who wrote an account of his life and method, claims that Kao was so great a master that he was not only able to do brushlike work with his fingers but also to do with them what is beyond the brush. Because Kao was busy with his official duties, the grandson says, he would prepare ink and forty or fifty sheets of paper in advance and then, about twice a month, would paint from nine in the morning till five in the afternoon, usually finishing as many as forty or so paintings. The grandson adds, "In a small album in my possession, depicting bamboo in the wind, the artist pressed his thumb in an outer movement. Divine," the grandson exclaims, "divine."[79] It isn't hard to understand why Kao complains in a poem:

I paint with my hand
with everything: nails, flesh, palm, and top.
My hand begins; nothing is there yet
But when I am finished, my hand is worn out.[80]

Kao would begin a painting day with finely detailed work, for which sharp nails were needed. As his nails wore down, he shifted to large screens and to landscapes painted in a splashed-ink or "boneless" technique with fingers he had dipped in ink. Flowers and birds painted in this technique, Kao's grandson says, "became imbued with subtle splendor."

For human figures, dragons and tigers he waited until his nails were still fairly sharp but on the verge of becoming blunt, just the right length for painting figures a few inches high. When painting the eyes he used the fleshy pad of his fingertip for the actual eye and his nails for the socket or the lashes. As soon as he dotted the eyes, the figures came to life. . . . Grandfather owned a seal with the following text: "Painting a lifelike portrait depends half on the nails and half on the flesh."[81]

Kao's vigorous painting in this unorthodox technique had a clear influence on many of the more independent painters in later China, especially during the eighteenth century. His finger painting had some influence in Korea, too, and even more in Japan. In Japan, the most notable artist to use fingers for painting was Ikeno Taiga (1723–76). Taiga's paintings made by other means were also stylistically influenced by the effects characteristic of finger painting. "Finger painting formed the basis for his understanding and handling of water and ink, a factor that accounts for the remarkable ease and buoyancy of his representative inkwash styles."[82]

. . .

Western artists have also had difficulties with the richness of their artistic tradition. Over the course of the twentieth century, the sense of the overrichness of the past was joined with the feeling that for an artist to follow the models of the past was to block self-expression and avoid the aesthetic challenges of the present. As a result, the nagging, though usually unspoken, question an artist is likely to hear is, "What's new in your art today?" In answer, the artist may look for some novelty that draws attention and serves as a mark of identification. To draw attention, an artist or dealer has to learn to be a showman. To gain attention, bribery, in money, art, or some other medium, is a not unknown aid.[83] It helps an artist to sell a painting to a collector with good ties to a museum, to which the painting is likely to be lent, and if it has been exhibited by a prestigious museum, the artist hopes, other museums will want it, other collectors will want it, its price will be raised, and a rush will begin to buy it before its price is raised still higher. With artists and dealers striving in such ways for even the briefest success, artistic innovation or claim to attention may be defiantly ephemeral. The artist hopes that one day of fame will be followed by another and that the succession of such days will be enough to create a name and a career.

It's a tough struggle. Artists find it painful to bargain with a gallery, kowtow to a prospective patron, and smile deferentially at a critic or curator. Even under the best conditions, Degas hated the business of selling his work, which he felt demeaned him. Ad Reinhardt (1913–67) insisted that art should stay free of the corruption of the business world. To avoid this corruption, he remained a full-time teacher all his life. The sharp-tongued "conscience of the art world," he drew on himself a lawsuit by Barnett Newman because he had described Newman and twelve others as avant-garde hucksters and holy roller explainers-in-residence. But Andy Warhol, whose moral sense was more accommodating, made a virtue of his ambition to get fame and money and did not hesitate to say that an artist

needs a gallery that will make the "ruling class" notice him and create enough confidence in his future to inspire collectors to buy his work. Yet success and acclaim, though always more pleasant than rejection, can feel like failure. When the work of Mark Rothko (1903–70) became a valuable commodity he was no longer able to evaluate it. "He did not know whether people were buying his paintings because they were good or because they were Rothkos"—maybe the people themselves did not know. In spite of his success, he complained that no one understood his work any longer.[84]

Looking too hard for the unique in oneself, one can get lost. How, in the words of the (now infrequently remembered) French artist Nicholas de Staël (1914–55), does an artist contrive "a continuous renewal," a continuous zig after every surprising zag. De Staël's answer is to have no ideas in advance but to be illogical and look for accidents to exploit. Then, he says, "I lose contact with the canvas at every instant, lose it, find it, lose it. . . . I can't imagine any progress except from one accident to another. As soon as I feel a logic in it, I get annoyed and I veer naturally to the illogical."[85]

Other artists, instead of using accident or straining their imaginations to give life to their work, try to become original by transposing the ordinary acts of life into art. Everything previously excluded from art is then drawn into it, including emptiness, simple repetition, ordinary noise, merely private associations, plain cruelty, real blood, real excrement, and, of course, threatened or actual social or political revolt. Sometimes the cultural ideal of artists is hard to distinguish from resentment, which, as a demand for attention, is hard to distinguish from a search for an intimacy uninfected by illusion. Art's hunger for intimacy transposes into its own media the tactics of ordinary life, in which what is wanted but not given is demanded by means of a naked invitation, joke, shout, slap, or direct question, so that art, too, now invites, jokes, shouts, slaps, and questions directly, in all the ways at its disposal. This is of course not how all or even many artists express themselves, but some of the most well known have learned that it is just such directness that is most likely to lead them to success.

SYMBOLIC DEATHS AND ERASURES OF THE PAST

To be free of art's past and be seen by others as free is for most artists not at all easy. It's not possible to will oneself into aphasia. Consciously or not, artists remember and take figures, poses, compositions, colors, and techniques from their predecessors. For that matter, what a young artist thinks of as the past may be little earlier than a ruling contemporary style. What artists may hope to escape remains cunningly concealed in what is intended to replace it. Kandinsky

wanted to turn painting into pure visual music, but many of his abstract compositions are more intelligible and easier to read as coherent wholes when one sees how they were abstracted from his earlier illustrations. One sees, for instance, that the long, narrow shape that projects upward in many of his works has its origin in the sword of St. George slaying the dragon—the horse and the dragon are also there though not recognizable as such. The sword, horse, dragon, and the story that joins them defy Kandinsky's attempt to drive story-telling imagery out of his pictures and show that he did not conceive these forms as purely abstract ones. For all his radical intentions, he was unwilling or unable to forbid his compositional intuitions from repeating the shapes and relationships of the stories he had once painted.[86]

There is, too, the conscious desire of writers and artists to become intimate with their audience by making use of the cultural memories that they share with it. Chinese tradition, we know, is filled with the conscious homage-by-imitation that artists pay their predecessors. As was said earlier, the ultimate homage the Chinese artist can pay is to copy with the purpose of keeping alive the art and spirit of an honored predecessor. The attention, skill, and measure of self-abnegation that this copying requires make it nearly the opposite of a photographic copy of a painting (though the making of highly accurate photographic copies calls for meticulous professional competence). The intuitive immediacy advocated by Ch'an artists was designed to counter such dependence on erudition, but Ch'an artists, too, could not fully escape the historical comparisons they were aware of and evoked.

Although not as obliged as the Chinese to demonstrate their erudition, Western painters and writers have of course also used or quoted a great deal from predecessors whose works played an essential role in their education. In the more academic past, the quotations made in painting were visible, as in China, only to those whose visual memory for paintings had been well trained. Apprentices were likely to paint the same subject matter in the same style as their teachers, and mature painters used earlier paintings for some pose or composition the painter remembered and needed. Earlier paintings served as a store of images to draw from that photographs and reproductions now supply much more fully.

It is in the nature of art now to be more brazen about quotation, as if indulging in a pleasure ordinarily forbidden in a time that exalts originality, or that tries to achieve originality by defiance of the commandment not to copy and not to be like anyone else. The result can be that an artist shows an ambivalent relation to the past by making a variation or set of variations that conspicuously distort the famous original that inspired it. This response belongs to the category of "art

about art" and is close to or belongs among parodies whose purpose is ironical "demystification." Victims of simple parody include Pisanello, Leonardo, Michelangelo, Vermeer, Velasquez, Rubens, Rembrandt, and many of the famous moderns. As might be expected, the *Mona Lisa,* reputedly the most famous painting in the world, has suffered an endless number of parodic quotations: inserted into an abstract collage and marked by large red X's to indicate that she's no longer valid, and distorted into sadness, transmuted into Jackie Kennedy, Stalin, and a gorilla, and even deprived of her famous head.[87]

Like the Chinese, some Western artists have been able to practice a carefree eclecticism. Take the reaction of Eduardo Paolozzi (b. 1924), for example, who sees the new freedom in a fully optimistic light. Anyone, he says, can now become a poet, musician, or sculptor. All that is needed is an open mind and the liberation of the faculty of choice. Just as the aerodynamicist does not build his own wind tunnel, so the artist does not have to execute what he has conceived—others have the practical skills. It no longer makes sense to shut oneself away in some artists' colony with a sack of plaster or a box of oil paints. Now art is biology, ethnology, everyday things, anything and everything seen in a certain light. Francis Bacon (1909–92) may not have disagreed, but he is said to have been pleased by the idea that he might end up as the last man in the world who still believed in painting.[88]

Bacon's belief and the pleasure he took in it lead me to the many symbolic deaths that painting suffered during the twentieth century. In 1919 Kasimir Malevich exhibited paintings some of which were crosses. The exhibition was meant, the artist announced, to end suprematism as a movement in painting, and indeed to end painting altogether. Malevich told a fellow artist that the cross was his cross, "so personally did he feel the 'death of painting.'" That other painter of (less visible) cross-shapes, Ad Reinhardt, said in 1956, "I'm just making the last painting which anyone can make."[89]

Though he did not prophesy the imminent death of painting, Willem de Kooning (1904–97) insisted that there were no longer any styles in which to paint but only eclectic stylelessness. Of the twentieth-century painters and schools that had influenced him, he said, "I have learned a lot from all of them and they have confused me plenty too. One thing is certain, they didn't give me my natural aptitude for drawing. I am completely weary of their ideas now." He considered himself an eclectic by choice. "I can open almost any book of reproductions," he said, "and find a painting I could be influenced by." After experiences he described as tormenting, he arrived at the conclusion that "there is no style of painting now." To this pronouncement he added, "To desire to make a

style is an apology for one's anxiety." To him, art had become "a style of living." Beginning with anything, the artist lives on canvas, he said, alert to the possibility of a new coherence.[90]

Art has since then changed, but de Kooning's statements remain pertinent. The skills and varieties of the art of the Western tradition, like the different skills and varieties of the art traditions of other cultures, remain everywhere preserved in books, universities, and museums. They represent what we want to keep in visual memory and cherish as the culture we have already acquired or still hope to acquire. They are also what, as artists, we may quote in a newly open or crude style, and what, as artists, we feel we have to take care to show are not merely tradition preserved. Under the rules of this freedom, art old and new, skillful and unskillful, knowing and ignorant, is set side by side in a state in which choice is likely to seem arbitrary. In this sense art dies, even though, as I have been saying, the approximate death of tradition has provided intensely fertile ground for all kinds of art to grow in disordered profusion. The killings of art's tradition are related to the hope for its regeneration in the same way as alienation or loneliness is related to its own implicit hope of overcoming itself.

Am I exaggerating? If we look through orderly art histories and well-planned museum exhibits, the changes that have taken place since the nineteenth century seem natural and inevitable. We know more or less how and why the changes occurred. The art that about the time of the First World War appeared so radical has now grown familiar and is cracked, faded, conserved, and tamed. The episode of cubism, so astonishing or enraging in its time, has been naturalized by its constant presence and the intensive scholarship with which it has been studied. It has become hard to shock, and we are so used to shocks that we feel cheated when censors interfere to stop us from being shocked again. But when we look forward from the nineteenth century and estimate the change, we can see that it has been enormous. The break in art between antiquity and the Middle Ages in Europe was created by the decay of the higher expressions of ancient culture in general and, despite antipaganism, was not created by the active volition of the artists involved. When, close to the present, a great deal of art became almost ruleless and even technically primitive, the artists who were the first to deprive it of its conventions sometimes doubted themselves and angered those around them who cared for art.

Given the destructive search for the positive, it should not be surprising to discover that an artist who takes the trouble to study in an art school finds that its influence is mostly negative. To the question why he rejected "modernism," the neorealist Philip Pearlstein (b. 1924) answered that "this modern stuff was as

foreign to me as Florentine painting or Greek art." Another neorealist, or at least neorealist for a time, Chuck Close (b. 1940), said that he found it easy to paint in the then dominant style of abstract expressionism, but that, disturbed by the predictability of his paintings, he turned to figurative art, just because he had not been taught it: "If I'd had to look around and find something about which I knew absolutely nothing, it was figuration."[91]

Some painters took the desire for renewal further. In 1977, Karel Appel, who had earlier defined painting as the destruction of what had gone before, said that his own aim was to destroy the education he had received, all the "cultural wealth" he had learned and soaked in: "I wanted to annihilate myself, wipe myself out, in order to get right back to zero. I started off painting white canvases with white paint." Not many years later, the Korean artist Lee Seung-taek expressed the desire to cut himself off not only from the past but also from his own past selves: "Once I've finished a work, I always try to free myself from it. In other words, I keep striving to destroy and change myself. To me, the process of self-destruction is inherent in the nature of the artist."[92]

The career of Jasper Johns (b. 1930) illustrates the refusal to refer to one's own past and the resolve to do only what is always absolutely new. Johns's early years prepared him for life in an isolating present. His parents had separated soon after he was born, and he lived successively with an aunt and uncle, with grandparents, with his mother and stepfather, with an aunt, and again with his mother and stepfather. After undistinguished studies in a commercial art school, he stayed here and there, working at various jobs. However, one great day in his life he decided to stop merely becoming an artist and to be one. "I decided," he said, "to do only what I meant to do and not what other people did. When I could observe what others did, I tried to remove that from my work. My work became a constant negation of impulses."[93]

Johns hesitated then to speak of his past, which he claimed was irrelevant to him. By his own admission, during his whole early career he tried, like his friend Marcel Duchamp, to keep his work from betraying his feelings. Talk of the future, he said, bored him. His explanation was that when he was young he had so many desires and wishes that he trained himself to think only of the present. (I think here of Andy Warhol's comment, "Every day is a new day because I don't remember the day before. Every minute is like the first minute of my life.") In this phase of his life, when Johns went down a street, he sometimes decided which way to turn, he said, only when he got to an intersection; in art, his notebooks say, he dealt with an object by doing something to it, then doing something else to it, and so on. His success began with a one-man show given him

by the dealer Leo Castelli, who recalled his first sight of Johns's work as a revelation: "I saw evidence of the most incredible genius, entirely fresh and new and not related to anything else."[94]

As Appel reminds us, one of the means by which painters have been able to cut away the past is by exalting monochromes, which are nothing or very little more than uniformly applied paint of the same color. Monochrome paintings are the evident end product of a radical regression. Long ago, a sketch was valued as the preparation for a painting; later, it came to be valued because it was spontaneous and not finished. But monochrome painting, into which category I would like to include, by reasonable extension, a raw canvas put up for exhibition just as it is, returns us to what used to be only the prepared surface on which the painting was made. The old beginning became the new end.

It has been argued that the earliest monochromatic painting was made by Kasimir Malevich about 1918.[95] He had been searching for a "zero point," totally separated from tradition, from the mere conglomerations of things painted by Raphael, Rubens, Rembrandt, and their likes, because such paintings conceal their true value, which is the feeling that gave rise to them. His hope was that the classics, and with them aestheticism, would die and the "savage mind" be reborn. Whiteness became an equivalent of light to him, and whiteness applied to itself, white on white, was meant to help him experience a new, transcendent reality. In 1923, to embody the sensation of infinity, he exhibited two squares of white cloth stretched over a white ceiling.[96]

Malevich's ambitions did not go unchallenged either by his scornful opposition or by other pretenders to the absolute. Aleksandr Rodchenko produced a counter series of paintings entitled *Black on Black,* interrupted and superimposed black circles on a black background meant not to express a philosophical concept but to demonstrate the invention of a new way in painting. In 1919, defining the absolute, Rodchenko announced the idea of "last paintings," reduced to single colors without opposition or contrast. In 1921, he did his part to "murder painting" by "declaring" the three primary colors "for the first time in art."[97] The three monochromes, Pure Red Color, Pure Yellow Color, and Pure Blue Color, each with no internal contrast, outlawed apparent recession, he declared, and outlawed illusionistic space. His aim was color in itself, at its highest, unique intensity.

I will not try to list all the varieties of monochrome since the time of Malevich and Rodchenko, but they include the following: all white by Lucio Fontana, Robert Rauschenberg, and (exhibited along with virgin canvas) by Piero Manzoni; all blue by Yves Klein (after various "unicolor paintings"); all black, on torn news-

paper glued to canvas, by Robert Rauschenberg; an all almost-black by Ad Reinhardt, who made matte, barely perceptible crosses on an oblong background; all white by Robert Ryman, who, after experiments with colored monochromes, made square white paintings on different surfaces and with different textures and densities; and all some-color-or-other monochromes by other artists. Each of these artists had his own justification. Klein's blue was his pursuit of the indefinable and his identification with space, in which, like Malevich in his white, he felt free; Rauschenberg's white was for him a hypersensitive reflector into which life entered by itself, while his black was meant to show a complexity of "much to see" despite "not much showing"; Manzoni's no-color ("achrome") exhibited empty, self-sufficient matter, not needing the artist's touch to establish its existence; Reinhardt's black, barely tinged with blue, green, red, or other colors, was meant to be both no-color and all-color, absorbing everything so as to be invisibility, purity, and the end of painting, "luminous darkness, true light, the undifferentiated unity, no divisions, no consciousness of anything, no consciousness of consciousness." In Ryman's square white pictures, "the application of the pigment," writes an appreciative critic, has "become the subject of the work," and Ryman himself has said that he uses the neutral color, white, to "make other aspects of painting visible that would not be so clear with the use of other colors." Similarly, but with more radical means, Robert Irwin tried to get people to become aware of their own perception and, in the process, to show them the limits of painting. The result was an "empty" room illuminated so as to draw attention to its edges, corners, shadows, textural differences, and whatever else had always been there but had remained essentially unseen.[98]*

*I can't resist quoting Ad Reinhardt's 1963 description of his Black Square paintings. I can't remember any brief description that so closely approximates what I imagine a Buddhist might think if and when unwisely struggling to experience the identity of the ordinary, workaday life (*samsara*) and transcendence (*nirvana*)—there's a famous hardly explicable statement that there is not the slightest shadow of a difference between the two. In Reinhardt's words his square is: "A square (*neutral, shapeless*) canvas, five feet wide, five feet high, as high as a man, as wide as a man's outstretched arms (*not large, not small, sizeless*), trisected (*no composition*), one horizontal form negating one vertical form (*formless, no top, not bottom, directionless*), three (*more or less*) dark (*lightless*), no-contrasting (*colorless*), brushwork brushed out to remove brushwork, a matte, flat, free-hand painted surface (*glossless, textureless, non-linear, no hard edge, no soft edge*) which does not reflect its surroundings—a pure, abstract, non-objective, timeless, spaceless, changeless, relationless, disinterested painting—an object that is self-conscious (*no unconsciousness*) ideal, transcendent, aware of no thing but art (*absolutely no anti-art*)."

This monochromaticizing was, among other things, a war of egos. Rodchenko challenged Malevich, while Klein, who knew better, insisted that he was the twentieth-century father of monochrome painting; and Manzoni painted white to overcome Klein's blue. Almost all of the monochromists I have mentioned voiced at least quasi-mystical sentiments and invented or reinvented the monochrome in order to go beyond the possibilities of painting and, most said, to free themselves and (using different terms) to enter the universal energetic continuum. In trying to go beyond painting, these artists were also returning to the beginning of painting, a state in which nothing had yet been done and the future, like the canvas, lay completely open before them. With Irwin, the canvas itself vanished, leaving variably lighted, variably continuous space, reduced to what might be considered immateriality. This return to the pastless beginning gives no sign of coming to an end. At least artists keep on making monochromes.

Because the human world is filled with monochrome surfaces of every color, the artists' ideas about monochromes are far more interesting than the monochromes themselves, handsome though they may be. It is a fact that staring at a monochrome can create a feeling of detached equanimity, even a sense of transcendence. To stare attentively is an old technique of meditative concentration.[99]*

My overriding impression is that the monochromes were less art than they were declarations of artistic freedom, a way to go on in any and every direction. Another, more recent declaration frees artists from the material presence of works of art or, more broadly, from their sensory or sensual or emotional presence. To say that the physical presence of objects is irrelevant to art goes far beyond Duchamp's preference for intellectual over "optical" art. According to the

*A technique that Buddhists used to tranquilize the mind was to fix it on an object as featureless as possible, such as a disk covered with dawn-colored clay. The person meditating was told to begin by staring at the disk with eyes open neither too little nor too much and simultaneously to think its name, such as earth, earth. The person was instructed to repeat this many times, now with eyes shut and now with eyes open, till the clay disk and its color filled consciousness in a dematerialized form. That was only the Buddhist's beginning, but it is enough to get an idea of how a long concentrated stare at any monochrome surface can change one's mind and mood. For far simpler though usually also therapeutic ends, modern hypnotists usually begin the process of hypnosis by asking a subject to stare at a small object, such as a colored thumbtack on the wall and to both relax ("you're getting sleepy, very sleepy") and concentrate.

conceptualist Joseph Kosuth (b. 1945), art no longer has anything to do with the presenting of visual or other experience. After Duchamp, he is sure, the value of particular artists is what they are able to add to the conception of art, which has no end other than itself. When a like-minded artist says, "My own art actually exists in the mind of other people as part of its very nature," Kosuth adds, "I think that obviously the way art lives is through influencing other artists, but not by the physical residue that exists in museums."[100]

Let me make the radical possibilities of conceptual art clear by citing the views and work of Sherrie Levine (b. 1947), though she, like most conceptualists, does not fit neatly into any simple conceptualist mold.[101] Levine also serves as an excellent example of an artist who feels oppressed by the age and richness of the Western tradition. Writing in 1982, she complains that "the world is suffocating," because every stone has a human token placed on it, every word and image is already leased and mortgaged, and every picture is "a tissue of quotations drawn from the innumerable centers of culture." By "appropriating," a painting, she proposes to demonstrate that "the truth of painting" is nothing other than the "profound ridiculousness" by which the painter pretends to be original and to have property rights over his art. Here she was going after the famous male modernists, and she made her point by exhibiting photographs or watercolor imitations not of their original paintings but of reproductions of them. Her reproductions of reproductions are signed with her own name in order to emphasize that painters, too, are only imitators, and that now it is the viewers of paintings, not the painters, who are in charge of the art of painting. The plagiarist, she claims, has succeeded the painter.[102] When she rephotographed the photos that Edward Weston made of his son Neil, she violated his copyright. She meant to imply (in imitation of the literary criticism of Roland Barthes) that there cannot be rights to such pictures because they are themselves imitations of pictures made by others, that are imitations of imitations that go back as far as the nude male torsos of early Greek sculpture.

When Levine says she feels smothered by the ubiquity and lack of originality of literary and pictorial art, she is attacking the pretensions of modern artists to originality. As she is aware, her abstract thought, like her photos of photos, is also unoriginal. Her pictures can be classified as works of postmodern art parasitic on the art they criticize, which they "demythologize" and, in doing so, themselves achieve the status of art.[103] My feeling is that most people would find much more interest in the way she justifies her appropriations than in their appearance.

I think that Levine's attack makes sense if leveled against what might be considered the cult of originality. However, children's art partly excepted, tradition-free works of art may not exist at all. Even the birds that invent many of their songs are likely to be deficient in singing unless they have learned to sing by hearing other birds of the same species sing when they, the learners, are quite young. Learning at least from her own previous views, Sherrie Levine has begun to think of herself as a still-life artist whose subject is a picture in a book and whose pictures "have a material presence that is as interesting as, but quite different from the originals," that is, more washed out. She writes further that the pictures she makes of pictures in a book are ghosts of ghosts. What she wants when she begins, she says, is "to put a picture on top of a picture so that there are times when both pictures disappear and other times when they're both manifest" and "the work is for her that space in the middle where there's no picture, rather an emptiness, an oblivion."

These words suggest that Levine's negation is directed as much against herself as against the ghosting of art by its successive reproduction. She sounds a little, too, like Derrida and like a Buddhist self-negator, who hopes for what Buddhists, too, call emptiness. But "empty" can be construed, as by the Buddhists, as inexpressibly more than simply "real," just as Levine wants the strangeness of her pictures, she says, to have an aura greater than that of the originals.[104*]

I end this section by using Robert Rauschenberg's *Erased de Kooning* as a metaphor for the process of the negation of art for the sake of reaffirming it and beginning it again. Rauschenberg studied but did not want to imitate the work of his older friends. To dramatize his independence, he proposed to de Kooning that de Kooning give him one of his drawings, which Rauschenberg would erase to turn it into a work of art by himself.

> With some alarm, de Kooning agreed—and chose a work that would be particularly hard to erase. After one month and forty erasers spent rubbing out

* By 1997 Levine sounds happier, full of gratitude for the museum without walls that photography has created. She claims that her works are unique in the sense that performances of the same music or recitations of the same poetry are unique. Does it make sense to grant the status of authentic art to such mechanically close though not identical copies? Can the idea of forgery be banished from art? Her answer is an interesting but unpersuasive "yes," for, as in music and poetry "every performance, every reading, every photograph, every sculpture, every drawing, every painting is an original, genuine, authentic, the same" and "all the different manifestations equally represent the work."

the thick crayon, grease pencil, ink, and pencil markings, Rauschenberg produced *Erased de Kooning Drawing* (1953). He jokingly called the work a "monochrome no-image." As Rauschenberg explained many years later, "I was trying both to purge myself of my teaching and at the same time exercise the possibilities."[105*]

MODERN "PRIMITIVES": CREATING AND DEBATING IDENTITIES

In this section I turn my attention to the stories of artists who many may regard as perhaps marginal. At our distance, these stories are a natural way to come somewhat closer to these artists—whether they are Papuan, Inuit, Aboriginal, or African—to grasp their efforts to adapt to the world, to see how they discovered or were helped to discover their ability and how they learned to use art to make a living. These are artists who have mostly come under the influence of twentieth-century Western art, either on their own, by efforts of teachers or patrons, or by the demands of buyers. The stories I will tell exhibit the problems that arise when newly invented or adapted "primitive" art is practiced in a world dominated by Western collectors, galleries, critics, museums, and auction houses. Not a few of the artists have discovered the pleasures of fame and have done their best to amplify it; and some have created an art of resentment at a world that has forced them to break and remake their lives.

When, one might ask, did modern "primitive" art begin? Among three of the four peoples I deal with, the most recent event that deserves to be classed as a beginning took place in the new nation of Papua New Guinea on February 28, 1969, in an exhibition of the pictures made by Timothy Akis. The beginning of modern Inuit art is easily dated between about 1949 and 1955, when the Inuit began to develop their sculpture and explore printmaking. The modernization of Aboriginal art, a more complicated phenomenon, can be given the not too misleading date of 1936, when Albert Namatjira first painted watercolors, or the alternative date of 1939, when an art gallery bought his watercolor *Haast's Bluff*, the first Aboriginal painting to be bought by a gallery or museum purely as a

*The well-known curator Klaus Kertess recalls, "Willem de Kooning was always drawing, never making a drawing—'finish' and 'closure' were not part of his vocabulary. He often drew on his canvas before starting to paint; in the course of his making, he sometimes drew with charcoal into wet paint; he drew endlessly on paper, with little regard for the differences between a preparatory sketch, a breathless notation, and an individual work. De Kooning was not averse to tearing up a drawing and recombining some of its sections with those of other torn-up drawings. Tearing up could be drawing."

work of art, not an ethnographic exhibit; but Aboriginal art had other begin-
nings, both earlier and later. Modern African art, too, had many beginnings, but
it may give some temporal perspective to recall the year 1901, when the realistic,
European-style paintings made by the Nigerian Aina Onabolu were first exhib-
ited, in the salon of a private home in Lagos.[106]

. . .

I begin my account of modern primitive art with Papua New Guinea (eastern
New Guinea and some neighboring islands), which became an independent
nation in 1975.[107] The heterogeneity of its peoples has made it hard to create
national coherence, yet it already has a distinctive modern art, whose first, self-
deprecating standard bearer was Timothy Akis (1940–85), the country's first
nontraditional professional artist.

Akis was born and spent most of his life in the highland village of Tsembaga,
whose two hundred or so inhabitants first came into contact with white men
in 1956.[108] Hired by an anthropologist to interpret and teach her his language,
when he couldn't find words for certain objects, plants, animals, and birds in
the pidgin in which they communicated, he explained with the help of scribbled
drawings. Obliged to study for a time at the university library in the capital, Port
Moresby, the anthropologist asked the artist Georgina Beier if Akis could spend
a few weeks in her studio. During the six weeks that followed. Akis expressed his
homesickness by drawing the animals and spirits that reminded him of his vil-
lage life. The freshness of his drawing fascinated Georgina Beier and her hus-
band, Ulli—both had spent years in Nigeria encouraging Africans to develop
their native talent for art. When Ulli Beier, speaking pidgin, criticized an early
drawing by Akis of a cassowary, snake, and wallaby as dead looking, Akis, add-
ing his own criticism, said that their skin and feathers "fail to vibrate like an
earthquake."[109] During his time in the city, his drawings grew more imaginative
and his line more sensitive. "Watching Akis," writes Georgina Beier, "was like
unearthing a complete culture—almost like excavating, peeling off layers of time
to reveal an unknown culture that is perfectly intact."[110]

At the end of the six weeks, Akis's discoverers arranged an exhibition of thirty
of his drawings in the university library. Nervous at first, after the exhibition Akis
burst into prolonged laughter at the absurdity of so many important people com-
ing to look at the drawings, he said, of someone who was "just a little man from
the bush." When the exhibition was over, he left Port Moresby, and returned to
work his farm. When he came back to the city two years later, he had drawn very
little, as drawing would have been a socially irrelevant activity at home. But dur-
ing the three months of his second sojourn in Port Moresby, he soon recovered

his skill and his work became more complex, sensitive, and strong; but he had no desire to experiment with new subjects or techniques and found little reason to use color. "He was not sidetracked by the desire to use effects," Georgina Beier explained.[111] Sometimes he gave his pictures titles such as *Man Mourning for His Dead Wife* or *Man Planting Taro,* but explained nothing about the creatures his imagination summoned up, though sometimes he would humor insistently curious buyers by making up stories about them. His drawn creatures, linear and fantastic, do not illustrate any myths and have no ceremonial or decorative function in his community. They do, however, reflect something of highland shield design and face and body painting and, generally, his people's sense of the unity of human and animal and natural and supernatural.

The most widely known of the modern Papua New Guinea artists is Mathias Kauage, or Kuage (c. 1954–2003), who came from a highland village in the province of Chimbu.[112] As a small child Kauage was much impressed by strangers who flew overhead in huge fantastic machines. He thought that the first helicopter he saw was a bird, so he took a bow and arrows and sat with other small, similarly armed children at the top of a forested mountain in order to shoot down the helicopter just as they shot down smaller birds. Even as a youngster, he insisted on his independence. He showed this determination early on, when he left his mission school because the teacher punished him harshly for writing the name of a girl still unable to write her name by herself. The teacher picked up a big Bible and hit him twice on the head. His ear, Kauage remembers, buzzed like an insect at night. Kauage then warned the teacher not to come to his village to get him. Kauage said to the other children, "I'm leaving the school. There's too much quarrelling," and he went off and never came back.[113]

Kauage moved in time to Port Moresby, where he had a low-paid job washing students' dishes and clothes. Invited along with other highlanders to Akis's exhibition, he decided that he too was able to draw, and he bought a small copybook and some colors and copied pictures from schoolbooks. On the advice of a friend who worked for the Beiers, he showed his pictures to Georgina. She thought they were worthless and did not reflect the forcefulness of this "powerful but unhappy man."[114] After some weeks of practice, Kauage began to show signs of originality, first in a series of imaginary insects, then in beaky, fantastic horses' bodies, with a pattern of faces or with patterned wings. Then came naked boys and girls, at first without sexual organs, the boys pursuing but never catching the girls. In 1970 there were drawings of men fighting "dragons" or riding on birds, and women with fish or with stars on their heads. Then came big women with

big heads and headdresses, warding off evil or standing impassively and carrying a newborn infant on their chests.[115]

Kauage had by now given up his job and come to live in a small building in the Beiers' garden. By the mid-seventies, using acrylic paints, he had arrived at his characteristic brightly colored, decorative, humorous narrative style of painting in which he remakes Port Moresby life into decorative works of art. This art joins the elements of traditional life—the natives in his pictures have pig tusks though their noses, feathers in their hair, and other accoutrements of a Chimbu warrior—with those of the modern world, the helicopters, airplanes, and automobiles out of whose windows these natives look. In his pictures traditional lovers hold hands and cross legs; a policewoman on a horse waves hello to Kauage himself, who is dressed in traditional Chimbu finery; foreign ladies in Chimbu costume play soccer with one another; the Queen of England visits; and the artist imagines flying to Glasgow on the occasion of the opening of its new Museum of Contemporary Art. Georgina Beier said of him in an exhibition catalog of 1987 that he invented an art form that "merges tradition with the urban environment" and that "subjects the foreign world to the discipline of his traditional ornamentation. He accepts the intrusion of the foreign culture with patience, intelligence, gentleness, and humor. He is an inventor and survival-artist." Throughout his work Kauage retains a regretful respect for his tradition. Painting is his life but, as he said to Georgina Beier, "I would like to keep to the old customs of our ancestors, but I don't know enough. They knew so much! But I know only how to paint pictures, that's all. I would like to do something that belonged to my ancestors, something genuine, but I don't know what."[116]

Kauage was honored by Queen Elizabeth II. In 1987 he was among the winners of an Australian prize for religious art, and in 1996, on the Beiers' recommendation, he took part in a project to paint outdoor murals in a German city street. In several visits to the Beiers in Sydney, Australia, the last in 1989, he was stimulated to paint pictures described as some of his most remarkable. Whenever he visits his native village, he is a big man there. Yet in spite of these successes and of the sale of some of his paintings at relatively high prices, he has found it hard to make ends meet. When white people asked for a picture, he demanded a down payment and, three or four days later, brought them the picture. But when too few buyers came to his home, he would stand outside some big hotel, along with his imitators, to sell his pictures to tourists. He has often felt frustrated by tourists' inability to see that his work is better than that of the imitators, by his lack of local recognition, and by the government's failure to buy

more of his pictures. "The saddest part of it is there is so much talent, evident not only in the work of Kauage but in pikinini bilong Kuage [Kauage's 'children,' the artists who adopted his style] and all the other pikinini who struggle to keep artistic expression alive in contemporary Papua New Guinea." Eager to please their public, there is nothing in them of the Western ideal of "the rebellious creator of art for art's sake."[117]

In a way the most surprising and, it seems, fortunate of the Papuan artists is "Jodam" Allingam. In an autobiography posted on the Web, he writes that he was born in a village on the east coast of New Guinea, in a very remote area. "I had the chance," he writes, "to live a Stone Age life in terms of my surroundings. . . . At the age of 7 I left my village on my father's dugout canoe and never looked back." He passed the exams at the end of his primary schooling with extremely high marks. Later adopted by an Australian family, he studied in Melbourne, graduated with a tertiary degree in fine arts, and went back to Papua New Guinea, where he taught art at the university. He has lived and worked for long periods in England, Australia, Canada, Zambia, Nepal, and the United States, and has been exhibited all over the world. "From time to time," he says, "I move with my family from one end of the globe to another, and so my sculptures get smaller and smaller while my paintings get bigger." Recently, he has had a sense of inspiration, which allows his art to develop in brushstrokes and imagery with, to him, an awe-inspiring spontaneity. Without mimicking any particular school, he tries to paint, he says, as the European impressionists did in their heyday. Lately, Allingam writes, the viewing of Cézanne's landscape studies at the National Gallery in Washington, D.C., has helped him develop greater maturity and depth.[118]

Allingam's sculptures, which are strikingly original, impress me more than his paintings. To judge by small reproductions, the paintings are handsome but might have been painted in Europe in the 1860s. While his progress from the Stone Age to the Web is extraordinary, it is ironical that, in comparison with Kauage, his painting seems to have returned to a period before European art was reinvigorated with the help of "primitive" and outsider art. With all the possibilities open to him, Allingam prefers to paint in a style inspired by late impressionism, but to sculpt in a style that is more imaginative and more his own.

· · ·

The story of the development of the modern art of the Inuit of Canada is an optimistic one. This optimism is evident both in the reactions of those who practice the art and, not surprisingly, in the art itself. It is true that this art was made to sell and so to please, not to express the individuality of the Inuit, disburden them

of their suffering, or reflect their problems, which have been severe. By its content, however, it reveals a steadfast interest, a cousin to pride, in all aspects of the Inuit way of life, that is, in the animals they are familiar with, make use of, and identify with; in legends such as those about the sea goddess, Sedna; in the still fearful mysteries of the shamans; and in their relations with one another.[119]

In spite of the motifs that Inuit art draws from shamanism, it has been an art so visually handsome and readable that it has sold as easily in airport gift shops as in museums. It had one true, steadfast opponent, the anthropologist Edmund Carpenter, who, out of love for the old Inuit life and spirit, denounced this new art as a reduced, painfully un-Eskimo variant of the work of Henry Moore.[120] Sometimes one can see what Carpenter means. Especially in the beginning, when the Inuit sculptors' own styles were still uncertain, there were signs of the influence of the Canadian artist James Houston, the person who, more than anyone else, was responsible for the invention of Eskimo printmaking and the reinvigoration of Inuit sculpture. But Houston was above all committed to helping the Inuit to express themselves, and Carpenter's impractical love for the old seems to have blinded him to the art's essential Inuit qualities and its imaginative shapes and designs.

Houston's first encounter with Inuit art was in 1948. The Inuit were having economic difficulties—their traditional work as fur trappers was no longer able to sustain them—and they were drifting to settlements and growing more dependent on the government. Luckily, government agencies were willing to help set up Inuit cooperatives, which were instrumental in developing both the old Inuit art of sculpture and the new one of printmaking. In well over half of the five hundred or so Inuit settlements, art grew into a major source of income. Printmaking was first practiced by the people of Cape Dorset, which then consisted of some three hundred and forty "strong family people" who helped and respected one another. The printmaking began as the result of an accident, in the early winter of 1957, when Houston's friend, the carver Oshaweektok, told him he could not understand how the pictures of heads on two packages of cigarettes had come out identical. Unable to explain the nature of offset printing in the Inuit language, Houston took a fifteen-inch ivory walrus tusk on which his friend had made bold engravings, smoothed some ink over it with his finger, laid some toilet tissue on the tusk, rubbed it lightly, and stripped it from the tusk. Looking at the print, which was clear, the carver said, "We could do that."[121]

No sooner said than done: with the agreement of two important elders of the settlement, four young men who had become interested in printmaking began to experiment. The fairly soft, close-grained green stone, serpentine, used for

carving, proved easy to ink. Women, who were used to cutting out designs for appliquéd silhouettes from animal hides, found their skill could be transferred to drawing, and the shapes they cut out were used as stencils for the prints.

Considering the preoccupations of this book, it is intriguing that the print-making techniques Houston taught the Inuit were not Western, but Japanese. He had used a long leave from his work to study in Japan with Un'ichi Hirat-suka, a teacher whose "vast knowledge acquired during a long and creative life-time stretches from the painstaking processes of the multiple carved cherry wood blocks of the Ukiyoe period to the most modern Hanga techniques." When Houston returned to Canada in the spring of 1959, he gathered the most enthu-siastic and talented printmakers in order "to develop a work and printing tech-nique that blended centuries of Japanese ingenuity with the wildly free talents and desires of the Eskimos."[122]

Many problems were encountered and solved, even though "on good hunting days the printmakers simply disappeared." A workshop was built, behind which, in a large tent, there was place for the men who chipped and smoothed the big printing stones. Drawings and skin stencils made by men, women, and some-times children came by dog teams from the winter camps. The four young men chosen to master the craft were given assistants to smooth the blocks and help with the design cutting. This division of functions, which separates the designer, the blockcutter, and the printer, follows the early practice of both Europe and the Far East, in contrast to the modern practice, in which the designing, cut-ting, and printing are the work of the same person. Water-based colors, which the Japanese used, were replaced by oil-based colors. These were applied with a soft roller to the incised stone blocks, which were printed on three thin, strong, beautiful, exceptionally durable types of Japanese paper, Fukui, Gifu, and Shi-mane.[123] The printmaking cooperative formalized the ways in which prints were to be numbered and sold and blocks and stencils destroyed after the set number of prints had been made, and a uniform method of signing the recently intro-duced syllabic writing system was adopted. The human and commercial prob-lems that arose were surmounted, and the whole experiment came to work sur-prisingly well.

Like many other peoples, the Inuit have no traditional term for art as such. Instead, they use a word, *sananguac,* that means "replica of," or more narrowly, "carved in the likeness of." They prefer a carving to be well made and relatively realistic, and, unlike the whites who buy a carving because of its appearance, they regard the carving's subject or meaning as more important. The carving should be "true" or "real" (*sulijuk*), they believe, but the notion of "real" is elastic

and can be used of stylized figures and representations of imagined supernatural beings.[124] It means something like "conveying the essence," without specifying in which of the great variety of Inuit styles this is to be done.

The testimony that Inuit artists have given has been direct and revealing. Take, for example, Pitseolak Ashoona (1905–83). Pitseolak—Inuit family names were only chosen in 1970—had been left a widow with five children, all that survived of the seventeen she had borne. A critic says of her work, "Her delightfully energetic drawings captured the spirit of traditional life on the land and the vibrancy of her own spirit." Pitseolak says of herself:

> My name is Pitseolak, the Eskimo word for sea pigeon. When I see pitseolaks over the sea, I say, "There go those lovely birds—that's me, flying . . ." I became an artist to earn money but I think I am a real artist. . . . I draw the things I have never seen, the monsters and spirits, and I draw the old ways, the things we did long ago before there were many white men. . . . Jim Houston told me to draw the old ways, and I've been drawing the old ways ever since.

To the question, "Does it take much planning to draw?" Pitseolak answers, "Ahalona! It takes much thinking and I think it is hard to think. It is hard like housework." After the drawings are carved into stone by Eegyvdluk, or Iola, Lukta, or Ottochie, they are always better, she says. "Now some of the drawings are also arranged on material and, when it is carefully done, it looks very well."[125]

Take, too, the example of Pitallousie Saila (b. 1942), whose work has been described as "realist, formal-abstract, direct and very powerful." Pitallousie recognizes that her art is important for her self-esteem, even though she knows she is not yet a great artist. "If someone likes the drawing that I make," she says, "it always encourages me to continue. Even if I myself do not like them and am not proud of them, it encourages me and I become proud of them and become proud of myself." Like Pitseolak, she stresses that it is hard to be an artist, "to know exactly what to draw as the piece of paper is completely blank, and you have to first create the drawing in your mind before it starts to come into being." Concerned to preserve the memory of her life for her descendants, Pitallousie says, "The drawings I do are my heritage to my children, my grandchildren and future generations. . . . I draw so that the Inuit traditional way of life can be preserved on paper, and it is only when I draw that it will be shown."[126]

Kenjouak Ashevak (b. 1927) has been praised for her powerful vision, fed by an imagination that leads her to create without a preconceived idea until, stroke having been added to stroke, the composition satisfies her—she thinks, she says, as she goes along. She was chosen to work with some other Inuit artists

on a carved mural for the Canadian pavilion for the 1970 Worlds' Fair in Osaka, Japan. In her biography, she recalls that that year the Canadian government honored her with the Order of Canada and issued a stamp with one of her designs. She says she continues to make drawings "primarily for the future these works of art will guarantee for my children." Sounding not unlike the romantic artist we have encountered in other cultures, she adds, "I am grateful to those people who are interested in, and admire my work. When I am dead, I am sure there will still be people discussing my art."[127]

In the more than fifty years that have passed since Inuit art was renewed, some of it has veered consciously toward abstraction or surrealism and some of its representatives have grown more self-conscious and more aware of the art world at large. Because their life has been changing so quickly, the stress in art on the old ways has helped the Inuit to feel continuity with their past. Inuit art has been successfully promoted in Canada and proclaimed to be a cultural treasure that gives Canada much of its distinctive character. But the history of Inuit art is so entwined with the non-Eskimos who revived it, supported it, and now consume it, that it still appears to many to be of doubtful authenticity (to use a problematic word) and not to belong in the mainstream of contemporary art. The artists who are praised as stars in the Canadian south may feel ashamed in the Inuit north because, not knowing how to hunt, they are not real Inuit men. But art is economically indispensable to the Inuit. A fifth or more of the adults are directly or indirectly employed in work related to art. Yet this work is such that an expert in Inuit art asks, when, if ever, the Inuit will begin to make art for themselves as well as for others?[128] The question is interesting but strikes me as unfair, suggesting impatience with their natural craftsman's modesty as opposed to the Western artist's narcissistic self-involvement.

· · ·

I have shown something already of the nature of traditional Aboriginal art. Here I confine myself to its modern development, which is more complicated than that of Inuit art.[129] I report this development in terms of three basic styles of painting: realistic watercolor painting, tradition-based abstract-looking acrylic painting, and tradition-based abstract and figurative bark painting.[130*]

*Although I have given the dates of 1936 and 1939 as possible beginnings for modern Aboriginal art, I might have cited nineteenth-century artists, such as "Mickie, the old crippled blackfellow," who lived on the Aboriginal reserve at the seaport of Ulladulla. His preserved works, the first dated 1875, are delicate, rather realistic drawings of a ship and of skiffs, with fish in the water below them, of birds, animals, of aboriginals hunting, and so

Albert Namatjira (1902–59), who became famous for his realistic watercolor paintings, was the first Aboriginal to have an entry in *Who's Who in Australia* and was the father of the Western Desert school of artists, beginning with his five sons, all painters.[131] Many of the following generation of painters were his close male kin, no doubt because he was obliged by tradition to help them and share his knowledge with them. His story begins in the Western Desert of central Australia, an area whose Aboriginals had been forced to retreat to towns and mission stations by disease, drought, violence, and dispossession of their land and sources of water.

Namatjira was born and grew up in the Lutheran mission of Hermannsburg. The mission's school was supervised by a student of Aboriginal culture, so his charges were taught not only Christian doctrine and the English language, but also the reading and writing of their own, Arrente (or Arrernte, Aranda) language. Influenced by Bible illustrations and the beginners' textbooks they used, the children learned to draw in a European style.

A good craftsman, young Albert made boomerangs and woomeras, some carved or painted in watercolor, and wooden plaques with burnt-in decorations, all to be sold in the mission store. In 1934, two Australian artists looking for picturesque sites held an exhibition of their works at the Hermannsburg mission. Albert, who studied the works carefully, asked the pastor what price the pictures would be sold for, and when the pastor answered, he said that he, too, could make paintings like these. The pastor got Albert a box of watercolors and watercolor paper and before long the boy had made his first painting, which he signed years later and named *The Fleeing Kangaroo*. The following winter, one of the artists, Rex Battarbee, returned to central Australia for a painting trip. He ended up taking Albert as his "camel boy," in return for which he gave him painting lessons during the two months of the trip. Albert advanced quickly, and as Battarbee reported, in a surprisingly short time understood the laws of perspective and

on. Or I might have mentioned William Barak (c. 1824–1903), a leader of his people and an invaluable informant of ethnographers. His rhythmical drawings in charcoal, natural pigments, and watercolor of Aboriginal ceremonies—such as dancers singing and clapping their boomerangs—were bought by ethnographical museums and collectors as evidence of a vanished life. Or Tommy McCrae (c. 1885–1901), who was commissioned to make his neatly sensitive pen-and-ink silhouettes, often in notebooks, of Aborigines meeting Europeans wearing top hats and long-tailed coats, or meeting the Chinese settlers, or engaged in corroborees, ritual fighting, hunting, town life, and so on. But these three artists, whose work records the Aboriginal life that was being destroyed, were, as artists, one of a kind, without any followers.

composition and had mastered the watercolor technique. In 1937, the pastor of the mission sold a few of Albert's paintings at a Lutheran conference, and, the same year, Battarbee exhibited his own works along with three of Albert's.

Thereafter Albert Namatjira, as he began to sign his pictures, made watercolors of the landscapes he knew and loved. Because Namatjira's pictures were realistic and handsome and proved that an Aboriginal could create civilized art, he had great success with the public, and his paintings were sold widely enough to inspire forgeries. Like all Aborigines, he was regarded as a ward of the state, and an advisory council headed by Battarbee was set up to limit the number of his pictures so that they could be sold at a good price. Among his honors were a flight to Canberra in 1954 to meet Queen Elizabeth II and the Duke of Edinburgh, then on a visit to Australia, and the grant in 1957 of full Australian citizenship to him and his wife—his children, like the other Aborigines, remained wards of the state.

Some time later, when he was visiting relatives at an Aboriginal camp, a woman there was murdered by her husband. Liquor, to which at the camp only he, a citizen, had legal access was said to have played an indirect part in the murder. He was charged with having illegally supplied rum to his tribesmen, in particular to a certain clansman (with whom he was duty-bound to share what he had). His sentence to six months hard labor was lightened to two months imprisonment with light duties at the Papunya Native Reserve. He was released in May 1959, in a state of severe depression, having lost his interest even in painting. In August, he died.

Critics often saw in Namatjira's paintings only his ability to imitate a tradition that was not his own, and to do so in a style that was too old-fashioned as Western art to be truly interesting. But at least in Australia, Namatjira's art is now done greater justice than in the past. It is stressed that, European as his art appears to be, he himself always remained in character an Aboriginal. The reason he did not use traditional Aboriginal motifs may be that he identified the Dreamtime mythology, of which he had a good knowledge, with sacred ceremonial and not with art.[132] What he above all accomplished was to show Aboriginals and whites that Aboriginals were able to cross the border into non-Aboriginal culture. But he used his visually European art to show how attached he remained to the landscapes of his homeland. The paintings he made of this land, with its light and color, its patched surfaces, its veined mountains and valleys, and its symmetries framed or broken by jutting foreground rocks and white, creaturelike ghost gum trees can be plausibly read as reminders of the landscape's ancient depths, into which his people's ancestors retreated after they had created the features that

mark it everywhere. Regarded simply as paintings, his works are certainly not extraordinary; looked at with care, his paintings show individuality and character. Taking Namatjira, therefore, for what he was, it is more pertinent and fair to judge him in the context of Aboriginal and not Western painting. He would have agreed with the words of his granddaughter, Jillian Namatjira, who said, "You must not lose it, you must always think about it, and always paint landscape. So that our country will be held strong. You must not lose it."[133]

In spite of Namatjira's fame and his direct successors, from about the 1970s, critics and artists took far more interest in the Western Desert painting that developed first at Papunya. Drawing on Aboriginal tradition, Papunya artists transferred the religious designs used for body painting, ground painting, and sacred objects to canvas and acrylics. Because this style satisfied the then ruling Australian preference for nonrepresentational art and had intimations of its religious origin, it became a favorite in exhibitions and galleries. Yet it, too, poses a problem of authenticity, in its detachment from its original, mostly ceremonial purposes and its incomplete but real surrender to commercialization. Aboriginals who saw the early Papunya pictures where they were stored or exhibited were scandalized, even frightened, by the revelation of clan secrets and reacted, at least on one occasion, by throwing stones.[134]

Papunya was a center set up by the government in 1959 for Aboriginals from four different "tribes." Later, when conditions and government policy made it possible, many of these groups moved back to the territories from which they had come and lived there in quite small homogeneous communities. At the time when Papunya was set up, the policy of the Australian government was to care for the Aboriginals' basic needs and influence them to accept a European way of life. The policy was a sad failure. The community remained poor and shiftless, its youngsters often became delinquents, and stealing and violence were not uncommon.[135]

In early 1971, Geoff Bardon came to teach "elementary Western knowledge" at the Papunya Special School, which had about 160 children between five and sixteen years of age. Having studied in art school, Bardon quickly became interested in the patterns he saw on the ceremonial objects of the Aboriginals. The children liked to draw in the sand, and he imitated them and made sand tracings of the track marks, circles, and spirals he saw on the ceremonial objects—he drew them so often on the blackboard that the children called him Mr. Patterns. Two members of the Papunya Council became his friends and, with the brushes he lent them, happily painted small traditional images and designs for him. Bardon writes, "I could help these quiet and seemingly obscure senior men, for I

was an art teacher who had access to government supplies." But at first they were reluctant to discuss the meanings of the paintings because "such encouragement of traditional art styles was quite unprecedented in this brutalized and impoverished settlement. It clashed with all preconceived European ideas, and with many of the racist and hierarchical assumptions of the nation."[136]

When the children and some of the elders repaired the shabby school building, they painted it with murals, which culminated in the mural representing the Honey Ant Dreaming, an ancestral myth that told, among other things, that the small hills alongside Papunya are the petrified bodies of the Honey Ant ancestors. The pictures made of honey ants were based on realistic European illustrations, but at Bardon's request were replaced by their traditional U-shapes. "The making of the murals gave enormous pleasure to the painters, and brought great happiness, pride, and hope to the Papunya community." To the government officials in charge, the murals had no importance and were later painted over, but the experience of making them opened the Aboriginals to Bardon's encouragement.[137] They brought in designs painted on all kinds of materials, from tins to fruit-box ends. Language barriers were crossed by smiles, gestures, and a common aim, and the Aboriginals were happy to continue with the paper, crayons, and other art materials Bardon gave them.

The large number of paintings that were made raised the prospect of selling them to earn desperately needed money. This need led to the establishment by the senior men of a cooperative, the Papunya Tula Artists. In the storage shed that was converted into a painting room, more than thirty men of different ages, different experience, and different cultural groups set to work painting. By the time Bardon left, in August of 1972, they had created some thousand paintings and had accepted Bardon's refrain, "We can beat the whitefella artists."[138]

After initial success came failure so great that it was even hard to give the paintings away, but lasting success was won with both critics and public by intense work and intelligent tactics (including the tactic of leaving the paintings exhibited abroad with the museums that had borrowed them, on condition that the museums kept them on permanent exhibit).[139] A number of white Australian artists were influenced by the Papunya Aboriginals, and public appreciation of their art grew. However, circumstances dictated that the Aboriginals modify their art's style and substance. In the beginning, some of their paintings were of designs forbidden to be shown to the uninitiated. Paintings with such designs were therefore covered with cloth until sent outside the settlement and sold to non-Aboriginals. Yet unauthorized Aboriginals could see the paintings at exhibitions, so the forbidden designs were made less readable by omitting some of

their symbols, or by concealing the symbolism by or within masses of round dots that covered the whole surface of the painting.

A word of explanation: Most of the early Papunya paintings were composed of the usual Aboriginal lines, stripes, dots, and so on. The shift to the more or less exclusive use of dots, sometimes only to fill space attractively, originates most obviously in the symbolic or outline-emphasizing dots that appear in earlier Aboriginal designs. But the dots of the paintings also recall the ceremonial look of the men who have tufts of bird down glued with blood to their bodies. The dots also recall the clumps of bird down fixed to ground sculptures, and recall the blobs of sticky pigment that make painted ground designs into colorful mosaics. Another proposed origin is the look of the vegetation-dotted landscape.[140]

As the practice of painting spread from one Western Desert community to another, the extreme simplicity of the technique, which used only dots, must have helped make painting the occupation of hundreds and then thousands of Aboriginals. The painting movement spread from one, perhaps newly established desert community to another—some years ago it was calculated that there were about six thousand Aboriginal artists, roughly the same number as non-Aboriginal Australian artists, about a thousand of them full-time, and among these about a hundred who could command quite high prices.[141]

The income that art brought in was the basic reason for the spread of painting. But the art also has helped to establish the cultural identity of each of the desert communities, has heightened the pride of the Aboriginals in their tradition, and has been the visible cause of a cultural renaissance. Women, too, took up painting seriously and successfully. Communities as a whole undertook community projects on the grounds, as one painter said, that "the money belongs to the ancestors." However, by the 1990s the more successful artists, who were quite conscious of their relative worth, were more likely to enter into "copyright" disputes with their elders and might be tempted to pursue an individual career.[142] Then the question of who made a painting could become more important than what the painting said. In 1988, the Aboriginal artist Clifford Possum Tjapaltjarri had a one-man show at the Institute of Contemporary Arts in London. At the Venice Biennial of 1990, Australia was represented by two Aboriginal artists, Rover Thomas and Trevor Nickolls, and in 1997, by three, Emily Kame Kngwarreye, Yvonne Koolmatrie, and Judy Watson.[143]

Of the latter three, I take up Emily Kame Kngwarreye (c. 1910–96). Emily Kngwarreye (pronounced Ung-warh-ay) was a particularly original painter in the acrylic Western Desert style. She was born at Alhalkere Soakage, but in the

course of her life she moved long distances, on foot when she was younger, for she had kinsfolk throughout the region. Her first memory of a white person was that of Australian policemen on horseback leading a chained Aboriginal prisoner.[144]

The land where Emily Kngwarreye was born was settled in the 1920s by a group of Germans, who set up a cattle station that they misnamed Utopia. Until the late seventies, when the land occupied by this station was returned to its native people, the Aboriginals made or supplemented their living by working for white neighbors—Emily worked as a domestic and a shepherd. After the land was given back to the Aboriginals, their community, possibly too poor to survive as it was, was saved by means of the batiks its women were taught to make. The women's guides were a crafts teacher and an Aboriginal who had already mastered the traditional Indonesian craft, which had been taught to another Aboriginal community a few years earlier by the New York artist Leo Brereton. When silk was introduced, the Utopia batik, originally meant for t-shirts and jeans, became attractive enough to be exhibited for itself as art. The designs of the batik were imitated from those of body painting, or were based on images of lizards, grasses, berries, yams, or on the Aboriginal motifs of footsteps, animal tracks, and dancing paths. But because the batiks were not taken as seriously nor sold as successfully as the Papunya acrylic paintings, the arts coordinator suggested to the women that they, too, take up painting in acrylics. When he saw the results, the coordinator remarked that there was a painting by Emily Kngwarreye's that shone out at him and would be, he knew, the star of the show.[145] Before long, Utopia art, with its more than two hundred painters, carvers, and batik makers became an extraordinarily successful business venture, and its most successful artist turned out to be Emily Kngwarreye. (In May of 2002, the Emily Kngwarreye Gallery was selling her pictures at prices ranging from US$18,000 to $52,000).*

Emily for years had no contact with outside art in the form of magazines, books, television, art galleries, or the work of artists outside of her own commu-

*The prices for her paintings were listed on the gallery's Web site. In the last chapter, I take up the crucial importance to present-day art of auction prices, but here I must mention that in the late summer of 2006, a Sotheby auction in London of Aboriginal paintings reached the following prices: $660,000 for Rover Thomas's *Bugaltji, Lissadell Country,* "depicting a dream in which the spirit of an aunt foresaw Cyclone Tracy." Another painting by Thomas (1926–98), who paints on wood, was bought in 2001 by the National Gallery of Australia for $778,500. In 2007, a painting by Clifford Possum Tjapaltjarri, was sold at auction for $2 million. By comparison, a painting by Otto Pareroultja (1914–73), an artist of Albert Namatjira's Hermannsburg school, sold earlier for $84,000.

nity. Although she began to paint in the Antipodean summer of 1988–89, when she was already an old woman, her output was prodigious—2,000 to 3,000 paintings over the course of several years—and within its abstract-seeming style, highly varied and adventurous. Instead of traditional designs, which might reveal information meant to be secret, she painted canvases that were generalized, imaginative expressions of her attachment to her tradition and to the land and the powers to which it referred. As she said in explaining the content of her painting *State of My Country,* her works were collectively of her own Dreaming, which included the pencil yam (bush potato), mountain-devil lizard, grass seed, Dreamtime pup, emu, Entekwe plant for the emu to feed on, green bean, and yam seed—"the whole lot."[146] Often she returned to the theme of "the green" time of the year, with its abundance of plant life. To yams she felt so closely related that the Aboriginals called her "boss woman, yam." She was also especially related to the emu, which feeds on the yam's flowers. When she first began to paint, Kngwarreye used designs like those she had made on batik in her younger years.

> As she aged, sinking lower and flowing bodily into the land itself, the soft dust covered her skin and caked on her large hands, which sometimes to observers appeared to take on the superficial appearance of emu's feet, the tracks of which she marked across her paintings. At first she painted the giant bird tracks as imprints in the sand then, over time, progressively abstracted these marks until they themselves were submerged and obliterated by the vegetation, the dots and layers above.[147]

In the reproductions I have seen of Kngwarreye's earlier paintings, there are branching pathways that look as if they were those taken by a Dreamtime ancestor. These pathways are in time invaded by the dots that fill the rest of the canvas, and then the pathways begin to disappear beneath the dots or, so far as one can see, simply disappear. She goes on, with many variants, to canvases covered with large deep-centered dots (made with a horizontal twisting of a brush with outer hairs cut short). These dots look like flowers or foliage that, seen from above, merge into masses of changing color.[148] The denseness and variation of color in these paintings may remind one of the late Monet. In her last years, Kngwarreye chose to abandon the omnipresent dots of the acrylic style and painted pictures constructed of differently disposed lines. Some are made of broad, free parallel lines that at times cross one another at right angles. Some are of "yam-dreaming" patterns with interconnected, sharply defined, wandering pathway-lines. Sometimes there are similar but denser line-strokes like those of

the abstract expressionists, but with a more relaxed effect. And sometimes there are irregularly joined masses of color that also recall the abstract expressionists, or, to make a distinction, the lyrical abstractionists. The yam-dreaming pathways are so different from one another and are often so tumultuously varied that it is hard to believe that they could serve as traditional mappings of the creation of the land; but if not mappings, they are certainly their echoes.

These changes in technique were spontaneous, but Kngwarreye did react to the comments of others. She could not only be loudly angry at a dismissive critic but quite openly enjoyed praise and was at times responsive to the desires of her patrons—the collectors and dealers who supplied her with materials must have told her what they preferred. But in spite of all her striking stylistic variations, when asked about them, she always gave the same answer, they all referred to her country, Alkakere, and to her Dreamings, or, in her own words, "It's the whole lot, everything."[149]

In intention, then, Emily Kngwarreye's paintings are always Dreamings and nothing Western. The long branching lines recall the long thin roots with tuberous swellings of the yams growing underground, the plant above having probably withered. Like the tuberous roots, the lines can form mazes, or can be crookedly joined like the cracks in the dry ground that reveal that there are yam roots below. Or the constellation of lines can recall designs of women's body painting, or, maybe, something of the creative journey of the Yam ancestor. But regardless of symbolism and reminiscence, in art appearances themselves ought not to be easily dismissed. Here what meets the eye are lines of black on white; or of white, red, or blue on black; or of colors that tinge or interlace with one another. In all of their colors, these are lines of unhesitating, interweaving force that fill the surface with their power. Even though Kngwarreye and the abstract expressionists and lyrical abstractionists have very different lives and attitudes, their paintings can look alike because, whatever the complex of ideas the paintings embody, the embodiments are made in a viscerally and visually similar way. These appearances, like the way in which we see colors and patterns, are autonomous enough to influence our reactions almost apart from our culture.

By this I mean that when we make pictures that look so—like force lines and color patches—and react to them as we in fact do, it is for reasons that are different from and psychophysically more deeply rooted than the thoughts the lines and patches are taken to translate or embody. To put it very simply, the use of round dots, even if large, to fill the area of a whole picture is an easy procedure but tedious, because it inhibits the large, natural motions of the arm (and, to a degree, of the mind). Even if Kngwarreye's straight lines are those of simple

body painting and her branched or tortuous lines are those of yams or cracked earth, in the Aboriginal acrylic painting of her time, and certainly in her own painting, these lines, straight, branched, or tortuous, are an expression of the freedom to make sweeping natural gestures. In their more complex way, her force lines and color patches also embody an expression of life that we see in the scribbling of children, in the drawings, with human help, made by chimpanzees and elephants, and in the wilder calligraphy of the Chinese and Japanese. So when, sitting cross-legged, Emily Kngwarreye made her heavy, vigorously curving lines that emerged from a mass of other curving lines, swinging her arm in an arc away from and back to her body, often changing the hand that painted, she was transferring the autonomous vigor of her motions and feelings to the canvas until the canvas became filled enough with it to satisfy her.[150]

Kngwarreye was ill and weak during the last few years of her life, but painting faster, in order, it seems, to catch up with her commissions (was she, like Picasso, staving off death, or providing for her family, or both?). If we like, we can see this convergence of appearances of recent Aboriginal and recent Western painting as an example of similar perceptual and proprioceptive reactions in art, or as an example of the evolutionary convergence of the art forms of two very different but nonetheless converging societies.

. . .

Aboriginal painting in acrylics on canvas, with its rich range of synthetic pigments and its abstract-looking style, is very different from Aboriginal painting on the bark of eucalyptus trees, with its limited range of pigments, all natural, and its mingling of the "abstract" or geometric with the figurative or narrative. Bark painting is related to ancient rock painting and seems to have once been widespread, but it is now confined to northern Australia. My account is based on the bark painting of the Yolngu-speaking clans of Arnhem Land, a peninsula in the far north of Australia.[151]

Bark paintings and carvings have for a long time been made for sale.[152*] But

* Bark paintings were exhibited in Paris in 1855 at the Universal Exposition, early ethnographers collected them, missions encouraged their production, museums might buy them, and tourists bought them as mementos. But by the 1950s and 1960s the atmosphere had changed, and it became possible for white Australians to regard bark paintings as fine art. From the Aboriginals' standpoint, this was encouraging because the more seriously their art was taken, the stronger their sense of the value of their cultural identity. However, for this very reason—the embodiment of Aboriginal cultural identity in "art"—the Western notion of "fine art" was inadequate. For Aboriginal artists, when a serious work of art is given as a gift, it implies, "This is our painting, where is yours?"

painted Aboriginal designs can also serve to make social and political claims. The Bark Petition of 1963, for example, was a protest sent to the Australian parliament against the leasing of traditionally owned land to a French mining company. The text was written in both English and Yolngu and attached to sheets of bark with clan designs painted on their margins—in Aboriginal law, the designs are claims to the land they identify. The justice of the claim was legally recognized in 1976, in the Aboriginal Land Rights (Northern Territory) Act.

One of the painters of the Bark Petition was Narritjin Maymura (c. 1914–81), a member of a Yolngu clan of artists, a clan open to change. He participated in a film made to record Yolngu life for the future, and he encouraged the women, among them his daughters, to paint sacred paintings. In 1976, when he was already well known, he and his son Banapana became the first Aboriginals of northern Australia to be granted a visiting artistic fellowship to the Australian National University. But the reason I have chosen him to represent the bark painters is that he was the friend and main informant of the scholar Howard Morphy, the author of *Ancestral Connection,* the deepest study of Yolngu painting.

Narritjin's life was not easy. His outstation, the small settlement to which he had moved, had suffered too many deaths to be maintained. Alcoholism was usual in his surroundings, and the disorder and violence that went with it often disturbed him and made his role as a father more difficult. Yet as Morphy relates, Narritjin kept on painting, spending hours

> doubled over his sheets of bark, his head inches from the surface as he drew the long thin hair of his brush across the painting, meticulously covering it with infilled lines. Often he would work late into the night, the bare electric bulb on the veranda illuminating his work. If ever I interrupted him while he was painting with my endless questions, he would threaten to charge me for the answer. For he was a painter and painting was his work which brought him money, and my interruptions cost him time.[153]

The "infilled lines" that Narratjin made were the fine cross-hatching that so often covers most of the surface of a bark painting. No longer confined to sacred paintings, the cross-hatching takes a lot of careful work to make it both fine and dense. The meaning of this pattern encourages the aware spectator to look at it closely and appreciate its variations, such as the changing angles of its segments and the way the segments and their angles blend in with a painting's geometric and figurative content.[154] In the eyes of the Aboriginals, the finely crosshatched surface of a sacred painting has the effect of shimmering scintillation—*bir'yun,* an experience that is related to the bright light in one's head by which a particu-

lar ancestor's power may be manifested. Mostly, this sensation is one of light-
ness or joy, occasionally it is that of vengeance, and always it is a manifestation of
ancestral power.[155] For contemporary Aboriginals, something of it can apparently
be retained even in the cross-hatching of paintings sold in the open market.

A Yolngu bark painting most often has a uniform background of red ocher,
which is taken to be ancestral blood transformed. Over the edges of this unchang-
ing background, a yellow border is always painted, defining the inner space. Vari-
ous "designs" and "figurations" are then painted upon the red background and,
where they impinge on the border, painted over again with yellow. Neither back-
ground nor border is mentioned when the painting is interpreted. The border
completed, the painting's surface is divided into segments, each with a different
figurative theme and reference to a specific area of land or mythological theme,
and generally with a different background pattern as well. The pictorial content
of the segments consists of symbolic geometric designs with a wide range of
possible meanings, and of figurative elements—narrow (windblown) spirits,
Dreamtime ancestors, animals, implements, and anything else that is essential
to the event. Each element, except for eyes, mouth, and so on, is painted in a
single color, usually black or yellow. All the segments interlock into a composite
reference or meaning. The geometric symbols have to be "right," meaning, the
way the old people used to make them, and the figures have to be "realistic," that
is, clearly recognizable for what they are. The figures of mammals, birds, and
fish are usually shown in profile, those of turtles, crabs, and snakes, from above,
and humans in a combined view from the front, above, and profile (of men's
genitals and women's breasts). The cross-hatching on the painting comes last,
though the figures may be redefined when most of it is finished, so that at the
end the painting may all come suddenly clear.[156]

The ambiguity of the geometrical elements, that is, their wide range of inter-
pretations, lends the bark paintings a good deal of their interest. Morphy remem-
bers that when he asked repeated questions about a pattern of red and black dots
in a small area of a painting, Narritjin answered, "It means blood and maggots,
sand and worms, itchy red spots and rotten flesh. . . . One small dot," he added
with a smile, "too many meanings." And a circle can stand for a waterhole, a
campsite or campfire, a mat, eggs, nuts, and so on.[157] Because geometric paint-
ings are harder to sell, painters, including Narritjin, tend to use pictures of ani-
mals instead of the geometric symbols for them; they also use pictures to tell
publicly allowable stories, or even to make up new stories that are all or almost
all in pictures, some of them whole complicated plots on single piece of bark.
Such paintings do not usually have clan designs on them, and their meanings

are much reduced in number and complexity. One can at once see that there is a picture of a hunter chasing a certain animal, but because there is no geographic symbol, we do not know in what area this story is located or, for this reason, to what other ancestral stories it is relevant. The story becomes barer, simpler, and more isolated. One may therefore say that the paintings in which figures are substituted for geometrical symbols are intellectually the poorer and less interesting.[158] Duchamp, I suppose, would disapprove of such impoverishment.

As Narritjin became aware that his art was valued in the world outside, he became dissatisfied with the art administrators' practice of dividing the community's income from paintings equally among all the artists. While touring as a member of a dance group he had seen that paintings were held in respect, and later, when he and Banapana spent three months in Canberra as fellows at the Australian National University, they exhibited and sold their paintings and carvings and saved the money to help reestablish their clan's isolated outstation and live again on their own land.[159] But Narritjin also wanted the white Australians to appreciate Yolngu culture, so at the opening of his exhibition he told the audience that as "a present back to you in this country" he was giving the university the biggest painting as a gift from his clan. All the paintings, he said, big and small, had meaning, their own story. "Everything has been done here," he said, so that the Europeans in Canberra "can understand the way we are traveling and why we are carrying on and the way and why we are living. That's all my message."[160]

. . .

Aboriginals who live in cities have been less bound to tradition and have used art for protest more than have their rural fellows.[161] Of the twenty-five artists who participated in the Sydney show "Koori Art '84," most were self-taught and about a third were women. They called themselves "Koori," a collective name for southeastern Aboriginals, to express their determination to claim their rights to land, to citizenship, and to their identity as Aboriginals. Their art, with its usually figurative style and blunt indignation, was criticized as being neither authentically Aboriginal nor of more than propagandistic interest. But though the show was ignored by the more important art journals, it taught its participants to recognize one another's work and cemented their common devotion to Aboriginal causes. Koori art, the art of Aboriginals who spoke, and spoke out, not from the deserts but from inside the cities of the whites, came in time to be regarded as a unique element of Australian art. Communal art enterprises were set up by Aboriginal communities, by urban and traditional Aboriginal artists, and by Aboriginal and white artists. A vision of an art that draws on both Aboriginal and European sources became plausible.

The urban art of the Aboriginals is too varied to be represented here adequately, but I will try to give some sense of its simultaneously Aboriginal and non-Aboriginal nature with the example of Lin Onus (1948–96), the son of a Scottish mother and an Aboriginal father, who had met at a Communist Party rally.[162] His mother was a physiotherapist; his father, Bill, a craftsman, film actor, Aboriginal-rights activist, the first Aboriginal justice of the peace, and a champion boomerang thrower—the son, Lin, demonstrated his own ability to throw boomerangs in a show that traveled to Japan in 1971. Bill Onus became a dealer in Aboriginal artifacts.[163] Kooris met and worked in his shop, to which white artists, too, were attracted; and visiting celebrities would come in to get a lesson in boomerang throwing. Lin had a hard time in the local high school, where he was the only "Abo." At the age of fourteen, he was picked up by the police, falsely accused of car theft, beaten during questioning, and expelled from school. Lin began work with his father, making souvenirs, and when his father died in 1968, he took over the business. Because the income was too small, he worked at all kinds of other jobs, including spray painter, electrician, tree lopper, mechanic, and snake catcher.

Lin Onus never had any formal lessons in art, but he had always watched the artists his father employed, and when he found an oil-painting set, he made a small landscape, and then, having made it again to get the water right, was surprised to discover that he was able to paint. A dealer bought the picture, and so Onus sort of just drifted, as he said, into the art world. He acknowledged the influence of Namatjira—"for the artist," he said, "the only role model of that era was Albert Namatjira"—who had visited his father's shop. He also acknowledged the influence of Western and Japanese art.[164] He recalled how hard it was to find a direction because "titles like half-caste were used and you didn't fit anywhere" and "I couldn't quite resolve the extent of my Koori-ness and I couldn't quite resolve the extent of my whiteness." The dingoes, the wild dogs of Australia, helped him to find his way. He came on them in his travels near Lake Eyre. Hunted and fenced off from their native territories, they had survived thanks to their strength and ability to adapt. Using his own part-dingo pet as a model, he sculptured and painted dingoes, his soul mates, he felt, and gave them stripes, like the bands of bark painting, of red, black, and yellow, the colors of the Aboriginal flag.[165]

During a visit to Arnhem Land as a representative of the Aboriginal Arts Board, Onus met the Aboriginal elder Jack Wunuwun, who adopted him as a son into his clan and gave him traditional images that he could by rights use. The outcome was a style that combines Western realism with true Aboriginal

designs, the secret ones being carefully avoided. Onus's landscapes often have inserts of traditional crosshatched, ocher-colored designs, each element deployed in a pun-like interplay of the literal and surrealistic with the symbolic and satirical. In explaining his use of so many different materials, techniques, and styles, Onus said that he belonged to the bowerbird school, "you know the one—picking up bits and pieces, here and there." He was the artist, too, of displacement, in whose paintings crosshatched fish might travel across the landscape searching for waterholes and a crosshatched, Aboriginal-striped stingray—a metaphor for an artist friend—fulfills its dreams by flying.[166]

Onus was enough the outsider from all the worlds of art to be able to pick and choose what he wanted from any of them and claim a tie with all, including, especially, the traditional Aboriginal. In the process be became a genuine exemplar of postmodernism. His art has been described as "a quirky combination of accessible imagery and Aboriginal issues, floating in a surreal visual world somewhere between Andy Warhol's pop imagery and intense social commentary."[167]

A good example of Onus's flair for offbeat synthesis and humor is the painting in which he gives himself and a friend a ride on top of some famous waves by Hokusai. The crest of the highest wave is being surfed by a crosshatched stingray that is his friend Michael Eather, on top of which the artist rides in the shape of a dingo with Aboriginal stripes. From a cross-cultural standpoint, the picture is a ridiculous hybrid, from a structural standpoint, it's neat and plausible, and altogether, it's wryly funny. The title, *Michael and I Are Slipping Down to the Pub for a Minute,* is funny too.[168]

Onus's anger at the white settlers of Australia comes to imaginative expression in a large acrylic painting, *And on the Eighth Day . . .* The painting shows two handsome angels dressed, more or less, in British-flag colors flying high over a bare, grassless landscape dotted with trees whose leaves have been shed or turned brown. One angel holds a pistol in her right hand and a lamb in the left, with a coil of barbed wire hung over her arm. The other angel has a "toilet duck" (a kind of toilet cleaner) in her right hand and a leather-bound Bible in her right.[169] The piece refers to a current debate on patriotism and the display of the flag. To the Aboriginals, Onus said, the red, white, and blue mean only despair, dispossession, and death. The toilet duck symbolizes the white Australian's excessive preoccupation with germs rather than the life and death of the Aboriginals and their culture. The lamb recalls the sheep, whose wool serves the settlers but whose hooves can turn the grasslands into deserts. The barbed wire needs no explanation, nor do the two weapons of destruction, the one, the pistol, physical, and the other, the Bible, cultural. The picture hung on his bedroom

wall and once as he looked at it he said to his wife, Jo, "You know something? I'll never die because I made all these paintings. As long as there is a painting of mine left, I'll still be alive!"[170]

From 1988 on, Onus spent much of his time making sculptures. He won many awards, had many exhibitions, and was for several years the somewhat unwilling chairman of the Aboriginal Arts Board. He noted, I assume proudly, that although the Aboriginals are only 1.7 percent of the population of Australia, they make up about half of all those who classify themselves as visual artists. He was obviously well on his way to becoming what he wanted to be, a bridge between cultures and a bridge between technology and ideas. His unexpected death occurred before he could fulfill this promise completely.

· · ·

Of the accounts I have given of modern primitive art, one area above others has shown a successively more complicated state of affairs. The modern art of Africa is too hard to describe briefly and almost too hard to describe at all, because Africa has some 760 million inhabitants—not all but many of them artists—three thousand or so ethnic groups, at least seven hundred languages, and fifty-three nations. In light of this vastness, the Africa of my discussion has turned out to be confined mostly to Nigeria, Zimbabwe (Rhodesia before 1980), Senegal, and, more briefly, the Democratic Republic of Congo (Zaire from 1971 to 1997).[171] My aim is not alone to understand the modern African art I discuss, but to see if the modern-art problems of the Nigerians, Zimbabweans, Senegalese, and Congolese can be compared with the modern-art problems of the Papua New Guineans, Inuits, and Aboriginals.

If we were to judge by the photographs in Carol Beckwith and Angela Fisher's 1999 work *African Ceremonies,* which documents ceremonies in twenty-six African countries, we would conclude that traditional art on the continent has survived surprisingly well. But the strange masks, gorgeous costumes, and complex coordination of roles we see in these photographs create a misleading impression. The traditions embodied in the spectacles have remained relatively strong in rural villages, city dwellers can watch them when they visit country relatives, and television features them. Some of the spectacles have considerable staying power. Surviving royal courts keep their traditional regalia and insist on the ceremonies that invest them with power; entertaining masquerades, with perhaps newly invented dances and masks, remain in favor; and tourists frequent favorite places to watch masked dancers. There are also picturesque funerals to attend and national festivals to celebrate; and divination and healing cults, with the help sometimes of television, keep updating themselves. But even in the countryside,

the great cult ceremonies have been losing their hold. Islamic and Christian preachers have opposed them, and historically both colonial and native governments have feared the cults as rivals for power. Whatever the reasons, ceremonies are increasingly neglected and are no longer taken to be self-justifying.[172]

Sometimes, it should be noted, an African nation combined commercial with political considerations and fostered a notion of authenticity that seemed expedient, even though the nation had been artificially created by a colonial government. Such was the case during the regime of Mobutu Sese Seko (1965–91) in what was then Zaire, when the villages, their importance and populations reduced by emigration to the cities, were encouraged to make a display of their tradition and Mobutu's "authenticity policy was related to the trade in African art." Mobutu's reign and policy lapsed, but for many Africans traditional-looking art "has come to serve as a kind of 'cash crop,' generating income, sometimes even wealth, for thousands of people."[173]

Earlier I ventured that it is possible to see the Nigerian Aina Onabolu (1882–1963) as the first modern African painter.[174] It was in September of 1901 that Onabolu's paintings, adapted stylistically from European magazines, books, and newspapers, were first exhibited. White visitors expressed doubt that an African could create "real" art. But Onabolu was convinced, as he later said, that "Africans should build up their courage with that sense of achievement and self-fulfillment to prove once and for all that they are not creatively inferior to any race." In imitating as he did, Onabolu had to show an innovating courage. It became his ambition to develop the artistic abilities of young Nigerians. In 1911, he set up free academic art lessons in Lagos. In the early twenties, he went to London to get a certificate that would qualify him officially to direct an academic art syllabus—this at a time when Africans with a European university education preferred to try to displace the old ways.[175] Onabolu went on to study in Paris as well, so it would be interesting to know if this would-be inventor of a new African art by means of old European realism learned how Picasso, Derain, and others had been using the symbolic art of traditional Africa to invent the new, unrealistic European art. Moving for the moment in opposite directions, the two traditions crossed one another.

"Mr. Perspective," as the Lagos art students called Onabolu, exhibited his own and his students' work, allowed everyone who was interested to visit his studio, and sometimes gave prizes in art materials to students. He believed, as he wrote in the preface of a primer for drawing, that "the technical power or faculty required in the making of an artist is not a conjuring trick, a mere sleight of hand to be learned in a set of tips, but must be acquired by severe academ-

ical training and by intellectual visual effort."[176] He justified his scrupulously realistic portraits of important Nigerians much as an ancient Chinese portraitist justified the preservation of the look and influence of the great and worthy. Like Namatjira, he broke down a barrier and was often forgotten or looked down on because he painted in a conventional, old-fashioned European style. It appears, however, that, also like Namatjira, his art has been rehabilitated, in his case by Nigerians who are in sympathy with his basic aims. For them, it is less important whether or not Onabolu, in Western terms, showed extraordinary skill as a painter than that he showed extraordinary courage and persistence in renewing African self-respect and in making art a serious academic concern.[177] It seems inevitable, however, that most African artists would follow paths very different from his.

There were many mentors or guides—white officials, teachers, gallery owners, artists—who opened the way for modern African art. Outstanding among them were Georgina and Ulli Beier, whose activity in Papua New Guinea I noted earlier.[178*] I tell the Beiers' story in relative detail because it is so interwoven with the development of modern African art and because it is such a good example of how an aesthetic symbiosis can develop between the people of different cultures, the friendly guides of one culture and the eager learners of the other.

Ulli Beier (b. 1922) was one of the great guides. He was the son of an assimilated Jewish father, who was both a doctor and a musician, and a Protestant mother. Toward the beginning of the Nazi period, his family emigrated from Germany to Palestine. While living there in a British internment camp, he got a B.A. degree as an external student of the University of London. In 1947, he moved to London, where he studied phonetics and took an external honors course in literature, the while earning his living by teaching disadvantaged children. Then, in 1950, without really knowing why, he says, he accepted a post as a teacher of

*To recall just a few of the discoverers or mentors that I do not take up: "Romain-Desfosses 'discovered' the talents of Bela, his car washer, and founded the Atelier d' Art 'Le Hangar' in Lubumbashi, Zaire; . . . Pancho Guedes, an architect living in Maputo, Mozambique, 'discovered' Malangatana Valente, who was working as a caddy at the golf club, and provided him with materials and criticism; the Belgian Victor Wallenda founded a school in Zaire that became the Académie des Beaux Arts in the capital, Kinshasa; Margaret Trowell directed the Makerere School of Art in Uganda; and Kevin Carrol and Sean O'Mahony, of the African Mission Society, educated Nigerian craftsmen." Some of these discoverers or mentors advocated distance from Western art; some, a compromise between Western and African forms of art; some, Western ideas combined with African forms; and some, exposure to Western art in particular.

phonetics at the University College in Ibadan, West Nigeria. He traveled there with Susanne Wenger (b. 1915), an artist of Austro-Swiss parentage whom he'd met in Paris. Wenger had briefly been a member of the Communist party—the Nazis had declared her imaginative, symbolical work "degenerate"—and now at a professional loss and fascinated by non-European cultures, she decided to accompany Ulli to Nigeria.

Teaching English phonetics in Nigeria appeared to Ulli less than socially useful, so he joined the adult-education department of the university, for which he created courses in modern African literature, said to be the first of their kind anywhere; but by doing so, he displeased the university authorities, who denied him any advance in rank. Ulli was also the cofounder of the periodical *Black Orpheus,* an important organ for African writers, and in 1961 he and the Nigerian writer Wole Soyinke set up the Mbari Artists and Writers Club. Eventually, Ulli and, with him, Susanne, left Ibadan and ended up in the town of Oshogbo. By then, Ulli had traveled a good deal in West Nigeria and had developed a deep interest in the culture and art of its indigenous peoples.

At this point, Georgina (b. 1938), later Georgina Beier, enters the story.[179*] The young woman had grown up in a culturally bleak suburb of London. Her

*Except for a few mentions in the text, the present note gathers what I have to tell about Susanne Wenger's notable career. Bedridden for a year with tuberculosis, she grew fascinated by the Yoruba religion and after a time became a priestess of the Nigerian creator-god Obatala. As it happened, the town of Oshogbo had a traditional pact with its goddess, Oshun, whose river, which bears her name, flows by it. On condition that her grove be respected, that is, kept clear of hunters, fisherman, houses, and farms, the goddess promised Oshogbo's first king to guard the town from danger. But Islam and Christianity became her effective antagonists, so her grove with its huge old trees was neglected and her shrines were decaying. In 1958, at the request of the Oshun priests, Susanne Wenger took it on herself to restore it all, a task that was to occupy her for several decades. She began with the roof of the main shrine and the hard-mud bricks of the wall that surrounded the sacred ground. The carpenters and the bricklayers she employed, although nominal Muslims, spontaneously made additions to their work. Wenger recognized the workers' potential and encouraged them to continue. Neither their style nor the style Wenger used for rebuilding shrines, some in wavelike curves, had any relation to traditional Yoruba art. For instance, the (Muslim) bricklayer and mason Adebisi Akanji made cement reliefs on the wall around the sacred territory, among them a relief of the Yoruba god Ogun, who in Akanji's version had a fantastic shape and was riding, gun in hand, on a wavy, fantastic horse. The group of artists who for years continued with this work formed something of a religious art movement, and the grove and its structures have become a national shrine. It has been hard and in part forbidden for Wenger to talk about her experiences in the Obatala cult. When she does try to explain her beliefs, she speaks, though

father, who made his living pushing a milk cart, would make up poems, which he wrote down at night as he pushed the cart. From him Georgina "inherited the ability to impose her imagination onto the bleakness of their world," a bleakness made the harsher by the German bombing of London. She had begun to draw and paint in early childhood, but the first time her passion for pictures was aroused was when the headmistress of her school, to whom her teacher had sent her to be disciplined, handed her a book on Brueghel. Art school, which, for lack of money, she had to leave after fifteen months, disappointed her, London remained depressing, and the only event that inspired her there was her discovery of the stories of the Nigerian writer, Amos Tutuola, stories full of the living dead and other fantastic creatures of his native Yoruba folklore. She married a British artist and art teacher, Malcolm Betts, and in 1959 went with him to University College in the city of Zaria, in northern Nigeria. Life in Zaria was diverse and lively, but in 1963 she decided to move to the town of Oshogbo, where Ulli Beier, whom she had earlier met and been attracted to, lived and worked.[180]

In Oshogbo, a not untypical Yoruba town, Ulli Beier, Susanne Wenger, and Georgina shared the everyday life of the African inhabitants. Despite the barriers of colonialism, the Yoruba villagers took them into their friendly, open lives and expected to be taken just as freely into theirs. To the other whites, however, the three seemed to have abandoned civilized ways and, most unfortunately, gone native—at some point the three had taken to wearing Yoruba dyed and handwoven clothing. The trio lived in a big three-story house of stone. On the ground floor there was a shrine of Obatala, which was visited by drummers early every fourth morning to praise the creator god. Some of the many rooms of the house were later to serve as artists' studios.

The scene shifts: In the center of Oshogbo, close to the palace of the king of Oshogbo, there was a compound owned by Duro Ladipo, the founder of a theater group and an impresario, playwright, and actor in plays he composed on Yoruba historical themes.[181] It was in his bar that in 1962 Ulli Beier had set up a theater club, the so-called Mbari Mbayo ("When We See It We Are Happy") Club, at which art exhibitions were also staged. Unlike its Ibadan predecessor, which drew writers and artists from everywhere in Nigeria, the club in Oshogbo provided a venue for local people, including the actors from Ladipo's troupe, who had to work at various odd jobs to supplement their meager salaries. Soon Geor-

not very clearly or consistently, of the androgyny of everything that lives and the continuous creation of life. I have read that the time came when she "commanded the respect that Yoruba culture accords to powerful older women."

gina was involved in the lives of the actors, musicians, and artists. Looking back, she says, "We resembled a rather eccentric extended family with Duro and Ulli at the head of the household. We lived for art, music and dancing."[182]

In 1962 and 1963, the club in Oshogbo set up brief, five-day workshops, both led by the Guyanese painter, novelist, and art historian Denis Williams. This workshop, like a previous one at Ibadan, was intended to free Nigerian art teachers of their conventions and inhibitions and introduce them to new attitudes, techniques, and materials. Just as in Ibadan, Ulli saw that completely untrained people who drifted into the workshop—a caretaker or a deliveryman—made pictures that were freer and more original than the art teachers.[183] The studio Georgina had set up after her arrival in 1963 also soon opened its doors to others. She worked intensively only with those with whom she felt an intuitive closeness, but never in the spirit of a teacher at a school, because she felt that was an impossible way to organize creativity.

Muraina Oyelami, a musician who was member of the theater troupe, remembers the first day that he and two friends attended a workshop at Georgina's studio. It was 1964, and her workshops were just starting.

> I took off my shirt and I started to paint. At first we didn't know what to do. Georgina never told us what to paint; she just gave us materials and we didn't know what she was looking for. But we loved doing it. . . . We never saw so much paint, so much color. . . . The art workshop was a wonderful experience, because it taught us to see our own potential. I think that I can say that Bisi Fabunmi, Rufus, Twins Seven-Seven and myself, each discovered a new dimension in ourselves. . . . Making a painting is really like going into a strange place, like an unknown territory and then you have nothing but your own integrity to guide you. But how can you be true to your own character, if you don't know who you are? The importance of the art workshop to us was that it gave us a sense of our own identity.[184]

Ulli and Georgina would exhibit the day's pictures they thought best, but as one of the workshop members, Rufus Ogundele, recalls, when Ulli came in to look, he would not comment at all, though Rufus could tell by his prolonged "mmmmmmmm!" when he was pleased. Georgina, in contrast, inspired Rufus, because when he was dissatisfied with a picture, she could, amazingly, identify the problematic area at once. "She saw things exactly the way I saw things . . . and I saw things the way she saw things. . . . Nobody is on the same wavelength with me as Georgina is. That is a great inspiration: to feel that somebody really understands what you are doing." Georgina agrees that she "had an instinct for

discovering the visual element that is unique to a person. She says that running a workshop "is like hunting for the original element, trapping it and making it safe, before it gets confused with so many other, alien elements. . . . I am saying this in hindsight: at the time we weren't thinking about it, we were just doing it."[185]

There were eighty participants in the 1964 workshop, ranging from five to sixty years of age. There was no plan, no one took things very seriously, people came and went, some to paint the one and only picture of their lives. It was just a painting-party. Every evening, Georgina remembers, out of the tumult of color, busyness, and laughter, there came at least fifty luminous paintings to be hung on the walls. But among the workshop's many talented participants, only four, all actors, had the inner drive to go on. They were given a studio in the king's palace and materials to work with. Two others, discovered earlier by Denis Williams, worked in the Beiers' home. Georgina helped them all to look critically at their work and exhibit only their best pictures—they knew that she often destroyed or painted over her own. Often, Georgina says, they were in a state of euphoria. She and the African artists lent one another the energy to work long and intensely as they learned to speak in their new voices.[186] The Africans all influenced one another and, despite everything, were influenced by their teachers, but each had a personal style, subject matter, and favorite media, whether colored beads, colored wool, or in the case of the artist Twins Seven-Seven, ink and mixed media on wood.

It became apparent that this group of artists could hope to make their living from art alone. Optimistically, they left their theater work, although Ulli and Georgina, who had been supplying them with art materials, had to help by giving them a monthly stipend. As the new artists ventured into the world, Ulli showed himself to be an effective entrepreneur. Within a relatively short time exhibitions were held in Munich, Vienna, Paris, Prague, Washington, and Mainz. In Nigeria itself, Oshogbo art was at first only rarely exhibited, but wherever exhibitions were held, they were usually successful and often sold out as soon as they opened. For the artists, the sale of the pictures could be difficult. Muraina Oyelami comments that he wasn't interested in money but had to sell his paintings in order to eat. But the trouble was, he wanted to have his paintings around him all the time. Selling them, he says, was "like giving away a piece of myself which will not come back."

Oyelami explains that he imitated no one. When he started to paint, he hadn't seen any European art and never looked at art books. But when his paintings were exhibited, in Edinburgh in 1967, for example, critics compared them with

those of Modigliani, Klee, or Rouault. Later, when he traveled, he made a point of looking for the works of these artists, and though he liked some very much, he could not really see the resemblance. He does not want to be classified as an African artist. He is of course Nigerian, he acknowledges, but he interacts with the rest of the world and doesn't know or care how a European or a Yoruba should paint. He and the other Oshogbo artists were lucky, he believes, because if they had gone to art school they would have had to study too much that was irrelevant or foreign and would not have been able to develop their inner eyes, their personal styles, or the techniques that expressed their ideas as early as they did.[187]

The widespread appreciation of Oshogbo art, which I share, has not saved it from criticism. A Nigerian art scholar, writing in 1989, in what sounds rather like sour grapes, dismisses the Beiers' Oshogbo workshop as a producer of showy art with no roots and no future, arguing that it, like similar ventures, ought to be displaced by formal university training and the museums and exhibitions that promote contemporary art.[188] A Western critic ridicules Wenger's "huge representations of spirits from the Yoruba pantheon" and describes them as "the re-creation of mythic figures through individual imagination fevered by Modernist media." He declares that, unlike the characters of Amos Tutuola's tales, they "had no native Yoruba impetus for their creation," and asks, rhetorically, if they are not less the "iconographic revival of a fading religious tradition" than "its exhumation and transformation into uplifting kitsch?"[189] As assessments go, not a generous one.

· · ·

A convenient way to describe the African art of recent decades is to classify its nontraditional artists by the way they learned their art, whether they were trained in workshops, trained academically, or self-trained (a less prejudicial description than "untrained").

Workshops were often established by concerned expatriates with two simultaneous aims, the practical, sometimes paternalistic aim of helping the Africans to make a living and the artistic aim of releasing what they were confident were innate, uniquely African powers of creation. One of the most successful among these mentors was the Englishman Frank McEwen (1907–94).[190] McEwen grew up in a home filled with art, including African art that his father, who was an art dealer, had picked up on his travels there. In 1926, the younger McEwen went to Paris to study art history at the Sorbonne in an institute headed by Henri Focillon, who was well known as an art critic, historian of art, and specialist in aesthetics. Focillon saw works of art as complex, changing beings, and the material forms of art—the consistency, color, and texture in which works of art begin to

be—as the liberators of other, transforming forms. Simply put, the wood hidden behind the bark of a tree or the clay hidden in the clay pit is transformed in the wood or the clay of a statue.

Focillon's thought deeply influenced McEwen, who throughout his career would remain alert to the nature of the materials of art. Moreover, Focillon's admiration for and connections in the Parisian art world led McEwen to become friendly with such artists as Brancusi, Braque, Matisse, Picasso, and Rouault, and this in turn led to his interest in the views of the artist Gustave Moreau, the teacher of Matisse and Rouault. Moreau, who wanted art to be spiritually ennobling, disliked the impressionists' ordinary street scenes as much as he disliked the academic painting of his time. Yet he was so sympathetic to his students and so proud of the more able among them that he could say to Matisse, whose strong colors and relatively abstract shapes seemed to him too simple and too close to the disintegration of painting, "Don't listen to me. What I say doesn't matter. A teacher is nothing. Do what you want, that's the main thing. I like what you do for me much better than the work of others with whom I don't interfere."[191] McEwen remembered Moreau's view of teaching, as he must have remembered Moreau's desire to transpose into art the inner flashes of intuition of the human experience. McEwen was also taken by the then fashionable Jungian doctrine, according to which art expresses the archetypes that inhabit the collective human unconscious.

McEwen's decision to become a painter led to a break with his family, and he wandered for a time among European museums, making a living as a laborer and a painter of wildflowers, which he made because such pieces were easy to sell. He worked as a restorer and later taught beginning art, always recalling Moreau's principles. In 1945, as a member of the British Council in France, he decided to show British art that the French would not scorn and put up a very successful exhibit of English children's pictures from Herbert Read's collection that obviously resembled those of French contemporaries such as Matisse and Bonnard. In 1952 he introduced Henry Moore to French artists, critics, and curators.[192] That same year, McEwen acted as a consultant for the design and policy of the Rhodes National Gallery, to be set up in Salisbury, the capital of Rhodesia (now Harare, Zimbabwe). Discouraged by what he saw as a descent into triviality among the younger members of the Paris school and encouraged by Picasso and Herbert Read, he applied for the job of director of the museum, was to his surprise accepted, and in 1957 sailed around the Cape to Mozambique and from there went overland to Salisbury.

Established in Salisbury, McEwen soon was able to put his views on art and

art education to the test. On the construction site of the National Gallery, he by chance opened a conversation with an African bicycle-messenger named Thomas Mukarobgwa (1924–99). Mukarobgwa talked to him about the religion, dance, and music of his people, the Shona. McEwen was able to get Mukarobgwa into the museum only as a cleaner.[193] When he gave Mukarobgwa watercolors to try out, Mukarobgwa had little idea, he remembers, of how to use them, but when he came back with what he had made, McEwen was pleased, bought the picture, and asked him to talk to other people who might enter a workshop in the museum. McEwen gave Mukarobgwa and the friends who followed him materials for drawing and painting and set up an unofficial workshop in the museum's basement. In McEwen's opinion, the paintings made in the workshop were adult child-art, and yet they quickly became, he thought, intuitively African and masterly, the unanticipated renewal, as if from nothing, of a centuries-old African expressionism to which the whole modern movement in Western art owed a debt.

Within a few years, the workshop in the museum had shifted, it seems spontaneously, from painting to soft-stone sculpture and, in sculpture, from soft to harder stone. McEwen encouraged the sculptors to take their themes from the Shona tradition. When the sculptures started to sell abroad, the museum board accepted the workshop, though reluctantly, and the white neighbors and white press remained hostile. Picasso, however, kept asking for photographs of outstanding work, and McEwen discovered that his workshop sculptors conceived and worked like Picasso: they first took their time to imagine a sculpture in all its detail and only then very quickly made the actual sculpture. (This quickness can apply only to soapstone carving, because, as McEwen writes in a 1957 catalog, "Our most courageous carvers . . . work with the toughest granite, not refusing the archaic technique of grinding one stone against another over a long period of time—producing only one work a month, or less.")

McEwen's appreciation of Picasso and Moore led him to bring traveling exhibitions of their work to the National Gallery. His goal was not to encourage imitation but to allow the workshop artists to sense the originality of the pieces and, in Moore's figures, the sculptural qualities of which stone is capable. Mukarobgwa recalled that McEwen always took the whole group to the exhibitions, and "everyone would have to join in order to hear what he was explaining." The main lesson, as Mukarobgwa recalls, was that Picasso "was doing a straight thing from his mind."[194]

Reminiscing later, Mukarobgwa, whose own paintings and sculptures were by then in many museums, shows how well he internalized what he had learned.

He says that McEwen taught that art should be deeply felt and deeply original and, speaking for himself, explains that you can't do work on behalf of someone else, because your work is very original only when "it is created definitely by your blood," as your child is created. Only by developing beyond what you have been taught, adds Mukarobgwa, can you be something and can you "show your tribe," by which he means, only by drawing on one's spiritual heritage, in his case the Shona mythology and past.[195]

McEwen's workshop eventually supported about seventy-five artists, who would come and go as they pleased, and on whose accomplishments he looked back with pride: "There was not a trace of art school mentality. No teaching, but an atmosphere of individual 'drawing out'; as Gustave Moreau had propounded and Henri Matisse and others had explained to me. Obviously, there must be an aura of vibrant art content to be drawn out."[196] His idea proved successful enough for the artists of his workshop to be shown at the Museum of Modern Art in New York in 1968, at the Musée Rodin in 1971, and at the Institute of Contemporary Arts in London in 1972. However, under increasing pressure from the Rhodesian government, which blacklisted him for fraternizing with blacks, and burdened by the demands of commercial success, McEwen moved his workshop to a rural highland community. He named this "bush school" Vukutu, and there his project was able to draw, as he wanted, more freely on the Shona tradition. In 1973, when the situation in Rhodesia finally became unbearable, he resigned his position and left Africa for good.

Validating McEwen's belief in the "explosive" talent of Africans, the sculptors he worked with have had international critical and commercial success, have won official Zimbabwean prizes, and have been promoted as symbols of Zimbabwean culture. This success, however, has not put them beyond criticism. McEwen's ideas and workshop practice have been disparaged by those who oppose cultural paternalism and, even more, oppose what they see as a demand that African artists should create in ignorance of or indifference to the international community of art. If it is true, as reported, that most Zimbabweans are uninterested in the work of McEwen's protégés, they are exercising another kind of criticism.[197]

. . .

I have chosen two artists, both very successful, to represent workshop training and the kind of work it inspired. Twins Seven-Seven may stand for the artists of the Beiers' Mbari Mbayo workshop, and Nicholas Mukomberanwa for those who emerged mostly from McEwen's National Gallery workshop.

Twins Seven-Seven, or Taiwo Olaniyi Salau, to use the short form of his given name, was born in Nigeria in 1944[198] He adopted the name Twins Seven-Seven

because he was the last surviving member of seven pairs of twins—twins, gifts of the gods, are believed to have entry into the supersensory world. One of his grandmothers was the head of the old *imole* cult of ancestral spirits, and his mother, too, worshipped them with great conviction. His father, who died when Twins was still very young, was a descendant of the king of the Ibadan city-state and belonged to a family that traditionally worshipped Oshun, the river goddess. "So it is not surprising," Twins says, "that 90% of my work has to do with Yoruba religion and *orisha* (Yoruba deities)." From the time he was born, his parents, told by those who could read the future, believed that he had connections with the spirit world, and that, in addition to being a twin, he would never quarrel and would become rich and a blessing to his family. Twins adds the belief that the strange episodes of suspended breath into which he fell as a child gave him special insights. While his mother was an especially pious Christian, he remains undogmatic, for in practice it was possible for a Christian to maintain Yoruba beliefs and customs. Twins explains that his life fluctuated between Christianity and *orisha* worship, but that he still feels closer to *orisha* and *orisha*-ritual.[199]

Twins has lived mostly in Oshogbo, where he has his own gallery, but he has also lectured and been an artist-in-residence in the United States. He has seven wives, all of whom practice batik painting, and at the time of this writing, twenty-two children. He's married so many women, he says, because he believes in Yoruba tradition and because he needs them to perform music and drama. His work has been exhibited in many museums and galleries, but though he makes his living from painting, he on the whole prefers to sing and dance and make records—in his words, "without music I cannot live, without music I am nothing."

Twins's commercial and critical success, with its invitations to exhibit and give lectures in the United States, gave him a sense of mission and made his way of living less carefree. When intellectuals tried to persuade him that the Beiers were exploiting him, he answered, "If I am what I am today, it is not because of you. It is because Ulli and Georgina believed in my talents, when you would not even talk to me." In appreciation, he goes on, "The uniqueness of it was, that they came from another culture, and they made us more aware of our own culture. They revealed our creativity to the world and to ourselves." But his success has its drawbacks. He is tempted to sell work that is not finished or that he thinks is inferior. He is also sad that some of his best works are not available to him, and he hates to visit someone who bought a painting from him because he feels that it is something private that belongs to him and wants to take it back. But he is at all times a businessman ready to trade in whatever commodity

comes to hand, whether cement, coffee, or cocoa. Generous with money, food, lodging, and help, he forgives those who take advantage of him and often finds his own finances short as a consequence. He likes to dress colorfully, shop, give parties, travel, drive fast cars and motorcycles, and take life as it comes.[200]

How did Twins's career come about? In his youth, he started to go to a teacher's college but soon left to join a theater company that performed the *Death and Resurrection of Christ* and similar plays, all accompanied by bongo jazz drums. A theater group of his own died quickly, and he became a dancer whose job it was to attract crowds to his employer, an itinerant seller of medicine. Everything he then did, day in, day out, was dancing. But he became a painter as the result of an accidental meeting at Oshogbo in 1964 with Ulli and Georgina Beier. When appearing there, he danced so well that Ulli Beier offered to pay him as much as he was earning as a dancer if he stayed in Oshogbo. Twins joined Duro Ladipo's acting troupe, but because he did not get along with Duro, Beier wrote a play for a rival producer that had parts for Twins and two of his followers. A few months later, when Georgina opened an art workshop at Mbari Mbayo, Twins joined it. Like the other novice artists, he was given sheets of brown packing paper, which is all the Beiers could afford, and a thick brush to paint with. He threw the brush away and picked up and began to draw with a very thin little palm rib from a Yoruba broom. As soon as Georgina gave him pen and ink instead, he began to draw in what proved to be his characteristic way. "Starting in the upper left-hand corner and working his way slowly to the bottom right-hand corner," he knitted his lines densely "as if the images had all been lying dormant in his soul" until he pulled them out.[201] This emergence of images as Twins's hand moved down over the surface reminds me of André Masson's lines, which also grew and multiplied until a subject emerged.

Twins says he never looks at any book when he makes his figures, that he was never moved by anyone else's painting, and that he does not even know where the shapes come from. He looks at other people's artwork but it doesn't enter his mind, he says, because all he sees is what he himself wants to do, and when somebody copies his own work, he gets very upset. He hates drawing sketches in advance and can never copy them while he is working on a painting because, he says, he closes his eyes and just paints things. There were times, he remembers, when he didn't know until he finished what the paintings would look like. "Something just keeps telling me to do this and that, and I just continue doing it. That's why at that time—when I was working—I wouldn't talk to anybody!" This can still happen, he adds, and when he wants to do a fantastic painting, he likes to fight, and so he fights his wives or throws them out and locks himself in.

**THE SMALLEST GHOST IN THE BUSH OF GHOSTS. ETCHING BY
TWINS SEVEN-SEVEN INSPIRED BY THE STORIES OF AMOS TUTUOLA.**
FROM *A DREAMING LIFE: AN AUTOBIOGRAPHY OF TWINS SEVEN-SEVEN*,
ED. ULLI BEIER, BAYREUTH, 1999.

*This uncanny image is one of many, strangely well matched to the fantastic Yoruba
stories that they illustrate.*

Someone seems to be sitting next to him and telling him what do to. He's not
crazy, but then he may talk to the wall or the leaves and maybe make use of the
title for his picture that this power suggests to him.[202]

The political satires that Twins painted reflect his own engagement in poli-
tics. For example, in the *Assembly's Headache*—the date, 1985, tells just which
headache he meant, the seizing of power by Ibrahim Babangida and curtailment

of political activity—the assemblymen are given the heads of a rooster, a rabbit, an owl, a lion, and a donkey; and many of his records have political messages.[203] The names he gives his pictures, *The Beast and the Rainbow Color Lost Drum, The Lovely Rabbit Tanner, The Hunter Moon Monster,* and *The Lazy Hunters and the Poisonous Wrestlers, Lizard, Ghost and the Cobra,* suggest that the fantastic creatures he makes are illustrations of Yoruba tales or myths or, at least, fantasies based on these tales—after painting for about six months, he started to have dreams, which he remembered only imperfectly, in which he saw most of the things that he wanted to paint.[204] The tales, which I assume are elaborations or reinventions of those he heard as a child, resemble the plots of the folk operas, with spoken parts, music, and dance, performed by Duro Ladipo's troupe, in which Twins briefly participated.

Twins's pictures suggest the Nigerian tales in which the human world and the extrahuman world of the "bush of ghosts" lead directly and mysteriously into one another. In 1938, the writer Daniel Fagunwa (1910–63) published a novel in his native Yoruba composed of such tales. The hero of his novel, later translated into English as *The Forest of a Thousand Daemons,* is a magically powerful hunter, whose father, also a hunter, is "deep in the art of the supernatural," while his magically still more potent mother is "a seasoned witch from the cauldrons of hell." At the start of the novel, the hunter goes to the bush of four hundred spirits "where he encounters fearful spirits and monsters (like the sixteen-eyed Agbako with whom he had a fight) and runs into a city of disease and death. He suffers torment and fear but gains miraculous rescue in each case."[205] The strange imagery and adventures of the novels of Amos Tutuola (1920–97), in the same vein as those of Fagunwa, have often been compared with the pictures of Twins Seven-Seven and are sometimes suggested as their source. Although Twins's childhood provided the foundation of his creative impulse, when Ulli Beier gave him Tutuola's tales, he was taken by their titles and etched strikingly inventive illustrations for them, so he must have felt a sense of connection and inspiration. Tutuola's tales and his illustrations went together well, for both express deeply African fantasies in which "one feels the bewilderment and fear, repugnance and despair, and also intoxication and exaltation, which one would expect to experience in the company of ghosts."[206]*

*The summary lesson of Yoruba tales like those in the writings of Fagunwa and Tutuola is that the human is a fragile being subject to terrifying nonhuman forces, but if one is determined and resourceful enough, one can lessen and even overcome those forces. Taken less abstractly, the tales tell of the adventures of the humans who enter into the

Twins uses ink, paint, and sometimes chalk to create his intricately filled pictures. His most characteristic works have come to be those drawn on large sheets of plywood, sometimes in sculptured layers of two or three thicknesses, to which he may attach newspaper clippings, bottle tops, and other objects. Apart from the grotesque outlined figures that populate them, his pictures' most striking quality is their extraordinary denseness. Every area inside and outside the figures is worked over and filled with repetitive small designs, within which, often, there are more, minute designs. The constant filling of the whole available space of a picture, the inability not to fill it all, is sometimes a mark of a psychotic artist, and Twins has been creating, almost compulsively, a kind of bush ghostland too densely thicketed for any alien, non-Twins's image to penetrate it. The intenseness of the filling-in is the intenseness of his possession of the territory he transfers from his imagination to his picture. The hallucinated look of his ghostland inhabitants is in effect a natural, theoryless surrealism (though imbued with Yoruba attitudes and imagination). In terms of the decorativeness and density of Twin's infilling, the closest parallels I can recall are the drawings of the insane Adolf Wölffli (1864–1930) and, even more, of certain "outsiders" of at least doubtful sanity, such as Augustin Lesage (1876–1954), who surrendered himself to his guiding spirits, which he obeyed, he said, like a child as a picture—not his at all, he insisted—came into existence unexpected detail by unexpected detail.[207] But both the Yoruba and the Igbo have a tendency to fill spaces with decorative details, there is no good reason to doubt Twins's sanity, and I must add that he takes his pictures humorously.[208]

Nicholas Mukomberanwa (1940–2002) was born in the village of Buhera, in what was then Southern Rhodesia.[209] At seventeen, he went to a mission school

thickets of the bush and the world of the ghosts. Amos Tutuola says that he and his friends would hear the Yoruba tales on their farms in the evening, and that he got the plot of his first book, *The Palm-Wine Drinkard*, published in 1952, from an old man on a palm plantation. Tutuola, whose parents were Christian, preferred to write in English, not Yoruba. His stories with their ghosts, monsters, and dramatic adventures are in character much like Fagunwa's. Even if he did not read Fagunwa's novel, he would have encountered Fagunwa's influence in the folktales in Nigerian grade-school readers. Like Fagunwa, he shows the influence of the Bible, *The Pilgrim's Progress*, and maybe Greek mythology. Though a great success in translation, for a time *The Palm-Wine Drinkard* was criticized by educated Nigerians for its colloquial West African English and its "primitivism," an objection not unlike that leveled against Twins Seven-Seven and other "primitive" Nigerian artists, whose success seems to them to misrepresent the level of contemporary Nigerian culture.

for two years, and aware of his interest in drawing, his teachers there encouraged him to continue at the Serima Mission, whose head, a Swiss priest, was also an architect. Father Grover introduced his students to both Christian and traditional African images and taught them the craft of woodcarving. At Serima, Mukomberanwa remembered, the seeds of art were sown in his heart and gave him the ambition to become an artist. To make a living, Mukomberanwa joined the British South Africa Police, but he spent all his spare time drawing. In 1962, he entered Frank McEwen's workshop, which gave him the opportunity he had been looking for. He said that although McEwen favored certain European artists, "he disliked copying and asked us to create something unique and new. He never told us what subjects to do but told us never to repeat."[210] These lessons stayed with Mukomberanwa, who even after he had achieved international acclaim, kept asking himself what in his sculptures made them good or bad.

The sculptures of Mukomberanwa, like those of others in McEwen's workshop, might have been mistaken for the work of an unknown Brancusi or Zadkine, but his figures and themes were drawn from his own experience and expressed his own beliefs. One example is particularly apt: *Heavy Responsibility*, the figure of a man's body that curves around an ear of maize (corn) enclosed within his massive arms. Mukomberanwa himself grew maize. His outdoor studio was only a few hundred feet away from the fields where his maize was harvested and where his extended family converted it to maizemeal. His explanation of the sculpture is this: In 1992 there was drought in most of the country, but he was lucky enough to have a good harvest, so people came to buy the maize from him. "What inspired me," he said, "was when a man bought about 15 kilograms of grain and told me he had six children and was going to carry the grain a very long way to feed his family."

Mukomberanwa would begin by confronting a cube of stone he had cut with the idea that he must in the final analysis know "which of us is the artist: the stone or I."[211] His earlier sculpture is boldly cut but relatively simple in conception, while his later sculpture—human shapes wedded to the geometry of curves and angles—shows more ingenuity and, I think, power. For instance, his *Mediator*, which looks at first like a single head with all its features curving in one direction with the effort of its task, has the lips of its sober mediating mouth inserted into the mouths of the two persons whose difference is being resolved. A similar ingenuity shows in Mukomberanwa's use of a deep longitudinal cleft or fissure cut into sculptures such as *Spiritual Man*. This man looks (like Rodin's most famous *Balzac*) as if he is inside a stone cloak. Its narrow opening is topped with a triangular suggestion of hair and two slight raised, rounded shapes, one

on each side of the fissure, which make up the two sides of a barely present face. This face has only a slight nose, the hint of a mouth, and two relatively large, half-closed eyelids. The rest of the man's body is suggested by the impersonal bulging of what I have called the cloak, but the body itself remains invisible, except as plain stone glimpsed through the edges of the cloak. In *The Spirit Has Left Him,* the body or cloak, which this time is mostly angular, has a hood over a solid blank triangle of a face, while the rest of the cloak remains open enough—like a box with its top and one long side cut away—to show that the expected human, being spiritless, is not inside. Mukomberanwa had the ability to work stone with subtlety enough to suggest the presence or absence of the immaterial spirit.

Mukomberanwa has served as the model for younger sculptors in Zimbabwe. These include his five sons, his two daughters and his wife, Grace, for some of whom sculpture is a fulltime occupation but for others a vital though part-time one. Two of the sons, Anderson and Laurence, have been widely exhibited, and the whole family's work has been exhibited together.[212]

. . .

Leaving the workshop training of African artists, epitomized in the projects championed by the Beiers and by McEwen, I turn to academic art, which in Africa has mainly shown itself in accord with the traditional European emphasis on life drawing, formal composition, and perspective, and, when possible, the copying of acknowledged masterpieces. (In Africa, the work of academically trained artists has been called "modern," "international," or "contemporary," the three terms being used more or less synonymously and applied to African "Euro-modernism" or modernism—but not African postmodernism.)[213]

The most notable patron of modern, that is, academic African art was Léopold Sédar Senghor (1906–2001), president of Senegal from the time it became independent, in 1960, until 1980, when Senegal's economic situation led him to resign. His life, career, and ideals had made him bicultural, but though it was in France that he wrote his doctoral thesis on Baudelaire, taught French literature and grammar, served in the army, joined the resistance movement, and became an acclaimed poet, he was unable, he said, to become a black-skinned Frenchman. Nostalgic, he could not forget the Senegalese animism he had known as a child, nor the talking drums that had once heralded the king's visits. And in Paris of the 1930s, he was affected by the discussion among his friends of an ideal, archetypal black culture, knowledge of which, they hoped, would restore Africans' pride in themselves. Moving from debate to action, he and two other poets then living in Paris, Aimé Césaire, from the West Indies, and Léon Damas,

from French Guiana, founded the movement called Negritude, the object of which was to make black Africans aware of their common humanity, emotional depth, and historical accomplishments.

Senghor went on to become the rare example of an intellectual who gains authority enough to make his word, if not exactly the law, the ideology required of an artist who hopes to live on a government subsidy.[214] In particular, Senghor thought that the art of Picasso, whom he had known in Paris, could serve to inspire African artists because his work, though rooted in the Mediterranean heritage of Andalusia, derived much of its power from the "rhythm of contrasts and of oppositions" of the African sculpture he had studied. The moral, for Senghor, is the main tenet of the Negritude movement, according to which Africans must learn from the West but remain faithful to their natively superior intuition, emotion, harmony, and vitality. Art may be assimilated from elsewhere, he taught, but "there is no original spirit without rootedness in the originary earth, without fidelity to one's ethnicity," not, Senghor qualifies, to one's "race" but to one's national culture.[215]

Because of the great importance that Senghor attributed to art, after he became president, the government bought and displayed Senegalese artists' works in its offices and its embassies, where they served to illustrate the country's pride and modernity. The government also set up an institute to do ethnographical art research; a museum, the Musée Dynamique, featuring contemporary art; and a national art gallery. The central art school, located in Dakar, the École Nationale des Beaux Arts, for the most part followed the model of French academies of art, though African art history was also taught.[216]*

The good fortune of Senegalese artists ended abruptly when Senghor resigned as president. The new government, embattled, showed itself to be socially more liberal but unwilling to pay more than lip service to the arts. Under Senghor,

*Almost all of the artists of the School of Dakar studied in this institution and were, by the definition I have given, modern artists. But I would not call them international artists and would now and then find it hard to distinguish between some of the workshop art and their generally more formal art. This is because the enthusiasm that followed on the independence of Senegal and the prestige and more or less official status of Negritude led these artists to draw their images from what was or what they took to be the native tradition, that is, from masks, mythology, folktales, and ritual, as well as from rural or urban life. Although individual, most of the artists shaped their images in a semiabstract, decorative style. When considered as a group, a historian remarks, the works of the School of Dakar formed "an idealized inventory of the nation's heritage, partially reworked in the modernizing language of paint on canvas."

artists had been able to get state-supported studios and living quarters in the so-called Village of the Arts, but in 1983 they were expelled from their village. The police unceremoniously heaped up their paintings, sculptures, and other possessions on the street. "The site was then turned over to the ascendant ministries for technical administration, water supply, and tourism."[217] The relation of Senegalese artists to their world had all at once changed from financially rather easy to very difficult, and ideologically from fixed to confusingly free.

To judge by the official positions they were given, the most influential artists in Senegal, at least during Senghor's first years as president, were Papa Ibra Tall (b. 1935) and Iba Ndiaye (b. 1928). Both men had lived in France and had acquired a French art education, and both were invited by Senghor to head departments in the École des Arts du Senegal in Dakar, which was to become the École Nationale des Beaux Arts. Tall set up a tapestry workshop in his department that was later moved to another location, where it became a center for the production of large-scale tapestries. He was assisted there by the Frenchman Pierre Lods, an "essentialist" in his understanding of African art. His philosophy favored students without formal education, and he encouraged the use of media like gouache because its colors recalled traditional African pigments.[218*]

Iba Ndiaye's ability and integrity move me to single him out. He was born in Senegal in 1928 in the port town of Saint Louis of a Muslim father and Catholic mother. At the age of fifteen he was employed to paint posters advertising the films in the town's two cinemas, one that showed French films and the other American. The painting of these posters, for which he had to copy movie stills, was what first interested him, as his later paintings also show, in ways of representing objects in motion. While studying architecture in France, he traveled widely and discovered the great museums of Europe. Sketchbook in hand, he learned the art he saw by drawing it. During a time when he thought of becoming a sculptor, he became aware of the importance of apprenticeship in techniques that every artist must undertake, even if by himself—in painting, Ndiaye regards himself as self-taught. Always mutable and curious, he testifies that painting was for him a way of discovering what others had done so that he could

* Senghor had heard of Lods's art workshop in Brazzaville, Congo, and had invited him to help Tall in teaching the Senegalese how to create an essentially African art. Congo having become independent, the subventions for the Brazzaville workshop had run out, and Lods accepted Senghor's invitation. He would have found it hard in Dakar to prefer students without schooling, and his approach proved quite different from that of Tall, an academic, and the opposite of that of Ndiaye.

understand the language of the craft he had taken up. Strange as it may sound, Ndiaye, who had come into contact with his ancestral heritage by stories and fables he heard in the evenings, first discovered African sculpture in the museums of Europe.[219]

When Senegal became independent, Ndiaye eagerly accepted Senghor's invitation to come to Dakar. In Senegal, where he headed the sculptural arts section of the École des Arts, he created the first African course in African art history— there already was one at Ghent University—and began his own small collection of African art.[220] But he was skeptical of the ideology of Negritude and was in principle opposed to art that was no more than superficial folklore or the product of Pierre Lods's kind of faith in untutored primal Africanness.[221] As he later commented, in Senegal he was a functionary, unable to continue his apprenticeship in art. "I chose," he said, "to stop being one and become wholly a painter, to be free."

In practice, for Ndiaye to be free meant going back to France. Now, at home in France, he wants above all to be in his atelier working on a picture. "This is my secret garden," he says, "my breathing." His paintings organize themselves in series. One such series represents a ritual he remembers from his early life—the sacrifice of the lamb to end the Muslim fast of Ramadan. It seems likely that Ndiaye sees this sacrifice as a symbol of the cruelty that Africans have undergone. The paintings called *The Cry of a Continent* express that suffering openly, and paintings in *Rhamb,* meaning, "the spirits of the ancestors," symbolize beliefs that in Africa are profound and inescapable. Ndiaye's interest in jazz, which he came to love as a student in Paris, is expressed in two series, *Jazz and Blues* and *Jazz in Manhattan.*

Ndiaye, who is a free figurative painter, acknowledges his debt to many of the European artists, among them Poussin, Velasquez, Ingres, and Picasso. When his figures stand out from the transparent-seeming darkness, one sees the Rembrandt in him, and when they are fantastic-cruel, one sees the Goya. But despite his many debts, Ndiaye says, "I am not a follower, I cannot be defined, I paint as I understand, I am myself, with no label!" As for Africanness, he contends that he, like every African, carries it within himself, and the certainty with which he knows that he is African makes it impossible for it to be a problem for him. If an artist is African and wants to explain himself "in a universal visual language," it is not enough for him "to proclaim his African nature, to declare himself attached to African values." It is in the practice of painting, sculpture, engraving that "artists fashion their uniqueness."[222]

Ndiaye's response to African sculpture is in keeping with this view. He judges

the work in universal visual terms, that is, in terms of its visual structures. When an African sculpture pleases him, for instance, he praises it first (though not exclusively) for the great number of the forms that it inscribes in space and volume, which encompass "all the possibilities of additions and collage"; or for the purity of its form; or for the simplicity that comes "from the separation of the forms in the treatment of the volumes" that make one want to know it by caressing it; or for the composition of the forms that construct a mask that screams like an unbearable strangled cry.[223]

The Nigerian sculptor and painter Ben Enwonwu (Odinigwe Benedict Chukwukadibia Enwonwu, 1921–94) also may be counted among pioneering African artists with an academic training.[224] An Igbo, whose mother was a well-off landowner and merchant and whose father was a traditional sculptor, Enwonwu was among the five young men chosen to inaugurate the formal teaching of art in Nigeria. A successful exhibition won him a scholarship, which brought him in 1944 to Ruskin College in Oxford, and from 1946 to 1948 to the Slade School of Fine Arts of the University of London.[225] After he received his master's degree, the colonial government in Nigeria appointed him art supervisor, a prestigious position that made him the official artist of Nigeria.

In 1956, Enwonwu proposed to the colonial secretary that he make a bronze bust and a bronze full-length portrait of Queen Elizabeth II. The portrait statue, designed to commemorate the queen's visit to Nigeria that year, was destined for the Nigerian House of Representatives after the impending self-rule of Nigeria had come into effect. Enwonwu's offer was weighed and accepted by the queen. She sat for him for an hour a day at Buckingham Palace, and when it proved inconvenient to transport her clay bust to the palace and to work there on the clay sketch of her full-length statue, the queen agreed to sit for him at his studio in Hampstead. The palace officials at first tried to keep the news of the queen's twice-weekly visits to Enwonwu's studio a secret. After the clay models were finished, plaster molds were made, and the pieces were cast in London by an Italian bronze caster. One bust went to the queen's collection, and another bust and the full-length bronze statue were sent to Nigeria. In 1957, before it was sent, the full-length statue was exhibited at the annual Royal Society exhibition in the Royal British Artists galleries, to which the queen came to observe her image (in one account it is said that what the queen observed was, incongruously, not the bronze statue but a painted epoxy copy). The full-length statue, with its realistic head and figure and expansive ceremonial skirt, was acknowledged by the queen and acclaimed, though not without arousing a significant controversy because

the lips seemed relatively full and a critic claimed that the features made an indefinably Negroid impression.[226]

This merely factual recital reveals the social victory won by a black Nigerian artist who, in his English environment, was taken to be a marvel of adaptation to sophisticated artistic norms. The news of the queen's visits to Enwonwu's studio made the blacks of London proud, and "served as an inspiration to younger African artists both within and outside Britain."[227] This social triumph, which shows something of Enwonwu's energy and ambition, gives little indication of his persisting dissatisfaction, even disaffection. He had always been an open anticolonialist, but his recent success opened him to accusations of political subservience to the oppressor and aesthetic subservience to the oppressor's standards. Enwonwu himself writes that the European interpretation of African art is very remote from the African interpretation and little of it is valid, but because the art traditions of politically suppressed peoples tend to die out and leave an artistic vacuum, "the preservation and continuity of the characteristic qualities of African art depends largely on how the modern African artists can borrow the techniques of the West without copying European art."[228] As the philosophy of Negritude makes clear, he says, the African spirit and mind has the capacity "to identify self with object" and preserve the vital force, or *nka*.[229]

Nka is an Igbo concept, which Enwonwu must have learned from his father. In translation it is "creative skill," "creative talent," or "artistry." Not unlike the modern Western artist, the Igbo artist is expected to discover new forms and enrich the old. Traditionally, this is largely a matter of sculptural elaboration or complexity.[230] Enwonwu says that *nka* relates to professional competence as handed down from generation to generation and has both traditional and religious associations, and he has recommended collecting African words with the same meaning, in order to create a neo-African concept of art in general and of new art in particular.[231] He in fact has used a Symbolist-like style to represent African dancers and Igbo spirits, imagined, dreamed, and even hallucinated—in 1994, lying on a hospital bed, he hallucinated Ogolo, one of the stealthy runner spirits that are beautiful to look at and dangerous to meet and, for him, impossible to forget in either reality or art.[232]

In 1987 Enwonwu became the *okpala,* the priest-elder, of his extended family. When the Negritude movement ended, he said in later life, his style changed, he incorporated masks and dances more into his art, and he went back to his roots and the time when with his father he saw carved images and masks that were more than works of art.[233] Given his return to his Igbo roots, it seems to me

ironic that of his work I have seen in reproduction, the only moving sculpture is the relatively realistic *Resurrection of Christ* he made in 1956. He was capable of more, I suspect, than he achieved.

. . .

I come to the last of my African examples, this time chosen from among the popular artists of Africa. Beginning as sign-painters or the like, taught by no one but themselves, their competitors, and their local urban public, their art lives only in the immediate present.[234] Like the newspapers, they take their subjects from the events of the day. This group includes artists like the Ivory Coast sculptors Emile Guebehi and Nicholas Damas, who make realistic, full-size wooden statues of dramatic local events; and the Nigerian Sunday Jack Akpan, originally a mason, who makes life-size realistic portraits, many of them funerary portraits, of molded cement. Also among this band is the Ghanaian Kane Kwei (1924–91), a cabinetmaker whose imaginative coffins for well-off clients dignified and celebrated their intended occupants with the shapes of eagles, fishes, elephants, onions, cocoa pods, boats, outboard motors, houses, and automobiles. (Kwei also sold smaller coffins to people who preferred to collect rather than be buried in them.)[235]

Chéri Samba, a painter from the Democratic Republic of Congo, has had the most international success.[236] Like the other self-taught artists, he has made his paintings for the literate but not intellectual middle-class city dwellers. Such art—which usually displays a simplified photographic realism and takes a Western lifestyle as its model—has come to be bought by Kinshasa intellectuals too, if only because nothing succeeds like success. Among the less recognized painters, those who do not sell a painting or so a day may not have enough money to buy materials for more paintings. The paintings ordered are often variants made from memory of earlier pictures, though the better-known painters may have an album of photographs of their recent work to order from. The taste of tourists and of the occasional foreign patron is also important to the painters, because without them even a painter who also paints signs may not make enough to live on.[237]

David Samba or, to give him the professional name he took in 1979, Chéri Samba, was born in a village in Lower Zaire in 1956.[238] He was given the name "Samba," a word that refers to praying, in memory of a paternal uncle who was a sculptor. In 1972, as the result of a presidential decree outlawing Christian first names, he acquired the "authentic" name Samba Son of Mbimba, Samba wa Mbimaba N'Zinga Nurisami. His father was a blacksmith—a profession asso-

ciated with chiefdom—and had technical ability great enough, as Samba points out, to repair guns.

Samba's father didn't like to see him drawing, but Samba was so attracted to the activity that when he had no paper and crayons, he would draw on the ground. His talent was recognized in primary school, where he would be asked to draw on the blackboard so the others could copy from him. In high school he would draw comics in his notebook and sell them to fellow students. Already he was dreaming of being a great, wealthy artist. In 1972, he went to the capital, Kinshasa, where he lived first with a stingy aunt and then with a poor but less stingy uncle. One day, he saw a "help wanted" notice on a sign painter's door and applied for the job of assistant drawer, claiming that he had all the necessary experience. He moved on to a second sign painter, who tested his ability to letter and to copy in pencil an enlarged identity photograph. Then Samba went back to his first employer and after eight months got a more responsible job, receiving clients as well. Fifteen months later, in October 1975, Samba set up his own workshop on the important Kasu-Vabhu Avenue. Paintings made by him alone, without the help of apprentices, were signed "Chéri Samba"—Chéri, he recalls, because all his many girl friends called him *chéri,* "dear." In the 1980s, after he had become successful, he demonstrated his pride by using a seal with the words "Chéri Samba, popular painter of Zaire, master in artistic works." If we are to judge by his growing success and wealth, at first Kinshasans and then the outside world accepted his assessment of his own work.

From the first, Samba knew how to attract attention. As he recalled in 1990, he hung his first painting "drawn from imagination," *The Rebellion,* in the mango tree near his workshop, with the result that Kasu-Vabhu Avenue was so jammed with curious spectators that vehicles couldn't get through.[239] At first, during the 1970s, he says, only blacks bought his work, but his fame spread, and since 1982, when his work was exhibited in Paris, most of his sales have been outside his country. The Paris exhibition of 1989, called *Magicians of the Earth,* consolidated his international reputation.

Samba remains buoyantly self-conscious, autobiographical, and always ready to exhort. He writes simple, humorous, often self-referential comments on his canvases in French, in one of two local African languages, and occasionally in English. Everything that could be allowably said in Zaire was said by him, to the pleasure of spectators standing outside of his shop and the possible displeasure of the police. He writes, "I paint for everyone. Obviously, I can't put all the languages of the world in my paintings. Otherwise, I would put them all in, if I

knew them. . . . I don't always paint for Africans only. But I can inspire myself from Africa when the same story can concern Europeans."[240]

Sometimes the words that Samba's figures speak leave their mouths like the blurbs of the comic strips he used to draw as a student. Samba considers the extensive use of writing on his pictures as their most original feature and believes, plausibly enough, that the texts keep spectators looking at his pictures longer and more carefully. The texts, Samba says, also limit the spectators' freedom of interpretation. He says, "For me, my work is incomplete if there aren't any texts."[241] He wants to be the showman-artist-moralist: "I really like showing what shocks people. I know that people don't like to tell the truth all the time, but what people don't like to say is exactly what drives me to paint." But his words, he says, and the images they accompany may have different implications, because "what we can see in the painting isn't always of the same nature as, and can even sometimes contradict, what is said and written."[242]

Samba, who was unhappy with the government's ban on erotic pictures, circumvented it by painting, for example, a seductive blond-haired mermaid (a popular, if scandalous version of the traditional "Mother Water"), whose features and body must have been copied from a Western magazine. Above, in the clouds, he himself flies, supported by an angel, his eyes looking straight ahead, the corners of his lips pulled sternly down, and a Bible under his arm. In the picture's title, *The Seduction and Fidelity to the Bible,* the word "fidelity" appears in much smaller letters than the rest.[243]

In another picture, *Why Have I Signed a Contract?* Samba shows himself well-dressed and prosperous looking but being choked by a rope, one end of which is close to signs that question whether he is an artist and the other end close to signs that question whether he is a journalist and ask why he accepted a contract. Blurbs assure spectators that he has not been duped and that his manager, who is one of his critics, has given him faith in his work. When the contract ends, whatever happens, he will remain Chéri Samba. On the floor in the painting there lie pages left by friends. On one page, a friend tells him that it is best for him to work for his clients without any rest, while on another page a friend says that there is a danger that he will inundate the market with his pictures, which will lose their value. Each friend gets the same answer, with the artist's signature, "I do not want to work like a horse." The occasion for this picture was the signing of an exclusive contract, offered following Samba's success at the *Magicians of the Earth* exhibition, with the Jean-Marc Patras Gallery in Paris.[244]

By 2001, Samba was living and working in Kinshasa, Brazzaville, and Paris. His later painting, richer in themes and more assured in technique, explores and

comments on the world outside, on the Paris, for instance, that he was discovering. In his later work, he joins his memories of Kinshasa with his experience of Europe and the United States and the influence of their mass media. I like the admiring assessment in which he is described as managing "to be original and commonplace at the same time," as standing apart from his community and yet remaining the perfect Kinshasan, a moralist who cannot escape his own human weaknesses—he is the person in his pictures who gives in to temptation—who remains the same Kinshasan at heart while seeing the world and taking advantage of the chances for success it has given him.[245] Having taken advantage of the chances, Samba is a Kinshasan who is ready to put himself on equal terms with any contemporary. This he does explicitly in a triptych, on the first panel of which, *What Future for Our Art? (Quel avenir pour notre art?)*, he paints a picture of Picasso behind which are Samba and the African masks that inspired Picasso. On the second panel, he paints himself going along with Picasso to the Pompidou Center, and on the third, where he calls himself a pop artist, he shows that Picasso has got in and he has been excluded, and he asks with a trio of question marks, "Isn't this museum of modern art racist???" But Samba is not bitter. His views on contemporary artists, so far as I know them, are generous: he likes all art, he says in conversation, even the works that can be understood only on reflection or only with their authors' explanations. "I like all works of art, all that my colleagues do interests me."[246]

Chéri Samba and others like him have painted in accord with two implicit rules, the first, to give pleasure, visual and emotional, and the second, to tell as much as they dare of the social and political truth. "Working under the restrictions of the Second Republic [which collapsed in 1990]," he and the others "created an idiom in which moralizing, eroticism, and politics were so mixed that one spoke for the other. In this game of fine substitutions, everyone seemed aware of what was meant, though it could not be verbalized without great risk."[247]

. . .

In ancient China, the practice of using art as a vehicle for social criticism, however well hidden, frequently made artists subjects of suspicion in the government's eyes. This has been no less true under oppressive regimes in Africa, whether we speak of the exile of Nigerian writers and artists or the arts in South Africa.[248] In South Africa, moreover, the lingering effects of apartheid continued at least into the late twentieth century to cripple the work of black artists. We can refer to the complaint, for instance, of the South African painter and curator David Koloane, who says that black artists in his country receive no formal training and no encouragement, and use art only as a means of subsistence: "The art

market is entirely white controlled, its components, art historian, critic, collector, viewer, restorer, archivist are also white." Accordingly, the visual arts "are often perceived as elitist and a specialist undertaking because they are associated with power and affluence."[249]

African artists who live and practice in the United States and England have an opposite complaint, that the doors of galleries and museums are shut to them because their art is not "primitive" or exotic as African art is expected to be. Olu Oguibe, the Nigerian-born artist and art historian—a poet whose memories of the Biafra war are very moving—writes that the art establishment of the West keeps non-Western artists at bay by making "otherness" a requirement. Curators, dealers, and university art historians seem to feel "that it would be an anomaly to accept such an artist wholly and unconditionally, as part of the mainstream of contemporary art."[250]

Nkiru Nzegwu, another Nigerian artist (and critic, curator, art historian, and poet) who lives and teaches in the United States, holds that the image of modern African art is only a stereotype represented "by people like Chéri Samba, Sunday Akpan, Kane Kwei—the Ghanaian carpenter who produces pineapple, Mercedes Benz, and rooster coffins, and Middle Art, creator of barbershop signs and patent medicine seller signs. Add to this mix the works of Oshogbo school." If an African artist does not fit this stereotype "then his or her works are . . . portrayed as weak copies of European or white American art," even though the historical truth is that "modern art is a provincial extension of African art."[251]

Tony Mahonda, an artist, critic, and curator who lives and works in Zimbabwe, objects that for Africans to accept the point of view of Western art criticism is in itself to reinforce the sense of otherness and to agree that Africans have to find their own identity. But our African identity, he says, is already there, so what we Africans need is "to address matters from our own local point of view" and create an institution liberal enough for intuitive and academic art to "live side by side without there being any problem."[252]

George Shire, a Zimbabwean now teaching English media and cultural studies in London, argues that there is no "authentic African critical language" and objects to an aesthetic based on the conception of a nation state. Yet he regards himself as an invention of the Negritude of his father's generation and realizes "the importance of an art criticism that unfreezes Africa from the past into the present and offers a future where African art is not a sin."[253]

The only African I have read who, despite African politics, poverty, and inadequate criticism, sounds a generally positive note, is Chinewe Uwatse. When

asked how it is to practice art in Nigeria, she answers that it is quite interesting because she has so many subjects to paint. "You get a lot of inspiration around you," she says. "And you find out that surprisingly, Nigerians do appreciate very good art. I know from the paintings, the people that buy them, they cut across all walks of life." Uwatse cannot refrain from adding that in art the Africans, from whom Picasso learned how to paint in his cubist style, have set the pace and come first. "Where did the whiteman learn installations? What are our shrines? What is Mbari house if it is not installation? What are the bases of our shrines if they are not installations?"[254]

The strongest plea for flexible, tolerant criticism is made by the Nigerian Chika Okeke, an artist who lectures at the University of Nigeria. His plea is made in the name of Olu Oguibe's "masquerade theory" for African art, a variant of the Igbo view expressed in the proverb according to which if you stay in one place you cannot understand the world because the world is a dancing masquerade. Applied to art, Oguibe's and Okeke's analogy is that art is performed in space and time, so that, like the masquerade of life, it "cannot be experienced through a monocular frame or singular mode of interpretation. Nor can it be adequately boxed into tailor-made conceptual packages." Okeke can "see no boundaries or conceptual territories separated by personalities, subject matter, geographies." To him, "the art from Oshogbo, Nsukka, Ife or Lagos becomes part of the multiplicity of frames through which art becomes manifest." Okeke feels obliged to go beyond the categorization that eventually leads "to hierarchies and grand gestures or to either/or attitudes in art critical discourses. Consequently," he writes, "the art critic needs to be able to change his tools of methods or language to suit either the given artistic phenomenon or the medium of expression he or she is addressing."[255]

. . .

Having reached the end of my description of the modern art of the Papua New Guineans, Inuit, Aboriginals, and Africans, I want to reflect on what we may learn from them as a group of peoples whose art is related by an ambivalent independence to the larger world on whose good opinion they have relied to survive with honor or survive at all. Surely, a basic lesson is that the art of all these peoples has been congregating into a vaguely single world of artistic discourse. The unique characteristics of the art of each people has made it interesting to the environing world, whose need for artistic novelty it has served and been more or less rewarded for. In each of the different peoples surveyed there has been a similar contest between pride in local or traditional values and in the ability to

arouse interest in the world at large and join it, if possible, on equal terms. I suspect that this contest, which I think of as a complicated parallel to that between different individuals, cannot be finally resolved.

Another, also very general lesson is that the ability to create original and even extraordinary art is widespread among humans everywhere. They are of course not equal to begin with or equal in the end. A number of times we have met someone with a natural passion for drawing or someone who, on seeing an example of a new kind of art, is immediately ready to say, "I can do it," or "we can do it too." Kauage (implicitly), Allingam (I assume), Oshaweetok, Namatjira, Onabolu, Mukomberanwa, Enwonwu, and Samba seem all to have begun with a conviction of ability and a natural passion for visual art, while Twins Seven-Seven has a passion for music and acting as well. Allingam, Namatjira, Onus, Onabolu, Ndiaye, and Enwonwu made the transition to the style of Western art in their own lifetimes, and, among them, Allingam, Onus, Ndiaye, and Enwonwu made that transition—without losing their devotion to the culture in which they were born—not only to the style of Western painting but, in varying measure, to its substance, that is, to a more than superficial grasp of its nature. Among the various artists I have described, some were notable mainly for daring to begin, and so proving to the prejudices of Western eyes that they and their people were fully human. In any case, although I do not want to rank the artists on a scale of ability, there is no doubt in my mind that almost all have created art that is characterful, and some, that is powerful as well.

What is most striking is that, given encouraging advisers, institutional support, and economic benefits, some of the Papuans, a large proportion of the Inuit and Aboriginals, and a large number of Africans proved able to create interesting, original art. They began with their respective experience in decoration, whether snow-drawing, appliqué, earth-drawing, traditional sculpture, body-painting, or masquerade art, but turned to previously unused media and tools, to paper and printing, canvas and acrylics and oils, and chisels, and succeeded well enough to live wholly or largely by creating art that is the work of distinct individuals who happen to be Papua New Guinean, Inuit, Aboriginal, or African. This is evidence that the desire and ability to create art shown by so many young children remain potentially alive in many adults.

It is also striking to see that the morale, the pride in tradition, and the interest in involving children in art making and in leaving them an artistic and financial legacy is common among the Inuit and the rural Aboriginals, who have a strong sense of collective responsibility. Papuans and Africans, too, are likely to have a sense of such responsibility for their extended families. But in Africa, except

in Senegal for a time, there was no equivalent to the (often insufficient) institutional support that two repentant governments, those of Canada and of Australia, gave to their native peoples. Inuit and Aboriginal artists have been usually more concerned to satisfy their clients than to express their most inward feelings or arrive at a new or newly moving vision of reality. They are not introverts or romantics. By the circumstances into which life has thrust them, the only ones likely to incorporate strong social criticism in their art are the urban Aboriginals and the African artists who are free of harsh censorship. Their lives seem to call for a war-terror art equivalent to that of an Otto Dix or to the satirical hatred of a George Grosz, but I have not seen it, although Ndiaye at his most fierce reminds me of Goya.

Everywhere, we have seen, there were non-native agents of change. Because they were so important in initiating change, I have described what kind of people they were and said or implied what satisfaction they too derived from their encouragement of local artists—Ulli Beier says that it was in Nigeria, that is, in his relationship with Nigerians, that he found his own identity. Some of the agents of change were missionaries playing their role of helping "natives" and in this way giving them faith in Christianity. But some of the agents came to exercise their transformative function as a matter of chance and to continue it out of the satisfaction of revealing what they took to be the innate creativity of the people they were helping to express themselves. This was the case for Ulli and Georgina Beier in Papua New Guinea and in Nigeria, where Susanne Wenger deployed her faith in both creativity and the Yoruba religion, as they did theirs in creativity alone. For the Inuit, James Houston played the hero's role, while for the even worse-off Aboriginals, the champion was Geoff Bardon. For Zimbabwe, the agent I have described was Frank McEwen, and for Congo and Senegal, Pierre Lods. The Beiers, who were concerned with the whole Third World, worked in Australia as well.

These agents of change brought with them or acquired helpful foreign techniques and materials. When James Houston brought Western printmaking to the Inuit and, afterward, printing techniques and paper from Japan, when Brereton brought the Indonesian technique of printing batik from New York to the Aboriginals and others introduced silk for the purpose, and when Bardon introduced the Aboriginals to acrylic paints, there was a relatively quick and, for the imagination, eyes, and hands, a not at all trivial penetration of materials and techniques from world to world. A potent example is the brightening of colors and the enlargement of their range that was made possible by oil paints and acrylics. The colors and surfaces used by Papua New Guineans, Inuit, and most

Aboriginals and Africans are now the same, so the world of art is to that extent unified. This is the more true when we realize that so much of the art they create is art in the modern Western sense of the word, art made because it gives pleasure, and because it helps to make a living, and, it is hoped, because it makes the artist well known to the world.

Behind the work of the agents and often of the artists there were points of view that might be called their philosophies. The educational ideals of Henri Focillon and Gustav Moreau, the psychological formulations of Carl Jung, the examples, maybe, of the Viennese magical realists and Klee, and the attitudes toward art of Picasso and Moore all played a role in Africa. Some of the agents who encouraged artists to draw from the resources of their own lives and traditions appear to have been thinking in a Jungian vein. Besides, the opposition to the giving of formal training or European examples could only have been nourished by the view, already widely adopted by European artists, that an academic education in art was more likely to be a liability than a help—a view increasingly reflected in higher art education, which deemphasized traditional academic practices and turned more adventurous and intellectual, often valorizing the uninhibited directness of children's art and "primitive" art. Why, then, should a European mentor of African artists teach them what so many European artists no longer accepted?

However, there was and remains the competition between workshop artists, so called, and self-educated, popular artists, and between both of these groups and academically trained artists. This competition is acute only for the Africans, but it is also visible in the contrasts between the art of rural and urban Aboriginals, even though urban Aboriginals refer to or use motifs of rural art and regard their protests as made on behalf of all Aboriginals. As the opinions of African artists and critics have shown, divisions among African artists spring from African pride or, more exactly, from the academic artists' pride in their credibility as knowledgeable and creative Africans, or as knowledgeable, creative citizens of one or another African state. Senghor's own ideal of Negritude favored academic competence in art but was inconsistent or broad enough to accept the antagonism to academic art training of Pierre Lods. It is easy to understand why a well-educated Nigerian would not want to be identified with an Africa defined by the art of Twins Seven-Seven or Chéri Samba. I assume that it would not satisfy the academically trained African artists to explain that unless an African who paints in the current Western fashion is overwhelmingly attractive or powerful, the Western critic or collector will probably prefer the work of Twins Seven-Seven and Chéri Samba because they stand out so clearly on the back-

ground of contemporary Western art. They stand out, of course, because they have an unmitigated directness, because they are fresh, colorful, and devoid of theoretical pretensions and explanations, and because the one is a natural kind of surrealistic artist and the second a natural kind of pop artist. The art of the first fascinates like a strange dream, humorous and ominous at once, and of the second, pleases and interests like a colorful street scene complete with conversational, reaction-provoking commentary.

I have not commented directly on the overwhelming importance to these (as to all) artists of the web of identifications in which they are situated—with what or with whom they identify themselves most deeply, and how their identities in their own eyes affect them and their art. Because I, like possibly you, cannot place myself with them, I cannot speak in their name. However, being myself, I think that if I were, say, an African, I would choose one of two positions I have spoken of, the self-confident, universalizing vision of Ndiaye or the accepting, tolerant perspective of Chika Okeke, which he rests on a masquerade theory for African art but is willing to extend to art in general. Chéri Samba seems to be and Muraina Oyelami surely is on the same actively tolerant side. But long live the differences!

THE COMMON UNIVERSE OF
AESTHETIC DISCOURSE

HUMAN PERCEPTUAL AND EMOTIONAL RESPONSES

The world's art is so immeasurable that we incline to accept it, like nature, as simply, ineluctably there. Like figures in a Chinese painting, we move among the artworks as if on the path that winds over the mountains' tree-dotted flanks, wondering at the incessantly changing view and accepting everything as it is because, astonishingly, it is already there and could hardly have been otherwise. So it can seem futile to hope to go beyond the immediate view to learn some hidden, enlightening truth or feel some emotion other or better than has come by itself. We accept the human reactions we find as we accept the wrinkles of the mountains and ascribe them to the effect of our inescapable master, time. Or we ascribe the reactions to such natural phenomena as curators, dealers, and critics, whose function it is to make distinctions between the more and less interesting. Or we agree that we are dominated by such cultural phenomena as postmodernism or post-postmodernism, which know no rhyme or reason to favor any artwork or aesthetic principle over any other. Yet it is a mistake to surrender ourselves so and forget that, as individuals, we do in fact make choices. We make them even if, for reasons of which we are not aware, we learn from experience, develop our critical capacities, distinguish between reliable and unreliable infor-

mation, distinguish between clear and confused thought, exchange opinions, and make an effort to persuade one another. Being social, we share the belief in a tacit underlying consensus or hope of consensus. Every particular view is disputable, but if we take one another at all seriously, we find ourselves in a common universe of discourse. That is, we affect and learn from one another, our interest in one another changes us, and we become more similar and more human.

I have been relying on our hope of consensus to persuade you that a relatively objective understanding of the nature and potentialities of art is possible. But I want to go a perhaps quixotic step further and persuade you that the judgments we make of art can and should be, not objective, because this is impossible, but *relatively* objective, that is, when of enough importance to us, based on careful scrutiny, an adequate grasp of context, and thought as clear as we can make it.

Of the many possible beginnings of my attempt to persuade, I choose a summary of human traits essential for aesthetic experience. It seems immediately apparent (though to the neurologist rather than the anthropologist) that sensations, perceptions, and basic aesthetic preferences are roughly alike among all human beings; that basic human emotions, however altered by social habit, are much alike; and that different cultures invent similar modes of response for the purposes they all have in common. The following enumeration of reasons could easily be developed but is enough for its present purpose:

1. The very ability of the brain to construct three-dimensional objects from the two-dimensional forms on the retina and to recognize these forms as the objects that they are is a universal human ability, based on the nature of the visual system that human beings (and many other creatures) share.[1]

2. Without referring to the detailed workings of this system, it is easy to conclude that, whatever their cultural variations, humans all perceive, respond to, and live in accord with the differences between high and low, top and bottom, left and right, the directions in which the sun rises and sets, and so on. So, too, they all perceive, respond to, and make use of symmetry and balance, and of geometrical shapes such as the square, oblong, triangle, circle, oval, and spiral, which exemplify symmetry and balance and invite the effects that come from their reiteration or contrast, their motion or stillness, their complication, and their disturbance.

3. Similarly, whatever their cultural variations, humans all perceive, respond to, and make use of rhythms, whether seen, heard, or felt. In rhythms, too, the effects of symmetry and balance, of motion and stillness, of contrast and sameness, are simplified or complicated, and disturbed and restored.

4. They also all perceive, respond to, and make use of the shapes, widths,

and other characteristics of lines and planes—their straightness, crookedness, sharpness, jaggedness, curvature, wandering, relative and absolute size, and so on. Three-dimensional objects also evoke similar uses of and responses to their different kinds of bulk.

5. Humans universally perceive, respond to, and make use of the textures of things—their roughness, raggedness, prickliness, stickiness, wrinkling, smoothness, softness, hardness, and so on. Whatever the use or interpretation of these textures, they are perceived in much the same way and recall objects with similar textures and the experiences in which these textures play a part.

6. Likewise, the neurology of vision gives almost all humans the ability to see and react to different colors and color combinations. These responses include the differences between dark and light colors, especially black and white, between saturated and unsaturated colors, between colors that are graduated (as from light to dark) and ungraduated, between colors that are graded into other colors and into ungraded colors, and between colors that are complementary.

7. The most salient colors are black, white, and red. Although there are great cultural differences among the colors that are recognized by being given explicit names, these colors tend to be chosen from among a small basic group in a way that is explained by a controversial "evolutionary" scheme.[2] To go into the details of this scheme and the debate it has aroused would be too distracting here, but it can be contended within reason that the variations in different cultural areas among favored colors and color combinations can be more or less systematically understood in relation to one another.[3] Various emotional qualities are widely equated, though in different ways, with the various colors.

8. What is universal is often not the relation between a particular emotion and a particular color but the felt closeness between color as such and emotion as such.[4]

9. The constancy of color—its tendency to be perceived as the same in different light—is universal among humans.

10. In average or "normal" persons anywhere, the sensory or perceptual responses I have called universal are only roughly the same—every individual senses somewhat differently from every other. These responses are conditioned by experience, especially early experience when the brain is at its most plastic; but such conditioned experience is often the similar result of similar maturation.

11. The personal associations that the responses accumulate, however different in detail, are often variants of the universal, primary responses.[5] In other words, the responses based on the nature of human perception are subject to

different uses and interpretations, but these uses and interpretations are often similar. Their differences and similarities color one another, so to speak, and the differences, I argue, are not simply random. For instance, the association of blue with the sky, of brown with the earth, of green with plants, and of red with fire and blood, seems unavoidable (though an anthropologist gives a counterexample from the Lower Congo, where blood, she says, is not at all associated with red).[6] White can be an indication of purity and innocence, or of mourning, or of much else, but the diametrical opposition of black and white (as well as the obvious contrast of both with red) seems to be unavoidable and must at many times and places have stimulated a symbolic polar response for the same perceptual reasons.[7]*

12. Analogously, the basic emotions are universally felt and are expressed everywhere in similar ways. Research shows this to be most likely true of fear, anger, sadness, disgust, happiness, and surprise, of their combinations, and of the varied wealth of their representations in art. The anthropologist C. A. Lutz makes the claim, now not uncommon in anthropology, that "emotional meaning is fundamentally structured by particular cultural systems and particular social and material environments." Her fieldwork taught her, she says, that "emotional experience is not pre-cultural but *preeminently* cultural."[8] That may be, I answer, but the study of the social complexity of emotional expression and its weaving into cultural meaning systems should not cause us to forget the common psychophysical basis. Diseases and reactions to them are also woven into cultural meaning systems, but this is not reason enough to neglect them as the objects of study by contemporary medicine. It is not insignificant that people born blind smile for the same reasons that sighted people do.

*It has been said, however, that there are non-European languages in which "black is assimilated to white." In his book *Blue: The History of a Color*, Michel Pastoureau goes so far as to claim, "Color is first and foremost a social phenomenon. There is no transcultural truth to color perception." He stresses the danger, especially to the art historian, of anachronism. "For centuries," he says, "black and white were considered to be completely separate from the other colors; the spectrum with its natural order or colors was unknown before the seventeenth century . . . and the contrast between warm and cool colors is a matter of convention and functions differently according to the period and society in question (in the Middle Ages, for example, blue was a warm color)." But while it is true that color symbolism has varied greatly, I am sure that Pastoureau goes too far and oversimplifies when he says, "human biology, and even nature are ultimately irrelevant to this process of ascribing meaning to color." As I outline in note 7, a different emphasis on the evidence, much of it literary, can leave a rather different impression.

13. The human face and figure have been of widespread importance in visual art—notwithstanding the Islamic tradition against representing humans, which has often been defied by Muslims, whether artists or those who commission them. As art in many places has shown, there is a strong natural tendency to be attracted to young, symmetrical, unblemished faces, and to young, strong, graceful, symmetrical bodies.

14. Lastly, art everywhere has served as an instrument of memories. The memories it serves are the usual social ones, the celebrations, rituals, and memorials that are needed to establish social identity. It also endlessly serves the memories of individuals. These, for all their differences, tend to be of the same general kinds, that is, memories of one's family and friends, of the stages of one's life, of one's work, travels, adventures, and so on.

· · ·

The types of perception, sensitivities, and responses I have just enumerated remain implicit in everything that we see or learn to see as art. They tend to exert their influence almost regardless of cultural differences and changes in fashion. It follows, as I see it, that the perceptual, emotional, and social overlap among cultures is very likely to reflect itself in an aesthetic overlap, immediate or potential. An imaginative outsider may therefore respond to art in a way not unlike that of a knowing insider.[9] There is more than enough evidence that receptive people from alien cultures can learn one another's principles and, if they are artists, can be influenced by learning them to become more complex or original. Understood as abstractions, the principles are easier to understand than to apply, because their application calls for a delicate balance with other principles, which in actual work always affect one another. For this reason their application is taught far better by example and imitation, that is, by something like apprenticeship, than by viewing alone or verbal explanation alone. But however taught or named, analogous principles are often followed in historically quite different cultures, so that Yoruba aesthetics, although applied in peculiarly Yoruba ways, coincide in their so-called ephebism with the ephebism of the ancient Greeks. Furthermore, the Yoruba principles, which have been clarified in some detail, are not alien to the modern West, so far as I can see, in even a single instance. Neither are the general principles of Chinese or Indian art.

Of course the application of Yoruba, Greek, Chinese, and Indian principles, for all their likeness, has led to very different results. These differences have been enough to create a long blindness, maybe especially among connoisseurs, to the values of any art but their own. For this blindness there were mitigating circumstances. The Chinese who disdained European paintings had not been shown

any that were very good by European standards, so that their possible intuitive sympathy was not aroused.[10] The Chinese also could see that, compared with their own brushwork, that of the Europeans whose paintings were available was lifeless. Yet there were also Chinese painters, we know, who were able to appreciate and assimilate something of what was to them the foreign expressiveness of European art; and there were a few European painters who were able to reciprocate by remaining open to the expressiveness of the Chinese art they saw.

The reaction of Picasso and his friends to African sculpture is instructive. To them, the sculpture was as anonymous culturally as it was personally. The cultural nakedness of the sculpture must have been part of its liberating effect, which could be exerted in the context of European art as if it were there that the sculpture should naturally belong. Before African sculpture had been studied, how could a European have known that the image of an Asante man with both hands on his stomach is meant to show the humiliation that comes from having to take food from enemies?[11] How could an uninstructed European have known that the careful balance and exact position of the eyes of a Yoruba mask show that it is not a portrayal of anyone corrupt or criminal, or that a closed mouth means composure and bared teeth mean impudence—except if the teeth are the two beautifully sharpened ones that are the sign and symbol of beauty?[12]

By local African standards, the sculptures that aroused the enthusiasm of Picasso and his friends may or may not have been good. There are many ways in which an African sculptor can weaken his art in African eyes. The sculptures that Picasso himself owned have been said by a critic to have been, as African sculptures, mediocre or worse. Yet what the French artists saw in them was really there. The African masks, whether well or badly made by African standards, might have been as conservative in their own cultural terms as the European art that Picasso was revolting against. Yet there was a great contrast, which could be put to revolutionary use, between the African and European traditions, because the African showed a powerful aesthetic and psychological vitality in, for instance, its masks' un-European deviations from the look of an ordinary human face. Picasso saw the controlled, forceful geometrization of the mask cutter and, as he later confessed, the masks' "magic"—not the magical resonance of one African mask as compared with another, but of an African mask as compared with the faces usual in European art. Having a strong desire to renovate art, Picasso was taken with this sculpture that could show him how to cut away the softness of the volumes that characterized the art of his contemporaries. In response, he made planes as sharp with his space-cutting brush as the African sculptor with his woodcutting adze.

A person ignorant of Chinese, Japanese, or Korean art but sensitive to the trace of a brush's motions is able to sense something of brush-mastery even in a painting that is poor by Chinese, Japanese, or Korean standards, because the Westerner's response is relative to the usually simple brushwork of the Western tradition. The basic types of sensitivity to the general values or skills displayed in art neither start nor stop at a cultural borderline. Certainly, a non-Chinese artist sensitive to the rhythmical interrelations of the movement of fingers, arm, brush, and mind can find inspiration in the rhythms inherent in Chinese brushwork.

Out of context, I maintain, a work of art loses the subtlety and depth of intimate acquaintance but can gain the strangeness that attracts or repels and that, whatever the loss or gain, keeps its proto- or pancultural expressiveness, rather as does the art of a young child.[13] Briefly, art everywhere has aesthetic values that are available to persons everywhere else. Once unfamiliar conventions have been identified as such, they can be either discounted in favor of the individuality shown in their use or, if we please, appreciated as variations on the art we are more familiar with.

If human beings resemble one another in such fundamental ways, and if we agree to accept an open aesthetics, and if we now have the resources to study the different traditions of art, and if these traditions have by now lost much of their once powerful hold, it seems possible for us to come closer than before to a wide-ranging aesthetic agreement with one another. Within limits, we can restore the contexts of the old traditions and the works of art that embody them, although we can do so only within the context of our own, present lives. This inevitable limitation makes it possible to recreate the many old contexts only within a single one, but one with an unprecedented range and depth of knowledge, all more readily communicated than could once be imagined. For an example of range, I hold in my hand a copy of the *International Herald Tribune* that reports an exhibition in the Capital Museum of Beijing, of classical Greek masterpieces of the fifth and fourth centuries BCE; in the Musée du Quai Branly of Paris, of women's pottery from rural Algeria and of repaired African objects (the visible repairs are said to attest to the importance of an object to an African individual or community); in the Tel Aviv Museum of Art, of Italian art of the early twentieth century; in the Bunkamura Museum of Tokyo, of Odilon Redon's black-and-white prints of the 1870s and 1880s; in the Seoul Museum of South Korea, of Monet's series of water lilies; in the Museo Tamayo of Contemporary Art of Mexico City, of paintings made in New York City between 1967 and 1975.

In principle, we are now limited not by the absence of the necessary instru-

ments of knowledge but by our native inclinations and prejudices, which can be modified or corrected, and by the shortness of our individual lives, which can be circumvented by our ability to transmit our ideas to others. Modified and circumvented, aesthetic pluralism, with its indeterminably many contexts and standards, is in practice encompassed within a more general world and subjected to the same opportunities, constraints, and standards as every other position. All kinds of difficulties arise, but we can face them more or less objectively with the help of accurate information and thoughtful comparison. Besides, we have come on enough evidence to show that a sensitive outsider can react perceptively to the aesthetic values of an alien culture, so that a spectator or artist may become, to his or her psychological benefit, doubly aware. As the extra language one learns after childhood is spoken with an accent, the art one sees outside of its natural, perhaps vanished, context is seen with always somewhat distorting eyes. Yet the experience of this foreignness may be to the good, as when it accentuates characteristics of the art that familiarity has made invisible to those who were born to it.

In addition, foreignness makes it easier to see how the art meets the standards of other traditions as well as its own, so one sees a work of art as it is in its native place and character and also as it reveals itself in relation to works of another tradition. As for standards, there is a set, quite explicit in Western and Chinese and Chinese-influenced art that can be accepted as general and even approximately universal. To the extent that this is true, when one affirms, for the sake of social decency, that every art tradition is the equal of every other (by virtue, at least, of its incommensurability), one may add (in a low voice) that it ought not to be heretical to favor one aesthetic tradition over another, especially for its richness or the qualities in which it excels. A mechanically tolerant pluralism blunts the desire to perceive sensitively. But there is no contradiction between the endless variety of aesthetic phenomena and the human universality that underlies it. The endless variety, which overlies and conceals the unity, is more helpful for the sensuous experience of art. But for understanding in the abstract sense, it is more helpful to become aware of how the endless variety makes up endlessly rich sets of variations on common human themes.

OLD AND NEW CRITERIA OF JUDGMENT

I take objectivity to be necessary for fairness and fairness to be a natural result of objectivity, so I will use the words as if they were more or less synonymous. Of the two words, "fairness" most needs clarification. It applies to the sense of reciprocity, to what, under given circumstances, it is acceptable or just to do, say,

require, demand, or decide. The difference between fairness and unfairness, like the difference between kindness and cruelty, has been felt, I am willing to guess, everywhere, even though there have always been individuals in whom it is absent or ineffective (like humans, other primates may help, feed, console, and befriend one another, and, in general, experience and expect reciprocity).[14]* Given the view taken here that there are common modes of appreciation and judgment, that is, general standards for art common to most humans, it should be possible to use them to judge works of art fairly, that is, to find persons who are informed, perceptive, open, unprejudiced, and objective enough to judge works of art in a way that other, like persons would concede to be relatively fair. I set aside the question of who would judge the judge of the judges—Chuang Tzu (Zhuangzi) has a more pessimistic and amusing answer than the one I give here; but even he says that it is possible to put oneself in others' positions and lend words the weight of experience (I recommend reading what he says about the winning of arguments in the second chapter of his book called by his name).[15]

Assuming, as I do, that complete objectivity or fairness is impossible, I begin by asking how art can be judged as competently, justly, fairly, or objectively as possible.[16]† Now judgment implies a choice based on the weighing of different

*A simple and widespread idea of fairness is that expressed in the different forms of the golden rule: "You should act toward others as you want them to act toward yourself." This rule seems based on the assumption that a person who acts in accord with it will find that other persons reciprocate. But the working out of the rule is immediately complicated by differences in status—for instance, of parents and children—so the rule has to be adapted for reciprocity in the sense of keeping to mutually understood expectations: "You should act and be treated in accord with your condition and status." This rule has been adapted to social hierarchies, like those of the Hindus and the Confucians, so that the fairness or equality appealed to is the perception of the just or impartial application of a mutually acceptable rule.

†There is a rich psychological literature spanning the past century that bears on the question of whether or not the judgment of art can be objective or, even if not, can be understood objectively. Drawing from this literature, cataloged in note 16, I find much to support my attempt to find a working definition of what that judgment might entail: (1) A comparison of the attitudes of persons academically concerned with those commercially concerned with art showed that the criteria for judging art of both groups were similar. This conclusion lends support to the view that the standards by which art is evaluated may be universal, that is, agreed to by judges with different backgrounds or no background in art. (2) Art judgment is significantly related both to personality traits and to measured intelligence. (3) Persons who are open and eager for experience prefer every form of art more than those who are more closed. The more abstract the art, the greater the degree of preference. (4) Paintings of different subject matter shown in different degrees of realism

possible responses, but judgments are preceded and affected by intuitive percep-
tual and emotional preferences. Judgment is therefore needed to supplement
and correct the preferences that precede it. As used here, "judgment" implies
the use of consciously formulated standards. Consciously formulated standards
usually need precedents, precedents need tradition, and precedents and tradition
need judges, who need special training to apply them acceptably.

Each kind of trained judge exercises a special mode of judgment. The func-
tion of the judge, referee, or umpire who officiates at a sporting event is to
ensure that every participant obeys the standard rules. If the judges of a rela-
tively uncomplicated sporting event, such as the hundred-meter sprint, do their
job well, and if the electronic clocks used are accurate and well synchronized and
no one is later identified as having used performance-enhancing drugs, there
is no doubt as to who the winners are: the criterion of winning, to run accord-
ing to the rules and come in first, is simple and beyond doubt. The teacher of
European (or Chinese, Japanese, or Korean) academic art is even today a judge
with a clearly defined idea of the rules of drawing, composition, coloring, and,
probably, of a hierarchy of subjects for painting and (in Europe) of sculpture.
Having certifiably mastered the rules of academic art and having taught it, this
judge is taken to be competent to decide how well a work of art demonstrates the
required skills. However, teachers or judges are now relatively rare and no longer
exert the institutional authority once granted academicians and academies of art.
Teachers of any of the other various surviving traditions of art are also likely to
lack the authority they once enjoyed because art is now usually conceived as a
means for expressing the artist's individuality and freedom rather than as a tra-
ditionally valued discipline.

Different cultures have had different standards and kinds of judges, but
standards and judges, formal and informal, there always have been, whether
of craft, art, or behavior. The Australian Aboriginals ensured that their world
would thrive through the accurate performance of their ceremonies and com-
plex system of "ownerships." In China, artists might try to combine the different

(from highly realistic to abstract) were judged for attractiveness. The similarity among the
judgments of different persons contradicted a "relativist" position in art and supported a
"universalist" one. (5) A cross-cultural study led to the conclusion that "when traditional
societies undergo the shock of culture contact, their previously profound aesthetic sys-
tems, whether explicit or implicit, tend to be replaced by concerns about craftsmanship,
intensiveness of work, and market value, as exemplified by pre- and post-contact Aztec
culture."

superlative abilities of the most famous old masters. I remember the advice Ch'en Hung-shou gave to artists, to achieve Great Synthesis by tempering Sung dynasty stiffness with T'ang dynasty harmoniousness and realize Yüan qualities by means of the order of the Sung. The abiding interest of the Chinese in authenticating, copying, and forging paintings and calligraphies of course bred great analytical and reproductive skills. Such acknowledged judges of art as Mi Fu believed in their ability to identify an indescribable quality, a species of spontaneity, beyond all the rules. In the case of India, there were the prescriptive craft manuals to obey, rulers to please. Among the rulers, I especially remember the Mughal emperor Akbar, with his intense interest in the real human and animal world, and the pride of his son, Jahangir, in his ability to judge which of his many artists had made even the eye and eyebrow in a painting.

In medieval Europe, the skill of an artist, like that of any professional, was judged, to begin with, by the masters who accepted him into their company, and judged in terms of the contract between himself and whoever used his services. In the course of time, academies and academic rules grew dominant. Apart from technical competence, there was a more spiritual standard, the ability to go beyond natural forms and reveal their essence, the perfection that the material forms of nature could only hint at. As in China, lists were compiled of paradigmatic artists and works. I have mentioned the seventeenth-century example of Roger de Piles, who graded the most famous artists of the High Renaissance for their ability in composition, drawing, color, and expression.

As European academic standards weakened, they were largely replaced by the competing standards of various so-called schools of art. If we look at the period from the late nineteenth century to about the middle of the twentieth and sharpen the schools' differences, we see how each school judged art by the success in achieving what it most valued: Impressionism (to put it with caricatural brevity) valued fresh-looking holiday scenery painted loosely in adjoining strokes of unblended colors; expressionism valued "primitive" authenticity, with form and color determined by often extreme emotion; Dadaism, "childish" primitiveness, spontaneous tomfoolery, and any disconcerting antiacademic, antiestablishment acts or objects; and surrealism valued individual, often erotic, fantasies, assumed to be derived, with little or no restraint, from the unconscious. There were as many public standards of judgment of the art of painting as there were schools of art or basic attitudes toward art.[17]*

* Richard R. Brettell's *Modern Art, 1851–1929* enumerates the following as the main schools of the period: realism, impressionism, symbolism, postimpressionism, neoimpression-

As described in these pages, the influence of non-European on European art began about the middle of the nineteenth century, with Japanese prints. The Universal Exposition of 1889 showed the attractions of what Gauguin indiscriminately called "primitive" art. About 1910, Indian art came to be accepted as true art. Then came the influence of African and Oceanic art, and, among some painters in the United States, of Native American art. Aboriginal art was certified as art only recently, by its exhibition in prestigious museums, not to say by the price of some recent Aboriginal paintings on the international art market. Ironically, Africans, Oceanians, and other peoples whose "primitive" art was in the course of time accepted without qualification as art remained in danger of reverting to what Westerners perceived as mediocrity. The danger arose when African and other "primitives" abandoned their "primitiveness" and tried to become recognized, without qualification, as contemporary artists. Their Western contemporaries were likely to feel that contemporaneity should be reserved for trueborn Westerners. Yet it was the influence of the non-European forms of art that had done much to undermine the confidence of Europeans in their own traditional aesthetic standards. So had the art of children and the insane, the criteria for which were immediacy, authenticity, and in the case of the insane, expressive strangeness. Whatever the influences, there remain mostly not schools of art but individual artists, who influence one another but whose standards can be learned only by studying them one by one. Museums still supply public criteria and act to a varying extent as aesthetic consciences. But they are influenced by the need to prove their own relevance by showing anything in which public interest is already high or, their curators believe, can be easily awakened or reawakened.

The older standards of art, now more or less absent from critics' judgment of contemporary art, were those of craftsmanship, beauty, tradition, and likeness. Yet the disappearance of these standards has been more nearly terminological

ism, synthetism, the nabis, the fauves, expressionism, cubism, futurism, Orphism, vorticism, suprematism/constructivism, neoplasticism, Dada, purism, and surrealism. Brettell says of what he calls "the '-ism' problem" that his brief summary "of the conventional movement-based history of modern art makes clear the inherent limitations and even the contradictions of the approach. . . . Indeed, the idea that the representational arts of a long period in the history of modern culture can be reduced to a few simple formulae would terrify most of us whose aim is to explain that art." Brettell is surely right, but my point is only that during this period there were many quite different criteria for art. The attitudes, tensions, misunderstandings, pains, and public and private responses that went into the recognition of a contemporary school of art are described in convincing detail in James Meyer's *Minimalism: Art and Polemics in the Sixties.*

and institutional than actual, because they continue to exist as implicit, almost underground values, most openly appreciated by those who take pleasure in art and do not share in the apparent indifference to them of the current aesthetic judges with the most influence.

Craftsmanship—the careful application of technical skill—has been a usual measure of art everywhere, except that it has often been subjected to a hierarchical distinction between the skill of a mere craftsman and the skill of a true artist. The only explicit, well-developed, non-Western argument I know against skill as a measure of the quality of a work of art is that of the Chinese scholar-amateurs. But I think that their argument was directed not so much against skill as against ostentation by means of skill and the turning of such ostentation into the primary criterion of art, as if it were the equivalent of insight or depth. Ch'an artists, too, were opposed to skill as such. While their opposition was more religious or philosophical than aesthetic, their standard of judgment, like that of the other Chinese denouncers of "skill," was an intuitively recognized authenticity.

Good craftsmanship still arouses pleasure and admiration, but I do not remember encountering it as a basic criterion for contemporary paintings, sculptures, or installations. The architect is still certainly concerned with it and is likely to take aesthetic pleasure in the ways in which the actual engineering of a building, ordinarily the work of an civil engineer, succeeds in expressing or enhancing the architect's conception. In the arts often thought of as minor, such as pottery and weaving, it is still natural to regard skill as necessary though never sufficient.

In the European tradition until recently, the degree of beauty of man-made objects was regarded as a synonym for the degree of art they display. The argument that many cultures had no equivalent for the concept of beauty turns out, on the whole, to be misleading. And beauty remains as important as ever when earlier art is considered. In other words, when it seems appropriate, we shift our aesthetic standards, as if earlier art and contemporary art do not have enough in common to be judged by the same standards. For many, maybe most contemporary artists, therefore, traditional art seems to exist mainly as a source of a traditional kind of pleasure and a source to borrow from, but not to compete with in kind or try seriously to renew.

Likeness-preserving portraiture seems to be important to the human ego and the human need to remember those we respect, love, or are interested in. Having been largely usurped by photography, the appreciation of the ability to reproduce appearances accurately has become relatively weak. The long attempt of Western artists, first in Greece and Rome and then, again, from the late Middle

Ages until recently, to learn to portray things realistically, makes the lapsing of the criterion of realism often seem like a willed return to childhood's schematic kind of art, to which the idea of skill seems not to apply.

In compensation, art enjoys an enormously enlarged scope for creative imagination—anything and everything seems possible: colors, shapes, and designs, as themselves alone; schematic distortions of anything at all; simple fantasies and elaborate dreamlike fantasies; childishness adapted to adulthood; social criticism of every kind and weight; sexuality in all its forms and degrees of intimacy; and scatology and brutality without limit. The most obvious loss is the depth that is sensed in a work of art that, by its adherence to tradition, represents the joint accomplishment of many artists as it comes to fruition in a particular successor. When the famous inveterate collector of contemporary art Charles Saatchi asked himself who would be the most highly regarded artists in a hundred years, he said: "General art books dated 2105 will be as brutal about editing the late 20th century as they are about almost all other centuries. Every artist other than Jackson Pollock, Andy Warhol, Donald Judd and Damien Hirst will be a footnote."[18] A defense of this undeniably subjective judgment would have to stress the ability of these artists to break with the art of the past, even their own immediate past, and certainly not to embody it as its culmination. The opposite would be true of any plausible choice of a few artists to represent the Renaissance and early baroque, a choice such as Leonardo da Vinci, Michelangelo, Raphael, and Rubens.

. . .

Contemporary art has not quite abandoned the use of explicit intrinsic criteria for art. There are at least three or four new, arguably intrinsic criteria. I will name two of them, in honor of Marcel Duchamp, the criterion of the readymade and the criterion of the intellect. The third I will name, in honor of Joseph Beuys, the criterion of social sculpture. Like the power to confer nobility, the criterion of the readymade grants a person or institution with the acceptable social status— of an artist, a museum, or the like—the power to declare anything; though only, says Duchamp, if it has had no prior emotional or aesthetic interest, to be a work of art. (Luckily, the privilege of granting the status of art to objects is not widely granted. If it were, readymades, which need no effort to prepare, might soon outnumber the more conventional works of art.)

Though moved from some ordinary place to a collection or museum, a new work of art-by-declaration remains visually the same as it was. Its only interesting quality as art is that it has no inherent quality that warrants it to be thought of as art. One explanation is that there is no clear explanation—Duchamp himself

said that the whole matter of the readymade was not clear to him.[19] Put somewhat differently, the readymade is thought to be important as art because an important artist named it a work of art, for reasons that cannot be doubted and cannot be understood, probably not even by the artist and certainly not by others. The essence, if any, of the readymade remains mysterious. Another explanation (contradictory to most but not all the relevant statements made by Duchamp) is that, thanks to the genius of the artist, we can appreciate the aesthetic qualities of an object so ordinary that it was earlier not observed to have any such qualities. Warhol's pop art often has this objective—Warhol was an inveterate collector of all kinds of things he happened to be interested in. A variation of this aesthetic principle recommends what is called "the art of non-art," the name given to it by one of its practitioners, Alan Kaprow. "Art which cannot be art" is meant to reverse the effect of the habits that make ordinary life into a mere routine and strengthen the tendency of art to dissolve itself into the activities of ordinary life. Kaprow says that the careful awareness of the act of brushing his teeth makes him more aware of his humanity and of how he deals with the image of himself and of others. An artist, he says, "concerned with lifelike art is an artist who does and does not make art."

The Duchampian criterion of the intellect demands that (visual) art should not be based on mere appearances. For art to be interesting, Duchamp says, it should be not optical, but intellectual. His own major example is *Large Glass*. As is well known, this is an ironical representation of sexual relations by means of a farcically complicated, pseudoscientific mechanism. The ideas it diagrams or symbolizes can be understood only with the help of Duchamp's own not completely consistent or intelligible notes. Duchamp's criterion of intellectuality is used to justify the conceptual art that consists of highly visible aphorisms on any subject the artist chooses, or of simple verbal descriptions or directions, maybe enhanced with or embodied in diagrams, pictures, or objects, and so on (see any recent book on conceptual art).

The Beuys criterion of social sculpture is the ability given by actual or symbolic objects and acts to influence, that is, to mold or model, humans to become more social and more sensitive to the affinity of humans with one another and with all living things. In Beuys's case, this sculpture was created above all by his imaginative miniature symbolic dramas. All socially symbolic images and actions, alone or together, are, as Beuys would say, instances of social sculpture. Most socially critical art of the present can be put within the Beuys category of social sculpture.

Still other criteria, which tend to be implicit, intuitive, vague, or individual,

are exercised by people in keeping with their different functions in art. To speak only of the present, the functions include those of the art critic, the museum curator, the art collector, the art dealer, and the art historian (I omit the auctioneer, of whom I will speak later, and the initiator of an art fair). Art is also judged to practical effect by sometimes-specialized officials, whether governmental or otherwise, who may play a part in granting subventions, and, from different but in their own ways relevant points of view, by psychologists, sociologists, anthropologists, and economists.

There is an entertaining literature that describes the critic who, naturally for a critic, uses skillful argument and not a little emotion to impose his views on artists and others (although, truth be told, I cannot recall any living art critic who has such an influence). The literature on curators, some of it autobiographical, may emphasize the curator's pride in his opinions and in the size and quality of the collection under his charge, and sometimes pictures him—it's always been a man—as a reckless adventurer or artistic dictator. The great art dealers I have read of were sometimes self-sacrificing partisans of the art they sold. But if very successful financially, they were not only good at buying, selling, and publicizing, but good at inflaming collectors' desires—in the earlier twentieth century, the most masterly was Joseph Duveen—because what must be common to collectors is the compulsive desire to own art for themselves and glory in it. (For his period, Andrew Mellon, who loved his collection more than he could love people, was a prime example; Duveen was his agent and the National Gallery of Art in Washington, D.C., his endowment).[20] These differences in function must be reflected in differences in attitude and must, in one way or another, affect judgment.

The most complicated job of judging, that is, the most complicated coordination of different criteria, seems to me to be that of a chief curator, or of a curator of contemporary art. The curator has to formulate general aims, including what to collect. Pressure is exerted by critics, whose artistic preferences are unlikely to match the curator's, and who make a point of commenting on the exhibitions the curator mounts. Pressure may also be exerted by the museum's board of directors, which is concerned with the curator's efficiency, with the museum's reputation and financial well-being, and, often enough, with the exhibition or nonexhibition of works from the board members' own collections. Hardest of all for the curator is the work of judgment of the artists who want their pictures, sculptures, videos, or installations to be bought or exhibited. Unable to satisfy most such artists or their friends who press their claims, the curator necessarily accumulates many more critics and enemies than friends.

FAME AND PRICE

The more influential individuals among the judges of the types I have named probably make up a small, interlocking, but not necessarily harmonious group that is in practice the court that decides locally on an artist's success or failure. To them I must surely add the more devoted art dealers and more talented auctioneers. These lead me to say a word on fame as a powerful, relatively unambiguous standard of value (measurable among academics most simply and directly by frequency of reference in the relevant literature) and on the usual complement of fame, money. Fame in contemporary art can be measured, somewhat as in traditional China and the Hellenistic, Roman, and modern periods of Western art, by sales to rich collectors and exhibition in prominent collections, now especially the collections of prestigious museums. But the clearest and most decisive criterion of the fame of a work of art is the price it commands, which is the measure of the strength of the desire of rich individuals, who often rely on expert advisers, and of rich institutions, which weigh what art they at the time most lack and therefore want. The strength of collectors' desire has played its natural role whenever collections have arisen—I have told the story of how the Chinese connoisseur Mi Fu went so far as to threaten suicide in order to get the scroll he coveted. Desire as measured by money might be an acceptable criterion if it were reasonable to assume that those with the most money were aesthetically the most informed and sensitive. It would also be more persuasive if the price of art did not so often represent the simultaneously expressed desire of a large number of the world's buyers of art for a relatively small number of highly publicized works. What makes the process so much more radical than ever before is the simultaneous spread of the same tempting information to all potential buyers, that is, the ability of auction-house experts to pay simultaneous attention to potential buyers throughout the world. When a mounted sponge soaked by Yves Klein in his special blue paint attracts the attention of specialists whose duty it is to explain the sponge's critical influence on the development of modern art and its uniquely profound soaking up of blue sensibility, and when the experts succeed in exacerbating the temptation the sponge exercises on susceptible collectors, the sale of the sponge seems to take on a momentary cosmic importance.

There are many agents who play a role in setting the prices of works of art. Besides the artist, these include the artist's dealer or gallerist (a politer name), collectors (whether self-reliant or dependent on art consultants), periodic art fairs, and auction houses. Among these, the most attention-catching and apparently dominant agents are the large international auction houses, whose staffs and auctioneers are experts in detecting and arousing flickers of interest in potential

buyers and fanning the flickers into flames of irresistible desire. An extraordinarily successful auctioneer has explained: "What I love to do is to put people in front of art and make them feel it, make them stop everything else they're doing and experience it deeply. That's how I make art expensive. And that's the job, for the company and for my clients. To make art expensive."[21]

Auctions can determine the height of a contemporary artist's success. One of the heads of Christie's, New York, makes the claim that "Jeff Koons was completely born and raised at auction," because, despite the good job his gallery does for him, "the strength of his market owes everything to auction, truthfully. There are other examples, like Richard Prince, Cindy Sherman, Takashi Murakami, etc."[22] The auctioneer's confidence in the inherent quality of an artist is not enough, however, because care must be taken not to burn out the artist's career by an asking price that proves too high to sustain. From the auctioneer's standpoint, the artist's market has to have depth, by which is meant an adequate number of buyers who are willing to pay at least the anticipated prices for the artist's work. "You have to really study the market" to understand its potentialities.[23]

Unless they depend on experts or on fashions, the choices made by individuals are intuitive, as they always have been. But having become used to an extraordinarily varied, quickly changing art, recent generations of art lovers have learned to emphasize the demand that art should, maybe above all, be original. This old demand has become so insistent that in immediate practice it often turns out to refer to anything that by its novelty draws attention away from the indiscriminate and therefore tiring variety of art as a whole—where in this kaleidoscopic variety can the eye find a place to dwell with excitement and pleasure?

The goal of fame, along with the tactics and novelties it inspires, is approached in too many individual ways to be described here. I leave them to the reader's experience or imagination, but they are all ways that serve ambition. The hierarchy of contemporary artists created by the prices of their works keeps fluctuating but is as simple and, for the moment in which it is set, as objective (auction-cheating apart) and convincing as the times of sprinters captured by electronic clocks. World records for runners and painters are set in equally unequivocal media, for the runners in clock times, and for the artists in denominations of U.S. dollars and other currencies.* It may be realistic to conclude that the way

*A convenient ranking of artists by price can be found online in the market reference *Artprice*, especially in its yearly summaries, with graphs, descriptions of leading markets, and rankings of the top 100 artists. The *Artprice* summary for 2005 informs us that in that year, as in the two previous ones, the ranking by auction turnover shows that the

to become a great artist, at least for a while, is the same as the way to become a great self-publicist—to become famous and to command great prices. Andy Warhol, who said this openly, practiced it with great success.

DIMINISHING THE SUBJECTIVITY OF JUDGMENT

I return to fairness or objectivity. I think that a plausible test of fairness would be the agreement of a majority of those who are judged that the standard or method of judgment used is objective or fair. It in fact appears that methods meant to be as fair as possible exist in all cultures, along with individuals called on to serve as mediators, arbitrators, go-betweens, referees, or the like. Yet how can such agreement be reached in art when there is no clear public standard that rests on what is internal to the quality of art and not alone on its fame or its price? By itself, neither fame nor price makes it clear how it is related to a con-

top artist was Picasso. Andy Warhol came second (in 2003, he was only third, but, as the text says, he continues his "inexorable rise"). Third (second in 2003) was Claude Monet, whose work, we are told, is progressively "drying up," i.e., becoming unavailable. Of the year 2005, *Artprice* says, "The international art market had never performed as well. The figures are record-breaking! In 2005, the turnover for Fine Art sales exceeded $4 billion, vs. $3.6 the previous year, despite a practically stable volume of 320,000 lots on sale." The market share of French fine art auctions apparently was diminishing, while, thanks to the economic boom in China, Hong Kong had become the fourth largest art market. "Both the Chinese Avant-garde and Chinese Old Masters segments recorded price rises of almost 80% in 2005. As major fortunes in China are accumulating, a new generation of collector is emerging intent on buying up works by home-grown artists. Even ZAO WOU-KI who has very close links with the Paris market and sells 48% of his works in France has seen his index appreciate by 60% this year." In the turnover of sales in the auction world of 2005, Chinese artists occupy places 33—just below Vlaminck and above Franz Kline— (WU GUANZHONG, $17,750,063); 39 (LIN FENGMIAN); 42—just below Alfred Sisley and above Edward Hopper;—ZAO WOU-KI, $14,862,811); and 50 (ZHANG DAQIAN).

Thanks to the enterprise of the auction houses, the prices of modern Indian art have also risen sharply. In 2005, a modern Indian painting established a record when it was sold at auction, in New York City, for over a million dollars. During latter part of the twentieth century, when Indian paintings were mostly bought by the better off among the middle class, the differences between the prices of the work of different artists were not great, and even established artists, who lived from the sale of their paintings, did not become very rich. But a former owner of an influential Indian art gallery sees an enormous change now that the auction houses have put Indian paintings on the international art market: "a few artists have become extremely rich, while others are starving. The works of artists whose prices have sky-rocketed no longer stay in India" (quoted by Ulli Beier in a letter of September 9, 2005).

sidered, objective judgment of the aesthetic qualities of the art it relates to. Espe-
cial respect is owed Alanna Heiss, the museum founder and director of P.S. 1
Contemporary Art Center in New York, who writes: "At no point in my life have
I ever bought a piece of work, at no point in my life have I ever sold a piece of
art. I'm a hard case, because for me, money and art have never matched up in a
significant way. I don't regard money for art as immoral. I just have never been
able to make these two quality-of-judgment assessments line up. I have no reg-
ister in my mind that equates the cost of the work with the value of the work."
Owning art is "an intimate, special relationship between yourself and the artist,
with the work of art as the vehicle, the intermediary, the spokesperson." Heiss
helps me to begin to explain my answer to the question on the possibility of
the fair judgment of art. She says, "I think that the greatest mistake is to think
that all art is equal, that it's just a matter of picking what you like. Art is inher-
ently undemocratic in this respect." To choose it really well "takes an enormous
amount of hard work."[24]

All things told, the search should not be for the impossible goal of a perfect
standard or an impeccable judge but for ways that although unable to achieve
ideal objectivity are able to bring us closer to it. They should be meant to arrive
not at correct judgments but at judgments that, all circumstances considered,
are relatively just because arrived at in relatively careful, reasonable ways.[25]* One
of these ways or methods—"method" is an uncomfortably formal name—is
inherently subjective. This is the way of empathy or sympathy. Its subjectivity
is related to, in part dependent on, and, as empathy, is now assumed to have its
physiological basis in "mirror neurons," which, as explained earlier, cause the
actions of other individuals to be understood by observers even in the absence
of any conscious representation. The other methods depend on the gathering

*Consider how necessary this reasonableness is in contemporary Holland, where media
artists, those who make videos and engage in other visual art projects, depend almost
exclusively on government subsidies. To justify the money spent to stimulate and main-
tain art of a high quality, the Dutch government, which itself is legally restricted from
judging the content of art, must rely on committees of experts to review and award its
grants. As Maya van der Eerden summarizes: "Usually the experts sitting on committees
have a good reputation and belong to networks in the art world and are therefore 'natural
gatekeepers.' They are gatekeepers in their professional life in the art world and they are
the ones who decide whether artists will be subsidized or not. In both situations they dis-
tinguish themselves as being professionals and therefore interested in the quality of art.
But how to they choose art? How do they measure? They make use of the so-called *judg-
ment of knowledge*, while outsiders are said to judge by taste."

of information and are therefore more nearly objective. They are what I call the ways or methods of fairness by understanding of context, fairness by historical ordering, and fairness by ecological ordering. I have added, as an inclusive way, in which the subjective and objective share, the way of prolonged acquaintance.

Whoever pursues any one of these methods long enough and intensively enough becomes expert in applying it. In applying it, the expert learns the relevant history, accumulates useful examples in memory, accumulates technical and nontechnical terms to describe the examples, and accumulates a variety of categories or models into which, experience teaches, the examples and their attributes can be usefully ordered. In whatever the method is applied to, the expert learns to discern more acutely and to judge in awareness of the judgments of others. To be expert requires perception to be sharply focused. The expert is literally more perceptive, that is, sees more of what is looked at, because his or her eye movements fix themselves everywhere on a work of art, taking in all the elements of its composition, while the gaze of an untrained person is likely to be fixed on the foreground and whatever stands out in it most obviously. To expert eyes, the meaning of a visual work of art is constituted by the total of its structure, color, inner movement, and awareness or unawareness of its artistic ancestry. The upshot is that although experts may be partial, they are less likely to describe or judge ignorantly, more likely to know how their descriptions or judgments compare with those of others, and more able, if temperamentally so disposed, to be relatively objective.[26]

A word now on each of the ways or methods I have mentioned: Without reference to the recent discovery of mirror neurons, the idea of empathy is that of "thinking oneself into" something or someone by projecting one's emotions onto the object or person, or it is the internalizing of an object or act by the feeling of its motions or emotions as if they were one's own. As far as I know, the most fully developed empathy in art—in the sense at least of feeling exactly how its motions go—is that of a Chinese, Japanese, or Korean connoisseur reading valued calligraphy, or of a Chinese or other artist "reading" a picture for an hour or more so closely that the artist can reproduce it relatively well from memory alone. To "read" so and try to repeat an artist's motions just as the artist made them is to try in a way to *be within* the artist, whose changing motions suggest changes in mood and active, individual mind-hand collaboration. To see, feel, and repeat the varying tensions of these motions and be conscious of this collaboration is to internalize and become identified with the artist's acts of writing (or painting). If the imitated calligraphy is close to that of the original, one in this

sense understands it rightly, though one is reacting by identification rather than by a judicious weighing of possibilities.

A more intellectual method is to learn to explain an artist by studying the artist's life and environment. This is the method of the careful biographer. More broadly, the study of context can be of the art of a school or a social group or, most broadly, of a whole art culture. Such a method reduces the misunderstandings that may estrange us from artists and allows us to respect art that we may not feel emotionally close to or intuitively admire. The appreciation of art is always enriched by the web of associations in which we set it. A rich web of associations makes it possible to see works of art from many points of view, to ask and answer many questions about them, to discover in them characteristics that are otherwise hidden, to remember them more easily, and altogether, to grasp them more fully and subtly.

Fairness or objectivity by historical ordering creates a narrative that in its way explains how and in a sense why art developed as it has. The creation of order can be equally helpful if it is sociological or anthropological. In the case of history, as of the other ways of establishing context, I speak of fairness on the conventional but often unjustified assumption that the biographer, historian, sociologist, or anthropologist is trying, within reason, to be objective.

An ecological kind of order can be especially illuminating. I borrow the term from biology but do not mean to use it as more than a suggestive analogy. To apply ecological ordering to contemporary art, one would have to know a great deal, certainly more than I do, but it seems to me that the effort would be worth making, even at the cost of reducing its scope. I think that the effort has become possible now because of the enormous scope of the information and the organizational powers inherent in the Internet and its search engines.

An ecological representation of contemporary art would describe all the groups of all the kinds of artists that inhabit the current world of art, the relations of individual artists with the groups of artists, and the relations of the groups with one another, with the institutions that affect them, and with the social and economic life in which they take part. Artists, groups of artists, and art institutions would be set into the niches they occupy in the art environment, and the art environment would be set into the surrounding human world. These niches are the presently viable roles played within the complicated life of the whole.

In such an ecological model, the criterion for the success of an art style, group, or institution would be the spreading or shrinking of the social area it occupied or the social force it exerted, its ability to adapt to changing conditions—in short,

its ability to survive. If weak yet valued, an art style, group, or institution could be regarded as an endangered art species that ought to be saved (as it is, for instance, in Japan). If one prefers, as I do, to weaken the distinction between the aesthetic and nonaesthetic, ecological criteria should prove relevant to a fuller, better-nuanced understanding of the nature or natures of art. If the application of these criteria proves relevant, it would make the ability to be fair in judging art more subtle than before. Biological background and terminology apart, an ecological explanation might not be very different from a close-grained sociological or anthropological explanation—anthropology being usually the more attentive to intimate human detail. (Naming but not making much use here of the social sciences, including psychology and social psychology, makes me feel like someone who drops names but neglects to say anything interesting about them.)

There is also the way of fairness by prolonged acquaintance. By this criterion, to be fair is to respond out of full and close acquaintance, with a minimal barrier of ignorance or strangeness, though subject to the (always-idiosyncratic) personality of a "normal" human being.

Briefly, for the sake of objectivity or fairness, I am for the use of multiple standards of judgment; for the use of explicitly universal standards along with explicitly local ones; and for fairness by the inclusive means of prolonged, intensive acquaintance.

LOCAL ART AND UNIVERSAL ART

I have said in different ways, with, I hope, strong enough qualification, that there are aesthetic responses common to all human beings and, for this reason, aesthetic standards common to them all. These standards, although rarely if ever spelled out in systematic detail, are expressed explicitly in the thought of the two most self-conscious, well-documented traditions of art, the Chinese (along with the Japanese and Korean) and the European. In basic principles, the two traditions can now be seen to be compatible and mutually enriching. However, to speak in socioeconomic terms, the relative worth of the art of the non-Western traditions depends mainly on its assessment by the Western, which has assumed the role of the worldwide tradition, the sea into which all the rivers of human culture flow. Since there is nothing preordained in this Western dominance, which flouts the nationalistic self-love of the non-Western peoples, it isn't hard to imagine it challenged, so that the price- and museum-dominance of the West would be weakened and there would then be many more "greatest" non-Western works of art to challenge the Western ones.

When I imagine what art might be (or deserve to be) universal, I think first of decorative art. For some reason, my memory calls up Peruvian feather fabrics, although I dismiss them as isolated from the worlds we have been considering; but I cannot dismiss a distant but still potent memory of Chinese and Japanese silks, whose colors and patterns struck me as more subtly, richly, and profoundly beautiful than any color patterns I had ever seen. They in turn remind me of the somewhat rougher, simpler patterned beauty of Chinese rugs or the more complex Persian rugs, and the Persian rugs reminded me of the beautifully tiled patterns of Muslim architecture. Then memory calls up medieval stained glass, and the glass recalls medieval illuminated breviaries and Bibles. I've allowed my memory too wander too far, but if it is the measure, the most naturally universal art is purely decorative art, which has no boundaries (or should have none). In the books on my lap I see illustrations of the multicolored geometry of the walls of the houses of the Basotho of South Africa and the exuberantly inventive design and color of the appliquéd blouses of the Kunas, who live on a coral archipelago near the Atlantic coast of Panama. And so on, without end.[27]

Figurative art, whose subject matter and, of course, style relates it strongly to its place and time, can nevertheless exhibit traits that transcend their culture. Think, for example, of images of the Buddha, or the Dancing Shiva, or the Madonna. Buddha images may affect non-Buddhists by their subtly sensitive impassivity, their rounded, calm benevolence, and the technical virtuosity of the sculptors who carved or cast them. A Dancing Shiva can impress anyone because it is the image of a many-armed, flame-ringed, primal dancer. Even apart from the frequent technical mastery of its portrayal, the image of the Madonna holding the infant Jesus can be appreciated by anyone anywhere because it is the image of a mother cherishing the infant she holds. The twisted lonely junipers of Wen Cheng-ming are somber, skillful, graphically daring, and emotional by Chinese, Western, and (I speculate) other standards.

I am certain that no reader of the preceding words on universality is tempted to regard it as a quality that is either present in a work of art or absent from it, like a light that is either on or off. It is, rather, a conception whose usefulness might be investigated by the sort of research I summarized in the first chapter of this book. If confined to abstract shapes, the research might not be hard to carry out, but the use of real works of art would create immediate difficulties. Instead of trying to imagine them, I recall Komar and Melamid's analogous research on preferences, reported in chapter 1. But I will make the usefulness of the term "universal" more evident by introducing the opposite term, "local" or "private."

The term "local art" or "private art" as used here applies to any supposed art object that has no visible sign, quality, or reason to make it interesting to those who merely see it. Or, to put it otherwise, the reasons for admiring it are not known or knowable by merely looking at it because they depend on personal experience, secrets, or associations confined to those who share them. Ordinary snapshots, which interest those who appear in them or know those who appear in them, will probably interest no one else. Or an old picture or letter that has nostalgic value has it only to the person who wrote or received it. A straight ruled line can hardly be interesting except to an individual who, for instance, remembers that his hands once trembled so violently that, even with a ruler, he could barely draw the line straight.

Because, like many jokes, there are many works of art that depend or appear to depend on merely personal or confined interest, the term "local" or "private" is useful to dismiss a supposed work of art or to explain while it may be of great interest to a coterie, it is of no interest to anyone outside of it. But one has to treat the term with caution, because, to revert to the example of the straight line, there are straight lines that for one or another reason can be quite interesting. One such line is the first approximately straight line drawn by a small child, for whom, for reasons that parents and experts in children's art and, I hope, readers of this book, understand, it can be an exciting adventure. Another interesting straight line is that drawn by a Chinese calligrapher, who draws it so that it has a bone structure with tension between its two knoblike ends, the coordination of pressure, speed, and balance that expresses the calligrapher's whole personality, maybe his warmth and compassion. Still another interesting straight line is one drawn by Mondrian, for whom the straight line corrects and fulfills the ephemeral curves and bends of visible nature and, as pure horizontal or vertical, expresses the universal equilibrium. I don't so much take to Mondrian's theory, but his use of rectangles and lines that cross at right angles has, we know, its effective angularity. For the rest, I refer the reader to Semir Zeki's enthusiastic advocacy, also explained in chapter 1, and the passage on Mondrian in the following pages. Tao-chi's single line, which will come up soon, is more versatile than any of the others.

I will give one simple and one complex instance of what I take to be local art, art that cannot be appreciated in ignorance of its full local environment. The first is the diagram an Inuit woman may make in snow or mud to illustrate a story she tells her child. The diagram is only an evanescent precursor to a work of art and is, in any case, incomplete without the words and singing that it illustrates. The second, more interesting example is a painting an Aboriginal may

make to embody a story, a belief. The painting is only a facet of the more complex and sacred art expressed along with song and dance, each element lending the others mutual support and depth. A non-Aboriginal is able to feel something of this depth if it is explained in patient detail, the more easily if the painting has recognizable pictures. But what if it is purely diagrammatic? A diagrammatic bark painting, with its groups of symbols made up of polyvalent dots, diamond shapes, parallel lines, differently colored areas of cross-hatching, and so on, conveys its meaning only to those who know the area and creation myth it maps, and it is completely clear only to those privileged to know the full meaning. Such a painting is too deeply local, too dependent on unobvious coded references, to be considered high on the vague universal scale. The "design" of the painting is meant to be a renewal of a life one can know only by having shared it. How, otherwise, could the cross-hatching on a painting convey to a Yolngu, along with its "brilliance" or "scintillation" (*bir'yun*), the more-than-iconographical joy of life within the ancestral past and power? If the painting's design is visually interesting, it may have a life apart from the traditional meaning for the sake of which it was created. However, to the extent that the painting becomes universal, it loses its symbolic references and therefore its depth. By Aboriginal standards, to appreciate it as an abstraction is to trivialize it.

The evaluative contrast I have just made is not the same as that made in traditional Inuit or Aboriginal life. In these two traditions, as in many others, some modes of expression were always recognized as deeper, that is, more fundamental, than others, but there was no conscious conception of fine art and no reason to compare their story or myth-history diagrams with images of Buddha, the Madonna, or Shiva.

Let me try to weaken the force of what may seem to be a dilemma. Like individual persons but more complexly, individual cultures are unique. The ability of art to be experienced as great by people of different times and traditions rests not only on its panhuman qualities, but also on the variable readiness of its spectators to appreciate it. It is natural for us to react to any art as, in my word, local if, to be appreciated at all, it needs long explanations. But if ever such explanations become so widely shared and internalized that they become a natural part of the common human memory, the explanations will become short or redundant and the previously local art become universal. Though I am neither prophet nor arbiter, I think that such reversals are possible and may already have taken place. Marcel Duchamp's urinal and readymades seemed in the beginning to be insider jokes or jokelike paradoxes meant to awaken people from their aesthetic slumbers. But when, thanks to unexpected turns of social history, the infamy

of readymades turned into fame and their paradoxical oddness into self-evident wisdom, they became the ruling paradigms of art, and everyone in the world with an interest in contemporary art learned them until they needed no teacher but themselves.

JUDGING ART FAIRLY

The ideal of objectivity or fairness in judging art can be elaborated, but it is hard to imagine any human being who could fulfill all its demands. But although the ideal is unreachable, it can be approached in various ways. I mean that it is impossible to be as objective or fair in practice as one can demand in theory, and yet there are, we've seen, many possible ways of being in practice more or less objective or fair. In this outline of an explanation, I will dwell less on the standards for judgment themselves than on the conditions that make fair judgment more likely or less likely. This explanation will be an attempt to find a point of balance between the commonsense objectivity that governs so many of the practices by which we live and the subjectivity of so many of our preferences and judgments—for documentation of which the whole of this book stands.

The suggested distinction between universally appreciable art and art that is local implies that the pleasure taken in local art is less dependent on its visible qualities and more on qualities hidden from even the sensitive outsider, to whom the art's symbolic or personal qualities cannot easily be made evident. But the suggested distinction between local and nonlocal tends to be neutralized in persons who have a strong sensitivity to aesthetic experience as such. These are persons who consciously enjoy experiencing the differences between things, and, in art, enjoy grasping the differences in individuality as such, or culture as such. A worm and butterfly, an ordinary person and an extraordinary one, may draw their equal aesthetic interest. Such a union of curiosity, aesthetics, and humaneness makes it harder to judge works of art as aesthetically better or worse than one another. What is then appreciated is the very variability of experience. But this nonjudgmental appreciation is not usual among those with a deep or professional interest in art. They seem to take much of their pleasure in constructing hierarchies of artists and works of art.

The question, "Can art be judged fairly?" can be fairly translated into another, less abstract one, "Is there a judge of art who is fair?" Two other questions that follow naturally are "Fair in what sense?" and "Fair to what extent?" These questions stimulate the counter-questions, "What is unfair in judging art?" and "What extent of fairness is at all possible?" "What is unfair?" is relatively easy to answer. It is unfair to judge very quickly, or to judge when one is impatient, ill,

preoccupied with something else, or, obviously, when one is deficient in some relevant perceptual or emotional ability. Poor hearing or even the loss of the ability to hear high notes lessens the ability to appreciate the sounds of music and the nuances of speech. Color blindness lessens or, if severe, disqualifies a person from appreciating the colors affected. And while motion blindness is rare, the perception of motion and stillness is more acute or less acute among different persons. Furthermore, just as there is color blindness, there is what might be called emotion blindness, found in varying degrees among the selfish, the narcissistic, and the autistic. The ability to empathize, to feel with others, that is, to react to observed, pictured, or described actions as if they were one's own, is highly variable and sometimes, as in autism, deficient or absent. Fairness, however, demands giving one's full, exclusive, not deficient, repeated attention to the art to be judged, that is, appreciated to the full, if possible for a time long enough to learn if one's perception of the art has been fully developed. It is also unfair to act as the judge of a work of art if it is of a kind that one intuitively dislikes. People who dislike the color purple, or dislike certain shades of purple, should not be regarded as fair judges of a visual work of art in which the color they dislike is prominent. The same is true for other qualities of a picture or sculpture— proportions, size, and, especially subject matter, which critics often seem to separate too sharply from aesthetic evaluation. It is true that one can recognize and respect certain qualities of an artist that one intuitively dislikes, but it is not reasonable to suppose that one will have studied this artist and other, similar artists with much persistence or attention.

It is unfair to be the judge of the work of someone one loves or hates, though possibly fair to judge the difference in quality between the works of a loved or hated person because one's emotional relation to the person is the same. It is unfair to make judgments of art that have serious consequences for anyone, such as the artist or owner, if the judgment may require crucial knowledge of which one is ignorant or experience that one lacks. I stress the word "may" because the responsibility falls on the person who wants to be the judge or on the person who chooses the judge for some serious act of judgment. What kind of knowledge may be needed? If symbolism is important to a work of art, then the knowledge includes an understanding of the symbolism. It is easy to see that knowledge of a medium, a style, a school, or a period of art is relevant, in the sense that the ability displayed in a work of art is most fairly judged in relation to others of the same style, school, or period—the most easily acceptable judge is the one who, like the judge of a running race, judges activities or objects that are as alike as possible in every relevant way. That is why it is relatively unfair

to judge between the aesthetic worth of a Byzantine icon and an impressionist painting. Not only are the conventions quite different, but the one was created as a holy object, painted and gilded for the sake of devout worship, and the other was created as a breath of fresh air, painted for the sake of one's pleasure in nature and the color and freely moving brush that capture the pleasure. It is true, however, that if one has a limited amount of money and wants to buy one of the two pictures, then one has to judge in the sense of having to make the choice, but what is then in question is not at all fair judgment but intuitive preference, or, possibly, resale value, or the desire to get something of a kind of which one has little.

Back then to the questions, "Can art be judged fairly" and "Is there a judge of art who is fair?" There are professions, such as that of a chief curator, the chief editor of an art periodical, the chief editor of an art-book publisher, or an art librarian, in which one may by nature or function want to be as fair as under the circumstances is possible. Such a person should become a judge of judges, whose self-chosen problem is to consult as good a group of judges as can be found. As good a group as can be found will not be a group of neutrals but of persons of different temperaments, different positions, and similar and different fields of knowledge, but each one within his or her field and temperamental range, knowledgeable, experienced, attentive, and seriously focused on the aesthetic quality of the art the particular judge has been chosen to deal with. Carefully identified, their collective verdict is for the while what we might hope from the verdict of time.[28] Maya van der Eerden, whose work focuses on exactly the questions I am asking, puts it well:

Experts have the ability (expertise) to judge whether a work of art is "good." This judgment is not simply based on subjective liking or disliking of a work of art. It is based on expertise, professional practice, theoretical background and knowledge of art history and art theory, that form the basis on which they are recognized as experts. Therefore the judgment of knowledge is considered to be objective. . . . However, true objectivity cannot be achieved, the maximum is intersubjectivity. In principle, it is plausible that the judgment contain a certain sense of agreement (intersubjectivity). In art reviewing the existence of a certain measure of agreement in the judgment of knowledge is confirmed by research that was carried out by Hekkert and Van Wieringen on the judgment of experts and outsiders. From these criteria, four appeared to explain the agreement regarding the variance in judgment by the experts: contents, craftsmanship, authenticity and development. These criteria are based on

knowledge of art history and art-theory. The measure in which a work of art fulfils these criteria determines the quality of the work. . . . The level of objectivity increases with "independent judgment," where the committee members come to their decision without discussion. Studies show greater reliability of the reviews if reviewers review individually. . . . Joint review may lead to a situation where all members conform their review to the judgment of just one member [according to Hekkert and Van Wieringen]. . . . The process of reviewing is always fallible, but the main issue is to reduce the chance of fallibility as much as possible.

No one is knowingly chosen to deal with what he or she is uninterested in or dislikes, or is unwilling to scrutinize patiently. Of course, experience teaches each judge which examples of a familiar art are worth scrutinizing carefully; but it is certain that other contemporary or later judges will be interested in the art that this judge had no patience for. It is not to be supposed that even the best judges, in the sense described here, can succeed in predicting which artists will achieve relatively lasting greatness.

Prediction in art, like that in politics or economics, is unable to cope with the complication of history in fact and the influence of chance, so that success in long-term prediction is hard or impossible to distinguish from accidental success.[29] Therefore the genuinely masterly accounts and judgments are backward-looking ones, not predictive but retrodictive. The conclusion is that it is easy to rule out certain judges as not fair, and easy to rule in others as well prepared and, within the limits of their personalities, good or excellent, even though in certain respects (as judged by a judge of judges) unfair. To hope for something more or better is to hope for the impossible. It's possible to try to be impossibly fair, better to try to be as fair as possible, and most realistic to hope for judges who are unusually fair in spite of their unfairness. The conception of complete fairness (like that of fully adequate knowledge) is natural and necessary as an ideal but impossible for merely human judges to exemplify. All the same, all art is open to relatively orderly understanding. There is little but impatience to support the notion that art and its judgment are in any serious sense random or unintelligible.

In answering the questions on fairness I have tried to be, sociologically speaking, realistic and not to evade problems because they were hard, and I have explored them as well as I briefly could. But as I foresaw before answering, my answer, "Yes, art can be judged fairly, and yes, there is a judge of art who is fair," is determinedly hesitant and, all the same, doggedly positive.

FUSION, OSCILLATION, REALISM, EQUILIBRIUM, BEAUTY

To the ideas on the nature of art I have so far explored, I add five others. Though I exemplify the five unequally, all of them seem to me essential to a full aesthetics, into which they might be turned if developed methodically. Take, for instance, the pleasure common to all human societies in the empathic closeness that I here call fusion. This closeness is the great though fugitive pleasure of unalloyed social connectedness. It is the consciousness of the persons who are led by their common action or emotion to feel that, for all their usual differences, they are now unusually one. Such is the song/dance euphoria of the Suyá described in chapter 2. To give another culturally distant but illuminating example, I can point again to the !Kung, the San people I introduced in the same chapter. The !Kung merge themselves in a stream of talk. They are so extraordinarily loquacious that their, encampment sounds like a brook whose endless murmuring is punctuated by shrieks of laughter. This talkativeness wards off loneliness and rejection, to which they are extremely sensitive, and it wards off (though sometimes also provokes) the rage the consequences of which they know too well. Their talk, interspersed with lyrics, rhythmical games, and dancing, is a current of sociability in which ordinary prose leads into and out of stylized eddies of art. The crises of their encampment life generate even greater volumes of sound. A particularly exciting or dangerous event arouses "volcanic eruptions of sound," which an anthropologist describes as "the greatest din I have ever heard human beings produce out of themselves."[30] An eruption of sound, lasting maybe ten minutes, it sets up a barrier of humanly generated talk-noise between themselves and their uncontrollable, nonhuman surroundings. Their noise is a vocal nest or home.

The constant chatter and occasional verbal eruptions of the !Kung belong to a style of life very different from that of African peoples such as the Bamana (or Bambara) and Dogon of Mali, who value silence and cast blame on "speech without a path and without seeds."[31] The !Kung style is also very different from that of Native American tribes, in which attentiveness and dignity are emphasized. As a Lakota chief once said, in the old days children were taught to sit still and enjoy their stillness. "They were taught to use their organs of smell, to look when there was something to see, and to listen intently when all seemingly was quiet. . . . A pause giving time for thought was the truly courteous way of beginning and ending a conversation."[32] To apply Western-style labels, !Kung eruptions are expressionist, while Native American reticence is minimalist. In either style—the chattering and explosive or the silent and controlled—the members of the group fuse themselves into a single expressive pattern of which a ritual,

with its art, is the most easily identified example. The patterns of everyday sociability are the substrata in which the fusions of ritual and art take shape.

In one of its aspects, the need for fusion leads to a denial that the arts are essentially separate from one another. A poem is then thought equivalent to a picture, a statue, a musical composition, a complex of emotions, the truth, and the cosmos as reflected in any of its constituent microcosms. In Europe, the artist who expressed himself equally in different media was a well-known phenomenon. In the fourteenth century, there was Guillaume de Machaut, poet, musician, and storyteller (and churchman and diplomat). In the Renaissance there were artists such as Lorenzo Ghiberti and the fabulously many-sided Leon Battista Alberti. In the romantic period, when ideology was favorable to the joining of the arts, there were multiply talented artists such as William Blake or E. T. A. Hoffmann, composer, critic, and storyteller (and for years, like many Chinese artists, a government official), and the poet-painter Dante Gabriel Rossetti. In China, the widely accepted ideal of the calligrapher-painter-poet was embodied in Wang Wei in the eighth century, in Su Shih in the eleventh, and in the fifteenth in the trio of Shen Chou, his pupil Wen Cheng-ming, and Wen's friend T'an Yin (Dan Yin).

A poem by a friend of Su T'ung-p'o (Su Tungpo) makes a good illustration of complex fusion. The subject of the poem is a picture painted jointly by Su and Li Kung-lin (Li Gonglin), *Herdboy with Bamboo and Rock*. The author's introduction, followed by the poem, reads "Su T'ung-p'o painted a clump of bamboo and a fantastic rock. Li Kung-lin added a slope in the foreground and a herdboy riding a water-buffalo. The picture, full of life, has inspired these playful verses":

Here's a little craggy rock in a wild place, shadowed by green bamboo.
A herdboy, wielding a three-foot stick, drives his lumbering old water buffalo.
I love the rock! Don't let the buffalo rub his horns on it?
Well, all right—let him rub his horns—but if he gets too rough he'll break
 the bamboo.[33]

As usual, the Chinese poetry translates as English prose, but it remains a clear instance of multiple fusions. Painted by two friends with a poem-commentary by a third, the literal subject is love and concern for a little rock, along with sympathy for both the old buffalo that may damage the rock by sharpening his horns on it and for the bamboo that the buffalo endangers. The conventional metaphor is the rock's resistance to time and weather, the bamboo's endurance through flexibility, and the interdependence of rock, bamboo, buffalo, and person. The underlying subject is the joint activity and emotion of the three friends,

each united with the others and with nature and with all with those who would sooner or later see the picture and read the poem. In other words, the underlying subject is fusion, of art with art, friend with friend, and art and nature with one another.

The desire for fusion is hard and in the last analysis impossible to distinguish from the need for intimacy, which involves all the emotions, not excluding hate, that bind people to one another. Like poetry and the other arts, painting and sculpture, with which I have been most concerned, record the intimacy the art-ist's fingers and imagination have created with the subject of the art and with the materials out of which the subject is created, and the need and, ultimately, the love for life as it reveals itself in the activity of creating.

To go on with China, this pervasiveness of the theme of intimacy and fusion can be illustrated first with the help of an essay written by the most famous of Chinese calligraphers, Wang Hsi-chih (Wang Xizhi), who lived during the fourth century CE, and then with the help of the treatise on painting written by the sev-enteenth century painter Tao-chi, or Shih-t'ao, of whom I have already written. Wang's essay is the preface to thirty-seven poems written by a select, influential group of men who had met for a traditional ceremony of purification. The pref-ace recalls the ceremony as a time of perfect communion. The air is clear, the breeze gentle, the conversation, interspersed with drinking and the composition of poetry, is altogether free, and the companions enter fully into one another's feelings. Looking up, they see the vastness of the heavens, looking down, the riches of the earth. The memory makes Wang call out, "What perfect bliss!"[34] The companions are prosaically and poetically attuned to one another and to the universe.

Wang explains that no one in the group was unreflective or insensitive to art. These were the kind of people who, in their journey through life, were able to "draw upon their inner resources and find satisfaction in a closeted conversation with a friend." Then Wang grows melancholy, remembers death, and remem-bers that young men are sometimes cut off in their prime. But he finds consola-tion in the sharing of poetry of even melancholy sentiments, and he says, "Even when circumstances have changed and men inhabit a different world, it will still be the same causes that induce the mood of melancholy attendant on poetical composition." He concludes, with every author's hope for sympathy, "Perhaps some reader of the future will be moved by the sentiments expressed in this preface."[35]

The thought of Tao-chi is related, in typically Chinese style, to nature. His object is to explain how and why art should be freed from method. He calls his

principle of the freedom and vitality of art "one-stroke" (or "oneness of stroke," or "one-strokedness"). "One-stroke" is meant to express the inherent unity of things, their common, undifferentiated source and deep affinity and, if the difference need be noted, the affinity between nature and true art: "The oneness of strokes is the origin of all beings, the root of myriad forms."[36] Tao-chi says, using not the common speech of the Ch'an Buddhists, with whom he had once cast his lot, but the elliptical language of the literati, "To have method, one must have transformations. Transformations, then, yield the method of no-method. Painting is the great way of the transformation of the world."[37]

To Tao-chi, this transformation is equivalent to self-realization. What he wants in theory and painting is something at once general and particular, vague and definite, easy and difficult, humble and universal. The very simplicity of his thought is meant to parallel the dynamism of the single stroke, the Chinese "one," which the child is first taught to write, and which remains, in all its nuances and powers, the test that distinguishes the mature master of calligraphy or painting from the immature. This simple, fundamental stroke is also identical with the horizontal line of the *Book of Changes,* the identity implying that the brushstroke in painting, like the symbol of the *Book,* is a form of the creation of the universe. The stroke is also assumed to be implied by Confucius in the *Analects,* when he says that "there's a single thread stringing my Way together."

Tao-chi therefore says boldly:

A single stroke which identifies with universality can clearly reveal the idea of man and fully penetrate all things. Thus the wrist seizes reality. When the wrist seizes reality, it moves the brush with a revolving movement, enriches the strokes by rolling the brush hairs, and leaves them unbounded by any limitations. . . . Painting is transmitted by the ink, ink is transmitted by the brush, brush is transmitted by the mind, just as heaven creates life and earth completes it. This is creative intuition.[38]

So the wrist, to which the universe is attached as cause and effect of the true act of painting, is able to seize the otherwise elusive primordial intuition. In Tao-chi's words, "All things become real and their manner is vividly and fully expressed."[39] As said earlier, it is likely that this bold ontology of art was an answer to the confusion of styles and profusion of knowledge that puzzled or intimidated students of calligraphy and painting in Tao-chi's time. For Chinese artists, his book on method was a powerful statement of the need for creativity by fusion and fusion by creativity.

. . .

As in Chinese art, so in the art of the West there have been uncountable expressions of the need for intimacy or, as I have been calling it, fusion. I might begin, as my memory leads me, with the letter in which Mozart says to his father that when the audience does not feel with him what he is playing, he gets no pleasure from the music; or with the first lines of Whitman's *Song of Myself,* "I celebrate myself, and sing myself, / And what I assume you shall assume, / for every atom belonging to me belongs to you."[40] But to keep within reasonable limits, I confine myself, for Europe, to a few testimonies, of Michelangelo for the Renaissance, of Bernini for the baroque, and for more modern times, of Van Gogh, Munch, Nolde, and Kirchner. To end with, I cite the American writer William Carlos Williams and the composer Arnold Schoenberg. My defense for choosing these particular artists is no more than the relevance and vividness of the statements I quote from them.

In his biography by Ascanio Condivi, Michelangelo (taken to be responsible for the biography's tone and content) is described in words strongly tinged with Neoplatonism. Some people think ill of Michelangelo, the biography says, because they cannot understand the love of beauty of the human body except as lascivious. But Michelangelo's love is all encompassing and pure:

> He has loved not only human beauty but everything beautiful in general: a beautiful horse, a beautiful dog, a beautiful landscape, a beautiful mountain, a beautiful forest, and every place and thing which is beautiful and rare of its kind, admiring them all with marveling love and selecting beauty from nature as the bees gather honey from flowers, to use it later in his works. All those who have achieved some fame in painting have always done the same.[41]

These sentiments of Michelangelo are attuned to his art but are too simple for it. A commentator says that stone was Michelangelo's life, triumph, and defeat: "He carved it for seventy-five years. He was born and died with it. In the very process of bringing shapes out of the 'hard and Alpine stone' he could find the metaphors of life, love, and death, discern the will of God, and foresee redemption."[42] But Michelangelo's frequent inability to finish his work shows that the redemption he foresaw was not always one he could give a body to; yet his failures too charged his work with the force of his struggle. It was the struggle that at the end of his life turned the *Rondanini Pietà* into an uncharacteristic renunciation of the body. In the process of carving and recarving this last, unfinished attempt to fuse mother and son, each was made out of what had been the other.[43]

The great baroque sculptor, architect, and painter Gian Lorenzo Bernini

(1598–1680) worked at sculpture as tirelessly as Michelangelo. "'Let me be, I am in love,' he would say when he was asked to rest, and such was his concentration that he seemed to be in ecstasy. It appeared . . . that the force to animate the marble was projected from his eyes. Before the angels in Sant' Andrea delle Fratte all this is credible."[44]

Van Gogh's love was more openly directed at human beings, with whom he hoped to be joined by means of his painting. He understood that he had often been rejected; but he kept reassuring himself in the language of his art, saying, in effect, "I, Vincent have not been rejected and cast off but am beloved by and united with those I love."[45] His work excited him and made him forget his loneliness. "The worse I get along with people," he says, "the more I learn to have faith in nature and concentrate on her." As Chinese painters put their feeling for endurance into rocks, for resilience into bamboos, and for old age into twisted trees, Van Gogh puts what he feels about strength, dependence, and company into the limbs, trunks, and relationships of trees. He pairs the sun and the moon like people and pairs complementary colors that "complete each other like man and woman."[46] In the intimacy of paint and imagination he loves others, himself, the world, and his work. "How rich in beauty art is," he writes. "If one can only remember what one has seen, one is never empty or truly lonely, never alone."[47] Even if it were true, he writes, that he is nothing, an eccentric, disagreeable man, he wants to show what there is in the heart of such an eccentric man, a nobody, for his ambition is founded less on anger than on love, more on serenity and less on passion. In spite of his frequent misery, he goes on, he feels a calm pure harmony and a music within himself.[48]

It is much in the same vein that Ernst Ludwig Kirchner (1880–1938), the German expressionist, writes that his work comes out of the longing for loneliness and the desire to show love, though for him at an unavoidably cautious distance:

> I was always alone, the more I ventured among men, the more I felt my loneliness. . . . I did not have the art of becoming warm in people's company. That is fate, and perhaps one of the major reasons for my becoming a painter. Art is a good way to show one's love for men, without inconveniencing them.[49]

Edvard Munch (1863–1944), for the most part a tortured person whose life was spent, in his own words, "walking by the side of a bottomless chasm, jumping from stone to stone," writes plainly, "All in all, art results from man's desire to communicate with his fellows."[50] He goes on to say that when an artist paints

a landscape, it is his feelings that are crucial, and nature is only the means for conveying them. "Whether the picture resembles nature or not is irrelevant, as a picture cannot be explained; the reason for its being painted in the first place was that the artist could find no other means of expressing what he saw."[51]

Emil Nolde (1867–1956), although a different kind of person, was, like Munch, preoccupied with the threat of insanity—he helped to get material for Hans Prinzhorn's pioneering study of the art of the insane. To him, painting is both attractive and dangerous. Lying on his back and gazing for hours at a successful picture, merging with the picture as if he had no existence separate from it, he feels an "incomparable joy," but he also feels that this joy threatens him with the possibility of annihilation, for he fuses with the things he contemplates and makes. He writes, "When I am painting with utmost intensity, I find that I have lost my voice. . . . As soon as I slack off, my voice comes back."[52]

Nolde most dislikes the people closest to him, and loves, along with the activity of creation, mostly the people he does not know. In his own words:

> Human beings are, nearly all of them, the artist's enemies, and his friends and near relations are the worst. He is like a man shunning the light, and they are like policemen with a lantern. He is like a man with the devil in his bones and God in his heart. Who can conceive the enmity and conflict of such powers? The artist lives behind walls, in a timeless state, seldom on the wing, and often withdrawn into his shell. He loves to watch strange things that go on in the depths of nature, but he also loves bright, clear reality, moving clouds, flowers that bloom and glow, the whole of creation. Unknown human beings are his friends, people he has never met, gypsies and Papuans—such people carry no lanterns.[53]

Of William Carlos Williams (1883–1963) I retain only a brief, touching description of his last days, when a stroke had paralyzed his right arm and deprived him of the ability to speak. All the same, he continued to write, because "when you're through with sex, with ambition, what can an old man create? Art, of course, a piece of art that will go beyond him into the lives of young people, the people who haven't the time to create. The old man meets the young people and lives on."[54]

Arnold Schoenberg (1874–1951) tried, at least sometimes, to create a relationship with others by crying out in pain or confessing failure. He suffered from both public and personal rejection, the public as a result of his musical radicalism and the personal as a result of abandonment by his wife (she left him for a friend, who committed suicide not long afterward). His art, reflecting his life,

has the isolated, unrecognized artist and the failed self as its theme. In *Pierrot Lunaire* the artist is the tragic clown, and in *Jacob's Ladder* both technique and text say, "Redeem us from our isolation!"[55]

Performing artists find it hard to live without the audiences that infuse them with their empathic responses. The need of Dickens for intimacy with his audience was so great that although he was well aware of the danger—his heart had weakened—he went on with his readings to the death they brought on him. He needed to be inspired by, to fuse with, his applauding audiences. It seems that artists need to be inspired and completed by the response of a real audience and, when that is lacking, an imaginary one. The need for and belief in inspiration have been so nearly universal that the sense of the power, exhilaration, surprise, disclosure, or gratitude to which we give the name must have been inherent in the experience of very many artists, and even in the experience of those who have only appreciated art.

. . .

The idea of fusion can be supplemented with two related ideas, oscillation and equilibrium.[56] Oscillation is like fusion in that it joins impulses, persons, and things that are quite different. The likelihood that a preference in art will change even into its opposite suggests that preferences are symmetrical with one another in the sense that that their alternation or mutual relationship over a period of time is more important socially than either of them alone. In fact, the whole history of art seems to be made of alternations or oscillations between extremes. Greek, Indian, and Chinese and Japanese art have all gone through historic stages that can be described in European terms as a movement from a stiff archaism to a supple, balanced classicism, to a swirling baroque, to a more decorative and more overtly rhythmical rococo.

The extremes between which art tends to oscillate include the pair of spontaneity as against habit or deliberation and, as contrasted in this book, the pair of tradition as against individualism or egocentricity. In the histories of art, such pairs coexist but also tend to oscillate as the dominance of one of them is succeeded by the dominance of the other. Among other such opposite extremes there are simplicity and complexity, seriousness and playfulness, realism and abstraction, and literalism and symbolism. Each extreme calls up the other and as a potentiality coexists with it. As I have shown, the cultures that serve as models of tradition also harbor artists who do not fit the humble, reverent, anonymous stereotype. Likewise, the cultures that serve as models of symbolic art show some tendency to produce realistic art as well.

. . .

Realism in art is a good example of a tendency that may appear foreign to a culture or time, but I believe it has never vanished anywhere for long. According to the Western historical convention, it was the Greeks who made realism possible. Realism reached its ancient heights in the portrait sculpture and perhaps also in the painting of the Hellenistic Greeks and Romans, and developed to its stylistic extreme in Europe during and after the Renaissance. But realism in painting and especially sculpture has shown itself at many other times and places, from which the stereotype of art history has excluded it. I skip the imperfectly understood but sometimes realistic cave art and dwell for a moment on the realistic art of Africa, of the Northwest Coast of America, of Egypt, and of China and Japan.

To begin with traditional Africa, sculpture intended to be portraiture has not been unusual, and this intention is fulfilled when, as photographs show, it bears a clear resemblance to its subjects.[57] Weightier evidence is given by the old life-sized heads of the kings, the Onis, of the city-state of Ife in what is now Nigeria. Like the Ife heads, the memorial statues of the Bangwa chiefs of Cameroon are meant to be true portraits.[58] If, in exploring the geography of realistic art, we turn to the Northwest Coast peoples of America, we find many statues and masks that have quite lifelike traits. The ability of the Northwest Coast Native Americans to carve realistically is early demonstrated by an old replica of a dead man's head and a portrait bust, carved in 1860, of the Englishman George Reid.[59] If we go back historically as far as ancient Egypt, we discover the phrase "statue after life," which implies the desire to make portraits. Mummies of some New Kingdom pharaohs prove that their statues were in fact portraits, though idealized ones. But Egyptian realism went further. An ancient death mask has been recovered.[60] In addition, the masks found in the workshop of Thutmose, Akhenaten's sculptor, are so realistic that Egyptologists have taken them to be either life masks or death masks. Close examination shows them to have been neither; but they are astonishingly realistic and astonishingly devoid of any of the marks of Egyptian stylization. It seems that Egyptian sculptors were quite capable of going counter to their own traditional styles.

The evidence from India is essentially literary.[61] It tells of the arrangement of marriages in which the participants first set eyes on one another in the form of portraits, painted by women specialists, whose realism was assumed to be accurate enough to base a marriage on. The evidence from China and Japan is more varied and interesting. Anecdotes like ancient Greek ones, which I have repeated in chapter 3 in discussing egocentric innovation, make it clear that the Chinese and Japanese were interested in realistic painting as a kind of magical illusion, for example, a fly one tries to brush off the scroll on which it is painted. Accuracy

of course required the close study of nature. Li Kan (1245–1320) loved bamboos and spent a great deal of effort in studying their species, growth, age, and quality. Another artist of the same period, Huang Kung-wang (Huang Gongwang, 1269–1354), who was interested in the changing effects of light, advised artists to carry brushes with them and immediately to sketch any striking bit of scenery, to be used to add life to studio-made pictures. However, the only surviving sketchbook of a famous painter is that of Tung Ch'i-ch'ang, who disregards formulas and explores the natural shapes of trees and rocks. Some Chinese artists, for example, Yao Tsui (c. 550 CE), sure that the spirit of things was best captured by fidelity to their outward forms, were in their own styles finicky realists. Others wanted to be so true to fact that they insisted that characters in paintings should wear historically accurate clothing.[62]

Chinese tradition required that portraits be made of ancestors.[63] Ch'an portraits had another purpose. Given to disciples as a sign of favor, they were painted with the economical exactness of caricature. Surviving examples in Japan have stereotyped bodies but carefully individualized heads. In Japan, portraits were made of the Zen masters, sometimes marked by strongly individual traits. In the twelfth and thirteenth centuries there were also painters who specialized in court portraits, called *nise-e*, meaning "lifelike" or "realistic."[64] In later Japan, realism was not uncommon. Okyo Maruyama sketched from nature, as I have said, as did Ogata Korin, the seventeenth-century master of decorative painting, and many others of their times. Sosen Mori (1747–1821), who specialized in monkeys, deer, and other animals, is said to have lived in the mountains for three years in order to learn to paint monkeys in their natural surroundings.[65] Thanks to human nature, realism in art is one of the natural and, I suspect, perennial tendencies. So is abstraction, its opposite, with which it tends to oscillate.

· · ·

As oscillation requires opposites to succeed one another, equilibrium requires their simultaneous presence. The greater the number of opposites or the stronger the opposition between them, the stronger the force needed for their union, and the more powerful whatever equilibrium is achieved.[66] Like many others (Nietzsche, for one, who said that harmony should ring out of every discord), I think that one of the best criteria for the depth of art is the extent to which powerful opposites are held in equilibrium.[67] Michelangelo's art is a self-evidently powerful equilibrium. Bach fuses German, Italian, and French music and holds an impressive, affecting equilibrium between polyphony, harmony, and melody; and Beethoven stretches, departs from, and returns to classical forms, everywhere intensifying musical equilibriums by threatening them.[68]

Chinese art makes frequent conscious use of principles of equilibrium. These principles became evident in calligraphy before painting. In an essay attributed to Ts'ai Yung (Zai Yong), of the second century CE, calligraphy is grasped as a process of checking, balancing, and redirecting, so that going to the left begins by going to the right.[69] An essay attributed to Wang Hsi-chih (Wang Xizhi) pictures the calligrapher as a general using his brush to fight on a paper battlefield. Wen Cheng-ming's *Seven Junipers of Ch'ang-shu,* which I have spoken of in chapter 2 in the context of tradition, is such a battle fought by a line of interlocking trees. Wen's later, less openly dramatic *Cypress and Old Rock* ties its tensions into a stubby knot.[70]

Although African music is culturally so distant from the Chinese tradition (and music), it is as much an art of equilibrium as Chinese calligraphy. As described by John Miller Chernoff, who studied African music by becoming a drummer in an African band, the rhythms of African music, each often individually simple, define one another by the tension between them. The musicians play around missing beats, which the audience supplies—even a coordinating time-line is played in syncopation—and must keep the audience in a state of "cool," that is, composed, excitement. When the rhythms are working well together, they prove to the Africans that music, like wisdom, can keep the balance between pleasure and excitement on the one hand, and morality and decorum on the other. The best drummers and the best dancers are old men who have learned to express their personal rhythms and coordinate them with those of others.[71] Their music is personal, free, yielding, responsive, complex, clear, and mature. Therefore it is beautiful.

. . .

We have come again to beauty. I am in no position to summarize what all or most "primitives" think, but I have said enough in earlier chapters to show that it is an error to assume that "primitives" never think in conscious aesthetic terms. Though I will not attempt to summarize it here, there is convincing research that shows that, granted a reasonable latitude to the semantic overlapping of the aesthetic terms of different cultures, every culture has ways of expressing the visual (or other, analogous) pleasure for which we use the word "beautiful." In this sense, the feeling for beauty is universal, even though what is considered beautiful varies greatly (though always, I think, within discernable limits).[72*]

*There is a great difference, which I feel on every page I write, between plausible-sounding hypotheses and empirically well-defended ones, even if empirical studies always reveal shortcomings and the need for further clarification. I feel especial gratitude to Wilfried

To give a few African examples out of the many possible "primitive" ones, French anthropologists who have studied certain African languages—of the Wolof of Senegal, Bamana (Bambara) of Mali, Susu of Guinea, and others—have found that they do have words for "good to look at" or "aesthetic."[73] But researchers have gone far beyond a study of vocabulary. The Yoruba, we have learned, hold an ideal of balance or "coolness," and so do the Gola. The criteria of the Dan are more intuitive than verbalized, but are clear in practice, in the preference, for example, for vertical symmetry and a balance and rhythm of a statue's masses,

van Damme for aiming at a multidisciplinary world aesthetics that is based on careful empirical evidence. In *A Comparative Analysis concerning Beauty and Ugliness in Sub-Saharan Africa*, he connects formal with moral beauty, takes up the religious function of beauty, and lists the African criteria for beauty as symmetry, moderation, clarity, delicacy, completeness, smoothness, youthfulness, and novelty. In contrast with earlier researchers, most of whom had a static conception of beauty, van Damme emphasizes the aesthetics of the dance as the central art of traditional West Africa. The dance is certainly the essential background on which a mask, meant for an active dramatic role, is to be understood. The context of figure sculpture, too, and of architecture is also symbolic and dramatic.

Van Damme's *Beauty in Context: Towards an Anthropological Approach to Aesthetics* carefully justifies the extension of aesthetics to the whole of human culture. He draws on what he calls the pluricultural aesthetic criteria. These, as he enumerates them, are skill, symmetry and balance, clarity, smoothness and brightness, youthfulness and novelty, and fineness. Not unexpectedly, van Damme discovers the extent to which a community's art is affected by the central conceptions, metaphors, and ideals that bind the community's members together and that may also hint at incipient changes in the community's attitudes. "Beauty in context," as van Damme concludes, needs to be analyzed in a more sophisticated and elaborate way than before. My only critical observation on van Damme's book is that the attention he allots to the art and aesthetic views of China, Japan, India, and the Islamic countries is inadequate, as he now recognizes and has made amends for.

Among van Damme's essays relating to world art, I suggest one turn first to "World Aesthetics: Biology, Culture, and Reflection," for its comprehensive views, and his brief "Anthropologies of Art." The second of the articles makes a careful assessment of issues that have so often preoccupied me in these pages. He contends, rightly, I think, that anthropology has by nature and history come to rely on detailed empirical study, on contextual intimacy, and, as far as possible, on even-handed cultural comparison. As he says, the anthropologists' examinations of art "create or enhance an awareness of the myriad ways in which a variety of artistic phenomena are related to the rest of culture." Anthropology makes it easier to see both cultural details and wholes and the ways in which they influence or constitute one another.

I recommend van Damme's two books and his articles, including those I have not noted here, for their empirical and theoretical seriousness, analytical ability, and breadth of vision. I feel that he is a true companion in the quest undertaken in the present book.

surfaces, and lines.[74] It is these criteria that a Dan sculptor is trying to satisfy when he stops and holds his work at arm's length while squinting at it or holding it, like modern European artists, upside down. The Asante add to the criteria of balance and symmetry those of the lightness or fineness of lines in a carving and of a smooth surface.[75] The Fang, too, demand smoothness, and ensure that a figure has vitality by the exactness with which arm matches arm, leg matches leg, and breast matches breast.

Although local or traditional standards in Africa vary as they do, they are hardly ever indulgent to poor craftsmanship. As should be obvious, there is complete awareness of the difference between the proportions of a sculpture and those of a living human being. It is just that realistic proportions are not usually considered appropriate or beautiful. Explaining this preference, an Igbo informant said to the anthropologist Herbert Cole, "Long necks are always beautiful; you will admit that yourself." Generalizing, the Igbo artist Ugo said, "Nobody will try to make a *mbari* figure look like a human being. It will turn out very ugly."[76]

THE SNOW WOMAN AS A UNIVERSAL PARADIGM

Art has so far been discussed here as if it were often universally appreciable and always life sustaining. But can this be said of art that is sad or even despairing? I will answer with the help of a Japanese folktale, which seems to me to convey the message that life is disappointing and that art, by creating illusions, augments this disappointment. The Japanese tale I will tell, about a snow woman, strikes me as inherently ambivalent, by which I mean that it says one thing and implies the opposite as well.

> Long ago there was a young bachelor. One winter night during a heavy snowstorm he thought he heard someone outside. He opened the door and saw an unknown young woman who had fallen in a heap by the door. He helped her into the house. She was beautiful, and he took her as his bride. Soon she grew well and strong and they lived together happily, but as spring approached and the weather became warmer, she gradually grew thinner and thinner and her health began to fail. One day the man's friends came to a party. As they were drinking *sake* and eating, the man called to his wife, but she did not answer. Wondering what was the matter, he went to the kitchen and saw that there was nothing there but the wife's kimono lying in a pool of water in front of the stove.[77]

That's the whole tale. The woman was what the Japanese call a snow woman, and she had, as her husband saw, melted away. The story is doubly sad—sad

because it reminds us that much of life is composed of dreams that melt away, and sad because it leads us to reflect that we too vanish like the dream woman, leaving only transient physical traces and memories to those who value us.

For us, the story functions as a parable, its overriding purpose, like that of all art, being to maintain our interest in life by answering our need to imagine its variations. The answer is especially interesting when the need is vital, like the need of the young bachelor in the story for a wife, especially of the kind a story can so easily grant—young, beautiful, undemanding. But the very story that expresses this need and in satisfying it transforms the man's life also expresses the disappointment that life so often brings, all the more severe in his case because the story had conjured up for him an ideal of youth and beauty. Implicitly the story says that the art it exemplifies, which allows us to imagine life suddenly becoming good, is illusory and itself, therefore, still another of life's disappointments. The story affirms that loneliness is not really countered by dreams, whether of ideal wives or anything else. Life is a vale of disappointment deepened by any attempt to imagine the contrary. But this doubly negative conclusion is counterbalanced by the ability of the tale to state the negative with positive effect. For it is an example of how art dissolves much of our sadness and loneliness in the pleasure of shared emotion. The pleasure of making up the tale and telling and reading it, which is the pleasure of inventing and sharing art, creates a current of feeling that runs, in immediate or imagined contiguity, from teller to hearer or reader and from one hearer or reader to another, and so demonstrates how the artist arouses optimism and vitality by a concentrated, imaginative act of sharing.

Let me elaborate. I have argued that in art at every level, even the nonhuman, the expressive act conveys the message, "This is what I am like," the *I* referring less to external than to internal characteristics, those that in human beings we are inclined to consider spiritual. This message has a natural extension, which can be put as an appeal or demand, made with any degree of insistence. The extension is, "Sympathize with me, empathize with me, identify with me, resemble me, join me, pay attention to me, or at least look carefully at what I have done." Although it may otherwise be ethically neutral, art always issues this moral invitation, which the artist would like to have the force of a demand.

This implicit invitation is likely to provoke a vague and yet sometimes urgent feeling in the spectator. This feeling is compounded of curiosity, free-floating friendliness, and a sense of possible duty toward the artist-stranger whose work is being exposed to our reaction. The feeling I am speaking of is the desire to participate and be participated in. These terms are reminiscent of the views of

Plato, Plotinus, and their many successors, whose philosophies infiltrate most of the older and some of the newer Western aesthetics. Do Plotinus's idea-powers have anything in common with the powers appealed to by African ritual art? Does the mystically inclined European aesthete, in everything attracted toward the indescribable God, have something in common with the Indian who feels and thinks of Shiva as dancing the world's creation? Does Shiva, as he dances the world, have anything in common with the Aboriginals whose ego in dancing, broken through by a higher (also aesthetic) emotion, experience intimations of the Dreamtime beings who created and still inhabit their landscape? Do the natural/supernatural forces that Africans call upon as they dance have an effect like that of the force that moves the Chinese artist's emotions, hand, and brush, maybe painting a self-portrait in the shape of an old tree?

. . .

I have been dealing with assumedly still living traditions and find it unnecessary to take into account the views of those who have recently put the whole of art and art theory into question, although I will now put art theory to a partial test, by turning to a description of characteristic aspects of European, African, Indian, Chinese, and Japanese art theory, theories invented in each different culture to explain to its members what the nature of art is or ought to be. Is there really, I ask, an aesthetics that cuts across all human cultures? In this book, there is a sometimes latent, sometimes explicit acceptance of this possibility. Yet as I will show, each traditional aesthetics has its own local color and is fully itself only when this color is unconcealed. This conclusion limits the degree of understanding that is possible as a result of the exploration of human characteristics viewed as more or less universal.

THE WEST: INTIMATIONS OF NEOPLATONISM

I begin my account of different traditions of aesthetics with the European, or Western, because it is, I assume, dominant in the reader's mind. A rich tradition, it is filled with an indefinite number of nuances of different sorts and rife with endless disagreements in principle and in detail. Yet, as I have said in earlier chapters, until relatively recently the dominant impulse in Western aesthetics has been the one that comes from Plato and Plotinus, which I will call, for short, the Neoplatonic. In the case of Plato himself, I am referring not to his polemic against the making of images, but to his belief that love for the beauties of the body reflects love for the beauties of the soul, and love for the beauties of the soul reflects the vision of superlative, everlasting beauty.[78] In the case of

Plotinus, I am referring to his dominant attitude toward beauty and art, and to his belief that the artist can grasp a sublime archetype:

> The arts do not simply imitate what they see; they go back to the logoi from which nature derives; and . . . they do a great deal in themselves: since they possess beauty they make up for what is defective in things. Phidias did not make his Zeus from any model perceived by the senses; he understood what Zeus would look like if he wanted to make himself visible.[79]

To Plotinus, the mind of the artist shares the nature of the creative form taken by the One or Good, which is in itself utterly impossible to think, imagine, or grasp. Beauty, says Plotinus, is Form, and even more than Form, is Life, for which reason badly proportioned but living faces have more beauty than symmetrical but lifeless ones.[80] To Plotinus, true beauty is the radiance cast upon the world by the Good or One, the source of the world's existence and beauty, or rather, of its beautiful existence, because existence is beautiful as such, in exact proportion to its intensity, which is the degree of its closeness to the One. Beauty in itself is formless. The experience of lovers shows this, because the lover is really in love only when the impression made on him goes beyond his senses and enters his undivided soul. "His first experience was love of a great light from a dim gleam of it. For Shape is a trace of Something without shape, which produces shape, not shape itself."[81]

Medieval aesthetics was always closely related to the Neoplatonic themes. The Renaissance requirement of anatomy and perspective did not change the dependence on Neoplatonic attitudes. It is true that Alberti, like other theorists of the early Renaissance, was not a transcendentalist, and he and others like him contented themselves with an emphasis on harmony, proportion, and the idealizing of merely human beauty.[82] But Marsilio Ficino, a thoroughgoing, erudite Neoplatonist, defined beauty as a "victory of divine reason over matter" and as "radiance from the face of God."[83] Neoplatonic theories like Ficino's became prominent in art theory from the second half of the sixteenth century, the artist being the person who gives nature a more than natural perfection. Michelangelo accepts Plotinus's view that the sculptor reveals the beauty already inherent in the stone.[84] The earlier comparison of the artist with God is extended and allows the artist to pride himself (more rarely, herself) on some measure of divinity.

It would be pointless to continue here with an abbreviated history of European aesthetics or to list all the many artists, writers, and musicians who have accepted or sometimes resisted the influence of Neoplatonism or its ana-

logues.[85] The secularism induced by science was often tinged by nature mysticism. Beginning in the late nineteenth century, Neoplatonic ideas were varied and reinforced (and in part contradicted) by those imported from India by Schopenhauer and others, while Buddhism, in its more simple and, later, in its Zen or more florid, magical, forms, played its skeptical-believing role.[86] Physics, which might be supposed to support atheism or agnosticism, stimulated the imaginations of the mystical-minded no less than the secular-minded. The creators of twentieth-century physics, Einstein, Bohr, Schrödinger, and Dirac, expressed views either compatible with mysticism or explicitly mystical: Einstein identified himself Spinozistically with the universe; Planck adopted a Kant-like thing-in-itself; Bohr favored contradictories in a way reminiscent not only of Kierkegaard but of negative theology and Neoplatonism; Schrödinger was an open Vedantist; and Dirac made a Neoplatonic equation of truth with beauty.

Mysticism certainly remained common among artists. The German expressionists often voiced mystical opinions, and so, in their distinctive vocabularies, did the surrealists.[87] Of the pioneering abstract artists, Kupka was mystical in the name of Orphism, Malevich in the name of suprematism, Kandinsky in the name at first of the Blue Riders, Mondrian in the name of De Stijl, or neoplasticism, Ozenfant and Jeanneret in the name of purism, and so on. To illustrate the importance of mysticism, at least for the creators of abstract art, I turn to the mystical views of Malevich, Kandinsky, and Mondrian. All three would have rejected as insufficient the once influential formalism of Roger Fry, according to which art was only itself, nothing but the relationships between forms. On the contrary, Malevich, Kandinsky, and Mondrian valued art, especially abstract art, for the metaphysical realities they took it to reflect and implicate.[88*]

Malevich painted in all the styles available to him: He began with Russian realism, continued with impressionism (sometimes in combination with art

*Though not detailed enough, the list of sources I provide in note 88 hints at my original intention to go more deeply into the changes in the views and styles of each of these three artists, but in the end I decided that a relatively undetailed reminder of the mystical or transcendental interpretations they gave their art would be enough. Both the artists' styles and their beliefs underwent many changes, and even the formal adherence of an artist, of Mondrian, for example, to Theosophy or an analogous doctrine, might later be modified or abandoned and would leave enough leeway for the artist's own stylistic choices. Still, it is hard to understand how an intelligent and well-informed person could have taken seriously the series of adventures undergone, as she claimed, by Helena Blavatsky (1831–91), the dominant figure of Theosophy, or have believed in the dematerialized Tibetan and the Secret Doctrine she insisted that he revealed to her. Life does have many mysteries.

nouveau) and symbolism, went on (in self-portraits) to fauvism and expression-
ism and, out of sympathy with peasants, took up neoprimitivism (in a Léger-like
manner) and then continued with cubism and futurism (in 1913 combined in a
style he called cubo-futurist realism). When he characterized his recent work as
instances of the "alogism of forms," his purpose was to proclaim the superiority
granted by creative absurdity over the banalities of common sense, not to speak
of the superiority of art as such over the objects that he thought had tyrannized
it for too long.

Given his volatile venturing from style to style and his deference to creative
absurdity, it is not hard to guess the enthusiasm with which Malevich invented
a style, suprematism—less a style, he said, than a penetrating metaphysical
insight—that includes all the worlds in a zero point of art, the all-creative shape
of the square, at first a red square on a white field, then a black one on white, and
finally just white on white. In praising suprematism, Malevich declares that out
of the zero point of the black square a vocabulary of colored forms can be devel-
oped to the point of achieving "absolute" creation. Concentrating within itself
eternal universal space, suprematism, he says, "transforms itself into other total
formulas, and expresses *everything* within the universe." Bold words, but one is
able to sense hesitation and its apparently spontaneous resolution if one looks
carefully at the famous black square that, along with the red one, he exhibited in
1915 (dated or predated 1913 on its back). When this key suprematist work is lit
from the side, the glancing light shows the varying height of the black that over-
lies it and reveals that there are a number of other, different geometric shapes
painted under the black square. Furthermore, the network of cracks that devel-
oped in the black paint shows that below the black surface there lies paint that is
red, blue, and green.[89]

Malevich is most accurately presented in his own enthusiastic, opaque meta-
phors. He explains that in suprematism, as in futurism, the units of the whole,
which is the organism, have been atomized and in this way freed, because we
now know that every solid is no more than a mass integration of free units. In
nature, there are no solids, but only energy, so that everything is at the same
time linked and separate in its motion. Malevich goes on:

> As a result, Suprematist abstraction of the picture and the reduction to a single
> color has released the action of atomization . . . onto the individual elements of
> color energy, which were not interconnected before. This process of isolation
> had created the form of the black or colorless square, a form that in its atomi-
> zation offered all kinds of other forms, and these in turn were painted many

different colors. The result is that, as planes, all the Suprematist forms are units of the Suprematist square. Most of these fall into line along diagonal and vertical axes and interact within a dynamic field of expression. . . . The forms are built exclusively on white, which is intended to signify infinite space.[90]

With the usual sky-blue background of realistic pictures in mind, Malevich says that his new thinking requires that a philosophical system of color must be created. "The blue color of the sky has been overcome by the Suprematist system, it has been broken through and has entered into white, which is the true actual representation of infinity—and therefore freed from the color background of the sky." There should be no more catering to commonplace tastes, no more insignificant utilitarian daubings, no more "little pictures of red roses," but systematic philosophical penetration into art, that is, into the nature of the world. Malevich proudly says to his "comrade aviators," "I have overcome the lining of the colored sky, torn it down into the bag thus formed, put color, tying it up with a knot" and exhorts them to "swim in this white free abyss, infinity is before you."[91]

Kandinsky, like certain other religious Russians, and like the Rosicrucian and Theosophists who influenced him, believed that mankind, about to awaken from the nightmare of materialism, was approaching a utopian era. He assumed that abstraction could be helpful because it expressed transcendental ideas. His love for color and the sound he (a synesthete) heard along with it was extraordinary. "I was often so strongly possessed by a strongly sounding perfumed path of blue in the shadow of a bush," he once recalled, "that I would paint a show landscape merely in order to fix this patch."[92] Along with the Theosophists, he believed that thoughts and feelings give off vibrations that the initiated could see and that every color was a spiritual tone and every color combination a spiritual harmony. He took it to be the artist's function to create expressive "vibrations" in the spectator.[93] This ideal reflects ideas prominent in Theosophy, for instance those expressed by Annie Besant, who had written of the effect of thought vibrations on the "arupa" level of meditation (the lowest of the seven Buddhist meditative levels):

These vibrations, which shape the matter of the plane into thought-forms, give rise also—from their swiftness and subtlety—to the most exquisite and constantly changing colors, waves of varying shades like the rainbow hues in mother-of-pearl, etherealized and brightened to an indescribable extent, sweeping over and through every form, so that each presents a harmony of rippling, living, luminous, delicate colors, including many not even known on earth. . . .

Every seer who has witnessed it, Hindu, Buddhist, Christian, speaks in rapturous terms of its glorious beauty. . . . On earth, painters, sculptors, musicians, dream dreams of exquisite beauty, creating their visions by the power of the mind, but when they seek to embody them in the coarse materials of the earth, they fall far short of the mental creation. . . . Each man, therefore, in a very real sense, makes his own heaven, and the beauty of his surroundings is indefinitely increased, according to the wealth and energy of his mind.[94]

Kandinsky's desire to awaken the ability to experience the spiritual as such was so strong that in a letter he suggested that brush and canvas could be given up and paintings created by spiritual irradiation alone.[95]

Mondrian was influenced by a Theosophist when still a young man, and in time he joined the Dutch Theosophical Society, of which he remained a member.[96] The reasoning of the Dutch mystic M. H. J. Schoenmakers was also precious to him. Though he did not approve of using oriental modes of thought, "Mondrian accepted the Theosophical [essentially Neoplatonic] notion of matter as a denser variant of the spirit. The spirit itself cannot be perceived through our senses; we are confined to observing matter. Gradually we approach the spiritual and leave material forms behind in the process . . . and 'the representation of matter becomes redundant.'"[97] In a notebook of 1914, Mondrian makes the assumption that the horizontal line is femininity (and the sea), and the vertical line is masculinity. The artist, he says, makes use of both the horizontal and the vertical and is happy, complete, and asexual. Later, in "Plastic Art and Pure Plastic Art," he says that vertical and horizontal lines express the two opposing forces whose reciprocal actions are "life."[98] He once sums up his belief in the statement, "Plastic art discloses what science has discovered: *that time and subjective vision veil the true reality.* If we cannot free *ourselves,* we can free our *vision.*"[99] Or, to sum things up grandly:

To love things in reality, is to love them profoundly; it is to see them as a microcosmos in the macrocosmos. *Only in this way can one achieve a universal expression of reality.* . . . Precisely by its existence non-figurative art shows that "art" *continues always on its true road.* It shows that "art" *is not the expression of the appearance of reality such as we see it, nor of the life which we live, but that it is the expression of true reality and true life . . . indefinable but realizable in plastics.*[100]

What Mondrian says here makes too neat a separation between "the appearance of reality" and "true reality." Which of the two was it, then or later, that prompted his "general revulsion against green and growth"? This was a revulsion

that made him change places when he was seated at a table from which he could see trees through a window, and that prompted him, who had loved the flowers in his Paris studio, to allow himself only a single, artificial, white-painted tulip in his New York studio, and that had caused him earlier, as a refugee in London, to live in an apartment with frosted windows so he could not see out, and that depressed him when he saw the green in an abstract composition by Ben Nicholson. Was it only his own private nature that was responsible for these compulsions, or was it "reality such as we see it," or "true reality"? Isn't it probable that all of these, in ways direct and oblique, continued to show themselves in his nature and therefore in his abstractions as well?[101] His abstractions were not in fact exempt from the nonmystical emotional realities we live; and we know that neither his abstractions nor those of others who shared his hopes have led humans to a higher spiritual plane. Speaking for myself, however, I cannot forget how brave and single-minded an artist he was.

. . .

To return to the theme of abstraction and mysticism, there are many mystical or semimystical statements by recent or contemporary artists. Among the members of the New York school, at least Reinhardt, Pollock, Rothko, Still, and Newman had mystical inclinations. Newman wanted to dig into metaphysical secrets, concern himself with the sublime, and by means of symbols "catch the basic truth of life . . . to wrest truth from the void."[102] I will not continue to take up the view of these artists but allow them to be represented by the religiously neutral kind of transcendence-by-art that Karel Appel describes. When he paints, he says, past and future disappear:

> The canvas is ready to be beyond consciousness. Just be. Beyond the human dualities. . . . Only in this nondual work together with my painting I lose myself, my body also. In my painting the form becomes vibrations, it enters the formless form, formless existence that I paint—vibrations of color.[103]

Even in this abbreviated account I have tried to preserve a little of the local color of European aesthetics. The conclusion I mean to draw is simple enough, although, in all conscience, it should be corrected by recalling the secular thought I have neglected, a secularism that too often has had the support of brutal governments. My conclusion is that the thought of European aestheticians and artists has been strongly tinged with mysticism, and when it has attempted to go deep has become the more mystical. The lesson to be drawn from this conclusion is one that I will for the moment postpone, but it will serve the argument that aesthetics everywhere has needed some concept of transcendence,

or in other words, has tended toward mysticism, by which I mean has tended toward values that go beyond prosaic naturalism and cannot be explained by it. To put it in words I prefer, art, along with aesthetics, needs to be completed not by prose but by poetry, which resists full explanations of any explicit kind, but which arrives at the depth and dignity of which it is capable only by means of the finally unsuccessful attempts that are made to explain it.

AFRICA: STATUE-LIKE BEAUTY AND GOODNESS AND CLARITY

I feel that it is unprofitable to make untested generalizations on so-called primitive art and therefore restrict myself to the art of indigenous black Africans. Even this restriction does not help much because Africa's peoples are so varied and because there are too few detailed descriptions of their aesthetic thought. Among the more detailed descriptions, there stand out some of the Yoruba artists, whom I have often mentioned. Here I use the art of the Baule, of the central Ivory Coast, whose creative independence as individuals I have also noted and whose work has been examined in an outstanding monograph by Susan Vogel.[104] To them I will add an account of the aesthetics of the Bamana, of Mali, after which I will end with some general, if conjectural, reflections on the aesthetics of black Africa as a whole.

To the Baule, there is an essential contrast between the world of the bush, which is nonhuman, and the world of the village, whose values are human, civilized—each world acting in the ways proper to it. In a deeper, mystical sense, dramatized by the Baule dances, the two worlds interpenetrate like male and female. This deeper, interpenetrating order is that of the forces of the always present, always active invisible world.[105] If a wandering nature spirit makes too much trouble—makes one sick or makes one fail in hunting—a diviner may advise that a statue be carved of it. To lure the troublesome spirit into the statue, the statue should be as beautiful, in a human sense, as possible, because "the more beautiful the figure, the better it can perform its function of localizing and placating the spirit, so that when the spirit settles down in the statue, it can be appeased." Hence the common Baule expression, "As beautiful as a statue."[106]*

* Baule take spirit spouses, which are usually sculptures. Spirit spouses help and protect their human partners and sleep with them in dreams on nights when, by custom, the humans are not allowed to sleep with one another. Sometimes, too, one spouse may dream of the other spouse's relations with its spirit spouse; or the spirit may complain about its human spouse to the other human spouse, the one to which it is not married; or the spirit may punish its spouse's human partner for his or her unfriendly acts. Showing one's spirit spouse to people is like showing one's soul to them and undergoing the dan-

To discover the aesthetic values of the Baule, Vogel asked some forty of them from different places—including ten practicing carvers and chiefs, family heads, diviners, and mask wearers—to rank traditional Baule figures they had not seen before. The results were unambiguous. They "liked" or "preferred" or found "good" (meaning also "efficacious") the figures that they found "beautiful" or "pleasing" (they used either the term *klanman*, which applied to conduct also means "appropriate," or another word meaning "pleasing" or "good"). The choice of words seemed to imply both aesthetic and moral pleasure. Another often-repeated phrase of approval was, "It looks like a human being," meaning, "It looks as we expect an idealized statue of a human being to look," that is, it has a smooth, unblemished, well-finished, "clean" surface. And the head, the abode of intelligence and freedom, should be large and held high on a long neck; and the calves of the leg, to be beautiful and, it seems, to promise strength, should be full and round.[107]

On the whole, Baule works of art give an impression of peacefulness, self-possession, and introspection, their vitality contained by the order they impose on it.[108] Concerned as they are with the powers of the objects they make, powers the Baule may consider to be those of life and death, they more often conceal than reveal the objects and have no category of art as such. "We live with the spirits more than with the statues," a Baule says. "You will never hear a Baule say, 'This is beautiful,' because that is not what they are looking for. Even though it *is* beautiful." Beautifully decorated doors, bronze weights, spoons, stools, musical instruments, and so on, which are all looked at freely, may serve the prestige of their owners, but they have no power and are regarded as amusing trifles. Because they attract no dangerous envy, one can look at them thoroughly and fixedly, as long as one pleases. Friends may give them as small gifts to one another, or artists make them on impulse.[109]

Although the Baule do not have a noun that is the equivalent of "art," they do have an adjective to distinguish between a merely useful object, such as a plain gong mallet, and the same object that a sculptor has transformed and made "beautiful" (*klanman*). This "beautiful" can be used to describe both natural beauty and the appearance of a girl "with a fine coiffure, special clothes, and orna-

ger of exposing it to ill will. Although other African peoples may take spirit spouses, the Baule seem to be the only people to have created "significant sculptures" for them. In ordinary conversation, people do not speak of the appearance of their spirit spouses. "Yet," as van Damme perceives, "it is impossible that people do not enjoy the beauty of their spirit spouses, as perhaps the only sculptures they can handle and see whenever they please."

ments rather than one born with pleasing features." Another relevant word is for "things skillfully made" (*ajuin*). Most commonly used to praise work in gold, it also means "magic" or "witchcraft," because it "associates the almost magical skill of casting gold and the genius of embellishment with the use of supernatural means to gain advantage over others." The use of words expressing admiration such as "beautiful," "skillful," "magical," "from the old times," "like a god," "like a dance," and "beautiful as a statue," but never of a word meaning "art" or "work of art," draws attention away from the physical body, the thinghood, of what is beautified or made to be beautiful and emphasizes the human reactions to it. The process of creation of the work is not glorified—although the tourist trade has changed things—nor is the name of even the trained and recognized artist who created it. If it is a question of the efficacy of a statue, its having been made of the right wood is likely to be more important than the skill of the carver. Yet sculptors, who are or were mostly farmers and, maybe, diviners as well, have often said that they made certain carvings just because they felt like making them.[110]

Among the Baule, the more important a sculpture, the more likely it is to be hidden from view. When carving masks or figures forbidden to ordinary sight, the carver finds a solitary place to work and hides even the unfinished object in the bush—only the goldsmiths do their work openly, in the village. Some sacred objects may be put away for decades. The women, on pain of death, are forbidden to look at other sacred objects. For anyone to stare too fixedly at a powerful mask, statue, or altar is dangerous, especially if one has been initiated into its secrets and might use this knowledge to express a malevolent intention.[111]

. . .

I have chosen as my second African example the art of the Bamana, who live in Mali, and whose aesthetics is described in an excellent study written for a 2002 exhibition in New York at the Museum for African Art.[112]* Although the Bamana

*An earlier name, Bambara, has been discarded by anthropologists. The names Bamana and Bambara are more nearly regional than ethnic and have had shifting connotations, but both mark out the peoples who were relatively resistant to Islam. "Bambara," which was applied by Muslims to those "who refuse to pray," was adopted by French administrators, while "Bamana" is what the people call themselves. Those who designate themselves "truly true Bamana" never pray to Allah. The Bamana, then, are the people who belong to certain initiation societies, make certain kinds of animal sacrifices, and communicate with their ancestors by way of ritual dancers. But there are places where practicing Muslims consider themselves to be Bamana because of their language, culture, lineage, and history. Confusingly, the first language of Mali is now officially called "Bambara," which is also the official name of the inhabitants of central-south Mali.

have by now mostly accepted Islam, they retain non-Muslim beliefs and rituals that relate to farming, fishing, hunting, the working of iron, and so on. Like the Dogon, who live not very far away, they believe that everything has an energy, too dangerous to deal with lightly, that they call *nyama*. In initiation rites, they are taught how to control *nyama* in order to help with the cultivation of crops, healing of the sick, working of iron, and so on.[113]

The variety and the changing aspects of Bamana associations, which may be regarded as ritual brotherhoods and sisterhoods, make any description of them tentative. Bamana children, women, and men participate or used to participate in the rites of the Chi-wara (*chi* is "to cultivate," and *wara* is "beast"). A masked Chi-wara dance with headcrests of antelopes and other primal animals is meant to enhance both the fertility of the land, caused by the union of sun-fire with water and earth, and the fertility of human beings, caused by the union of man and woman.[114] Every seven years, another society, having gradually prepared the boys of the community, initiates them into manhood. At the terrifying initiation itself, the boys of the age-set being initiated are symbolically killed, instructed in tribal lore and obligations, and taught by the infliction of pain to endure hardship and keep secrets. Having become men, they can enter one of the other societies and build up their knowledge and power.

Age groups of both boys and younger men take part in the yearly puppet masquerade dramas called the *Sogo bo* ("The Animals Come Forth")—the small puppets involved come out of mobile beast-headed theaters. In these lively, often satirical dramas, bush animals play the major roles, and assertiveness and courage are celebrated. During the masquerade, a masked dancer, Vulture, who represents the hunter-hero, dances and sings the praises of the Roan Antelope, he who, as a primal ancestor, taught the first Bamana how to work the land. Vulture's song has a dirgelike tempo that implies that the hunter is sad over the fate of the roan antelope he has caught. For the hunter must not only have the means to withstand this antelope's beauty but must also "have the *nyama*, the energy or life force, to protect himself from the wrath of the bush spirits, the animal's protectors."[115]

Nyama is commanded especially by blacksmiths, who are also healers, circumcisers, and sorcerers. The possessors, they believe, of a distinctive heritage, they do not intermarry with ordinary people, who are farmers and traders. The blacksmiths can all work wood and, in spite of their professional classification, some specialize in wood sculpture, while the women are potters. Each of the stages of the blacksmiths' work—the finding and extracting of the iron ore, the making of the coke for the fire, the bringing of the ore and coke to the furnace,

and the smelting and extraction of the iron—require ritual gestures or sacrifices to ensure that the work goes well. During the collective rite for the trimming of the iron, there are blacksmiths who demonstrate the occult knowledge by which what is "hot" is mastered. The "heart" of the whole process is "the hollow cavity of the smelting furnace where transformation of the iron ore takes place, something which is thought of as both difficult and magical."[116]

To allow Bamana aesthetics to keep something of its character, I use the admittedly inadequate translations of six of its terms: goodness (*nyumaya*), clarity (*jaya*), way (*cogo*), tastiness or pleasure (*jakaya*), embellishment (*jako*), and identity (*ja*)—more literally, double, shadow, or mirror reflection. When applied to the arts, the first term, "goodness," designates the qualities that give the arts' forms an identifiable, suitable shape. The goodness of the forms is their retention of the cultural identity that has been given them by past generations, this goodness having been arrived at or condensed, "dried down," by generations of experiment. Such goodness rests on the "clarity" of understanding granted by these generations' accumulated wisdom. Every aesthetic act has a particular "way," the set of instructions for its pattern, appearance, or performance.[117]

But goodness, with its attendant clarity and way, is not enough, because the power or *nyama* of the arts gives them a complementary "tastiness," a term that refers to the qualities that in some way challenge the recognized traditional forms in order to arouse imagination or stimulate involvement. To arouse, art needs "embellishment," which—unlike clarity, which "cools"—works to "heat up" forms. When yielded to without restraint, this power is able to drive the individual back into the primal wildness of the bush. In music and dance, for example, fast tempos help performers to heat performances and stimulate them to improvise.

To link art with tradition and yet recreate it for the community, performers "heat" a form and do their best to lend it the grace of the virtuosity or "suppleness" that renews its energy while retaining the essentials of its form. Effective performances give those who attend them a sense of their unity as a social group. What mediates between this social group, which is external to the individual, and the individual soul is the person's "identity," the "shadow" or reflection of the person's character and intelligence that reveals itself in art. "Art is said to express the person's *ja,* and thus provide access to the creator's identity."[118]

. . .

Baule and Bamana aesthetics are not sufficient in themselves for generalizations about the art of black Africa. However, one safe generalization is that African art is intended to ensure fertility, the germination of seeds and the multiplication

of animals and human beings. Although this is reflected better in my account of the Bamana than of the Baule, I must point out that the Baule's oldest deity is Asye, the genderless earth, which produces children, game, and crops—everything, as a Baule said, depends on it.[119] In short, art is intended to help with the process of birth, growth, death, and birth again, which in African eyes constitutes an endless and always precariously balanced process that requires both supplications to and manipulations of the natural powers that be. This ritual art, an art of performance, demands the reciprocity of all the persons involved: performers and audience give one another the encouragement they need in order to invent human responses and to participate in their invention. The reciprocity is also one between human beings and the capricious forces that inhabit and surround them.[120] These forces are caught, invigorated, deployed, and absorbed by the art, that is, the sounding of its music, the symbolism of its masks, the gestures of its dancers, its incantations, and its old, powerful stories. African art is the style in which the powers are mingled and balanced and the visible and invisible are encouraged to enter into a more empathic, life-giving intimacy. Everywhere there are rules for the proper making and use of ritual objects. The objects' attractive appearance—that of the beauty of beautiful women apart—follows from the care with which they are made and their appropriateness for their roles; but the inevitably spontaneous variations introduced by the impresarios, sculptors, costume makers, and actors are necessary for the vitality and efficacy of the performance in which they appear. Regardless of the exceptions, most of this art, with all its artfulness, has a magical aim.

Although it is true that African art is highly varied, if we accept the view of the expert Susan Vogel, recent studies of African art lead us back toward the generalizing attitudes of an earlier generation of scholars, so that "the greatest interest of a tightly focused art study . . . may be precisely in how much light is shed on the place of art in other, distant cultures."[121]

INDIA: DEPERSONALIZED EMOTION

In India, traditional craftsmen are often guided by manuals specific to their art. Although each kind of manual invokes its particular patron god, the manuals are mostly compressed, matter-of-fact directions that venture very little, if at all, into philosophical justification.[122] Aesthetically, Indian craftsmen have been nourished by the sense that the energy of the universe is a breathing, *prana*, evident in any instance of motion, change, transmutation, or life.[123] This feeling appears in the inherent energy of early Indian sculpture and the remnants of its early paintings. The figures, flexible, rhythmic, round limbed, and sensuous, are

often set among twining creepers and touch or lean on trees, as if to take in their own life from the trees' life and the fertile earth. They all express the fertility of nature, the sculptured forms of which include invitingly beautiful women, amorous and copulating couples, and phallus-shaped gods. The figures are generally fixed in the attitudes of Indian dance because they reflect danced ceremonial.

This relation of visual art to dance and therefore to music is the subject of an old text, the *Vishnudharmmottara*, which connects them in the following way: One cannot discern the characteristics of images without knowing the rules of *chitra*, that is, sculpture and painting; it is hard to understand the rules of painting without knowing the art of dancing; the practice of dancing is hard to understand for anyone who is not acquainted with music; and without music dancing cannot exist at all. Therefore, "He who knows the art of singing is the best of men and knows everything."[124] This conception of the essential oneness of the arts is consonant with the Indian view that everything expresses the ultimate reality, *Brahman*, or perhaps the ultimate reality conceived as the god Shiva.[125]

Usually, the hierarchy of the arts is headed not by music, but by drama, regarded as a form of poetry. The scripture, so to speak, of Indian dramaturgy and dance, Bharata's *Natya Shastra* (second, some say fourth, century CE) tells how the god Brahma, in trying to placate some disaffected demons, created the dramatic art in order to delight and edify gods and humans (and presumably demons) by including within itself all knowledge, every craft, learning, art, practical skill, and activity. Indian drama is, in fact, an art of arts that exert a strong mutual influence on one another. Instrumental music is as essential to a drama's beauty, says Bharata, as color is to that of a drawing. The pattern of its drumbeats is essential to its rhythm and tempo, and singing is essential to its text, and the dance and mime to its action.

Every drama has a predominant emotion. According to Bharata, there are eight basic emotions paired with eight aesthetic emotions, the latter called *rasas*, flavors. The pairs of emotions may be translated, with the basic emotion of each pair first, as follows: love/the erotic, laughter/the comic, sorrow/the compassionate, anger/the furious, energy/the heroic, disgust/the odious, and wonder/the wondrous. These pairings invite comparison with the European theory of "affections," including anger, excitement, grandeur, heroism, contemplation, and mystical exaltation, which baroque musicians and musical theorists took to express their aims.[126]

Each *rasa* predominates in a given poem or play—or, in principle, in a given musical composition, dance, painting, or sculpture.[127] The causes that arouse and the effects that follow from the basic emotions conjoin with those of other, tran-

sitory emotions and give rise to a state in which a basic emotion gives pleasure, which is to say, is relished as an aesthetic emotion, a *rasa*. Although depending for its existence on its basic counterpart, the aesthetic emotion is isolated from the circumstances of real life and therefore from the direct influence of biological and psychological impulses. For this reason, it may be said to be depersonalized or delocalized, or, to put it in positive terms, to be universalized. To the extent that this is so, the whole state of mind of the reader of a poem or spectator of a play has been depersonalized, delocalized, or universalized. A play or poem (or piece of music, picture, or statue) is therefore an autonomous creation, to be appreciated in a timeless, impersonal spirit to which truth and falsity, the criteria of ordinary life, are irrelevant.[128]

Each of the character types—the amorous and heroic are the most important—has its typical color (blue/black for the amorous, yellow for the heroic), typical ornaments, and typical gestures or poses, thirteen gestures for the head, thirty-six for the eyes, nine for the neck, thirty-seven for the hand, ten for the body, and so on. As Bharata points out, the muteness and stillness of a painting or sculpture make it artistically inferior to the full, dynamic expressiveness of a drama.[129] He reports that Brahma promised that a dramatic representation of the world would embolden the weak, energize the strong, enlighten the ignorant, teach the miserable fortitude and the agitated firmness, and show the materially minded how gains are made. An attuned spectator will relish the drama just as a gastronome relishes an artistically prepared and embellished feast.[130] As for painting and sculpture, their part in drama, according to the *Natya Shastra*, is to decorate the theater and create a suitable general atmosphere for the plays.

With the *Natya Shastra* as its main basis, aesthetics of a more articulated, philosophical kind began to develop in India about the fourth or fifth century CE. It describes an emotive—not didactic or philosophical—poetry, *kavya*, and ranges from brief lyrics to extensive court epics and dramas, the dramas regarded, one might say, as "spectacle-poems." *Kavya* literature was mostly in Sanskrit, by then a mother tongue to only few, but for the educated, a second, literary language. This language has an extraordinarily large vocabulary and commensurate resources for what the aestheticians called "ornaments," forms of word play, from figures of speech and kinds of alliteration to puns, similes and metaphors, ambiguities, palindromes, and whatever else linguistic ingenuity might invent and categorize. The often proud writers of this poetry, an occasional woman among them, do not appear to have felt any special identification with the craftsmen who made stone or metal images.[131] Yet the orbit of their aesthetics extends, as I have been emphasizing, to all the Indian arts. This is not simply because

of the claim that drama occupies the highest position in the hierarchy of the arts. It is, rather, because their conception is the fullest aesthetic expression of the point of view of those who dominated all art (except, I suppose, folk art). The poets were court poets writing competitively in the same literary language. Their patrons, like those of painters, sculptors, and architects, were aristocrats and rulers, who might themselves practice one or more of the arts. As a result, there developed a whole aesthetically sensitive culture, much of it based on the two great Indian epics, the *Mahabharata* and the *Ramayana*, rather as Greek culture was based on the *Iliad* and the *Odyssey*. Therefore the themes of painting, sculpture, poetry, and drama drew on the same narrative sources and imagery, and the same general aesthetic principles applied to it. Apart from the cut-and-dried manuals, by nature limited in their vision, the best developed keys to the understanding of the visual arts of India are those found in its literature, because everything in every art is part of a story with a poetic resonance. The attitudes, figures, jewelry, moon-shaped brows, languor, hope, suffering, and extraordinary voluptuousness of the heroines of poetry and drama are those that appear in the sculptures of the time, even on temples, as they presumably appeared in now lost paintings.[132] Ancient Indian sculptures are often embodiments of literary descriptions, or are visual puns, resembling verbal word play. Thus we find the sculptural example of an elephant/bull, the trunk and tusks of the elephant forming the bull's hump and horns and the snout of the bull forming the temples of the elephant; another example, related to "wonder," is the Ganges appearing as both a river and a person.[133]

It was a great step forward in the development of Indian aesthetics when the idea of aesthetic emotion, *rasa,* was connected with the power of suggestion, *dhvani,* that reveals what is above and beyond literal meaning. Its most notable theorist was the Kashmiri Anandavardhana—Ananda for short—who lived in the ninth century CE.[134] Ananda connects aesthetic emotion with suggestion by distinguishing between three levels of the meaning of words and sentences: the primary or literal meaning, the secondary or contextual meaning, and the tertiary or suggestive meaning. Given suggestion, even the oldest, most familiar language, he says, acquires fresh color and elicits an aesthetic reaction in those who have been sensitized by nature and by the study and practice of poetry.[135]

Ananda remains faithful to the view, which he attributes to "wise men," that suggestion, *dhvani,* is the soul or essence of poetry, the word that "lights up a beauty" impossible to any literal or merely decorative expression. "Anything," he says, "is beautiful if a person's mind rises at it, realizing that something special has suddenly flashed before him." He holds that aesthetic emotion, *rasa,* is the

essence of suggestion, and suggestion the essence of poetry, or in reverse, that poetry is based on suggestion and suggestion on aesthetic emotion.[136]

After Anandavardhana, the most distinguished commentator on aesthetics was another Kashmiri, the great tenth-century philosopher Abhinavagupta (Abhinava), who "alone turned poetics into a science."[137] I concentrate on what I take is for him the main point, the ability of poetic technique and knowledge to achieve the universal. It is its universalization that distinguishes aesthetic from ordinary experience. The ordinary experience of people is saturated with the pain of illness, the tiredness of long journeys, the death of relatives, and the weakness caused by ascetic practices. Drama, by the pleasure it gives, can neutralize these negative emotions, calm the sad, distract the ill, and give the weary happiness. And it teaches its spectators the ways of the world and so makes them happy and gives them the wisdom to grow.[138]

Drama and, with it, poetry (and, in principle, music, dance, painting, sculpture, and no doubt architecture) have this effect because the experiences they yield are deeply different from those in ordinary life that they resemble. The sights one sees and sounds one hears in drama and poetry lead to a strange longing that comes from memories that are not fully conscious and are too vague to have an identifiable object. These memories are latent impressions of pleasure or pain, the residues of experiences of an earlier life. For example, in a drama, a character's grief—marked by conventional signs, expressed in metrical, poetic words, and surrounded by the reality-neutralizing decor of a theater—arouses the spectator's own latent memories of grief. This grief by empathic revival of old, vague memories is not grief itself but, by the melting together of all one's thoughts, the taste or *rasa* of compassion. Purified of all direct pain, it is superior to the emotion it is related to.[139] Like any aesthetic emotion, it cannot be directly perceived because an aesthetic experience, that is, a *rasa*-experience (*rasapratiti*), is possible only when the stimuli that arouse it have been generalized or universalized. The clarity, softness, and vigor of the *rasa*-stimulating words are such that the experience they convey is transcendental. Summing all this up in a metaphor, Abhinava says that aesthetic experience "opens like a flower born of magic," without any relation with anything in time or space, or relation with the practical life that precedes and follows it.[140]

Aesthetic detachment is possible because our response in art, basically our identification with the hero of the drama, is sympathetic rather than selfish. Our identification fails to become aesthetic if it is too personal, too concentrated within the individual self—in a modern term, too narcissistic. By this aesthetics, art requires one to be as much out of oneself as in oneself and as much in as

out, and for this reason, it requires nothing less than inspiration, poetic genius (*pratibha*), "which has its seat in the poet's heart, and which is eternally in creative motion."[141] So great is the true poet's accomplishment, says Abhinava, that he can be compared to the God whose will creates the world. "In the shoreless world of poetry," he says, "the poet is the unique creator. Everything becomes transformed into the way he envisions it."[142] By means of the poet's genius, the pleasure of the spectator or reader grows so great, so far beyond that of ordinary experience, that the ego is temporarily transcended and the person enters into a unique state of emotion, the higher, undifferentiated pleasure in which all sensual desire dies, the *rasa* of peace, *shantarasa* (*śantarasa*). The sensitive spectator of a drama, like the mystic, forgets the self, forgets material gain, transcends the subject-object difference, is unconscious of space and time, and at the height of aesthetic experience attains the goal of peace. This verges on and draws toward mystical experience. This is because in aesthetic tranquility we come into contact with the memory of the primeval unity of man and universe, that is, with the primeval spontaneous expression of overflowing bliss that is the creative source of the universe.[143]

Although profoundly mystical, Abhinava accepts the world and the pleasures that humans find in it as real and not, as most often among Vedantic philosophers, as unreal.[144] To him, a follower of Shiva (Śiva), the world is the manifestation of the pure self or supreme consciousness, or as I would put it, objective subjectivity, which contains but transcends all differences. Like Ananda, he sees the *Mahabharata* not only as a vast scripture filled with moral examples but also as a profoundly moving work of literature. As an expert in Tantric ritual and a lover of literary drama, it is easy for him to compare human life with a drama or compare the poet with Shiva, who out of purposeless, spontaneous ecstasy, dances world creation, destruction, incarnation, and salvation, although the poet creates at most the semblance of that salvation.[145] Therefore, despite the contentiousness of Indian aesthetic thought, there is no doubt of the commanding stature and lasting effect of Abhinava. The extent of his influence in India is like that I have attributed to Plato and Plotinus in the West.

The *kavya* philosophy of art and the performing tradition to which it was related remained creative until about the eleventh or twelfth century, when after centuries of successive Muslim invasions the traditions began to falter. Remarkably, the influence of the old aesthetics became prominent again in the Rajput miniatures of the eighteenth century. These miniatures, the pictorial expressions of a revival of Hinduism, are different in style from the miniatures painted for the Muslim (Mughal) rulers of India. In the Rajput miniatures, there is little if

any of the Mughal three-dimensionality or of the hard, realistic Mughal portraiture. In their space, things fit together metaphorically and emotionally rather than realistically. The themes of the miniatures are likely to be based on the old Indian mythology and poetry. Sometimes a whole series of miniatures is composed of faithful illustrations of the Sanskrit literature. The best example of which I know is a series of well-composed, mostly brightly colored miniatures that illustrate the famous love story of King Nala and the superlative woman Damayanti.[146] The illustrations are not to the original tale in the *Mahabharata,* but to a version by the twelfth-century court poet and philosopher Śri Harsha, who elaborates it in the longest, most difficult, most "ornate," pun-filled, purposely ambiguous, wandering, mannered, and perhaps best of the epic *kavyas,* the *Naisasdhacarita.* One set of these illustrations consists only of drawings to which no color has yet been applied. On the drawings, there are written instructions to the artist that insist on faithfulness to details mentioned in Harsha's poem but left out of the sketch.[147] The learned person or persons who made these corrections were able to understand the difficult text and able, it may be assumed, of grasping its stylistic expedients, an exhaustive exhibition of the effects taught by the *kayva* aestheticians.

CHINA: REVERBERATIONS OF THE LIFE-BREATH

With Chinese theory I can be relatively brief because I have already dealt in some detail with a number of its aspects. To approach Chinese aesthetic thought in its own terms, I begin with the all-important concept of *ch'i* (*qi*).[148] Its early meanings include vapor, breath, exhalation, and life-spirit. *Ch'i* is not at all abstract because, among other things, it is the very air we breathe. The source of our life, it increases as we swell in anger, diminishes as we shrink in old age, and disperses as we die. Considered to be the universal energy, present everywhere in different concentrations, it came to be regarded as not only the life in living things but also as that into which solids condense and dissolve.

The concept of *ch'i* plays an essential role in the theory of every Chinese art. In literature, it is the rhythmic force that impels, changes speed, connects, and gives a literary composition its unity.[149] Elusive though it is, it can be captured if one shares the tension-creating twists and turns by which words are related to one another. A literary composition is considered, as by Herder and other Europeans, to resemble a living organism, and, beyond that metaphor, as perhaps literally alive.

For calligraphy and painting, the concept of *ch'i* is most used in combination with *yün* (*yun*), meaning "reverberation" or "resonance." *Ch'i-yün* (*qi-yun*) is

therefore often translated as "reverberation of the life-breath." In the first of the famous canons of Chinese art, enunciated by Hsieh Ho (Xie Ho) in the late fifth century CE, this term is coupled with another, *sheng-tung* (*sheng-dong*). Leaving aside relatively unimportant variations, these terms can be translated by two parallel phrases, first, "the reverberation of life-breath, that is, the creation of movement," and taking the second term to continue the first, "the reverberation of the life-breath creates life-movement."[150*]

In the early development of Chinese art theory, *ch'i-yün* appears to have been used to indicate the life force of the objects that were depicted, which is the force that the painter aims to capture. The force might be supposed quite real. A fourteenth-century critic believes that success in infusing it into a painting ensures, for instance, that "a painted cat hung on a wall may stop the rats" and a painted "venerable sage or war-god can be prayed to and its voice will answer."[151] As the term widened its meaning, it took on cosmic and moral overtones and expressed the creative force of the universe, in which everything takes part. The presence of *ch'i* in a work of art was then equivalent to the presence in it of the vital spirit of the universe, the *tao*.[152]

Based on this idea of the unifying vital spirit, Chinese aesthetics tends to specify its subprinciples as polar opposites. Tung Ch'i-ch'ang emphasizes such compositional principles as "opening and closing" or "open-join" (*k'ai-ho*), "void and solidity" (*hsü-shih, xu-shi*), and "frontality and reverse" (*hsiang-pei, xiang-bei*).[153] Ideas like these, clarifications or expansions of earlier ones, continued to be elaborated. For example, to bring out the omnipresent activity of *kai-ho*, that is, of *ch'i* as the rhythmically differentiated expansion and contraction of everything within everything, the eighteenth-century critic Shen Tsung-ch'ien (Shen Zong-jian) writes the following:

> From the revolution of the world to our own breathing there is nothing that is not k'ai-ho. If one can understand this, then we can discuss how to bring

*The passage in Hsieh Ho, in which the famous canons first appear, says that from ancient times to the present, individual painters have excelled in one or another branch of painting and few are able to combine them. To the question, "What are these six elements?" the text answers: "First, Spirit Resonance which means vitality; second, Bone Method which is (a way of) using the brush: third, Correspondence to the Object which means the depicting of forms; fourth Suitability to Type which has to do with the laying on of colors; fifth, Division and Planning, i.e. placing and arrangement; and sixth, Transmission by Copying, that is to say the copying of models."

the painting to a conclusion. If you analyze a large k'ai-ho, within it there is more k'ai-ho. Even down to one tree and one rock, there is nothing that does not have both expanding and winding up. Where things grow and expand that is k'ai, where things are gathered up, that is ho. When you expand (k'ai) you should think of gathering up (ho) and then there will be structure; when you gather up (ho) you should think of expanding (k'ai) and then you will have inexpressible effortlessness and an air of inexhaustible spirit. In using [the] brush and in laying out the composition, there is not one moment when you can depart from k'ai-ho.[154]

As this passage shows, in China, too, the work of art is always regarded as an organism the parts of which have an always changing, always self-restoring balance with one another. Always there is the sense of forces that give life by their harmonized opposition within and between the parts and parts of parts that make up the whole. Always there are expansion and contraction, the alternation of dense and rare, of closed and open, of excessiveness restrained and want supplied, and, if one sees sharply enough, of individual and universe containing and contained within one another.[155]*

To end this series of references to Chinese aesthetic principles, I cite the seventeenth-century critic Wang Fu-chih (Wang Fu-zhi), who does not believe in the impossible effort to hold everything poetic under conscious control.[156] Poetry, he insists, is more concerned with life than with literature as such because it is a continuation of the processes of the universe as human consciousness interacts with it, so that poetry helps to recreate the human universal bond that too many persons have broken.

*In a fuller account it would be necessary to comment on the extraordinarily developed technical terminology of the Chinese criticism of art, which makes it possible to give stylistic descriptions of Chinese paintings an exactness hard to attain in Western criticism. Take for example the sheer number of brushstrokes known as *tsun*, which as a noun is often given the unilluminating translation "wrinkles." *Tsun* are used to shade, model, or give texture to paintings, especially of trees, rocks, mountains, and terrain in general. There are about twenty-five varieties of *tsun*, divided into three main groups. The similes that follow do not of course give an adequate idea of the *tsun*'s formal resemblances and differences. The *tsun* of the first group are compared to differently related hemp fibers and to brushwood, lotus-leaf veins, raveled rope, clouds, cattle hair, torn nets, lumps of alum, whirlpool eddies, and devil's-face wrinkles. Those of the second group are compared to the halves of a split bean, raindrops, and thorns. Those of the third group are compared to small or large axe-cuts, axe splits, severed bands, severed bands dragged in mud, nails pulled up from mud, horses' teeth, and stiff iron wires.

Wang is surely referring to two doctrines of the Neo-Confucians: the one that the human mind and nature are identical, and the other that the virtue of "humanity" should be widened to fit this identity. In a famous essay of 1527, the Neo-Confucian philosopher Wang Yang-ming wrote, in a traditional but newly elaborated vein, that when a person sees a child about to fall into a well, he cannot avoid alarm and sympathy; and much the same happens when he hears and sees birds and beasts about to be slaughtered; and he cannot help feeling pity when he sees plants broken and destroyed. Evidently, the same humanity that joins him with the child joins him with the birds, beasts, and plants. True, even plants are living things and so they are open to fellow feeling, but the shattering of tiles and a stone also gives him a feeling of regret, which shows that his humanity unites him with tiles and stones as well. "This means that even the heart of the small (unlearned) man must have this humanity which unites him (potentially) to all things."[157] And so, transcending itself, the human heart becomes one with anything and everything, and thereby shows itself to be essentially its innate consciousness of the good (*liang-chih, liang-zhi*) that is the very force of goodness that unites the cosmos—in Neo-Confucianism, like Neoplatonism, oneness and goodness are identical.[158]

JAPAN: BEAUTY TEMPERED BY REGRET

In my description of Japanese aesthetics, I concentrate on the classical or "medieval" period as being a defining one for the culture. The Japanese emphasis on sensitivity to nuances of feeling and expression was characteristic, to begin with, of small, sophisticated groups of aristocrats. These aristocrats lived and created in accord with the ideal of spontaneous but refined self-expression. Proud of their aesthetic refinement, they depreciated the types and genres of art that were given over to professional artists. It was the aristocrats' shared way of life, as sharply defined as that of the Chinese literati, that made it possible for them to express themselves by means of allusions that would be lost on a less esoteric audience.[159]*

*For Japan, the medieval period is reckoned in different ways. The *Cambridge History of Japan* conceives of the Middle Ages as beginning toward the end of the twelfth century and ending during the middle of the sixteenth. But Jin'ichi Konishi, the learned, original historian of Japanese literature on whom I draw in this paragraph, has a much more extended conception of the Middle Ages and, conceiving them as divided into Early, High, and Late periods, begins them in the second half of the ninth century and ends them with the first half of the nineteenth.

Along with attitudes toward aesthetics, Chinese and Japanese painting share so much that it is hard to make a general stylistic distinction between them, especially when the

In the eleventh century, the most sensitive literature was written by women of the aristocratic class. But from the twelfth century on, Japanese literature was increasingly sustained by recluses who had renounced the world mainly to devote themselves, not to Buddhism, but to art. Among the recluses were nobles who had given up their worldly status (though they probably lived from property they retained). These recluses kept up their passionate interest in art and lost no chance to praise the way the moon looked. Kamo no Chomei (1155–1216), who after becoming a recluse lived in a hut in the mountains, relates how he lost his "attachment to fame and profit" and entered the path "of freedom from illusion" by giving up social intercourse, by refusing to grieve over misfortune, and by retaining his "aestheticism." For aestheticism (*suki*), he says, also means "feeling touched by the bloom and fall of flowers, and longing for the rise and set of the moon."[160]

Yet the aesthetic responses of the Japanese were both richer and more disharmonious than this stated devotion may imply. One obvious reason, which has been called a "fracture of meaning," was the disharmony between the art's Japanese substance and its Chinese form.[161] Thus, the great literary scholar Motoori Norinaga (1730–1801) argues that the Japanese should accept the ancient Shinto account of the world's creation and not the mistaken cosmological notions of

subjects of the paintings are common to both. However, Joan Stanley-Baker, a well-informed historian of Chinese and Japanese art writes, unafraid, "Chinese forms tend to be self-contained and relaxed, while Japanese forms are affected by the overall composition of a picture, and emotional tension charges both motifs and the space around and between them. The inward-directed motifs of Chinese paintings tend to stress solidity and depth (an effect often achieved by the complex interweaving of brushstrokes), whereas the motifs in Japanese paintings, each conceived as part of a larger emotional whole, tend to reach laterally across the picture-plane in a 'layered' technique and to be draw in together by the treatment of the intervening space. The ease and grandeur of Chinese art generate forms which are malleable: each can be slightly changed in space without disturbing the overall visual harmony. Japanese art, by contrast, is often focused on nuances of emotions, and works tend to be so charged with tension that altering the position of any part would drastically change the overall effect."

According to Konishi, Chinese, Japanese, and Korean literature are alike in making the assumption that author and audience share the same classic world and sense of what constitutes literature. But Japanese literature is more emotional, that is, more sensitive to mood, more introverted, and only lyrical, not political. In contrast, Chinese literature, along with the Korean, is "volitional, intellectual, and extroverted." That is, Chinese literature has a greater interplay of the introverted (the Taoist or Buddhist) with the extroverted (the Confucian) and is more explicit and socially critical. These generalizations of course need both examples and qualifications.

the Chinese—where the Shinto texts are especially inadequate or implausible, he points out that all that concerns the gods and goddesses is beyond human understanding. Unfortunately, the ancient records of the Japanese are written in Chinese script, but they should be interpreted, he holds, in the light of their Japanese nature and not of the moralizing conceptions of the Confucians or Buddhists. To him, the "ornateness" of Chinese writing, with its artificially ordered antitheses and its forms divorced from their content, is dull and cold and does not speak to the heart, while the Confucian "logic" of the Chinese, which grasps everything in terms of reward for good and punishment for evil, falsifies the unpremeditated simplicity and beauty of life.[162] Literature, he says, should break through the superficial surface of didacticism and rationality and penetrate the inborn heart granted the Japanese by their gods of creation. Poetry must be heartfelt, for, as is said in the preface to the *Kokinshu* (a tenth-century anthology), "so much happens to us while we live in this world that we must voice the thoughts that are in our hearts," and with poetry, not force, "wake the feelings of the unseen gods and spirits, soften the relations between man and woman, and soothe the spirit of the fierce warrior."[163]

In keeping with his preference for native attitudes, Norinaga emphasizes the old Japanese sensitivity to *aware*. *Aware* was at first the exclamation, the "ah!" of surprise or delight, said to have been evoked in the ancient poets by, for instance, the birds' melancholy calls or by the rain in the spring. The word *aware* came to be used for whatever was emotionally moving, especially if beautiful. In the later poets, the word means that the joy aroused by beauty is accompanied by the regret that beauty is fragile and short-lived. So to Norinaga, the word *aware* or the phrase *mono no aware*—*mono* is literally "thing(s)"—expresses the ancient, now rare sensitivity to the perishable beauty of things. It most naturally comes, Norinaga says, with profoundly moving love and, even more so, with grief, to which love often turns. The sharing of this feeling with someone else is a great consolation and pleasure, he says, which explains the need to write stories and poems. No one who lacks the spontaneous, unreasoned experience of *aware*, which is deeper than reason or will, can distinguish beauty from ugliness or good from evil.[164]

In Japanese art, another basic aesthetic concept is *yūgen*, a state of mysterious, sad depth. This is the emotion evoked by ideal beauty. Etymologically made up of *yū* (deep, dim, or hard to see) and *gen* (relating to the primordial essence), *yūgen* refers to the "profound truth" of the universe. It is that which, unseen and indescribable, lies below the perceived surface of things. The emotion that can be expressed by words alone is inevitably shallow. But soundless, colorless,

inexplicable, ineffable, *yügen* can arouse sudden, painfully pleasurable tears. It is there in the simple, perfect Chinese vase, in the bright cloud that hides the moon, and in the beautiful flow of sad music. To the great Noh actor, writer, and theorist Zeami (1363–1443), who was deeply influenced by Zen Buddhism, *yügen* is the profound inward beauty that manifests itself outwardly. But all beauty's elegance, Zeami says, is perishable, and so *yügen*, which is cosmic truth, invokes feelings of mutability and sadness as well. Very few actors possess it, he says, but those who do are most admired by their audiences. It can be revealed by the actor's grace, but even more by his stillness, when, going beyond conscious judgment, the spectator becomes one with the performance. At the highest stage of the art of Noh, the actor reaches nonduality, in which being and nonbeing are no longer different from one another. Then "admiration transcends the comprehension of the mind, and all attempts at classification and grading are made impossible," for art has caused the miraculous to flower.[165]

There are many other Japanese terms, or rather aesthetic concepts, that might be invoked, but of these I add only *sabi*, which in Noh drama is closely allied with *yügen*. *Sabi* is the beautiful sense of loneliness such as that felt by someone who, traveling in a desolate place, senses the pathos and insubstantiality of life. Desolation's beloved beauty, *sabi*, was taken to be based on an intensified deprivation, or, said others, an intensified stillness.[166]

The aesthetic terms and attitudes I have just described are those of the self-consciously aesthetic Japanese, but they are not as characteristic of the people at large or of the popular painters, sculptors, singers, and dancers, who gave the people less introverted aesthetic pleasures. It is this popular art that was enjoyed by the Japanese regardless of their status in life. In the larger world, from which the smaller aesthetic worlds were not isolated, art might express the feeling that good emerges only from suffering, but also that the gods take compassion on sufferers, that there are magical words that move gods and humans, that the underdog deserves sympathy, that impetuous, sincere acts should be admired, and that one can take great satisfaction in suppressing and sublimating oneself. I cannot complete this list of values, which are, like *aware*, *yügen*, and *sabi*, both aesthetic and social, but only note how different they are and how much vitality they lend Japanese art as a whole.[167]

THE COMMON UNIVERSE OF AESTHETIC DISCOURSE

I have finished my account of aesthetic theories or attitudes—of the Neoplatonic or otherwise mystical thought of Europe; of the fertility-seeking, community-binding powers of Africa; of the dramatic art leading to rapt identification and

releasing equanimity of India; of the interlocking vital forces of China; and of the indescribable, often sadly pleasurable overtones and undertones of Japan. Now, to complete the aim of this chapter, I try to make out what these theories may have in common, what might be generalized into principles that bear on a universal human aesthetics. Because I have avoided slanting the description of the theories to make them spuriously easy to generalize from, the most obvious difficulty is their heterogeneity. To balance this heterogeneity and incompleteness, which I have often noted, I allow myself to refer to concepts dealt with elsewhere in this book.

Finally, then, I ask what not too obvious or too questionable generalizations can be drawn from the aesthetics of the five cultures I have outlined? (I need not add, before I begin, that I'm under no illusions about unequivocal answers.)

First, the conception of art and, with it, of beauty in and for itself is highly variable and often implicit rather than explicit. Among the Bamana, for instance, in the absence of other, deeper values, art is taken to be trivial. With respect to what is merely ornamental, the Baule attitude is similar. In many cultures, the idea of beauty tends to be equated with the difference between what is well made as against badly made, the term "well made" having a moral overtone like that of authenticity, honesty, serious intention, and even devoutness. Often a "well-made" object is the equivalent of what Westerners consider a "beautiful" one. I think, too, that there are overtones everywhere (East, West, North, and South) of beauty in the sense of the attractiveness of a man and, especially, a woman, and hence of the images that represent them and, in a borrowed sense, of the clothing and ornaments that help make them attractive.

Second, non-Islamic Africa and the modern West excepted, there is a general tendency to set the literary arts above the others and to model all aesthetics on that of literature and, in China and Japan, of calligraphy, in the absence of which the literature could not have existed. Initially, Chinese calligraphy owed its importance, which was magical, to the reverence of the sources it transcribed and the magic of the impulse that moved the hand of the author-transcriber, so that at first the scholar painting of China derived its prestige from the prestige of calligraphy. The great Chinese writer, calligrapher, or painter enjoyed the status of a great personage. But when, for example, in ancient Greece, India, or China, sculpture was regarded as the work of a professional, who works in terms of traditional knowledge and not spontaneous inspiration, the sculptor might be regarded as an estimable, even important person, but his status as an artist was denied or put into question. In Europe, we know, this attitude began to change during the Renaissance.

Third, primarily in black Africa, the status of the artist has depended on prestige related to his (or sometimes her) age, initiation into sacred matters, and the importance—sometimes equivalent to the secrecy—of a work's ritual purpose. Often, the importance of the function of a "work of art" far outweighs that of the person who has been chosen to make it. But in Africa too, there have been artists who were regarded or insisted on being regarded as "geniuses." An aggrandizing self-importance is a constant human possibility.

Fourth, at least locally, the style and personality of an artist is recognized as his or hers. Such recognition may have been confined to relatively small areas because of differences in language, the absence of open markets, and the absence of communication and written records. China excelled in its insistence on the individual personality of the writer, calligrapher, or painter, and the classical Indian writers were well aware of it. I have found it remarkable that the Bamana idea of an artist's identity, or double, shadow, or reflection, is quite like the idea that I have myself repeatedly used when defining art.

Fifth, there is a consistent likeness in the structures of art. For instance, the aesthetic vocabulary of the Bamana could easily be adapted to the expedients of an improvising jazz musician. In spite of the unfamiliarity of the terms to us, the content of the terms is just what might be expected of Westerners or, for that matter, of Indians, Chinese, and Japanese: to become or remain interesting, a received, expectable, that is, conventional structure for each form of art has to be imaginatively varied, though never so imaginatively or emotionally—not made so hot, as Westerners fond of jazz might also say—that the structure of the art is destroyed. The Indian theory of inspired suggestion depends on the relatively conventional character of the text that is made fresh again by the poet's power of verbal suggestion. Though I have no desire to attempt it, it seems to me that nearly everything that has been written here on Chinese art and the life-movement that animates it could be rephrased using the Bamana vocabulary. As for the Japanese and Chinese, sensitivity is adjusted—as it is everywhere, even when the vocabulary is undeveloped—to rising and falling, opening and closing, and every other verbal, visual, and musical rhythmic and compositional device.

Sixth, there are interesting variations in the different peoples' sense of the "psychic distance" of art from mundane reality. Legends of works of art so realistic or life infused that they turned literally alive seem to be found everywhere. When the art is sacred, the possibility of an indwelling deity may be accepted. However, at least in India and Africa, the life of a statue or mask may come to an end: however handsome, an African mask that has served its function and need not be kept for a future performance was likely to be treated as of little

value, an attitude that is the reverse of the near-religious respect in other cultures for great works of art as such. In China and Japan in particular, the work of art could be great in itself, in virtue of the quality and immediacy of touch that had created it. But in India and, to a lesser extent, in Japan and Europe, a theory of psychic distance or artistic detachment was developed to account for the artistry of art. In India, the universalization of emotions was an abstraction from any particular individual's emotion, and the doctrine of *rasadhvani* culminated in the *rasa* of peace, *shantadhvani,* which is one of near-mystical detachment. But while in India impersonal emotion was the essence of art, in China and, with it, Japan, there was detachment from any emotion (in the usual sense) when it was decided that the aesthetic quality—the variable dynamism—of calligraphy was quite apart from the verbal meaning or emotive qualities of the text. In Japan there was also a principle, reminiscent of Buddhism (and not antagonistic to the *rasa* of peace), according to which the goal of art, like that of life, is detachment, so that *aware* and *yügen* can be equated with tranquility and with Buddhist "suchness" or "emptiness."[168] In Europe, the idea of psychic distance was cultivated by the romantics along with that of the sacredness of art as such and of art for art's sake. As has been shown, the notion of psychic distance (from everyday, realistic experience) has often justified abstract painting and the ascription to it of mystical virtues.

Seventh, in every one of the cultures discussed, everything in art, as understood in Western terms, is in the end dependent on a great, singular, mysterious force and the subforces that can in some way or other be summoned up or blocked. This is of course true if the "art" is part of a sacred ritual, or if the art— like the great classical Greek sculpture of Zeus, or like medieval paintings, or like Michelangelo's Sistine frescoes, or like the great images of the Buddha or Shiva—is itself sacred or is the sacred representation of something even more sacred, whose life and power depend on the indwelling life and power of Zeus, Christ, the Buddha, Krishna, or Shiva. This force and its power, like the creative power of any maker, are later assimilated to the inspiration that an artist needs to attain exceptional success. It has been natural to assimilate sacred art to prayer and to hope that art alone or in ritual performance will guard the well-being, in every sense, of the people it represents. When the literal relation to God, Shiva, the Buddha, or any sacred force is weakened or lost, it retains a power in a symbolic sense. I suppose that it is the sense of the possible closeness to a cosmic creator that stimulates the idea that poet or artist is godlike in that he or she creates or recreates a whole living reality. Certainly, this is Bharata's view of the dramatist and Leonardo's of the painter, and something like it animates Wagner's

idea of the opera as the total work of art, and must have animated some of the creators of cinema.

Note that in both the sixth and seventh points, I have related art to mystical experience, or at the least, to something transcendental, or to what may be called "fusion," or on a more modest level, "empathy." These experiences, emphases, and terms all seem to be related to the importance that humans everywhere ascribe to symbolism and to the relation between the cosmic, the social, and the individual human's abilities to create.

. . .

In this discussion, I have lost the desire to try—and have not by accident succeeded—in reducing these different cultural views of aesthetics to a few easily assimilated generalizations. On the contrary, each generalization has been shown to refer to aesthetic conceptions that would become far less interesting if deprived of the color of their historical surroundings, so my generalizing passion, though now and then indulged, has not overcome the specificity of their differences. But to the extent that my discussion has been convincing, I have shown that all the suggested similarities and dissimilarities are best appreciated as belonging to a common universe of discourse, in which the humanity of the art is never quite concealed by its locality, because its local appearance is most clear when viewed from some distance beside or within the other, contrasted localities, which together make up a recognizably common universe. In this universe everyone who takes enough trouble can communicate, whether haltingly, fluently, or eloquently, with everyone else.

FINAL THOUGHTS

If I were forced to state what I take to be the most general underlying theme of the present book, it would be this ability to communicate. Such a common universe exists because it is possible to balance the uniqueness of works of art, which is their foreignness, against the generalization that opens them to the discovery of their common traits. The open aesthetics advocated at the beginning of this book and the balance advocated here, toward its end, establish between them an intellectual area within which the uniqueness of everything in art is to a surprising degree communicable by means of empathy heightened by attentiveness and learning, and by the generalization that reveals the likeness concealed under dissimilar surfaces and distracting details.

The first condition of the open aesthetics advocated here has been the refusal to begin with any set of exclusionary principles. The one allowed exclusion was that of any aspect of experience that did *not* affect the imagination. This open-

ness made it easy to assume that art has existed everywhere among humans because it has served the inescapable need to imagine. Each human brain, we discover, is curiosity inborn; inborn curiosity needs imagination to reconnoiter what its physical projection, the eyes, are not able to see or its physical explorers, the fingers, are not able to feel; and imagination, in turn, needs art, or rather, takes the form of art in order to make the imagined possibility less fleeting and more vivid. As was said in the beginning, art exists because it satisfies the inescapable human hunger for imagined experience in all of its imaginable variations. It is this conclusion that opens the journey toward the understanding of art everywhere.

When these and other ideas were joined in the theory that ends the first chapter of this book, the result was a kind of indeterminacy. Art's problems showed themselves to be better fitted to the permissive logic of yes and/or no than to the usual two-valued logic of yes or no. This became clear when some of art's dichotomies were encountered, including the contrast between art and non-art, the uneasy relation of visual experience with verbal description, and the conflicts between absolute and relative standards of judgment, personal and impersonal expression, and traditional and antitraditional art. It became obvious that the dependence of thought upon diametrically opposed terms conceals the possibilities that lie between them and sets us at odds with the reality whose elusiveness provoked the dichotomous ideas.

The recognition that it is best to be cautious in the use of the two-valued, yes-no logic for the understanding of art gives reason to turn to disciplines, such as anthropology and sociobiology, that can give a relatively full reflection of the complexity of art's social life. These disciplines enable an understanding of art that is both more comprehensive and closer to life—in an anthropological sense, thicker.

. . .

There are a few general ideas that I have implicitly or explicitly applied everywhere, and I should like to recall them here because they have lighted our path. One of these ideas is that of the complexity of the notion of context. The art that we want to grasp is often exhibited far outside of its natural context. Whether it is or not, we recognize, at least in theory, that the art is most revealing when understood as if it were in its own context. The contexts we learn about on museum walls or, more fully, in books are, of course, highly selective and far from complete. Furthermore, when we reconstruct the context of a work of art in our minds, we reconstruct it within the embracing context of our own lives. This reconstruction is artificial, but it can serve a serious desire to learn. Given

the desire, one can learn Chinese, Japanese, Sanskrit, or Hindi wherever there is a competent teacher. Likewise, given a competent teacher, we can learn Chinese, Japanese, or Indian art anywhere, so that although the learning takes place within the context of a different culture, it can be sound as far as it goes. But just as a language learned after childhood is spoken with an accent, the art one sees out of its full (perhaps no longer existent) context is seen with a foreign accent. This foreignness may make it possible to appreciate characteristics of the art that familiarity has made invisible to those who were born to it. Another possible advantage is that it becomes easier to see the characteristics that demonstrate how art can meet cross-societal standards, for one can see the work of art as it is in its native place and yet see beyond it as it is reveals itself almost everywhere. We have seen a set of standards, explicit in Western, Chinese, and Chinese-influenced art, that can be accepted as approximately universal. To the extent that this holds true, one may, without flinching, deny that every art tradition is to be considered the equal (by virtue of its incommensurability at least) of every other art tradition, and, by means of that denial, justify one aesthetic tradition over another, at least in what it excels. A fully tolerant pluralism misses some judgments that may justifiably depart from it. Ranking is not necessarily absurd or evil.

Is there really an aesthetic that cuts across all human cultures? In this book there is a sometimes latent, sometimes overt acceptance of this possibility. If pressed, I'd answer the questions with both a yes and a no. The reason for the no, given earlier in this chapter, is the evidence that the identity of each of the main varieties of aesthetics becomes too vague when it is deprived of what may appear at first sight to be only its local color.

This generalization, which holds as well for the aesthetic principles accepted by different artists, leads me to repeat what I have said earlier on the difference between generalizations and their examples. An example does not exist simply in its right as an example but has an independent existence, with a rich, maybe endless set of characteristics of its own. That is, a clear abstraction has a clear direction, but a good example has a life apart from the abstraction it illustrates. The more fully the example is described, the more directions it leads in, until, imagined from its innumerable possible angles, it leads everywhere imaginable.

· · ·

All true, I think, but I am unhappy to end so, as if the force of art could be fully understood by plausible reasoning alone. As I say this I remember two simple, anonymous lines from an anthology compiled in Japan in the tenth century, "If I

love and keep on loving / can we fail to meet?" These lines fit in with the understanding that art is both an instinctive and a willed response to the fear of loneliness, which has as many antidotes as it has varieties.[169] But art, as I argue, is present in every form we give our acts and is by nature inexhaustibly variable, and not at all as single or bare as a longing for the possible lover. Art is more because it reveals the inward forms of individual and culture; because it opposes anarchy and apathy by the force with which it orders and arouses; because it opposes stasis by the force with which it creates, disrupts, and recreates order; and because it insists, quietly or shrilly, on a human response. If the response is full, imaginations and memories coalesce and, in a manner of feeling, the many are almost one.

This semimystical attitude leads me to a metaphor that occurs toward the end of an ancient Chinese poem. The interpretation I give it cannot be exactly what the poet had in mind, but it is compatible with his kind of thought, and I choose it because I want to end with words that have a simple enough literal meaning but suggest more than they say directly. The poet is the seventh- or eighth-century hermit Han-shan (Hanshan, Kanzan in Japanese), in translation, Cold Mountain. He's going home, he says, by a laughable path—in Zen art, he and his friend with the broom, Shih-te (Shide, Jittoku in Japanese) are often painted with smiles as round as children draw them. The poem, which has no title in the original, is written, as usual with Han-shan, in colloquial, not literary Chinese. The first words, "the path," are the translator's own invention:

> The path to Hanshan's place is laughable,
> A path, but no sign of cart or horse.
> Converging gorges—hard to trace their twists
> Jumbled cliffs—unbelievably rugged.
> A thousand grasses bend with dew,
> A hill of pines hums in the wind.
> And now I have lost the shortcut home,
> Body asking shadow, how do you keep up?[170]

It's the last two lines that I want to comment on. Because Han-shan is Buddhist, I interpret going home as going toward enlightenment, and interpret "body" as the person trying to get to enlightenment by a shortcut he's lost sight of. Because Han-shan is also a poet, an artist, I interpret "shadow" as the inseparable apparition—dream, idea, ideal, vision—that is leading him on, whether toward home or not he doesn't know. The shadow's shapes are those the human being projects, the art that, even when lifelike or lifeworthy, is no more than the

HANDS LOOKING FOR ONE ANOTHER.

DRAWING BY BEN-AMI SCHARFSTEIN.

illusion of a material work, which never feels identical with anything really real, above all with the loudly sounding, freely moving, fully material human's being. In the poem, it's the body that asks the shadow for an answer, but the shadow's shapes and voices keep changing. But when the light gets so bright that it eats away the edges of the body and makes it cast a deep black shadow, it's not so clear whether the shadow is not the real body and the body the shifting, illusory shadow. Reality and imagined reality collude to change places.

I'm happy to end with this metaphor of the reversibility of reality and illusion or of the force of art's creative power. It marks the end of a long journey that has taken us everywhere, I'd say, if only I knew where everywhere was. We may not have got as far as we'd hoped, but it's been captivating all the way. Thanks for coming along with me and keeping me company.

NOTES

This book is too wide-ranging to make a single bibliography useful, or indeed realistic. My reading lists on a variety of subjects appropriate to each section of this book appear throughout the endnotes. These lists are in no case meant to be complete, and the absence of a particular book is not meant to imply that it is not important. With quite rare exceptions, the books to which I point the reader were all before me and, in one way or another, were all consulted as I wrote.

CHAPTER 1: AN OPEN AESTHETICS

1. W. L. d'Azevedo, "Mask Makers and Myth in Western Liberia," in A. Forge, ed., *Primitive Art and Society,* London, 1973, p. 148.

2. See Werner Muensterberger, *Collecting: An Unruly Passion,* Princeton, 1994, pp. 254–56. A psychoanalyst, Muensterberger describes collecting as a shield against insecurity and an attempt to "hear pronouncements of praise and admiration."

3. See A. R. Luria, *The Mind of a Mnemonist,* New York, 1968. R. E. Cytowic, *The Man Who Tasted Shapes,* Cambridge, MA, 1998, gives a more general description of synesthesia. K. T. Dann, *Bright Colors Falsely Seen: Synaesthesia and the Search for Transcendental Knowledge,* New Haven, 1998, concentrates mainly on the mystical attractions of synesthesia. J. Harrison, *Synaesthesia: The Strangest Thing,* Oxford, 2001, describes research methods and presents data and doubts. V. S. Ramachandran and E. M. Hubbard, "Hearing Colors, Tasting Shapes," *Scientific American,* May 2003, pp. 42–49, summarizes recent

experiments and makes interesting speculations. [My footnote cites Luria, *The Mind of a Mnemonist,* pp. 22–23.]

4. E.g., in B.-A. Scharfstein, *The Dilemma of Context,* New York, 1989, I argue that contexts are essential to understanding but, because they are endlessly complicated, can be grasped only in part. I go on to argue that the only reasonable responses to this dilemma are intermediate between relativism and absolutism. My *Comparative History of World Philosophy,* Albany, 1998, gives extensive illustrations that show that likeness can be discovered when even contextually distant philosophies are compared.

5. It was only well after I had arrived at this conclusion that I was reminded by a friend that John Dewey expresses similar ideas. See his *Art as Experience,* New York, 1934, chap. 1. See also his *Experience and Nature,* in *The Later Works,* Carbondale and Edwardsville, 1981. Two contemporary aesthetic philosophers who have expressed similar views are Arnold Berleant, *The Aesthetics of Environment,* Philadelphia, 1991 (e.g., p. 59); and Crispin Sartwell, *The Art of Living,* Albany, 1995 (e.g., p. xi).

6. [My footnote refers to L. S. Squire and E. R. Kandel, *Memory: From Mind to Molecules,* New York, Scientific American Library, 1999, p. 197. Experiments showing the neural development of adult brains are described in G. Kempermann and F. H. Gage, "New Nerve Cells for the Adult Brain," *Scientific American,* May 1999, pp. 38–43.]

7. I quote from Y. Menuhin and W. Primrose, *Yehudi Menuhin Music Guides: Violin and Viola,* London, 1976, p. 7; and Charles Rosen, "On Playing the Piano," *New York Review of Books* 46.16, Oct. 21, 1999, pp. 50, 52. Similarly, Chopin's love for the piano is documented in A. Walker, ed., *Frédéric Chopin,* 2nd ed., London, 1979, p. 251 n. 22.

8. R. Alberti, *To Painting: Poems,* trans. C. L. Tipton, Evanston, 1997, p. 11.

9. Close is quoted in M. Kimmelman, *Portraits,* New York, 1998, p. 237.

10. J. Elkins, *What Painting Is,* New York, 1999, p. 161. Elkins often invokes the materiality of painting and the excitement of achieving some transcendence by its means. He makes extended comparisons of painting with alchemy.

11. Robert Pinsky, *The Sounds of Poetry,* New York, 1998, p. 4.

12. See W. J. M. Levelt, *Speaking,* Cambridge, MA, 1989, p. 413, for a careful description of the whole process of speaking.

13. On gesture and facial expression, see B.-A. Scharfstein, *Ineffability,* Albany, 1993, pp. 7–11; on the musicality of speech, pp. 35–36. For documentation and detail on gesture and facial expression, see H. Friedman, "The Modification of Word Meaning by Nonverbal Clues," in M. R. Kay, ed., *Nonverbal Communication Today,* Amsterdam, 1982; and M. Argyle, *Bodily Communication,* 2nd. ed., London, 1988, pp. 107–119, 145–47. See also V. Bruce and A. Young, *In the Eye of the Beholder: The Science of Face Perception,* New York, 1998, chap 6.

14. Quoted by Adam Zagajewski in his book *Another Beauty,* New York, 2000, p. 128.

15. Robert Frost, "Some Definitions," 1923, in Robert Frost, *Collected Poems, Prose, and Plays,* ed. R. Poirier and M. Richardson, New York, 1995, p. 701. See M. Richardson, *The Ordeal of Robert Frost,* Urbana, 1997, pp. 220–21.

16. Wallace Stevens, "The Noble Rider and the Sound of Words," 1941, in Wallace Ste-

vens, *Collected Poetry and Prose,* ed. F. Kermode and J. Richardson, New York, 1997, p. 665. See J. McCann, *Wallace Stevens Revisited,* New York, 1995, pp. 59–60.

17. M. Csikszentmihalyi and R. E. Robinson, *The Art of Seeing: An Interpretation of the Aesthetic Encounter,* Los Angeles, 1990.

18. H. Morphy, "The Anthropology of Art," in T. Ingold, *Companion Encyclopedia of Anthropology,* London, 1994, pp. 662–63.

19. D. Maybury-Lewis, *Millennium: Tribal Wisdom and the Modern World,* New York, 1992, pp. 147–53 (pp. 152–53 quoted).

20. S. Zeki, *Inner Vision: An Exploration of Art and the Brain,* New York, 1999, p. 1.

21. S. Zeki, "The Disunity of Consciousness," *Trends in Cognitive Sciences* 7.5, May 2003, pp. 214–18; available online (www.trends.com/tics/).

22. For a varied idea of the current study of consciousness, see the volumes of abstracts, available online, of the annual meetings of the Association for the Scientific Study of Consciousness (www.assc.caltech.edu/). The latest of these abstracts I have seen are those of the ninth meeting, held in Pasadena, in June of 2005. [My footnote refers to A. R. Damasio, *The Feeling of What Happens,* New York, 1999, chap. 6 (esp. pp. 170, 171–72, 174–76) and chap. 7 (esp. pp. 195–200, p. 196 quoted). For my remark on Damasio and the Buddhist theory of knowledge, see B.-A. Scharfstein, *A Comparative History of World Philosophy,* Buffalo, 1998, chap. 13.]

23. See M. Csikszentmihalyi and R. E. Robinson, *The Art of Seeing: An Interpretation of the Aesthetic Encounter,* Los Angeles, 1990, pp. 119–24 (p. 119 quoted).

24. A. Hobson, *Consciousness,* New York, 1999, pp. 218–19, 229. For a lucid survey of relevant ideas, see "Cognition: How Does the Brain Create?" chap. 2 of D. K. Simonton, *Origins of Genius: Darwinian Perspectives on Creativity,* New York, 1999.

25. B. Hrabal, "Dancing Lessons for the Advanced in Age," New York, 1995, p. 117.

26. D. Ackerman, *A Natural History of the Emotions,* New York, 1990, pp. 292–93. For other entertaining examples of ways that writers stimulate themselves to write, see pp. 292–99.

27. See Damasio, *The Feeling of What Happens,* pp. 121–22.

28. G. Underwood, "Consciousness," in *The Blackwell Dictionary of Neuropsychology,* ed. J. G. Beaumont, P. M. Kenealy, and M. J. C. Rogers, Oxford, 1996, pp. 240–46.

29. See D. L Schacter, M. P. McAndrews, and M. Moscovich, "Access to Consciousness: Dissociations between Implicit and Explicit Knowledge in Neuropsychological Syndromes," in L. Weiskrantz, ed., *Thought Without Language,* pp. 242–78. Damasio, *The Feeling of What Happens,* pp. 43–47, tells of the case of "David," who had a very severe memory defect and yet learned to prefer the "good guy" experimenter from the (beautiful but) "bad guy," neither of whom he could in any way consciously remember. Emotional memory was enough. [My footnote is from Damasio, *The Feeling of What Happens,* pp. 121–22.]

30. See D. Howes, ed., *The Varieties of Sensory Experience: A Source Book in the Anthropology of the Senses,* Toronto, 1991.

31. On visual processing and intelligence, I recommend the following sources: H. Barlow, C. Blakemore, and M. Weston-Smith, eds., *Images and Understanding,* Cambridge,

1990, a collection of articles under the headings "The Essence of Images," "Narration," "Making Images," "Images and Thought," and "Images and Meaning"; D. D. Hoffman, *Visual Intelligence*, New York, 1997, esp. chap 1; R. L. Gregory, *Eye and Brain*, 5th ed., Princeton, 1997; S. A. Greenfield, *Journey to the Centers of the Mind*, New York, 1995, p. 32; D. H. Hubel, *Eye, Brain, and Vision*, New York, 1988, pp. 66–87, 95–97; M. Livingstone, *Vision and Art: The Biology of Seeing*, New York, 2002 illustrated with many paintings and dealing especially with color perception and luminance (objective brightness, the objective equivalent of the subjective intensity of light); S. Pinker, *How the Mind Works*, New York, 1997, chap. 4. An authoritative book that deals in detail with the visual areas of the brain is S. Zeki, *A Vision of the Brain*, Oxford, 1993. Zeki's later book, *Inner Vision*, is directly focused on the understanding of art. See also his chapter, "Art and the Brain," in J. A. Goguen, ed., *Art and the Brain*, special issue of *Journal of Consciousness Studies* 6/7, July/Aug. 1999.

32. See Pinker, *How the Mind Works*, pp. 268–75. For a different, more phenomenological account of visual construction, see J. Willats, *Art and Representation*, Princeton, 1997. [Pinker refers to, and I summarize in my footnote, I. Biedermann, "Visual Object Recognition," in S. M. Kosslyn and D. N. Osherson, eds., *An Invitation to Cognitive Science*, vol. 2, *Visual Cognition*, 2nd ed., Cambridge, MA, 1995.]

33. S. Zeki, "The Ferrier Lecture 1995. Behind the Seen: The Functional Specialization of the Brain in Space and Time," *Philosophical Transactions of the Royal Society* (London) B, 2005, p. 1178 (published online June 29, 2005). The same ideas are presented much more briefly and simply in Zeki's well-illustrated article "The Disunity of Consciousness," pp. 214–18; see also Zeki, *Inner Vision*, chap. 7, "The Modularity of Vision."

34. Most of the above remarks on visual defects are from Zeki, *Inner Vision*, chaps. 7 ("The Modularity of Vision") and 8 ("Seeing and Understanding"). Some are from J. C. Marshall and P. W. Halligan, "Visuoperceptual Disorders," in *The Blackwell Dictionary of Neuropsychology*, pp. 759–63, and by the same two authors (signing in reverse order), "Visuospatial Disorders," pp. 763–67.

35. A. W. Young, "Face Recognition," in *The Blackwell Dictionary of Neuropsychology*, pp. 341–42. See also Pinker, *How the Mind Works*, pp. 272–74, and Bruce and Young, *In the Eye of the Beholder*, pp. 233–50 (for brain locations involved in face perception, as identified by brain scans, p. 236).

36. On the oversimple attribution of brain functions to particular areas, see Zeki, *A Vision of the Brain*, pp. 203, 205. On the incidence and severity of face blindness, see the article published in the *American Journal of Medical Genetics, Part A*, June 2006 (as reported in *Time*, September 18, 2006, p. 49).

37. O. Sacks, *The Man who Mistook His Wife for a Hat*, London, 1985, pp. 11–14.

38. Zeki, *A Vision of the Brain*, pp. 328–29.

39. I first came across Semir Zeki's views on art in a report, including references to other relevant research, in the *Economist*, April 3, 1999, pp. 69–71. See S. Zeki, "Art and the Brain," *Daedalus* 127.2, spring 1998, and his *Inner Vision*, especially chap. 19, "The Fauvist Brain," pp. 197–204.

40. Zeki, *Inner Vision*, p. 201. [For my footnote, see the introductory material, including downloadable papers by Zeki, at the Web site of the Laboratory of Neurobiology, www .vislab.ucl.ac.uk. The critique I mention is J. Hyman's "Art and Neuroscience," from the Internet Art and Cognition Workshops," http://www.interdisciplines.org/people/authors/ john_hyman. I owe this reference to Shimon Edelman of Cornell University. See Edelman's "Constraining the Neural Representation of the Visual World," *Trends in Cognitive Sciences*, 6.3, March 2002, pp. 125–31.]

41. R. Latto, "Do We Like What We See?" in G. Malclom, ed., *Multidisciplinary Approaches to Visual Representations*, Amsterdam, 2004, pp. 343–56.

42. See J. LeDoux, "The Power of Emotions," and J. A. Hobson, "Order from Chaos," in R. Conlan, ed., *States of Mind: New Discoveries abut How Our Brains Make Us Who We Are*, New York, 1999, pp. 135–36 and 197 respectively. See also E. Salman, "A Collection of Moments," in U. Neisser, ed., *Memory Observed*, San Francisco, 1982, p. 51; and Squire and Kandel, *Memory*, pp. 15, 167.

43. D. L. Schacter, *Searching for Memory*, New York, 1996, pp. 39–40, 50–51. Quotation from K. McShine, *The Museum as Muse: Artists Reflect*, New York, 1999, pp. 136–38.

44. McShine, *The Museum as Muse*, pp. 136–38.

45. S. Edelman, "Constraining the Neural Representation of the Visual World," in *Trends in Cognitive Sciences* 6.3, March 2002, pp. 125–131, esp. pp. 126–27.

46. D. Semin, T. Garb, and D. Kuspit, *Christian Boltanski*, London, 1997, p. 8.

47. Schacter, *Searching for Memory*, pp. 192–93. The artist in question is Melinda Stickney-Gibson.

48. Schacter, *Searching for Memory*, p. 180.

49. J. Briggs, *Fractals: The Patterns of Chaos*, New York, 1992, pp. 74, 32.

50. For a good, relatively brief summary of psychologists' findings on preference in art up to about 1980, see E. Winner, *Invented Worlds: The Psychology of Art*, Cambridge, MA, 1982, especially chaps. 2 and 4. E. Brattico, "Neuroaesthetics," 1985, is a comprehensive, up-to-date, notably laconic review of the whole field (PowerPoint presentation, available online). Brattico, a member of the Cognitive Brain Research Unity of the Department of Psychology of the University of Helsinki, specializes in the neuroesthetics of music. For a summary of neurological research, see A. L. Strachan, "In the Brain of the Beholder: The Neuropsychological Basis of Aesthetic Preferences," *Harvard Brain* 7, spring 2000 (available online, http://www.hcs.harvard.edu/~hsmbb/BRAIN/vol7-spring2000/aesthetics.htm); supplemented by the same author's "A Portrait of the Artist as a Nutcase: A Perspective on the Biological Basis of Aesthetic Preferences from Neuropsychological Study of Artistic Creativity," *Harvard Brain* 8, spring 2001. I also use H. Kawabata and S. Zeki, "Neural Correlates of Beauty," *Journal of Neurophysiology* 912004, pp. 1699–1705 (available online, www.jn.org); V. Oshin and V. Goel, "Neuroanatomical Correlates of Aesthetic Preferences for Paintings," *Neuroreport* 15.5, April 9, 2004, pp. 893–97; and S. Zeki, "Neural Concept Formation and Art: Dante, Michelangelo, Wagner," *Journal of Consciousness Studies* 9.3, 2002.

For similar research on music, see A. J. Blood and R. J. Zatorre, "Intensely Pleasurable

Responses to Music Correlate with Activity in Brain Regions Implicated in Reward and Emotion, *Proceedings of the National Academy of Sciences* 98.20, 2001, pp. 118–23 (available online, www.pnas.org); E. Braticco, T. Jacobsen, W. de Baene, N. Nakari, and M. Tervaniemi, "Electrical Brain Responses to Descriptive versus Evaluative Judgments of Music," *Annals of the New York Academy of Sciences* 999, Dec. 2003, pp. 255–57; K. R. Scherer and M. R. Zentner, "Emotional Effects of Music: Production Rules," in P. N. Juslin and J. A. Sloboda, eds., *Music and Emotion: Theory and Research,* New York, 2001, pp. 361–92 (a lucid critical summary).

51. Kawabata and Zeki, "Neural Correlates of Beauty," p. 1704.

52. Ibid. [For my footnote on music, see Scherer and Zentner, "Emotional Effects of Music," Blood and Zatore, "Intensely Pleasurable Effects of Music," and Brattico et al., "Electrical Brain Responses to Descriptive versus Evaluative Judgments of Music."]

53. Zeki, "Neural Concept Formation and Art," pp. 53–76.

54. Ibid., p. 60.

55. Ibid., p. 62.

56. My remarks follow a survey of the volumes of the periodical *Empirical Studies of the Arts.* Its articles are all available on the Internet, but nonsubscribers have to pay to read the full texts.

57. On methods of determining the speech center of left-handers, see M. Dragovici, L. Allet, and A. Janca, "Electroconvulsive Therapy and Determination of Cerebral Dominance," *Annals of General Hospital Therapy* 3.14, 2004 (available online, www.annals-general-psychiatry.com).

58. For handedness and the laterality of the brain, see R. W. Boven et al., "Tactile Form and Location Processing in the Human Brain," *Proceedings of the National Academy of Sciences* 102.35, August 30, 2005, pp. 12601–5 (based on MRI study); two articles by M. S. Gazzaniga, "The Split Brain Revisited," *Scientific American* 279.1, 1998, pp. 35–39 (available online, courses.dce.harvard.edu/~phils4/splitbrain.pdf), and "Facts, Fictions and the Future of Neuroesthetics," in J. Illes, ed., *Neuroethics,* New York, 2005 (available online through the Department of Cognitive Science, University of California, San Diego, www .cogsci.ucsd); H. J. Neville and D. Bavelier, "Specificity and Plasticity in Neurocognitive Development in Humans," in M. S. Gazzaniga, ed., *The Cognitive Neurosciences,* 2nd ed., Cambridge, MA, 2000; B. E. Morton, "Inevitability of Brain Laterality–Based Behavioral Differences from the Variable Sidedness of the Brain Executive System," *Hemisity Review* 11, 2004, based on MRI scanning (available online, www2.hawaii.edu/~bemorton/ Hemisphericity/11HemisityRev.html); S. P. Springer and G. Deutsch, *Left Brain, Right Brain: Perspectives from Cognitive Neuroscience,* New York, 1982; S. Walker, "Lateralization of Functions in the Vertebrate Brain: A Review," *British Journal of Psychology* 71, 1980, pp. 329–67 (detailed comparison of lateralization of the human brain with that of other animals). My summary also reflects the research projects during recent years on language and the brain carried out by C. Chiarello and others at the Cognitive Neuroscience Laboratory of the University of California, Riverside (www.faculty.ucr.edu/~chrisc/research). [Remarks in my footnote on the excision of whole hemispheres are drawn from C. Ken-

neally, "The Deepest Cut: How Can One Live with Only Half a Brain?" *New Yorker,* July 3, 2006, pp. 36–42.]

59. See C. C. Bambach, "Leonardo, Left-Handed Draftsman and Writer," in C. C. Bambach, ed., *Leonardo da Vinci Master Draftsman,* New York, 2003, pp. 59–77(p. 52 quoted).

60. C. Faurie and M. Raymond, "Handedness Frequency over More than Ten Thousand Years," *Proceedings of the Royal Society* (London) B (suppl.) 271, 2004, pp. 43–45.

61. See O. Grusser, T. Selker, and B. Zynda, "Cerebral Lateralization and Some Implications for Art, Aesthetic Perception, and Artistic Creativity," in I. Rentschler, B. Herzberger, and D. Epstien, eds., *Beauty and the Brain: Biological Aspects of Aesthetics,* Basel, Germany, 1988; as summarized in Strachan, "In the Brain of the Beholder," p. 2. [My comments in the footnote on directionality of vision and writing depends on I. Nachson, E. Argaman, and A. Luria, "Effects of Directional Habits and Handedness on Aesthetic Preference for Left and Right Profiles," *Journal of Cross-Cultural Psychology* 30.1, Jan. 1999, pp. 106–14.]

62. I have presented a partial group of hypotheses and counterarguments, taking as a model A. Chatterjee, "Portrait Profiles and the Notion of Agency," *Empirical Studies of the Arts* 20.1), 2002, pp. 33–41 (I do not present Chatterjee's own hypothesis).

63. J. Coney and C. Bruce, "Hemispheric Processes in the Perception of Art," *Empirical Studies of the Arts* 22.2, 2004, pp. 181–200.

64. [My footnote cites ibid., p. 196.]

65. For the biological need to respond to the symmetries of nature, see I. Stewart, *Life's Other Secret: The New Mathematics of the Living World,* New York, 1998, pp. 165–66, 168. I. Stewart and M. Golubitsky, *Fearful Symmetry,* Oxford, 1992, is a lucid nontechnical book on symmetry in nature. There is good presentation of symmetry in aesthetics and an investigation of its nature in Italian Renaissance painting in I. C. McManus, "Symmetry and Asymmetry in Aesthetics and the Arts," *European Review.* 13, suppl. 2, 2005, pp. 157–180. D. Washburn, "Perceptual Anthropology: The Cultural Salience of Symmetry," *American Anthropologist* 1101.3, 1999, pp. 547–62, emphasizes how culture depends on embedded metaphorical patterns and gives the example of Hopi pottery. Two books I know only from reviews: H. D. K. Washburn, ed., *Embedded Symmetries, Natural and Cultural,* Albuquerque, 2004, has three general chapters (on preferences at different ages, on perceptual psychology, and on changes in the course of human evolution) followed by case studies. D. K. Washburn and D. W. Crowe, *Symmetry Comes of Age: The Role of Pattern in Culture,* Seattle, 2004 is based on a workshop on "symmetries of patterned textiles."

There is a complete, well-illustrated monograph on the subject of symmetry in art: Slavik V. Jablan's *Theory of Symmetry and Ornament,* originally published by the Mathematical Institute, Belgrade, 1995 (now available online (http://www.emis.de/monographs/jablan/). Jablan has also posted a detailed, illustrated summary, "Modularity in Art," for the online journal *Visual Mathematics* (http://www.mi.sanu.ac.yu/~jablans/). Anyone with mathematical interests will surely enjoy reading H. Weyl's classic monograph, *Symmetry,* Princeton, 1952. E. H. Gombrich, *The Sense of Order: A Study in the Psychology of Decorative Art,* London, 1979, which deals with perception rather than mathematics, is another classic.

66. I have relied here on J. L. Locher, *The Magic of M. C. Escher*, New York, 2000; D. Schattschneider, *M. C. Escher: Visions of Symmetry*, rev. ed., New York and London, 2004; also the following Internet sources: Platonic Realms MiniTexts, *The Mathematical Art of M. C. Escher*; the introduction to Coxeter's "The Mathematics in the Art of M. C. Escher," *Mathematical Intelligencer*, no. 4, 1966; and the Wikipedia article "M. C. Escher."

67. Locher, *The Magic of M. C. Escher*, p. 241.

68. Schattschneider, *M. C. Escher*, pp. 10, 21–22

69. Gombrich, *The Sense of Order*, p. 9, stresses the link between ease of perception and ease of construction. I think he means to contrast work that is interesting because it is reasonably varied with work that is repetitive to the point of tediousness. For a reference on the mathematics of natural patterning, see note 50 above.

70. [My footnote summarizes and quotes from T. Jacobsen, R. I. Schubotz, L Höfel, and D. Yves v. Cramon, "Brain Correlates of Aesthetic Judgment of Beauty," *NeuroImage* 29, 2006, pp. 276–85. See also D. Humphrey, "Preferences in Symmetries and Symmetries in Drawings: Asymmetries between Ages and Sexes," *Empirical Studies of the Arts*, no. 1, 1997, which contrasts symmetry preferences for dot patterns of girls and women with those of men, and of children and adults (with age, there was increasingly complex and creative use of symmetries in drawings).]

71. [My footnote cites Washburn, "Perceptual Anthropology," pp. 555, 557.]

72. A. Gell, *Art and Agency*, Oxford, 1998, p. 95.

73. R. D. Ellis, "The Dance Form of the Eyes: What Cognitive Science Can Exact from Art," in J. A. Goguen, ed., *Art and the Brain*, special issue of *Journal of Consciousness Studies* 6/7, June/July, 1999, p. 161.

74. Quoted from M. Enquist and A. Arak, "Neural Representation and the Evolution of Signal Form," in R. Dukas, *Cognitive Ecology*, Chicago, 1998, p. 75.

75. The quotation is from T. W. Allan Whitfield, "Aesthetics as Pre-Linguistic Knowledge: A Psychological Perspective," *Design Issues* 21.1, winter 2000, p. 7. This article develops the contrast between closed and open categories. It is disputed in M. Enquist and A. Arak, "Neural Representation and the Evolution of Signal Form," in Dukas, *Cognitive Ecology*, p. 75. See also R. Reber, N Scharz, and P. Winkielman, "Processing Fluency and Aesthetic Pleasure: Is Beauty in the Perceiver's Processing Experience?" *Personality and Social Science Review* 8.5, 2004, pp. 371–72. The latest opposing experimental study of which I know is L. Brant, P. H. Marshall, and B. Roark, "On the Development of Prototypes and Preferences," *Empirical Studies of the Arts* 13.2, 1995.

76. T. Garb, *Bodies of Modernity*, London, 1998, pp. 11, 218. Since I do not discuss the body and will discuss sexuality only incidentally, I append the following brief list of sources: J. Elderfield, P. Reed, M. Chan, M. del Carmen Gonzalez, eds., *ModernStarts: People, Places, Things*, New York, 1999, a well-illustrated discussion of examples from modern European art, see esp. pp. 49–65 ("The Language of the Body") and pp. 66–73 ("Expression and the Series"); A. Ewing, *The Body: Photoworks of the Human Form*, London, 1994, a handsome and well constructed anthology. For a brief, well-illustrated text on sexuality, see E. Lucy-Smith, *Sexuality in Western Art*, rev. ed., London, 1991. T. Flynn, *The*

Body in Sculpture, London, 1998, gives a partial, well-illustrated survey of Western sculpture. T. Garb, *Bodies of Modernity: Figure and Flesh in Fin-de-Siècle France,* London, 1998, offers a detailed, often acute discussion, culminating in an analysis of Cézanne's bathers. R. R. Bretall's *Modern Art, 1851–1929,* Oxford, 1999, has a relatively long chapter called "Sexuality and the Body." See also N. Schneider, *The Art of the Portrait,* Cologne, 1994, on the sixteenth and seventeenth centuries in Europe. P. Renaud, *Le visage,* Paris, 1994, provides large details of classical European paintings. Chinese and Indian sexuality will be mentioned later.

77. D. McNeill, *The Face: A Natural History,* New York, 1998, pp. 5–6, 8.

78. Here I rely on two books, Bruce and Young's *In the Eye of the Beholder* and McNeill's *The Face.* Bruce and Young's book is illustrated marvelously; McNeill's has a wider scope. For the sake of clarity, I run the testimony of the two books together, although McNeill often reports research for which he gives no references. The research he usually relies on is American, while that relied on by Bruce and Young is usually British. For a clear description of an "evolutionary" computer technique, see V. S. Johnston, *Why We Feel: The Science of Human Emotions,* Reading, MA, 1999, pp. 144–59 (pp. 201–2 gives references, including some to Johnston's own research). B. Bates with J. Cleese, *The Human Face,* London and New York, 2001, is comprehensive in scope and has extraordinary illustrations. N. Etcoff, *Survival of the Prettiest: The Science of Beauty,* London, 2000, which I know only from reviews, deals with what she sees as the strong survival value of beauty from the standpoint of evolution.

79. [The experiment I summarize in the footnote is D. W. Zaidel, D. M. Aarde, and K. Baig, "Appearance of Symmetry, Beauty, and Health in Human Faces," in *Brain and Cognition* 57, 2005, pp. 261–63 (available online through Cogprints, http://cogprints.org).]

80. Bruce and Young, *In the Eye of the Beholder,* pp. 133–39; McNeill, *The Face,* pp. 329–30.

81. McNeill, *The Face,* pp. 334–35. McNeill gives no reference, but the research he mentions is that of J. H. Langlois and L. A. Roggman, "Attractive Faces Are Only Average," *Psychological Science* 1, 1990, pp. 115–21. See also E. I. Schwarz, "A Face of One's Own," *Discover,* December 1995; and N. Negroponte, *Being Digital,* New York, 1995. What McNeill reports is generally consistent with Bruce and Young, *In the Eye of the Beholder.* For a brief general overview, with references, see D. M. Buss, *Evolutionary Psychology,* Needham Heights, MA, 1999, pp. 140–45, 405–6.

82. Bruce and Young, *In the Eye of the Beholder,* pp. 136–40.

83. McNeill, *The Face,* pp. 342–46.

84. Cicero, *De Inventione* 2.1.1, in J. J. Pollitt, *The Art of Greece,* Englewood Cliffs, NJ, p. 156.

85. See, e.g., E. Panofsky, *Idea: A Concept in Art Theory,* New York, 1968, chap. 4, pp. 49–50, 57–59 (on Alberti), and 59–60 (on Raphael); also, M. Barasch, *Theories of Art! From Plato to Winckelmann,* New York, 1985, pp. 124–27, 131–32, 319. At the end of his *De statua,* Alberti has a detailed list of ideal proportions.

86. See R. H. van Gulik, *Sexual Life in Ancient China,* Leiden, 1961, p. 216. H. S. Levy,

Chinese Footbinding: The History of a Curious Erotic Custom, New York, 1966, is a comprehensive monograph on the subject.

87. For eighteenth-century European observations, see, e.g., A. Peyrefitte, *The Immobile Empire,* New York, 1992, pp. 58–60; and J. Spence, *The Chan's Great Continent,* New York, 1988, pp. 49–50, 114–15.

88. *The Plum in the Golden Vase; or, Chin P'ing Mei,* trans. D. T. Roy, vol. 1, Princeton, 1993, pp. 123, 490 nn. 19 (on drinking a "shoe cup") and 51 (a poem).

89. Van Gulik, *Sexual Life in Ancient China,* p. 218.

90. J. Wypijewski, ed., *Painting by Numbers: Komar and Melamid's Scientific Guide to Art,* New York, 1997.

91. Ibid., pp. 89–91, 141–97.

92. For a list of references on the perception of color in different societies, see chap. 5 of the present work, notes 2 and 3. [My footnote is drawn partly from M. Pastoureau, *Blue: The History of a Color,* Princeton, 2001. For my summary, see pp. 10, 15, 17, 23, 49, 90, 134, 169, 175.]

93. Wypijewski, *Painting by Numbers,* pp. 89–91, 141–97.

94. Ibid., p. 7.

95. Ibid., pp. 11, 22, 38, 47 (pp. 11 and 47 quoted).

96. Ibid., pp. 11–13.

97. For a brief introduction to the savanna hypothesis, see D. M. Buss, *Evolutionary Psychology,* Needham Heights, MA, 1999, pp. 83–85. G. H. Orians and J. H. Heerwagen, "Evolved Responses to Landscapes," and S. Kaplan, "Environmental Preference in a Knowledge-Seeking, Knowledge-Using Organism" are more advanced. Both essays appear in J. H. Barkow, L. Cosmides, and J. Tooby, eds., *The Adapted Mind,* New York, 1992.

98. Wypijewski, ed., *Painting by Numbers,* pp. 14, 16.

99. Ibid., p. 26.

100. Komar and Melamid, with Mia Fineman, *When Elephants Paint: The Quest of Two Russian Artists to Save the Elephants of Thailand,* New York, 2000, p. 5.

101. Ibid., p. 138.

102. Ibid., p. 40.

103. H. Glassie, *The Spirit of Folk Art,* New York, 1989, pp. 88, 258.

104. See the attractive, sometimes powerful examples of "outsider" art, folk art, "marginal" art, and the like in J. Maizels, *Raw Creation: Outsider Art and Beyond,* London, 1996. Or see the many illustrations of "environments" in D. von Schaewen and J. Maizels, *Fantasy Worlds,* Cologne, 2000.

105. The psychologist Mihaly Csikszentmihalyi and his colleagues have been working for many years on the nature of creativity in general and what they call "flow" in particular. Here I have made use of M. Csikszentmihalyi, *Creativity: Flow and the Psychology of Discovery and Invention,* New York, 1996, esp. chap. 5; M. Csikszentmihalyi and R. E. Robinson, *The Art of Seeing: An Interpretation of the Aesthetic Encounter,* Los Angeles, 1990, esp. pp. 7–9; and M. Csikszentmihalyi and I. Selega, eds., *Optimal Experience,* Cambridge, 1988.

106. Csikszentmihalyi and Robinson, *The Art of Seeing*, p. 73; on this subject more generally, chap. 3.

107. Csikszentmihalyi, *Creativity*, pp. 111–12, 119; Larson, "Flow and Writing," in Csikszentmihalyi and Selega, *Optimal Experience*, pp. 163–64.

108. Csikszentmihalyi, *Creativity*, p. 121; see also A. J. Wells, "Self-Esteem and Optimal Experience," in Csikszentmihalyi and Selega, *Optimal Experience*, p. 327.

109. See Reber, Schwarz, and Winkielman, "Processing Fluency and Aesthetic Pleasure," 364–82. [My footnote cites pp. 377–78.]

110. Quoted in Csikszentmihalyi and R. E. Robinson, *The Art of Seeing*, pp. 65–66.

111. [My footnote cites A. Gell, *Art and Agency*, Oxford, 1998, p. 258.]

112. J. Bell, *What Is Painting?* New York, 1999, p. 170.

113. Pablo Neruda, "Childhood and Poetry," quoted in R. Bly, ed., *Neruda and Vallejo: Selected Poems*, Boston, 1933, pp. 12–13.

114. G. Rizzolatti and L. Craighero, "The Mirror-Neuron System," *American Review of Neuroscience* 27, 2004, pp. 172, 183 (the article is available online through the Scholarpedia Web site, http://www.scholarpedia.org/article/Mirror_neurons). [For the summary in the footnote and a basic definition of terms, see in addition to Rizzolatti and Craighero article, "Mirror Neurons," on Wikipedia, last modified November 24, 2005.]

115. The concept of empathy is relevant enough to this book to merit a reading list: O. Ewart, "*Einfühlung*," and W. Perpeet, "*Einfühlungsästhetik*," both in J. Ritter, ed., *Historisches Wörterbuch der Philosophie*, Basel/Stuttgart, 1971 (a brief history of the concept, with bibliography); C. E. Gauss, "Empathy," in *Dictionary of the History of Ideas*, ed. P. P. Wiener, New York, 1973–74; M. Podro, *The Manifold in Perception*, New Haven, 1982, pp. 104–110; P. Selz, *German Expressionistic Painting*, Berkeley, 1957, pp. 6–11; M. Barasch, *Modern Theories of Art*, vol. 2: *From Impressionism to Kandinsky*, New York, 1998, pp. 81–187, esp. pp. 102–4; C. Harrison, P. Wood, and J. Gaiger, eds., *Art in Theory, 1815–1900*, London, 1998, an annotated anthology of extracts from the sources (the quotations, pp. 690–93, are from R. Vischer, "The Aesthetic Act and Pure Form," 1874). On dance and literature, see the essays in M. Hjort and S. Laver, eds., *Emotion and the Arts*, New York, 1997, especially S. L. Feagin, "Imagining Emotions and Appreciating Fiction"; F. Sparshott, "Emotion and Emotions in Theatre Dance"; and K. Oatley and M. Gholamain, "Emotions and Identification: Connections between Readers and Fiction." For music, see, e.g., R. Scruton, *The Aesthetics of Music*, Oxford, 1997, chap. 11, esp. pp. 360–65. K. F. Morrison, *"I Am You": The Hermeneutics of Empathy in Western Literature, Theology, and Art*, Princeton, 1988, goes well beyond the subject of empathy in its direct sense. S. Dissanayake, "'Empathy Theory' Reconsidered: The Psychobiology of Aesthetic Responses," chap. 6 of *Homo Aestheticus*, Seattle, 1995, discusses empathy and proposes that it should be reconceived in terms of current neurophysiology (p. 185).

116. A. Zagajewski, *Another Beauty*, New York, p. 206.

117. See Edelman, "Constraining the Neural Representation of the Visual World," esp. pp. 126–27.

CHAPTER 2: SELFLESS TRADITION

1. Hsün Tzu, *Basic Writings,* trans. Burton Watson, New York, 1963, p. 157 (sec. 23). For the other references, see B.-A. Scharfstein, *Amoral Politics: The Persistent Truth of Machiavellism,* Albany, 1995, pp. 68, 116.

2. J. Gonda, *Vedic Literature,* Wiesbaden, 1975, p. 74.

3. A. Alpers, *The World of the Polynesians Seen through Their Myths and Legends, Poetry and Art,* New York, 1987, p. 32. Alpers quotes from H. M. Chadwick and N. K. Chadwick, *The Growth of Literature,* vol. 2, Cambridge, 1940, pp. 400, 234, 232–33, 260.

4. A. Hampâté Bâ, "Oral Tradition and Its Methodology," chap. 8 in *General History of Africa* (UNESCO), abridged ed., vol. 1, *Methodology and African Prehistory,* ed. J. Ki-Zerbo, Paris, London, and Berkeley, 1989, p. 64. For recent attempts to preserve and use African oral narratives by scholars and creative writers, see I. Okpewho, *Myth in Africa,* Cambridge, 1983, chap. 5, "Myth and Contemporary African Literature." On earlier attempts and the debate for and against the use of oral evidence, see chap. 4, "Myth and Social Reality: The Poetic Imperative."

5. Hampâté Bâ, "Oral Tradition and Its Methodology," quoting pp. 71 and 65.

6. J. W. Fernandez, *Bwiti: An Ethnography of the Religious Imagination in Africa,* Princeton, 1982, p. 20.

7. Ibid., pp. 11–12, 13.

8. [My footnote cites C. Geertz, *Available Light: Anthropological Reflections on Philosophical Topics,* Princeton, 2000, p. 30.]

9. P. Descola, *The Spears of Twilight: Life and Death in the Amazon Jungle,* New York, 1996, p. 401.

10. Ibid., p. 445. For the countervailing view, see, e.g., P. C. W. Gutkind, "The Social Researcher in the Context of African National Development: Reflections on an Encounter," pp. 21–23, and R. M. Weintrob, "An Inward Focus: A Consideration of Psychological Stress in Fieldwork," both in F. Henry and S. Saberwal, eds., *Stress and Response in Fieldwork,* New York, 1969. On the problems and status of ethnographical writing, see J. Clifford, "On Ethnographical Authority," in his book *The Predicament of Culture: Twentieth-Century Ethnography, Literature, and Art,* Cambridge, MA, 1988. See also P. Bohannen and D. van der Elst, *Asking and Listening: Ethnography as Personal Adaptation,* Prospect Heights, IL, 1998.

11. A. Kuper, *Culture: The Anthropologists' Account,* Cambridge, MA, 1999, p. 19.

12. Geertz, *Available Light,* p. 18. For another, similar assessment, see G. E. Marcus, *Ethnography through Thick and Thin,* Princeton, 1998, esp. pp. 231, 250. Both Geertz and Marcus have an account of the instructive polemic between two able anthropologists, Gananath Obeyesekere, who defends the commonsense rationality of "natives," in particular of the Hawaiian natives who are said to have believed that Captain Cook, whom they killed, was the god Lono, and Marshall Sahlins, who defends the traditional account. For the full polemic, see G. Obeyesekere, *The Apotheosis of Captain Cook: European Mythmaking in the Pacific,* Princeton, 1992; and M. Sahlins, *How "Natives" Think: About Captain Cook, for Ex-*

ample, Chicago, 1995. For a modern, relatively full description of anthropology as a whole, see T. Ingold, ed., *Companion Encyclopedia of Anthropology: Humanity, Culture and Social Life*, London and New York, 1994.

13. See, for background on theories of social evolution, T. Earle, "Political Domination and Social Evolution," in Ingold, *Companion Encyclopedia of Anthropology*, pp. 940–61, esp. pp. 941–43; on the need for anthropologists to abandon such theories, see A. Kuper, *The Invention of Primitive Society: Transformations of an Illusion*, London and New York, 1988; and on hierarchy of value implied by the term "primitive," see C. R. Hallpike, *The Principles of Social Evolution*, Oxford, 1988, pp. 8–15.

14. For early European reactions, see, e.g., J. H. Elliott, *The Old World and the New*, London, 1970, pp. 25–27; J. M. Cohen, trans., *The Four Voyages of Christopher Columbus*, Harmondsworth, 1969, pp. 117–18; and Montaigne's famous essay, "Of Cannibals." For contemporary favorable reactions, see, e.g., J. Rothenberg, ed., *Technicians of the Sacred*, New York, 1968, 1985; and J. Rothenberg and D. Rothenberg, eds., *Symposium of the Whole*, Berkeley, 1983.

15. K. A. Appiah, "Ethnicity and Identity in Africa: An Interpretation," in K. A. Appiah and H. L. Gates, eds., *Africana: The Encyclopedia of the African and African-American Experience*, NY, 1998, pp. 703–5.

16. See J.-F. Mattéi, ed., *Le discours philosophique*, vol. 4 of H. Jacob, ed., *Encyclopédie universelle*, Paris, 1998, esp. "The Writing of Oral Cultures," p. 791, the introduction to section 48, which includes essays on and summaries of relevant books dealing with the preliterate thought (including illustrative examples) of Africa, the Americas, South-East Asia, Europe, and Oceania. Section 18 has an analogous survey of views, "Philosophy in [Traditional] Africa."

17. See W. Bascom, "African Dilemma Tales," in R. M. Dorson, ed., *African Folklore*, New York, 1972, pp. 143–45; and K. Rasmussen, *Intellectual Culture of the Iglulik Eskimos, Report of the Fifth Thule Expedition, 1921–1924*, Copenhagen, 1930, pp. 54–56.

18. C. R. Hallpike, *The Foundations of Primitive Thought*, Oxford, 1979, pp. 487, 489.

19. See R. B. Lee, *The Dobe !Kung*, New York, 1984, pp. 147–50; J. Yellen, "Bushmen," *Science 85*, May 1985, pp. 41–48; N. B. Ione and M. J. Konnor, "Kung Knowledge of Animal Behavior," in R. B. Lee and I. Devore, eds., *Kalahari Hunter-Gatherers*, Cambridge, MA, 1972. On the distance between !Kung and anthropologists and an extraordinary attempt to bridge it, see M. Shostak, *Return to Nisa*, Cambridge, MA, 2000. See also M. J. Konnor, *The Tangled Wing: Biological Constraints on the Human Spirit*, New York, 1982.

20. P. Parin, F. Morgenthaler, and C. Parin-Matthey, *Les blancs pensent trop: 13 entretiens psychoanalytiques avec les Dogons*, Paris, 1966 (trans. from German), pp. 464–65.

21. A. P. Elkin, *The Australian Aborigenes*, Garden City, 1964.

22. G. P. Murdock, *Atlas of World Cultures*, Pittsburgh, 1981.

23. C. A. Lutz, *Unnatural Emotions: Everyday Sentiments on a Micronesian Atoll and their Challenge to Western Theory*, Chicago, 1988. The best-known researchers of the facial expression of emotion are the psychologists Paul Ekman and his associates. See,

for its inherent historical interest, Ekman's introduction, commentaries, and afterword to Charles Darwin's *The Expression of the Emotions in Man and Animals,* London, 1998 (3rd edition; based on the 2nd, issued after Darwin's death in 1889).

24. See note 40 of chap. 1 above. The pioneering study is B. Berlin and P. Kay, *Basic Color Terms,* Berkeley, 1969. Their observations and "system" have, of course, been criticized and modified.

25. K. Endicott, *Batak Negrito Religion,* Oxford, 1979, p. 39, as cited in D. Howes and C. Classen, "Sounding Sensory Profiles," in D. Howes, ed., *The Varieties of Sensory Experience: A Sourcebook in the Anthropology of the Senses,* Toronto, 1991, p. 283.

26. K. Buddle, "Sound Vibrations: An Exploration of the Hopi Sensorium," *Journal of Religion and Culture* 4.2, p. 10, as cited in Howes and Classen, "Sounding Sensory Profiles," in Howes, *The Varieties of Sensory Experience,* pp. 257–58, 281.

27. A. Gebhart-Sayer, "The Geometric Designs of the Shipibo-Conibo in Ritual Context," *Journal of Latin American Lore* 11.2, pp. 161–72, as cited in Howes, *The Varieties of Sensory Experience,* pp. 7–8.

28. I point readers to the following sources in the anthropology of art:

General books: R. L. Anderson's *Art in Primitive Societies,* Englewood Cliffs, NJ, 1979, and *Calliope's Sister: A Comparative Study of Philosophies of Art,* Englewood Cliffs, NJ, 1990; W. van Damme, *Beauty in Context,* Leiden, 1996; S. Errington, *The Death of Authentic Primitive Art and Other Tales of Progress,* Berkeley, 1998; A. Forge, ed., *Primitive Art and Society,* London, 1973; A. Gell, *Art and Agency: An Anthropological Approach,* Oxford, 1998; R. Layton, *The Anthropology of Art,* London, 1981.

Collections of articles: D. P. Biebuck, ed., *Tradition and Creativity in Tribal Art,* Berkeley, 1969; J. Clifford, *The Predicament of Culture: Twentieth-Century Ethnography, Literature, and Art,* Cambridge, MA, 1988, esp. "On Collecting Art and Culture"; J. Coote and A. Shelton, eds., *Anthropology, Art, and Aesthetics,* Oxford, 1992; T. Ingold, ed., *Companion Encyclopedia of Anthropology,* London and New York, 1994, esp. H. Morphy, "The Anthropology of Art."

Annotated anthologies of pictures: D. Newton and H. Waterfield, *Tribal Sculptures: Masterpieces from Africa, South East Asia, and the Pacific in the Barbier-Mueller Museum,* London, 1995; A. Wolfe, *Tribes,* New York, 1997 (body art).

Effects on modern art: J. Clifford, "On Ethnographic Surrealism" and "Histories of the Tribal and the Modern," both in J. Clifford, *The Predicament of Culture,* Cambridge, MA, 1988; Errington, *The Death of Authentic Primitive Art and Other Tales of Progress,* Berkeley, 1998; R. Goldwater, *Primitivism in Modern Art,* rev. ed., New York, 1937; S. Price, *Primitive Art in Civilized Places,* Chicago, 1989. C. Rhodes, *Primitivism and Modern Art,* London, 1994; W. Rubin, ed., *"Primitivism" in 20th Century Art: Affinity of the Tribal and the Modern,* 2 vols., New York, 1984; S. Wichmann, ed., *Weltkulturen und moderne Kunst,* Munich, 1972.

Aboriginal art: E. J. Brandl, *Australian Aboriginal Paintings in Western and Central Arnhem Land: Temporal Sequences and Elements of Style in Cadell River and Deaf Adder Creek Style,* Canberra, 1988; R. M. and C. H. Berndt, *The World of the First Australians: Aboriginal*

Traditional Life, Past and Present, 5th ed., Canberra, 1988, esp. chaps. 11 and 12; W. Caruna, *Aboriginal Art,* London, 1993; M. Charlesworth, H. D. Bell, and K. Maddock, eds., *Religion in Aboriginal Australia: An Anthology,* Queensland, Australia, 1984; J. Coote and A. Shelton, eds., *Anthropology, Art and Aesthetics,* Oxford, 1992, esp. chaps. 3 (by R. Layton) and 8 (by H. Morphy); H. Morphy, *Aboriginal Art,* London, 1998, and *Ancestral Connections: Art and an Aboriginal System of Knowledge,* Chicago, 1991; J. Isaacs, *Australian Aboriginal Paintings,* New York, 1989; N. Munn, *Walbiri Iconography,* Ithaca, 1973; P. Sutton, ed., *Dreaming: The Art of Aboriginal Australia,* New York, 1989; A. Quail, *Marking Our Times: Selected Art from the Aboriginal and Torres Strait Islander Collection at the National Gallery of Australia,* Canberra, 1996; D. Stubbs, *Prehistoric Art of Australia,* New York, 1974; D. Tunbridge, *Flinders Range Dreaming,* Canberra, 1988 (stories and myths).

Contemporary Aboriginal art: S. McCulloch, *Contemporary Aboriginal Art: A Guide to the Rebirth of an Ancient Art,* Honolulu, 1999; Warlukurlangu Artists, *Kuruwarri: Yuendumu Doors,* Canberra, 1996. Additional sources are provided in chap. 6 of the present book.

African Art, comprehensive surveys: T. Phillips, ed., *Africa: The Art of a Continent,* Munich, 1995 (based on an extensive exhibition); M. B. Visonà, R. Poynor, H. M. Cole, and M. D. Harris, eds., *A History of Art in Africa,* New York, 2000 (systematic, even-handed); F. Willet, *African Art,* rev. ed, New York, 1993 (brief).

African art, general books: M. G. Anderson and C. M. Kreamer, *Wild Spirits: Strong Medicine, African Art and the Wilderness,* New York and Seattle, 1989; W. L. d'Azevedo, ed., *The Traditional Artist in African Societies,* Bloomington, 1973; H. M. Cole, *Icons: Ideals and Power in the Art of Africa,* Washington, DC, 1989; H. Himmelheber, *Negerkunst und Negerkünstler,* Braunschweig, 1960; E. Schildkrout and C. A. Keim, eds., *The Scramble for Art in Central Africa,* Cambridge, 1998.

African art, particular peoples: R. Abiodun, H. S. Drewal, and J. Pemberton III, *The Yoruba Artist,* Washington, DC, 1994; P. G. Ben-Amos, *The Art of Benin,* rev. ed., London, 1995; H. S. Drewal and J. Pemberton III, with R. Abiodun, *Yoruba: Nine Centuries of African Art and Thought,* New York, 1989; K. Ezra, *Art of the Dogon,* New York, 1988; M. N. Roberts and A. F. Roberts, *Memory: Luba Art and the Making of History,* New York and Munich, 1996; E. Schildkrout and C. A. Keim, *African Reflections: Art from Northeastern Zaire,* New York and Seattle, 1990; Z. S. Strother, *Inventing Masks: Agency and History in the Art of the Central Pende,* Chicago, 1998; R. F. Thomson, *African Art in Motion: Icon and Act,* Berkeley, 1974; S. M. Vogel, *Baule: African Art / Western Eyes,* New Haven, 1997; G. N. van Wyk, *African Painted Houses: Basotho Dwellings of Southern Africa,* New York, 1998.

African art, annotated anthologies of pictures: J. Baldwin et al., *Perspectives: Angles on African Art,* New York, 1987 (comments solicited from well-known persons, expert and not); C. Beckwith and A. Fisher, *African Ceremonies,* 2 vols., New York, 1999; M. Courtney-Clarke, *African Canvas,* New York, 1990 (art and architecture on site); E. Elisofon, with text by W. Fagg, *The Sculpture of Africa,* London, 1958; A. Fisher, *Africa Adorned,* London, 1984; S. Haskins, *African Images,* London, 1967 (photos of art and life); M. Huet, *The Dance, Art, and Ritual of Africa,* New York, 1978; G. N. Preston, *African Art Masterpieces,* New York, 1991; J. L. Thompson and S. M. Vogel, *Closeup: Lessons in the Art of Seeing*

African Sculpture, New York and Munich, 1991; G. Verswijver, E. De Palmenaer, V. Baeke, and Am.-M. Bouttiaux-Ndiayem, eds., *Masterpieces from Central Africa,* Munich, 1996; A. Vogel, ed., *For Spirits and Kings: African Art from the Tishman Collection,* New York, 1981; S. M. Vogel, *African Aesthetics: The Carlo Monzini Collection,* New York, 1986.

Contemporary African art: S. L. Kasfir, *Contemporary African Art,* London, 1999; A. Magnin and J. Soulillou, *Contemporary African Art,* London, 1996; S. M. Vogel, ed., *Africa Explodes: 20th Century African Art,* New York and Munich, 1991.

Inuit (Eskimo) art: W. W. Fitzhugh and S. A. Kaplan, *Inua: Spirit World of the Bering Sea Eskimo,* Washington, DC, 1982; I. Hessel, *Inuit Art,* New York, 1998; H. Himmelheber, *Eskimokünstler,* Eisenach, 1953; D. J. Ray, *Eskimo Masks: Art and Ceremony,* Seattle, 1967; *A Legacy of Arctic Art,* Seattle, 1996.

Contemporary Inuit art: R. Annaqtuusi, J. Blodgett, *Kenojuak,* Toronto, 1985; J. Houston, *Eskimo Prints,* Barre, MA, 1971; O. Leroux, M. E. Jackson, and M. A. Freeman, *Inuit Women Artists,* Vancouver, BC, and San Francisco, 1994; Pitseolak, *Pictures out of My Life,* Seattle, 1971; G. Swinton, *Sculptures of the Eskimo,* Greenwich, CT, 1972; R. A. Tulurialik and D. F. Kelly, *Images of Inuit Life,* Toronto, 1986.

Native American (Amerindian) art: J. Berlo, ed., *Plains Indian Drawings, 1865–1935: Pages from A Visual History,* New York, 1986; E. L. Wade, ed., *The Art of the North American Indian: Native Traditions in Evolution,* New York, 1986.

Contemporary Native American art, Northwest Coast: B. Holm and W. Reid, *From and Freedom: Dialogues on Northwest Indian Art,* Houston, 1975. A. Jonaitis, *From the Land of the Totem Poles: The Northwest Coast Art Collection at the American Museum of Natural History,* New York and Seattle, 1988. P. L. Mcnair, A. L. Hoover, and K. Neary, *The Legacy: Tradition and Innovation in Northwest Coast Indian Art,* Vancouver and Toronto, 1984. D. Shadbolt, *Bill Reid,* Vancouver and Toronto, 1986.

Contemporary Native American art, Southwest, Mesoamerica, Central America, Andes, and Amazon: B. Braun, ed., *Arts of the Amazon,* London, 1995; M. Perrin, *Magnificent Molas: The Art of the Kuna Indians,* Paris, 1999; R. F. Townsend, ed., *The Ancient Americas: Art from Sacred Landscapes,* Chicago and Munich, 1993.

Oceanic art: B. Brake, J. McNeish, and D. Simmons, *Art of the Pacific,* New York, 1980; M. Kirk, *Man as Art: New Guinea,* introduction by A. Strathern, New York, 1981; D. Newton, *Crocodile and Cassowary,* New York, 1971; S. M. Mead, *The Maori: Maori Art from New Zealand Collections,* New York, 1984; A. J. P. Meyer, ed., *Oceanic Art,* 2. vols., Cologne, 1995; A. Strathern and M. Strathern, *Self-Decoration in Mount Hagen,* Toronto, 1971; N. Thomas, *Entangled Objects: Exchange, Material Culture, and Colonialism in the Pacific,* Cambridge, MA, 1991, and *Oceanic Art,* New York, 1995.

29. The issue is of course much wider than the problem of how "primitive art" should be exhibited. See the relatively full accounts in van Damme, *Beauty in Context,* pp. 7–12, 22–26, and, especially, 143–58. On the institutional acceptance of Aboriginal art and on the marketing of this art, see S. Kleinert and M. Neale, eds., *The Oxford Companion to Aboriginal Art and Culture,* Melbourne, 2000, pp. 454–470; pp. 471ff., on "cultural exchange," are also relevant.

30. S. Errington, *The Death of Authentic Primitive Art*, pp. 80–81. Errington quotes S. M. Vogel and F. N'Diaye, *African Masterpieces from the Musée de l'Homme*, New York, 1985, p. 148, item 66. J. Clifford, *The Predicament of Culture*, p. 203, describes the art-ethnography ambivalence (in late 1984) in the Hall of Pacific Peoples of the American Museum of Natural History.

31. Morphy, "The Anthropology of Art," pp. 653–54.

32. For African masks meant to be "beautiful" and "ugly," see A. van Damme, *A Comparative Analysis Concerning Beauty and Ugliness in Sub-Saharan Africa*, Ghent, 1987. See also van Damme's, "African Verbal Arts and the Study of African Visual Aesthetics," in the *Poetics of Africa Art* issue of *Research in African Literatures* 31.4, winter 2000, pp. 8–19. For female masks of the Pende of Zaire (the Democratic Republic of the Congo), see Strother, *Inventing Masks*, pp. 217–21. [My footnote cites pp. 220–21 of Strother's study.]

33. Gell, *Art and Agency*, p. 153.

34. F. A. Hanson, "When the Map Is the Territory: Art in Maori Culture," in D. K. Washburn, ed., *Structure and Cognition in Art*, Cambridge, 1983, pp. 74–89 (esp. p. 84); as summarized in Gell, *Art and Agency*, p. 160. See the comparison of the formal characteristics of Marquesan motifs in Gell, pp. 168–90.

35. A. Shelton, "Predicates of Aesthetic Judgement: Ontology and Value in Huicho Material Representations," in Coote and Shelton, *Anthropology, Art, and Aesthetics*, p. 234. I rely on Shelton's account throughout this discussion.

36. Ibid., pp. 238, 239.

37. Ibid., p. 237.

38. Ibid., p. 241.

39. H. Morphy, "From Dull to Brilliant: The Aesthetics of Spiritual Power among the Yolngu," in Coote and Shelton, *Anthropology, Art, and Aesthetics*, p. 183.

40. Ibid., p. 186.

41. Ibid., pp. 189, 192–94.

42. F. E. Williams, *Drama of Orokolo*, Oxford, 1940, pp. 52, 84, 91, 190ff.

43. F. E. Williams, *Orokaiva Society*, London, 1950, pp. 356–57.

44. Ibid., p. 418.

45. This description of the Suyá depends completely on A. Seeger's "Music and Dance," in T. Ingold, *Companion Encyclopedia of Anthropology*, pp. 693–701. Seeger gives as reference his book *Why Suyá Sing: A Musical Anthropology of an Amazonian People*, Cambridge, 1987.

46. See M. Griaule, *Masques Dogons*, Paris, 1932; and M Griaule and G. Dieterlin, *Le renard pâle*, Paris, 1965 (the Dogon creation myth); trans. as *The Pale Fox*, Chino Valley, AR, 1986. A concise summary is given by Griaule and Dieterlin in "The Dogon," in D. Forde, ed., *African Worlds: Studies in the Cosmological Ideas and Social Values of African Peoples*, London 1954. A longer summary of the complicated basic myths of the Dogon is given by Dieterlin in vol. 1 of Y. Bonnefoy, ed., *Mythologies*, Chicago, 1991, pp. 39–41, 42–43, 45–49 (on the Sigui), 51–52. See also D. Attenborough, *The Tribal Eye*, London, 1978; and Ezra, *Art of the Dogon*. Beckwith and Fisher, *African Ceremonies*, vol. 2, pp. 262–95, has

beautiful photographs of the Dama, a collective funeral ceremony that takes place every twelve years.

47. Griaule, *Masques Dogons,* pp. 62–63, 147ff.

48. Ibid, p. 10.

49. [On Liberian practice, my footnote cites G. W. Harley, "Masks as Agents of Social Control in Northeast Liberia," *Pages of the Peabody Museum,* Harvard University, 32.2, Cambridge, MA, 1950.]

50. Suzanne Preston Blier, *Royal Arts of Africa: The Majesty of Form,* London, 1998, p. 33. There is a brief account of art in traditional African kingdoms in Layton, *The Anthropology of Art,* pp. 60–79.

51. Blier, *Royal Arts of Africa,* pp. 26–29.

52. Ben-Amos, *The Art of Benin,* p. 33.

53. All I have to say about the Luba depends on Roberts and Roberts, *Memory.*

54. Ibid., p. 37; see also pp. 126–44.

55. Griaule and Dieterlin, "The Dogon," pp. 83–84.

56. M. Griaule, *Conversations with Ogotemmêli,* London, 1965, pp. xvi, 3, 220.

57. The main documents are these: W. E. A. van Beek, "Dogon Restudied: A Field Evaluation of the Work of Marcel Griaule," to which are joined comments by a number of other anthropologists and a reply by Van Beek, *Current Anthropology* 32.2, April 1991, pp. 139–67; G. Calame-Griaule, "On the Dogon Restudied, *Current Anthropology* 332.5, Dec. 1991, pp. 575–77; L. de Heusch, "On Griaule on Trial," *Current Anthropology* 32.4, Aug.–Oct. 1991), pp. 434–37. J. Clifford, "Power and Dialogue in Ethnography: Marcel Griaule's Initiation," in Clifford, *The Predicament of Culture,* contains an interesting description of Griaule, his collaborators, and his method. Though his essay was first published in 1983, well before Van Beek's evaluation, Clifford reports earlier doubts and is already aware of extreme skepticism on the part of some anthropologists, which he rather discounts (p. 59).

58. Clifford, "Power and Dialogue in Ethnography," pp. 58–59, 60, 73.

59. Quoted in ibid., p. 75. [For my footnote citations, see Van Beek, "Dogon Restudied," pp. 157–58. The excerpts from Leiris's journal are taken from Price, *Primitive Art in Civilized Places,* pp. 71–73, who quotes from M. Leiris, *L'Afrique fantôme,* Paris, 1934 and 1981.]

60. Calame-Griaule, "On the Dogon Restudied," pp. 575–76. For Griaule's urgent questioning, see Clifford, "Power and Dialogue in Ethnography," pp. 76–79; and on the Dakar-Djibouti Mission, pp. 55–56 (p. 56 quoted). Referring to all their investigations, Griaule and Calame-Griaule list the names of their three main interpreters and many main informants, Dogon "collaborators," and French assistants (*The Pale Fox,* pp. 20–24).

61. D. Crystal, *The Cambridge Encyclopedia of Language,* Cambridge, 1987, pp. 120, 284.

62. Clifford, *The Predicament of Culture,* esp. chaps. 9 ("Histories of the Tribal and the Modern,") and 10 ("On collecting Art and Culture"); Errington, *The Death of Authentic Primitive Art;* Price, *Primitive Art in Civilized Places;* Schildkrout and Keim, *The Scramble for Art in Central Africa;* Thomas, *Entangled Objects* (for full entries, see note 28 above).

63. Errington, *The Death of Authentic Primitive Art*, p. 7.

64. Thomas, *Entangled Objects*, p. 130.

65. E. Schildkrout and C. A. Keim, "Objects and Agendas: Re-Collecting the Congo," in Schildkrout and Keim, *The Scramble for Art in Central Africa*, pp. 16–17, 19–20.

66. Ibid., pp. 23, 26.

67. Ibid., p. 31.

68. E. Schildkrout, "Personal Styles and Disciplinary Paradigms: Frederick Starr and Herbert Lang," in Schildkrout and Keim, *The Scramble for Art in Central Africa*, pp. 178–79.

69. Ibid., pp. 179–80, 182.

70. Ibid., p. 183.

71. Ibid., p. 184.

72. Ibid.

73. This is on the authority of Chinua Achebe, as expressed in the foreword to H. M. Cole and C. C. Aniakor, eds., *Igbo Arts: Community and Cosmos*, Los Angeles, 1984, p. ix; quoted in Clifford, *The Predicament of Culture*, p. 207.

74. Strother, *Inventing Masks*, pp. 89–90. [My footnote cites Errington, *The Death of Authentic Primitive Art*, p. 143, who refers to and quotes Deirdre Evans-Pritchard's "Tradition on Trial: How the American Legal System Handles the Concept of Tradition," Ph.D. diss., University of California, Los Angeles, 1990, p. 134.]

75. Bohannen and Van der Elst, *Asking and Listening*, p. 51.

76. A. Gell, "The Technology of Enchantment and the Enchantment of Technology"; cited in Coote and Shelton, *Anthropology, Art and Aesthetics*, p. 62 n. 1.

77. B. Holm, "The Art of Willie Seaweed: A Kwakuitl Master," in M. Richardson, ed., *The Human Mirror*, Baton Rouge, 1974, pp. 59–60. I have taken the quotation from Prince, *Primitive Art in Civilized Places*, p. 65.

78. On authenticity in Chinese art, I point to the following sources: J. Cahill, *The Painter's Practice: How Artists Lived and Worked in Traditional China*, New York, 1994, esp. pp. 18–24, 107–12, 134–48; W. C. Fong, *The Problem of Forgeries in Chinese Painting*, Ascona, 1962 (reprinted from *Artibus Asiae* 25); M. Fu and S. Fu, *Studies in Connoisseurship: Chinese Paintings from the Arthur M. Sackler Collection in New York and Princeton*, Princeton, 1973; R. H. van Gulik, *Chinese Pictorial Art as Viewed by the Connoisseur*, Rome, 1958, esp. pp. 374–49; L. Ledderose, *Mi Fu and the Classical Tradition of Chinese Calligraphy*, Princeton, 1979; M. F. Linda, *The Real, The Fake, and the Masterpiece*, New York, 1988 (catalog of exhibition at the Asia Society Galleries, June 11–August 28, 1988).

79. Cahill, *The Painter's Practice*, pp. 107–10 (including nn. 93, 95).

80. Ibid., pp. 138–39. On Hui-ts'ung, see, e.g., Y. Xin et al., *Three Thousand Years of Chinese Painting*, Taipei, 1996, pp. 119–26.

81. Cahill, *The Painter's Practice*, pp. 141–43.

82. Ibid., p. 143. As Cahill notes, the quotation is from G. C. Hsü, "Patronage and the Economic Life of the Artist in Eighteenth-Century Yangchow Painting," 2 vols., Ph.D. diss., University of California, Berkeley, 1987, p. 199 n. 51.

83. Ledderose, *Mi Fu*, pp. 33–35; Van Gulik, *Chinese Pictorial Art*, pp. 397–401.

84. Van Gulik, *Chinese Pictorial Art*, p. 399.

85. Ledderose, *Mi Fu*, p. 38.

86. Cahill, *The Painter's Practice*, pp. 134–36; Fong, *The Problem of Forgeries in Chinese Painting*; Ledderose, *Mi Fu*, pp. 38–39.

87. Van Gulik, *Chinese Pictorial Art*, pp. 381–-82. For the fourteenth-century reference, see S. Bush and H. Shih, *Early Chinese Texts on Painting*, Cambridge, MA, 1985, p. 259.

88. Cahill, *The Painter's Practice*, p. 136.

89. On authenticity in Indian art, I point to the following sources: R. H. Davis, *Lives of Indian Images*, Princeton, 1997; P. Chandra, *On the Study of Indian Art*, Cambridge, MA, 1983; M. F. Linda, *The Real, the Fake, and the Masterpiece*, New York, 1988 (catalog of exhibition at the Asia Society Galleries, June 11–August 28, 1988); P. Mitter, *Much Maligned Monsters: History of European Reactions to Indian Art*, Oxford, 1977.

90. Davis, *Lives of Indian Images*, pp. 242–43.

91. M. F. Linda, "Believing Requires Seeing: Altered Chola Period Bronzes," in Linda, *The Real, the Fake, and the Masterpiece*, pp. 59–61.

92. Davis, *Lives of Indian Images*, p. 253.

93. Ibid., p. 13.

94. Ibid., pp. 258–59.

95. [My footnote cites A. Kinzer's article "Museums and Tribes: A Tricky Truce," published in the *New York Times* of Dec. 23, 2000.]

96. Davis, *Lives of Indian Images*, pp. 163–67 (p. 164 quoted).

97. See Mitter, *Much Maligned Monsters*, p. 215, citing P. B. Ostmaston's translation of Hegel's *Philosophy of Fine Art* (*Vorlesungen über die Ästhetik*), vol. 2.

98. Ruskin's *The Two Paths*, lecture 1, "Conventional Art" (1859), in *Works*, vol. 16, 1905, pp. 265ff; quoted in Mitter, *Much Maligned Monsters*, pp. 238–46, 245–46. Ruskin's remarks on Indian color are from vol. 3 of his *Modern Painters* (1856), in *Works*, vol. 5, 1904, p. 123; quoted by Mitter, pp. 240–41.

99. Cited in Mitter, *Much Maligned Monsters*, pp. 270–77. I've omitted Indian architecture and its pioneering Indian appreciator, Ram Raz, and its first great English historian and admirer, James Fergusson (whose admiration was for Buddhist and Muslim, not Hindu, architecture). On both, see in addition to Mitter, and Chandra, *On the Study of Indian Art*. Chandra has a brief review, as well, of the more important students of Indian sculpture and painting.

100. Quoted in Davis, *Lives of Indian Images*, pp. 177–78 (also in Mitter, *Much Maligned Monsters*, p. 269). The account of the clash between Havell and Birdwood is derived from R. Skelton, "The Indian Collections 1798 to 1978," *Burlington Magazine* 120, May 1978, pp. 297–304, who draws on the proceedings recorded in the *Journal of the Royal Society of Arts* 58, February 4, 1910, pp. 273–98.

101. Quoted in Mitter, *Much Maligned Monsters*, p. 270.

102. B. Khanna and A. Kurtha, *Art of Modern India*, London, 1998, p. 9. [On the Aban-

indranath Tagore and the Bengal school discussed in my footnote, see N. Tuli, *Indian Contemporary Painting*, New York, 1998, pp. 187–89.]

103. See P. Kidson, "The Figural Arts," in M. I. Finely, ed., *The Legacy of Greece*, Oxford, 1981, p. 147.

104. A. Spiro, *Contemplating the Ancients: Aesthetic and Social Issues in Early Chinese Portraiture*, Berkeley, 1990, pp. 177, 222 (nn. 40, 41, referring to S. Nodleman, "How to Read a Roman Portrait," *Art in America* 63, 1975, pp. 27–33).

105. H. Schäfer, *Principles of Egyptian Art*, London, 1974, pp. 16, 17; also p. 13. In addition, see C. Aldred, *Egyptian Art*, London, 1980, pp. 69–70; N. Grimal, *A History of Ancient Egypt*, Oxford, 1992, pp. 94–98; R. Schultz and M. Seidel, eds., *Egypt: The World of the Pharaohs*, Cologne, 1998, pp. 101–3, 331–40.

106. The birdlike spirit is the Ba, one of a number of interrelated vital forces. For a clear, extended explanation, see, e.g., H. Frankfort, *Kingship and the Gods*, Chicago, 1948, pp. 61–78.

107. H. Satzinger, quoted in Schultz and Seidel, *Egypt*, p. 101.

108. See N. Ray, *An Approach to Indian Art*, Chandigarh, 1974, pp. 174–78 (p. 175 quoted). See also H. Elgood, *Hinduism and the Religious Arts*, London, 1999, p. 30, on the beautiful countenance prescribed for religious images.

109. Blier, *Royal Arts of Africa*, p. 32.

110. R. F. Thompson, "Yoruba Artistic Criticism," in D'Azevedo, *The Traditional Artist in African Societies*, 10–61. See in addition Thompson's *African Art in Motion*, Berkeley, 1972; *Black Gods and Kings*, Berkeley, 1971; along with W. Fagg, J. Pemberton, and A. Holcombe, eds., *Yoruba Sculpture of West Africa*, New York, 1982. Also van Damme's *A Comparative Analysis Concerning Beauty and Ugliness* and "African Verbal Arts."

111. Thompson, "Yoruba Artistic Criticism," pp. 37–38.

112. Thompson, *Black Gods and Kings*, p. 26.

113. Berndt and Berndt, *The World of the First Australians*, pp. 28–37.

114. See Berndt and Berndt, *The Speaking Land: Myth and Story in Aboriginal Australia*, Rochester, VT, 1994 [Australia, 1988], p. 15, and more generally, chaps. 2 ("Shaping the Original World") and 3 ("Rainbows and Snakes"). For "soft and jellylike," see A. Voight and N. Drury, *Wisdom from the Earth: The Living Legacy of the Aboriginal Dreamtime*, Boston, 1998, p. 24, quoting elder David Mowaljarlai, of the Imberley region, who used the phrase "everything soft like jelly."

Granted the variety of sources for the myths, it seems best not to expect consistency, but to assimilate differences and contradictions. In addition to the works cited above, other useful sources on Dreamtime and the Rainbow Snake include the Berndts' *World of the First Australians*, pp. 368–87; and Charlesworth, Bell, and Maddock, *Religion in Aboriginal Australia*, pp. 31–55, 94–96, 286–88; M. Eliade, *Australian Religions*, Ithaca, NY, pp. 76–80, 113–16; L. R. Hiatt, "Swallowing and Regurgitating in Australian Myth and Rite," in Charlesworth, Bell, and Maddock, *Religion in Aboriginal Australia*, pp. 37–50; Kleinert and Neale, *The Oxford Companion to Aboriginal Art and Culture* (clear and full, with much on

the present); Morphy, *Aboriginal Art*; R. Poignant, *Oceanic Mythology: The Myths of Polynesia, Micronesia, Melanesia, Australia*, London, 1967, pp. 114–41 (Rainbow Snake, pp. 132–36); Stubbs, *Prehistoric Art of Australia*, pp. 60–62; T. G. H. Strehlow, "The Art of Circle, Line, and Square," in R. M. Berndt, *Australian Aboriginal Religion*, fascicle 1, Leiden, 1974, pp. 60–62 (Dreamtime); D. Tunbridge, *Flinders Ranges Dreaming*, Canberra, 1988 (stories, in authentic form); Walukurlangu Artists, *Kuruwarri*.

[My footnote cites Berndt and Berndt, *The Speaking Land*, p. xxviii.]

115. See the relatively full account in Morphy, *Aboriginal Art*, pp. 67ff.

116. Berndt and Berndt, *The Speaking Land*, p. 16.

117. Oodgeroo Noonuccal and Kabul Oodgeroo Noonuccal, *The Rainbow Serpent*, London, 1994, p. 52; cited in Voigt and Drury, *Wisdom from the Earth*, p. 36.

118. See, e.g., Morphy, *Aboriginal Art*, pp. 67ff.; and Kleinert and Neale, *The Oxford Companion to Aboriginal Art and Culture*, pp. 9–14, 577–78.

119. Tunbridge, *Flinders Ranges Dreaming*, p. xxxiv.

120. Berndt and Berndt, *The Speaking Land*, p. 18.

121. N. D. Munn, *Walbiri Iconography*, Ithaca, 1973, pp. 32–44. See also Berndt and Berndt, *The World of the First Australians*, chap. 11 (singing, poetry, dance, performances, oral literature).

122. I quote Pat Torres, whose description of herself and whose stories I found on the Australia Museum's Web site "Indigenous Australia," www.dreamtime.net.au/.

123. Hiatt, "Swallowing and Regurgitation in Australian Myth and Rite," and K. Maddock, "The World-Creative Powers," both in Charlesworth, Bell, and Maddock, *Religion in Aboriginal Australia*, pp. 31–55 (Hiatt) and 85–98, esp. p. 98 (Maddock).

124. Berndt and Berndt, *The Speaking Land*, p. 123.

125. I take this story from Caruna, *Aboriginal Art*, pp. 47–48.

126. Tunbridge, *Flinders Ranges Dreaming*, pp. 5–7 (the story, told by Anne Coulthard in the Yura Ngawarla language, is on p. 6, opposite a picture of one of Akurra's camps).

127. See ibid., pp. xxxviii–xli (xxxix and xl quoted).

128. Stubbs, *Prehistoric Art of Australia*, pp. 60–62.

129. For these dates see Morphy, *Aboriginal Art*, pp. 48–50, 429. See also B. M. Fagan, ed., *The Oxford Companion to Archeology*, New York, 1996, pp. 73–75, 600–1 (quoted); Kleinert and Neale, *The Oxford Companion to Aboriginal Art and Culture*, pp. 105–18; and Sutton, *Dreamings*.

130. For Shiva, readers can turn to the following sources: C. Dimmitt and J. A. B. van Buitenen, trans., *Classical Indian Mythology*, Philadelphia, 1978, pp. 147–218; S. Kramrisch, *The Presence of Śiva*, Princeton, 1981; H. Elgood, *Hinduism and the Religious Arts*, London, 1999, pp. 44–55; D. H. Ingalls, trans., *An Anthology of Sanskrit Court Poetry*, Cambridge, MA, 1965, pp. 68–91; J. Masselos, J. Menzies, and P. Pal, *Dancing to the Flute: Music and Dance in Indian Art*, Sydney, 1997; W. D. O'Flaherty, *Asceticism and Eroticism in the Mythology of Siva*, London, 1973, and *Hindu Myths*, Harmondsworth, 1975, pp. 137–74; C. Śivaramamurti, *Nataraja in Art, Thought, and Literature*, New Delhi, 1974, chap. 1

(the most detailed book). For illustrations, see also A. R. Mathur, ed., *The Great Tradition: Indian Bronze Masterpieces,* New Delhi, 1988.

131. See L. J. N. Banerjea, *The Development of Hindu Iconography,* 3rd ed. (reproduction of 2nd ed.), New Delhi, 1974; "The Phallic Emblem in Ancient and Medieval India," *Journal of the Indian Society of Oriental Art* 3.1, June 1935; Kramrisch, *The Presence of Śiva,* pp. 438–42; Śivaramamurti, *Nataraja,* pp. 23–24. On the contradictions embodied in the conception of Shiva, see especially O'Flaherty, *Asceticism and Eroticism.* O'Flaherty finds the irrational solution to the myths of Shiva in the worshipper's devotion, *bhakti.*

132. Dimmitt and Van Buitenen, *Classical Indian Mythology,* pp. 198–203; O'Flaherty, *Hindu Myths,* pp. 173–74; Kramrisch, *The Presence of Śiva,* pp. 439–40; Śivaramamurti, *Nataraja,* p. 30.

133. Somanathaprasasti, in Ingalls, *An Anthology of Sanskrit Court Poetry,* p. 78, no. 50. The anthology of court poetry collected by Vidyakara under the name of *Treasury of Well-turned Verse* goes back to the latter half of the eleventh century CE.

134. Śivaramamurti, *Nataraja,* p. 8.

135. Ibid., pp. 37–38. See the passage on Abhinavagupta in the last chapter of the present book.

136. "Circle of flames" represents my own composite summation of somewhat conflicting views. See Śivaramamurti, *Nataraja,* p. 30. For the richness of meanings of fire in the mythology of Shiva, see the index of motifs in O'Flaherty, *Eroticism and Asceticism,* pp. 375–89.

137. Śivaramamurti, *Nataraja,* p. 161.

138. On the symbolism of the old tree and the rock in Chinese art, see R. Barnhart, *Wintery Forests, Old Trees: Some Landscape Themes in Chinese Painting,* New York, 1972; A. de Coursey Clapp, *Wen Ching-ming,* Ascona, 1975, p. 67; Lin-ts'an Li, "Pine and Rock, Wintry Tree, Old Tree and Bamboo and Rock: The Development of a Theme," *National Palace Museum Bulletin* 4.6, Jan./Feb. 1970, pp. 4–10. For Chuang Tzu on the old tree, see *The Complete Works of Chuang Tzu,* trans. B. Watson, New York, 1968, pp. 29–30, 61–62.

139. Chuang Tzu, chap. 1.7, in B. Watson's *The Complete Works of Chuang Tzu,* p. 35 (the story also appears in translations by A. C. Graham, Kuang-ming Wu, V. Mair, and S. Hamill and J. P. Seaton). A similar, more elaborate tale appears in chap. 4 of Watson's translation, pp. 63–65, where a huge oak explains that it has survived by learning to be useless.

140. Confucian poet and Ch'an poet, in R. Barnhart, *Wintry Forests, Old Trees,* pp. 9–10.

141. Clapp, *Wen Cheng-ming,* p. 67.

142. K. Munkata, *Ching Hao's "Pi-fa-chi": A Note on the Art of the Brush,* Ascona, 1974, pp. 13–14.

143. Confucius, *Analects* 9.27; Barnhart, *Wintry Forests, Old Trees,* pp. 15–16, 18–21; Lin-ts'an Li, "Pine and Rock," pp. 4–10.

144. See Barnhart, *Wintry Forests, Old Trees,* pp. 23–27; Bush and Shih, *Early Chinese Texts on Painting,* pp. 145–50, 159–60; J. Cahill, *Parting at the Shore: The Painting of the*

Early and Middle Ming Dynasty, 1368–1580, New York and Tokyo, 1978; Clapp, *Wen Cheng-ming,* chap. 7; R. Edwards, *The Art of Wen Cheng-ming, 1470–1559,* exhibition catalogue, University of Michigan Museum of Art, Ann Arbor, 1976, pp. 119–23, 166–67; Munkata, *Ching Hao's "Pi-fa-chi."*

145. Clapp, *Wen Cheng-ming,* pp. 11–12, and on his reverence for the old masters, p. 27, on the testimony of Kung Ting-tzu, written in 1657.

146. A comment in Cahill, *Parting at the Shore,* p. 259 n. 17, speaks of "the much overpraised scroll in the Honolulu Academy of Art."

147. Edwards, *The Art of Wen Cheng-ming,* pp. 121–22, 123. [My footnote refers to p. 121 in Edwards and p. 72 in Anne Clapp's *Wen Cheng-ming.*]

148. On the Apollo-figures, readers may turn to the following sources: L. Barkan, *Unearthing the Past: Archeology and Aesthetics in the Making of Renaissance Culture,* New Haven, 1999; J. Boardman, *Athenian Red Figure Vases,* London, 1975, esp. pp. 22ff.; K. Clark, *The Nude,* Harmondsworth, 1956; B. S. Ridgway, *The Archaic Style in Greek Sculpture,* Princeton, 1977, esp. chap. 3; C. Seymour, Jr., *Sculpture in Italy, 1400 to 1500,* Harmondsworth, 1966, esp. pp. 4ff.; N. Spivey, *Understanding Greek Sculpture: Ancient Meanings, Modern Readings,* London, 1996, esp. pp. 36–50, 105–122; A. Stewart, *Art, Desire, and the Body in Ancient Greece,* Cambridge, 1997, esp. pp. 63–107, 228–29.

149. Stewart, *Art, Desire, and the Body in Ancient Greece,* p. 27; H. I. A. Marrou, *A History of Education in Antiquity,* New York, 1956; repr., Madison, 1982, chap. 3; A. Chastel, *Art et humanisme à Florence au temps de Laurent le Magnifiques,* Paris, 1959, pp. 278ff.

150. See Chastel, *Art et humanisme à Florence,* pp. 278ff., 289ff.; R. Wittkower and M. Wittkower, *Born under Saturn: The Character and Conduct of Artists; A Documented History from Antiquity to the French Revolution,* London, 1963, pp. 169–75.

151. H. Honour, *Romanticism,* London, 1979, p. 60; and *Neo-Classicism,* Harmondsworth, 1968, p. 15; see also p. 117.

152. Himmelheber, *Negerkunst und Negerkünstler,* pp. 85–86. Himmelheber was, in his way, a pioneer, but subsequent research shows that he often missed the individuality of the work he observed.

153. Ibid., pp. 85–86.

154. Ben-Amos, *The Art of Benin,* p. 17; see also p. 97.

155. Ibid., p. 18.

156. Strother, *Inventing Masks,* pp. 91–92, 95.

157. See A. K. Coomaraswamy, *The Arts and Crafts of India and Ceylon,* London, 1913, and *Medieval Sinhalese Art,* 2nd ed., New York, 1956; S. Kramrisch, "Traditions of the Indian Craftsman," in M. Singer, ed., *Traditional India,* Philadelphia, 1959; M. S. Randwha, *Bahsoli Painting,* New Delhi, 1959, p. 116.

158. Kramrisch, "Traditions of the Indian Craftsman," p. 20; R. C. Majumdar, *Corporate Life in Ancient India,* Calcutta, 1919, chap. 1; G. Michell, *The Hindu Temple,* London, 1977, pp. 55–57.

159. A. Boner and S. R. Sarma, with R. P. Das, *New Light on the Sun Temple of Konaraka,* Varanasi, 1972, pp. xli–xliii; Michell, *The Hindu Temple,* pp. 78–85.

160. J. S. Burgess, *The Guilds of Peking*, New York, 1928; S. van der Sprenkel, *Legal Institutions in China*, London, 1962, pp. 92–96; Y. Shimuzu, "Workshop Management of the Early Kano Painters, ca. A.D. 1530–1600," *Archives of Asian Art* 34, 1981; T. Takeda, *Kano Eitoku*, Tokyo, 1957, pp. 11–14.

161. A. Burford, *Craftsmen in Greek and Roman Society*, London, 1972, chap. 3.

162. On the medieval guilds, see the following sources: J. Gimpel, *Les Batisseurs des cathédrales*, Paris, 1958, esp. chap. 5; F. Icher, *Building the Great Cathedrals*, New York, 1998 (especially well illustrated); E. Welch, *Art and Society in Italy, 1350–1500*, Oxford, 1997, esp. chap. 3, "The Organization of Art."

163. From R. Dez, *Regius, manuscrit 1390, première lueur de l'aube au pied des cathédrales, la charte la plus ancienne des franc-mestiers de bâtisseurs*, Paris, 1987; cited in Icher, *Building the Great Cathedrals*, pp. 163, 164, 166.

164. W. Cahn, *Masterpieces*, Princeton, 1979, is a good introduction to the subject.

165. Welch, *Art and Society in*, p. 90. See also C. E. Gilbert, *Italian Art, 1400–1500: Sources and Documents*, Englewood Cliffs, NJ, 1980, p. 34.

166. M. Baxendall, *The Limewood Sculptors of Renaissance Germany*, New Haven, 1980, p. 123.

167. For China in the light of these generalizations, see J. B. Henderson, *The Development and Decline of Chinese Cosmology*, New York, 1984. The historical variety of views and practices is so great that I find it hard to give more than a basic summary.

168. E. Guidoni, *Primitive Architecture*, London, 1975, is a well-illustrated introduction, based on serious anthropological literature.

169. M. Griaule, *Conversations with Ogotemmêli*, pp. 94–95; quoted in Guidoni, *Primitive Architecture*, p. 148.

170. For more on Chinese architecture, see the following sources: L. G. Liu, *Chinese Architecture*, New York, 1989; J. Needham, *Science and Civilisation in China*, vol. 2, *History of Scientific Thought*, Cambridge, 1991; C. Ronan and J. Needham, *The Shorter Science and Civilisation in China*, vol. 5, Cambridge, 1995, esp. chap. 2, "Building Technologies; L. Sickman and A. Soper, *The Art and Architecture of China*, 3rd ed., Harmondsworth, 1971; W. Watson, *Art of Dynastic China*, London, 1979.

171. Liu, *Chinese Architecture*, p. 29; Ronan and Needham, *The Shorter Science and Civilisation in China*, p. 361.

172. Ronan and Needham, *The Shorter Science and Civilisation in China*, p. 52.

173. Liu, *Chinese Architecture*, p. 279.

174. Ronan and Needham, *The Shorter Science and Civilisation in China*, p. 53; see also Liu, *Chinese Architecture*, p. 30. [The footnote below is from Ronan and Needham, p. 77.]

175. For more on building in India, see the following sources: J. Auboyer, *Introduction à l'étude de l'art de l'Inde*, Rome, 1965, pp. 34ff.; T. Bhattacharyya, *The Canons of Indian Art*, 2nd ed., Calcutta, 1963; H. Elgood, *Hinduism and the Religious Arts*, London, 1999, esp. chaps. 2 and 4; G. Michell, *The Hindu Temple*, London, 1977; K. V. S. Rajan, *Indian Temple Styles*, New Delhi, 1970; H. Stierlin, *Hindu India: From Khajuraho to the Temple City of Madurai*, Cologne, 1998 (clear, simple text and excellent illustrations).

176. Auboyer, *Introduction*, pp. 34–36; Bhattacharyya, *The Canons of Indian Art*, chap. 21; Elgood, *Hinduism and the Religious Arts*, pp. 93–134; Michell, *The Hindu Temple*; Stierlin, *Hindu India*, pp. 55–76.

177. Auboyer, *Introduction*, p. 46.

178. P. N. Bose, ed., *Silpa-Sastram*, Lahore, 1928, pp. 639–60.

179. Stierlin, *Hindu India*, p. 66; see also Michell, *The Hindu Temple*, pp. 71–74. [My footnote cites Stierlin, p. 64.]

180. T. A. G. Rao, *Talamana or Iconometry*, Calcutta, 1920, pp. 36ff. On Indian religious art in general, see R. H. David, *Lives of Indian Images*, Princeton, 1997; and Elgood, *Hinduism and the Religious Arts*, esp. chap. 2.

181. Auboyer, *Introduction*, p. 49. On the absence of full coincidence, see Elgood, *Hinduism and the Religious Arts*, p. 31, citing A. Gail, in A. Dellapiccola, ed., *Shastric Traditions in Indian Art*, Stuttgart, 1989, p. 109.

182. Elgood, *Hinduism and the Religious Arts*, p. 31, citing A. Mosteller, in the *Art Journal* 49.4, 1990, p. 389.

183. Elgood, *Hinduism and the Religious Arts*, p. 30.

184. But see Banerjea, *The Development of Hindu Iconography*, pp. 332–33. Speaking of images, Banarjea says that often the approximation with theory was quite close. See also Elgood, *Hinduism and the Religious Arts*, pp. 30–31.

185. Aristotle, *Metaphysics* 985b23, as translated in G. S. Kirk, J. E. Raven, and M. Schofield, *The Presocratic Philosophers*, 2nd ed., Cambridge, 1983, pp. 329–30.

186. Vitruvius, *The Ten Books on Architecture*, trans. M. H. Morgan, repr., New York, 1960. On different measurements, see J. J. Coulton, *Greek Architects at Work: Problems of Structure and Design*, London, 1977, pp. 65ff. A plausible general explanation is given by L. Haselberger, "The Construction Plans for the Temple of Apollo at Didyma," *Scientific American*, Dec. 1985, p. 118.

187. Vitruvius, *The Ten Books on Architecture*, bk. 3, chap. 1, p. 73.

188. Haselberger, "Construction Plans for the Temple of Apollo," pp. 118, 122.

189. Pollitt, *The Ancient View of Greek Art: Criticism, History, and Terminology*, New Haven, 1974, p. 162; Coulton, *Greek Architects at Work*, pp. 167, 171 n. 49.

190. C. Norburg-Schultz, *Intentions in Architecture*, Cambridge, MA, 1965, pp. 88–91; R. Wittkower, *Architectural Principles in the Age of Humanism*, London, 1962.

191. Norberg-Schultz, *Intentions in Architecture*, p. 92. On Chinese doubts, see Henderson, *The Development and Decline of Chinese Cosmology*, chaps. 7–9.

192. E. Iverson, "The Canonical Tradition," in J. R. Harris, ed., *The Legacy of Egypt*, London, 1971, pp. 56–57; B. S. Ridgeway, *The Archaic Style in Greek Sculpture*, Princeton, 1977, pp. 29ff. A Greek tradition says two sculptors, Theodorus and Telecles, sons of Rhoecus, got the grid technique from the Egyptians: see Pollitt, *The Ancient View of Greek Art*, p. 13. Classicists tend to minimize Egyptian influence: see Boardman, *Athenian Red Figure Vases*, pp. 18ff; and Spivey, *Understanding Greek Sculpture*, pp. 39–43. For the influence of Polyclitus on Renaissance artists, see L. Barkan, *Unearthing the Past: Archeology and Aesthetics in the Making of the Renaissance*, New Haven, 1999, pp. 247–69.

193. Galen, *De placitis Hippocratis et Platonis* 5.448; translated by Spivey, *Understanding Greek Sculpture*, p. 41. I've changed "Polykleitos" to "Polyclitus." See also Coulton, *Greek Architects at Work*.

194. "Virtually stereotyped"—Varro's words, in Pliny, *Naturalis Historia* 34.56; and "perfection arises," from Pollitt, *The Ancient View of Greek Art*, pp. 15, 88.

195. Stewart, *Art, Desire, and the Body in Ancient Greece*, p. 93.

196. My comments echo Plato's *Republic* 503a, 536a, 543c (readers may refer to the Loeb Classical Library edition, trans. Paul Shorey).

197. Pliny, *Naturalis Historia* 34.55.

198. Cicero, *De Inventione* 2.1.1, in J. J. Pollitt, *The Art of Greece, 1400–31 B.C.: Sources and Documents*, Englewood Cliffs, NJ, 1965, p. 156.

199. Barkan, *Unearthing the Past*, p. 251.

200. Grimal, *A History of Ancient Egypt*, p. 181. See also the references in the following note.

201. J. Assman, "Kulturelle und literarische Texte," pp. 75–77; J. Baines, "Classicism and Modernism in the New Kingdom," pp. 159, 166–171; C. J. Eyre, "Is Egyptian Historical Literature 'Historical' or 'Literary?'"; A. Loprieno, "Defining Egyptian Literature," pp. 56–57; A. Loprieno, "Linguistic Variety and Egyptian Literature," pp. 522–23—all in A. Loprieno, *Ancient Egyptian Literature: History and Forms*, Leiden, 1996.

202. M. Lichtheim, *Ancient Egyptian Literature: A Book of Readings*, vol. 2, *The New Kingdom*, Berkeley, 1976, p. 177 (from the Chester Beatty Papyrus IV, 2.5v–3.11).

203. Eyre, "Is Egyptian Historical Literature 'Historical' or 'Literary?'" p. 429. See also J. A. Wilson, *The Burden of Egypt: An Interpretation of Ancient Egyptian Culture*, Chicago, 1951, chap. 11; and Schultz and Seidel, *Egypt*, p. 340.

204. Wilson, *The Burden of Egypt*, pp. 294–95.

205. Confucius, *Analects* 307.25.2.

206. The quotation from the Great Preface to the *Song of Songs* is from Fusheng Wu, *The Poetics of Decadence: Chinese Poetry of the Southern Dynasties and the Late Tang Periods*, Albany, 1998, p. 11. See also D. Holzman, "Confucius and Ancient Literary Criticism," in A. A. Rickett, ed., *Chinese Approaches to Literature from Confucius to Lian Ch'i-ch'ao*, Princeton, 1978; S. Owen, *The Poetry of the Early T'ang*, New Haven, 1977, pp. 3–7; Liu Hsieh, *The Literary Mind and the Carving of Dragons*, trans. V. Yu-chung Shih, New York, 1959, pp. xxxiv, xl, 21.

207. Owen, *The Poetry of the Early T'ang*, pp. 6–7, and more generally, chap. 2; also Liu Hsieh, *The Literary Mind and the Carving of Dragons*, p. xliii.

208. Owen, *The Poetry of the Early T'ang*, p. 15; on "decadence" and "lasciviousness," see chap. 2, also the poems in Wu, *The Poetics of Decadence*.

209. For background on classical Japanese literature, readers may turn to the following sources: R. H. Brouwer and E. Miner, *Japanese Court Poetry*, Stanford, 1961, esp. pp. 23, 286–87, 291; Jin'ichi Konishi, *A History of Japanese Literature*, vol. 3, *The High Middle Ages*, Princeton, 1991, esp. pp. 139–43, 185–86, 471.

210. Konishi, *A History of Japanese Literature*, p. 142.

211. For Chinese commentators on painting, I point readers to the following works: W. R. B. Acker, *Some T'ang and Pre-T'ang Texts on Chinese Printing*, Leiden, 1954; S. Bush and H. Shih, *Early Chinese Texts on Painting*, Cambridge, MA, 1985; J. Cahill, "Confucian Elements in the Theory of Painting," in A. F. Wright, ed., *The Confucian Persuasion*, Stanford, 1960, pp. 115–40.

212. Acker, *Some T'ang and Pre-T'ang Texts*, p. 61.

213. From the "Discourse on Calligraphy" of Chang Huai-kuan (first half of the eighth century CE), as quoted in Cahill, "Confucian Elements in the Theory of Painting," p. 127.

214. Chang Yen-yüan, *A Record of All the Famous Painters of All the Dynasties*, quoted in Cahill, "Confucian Elements in the Theory of Painting," p. 61 (I've removed parentheses around a few supplementary words provided by the translator and, in brackets, added explanations based on his notes and the remarks on pp. 81ff.).

215. Ibid., pp. 73–75, 78 (p. 75 quoted).

216. The following sources are useful on the Chinese scholarly style: E. Bush, *The Chinese Literati on Painting*, Cambridge, MA, 1971, esp. pp. 121–24; J. Cahill, *Hills beyond a River: Chinese Painting of the Yüan Dynasty, 1279–1368*, New York and Tokyo, 1976, esp. pp. 38–46; C. Li, *The Autumn Colors on the Ch'iao and Hua Mountains: A Painting by Chao Meng-fu*, Ascona, 1965; and "Stages in the Development in Yüan Landscape Painting," *National Palace Museum Bulletin* 4.2, May/June 1969, and 4.3, July/Aug. 1969; Lin Yutang, *The Chinese Theory of Art*, London, 1967, esp. pp. 107–10; O. Siren, *The Chinese on the Art of Painting*, [Beijing], 1936; W. C. Fong, "Archaism as a 'Primitive' Style," in C. Murck, *Artists and Traditions: Uses of the Past in Chinese Culture*, Princeton, 1976, pp. 89–129; N. I. Wu, "The Evolution of Tung Ch'i-ch'ang's Landscape Style," in paper delivered at the International Symposium on Chinese Painting, National Palace Museum, Taipei, 18–24 June, 1970.

217. For both Chao's comments, see Li, *The Autumn Colors*, p. 76.

218. P. C. Sturman, *Mi Fu: Style and the Art of Calligraphy in Northern Sung China*, New Haven, 1997, p. 3. I have adopted the dates for Mi Fu's life from Sturman, the most recent monograph. The usually cited dates are 1051–1107. On Mi Fu's desire to return to antiquity, see Sturman, p. 169. See also Bush, *The Chinese Literati on Painting*, pp. 67–74; Van Gulik, *Chinese Pictorial Art*; Ledderose, *Mi Fu*; W. C. Fong et al., *Images of the Mind*, Princeton, 1984, pp. 84–91 (on the Elliott Collection at the Princeton University Art Museum).

219. Quotation from Sturman, *Mi Fu*, p. 43; for Mi's wide-ranging expertise, see Ledderose, *Mi Fu*, p. 45.

220. [My footnote cites F. Ames-Lewis, *The Intellectual Life of the Early Renaissance Artist*, New Haven, 2000, pp. 127–28, and on doubts about the veracity of the story, p. 287 n. 42.]

221. Ledderose, *Mi Fu*, pp. 52–53.

222. Sturman, *Mi Fu*, pp. 216 (scrubbing of gowns), 213; for a translated group of anecdotes involving Mi Fu, see pp. 212–24.

223. Fong et al., *Images of the Mind*, p. 83 (Hsieh An calligraphy); Sturman, *Mi Fu*, pp. 222 (drowning threat) and 279 (emperor's inkstone).

224. Van Gulik, *Chinese Pictorial Art,* p. 188. [T'ang Hou's advice quoted in my footnote appears in Bush and Shih, *Early Chinese Texts on Painting,* pp. 256, 258.]

225. Sturman, *Mi Fu,* p. 223; see also Van Gulik, *Chinese Pictorial Art,* p. 192.

226. Sturman, *Mi Fu,* p. 70. [My footnote cites Van Gulik, *Chinese Pictorial Art,* p. 44.]

227. Ledderose, *Mi Fu,* pp. 57–58. [My footnote draws on W. C. Fong, "Orthodoxy and Change in Early-Ch'ing Landscape Painting, *Oriental Art,* n.s. 16.1, 1970, pp. 38–44; and Ledderose, *Mi Fu,* pp. 38, 58–60, 92–94. On ibn Muqleh, see A. Khatibi and M. Sijelmassi, *The Splendour of Islamic Calligraphy,* London, 1976, p. 132.]

228. Cahill, *The Painter's Practice,* p. 128.

229. J. Cahill, *The Distant Mountains: Chinese Painting of the Late Ming Dynasty,* New York and Tokyo, 1982, pp. 250–51.

230. Ibid., p. 259. The end of this poem, which I do not quote, is more optimistic.

231. Ibid., pp. 255–56.

232. J. Cahill, *The Compelling Image,* Cambridge, MA, 1982, pp. 107–45, and *The Distant Mountains,* 203–6, 244–66; V. Contag, *Chinese Masters of the 17th Century,* London, 1969, pp. 43–45; T. Lawton, *Chinese Figure Painting,* Washington, D.C., 1973, pp. 130–31, 192–98; Fong, "Archaism as a 'Primitive' Style," pp. 101ff.; Y. Xin, "The Ming Dynasty," in Xin et al., *Three Thousand Years of Chinese Painting,* pp. 236–43; W. C. Fong and J. C. Y. Watt, *Possessing the Past: Treasures from the National Palace Museum, Taipei,* New York and Taipei, 1996, pp. 404–17.

233. I take this point from Cahill, *The Compelling Image,* p. 106.

234. Fong, "Archaism as a 'Primitive' Style," p, 108.

235. Fong, "Archaism as a 'Primitive' Style," p. 105; Cahill, *The Distant Mountains,* pp. 204–5, and Cahill, *The Compelling Image,* pp. 107–8, 116–20.

236. Cahill, *The Distant Mountains,* p. 205. I have dropped Cahill's parentheses around explanatory completions.

237. Ibid., p. 265.

238. Ledderose, *Mi Fu,* p. 41. For collections generally, see pp. 39–44.

239. Van Gulik, *Chinese Pictorial Art,* pp. 29ff.

240. Ibid., pp. 47–48.

241. Van Gulik, *Chinese Pictorial Art,* p. 478.

242. Hongnam Kim, *The Life of a Patron: Zhou Lianggong (1612–1672) and the Painters of Seventeenth-Century China,* New York, 1996, p. 21.

243. See in addition to Cahill's *The Compelling Image* and *The Distant Mountains,* his chapter "The Orthodox Movement in Chinese Painting," in Murck, *Artists and Traditions.* See also Fong et al., *Images of the Mind,* pp. 166–79; W. Ho, ed., *The Century of Tung Ch'i-ch'ang, 1555–1636,* 2 vols., Kansas City (Nelson-Atkins Museum of Art) and Seattle, 1992; M. Q. Pang, "Tun Ch'i-ch'ang and His Circle," in J. Cahill, ed., *Shadows of Mt. Huang,* Berkeley, 1981; Siren, *The Chinese on the Art of Painting;* and Wu, "The Evolution of Tung Ch'i-ch'ang's Landscape Style."

244. J. Cahill, "Tung Ch'i-chang's Painting Style: Its Sources and Transformations," in Ho, *The Century of Tung Ch'i-ch'ang,* vol. 1, p. 77.

245. On *fang*, see Cahill, *The Distant Mountains*, pp. 120–26, and the equivalent pages, 47–63, in Cahill's *The Compelling Image*.

246. See S. G. Galassi, *Picasso's Variations on the Masters*, New York, 1996.

247. Cahill, *The Compelling Image*, p. 63. The comparison with Picasso is also from Cahill. When making his comparison with Stravinsky, Cahill says, he was thinking of the passage in Stravinsky's *Poetics of Music*, Cambridge, MA, 1942, in which Stravinsky compared Beethoven's inspired but hardly melodic music with Bellini's melodic but otherwise empty music.

248. C. C. Riely, "Tung Ch'i Chang's Life (1555–1636)," in Ho, *The Century of Tung Ch'i-ch'ang*, vol. 2, pp. 436–37.

249. Siren, *The Chinese on the Art of Painting*, p. 143.

250. W. Ho, "Tung Ch'i-ch'ang's New Orthodoxy and the Southern School Theory," in Murck, *Artists and Traditions*, p. 119.

251. Ibid., pp. 120–24.

252. Ibid., p. 122.

253. W. Ho and D. Ho Delbanco, "Tung Ch'i-ch'ang's Transcendence of History and Art," in Ho, *The Century of Tung Ch'i Ch'ang*, vol. 1, p. 19.

254. Ho, "Tung Ch'i-ch'ang's New Orthodoxy," pp. 124–29.

255. Ho and Delbanco, "Tung Ch'i-ch'ang's Transcendence of History and Art," in Ho, *The Century of Tung Ch'i Ch'ang*, vol. 1, p. 19.

256. Fong et al., *Images of the Mind*, pp. 167–68, quoting from Tung's notes on painting, *Hua-yen*.

257. See, e.g., the protest in Ho, *The Century of Tung Ch'i Ch'ang*, vol. 1, p. 20, and remarks on pp. 30–31.

258. Cahill, *The Compelling Image*, pp. 37–38.

259. On landscape construction and brushstrokes, see Cahill, "The Orthodox Movement in Chinese Painting, p. 176. For a description of "dragon veins," see Siren, *The Chinese on the Art of Painting*, pp. 204–5; and R. Whitefield, *In Pursuit of Antiquity*, Rutland, VT, and Tokyo, 1969, pp. 185–86.

260. Ho and Delbanco, "Tung Ch'i-ch'ang's Transcendence of History and Art," p. 28. The short, immediately preceding quotation is from p. 31.

261. Ibid, pp. 19, 20, 33. The favorable verdict of the two authors is aimed in part at what they feel to be the too dismissive view of James Cahill, of whom, as my notes make evident, I have made much use, and Max Loehr, to whom I've not referred. They quote Cahill's *The Compelling Image*, p. 37.

262. R. P. Hardie, in S. Hornblower and A. Spawforth, eds., *The Oxford Classical Dictionary*, 3rd ed., Oxford, 1996, p. 336.

263. Longinus, quoted in D. A. Russell and M. Winterbottom, *Ancient Literary Criticism*, London, 1981, pp. 475–76. See also R. Pfeiffer, *History of Classical Scholarship*, London, 1968; M. A. Grube, *The Greek and Roman Critics*, London, 1965.

264. On European classicism, see R. Pfeiffer, *History of Classical Scholarship 1300–1850*, London, 1976; R. A. Bolgar, *The Classical Heritage and Its Beneficiaries*, London, 1954.

265. J. Burckhardt, *The Civilization of the Renaissance*, London (Phaidon), 1995, p. 130; on Niccolò Niccoli, see p. 121. Also, more elaborately, D. Kent, *Cosimo de' Medici and the Florentine Renaissance*, New Haven, 2000, pp. 23–25. On the learning of Petrarch, see Pfeiffer, *History of Classical Scholarship*, pp. 3–15.

266. J. Hale, *The Civilization of Europe in the Renaissance*, London, 1993, p. 190.

267. A. F. Steward, "Retrospective Styles in Sculpture," in Hornblower and Spawforth, *The Oxford Classical Dictionary*, pp. 1307–8; N. Spivey, *Greek Art, Greek Art,* London, 1997, pp. 382–94, and *Understanding Greek Sculpture*, pp. 218–25.

268. Spivey, *Understanding Greek Sculpture*, pp. 219–20.

269. R. R. R. Smith, *Hellenistic Sculpture*, London, 1991, p. 258.

270. Spivey, *Greek Art,* p. 222. On Greek copies, see also Spivey's *Understanding Greek Sculpture*, pp. 222–23; J. Boardman, *Greek Sculpture: The Late Classical Period*, London, 1995, pp. 73–77; Smith, *Hellenistic Sculpture*, pp. 258–61; and D. Strong, *Roman Art*, 2nd, rev. ed., Harmondsworth, 1980, pp. 58–63.

271. F. Haskell and N. Penny, *Taste and the Antique*, New Haven, 1980.

272. For an extensive anthology of sources, see Harrison, Wood, and Gaiger, *Art in Theory, 1648–1815: An Anthology of Changing Ideas,* Oxford, 2000, esp. pp. 67–143.

273. See E. Panofsky, *Idea*, New York City, 1968, pp. 105–7, 155–77. (See the summary in M. Barasch, *Theories of Art*, vol. 1, *From Plato to Winckelmann*, New York, [1985] 2000, pp. 315–22.)

274. Quoted in Panofsky, *Idea*, pp. 155, 157, 165.

275. Ibid., p. 171.

276. J. J. Winckelmann, *Reflections on the Imitation of Greek Works in Painting and Sculp-ture* (excerpts from his first book, printed in 1755, and translated by E. Heyer and R. C. Nor-ton), in D. Preziosi, ed., *The Art of Art History: A Critical Anthology*, Oxford, 1998, pp. 31–39. See also M. Barasch, *Theories of Art*, vol. 2, *From Winckelmann to Baudelaire*, New York, [1990] 2000, pp. 97–119; W. Davies, "Winckelmann Divided: Mourning the Death of Art History," in Preziosi, *The Art of Art History,* pp. 40–51; L. Eitner, *Neoclassicism and Roman-ticism, 1750–1850,* Englewood Cliffs, NJ, 1970, pp. 30–32; Harrison, Wood, and Gaiger, *Art in Theory, 1648–1815,* pp. 466–75; D. Irwin, *Neoclassicism,* London, 1997, pp. 25–35; Panof-sky, *Idea,* pp. 242–43, Pfeiffer, *History of Classical Scholarship,* pp. 168ff.

277. Harrison, Wood, and Gaiger, *Art in Theory, 1648–1815,* pp. 466–67, 471.

278. Winckelmann, *Reflections on the Imitation of Greek Works*, in Preziosi, *The Art of Art History,* pp. 31, 33, 38. See also Harrison, Wood, and Gaiger, *Art in Theory, 1648–1815,* p. 451.

279. On Winckelmann's erotic life and its possible relation to his work, see Davies, "Winckelmann Divided," pp. 42–43, 47–51. R. Jenkyns, *The Victorians and Ancient Greece,* Cambridge, 1980, is relevant.

280. See, e.g., Irwin's *Neoclassicism* and, especially for the illustrations, R. Toman, ed., *Neoclassicism and Romanticism: Architecture, Sculpture, Painting, Drawings, 1750–1848,* Cologne, 2000.

281. Poussin's varying ideas of painting include "delight" and expressing the "passions

of the soul" as visible in human actions and facial expressions. See Barasch, *Theories of Art,* vol. 1, pp. 322–30. Poussin's words, as quoted on p. 326 of Barasch, are derived from Bellori's life of Poussin.

282. Joshua Reynolds, *Discourses on Art,* discourse 3, in Eitner, *Neoclassicism and Romanticism,* p. 39. See M. Barasch, *Modern Theories of Art,* vol. 2, *From Impressionism to Kandinsky,* New York, 1998, pp. 132–40.

283. J. Rosenberg, *On Quality in Art,* Princeton, 1967, pp. 34–47. On seventeenth- and early-eighteenth-century hierarchies of value and rules for grading paintings, see Barasch, *Theories of Art,* vol. 1, pp. 340–44.

284. See Barasch, *Theories of Art,* vol. 1 chap. 6 ("Classicism and Academy"); Karen-edis Barzman, "Academies, Theories, and Critics," in M. Kemp, ed., *The Oxford History of Western Art,* Oxford, 2000, pp. 290–92; A. Blunt, *Art and Architecture in France, 1500–1700,* 2nd ed., Harmondsworth, 1970; A. Boime, *The Academy and French Painting in the Nineteenth Century,* London, 1975, pp. 3–15; M. Crasky, *Art in Europe, 1700–1830,* London, 1997, pp. 130–37; S. Lee, *David,* London, 1999; A. Mérot, *French Painting in the Seventeenth Century,* New Haven, 1995, chaps. 1 and 6.

285. Lee, *David,* pp. 21–22.

286. [My footnote cites Simon Lee, ibid., p. 151.]

287. Ibid., p. 36.

288. Blunt, *Art and Architecture in France,* pp. 344ff. Boime, *The Academy and French Painting,* pp. 15ff. Much of the detail of the last few paragraphs is from Barzman, "Academies, Theories, and Critics."

289. Boime, *The Academy and French Painting,* pp. 42–43.

290. Delacroix quoted in ibid., pp. 42–43, 122–23.

291. Ingres quoted in ibid., pp. 94, 124.

292. Barkan, *Unearthing the Past,* p. 273.

293. G. Vasari, *Lives of the Painters, Sculptors and Architects,* trans. G. de C. de Vere, vol. 2, London, [1912] 1996. pp. 273–74. See Barkan, *Unearthing the Past,* pp. 276–77; on the attachment of a different restoration of the arm, see p. 11.

294. Vasari, *Lives of the Painters,* p. 743.

295. Ibid., pp. 650–51.

296. The quotations about Michelangelo are from Barkan, *Unearthing the Past,* pp. 200–203, who relies on Condivi, Vasari, and others.

297. [The account by Francesco da Sangalla quoted my footnote appears in Barkan, *Unearthing the Past,* p. 3. On the possibility that the Laocoön is a forgery by Michelangelo, I quote from an online posting of the Columbia [University] News Service, dated May 2, 2005. I thank Wilfried van Damme for drawing the charge of forgery to my attention.]

298. Barkan, *Unearthing the Past,* p. 198.

299. Ibid., p. 207.

300. Ibid., p. 14.

301. Ibid., p. 15. See also R. S. Lieber, *Michelangelo: A Psychoanalytic Study of His Life and Images,* New Haven, 1983, pp. 164, 170, 172–73 (a psychoanalytic speculation on the pos-

sible effect of the Laocoön on Michelangelo as a dramatic portrayal of the union of father and sons in death).

302. J. D. Rosenberg, *The Genius of John Ruskin*, p. 184.

303. See R. Hewison, *John Ruskin*, Princeton, 1976, pp. 134–38; J. D. Rosenberg, ed., *The Genius of John Ruskin*, London, 1979, pp. 182–96; also (in criticism) D. Pye, *The Nature and idea of Workmanship*, London, 1971, pp. 47–56.

304. On the Arts and Crafts movement, see E. Lucie-Smith, *The Story of Craft: The Draftsman's Role in Society*, Oxford, 1980.

305. B. Leach, *The Potter's Challenge*, London, 1976.

306. Ibid., pp. 20–21ff.

307. Leach's introduction to S. Yanagi, *The Unknown Craftsman*, Tokyo, 1972, pp. 97–98. See also K. Muraoka and K. Okamura, *Folk Arts and Crafts of Japan*, New York/Tokyo, 1973; and B. Moeran, *Folk Art Potters of Japan: Beyond an Anthropology of Aesthetics*, Honolulu, 1997.

308. Yanagi, *The Unknown Craftsman*, pp. 132–35 (p. 134 quoted).

309. I've lost my note of the source but find the quotation too hard to resist.

310. Yanagi, *The Unknown Craftsman*, pp. 197–202.

311. Moeran, *Folk Art Potters of Japan*, pp. 1–3, 67–69.

312. Ibid., p. 121; see also pp. 210–13.

313. Ibid, pp. 182–83; on success and disequilibrium, see pp. 164ff.

314. Ibid., pp. 184–86.

315. Ibid., pp. 184–87 (pp. 186 and 187 quoted).

316. Ibid., pp. 188–89; see also p. 194.

317. H. Glassie, *The Spirit of Folk Art: The Girard Collection at the Museum of International Folk Art*, New York, 1989, p. 31.

318. For an initiation into Coomaraswamy's views on art, see the anthology *Coomaraswamy: Traditional Art and Symbolism*, vol. 1 of Coomaraswamy's *Selected Papers*, Princeton, 1977; and A. K. Coomaraswamy, *The Transformation of Nature in Art*, Cambridge, MA, 1935. [On the discussion of Coomaraswamy's character in my footnote, see R. Lipsey, *Coomaraswamy*, Princeton, 1977, pp. 144ff.

319. A. K. Coomaraswamy, *Medieval Sinhalese Art*, 2nd ed., New York, 1956.

320. R. Lipsey, in Coomaraswamy, *Traditional Art and Symbolism*, p. xxxii.

321. On the influence of Gilson and Guenon, see Lipsey, *Coomaraswamy*, pp. 168ff., 172.

322. E.g., A. K. Coomaraswamy, *The Religious Basis of the Forms of Indian Society*, New York, 1946.

323. Coomaraswamy, *Traditional Art and Symbolism*, p. 45; also in Lipsey, *Coomaraswamy*, p. 189.

324. Lipsey, *Coomaraswamy*, p. 268.

325. Ibid., p. 189.

326. Coomaraswamy, *The Transformation of Nature in Art*, pp. 5–6.

327. A. K. Coomaraswamy, "The Intellectual Operation in Indian Art," *Journal of the Indian Society of Oriental Art* 3.1, June 1935; also, with addenda, in Coomaraswamy, *Tradi-*

tional Art and Symbolism, pp. 131–46. See also H. Zimmer, *The Art of Indian Asia*, vol. 1, New York, 1955, pp. 318–21. [My footnote on the Trobriand carver quotes Gell, "The Technology of Enchantment," cited in Coote and Shelton, *Anthropology, Art and Aesthetics*, p. 54.]

328. Dante *Convivio,* canzone 3.53–54, quoted in Coomaraswamy, "The Intellectual Operation in Indian Art," p. 9.

329. Coomaraswamy, *The Transformation of Nature in Art*, p. 17, "The Intellectual Operation in Indian Art," p. 57.

330. Mitter, *Much Maligned Monsters*, p. 286.

331. N. Ray, *An Approach to Indian Art*, Panjab University, Chandigarh, 1974, p. 18.

332. For a historic survey of the so-far inadequate metaphors used for memory, from seals in wax to holograms and neural networks, see D. Draaisma, *Metaphors of Memory: A History of Ideas about the Mind*, Cambridge, 2000.

333. S. Kierkegaard, *Either/Or*, pt. 1, trans. H. V. Hong and E. H. Hong, Princeton, 1987, p. 47.

CHAPTER 3: EGOCENTRIC INNOVATION

1. The words "Zuni Indians compete" refer to criticisms made of Ruth Benedict's stylized account of the Zuni in her *Patterns of Culture*, Boston and New York, 1934. On the Ch'an monk, see H. Welch, *The Practice of Chinese Buddhism*, Cambridge, MA, 1967, esp. pp. 55, 62, 71, 80–88.

2. On the architect's position in ancient Egypt, see C. Aldred, *Akhenaten and Nefertiti*, New York, 1973, pp. 56, 63; H. Junker, *Die gesellschaftliche Stellung der Ägyptischen Künstler im Alten Reich*, Vienna, 1959; H. Kees, *Ancient Egypt*, London, 1961, pp. 154, 255, 258, 262, 264, 300; W. S. Smith, *The Art and Architecture of Ancient Egypt*, rev. ed., Harmondsworth, 1981, pp. 226, 228, 297, 299.

On the architect in ancient India, see M. K. Dhavalikar, "Sri Yugdhara—a Master-Artist of Ajanta," *Artibus Asiae* 31, 1969, pp. 101–2.

On the architect in medieval Europe, see J. Gimpel, *Les battiseurs des cathédrales*, Paris, 1958, pp. 116–20 ; L. Grodecki, *Gothic Architecture*, New York, 1977, pp. 31–22; F. Harvey, *The Master Builders: Architecture in the Middle Ages*, London, 1971; H. Kraus, *The Living Theatre of Medieval Art*, London, 1967.

On the architect in Islamic culture, see R. Lewcock, "Materials and Techniques," in G. Michell, ed., *Architecture of the Islamic World*, London, 1978, pp. 129–33.

3. See L. Kohn, *The Taoist Experience*, Albany, 1993, pp. 279–302.

4. Chuang Tzu (Zhuangzi), chap. 2.11, from V. H. Mair, *Wandering on the Way: Early Taoist Tales and Parables of Chuang Tzu*, New York, 1994, p. 21. Compare the translation in B. Watson, *The Complete Works of Chuang Tzu*, New York, 1968, p. 46. An older, still sometimes useful translation can be found in J. Legge, *The Texts of Taoism*, pt. 1, London, 1891; repr., 1927.

5. S. Eskildsen, *Asceticism in Early Taoist Religion*, Albany, 1998, pp, 22–24, 44–46.

6. Watson, *Complete Works of Chuang Tzu*, p. 228 (chap. 21.5). It's likely that "pictures" should be translated as "maps" or "charts," and "true artist," as Mair and Legge translate

it, should be "true draftsman." But though these words may seem more unexpected to us, the point is just the same.

7. Chuang Tzu, chap. 19.9 (Legge, *The Texts of Taoism*, pt. 1, p. 22; Mair, *Wandering on the Way*, p. 182–83; Watson, *Complete Works of Chuang Tzu*, pp. 206–7).

8. D. Holzman, *Poetry and Politics: The Life and Works of Juan Chi*, Cambridge, 1976, p. 202. I've not respected line-length in the quoted (prosaic) lines and have removed some of the brackets that enclose words added by the translator to clarify the text.

9. See, e.g., Kohn, *The Taoist Experience*, pp. 299–302.

10. J. A. Frodsham and C. Hsi, *An Anthology of Chinese* Verse, Oxford, 1975, pp. xvii–xxviii; D. Holzman, *Poetry and Politics: The Life and Works of Juan Chi (A.D. 210–263)*, Cambridge, 1970, pp. 73, 88, 135–36.

11. R. Barnhart, "The 'Wild and Heterodox' School of Ming Painting," in S. Bush and C. Murck, eds., *Theories of the Arts in China*, Princeton, 1983, p. 371. On Shih Chung, see J. Cahill, *Painting at the Shore*, New York and Tokyo, 1978, 139–53.

12. Barnhart, "The 'Wild and Heterodox' School of Ming Painting," p. 383. "Heroic spirit" is Barnhart's translation for *meng-ch'i*, and "heroic, powerful spirit" for *hsiung-wei chih ch'i*.

13. On the king's will, see M. Seidel and D. Wildung, p. 241, and J. Assman, "Flachbildkunst Des Neuen Reiches, pp. 304–7, both in C. Vandersleyen, ed., *Das Alte Ägypten*, Berlin, 1975. I give the Egyptian dates as determined in I. Shaw, ed., *The Oxford History of Ancient Egypt*, Oxford, 2000, p. 481.

14. On Akhenaten, see C. Aldred, *Akhenaten, King of Egypt*, London, 1988, pp. 92–94; J. Malek, *Egyptian Art*, London, 1999, pp. 266, 274–275; W. S. Smith, *The Art and Architecture of Egypt*, rev. ed., 1998, New Haven, pp. 153–54.

15. G. Robins, *The Art of Ancient Egypt*, London, 1997, p. 150, depending on J. Baines, *Fecundity Figures*, Warminster, 1985.

16. B. J. Kemp, *Egypt: Anatomy of a Civilization*, London, 1989, p. 266, depending, it appears, on R. Anthes, *Der Maat des Echnaton von Amarna* (supplement to *Journal of the American Oriental Society* 14, April/June, 1952).

17. Smith, *The Art and Architecture of Egypt*, pp. 173–75.

18. Jacobus van Dijk, "The Amarna Period and the Later New Kingdom," in Shaw, *The Oxford History of Ancient Egypt*, pp. 281–82.

19. Aldred, *Akhenaten, King of Egypt*, pp. 231–36.

20. Vandersleyen, *Das Alte Ägypten*, p. 311.

21. Aldred, *Akhenaten and Nefertiti*, pp. 53 (on hands), 76 (on childlike ways), 79 (on gestures).

22. E. Hornung, *The Valley of the Kings: Horizon of Eternity*, New York, 1990, pp. 39–48; N. Grimal, *A History of Ancient Egypt*, Oxford, 1992, pp. 277–87; F. Kampp-Seyfried, "Overcoming Death—the Private Tombs of Thebes," in R. Schulz and M. Seidel, *Egypt: The World of the Pharaohs*, Cologne, 1998, pp. 259–63; Kemp, *Ancient Egypt*, pp. 248–53; L. Manniche, *City of the Dead: Thebes in Egypt*, London, 1987, pp. 79–83, 127.

23. Kampp-Seyfried, "Overcoming Death," p. 263.

24. C. Aldred et al., *L'empire des conquérants: Égypte au Nouvel Empire (1560–1070)*,

Paris, 1979, p. 79. Illustrations from the tomb (no. 191) of Ipuky and Nebamun are on pp. 97, 98, and 266; the pictures referred to are on pp. 97 and 98. See Manniche, *City of the Dead*, pp. 57, 127. See also the illustrations from the modest but attractive tomb of the workman Sennedjem (tomb 1), in Robins, *The Art of Ancient Egypt*, pp. 184–85.

25. P. Montet, *Everyday Life in Egypt in the Days of Ramesses the Great*, Philadelphia, [1958] 1981, p. 157.

26. Ibid., pp. 159–160.

27. Ibid., pp. 160 and 349 n. 44 (reference to the argument that "prince" and "scribe" refer to a professional artist).

28. Ibid., p. 159.

29. Vandersleyen, *Das Alte Ägypten*, p. 94.

30. On Greek craftsmen in general, see A. Burford, *Craftsmen in Greek and Roman Society*, London, 1972; on signatures, see pp. 202–13, also J. Boardman, *Athenian Black Figure Vases*, London, 1974, and *Athenian Red Figure Vases*, London, 1975. I've also consulted various entries in S. Hornblower and A. Spawforth, eds., *The Oxford Classical Dictionary*, 3rd ed., Oxford, 1996, notably "art, ancient attitudes to," by J. J. Pollitt; and "artisans and craftsmen" by A. J. S. Spawforth. R. Wittkower and M. Wittkower, *Born under Saturn: The Character and Conduct of Artists; A Documented History from Antiquity to the French Revolution*, London, 1963, pp. 2–7.

31. Boardman, *Athenian Red Figure Vases*, pp. 29–30 (p. 29 quoted).

32. N. Spivey, *Greek Art*, London, 1997, p. 18.

33. Xenophon, *Memorabilia* 1.4.4, in Xenophon, *Conversations of Socrates*, trans. H. Tredennick and R. Waterfield London, 1990, pp. 89–90.

34. Pliny the Elder, *Natural History* 35.65, in *Natural History: A Selection*, trans. J. F. Healy, London, 1991, p. 330.

35. Burford, *Craftsmen in Greek and Roman* Society, pp. 212–13; J. J. Pollitt, *The Art of Greece*, Englewood Cliffs, NJ, 1965, p. 160. The anecdotes about Zeuxis or Apollodorus and Parrhasius are from Athenaeus (fl. c. 200 CE), *The Learned Banquet* 12.543 and Pliny, *Natural History* 35.60, 76.

36. Pliny, *Natural History* 35.85 (Healy translation, p. 332).

37. Ibid., 35.86–87 (Healy translation, pp. 332–33). See also J. Onians, *Art and Thought in the Hellenistic* Age, London, 1979, p. 37; and Pollitt, *The Art of Greece*, pp. 120–31.

38. Pliny, *Natural History* 35.88–89 (Healy translation, p. 333).

39. J. J. Pollitt, *The Ancient View of Greek Art*, New Haven, 1974, pp. 53–55, 57, 81–83, 204–5 (p. 83 quoted). See also E. Tatarkiewicz, *A History of Six Ideas*, The Hague, 1980, pp. 104–7.

40. Lucian, *The Dream* 7–9, quoted from *Lucian: A Selection*, trans. M. D. MacLeod, Warminster, 1991, p. 27.

41. Lucian, *Zeuxis*, from MacLeod's translation, p. 191.

42. J. S. Scott, "Roman Music," in E. Wellesz, ed., *The New Oxford History of Music*, vol. 1, *Ancient and Oriental Music*, London, 1957.

43. Pollitt, *The Ancient View of Greek* Art, pp. 53–55, 57, 81–83, 204–5. [My footnote also

cites Pollitt, pp. 205–16. For the Indo-European root *gen* see *The American Heritage* Dictionary, 4th ed., Boston and New York, 2000, app. 1, p. 2028.]

44. I follow the direct, simple translation of F. M. Cornford, *Plato's Cosmology*, London, 1937, p. 22.

45. See Plotinus, *Enneads* 4.3.10 and 5.8.1–40, trans. A. H. Armstrong, Cambridge, MA, vol. 4, p. 67 and vol. 5, pp. 237–39. I've changed the spelling of Phideias to Phidias.

46. A. Erlande-Brandenburg, *The Cathedral Builders of the Middle Ages*, London, 1995, pp. 39–40; see also pp. 130–35.

47. The stained-glass panel in question, which is dated at about 1150, is from the former Premonstratensian abbey at Arnstein, and is now in the Westfälisches Landesmuseum für Kunst und Kulturgeschichte in Münster, Germany. See A. Petzold, *Romanesque Art*, London, 1995, p. 27.

48. Ibid., p. 28. [For my examples in the footnote on signatures and pride, see Erlande-Brandenburg, *The Cathedral Builders of the Middle Ages*, pp. 98–100 (on masons' marks); Wittkower and Wittkower, *Born under Saturn*, pp. 22–23; Kraus, *The Living Theatre of Medieval Art*, p. 185 (Wiligelmus, Natalis); Gimpel, *Les batisseurs des cathedrals*, p. 110 (Eadwine). R. Wittkower, *Sculpture*, London, 1977, is also a good source.]

49. Kraus, *The Living Theatre of Medieval Art*, p. 187.

50. A. Papadopoulo, *Islam and Muslim Art*, New York, 1979, pp. 25–26, 197–98.

51. See, e.g., the following accounts, of varying degrees of elaboration: J. M. Roberts's translation and expansion of F. Çağman and Z. Tanindi, *The Topkapi Saray Museum: The Albums and Illustrated Manuscripts*, London, 1986, pp. 15–20; S. C. Welch, *A King's Book of Kings*, New York, 1972, pp. 18–28; *Royal Persian Manuscripts*, London, 1976, pp. 12–13; and *Imperial Mughal Painting*, London, 1978; as well as O. Grabar, *Mostly Miniatures: An Introduction to Persian Painting*, Princeton, 2000, pp. 128–30.

For the organization of art production at a Mughal court, see the general historical account in M. C. Beach, *Mughal and Rajput Painting*, Cambridge, 1992 (*The New Cambridge History of India* 1.3). There are technical details in M. C. Beach and E. Koch, *King of the World: The Padshanama*, London, 1997, pp. 131–42; and S. C. Welch et al., *The Emperor's Album: Images of Mughal India*, New York, 1987, pp. 23–26.

52. Relevant passages from the Koran are 39.63 and 59.24. The passage on punishment is quoted from al-Bukhari, the ninth-century authority on tradition. See R. Ettinghausen and O. Grabar, *The Art and Architecture of Islam, 650–1250*, Harmondsworth and New York, 1987, pp. 21–22; and "Sura," in H. A. R. Gibb and J. H. Kramers, eds., *The Shorter Encyclopedia of Islam*, Leiden, 1953, pp. 554–55. See also S. S. Blair and J. M. Bloom. "Art and Architecture: Themes and Variations," in J. L. Esposito, ed., *The Oxford History of Islam*, New York, 1999, pp. 230–36; and Papadopoulo, *Islam and Muslim Art*, pp. 48–57.

53. [The quotation of al-Nawawi in my footnote appears in Papadopoulo, *Islam and Muslim Art*, p. 53.]

54. Qadi Ahmed, *Calligraphers and Painters: A Treatise by Qadi Ahmed, Son of Min-Munshi, c. A.H. 1015/A.D. 1606*, trans. V. Minorsky, Freer Gallery Occasional Papers, Washington, D.C., 1959, p. 23.

55. Welch, *Royal Persian Manuscripts*, p. 13. [My footnote cites Papadopoulo, *Islam and Muslim Art*, p. 109.]

56. Grabar, *Mostly Miniatures*, p. 130.

57. Ibid., pp. 132–33.

58. Abu'l Fazl, *The Ain-i-Akbari*, trans. H. Blochmann, Calcutta, 1927, pp. 113–14; cited in A. Chakraverty, *Indian Miniature Painting*, London, 1996, p. 27.

59. Ibid., p. 115; cited in Chakraverty, *Indian Miniature Painting*, p. 27.

60. Quoted in Beach, *Mughal and Rajput Painting*, p. 39, from a translation by C. M. Naim. See Abu'l Fazl, *Ain-i-Akbari*, p. 114, as quoted in Chakraverty, *Indian Miniature Painting*, p. 31.

61. Beach, *Mughal and Rajput Painting*, p. 40.

62. Abu'l Fazl *Ain-i-Akbari*, pp. 114–15, as quoted in Chakraverty, *Indian Miniature Painting*, p. 27.

63. Beach, the *Mughal and Rajput Painting*, pp. 25ff. (on Akbar's forging of the style), 78ff. (on Jahangir's).

64. From Jahangir's memoirs, *The Tuzuk-i-Jahangiri*, London, 1909–14 [repr., New Delhi, 1968], vol. 2, pp. 20–21; quoted in Welch, *Imperial Mughal Painting*, p. 27, and in Chakraverty, *Indian Miniature Painting*, p. 35.

65. Welch, *Imperial Mughal Painting*, pp. 107–9, drawing from Jahangir's memoirs, *Jahangirnama*, a version of which was illustrated. Inayat Khan's death took place in 1618 or 1619 (pp. 26, 84).

66. Qadi Ahmed, *Calligraphers and Painters*, p. 111.

67. Welch, *A King's Book of Kings*, p. 34.

68. A. Welch, *Artists for the Shah: Late Sixteenth-Century Painting at the Imperial Court of Iran*, New Haven, 1976, p. 200 n.

69. Grabar, *Mostly Miniatures*, p. 75.

70. Qazi Ahmad, *Calligraphers and Painters*, p. 192; cited in Grabar, *Mostly Miniatures*, p. 105. I haven't had the chance to read Sheila Canby's monograph on Riza, *The Rebellious Reformer: The Drawings and Paintings of Riza-Yi Abbasi of Isfahan*, London, [1996] 1999.

71. Sadiqi quoted in Welch, *Artists for the Shah*, pp. 48–49, 49–50.

72. Ibid., pp. 50–51.

73. Qazi Ahmad, writing in 1596–97, quoted in ibid., p. 55.

74. Sadiqi's reputation, as described by his contemporary Iskandar Munshi, in ibid., p. 56; for the artists view of himself as a "rare man," p. 67.

75. From *The Tuzuk-i-Jahangiri*, vol. 2, p. 116; cited in ibid., p. 68.

76. Ibid., pp. 68–69.

77. I have most often depended on the Everyman edition: G. Vasari, *Lives of the Painters, Sculptors and Architects*, trans. C. de Vere, 2 vols., London, [1912] 1996.

78. Wittkower and Wittkower, *Born under Saturn*, p. 299 n. 93.

79. Ibid., pp. 54–55, 60, 69–71 (pp. 60 and 71 quoted); on Matteo Bandelli, see p. 299 n. 43.

80. Vasari, *Lives of the Painters*, vol. 2, p. 442; see also Wittkower and Wittkower, *Born under Saturn*, p. 71.

81. A. Steptoe, "Artistic Temperament in the Italian Renaissance: A Study of Giorgio Vasari's Lives," in A. Steptoe, ed., *Genius and the Minds: Studies of Creativity and Temperament*, New York, 1998, p. 266.

82. Wittkower and Wittkower, *Born under Saturn*, pp. 257–58, 263–77, 91; F. Baudouin, *P. P. Rubens*, New York, 1977, chap. 15.

83. F. Haskell, *Patrons and Painters*, rev. ed., New Haven, 1980, pp. 5, 19–20.

84. Ibid., pp. 21–23 (p. 22 quoted).

85. E. Welch, *Art and Society in Italy, 1350–1500*, Oxford, 1997, p. 128. See also A. Grafton, *Leon Battista Alberti, Master Builder of the Italian Renaissance*, New York, 2000, esp. pp. 3–29, 331–39.

86. J. Burckhardt, *The Civilization of the Renaissance in Italy*, 3rd ed., London, 1995, pp. 92–93. [My footnote cites Grafton, *Leon Battista Alberti*, p. 339.]

87. Vasari, *Lives of the Painters*, vol. 2, p. 625.

88. Ibid., p. 642.

89. I. Richter, ed., *Selections from the Notebooks of Leonardo da Vinci*, Oxford, 1977, pp. 195, 216.

90. On "genius," I direct readers to the following sources:

History and nature of the idea of genius: J. Ritter's detailed summary with ample bibliographical guidance, "Génie," in J. Ritter, ed., *Historisches Wörterbuch der Philosophie*, Basel, 1971–, vol. 3, pp. 279–310. Similar summaries can be found in G. Tonelli, "Genius from the Renaissance to 1770," and E. R. Wittkower, "Genius: Individualism in Art and Artists," both in P. Wiener, ed., *Dictionary of the History of Ideas* Wiener, New York, 1968–74. See also M. Barasch, *Theories of Art*, vol. 2, *From Winckelman to Baudelaire*, New York, [1990] 2000; C. Harrison, P. Wood, and J. Gaiger, eds., *Art in Theory, 1648–1815: An Anthology of Changing Tastes*, Oxford, 2000, and their earlier volume, *Art in Theory, 1815–1900*, Oxford, 1998; E. Kris and O. Kurz, *Legend, Myth, and Magic in the Image of the Artist: A Historical Experiment*, New Haven, 1979; P. Murray, ed., *Genius: The History of an Idea*, Oxford, 1989; C. M. Soussloff, *The Absolute Artist: The History of a Concept*, Minneapolis, 1997.

Contemporary research in creativity: M. Csikszentmihalyi, *Creativity: Flow and the Psychology of Discovery and Invention*, New York, 1996 (based on interviews with eminent persons); H. Gardner, *Creating Mind: Anatomy of Creativity Seen through the Lives of Freud, Einstein, Picasso, Stravinsky, Eliot, Graham, and Gandhi*, New York, 1993, and *Extraordinary Minds: Portraits of Four Exceptional Individuals and an Examination of Our Own Extraordinariness*, New York, 1997; D. Nettle, *Strong Imagination*, London, 2001 (informal, widely informed); R. Ochse, *Before the Gates of Excellence: The Determinants of Creative Genius*, Cambridge, 1980; A. Roe, *The Making of a Scientist*, New York, 1953; D. K. Simonton, *Genius and Creativity: Selected Papers*, Greenwich, CT, 1997 (statistically technical papers), and *Origins of Genius: Darwinian Perspectives on Creativity*, New York, 1999; R. J. Sternberg, ed., *Handbook of Creativity*, Cambridge, 1999, esp. chap. 2 ("A History of Research in Creativity"); A. Steptoe, ed.,

Genius and the Mind: Studies of Creativity and Temperament, Oxford, 1998; T. H. Ward, S. M. Smith, J. Vaid, eds., *Creative Thought: An Investigation of Conceptual Structures and Processes,* Washington, DC, 1997; W. Winner, *Gifted Children: Myths and Realities,* New York, 1996.

Contemporary studies of pathology: K. R. Jamison, *Touched with Fire: Manic-Depressive Illness and the Artistic Temperament,* New York, 1993; H. Killick and J. Schvarein, eds, *Psychotherapy and Psychosis,* London, 1997; L. A. Sass *Madness and Modernity: Insanity in the Light of Modern Art, Literature, and Thought,* Cambridge, MA, 1992.

91. G. Most, "The Second Homeric Renaissance: Allogoresis and Genius in Early Modern Poetics," and J. Bate, "Shakespeare and Original Genius," both in Murray, *Genius.*

92. E. Young, *Conjectures on Original Composition,* facsimile ed., Leeds, 1966; quoted in Harrison, Wood, and Gaiger, *Art in Theory, 1648–1815, p. 359*

93. Ibid., p. 540.

94. Ibid., p. 541.

95. W. Duff, *Critical Observations on the Writings of the Most Celebrated original Geniuses in Poetry,* London, 1770; quoted in ibid., *p. 753.* On Duff, see also Bate, "Shakespeare and Original Genius," pp. 91–93, and Barasch, *Theories of Art,* vol. 2, pp. 285–89.

96. M. Eaves, *William Blake's Theory of Art,* Princeton, 1982, pp. 107–9; Wittkower, "Genius," p. 306.

97. W. von Humboldt, as quoted in the anthology of his writings, *Humanist without Portfolio,* trans. M. Cowan, Detroit, 1963, pp. 160, 161, 164.

98. M. Beddow, "Goethe on Genius," in Murray, *Genius,* p. 100.

99. Ibid., quoting Goethe's essay "On German Architecture," published in 1772.

100. Ibid. The first poem, which is brief, is "Kenner und Künstler" ("Connoisseurs and Artists"; for English, see R. Gray, *Poems of Goethe,* Cambridge, 1966, pp. 54–55); for the second, "Wanderer's Storm-Song," I've used the translation in *Goethe: Selected Poems,* ed. C. Middleton, Princeton, 1983, pp. 17–22.

101. [My footnote refers to the article "Génie," in the *Encyclopédie,* mistakenly attributed to Diderot. I have used the text in Diderot, *Oeuvres philosophiques,* ed. P. Vernière, Paris, 1961. Apart from Diderot, Hevétius is said to have influenced the essay. For a summary, see A. M. Wilson, *Diderot,* New York, 1972, pp. 528–33.]

102. Wilson, *Diderot,* p. 111. The letter to Humboldt, written a few days before Goethe's death, is dated March 17, 1832.

103. Kant's doctrine of genius is stated in pt. 1, bk. 2 of *The Critique of Judgment,* "The Analytic of the Sublime," secs. 46–50. I've used the translation by J. C. Meredith, Oxford, 1928, pp. 168–83. The following expositions have been helpful: D. W. Crawford, *Kant's Aesthetic Theory,* Madison, 1974, pp. 118–24, 162–64; E. Schaper, "Taste, Sublimity, and Genius: The Aesthetics of Nature and Art," in P. Guyer, ed., *The Cambridge Companion to Kant,* Cambridge, 1992; J. H. Zammito, *The Genesis of Kant's Critique of Judgment,* Chicago, 1992. Kant gives another exposition of his doctrine of genius in *Anthropology from a Pragmatic Point of View,* pt. 1, secs. 57–58. See the translation by M. J. Gregor, The Hague, 1974, pp. 92–97, 180 n.

104. Kant, *Critique of Judgment,* pp. 168–69, 171.

105. Kant, *Anthropology*, p. 10 n.

106. Kant, *Critique of Judgment*, sec. 17. See T. Cohen, "Why Beauty Is a Symbol of Morality," in T. Cohen and P. Guyer, eds., *Essays in Kant's Aesthetics*. Cohen puzzles out the relation in Kant between morality—in the sense of willingness to do something out of a sense of pure duty, and not for any practical gain—and beauty as purposive in itself, without any practical purpose.

107. *Immanuel Kant's Critique of Pure Reason*, trans. N. K. Smith, London, 1933, p. 28 (*Critique of Pure Reason*, p. Bxxviii).

108. [My footnote cites Zammito, *The Genesis of Kant's Critique of Judgment*, pp. 184, 288.]

109. F. Schiller, *On the Aesthetic Education of Mankind, In a Series of Letters*, trans. E. M. Wilkinson and L. A. Willoughby, Oxford, 1967; F. Beiser, "Schiller, Johann Christoph Friedrich (1759–1805), in *Routledge Encyclopedia of Philosophy*, version 1.0, London and New York, 1998; J. A. Elias, "Art and Play," in Wiener, *Dictionary of the History of Ideas*; D. Henrich, "Beauty and Freedom: Schiller's Struggle with Kant's Aesthetics," in Cohen and Guyer, *Essays in Kant's Aesthetics*.

110. Henrich, "Beauty and Freedom," p. 245.

111. Schiller, *On the Aesthetic Education of Man*, p. 102.

112. Ibid., pp. 107–9.

113. Ibid., p. 197.

114. L. Lambourne, *The Aesthetic Movement*, London, 1996, is well-informed, wide-ranging, and intelligent.

115. T. Gautier, translated and quoted in Harrison, Wood, and Gaiger, *Art in Theory, 1815–1900*, pp. 97, 99, 100.

116. Walter Pater, from a review of William Morris's poetry that was the conclusion of the first edition of Pater's *Studies in the History of the Renaissance* (later published as *The Renaissance*), in 1873. As reprinted in Harrison, Wood, and Gaiger, *Art in Theory, 1815–1900*, pp. 828–30. Baudelaire's phrase is from the brief article "Philosophical Art" that was found among his papers after his death.

[As background to my comments in the footnote, see, e.g., Yu-lan Fung, *A Short History of Chinese Philosophy*, New York, 1964, chaps. 19, 20, esp. pp. 231ff. On Mallarmé see, e.g., R. Goldwater, *Symbolism*, London, 1979, pp. 116–17.]

117. Harrison, Wood, and Gaiger, *Art in Theory, 1648–1815*, pp. 860–61.

118. Ibid., p. 815. See also, H. Honour, *Romanticism*, London, 1979, p. 243.

119. Hans von Marées, quoted in Harrison, Wood, and Gaiger, *Art in Theory, 1815–1900*, pp. 703–4, from a letter to the art theorist Konrad Fiedler, who supported him financially.

120. L. M. Sleptzoff, *Men or Supermen? The Italian Portrait in the Fifteenth Century*, Jerusalem, 1978, pp. 130 (Benozzo Gozzoli), 108–9 (Lorenzo Ghiberti), 247–49 (romantic artists).

121. On Byron's influence see, e.g., H. G. Schenk, *The Mind of the German Romantics*, Garden City, NY, 1969.

122. D. Gill, ed., *The Book of the Piano*, Oxford, 1981, p. 116; N. Lebrecht, *The Book of Musical Anecdotes*, Oxford, 1981, p. 146.

123. For Plato see, e.g., *Phaedrus* 244–45; the translation quoted is by R. Hackforth, Cambridge, 1952.

124. *Problemata* 30.2, the passage attributed to Aristotle and written, it seems, by one of his students, is quoted in E. Panofsky, *The Life and Art of Albrecht Dürer*, 4th ed., Princeton, 1955, p. 165. It is quoted and explained, in the context of Greek psychological speculation, in B. Simon, *Mind and Madness in Ancient Greece*, Ithaca, NY, 1978, pp. 228–31. D. A. Russell and M. Winterbottom, *Ancient Literary Criticism*, London, 1972, p. 291, quote a satirical passage from Horace's *Ars Poetica* 450–70 on the "mad poet." See also E. R. Dodds, *The Greeks and the Irrational*, Berkeley, 1951, chap. 3, "The Blessings of Madness."

125. Panofsky, *The Life and Art of Albrecht Dürer*, p. 165. Wittkower and Wittkower, *Born under Saturn*, pp. 102–4.

126. Wittkower and Wittkower, *Born under Saturn* pp. 104–5 (p. 104 quoted); see also Panofsky, *The Life and Art of Albrecht Dürer*, p. 166.

127. See, e.g., P. Strieder, *Albrecht Dürer*, New York, 1982, p. 260.

128. Wittkower and Wittkower, *Born under Saturn*, pp. 108–32.

129. M. Milner, *Littérature française: Le Romantisme, 1828–1848*, Paris, 1973, p. 152.

130. Honour, *Romantism*, p. 275.

131. W. Lange-Eichbaum, *Genie, Irrsinn and Ruhm*, Munich and Basel, 1956. I refer to this edition because the editors of later editions softened and even neutralized his characteristic position.

132. Lambroso quoted in C. Martindale, "Biological Bases of Creativity," in Sternberg, *Handbook of Creativity*, p. 143. On such views see also the brief accounts in N. Kessel, "Genius and Mental Disorder: A History of Ideas concerning Their Conjunction," in Murray, *Genius*, pp. 196–203.

133. A. H. Maslow, *The Psychology of Science: A Reconnaissance*, New York, 1966, pp. 30–31.

134. Csikszentmihalyi, *Creativity*, p. 19.

135. See, e.g., A. Calder, *Russia Discovered: 19th Century Fiction from Pushkin to Chekhov*, London, 1976.

136. I refer readers to the extensive reading lists provided on genius, creativity, and their possible pathologies in note 90 above.

137. M. F. X. Lythgoe et al., "Obsessive, Prolific Artistic Output following Subarachnid Hemorrhage," *Neurology* 64, Jan. 2005, pp. 397–98.

138. J. Bogousslavsky, "Artistic Creativity, Style and Brain Disorder, *European Neurology* 54, 2005, pp. 103–11.

139. L. Miller, G. Yener, and G. Akdal, "Artistic Patterns in Dementia," *Journal of Neurological Sciences* [Turkish] 22.3, 2005, p. 246. See also R. Friedman, "Creativity and Psychopathology," *Harvard Brain*, vol. 7, spring 2000.

140. Miller et al, "Artistic Patterns in Dementia," p. 247. In the text of the cited study, the authors misspell the artist's name "Peaks."

141. Ibid., p. 247.

142. [My footnote discusses and quotes C. Waddell, "Creativity and Mental Illness: Is there a Link?" *Canadian Journal of Psychiatry* 43, 1988, pp. 166–72.]

143. In general, see G. Claridge, "Creativity and Madness: Clues from Modern Psychiatric Diagnosis," in Steptoe, *Genius and the Mind*, especially pp. 227–30. [I am reluctant to provide a comprehensive reading list for my footnote, but still more reluctant to appear to be writing arbitrarily. The quotation from Nancy Andreasen is from her lecture, "Schizophrenia: The Fundamental Questions," at the Fifty-first Institute on Psychiatric services, New Orleans, LA, lecture 10, Oct. 30, 1999, as reported in "Deconstructing Schizophrenia," part of the conference summary as it appeared on Medscape. For the rest, I cite only two articles: D. F. Levinson, C. Umapathy, and M. Musthaq, "Treatment of Schizoaffective Disorder and Schizophrenia with Mood Symptoms," *American Journal of Psychiatry* 156.8, August 1999; and S. L. Varma, "Genetics of Schizophrenia and Affective Disorder," *Psychiatry On-Line*, 1997, www.priory.com/psych.htm/ (first published Feb. 1997).]

144. Since in this section I focus on psychopathology, I'd like to draw attention to A. Kleinman and B. Good, eds., *Culture and Depression: Studies in the Anthropology and Cross-Cultural Psychiatry of Affect and Disorder*, Berkeley, 1985; and the philosophical (not psychological or psychiatric) studies in J. Marks and R. T. Ames, eds., *Emotions in Asian Thought: A Dialogue in Comparative Philosophy*, Albany, 1995, should also be of interest.

145. This paragraph is a highly abbreviated summary of "Variation: Is Genius Brilliant—or Mad?" chap. 3 in Simonton, *Origins of Genius*, pp. 87, 90–92.

146. The findings of A. Ludwig, *The Price of Greatness: Resolving the Creativity and Madness Controversy*, New York, 1995, are summarized from the account in Simonton, *Origins of Genius*, pp. 97–98. The quotation is from p. 99.

147. For a summary of studies on personality characteristics common to creative artists and scientists—introversion, independence, hostility, and arrogance—see G. J. Feist, "Influence of Personality on Artistic and Scientific Creativity," in Sternberg, *Handbook of Creativity, p.* 284. For a limited, relatively simple, now old, but convincing study of the psychology of normal scientists, see Roe, *The Making of a Scientist*.

148. See J. Schildkraut, A. J. Hirshfeld, and J. M. Murphy, "Mind and Mood in Modern Art," pt. 2, "Depressive Disorders, Spirituality, and Early Deaths in the Abstract Expressionist Artists of the New York School," *American Journal of Psychiatry* 151, 1994, pp. 482–88 (quotation from the journal's abstract, posted online). In addition to the abstract, I depend on K. Jamison's summary in "Manic-Depressive Illness and Creativity," *Scientific American* 272.2, Feb. 1995, pp. 62–67. Jamison reports on her own work and on experiments of others in greater detail in her book *Touched with Fire*, pp. 53–90.

149. Jamison, *Touched with Fire*, p. 76; see also pp. 75–80, and for comparative suicide rates, the table on p. 89.

150. The words on her own experience are quoted from Jamison's interview in A. Clare, *In the Psychiatrist's Chair*, vol. 3, London, 1998, p. 205.

151. On the genius-madness link, I quote Simonton, *Origins of Genius*, p. 99. [Alfred Brendel's quotation in my footnote is from an article by A. Alvarez, "The Playful Pianist," *New Yorker*, April 1, 1996, p. 49, cited by Gardner, *Extraordinary Minds*, p. 143.]

152. [My footnote depends on G. Tucci, *Tibet*, London, 1967, p. 111; and R. A. Stein, *Tibetan Civilization*, London, 1972, p. 153. For information on five other important Tibetan artists, all of the fifteenth to seventeenth centuries, see D. Jackson, "Chronological Notes on the Founding Masters of Tibetan Painting Traditions," in J. Casey and P. Denwood, eds., *Tibetan Art: Towards a Definition*, London, 1997, pp. 254–61. I've substituted the name Chöying Gyatsho, as in Jackson, pp. 260–61, for Tucci's Tödrup-gyatso. The two names obviously refer to the same painter.]

153. As translated in R. R. Jackson, "Poetry in Tibet," in J. C. Cabezón and J. J. Jackson, eds., *Tibetan Literature: Studies in Genre*, Ithaca, NY, p. 378. See the same passage in a different translation in G. C. C. Chang, *The Hundred Thousand Songs of Milarepa*, vol. 1, New Hyde Park, NY, 1962, p. 27. See also Lobsang P. Lhalungpa, *The Life of Milarepa: A New Translation from the Tibetan*, New York, 1977.

154. C. M. Soussloff, *The Absolute Artist: The Historiography of a Concept*, Minneapolis, 1997, pp. 138–39.

155. My whole discussion of the myth of the artist depends on Kris and Kurz, *Legend, Myth, and Magic*. The quotation on Giotto is from Vasari, *Lives of the Painters*, vol. 1, p. 97.

156. Vasari, *Lives of the Painters*, vol. 1, pp. 89 (Beccafumi), 783 (Sansovino), 448–49 (Castagno).

157. All these examples are from Kris and Kurz, *Legend, Myth, and Magic*, pp. 62–64, where they are documented.

158. Ibid., p. 75.

159. S. Freud, *Introductory Lectures on Psychoanalysis*, London, [1916] 1933, conclusion of lecture 23.

160. R. Fine, *A History of Psychoanalysis*, New York, 1979, pp. 267–71, 304–5; H. Kohut, *The Analysis of Self*, New York, 1971, pp. 2–21, 27–28, 309–10, 316.

161. J. W. Getzels and M. Csikszentmihalyi, *The Creative Vision*, New York, 1976, p. 20.

162. Ibid., pp. 38–39.

163. Ibid., p. 216.

164. Ibid., p. 233 (on rebellion), 154 (on narcissism), 238 (on childhood play).

165. Ibid., p. 197.

166. The passage on what happened after art school is summarized and quoted from M. Csikszentmihalyi, "Creativity and Genius: A Systems Perspective," in Steptoe, *Genius and the Mind*, p. 59.

167. Quoted in K. R. Jamison, "Lord Byron: The Apostle of Affliction," in Steptoe, *Genius and the Mind*, p. 221.

168. The following list of sources is limited to books I have consulted that help to understand the amateur, antiprofessional painting of the Chinese literati—other books will be cited in the course of the exposition. Monographs on individual painters are excluded.

Histories of Chinese art: R. M. Barnhart, *Painters of the Great Ming: The Imperial Art and the Zhe School*, Dallas, 1993; four works by J. Cahill, *Chinese Painting*, Geneva, 1960; *The Distant Mountains: Chinese Painting of the Late Ming Dynasty, 1570–1644*, New York and Tokyo, 1982; *Hills beyond a River: Chinese Painting of the Yüan Dynasty, 1279–1368*, New

York and Tokyo, 1976; and *Parting at the Shore: The Painting of the Early and Middle Ming Dynasty, 1368–1580*, New York and Tokyo, 1978; C. Clunas, *Art in China*, New York, 1997; W. C. Fong, *Beyond Representation: Chinese Painting and Calligraphy 8th–14th Century*, New York and New Haven, 1992; V. Contag, *Chinese Masters of the 17th Century*, London, 1969; W. C. Fong et al., *Images of the Mind*, Princeton, 1984; W. C. Fong and J. C. Y. Watt, eds. *Possessing the Past: Treasures from the National Palace in Taiwan*, New York, 1996; M. Loehr, *The Great Painters of China*, London, 1980; Y. Xin et al., *Three Thousand Years of Chinese Painting*, Taipei, 1996.

Translated Chinese sources: S. Bush, *The Chinese Literati on Painting: Su Shih (1037–1101) to Tung Ch'i-ch'ang (1555–1636)*, Cambridge, MA, 1971 S. Bush and H. Shih, *Early Chinese Texts on Painting*, Cambridge, MA, 1985; S. Coleman, *Philosophy of Painting by Shih Tao*, The Hague, 1978; V. Contag, *Die beiden Steine* (includes a translation of *Tao-chi*), Braunschweig, 1970; R. Maeda, *Two Twelfth Century Texts of Chinese Painting*, Ann Arbor, 1970; O. Siren, *The Chinese on the Art of Painting*, [Beijing], 1936; Lin Yutang, *The Chinese Theory of Art: Translations from the Masters of Chinese Art*, London, 1967.

Monographs and collections of articles: S. Bush and R. Murck, eds., *Theories of the Arts in China*, Princeton, 1983; J. Cahill, *The Compelling Image: Nature and Style in Seventeenth-Century Chinese Painting*, Cambridge, MA, 1983; and *The Painter's Practice: How Artists Lived and Worked in Traditional China*, New York, 1994; Marilyn and Shen Fu, *Studies in Connoisseurship*, Princeton, 1973; H. Kim, *The Life of a Patron: Zhou Lianggong (1612–1672) and the Painters of Seventeenth-Century China*, York, 1996; Chu-tsing Li and J. C. Y. Watt, eds., *The Chinese Scholar's Studio: Artistic Life in the Late Ming Period*, London, 1987.

169. W. R. B. Acker, ed., *Some T'ang and Pre-T'ang Texts on Chinese Painting*, Leiden, 1954, p. 61.

170. Chang Yen-yüan, *Record of All the Famous Painters of All the Dynasties*, finished in CE 847; from Acker, *Some T'ang and Pre-T'ang Texts*, p. 183.

171. A. C. Soper, *Kuo Jo-Hsu's Experiences in Painting*, Washington, DC, 1951, p. 15.

172. Quoted in ibid., p. 19, with square brackets marking the translator's additions removed.

173. M. A. Fuller, *The Road to East Slope: The Development of Su Shi's Poetic Voice*, Stanford, 1990, p. 88. For Su's poetically expressed ideas see also B. Grant, *Mount Lus Revisited: Buddhism in the Life and Writings of Su Shih*, Honolulu, 1994.

174. Fuller, *The Road to East Slope*, pp. 85, 87. See another translation in Bush, *The Chinese Literati on Painting*, p. 41; see also C. Murck, "Su Shih's Reading of the *Chung Ying*," in Bush and Murck, *Theories of the Arts in China*, pp. 267–92.

175. Lin Yutang, *The Chinese Theory of Art*, p. 92; Bush, *The Chinese Literati on Painting*, p. 67; and Bush and Shih, *Early Chinese Texts on Painting*, p. 224. Lin omits the line on genius and originality.

176. Bush, *The Chinese Literati on Painting*, p.29.

177. Ibid., p. 42.

178. Ibid., p. 31.

179. F. W. Mote, *Imperial China, 900–1800*, Cambridge, MA, 1999, p. 155.

180. Cahill, *Hills beyond a River, p. 3.*

181. Ibid., p. 4.

182. For a better nuanced view, which also tells of the pride the Chinese elite took in the reunification of China, see Mote, *Imperial China*, pp. 504–7.

183. M. Whitfield, *In Pursuit of Antiquity*, Rutland, VT and Tokyo, 1969, p. 20. C. Li, *The Autumn Colors on the Ch'iao and Hua Mountains: A Painting by Chao Meng-fu*, Ascona, Switzerland, 1965.

184. See, e.g., S. E. Lee and W. Ho, *Chinese Art under the Mongols*, Cleveland, 1968, pp. 51–52.

185. J. Cahill, ed., *Shadows of Mt. Huang*, Berkeley, 1981, introduction," pp. 22–23; *Parting at the Shore*, pp. 87–88.

186. Cahill, *Parting at the Shore*, p. 217.

187. Cahill, *The Distant Mountains*, pp. 32–33, 175.

188. Cahill, *Shadows of Mt. Huang*, pp. 22–23; *Parting at the Shore*, pp. 87–88.

189. Barnhart, "The 'Wild and Heterodox School' of Ming Painting," pp. 379–80 (p. 380 quoted).

190. R. Barnhart, "The Disappearance of Academic Craft, 'Heterodoxy' and the End of an Era," in Barnhart, *Painters of the Great Ming*, pp. 299–300.

191. On the reasons for the use of "Northern" and "Southern," see, e.g., W. Ho, "Tung Chi-ch'ang's New Orthodoxy and the Southern School Theory," in Murck, *Artists and Traditions*, pp. 113–29.

192. Cahill, *Hills beyond a River*, pp. 114–20. On Ni Tsan see also J. Cahill, "The Yuan Dynasty (1271–1368)," in Xin et al., *Three Thousand Years of Chinese Painting*, pp. 169–75, who mentions (p. 169) less favorable, revisionary views of Ni; A. W. E. Dolby, "Ni Tsan, Unconventional Artist of the Yüan Dynasty," *Oriental Art*, n.s. 19.4, winter 1973, p. 429; Fong, *Beyond Representation*, pp. 475–97; Fong et al., *Images of the Mind*, pp. 105–29; M. K. Hearn, "Reunification and Revival," in Fong and Watt, *Possessing the Past*, pp. 311–19.

193. Dolby, "Ni Tsan," p. 429.

194. See ibid., passim, and Fong et al., *Images of the Mind*, pp. 105–6, 107–8.

195. Cahill, *Hills beyond a River*, p. 116; Fong et al., *Images of the Mind*, pp. 126–27.

196. Cahill, *Hills beyond a River*, p. 119.

197. Quoted in Dolby, "Ni Tsan," p. 431; on his comment about his unpeopled landscapes, see Cahill, *Hills beyond a River*, p. 118.

198. Bush, *The Chinese Literati on Painting, p. 136.*

199. Fong, *Beyond Representation*, p. 487.

200. Here I summarize two often-quoted passages. See Dolby, "Ni Tsan," p. 86; Bush, *The Chinese Literati on Painting*, pp. 134–35; Bush and Shih, *Early Chinese Texts on Painting*, p. 280; Hearn, "Reunification and Revival" and "The Artist as Hero," both in Fong and Watt, *Possessing the Past*, pp. 269–98 and 299–305, respectively; Siren, *The Chinese on the Art of Painting*, pp. 110–11.

201. See Cahill, *The Compelling Image*, pp. 168–83; "The Early Styles of Kung Hsien," *Oriental Art*, n.s. 16.1, spring 1970, pp. 147–81; and "Kung Hsien: Theorist and Technician in Painting," *Nelson Gallery and Atkins Museum Bulletin* 4.9, 1969. Also A. Lippe, "Kung Hsien and the Nanking School," *Oriental Art*, n.s. 2, spring 1956, pp. 21–29; Nie Chongzheng, "The Qing Dynasty (1644–1911)," in Xin et al., *Three Thousand Years of Chinese Painting*, pp. 266–67; W. Wu, "Kung Hsien's Style and His Sketchbooks," *Oriental Art*, n.s. 16.1, spring 1970.

202. Lippe, "Kung Hsien: Theorist and Technician in Painting," p. 9; see also p. 14 and "Kung Hsien and the Nanking School," p. 14.

203. Lippe, "Kung Hsien: Theorist and Technician in Painting," pp. 19, 23–24. 168.

204. Cahill, *The Compelling Image*, pp. 168, 170–81 (p. 168 quoted) (comparison of Kung landscapes with European engravings).

205. Wu, "Kung Hsien's Style," p. 74.

206. Cahill, *The Compelling Image*, pp. 176, 181.

207. Lippe, "Kung Hsien and the Nanking School, p. 23. On the *The Mustard Seed Garden Repertory of Painting*, see Wu, "Kung Hsien's Style."

208. Cahill, *The Compelling Image*, chap. 6; Contag, *Chinese Masters*, pp. 2–25; R. Edwards, "Tao-chi the Painter," in J. Spence et al., *The Painting of Tao-chi*, exhibition catalog, Museum of Art, University of Michigan, Ann Arbor, 1967; W. C. Fong, introduction and commentaries to *Returning Home: Tao-chi's Album of Landscapes and Flowers*, New York, 1976; M Fu and S. Fu, *Studies in Connoisseurship*, Princeton, 1973. (For Tao-chi's dates see Fu and Fu, pp. 38–40. The date of his birth is often given as 1642. The date of his last-known painting can be read as 1707 or 1717. Fu and Fu say the date of his death is unknown, but I've seen it given as 1708).

209. Fong, *Returning Home*, p. 29.

210. Fu and Fu, *Studies in Connoisseurship*, p. 38.

211. Ibid., p. 47; for a summary of Tao-ch'i's views of art, see, pp. 55–58.

212. Edwards, "Tao-chi the Painter," p. 37.

213. Cahill, *The Compelling Image*, pp. 219–25 (p. 225 quoted).

214. D. Chattopadhyaya, ed., *Taranatha's History of Buddhism in India*, Simla, India, 1970, p. 347–49, with annotations on pp. 445–47.

215. C. Sivaramamurti, *The Painter in Ancient India*, New Delhi, 1978, pp. 2–3. The respective references are given as the *Mahabharata* 1.66.28–31 and 13.135.139.

216. Sivaramamurti, *The Painter in Ancient India*, p. 21.

217. C. Sivaramamurti, "Sanskrit Sayings Based on Painting," *Journal of the Indian Society of Oriental Art* 2.2, Dec. 1934, p. 14; *The Painter in Ancient India*, pp. 9–10, 14. The art-loving king is described in Kalidasa's poetic epic, *Raghuvamsha* 8.31.

218. Sivaramamurti, *The Painter in Ancient India*, p. 21.

219. C. Sivaramamurti, *Indian Sculpture*, New Delhi, 1961, pp. 5–6; *The Painter in Ancient India*, p. 7.

220. Beach, *Mughal and Rajput Painting*.

221. See, e.g., M. S. Randhwa, *Kangra Paintings of the Bihari Sat Sai*, New Delhi, 1966,

pp. 21–22, 36, for mentions of particular artists. Other attributions to individual painters can be found in S. Kossak, *Indian Court Painting*, London, 1997, pp. 28ff. On the Krishna cult in art, see A. L. Dallapiccola, ed., *Krishna the Divine: Myth and Legend through Indian Art*, London and Boston, 1982; and J. Masselos, J. Menzies, and P. Pal, *Dancing to the Flute: Music and Dance in Indian Art*, Sydney, 1997.

222. On Bana, Dandin, and Puspadanta, see A. K. Warder, *Indian Kavya Literature*, vol. I, Delhi, 1972, pp. 208–13 (p. 212 quoted).

223. D. S. Ingalls, trans., *An Anthology of Indian Court Poetry*, Cambridge, MA, 1965, p. 443, no 1714.

224. Ibid., pp. 444–45, no. 1726. For poems praising other poets, see pp. 539–446. "Praise of poets" was spoken in the prologue of a play by the stage-manager, who said a word about the play's author. But, apart from this convention, it was natural for poets to include praise of others in their poems.

225. E. Christie, "Indian Philosophers on Poetic Imagination (Pratibha)," *Journal of Indian Philosophy* 7.2, June 1977, esp. pp. 58–60; J. L. Masson and M. W. Patwardhan, *Santarasa and Abhinvagupta's Philosophy*, Poona, 1969, p. xii.

226. Masson and Patwardhan, *Santarasa and Abhinvagupta's Philosophy*, p. xii.

227. S. Kleinert and M. Neale, eds., *The Oxford Companion to Aboriginal Art and Culture*, Melbourne, 2000, p. 148; see also pp. 328–33. For a hint on the complexities of ownership arts of music and designs see H. Morphy, *Aboriginal Art*, London, 1998, pp. 158–63, and Morphy's relevant chapter in the *Oxford Companion*. For greater detail, see his *Ancestral Connections: Art and an Aboriginal System of Knowledge*, Chicago, 1991.

228. On the Songman, see A. P. Elkin, *The Australian Aborigines*, Garden City, NY, 1964, pp. 267–68, 271.

229. Kleinert and Neale, *Oxford Companion to Aboriginal Art*, pp. 347–48.

230. R. Piddington, *Essays in Polynesian Ethnology*, chap. 4, esp. pp. 121–30; D. L. Oliver, *Oceania*, vol. 2, Honolulu, 1989, pp. 99–32.

231. Oliver, *Oceania*, p. 929.

232. R. I. Anderson, *Art in Primtive Societies*, Englewood Cliffs, NJ, 1979, p. 91; A. A. Gerbrands, "Art and Artist in Asmat Society," in M. Rockefeller, ed., *The Asmat of New Guinea*, New York, 1967, pp. 21–23; R. Layton, *The Anthropology of Art*, London, 1981, pp. 193–202.

233. D. Ben-Amos quoted in H. El-Hamy's review of Ben-Amos's *Sweet Words: Storytelling Events in Benin*, in *African Arts* 10.1, Oct. 1976.

234. A. P. Merriam, "The Bala Musician," in W. L. d'Azevedo, ed., *The Traditional Artist in African Societies*, Bloomington, 1973.

235. C. Keil, *Tiv Song*, Chicago, 1979, pp. 101–2, 119.

236. Ibid., pp. 134, 146.

237. J. Nunley, "Ntowie: Sisala Carver," *African Arts* 12.1, Nov. 1979, p. 70.

238. R. Brain, *Art and Society in Africa*, London, 1980, p. 266.

239. H. Himmelheber, *Eskimokünstler*, Eisenach, 1953; *Negerkunst und Negerkünstler*, Braunschweig, 1960.

240. Himmelheber, *Negerkunst und Negerkünstler*, pp. 96–97 (in English); *Eskimo-künstler*, pp. 171–76 (in German).

241. Himmelheber, *Negerkunst und Negerkünstler*, p. 97 (in English); *Eskimokünstler*, 175 (in German).

242. Himmelheber, *Negerkunst und Negerkünstler*, pp. 100–105.

243. Ibid., p. 103.

244. Ibid., p. 105.

245. S. M. Vogel, *Baule: African Art / Western Eyes*, New Haven, 1997, p. 74.

246. Ibid., p. 108; on courting misfortune, see p. 76.

247. Ibid., p. 73.

248. Ibid., p. 49.

249. Ibid., pp. 69–70.

250. R. Abiodun, H. J. Drewal, and J. Pemberton III, eds., *The Yoruba Artist*, Washington, D.C., 1994; see chaps. 1 and 2, esp. pp. 41–43.

251. On Yoruba praise poetry see I. Okpeweho, *African Oral Literature*, Bloomington, 1992, pp, 144–47. [My footnote cites B. Hallen, *The Good and Bad and the Beautiful: Discourse about Values in Yoruba Culture*, Bloomington, 2000, pp. 98, 100.]

252. R. A. Walker, "Anonymous Has a Name: Olowe of Ise," in Abiodun et al., *The Yoruba Artist*, pp. 91–93, 98 (p. 93 quoted).

253. Ibid., p. 102.

254. J. Pemberton III, "Introduction: In Praise of Artistry," in Abiodun et al., *The Yoruba Artist*, p. 127.

255. W. Ambiola, "Lagbbayi: The Itinerant Wood Carver of Ojowon," in Abiodun et al., *The Yoruba Artist*, pp. 137–140 (p. 140 quoted),

256. Ibid., p. 139.

257. W. L. d'Azevedo, "Mask Makers and Myth in Western Liberia," in A. Forge, ed., *Primitive Art and Society*, London, 1973; "Sources of Gola Artistry," in d'Azevedo, *The Traditional Artist in African Societies*.

258. D'Azevedo, "Sources of Gola Artistry," pp. 136, 142; "Mask Makers and Myth," pp. 134–36, 290–91.

259. D'Azevedo, "Mask Makers and Myth," p. 323, see also pp. 291–96, 298, and "Sources of Gola Artistry," pp. 136–39, 141–44.

260. D'Azevedo, "Mask Makers and Myth," p. 337.

261. H. E. Cole, *Mbari*, Bloomington, Indiana, 1982. p. 79; see also p. 77.

262. [My footnote cites Z. S. Strother, *Inventing Masks: Agency and History in the Art of the Central Pende*, Chicago, 1998, p. xix.]

263. Pemberton, "Introduction: In Praise of Artistry," in Abiodun et al., *The Yoruba Artist*, pp. 120, 123.

264. Ambiola, "Legbayi, pp. 138–40.

CHAPTER 4: INTERSECTING WORLDS AND IDENTITIES

1. Bourdieu's research on class-structure and art in France is detailed in P. Bourdieu, *Distinction: A Social Critique of the Judgement of Taste*, Cambridge, MA, 1984.

2. *The Classic of the Way and Virtue: A New Translation of Laozi as Interpreted by Wang Bi*, trans. R. J. Lynn, New York, 1999, p. 75 (Wang Bi's commentary on sec. 16).

3. I cite M. Kaltenmark, "The Ideology of the Ta'i-p'ing ching," in H. Welch and A. Seidel, eds., *Facets of Taoism: Essays in Chinese Religion*, New Haven, 1979. The T'ai-p'ing ching is a Taoist work that goes back to at least the sixth century CE. I summarize and from pp. 41–43.

4. S. Alpers, *The Art of Describing: Dutch Art in the Seventeenth Century*, Chicago, 1983.

5. J. L. Daval, *Photography*, Paris, 1982; L. Hudson, *Bodies of Knowledge: The Significance of the Nude in Art*, London, 1982; A. Scharf, *Art and Photography*, London, 1983; A. Feininger, *Photographic Seeing*, London, 1974, pp. 14ff.; I. Rock, *Perception*, New York, 1984.

6. R. Barthes, *Camera Lucida: Reflections on Photography*, New York, 1981; M. Kozloff, *Photography and Fascination*, Danbury, NH, 1979, chap. 1.

7. Quotations from Scharf, *Art and Photography*, pp. 89, 90; see also Newhall, *The History of Photography*, rev. ed., New York and Boston, 1982, p. 82.

8. Scharf, *Art and Photography*, pp. 197, 198; D. Ashton, *Picasso on Art*, New York, 1972, p. 109.

9. See Scharf, *Art and Photography*, pp. 170, 199–201.

10. Useful sources include J. Darius, *Beyond Vision*, New York, 1984 (historical scientific photographs); A. Feininger, *Roots of Art*, London, 1975; P. Francis and P. Jones, *Images of the Earth*, London, 1984 (earth from space); M. Marten et al., *World within Worlds*, London, 1977; P. Murdin and D. Malin, *Colours of the Stars*, Cambridge, 1988.

11. Scharf, *Art and Photography*, p. 236.

12. F. Haskell, *Rediscoveries in Art*, London, 1976, p. 6; see also F. Haskell and N, Penny, *Taste and the Antique*, New Haven, 1981.

13. Haskell, *Rediscoveries in Art*, pp. 114–15.

14. Ibid, pp. 113–14.

15. On Dürer, see J. W. Alsop, *The Rare Art Traditions: The History of Art Collecting and Its Linked Phenomena Wherever These Have Appeared*, London, 1982, pp. 6–7; and A. Bernal, *A History of Mexican Archeology*, London, 1980, pp. 130–31. On Rembrandt, see B. Haak, *Rembrandt*, New York, 1969, pp. 262–63.

16. On these manias, see H. Glasenapp, *Das Indienbild deutwcher Denker*, Stuttgart, 1960; H. Honour, *Chinoiserie*, New York, 1961, p. 56; R. Schwab, *La renaissance orientale*, Paris, 1950, chap. 3; and M. Sullivan's *The Meeting of Eastern and Western Art*, available in numerous editions (London, 1973, 1981; 2nd ed., Berkeley, 1989; rev. ed., Berkeley, 1998). See also K. Berger, *Japonismus in der westlichen Malerei, 1860–1921*, Munich, 1980; B. Dorival, "Ukiyo-e and European Painting," in *Dialogue in Art: Japan and the West*, ed. C. F. Yamada, Tokyo, 1976; C. Ives, *The Great Wave*, New York, 1974; S. Wichmann, *Japonisme*, London, 1981; S. Wichmann, ed., *Weltkulturen und moderne Kunst: Die Begeg-*

nung der europäische Kunst und Musik im 19. and 20. Jahrhundert mit Asien, Afrika, Ozeanien, Afro- und Indo-Amerika, Munich, 1972 (exhibition catalog).

17. On Rousseau, see Berger, *Japonismus in der westlichen Malerei*, pp. 210–22; and on both Rousseau and Millet, Dorival, "Ukiyo-e and European Painting," pp. 33, 34.

18. See J. Adhémar and L. Cachin, *F. Degas: The Complete Etchings, Lithographs, and Monotypes*, London, 1974, p. 82 (on Degas); Berger, *Japonismus in der westlichen Malerei*, pp. 13–17(on Degas), 78–93 (on Monet); Ives, *The Great Wave*; Dorival, "Ukiyo-e and European Painting"; Wichmann, *Weltkulturen und moderne Kunst*, pp. 202–7 (on Degas).

19. Letter late Sept. 1888, in V. van Gogh, *The Letters of Van Gogh*, trans. M. Roskill, London, 1963, p. 296; see also pp. 19–20.

20. Berger, *Japonismus in der westlichen Malerei*, pp. 200–14.

21. Ibid., pp. 214–17; Ives, *The Great Wave*; Dorival, "Ukiyo-e and European Painting."

22. On Gauguin and on the Polynesians he met and imagined, I have consulted the following: B. Braun, *Pre-Columbian Art and the Post-Columbian World*, New York, 1993; C. Frèche-Tory, *Gauguin* (catalog of the exhibition held in 1988–89 in Washington, Chicago, and Paris), Paris, 1989); S. F. Eisenman, *Gauguin's Skirt*, London, 1997; P. Gauguin, *Noa Noa*, trans. O. F. Theis, San Francisco, 1994; A. Barskaya, *Paul Gauguin in Soviet Museums*, Leningrad, 1988; P. Grosskurth, *Margaret Mead*, London, 1988; M. Hoog, *Paul Gauguin*, New York, 1987; D. L. Oliver, *Oceania*, 2 vols., Honolulu, 1989; S. Price, *Primitive Art in Civilized Places*, Chicago, 1989; C. Rhodes, *Primitivism and Modern Art*, London, 1994; R. A. Rubenstein, "Collective Violence and Common Security," in T. Ingold, ed., *Companion Encyclopedia of Anthropology*, London, 1994, chap. 36; I. Sandler, *Art of the Postmodern Era: From the Late 1960s to the Early 1990s*, New York, 1996; B.-A. Scharfstein, *Amoral Politics*, Albany, 1995, chaps. 5, 7; D. Silverman, *Van Gogh and Gauguin: The Search for Sacred Art*, New York, 2000; D. Sweetman, *Paul Gauguin*, London, 1995; W. van Damme, *Beauty in Context: Towards an Anthropological Approach to Aesthetics*, Leiden, 1996; K. Varnedoe, "Gauguin," in William Rubin, ed., *"Primitivism" in 20th Century Art: Affinity of the Tribal and the Modern*, vol. 1, New York, 1984; R. Goldwater, *Primitivism in Modern Art*, rev. ed., New York, 1937, pp. 63–85. D. Newton, "Primitive Art," in *The Nelson A. Rockefeller Collection: Masterpieces of Primitive Art*, New York, 1978, pp. 36–37; W. Schmalenbach, "Gauguin's Begegnung mit der Welt der Naturvölker," in Wichmann, *Weltkulturen und moderne Kunst*, 444–55; R. Selz, *German Expressionistic Painting*, Berkeley, 1957, pp. 288–89; N. Wadley, ed., *Noa Noa: Gauguin's Tahiti*, Oxford, 1978.

23. Braun, *Pre-Columbian Art*, p. 51.

24. Ibid., pp. 51–53; Sweetman, *Paul Gauguin*, pp. 25–26.

25. Braun, *Pre-Columbian Art*, p. 56.

26. [For the summary of interpretations of the self-portrait in my footnote, see Claire Frèche-Tory's account in *Gauguin*, pp. 145–46; see also p. 147, with the somewhat later ceramic self-portrait of the artist as a grotesque sufferer. Gauguin compares this self-portrait with Dante's portrayal of an artist in hell. See also Sweetman, *Paul Gauguin*, p. 217.]

27. See Barskaya, *Paul Gauguin in Soviet Museums*, pp. 82–83; and Sweetman, *Paul Gauguin*, pp. 46 and 301.

28. Eisenman, *Gauguin's Skirt*, pp. 137–38, 141, from a letter of Feb. 1898 to Daniel de Monfreid; quoted from H. Dorra, ed., *Symbolist Art Theories: A Critical Anthology*, Berkeley, 1995, pp. 208–9. See also Sweetman, *Paul Gauguin*, pp. 456–57, whose quotation is briefer.

29. See the reproductions in Sweetman, *Paul Gauguin*, following p. 88; and see Braun, *Pre-Columbian Art*, pp. 82, 88. The mummy image is also found in Gauguin's *Breton Eve*, in his several pictures called *Human Miseries* (*Misères humaines*), and in his wood relief *Be in Love and You Will be Happy* (*Soyez amoureuses*).

30. See Eisenman, *Gauguin's Skirt*, pp. 48 and 53, citing M. Maline, ed., *Paul Gauguin: Letters to his Wife and Friends*, London, Cleveland, and New York, 1949. p. 142. [For my footnote see Maline, pp. 118–21, and Gauguin, *Noa Noa*, p. 37.]

31. Sweetman, *Paul Gauguin*, p. 324, quoting the French officer, P. Jénot, the first person on Tahiti to greet Gauguin; on the death of Aline, see p. 446.

32. Picasso quotation from J. Flam, "Matisse and the Fauves," in Rubin, *"Primitivism" in 20th Century Art*, vol. 1, p. 214—reported by Francis Carco. On Ensor and Kirchner, see J. Elderfeld, *The "Wild Beasts": Fauvism and Its Affinities*, New York, 1976, pp. 109–10. See also Goldwater, *Primitivism in Modern Art*, chap. 4; J.-L. Paudrat, "The Arrival of Tribal Objects in the West from Africa," in Rubin, *"Primitivism" in 20th Century Art*, vol. 1, pp. 456–57, along with Rubin's introduction to his edited volume, "Modernist Primitivism." On Vlaminck, Derain, and others, see J. Laude, "Die französischen Malerei und die 'Negerkunst,'" in Wichmann, *Weltkulturen und moderne Kunst*, p. 476. See also M. Antliff and P. Leighton, *Cubism and Culture*, London, 2001, pp. 30–39; Newton, "Primitive Art," p. 37; P. Selz, *Chillida*, New York, 1986, p. 109; F. Willett, *African Art*, London, 1971, p. 35.

33. On Picasso's affinities for as opposed to intentional borrowings from African art, see Goldwater, *Primitivism in Modern Art*, chap. 5; Rubin, "Modernist Primitivism," and "Picasso," both in Rubin, *"Primitivism" in 20th Century Art*; J. Richardson, *A Life of Picasso*, vol. 2, *1907–1917: The Painter of Modern Life*, London, 1996, pp. 24–27. On Max Jacob's comment about Picasso's move to cubism, see D. Fraser, "The Discovery of Primitive Art," in *Anthropology and Art*, ed. C. M. Otten, Garden City, NY, 1971, p. 32.

34. A. Malraux, *Picasso's Mask*, New York, [1976] 1994, p. 11, as quoted in Richardson, *A Life of Picasso*, vol. 2, p. 24. See also A. Malraux, Foreword to Newton, *The Nelson A. Rockefeller Collection: Masterpieces of Primitive Art*.

35. See D. E. Gordon, "German Expressionism," in Rubin, *"Primitivism" in 20th Century Art*"; H. Schneckenburger, "Bemerkungen zur 'Brücke' und zur 'primitiven' Kunst," in Wichmann, *Weltkulturen und moderne Kunst*, 456–73.

36. Selz, *German Expressionistic Painting*, pp. 124–29, 289.

37. Goldwater, *Primitivism in Modern Art*, p. 36; R. Fry, *Last Lectures*, London, 1939.

38. See L. Maurer, "Dada and Surrealism," and P. Peltier, "The Arrival of Tribal Objects in the West from Oceania," in Rubin, *"Primitivism" in 20th Century Art*; also Newton, "Primitive Art," pp. 34, 41.

39. D. Stubbs, *Prehistoric Art of Australia*, New York, 1974, p. 97.

40. See N. Cox, *Cubism*, 2000, esp. pp. 11–14, 82–83; Antliff and Leighton, *Cubism and Culture*, on the broad cultural context; Richardson, *A Life of Picasso*, vol. 2, chap. 7 ("The Coming of Cubism"). See also Ashton, *Picasso on Art*, pp. 59–68; C. Harrison and P. Wood, eds., *Art in Theory, 1900–1990 : An Anthology of Changing Ideals*, London, 1992, pp. 177–213.

41. In both the text and my footnote, I cite Antliff and Leighton, *Cubism*, p. 74.

42. I quote from Picasso's interview with Marius de Zayas, published as "Picasso Speaks" in *The Arts*, New York, May 1923, pp. 315–26; cited in Harrison and Wood, *Art in Theory*, p. 212; and from Richardson's interview with Braque, "The Power of Mystery," *Observer* (London), Dec. 1, 1957, in Richardson, *A Life of Picasso*, vol. 2, p. 97.

43. D. Vallier, "Braque: La peinture et nous," *Cahiers d'Art* (Paris), Oct. 1954, pp. 14–16; cited in Richardson, *A Life of Picasso*, vol. 2, p. 105.

44. Richardson, *A Life of Picasso*, vol. 2, p. 103, reporting a conversation of Picasso with Richardson.

45. Quoted by A. Liberman in "Picasso," *Vogue* (New York), Nov. 1, 1956, pp. 132–34ff.; cited in Ashton, *Picasso on Art*, p. 61.

46. Selz, *German Expressionistic Painting*, p. 22.

47. P. James, ed., *Henry Moore on Sculpture*, London, 1966, p. 33.

48. Moore's words on Egyptian and archaic Greek art from ibid, p. 157.

49. Ibid., pp. 42–43.

50. Ibid., p. 74; and on Moore's views of Chinese art, p. 93.

51. On Eastern borrowings from Western art traditions, I direct readers to the following sources: Sullivan, *The Meeting of Eastern and Western Art*; E. Lucie-Smith, *Art Today*, London, 1995 (mostly illustrations); A. Poshyananda et al., *Contemporary Art in Asia: Traditions/Tensions*, New York, 1996 (exhibition catalog of works from India, Indonesia, the Philippines, South Korea, and Thailand); E. J. Sullivan, ed., *American Art in the Twentieth Century*, London, 1996; S. Wichmann et al., *Weltkulturen und moderne Kunst: Die Begegnung der europäische Kunst und Musik im 19. and 20. Jahrhundert mit Asien, Afrika, Ozeanien, Afro- und Indo-Amerika*, exhibition catalog, Munich, 1972.

On modern Japanese art, see M. Kawakita, *Modern Currents in Japanese Society*, New York and Tokyo, 1961; Sullivan, *The Meeting of Eastern and Western Art*, chaps. 4 and 6.

52. Y. Okamoto, *The Namban Art of Japan*, New York and Tokyo, 1972, p. 77.

53. C. L. French, *Shiba Kokan*, New York and Tokyo, 1974; Kawakita, *Modern Currents in Japanese Society*, pp. 15–27.

54. French, Shiba Kokan, pp. 3, 158–59 (p. 3 quoted).

55. J. Hillier, *The Uninhibited Touch: Japanese Art in the Shijo Style*, London, 1974, pp. 19–20, 25–27.

56. Kawakita, *Modern Currents in Japanese Society*, p. 27

57. See Sullivan, *The Meeting of Eastern and Eastern Art*, (1973 ed.), pp. 41–87; Hsiang Ta, "European Influences on Chinese Art in the Later Ming and Early Ch'ing Periods," in J. C. Y. Watt, ed., *The Translation of Art: Essays in Chinese Painting an Poetry*, Hong Kong, 1976.

58. Hsiang Ta, "European Influences on Chinese Art," p. 164; see also J. Cahill's *The Compelling Image: Nature and Style in Seventeenth-Century Chinese Painting*, Cambridge, MA, 1983, pp. 116–20; and *The Distant Mountains: Chinese Painting of the Late Ming Dynasty, 1570–1644*, New York and Tokyo, 1982, pp. 213–14.

59. Hsiang Ta, "European Influences on Chinese Art," pp. 165–66.

60. Ibid., pp. 172–75 (p. 175 quoted).

61. See C. Beurdley and M. Beurdley, *Guiseppe Castiglione*, Rutland and Tokyo, 1971, p. 147; Hsiang Ta, "European Influences on Chinese Art," pp. 172–75.

62. Castiglione cited in his biography by Beurdley and Beurdley, *Guiseppe* Castiglione, p. 148.

63. Cahill, *The Compelling Image*, p. 94.

64. Ibid., pp. 75–77; Cahill, *The Distant Mountains*, pp. 176–77.

65. On Kung, see J. Cahill, "The Early Styles of Kung Hsien," *Oriental Art*, n.s. 16.1, spring 1970; Y. Woodson, "The Problem of Western Influence," in J. Cahill, ed., *Shadows of Mt. Huang*, Berkeley, 1981; on Chang, Cahill, *The Distant Mountains*, pp. 176–77.

66. See the article "Chinese Concept in Modern Art," *Free China Weekly*, Feb. 6, 1983, on a January 1983 exhibit of Zao Wou-ki at the National Museum of History in Taipei; also "The Agony of Zao Wou-ki," *Free China Review*, March 1982. Zao Wou-ki is represented widely on the Internet. The Gallery Heede & Moestrup (www.home3.inet.tele.dk/mheede/zaowouki.htm) has an extensive biography by F. Marquet and M. Sarkari, and six essays by different authors, and a list of his work in different museums and public collections. For his pictures, see, e.g., Postershop (www.postershop.com/Zao-Wou-Ki-k.html).

[For comments in my footnote, see B. Bowen, "Introduction," in *Tobeys's 80: A Retrospective*, Seattle, 1970; Sullivan, *The Meeting of Eastern and Western Art* (1981 ed.), pp. 151–52 (on Mark Tobey), p. 253 (on Morris Graves); Yamada, ed., *Dialogue in Art*, pp. 303–5 (p. 304 quoted). For Isamu Noguchi, see D. Ashton, *Noguchi: East and West*, New York, 1992; S. Hunter, *Isamu Noguchi*, New York, 1978.]

67. "Chinese Concept in Modern Art," p. 39. [My footnote quotes a comment that Zao followed soon after with a painting entitled *Hommage à Henri Matisse*. Cited on the French Internet site My Climats (http//:myclimatspainters.free.fr/zao/)]

68. "The Agony of Chou Wouki," p. 40.

69. Ibid.; "Chinese Concept in Modern Art," pp. 39–40. See also Sullivan, *The Meeting of Eastern and Western Art*, (1973 ed.), pp. 171, 179–80, 193.

70. T. F. Chen, "Towards a Universal Approach: Is East-West Convergence at Hand?" paper delivered at the Ninth International Conference on the Unity of the Sciences (International Cultural Foundation), Miami Beach, Nov. 27–30, 1980. For more on Chen, see the gallery link on the Internet art site 123soho (www.123soho.com) and the Web page of the T. F. Chen Arts for Humanity Foundation (www.tfchen.org).

71. Chen, "Towards a Universal Approach," p. 2.

72. C. Li, *A Thousand Peaks and Myriad Ravines: Shine Paintings in the Charles A. Drenowatz Collection*, vol. 1, Ascona, 1974, p. 81. See also M. Sullivan, *Symbols of Eternity: The Art*

of Landscape Painting in China, Stanford, 1979, p. 144; V. S. Bush and C. F. Murck, eds., *Artists and Traditions: Uses of the Past in Chinese Culture*, Princeton, 1976.

73. See, e.g., A. de C. Clapp, *Wen Cheng-ming*, Ascona, 1975, p. 89.

74. R. J. Lynn, "Alternate Routes to Self-Realization in Ming Theories of Poetry," in Bush and Murck, *Artists and Traditions*, pp. 317–40.

75. R. Barnhart, "The 'Wild and Heterodox' School of Ming Painting," in Bush and Murck, *Artists and Traditions*, 365–96; R. Edwards, "The Orthodoxy of the Unorthodox," in J. Spence et al., *The Painting of Tao-chi*, exhibition catalog, Museum of Art, University of Michigan, Ann Arbor, 1967.

76. K. Ruitenbeek, *Discarding the Brush: Gao Qipei (1660–1734) and the Art of Chinese Finger Painting*, Amsterdam and Ghent, 1992, pp. 20, 24 (p. 24 quoted).

77. Ibid., pp. 16, 20, with the omission of some Chinese phrases.

78. Ibid., p. 24.

79. Ibid., p. 296, 298 (secs. 2 and 3 of the grandson's *Treatise on Finger Painting*).

80. Ibid., p. 28.

81. Ibid., pp. 298, 304, 300 (sec. 6, 29, 12).

82. Ibid., pp. 54–57, 70–93 (p. 86 quoted). The quotation is from an essay included in Ruitenbeek's book, J. Stanley-Baker's "Finger Painting in Tokugawa Japan (1603–1867)."

83. S. Burnham, *The Art Crowd*, New York, 1973.

84. I. Dunlop, *Degas*, London, 1979, p. 122; L. R. Lippard, *Ad Reinhardt*, New York, 1981, p. 124; A. Warhol and P. Hackett, *POPism: The Warhol 60's*, New York, 1983, p. 21; L. Seldes, *The Legacy of Mark Rothko*, New York, 1978, p. 101.

85. G. Dumur, *Nicolas de Staël*, New York, 1976, p. 81.

86. R.-C. Washton Long, *Kandinsky: The Evolution of an Abstract Style*, New York, 1980.

87. J. Lipman and R. Marshall, *Art About Art*, New York, 1978.

88. C. Finch, *Image as Language: Aspects of British Art, 1950–1968*, London, n.d., pp. 87–88; J. Russell, *Francis Bacon*, rev. ed., London, 1979, p. 50.

89. C. Gray, *The Russia Experiment in Art, 1863–1922*, London, 1962, p. 240; Lippard, *Ad Reinhardt*, p. 158.

90. H. Rosenberg, *De Kooning*, New York, 1973, pp. 38, 145.

91. Philip Pearlstein cited in P. Cummings, *Artists in Their Own Words*, New York, 1979, p. 157; Chuck Close, in G. Battock, *Super Realism*, New York, 1975, p. 156.

92. Quotations from A. Frankenstein, ed., *Karel Appel*, New York, 1980, p. 157; and J.-L. Pradel, ed., *World Art Trends 1982*, New York, 1983, p. 28.

93. M. Crichton, *Jasper Johns*, New York, 1977, p. 27.

94. Johns cited in Crichton, *Jasper Johns*, pp. 19, 21; Warhol in *From A to B and Back Again*, London, 1975, p. 181; Leo Castelli cited in C. Tomkins, *Off the Wall*, Garden City, NY, 1980, p. 142.

95. See, e.g., H. Chipp, *Theories of Art*, Berkeley, 1969, pp. 341–46; N. Stangos, ed., *Concepts of Modern Art*, rev. ed., London, 1981, pp. 138–39; D. Vallier, *L'art abstrait*, Paris, 1967; L. A. Zhadova, *Malevich*, London, 1982.

96. Chipp, *Theories of Art*, p. 342; Zhadova, *Malevich*, pp. pp. 58, 284ff., 125 n. 3.

97. D. Elliot, ed., *Rodchenko and the Art of Revolutionary Russia*, New York, 1979, pp. 57, 53–54; see also G. Karginov, *Rodchenko*, London, 1979.

98. On Rauschenberg, see Tomkins, *Off the Wall*, pp. 71–72, 269; and I. Sandler, *The New York School*, New York, 1978, pp. 175–76. On Reinhardt, see Lippard, *Ad Reinhardt*. On Klein, see P. Restany, *Le nouveau réalisme*, Paris, 1978; and *Yves Klein*, New York, 1982. On Ryman, see T. Crow, *The Rise of the Sixties*, London, 1996, pp. 114–18 (the quotation from the critic Marcia Tucker is from the Whitney Museum catalog, *Anti-Illusion: Procedures/Materials*, New York, 1969, p. 36; and the quote from Ryman, dated 1983, is from K. Stiles and P. Selz, eds., *Theories and Documents of Contemporary Art: A Sourcebook of Artists' Writings*, Berkeley, 1996, p. 607). On Irwin, see L. Wechsler, *Seeing Is Forgetting the Name of the Thing One Sees: A Life of Contemporary Artist Robert Irwin*, Berkeley, 1982. [Reinhardt's words in my footnote are from p. 91 of Stiles and Selz, *Theories and Documents of Contemporary Art*.]

99. M. R. Nash, "The Truth and the Hype of Hypnosis," *Scientific American* 285.1, July 2001, pp. 36–43.

100. A. Alberro et al., eds. *Lawrence Weiner*, London, 1998, p. 96 (from *Art Without Space*, a symposium of 1969 moderated by Seth Diegelaub with Lawrence Weiner, Robert Barry, Douglas Huebler, and Joseph Josuth); J. Kosuth, *Art After Philosophy and After: Collected Writings, 1966–1990*, ed. G. Guercio, Cambridge, MA, 1991; as quoted in Stiles and Selz, *Theories and Documents of Contemporary Art*, p. 843. See also See T. Godfrey, *Conceptual Art*, London, 1998.

101. Sandler, *Art of the Postmodern Era*, pp. 386–90.

102. Harrison and Wood, eds., *Art in Theory*, p. 1067; quoting the magazine *Style*, Vancouver, March 1982, p. 48.

103. The preceding paragraph is an (unoriginal) summary of R. Kraus, *The Originality of the Avant-Garde and Other Post-Modernist Myths*, Cambridge MA, 1986, as quoted in Harrison and Wood, *Art in Theory*, pp. 1060–65, esp. pp. 1064–65.

104. In both the text and my footnote, I quote Levine as cited in K. McShine, *The Museum as Muse: Artists Reflect*, New York, 1999, p. 140.

105. M. L. Kotz, *Rauschenberg / Art and Life*, New York, 1990, p. 108. [My footnote cites K. Kertess, *Willem de Kooning: Drawing Seeing / Seeing Drawing*, San Francisco, 1998, p. 11.]

106. S. Vogel, "International Art: The Official Story," in S. Vogel, ed., *Africa Explores: 20th Century African Art*, New York and Munich, 1991, pp. 179, 186. Vogel gives the date 1906, which I have changed in keeping with Ola Oloidi's 1992 article "Artists in Lagos: The Challenge of Traditions," written for the tenth anniversary exhibition of the Society of Nigerian Artists (SNA), Lagos State Chapter, organized by Baffles Art Gallery, Lagos (posted on the Web site of the Nigerian newspaper *This Day Online*, Sept. 2, 2001, in honor of the twentieth anniversary of the SNA, www.thisdayonline.com). Olidi has done the basic research on Onabolu.

107. On modern Papuan art, see S. Cochrane and M. A. Mel, *Contemporary Art in Papua*

New Guinea, Craftsman House, 1997 (unfortunately not available to me); and N. Thomas, *Oceanic Art*, London, 1995, pp. 165–96.

108. U. Beier, *Akis*, Sydney, n.d. (1990?). Since this is a first-hand account of the artist, written for the Ray Hughes Gallery, I have relied on it heavily, as on A. Tröger, "A Short Biography of Georgina Beier," in A. Tröger, ed., *Georgina Beier*, Nuremberg, 2001, esp. pp. 19–25, 30–37.

109. Beier, *Akis*, p. 3.

110. Beier, *Akis*, p. 4.

111. Ibid., p. 6.

112. See U. Beier and G. Beier, with M. Kauage, *Mathias Kauage: A Retrospective 14th October–18th October 2000*, London, 2000 (an exhibition catalog for the Rebecca Hossack Gallery, with a brief essay by U. Beier followed by Kauage's reminiscences of his life, as told to Georgina Beier during Kauage's visits to Sydney; also published for an earlier German exhibition: *Kuage, Papua Neu Guinea: Retrospective 5. Mai–10. Juni, 1990*, Bayreuth, 1990). See also Thomas, *Oceanic Art, pp.* 190–93. My account of Kauage also draws on various Internet sources, including the Web sites of the October Gallery (http://www.theoctobergallery.com/kauageprof.htm); Papua Kunst Kollektion (www.papua-art.de/seiten/pkunst6.htm); and the National Gallery of Australia (http://www.australianprints.gov.au). *Mathias Kuage—Künstler aus Papua Neuguinea*, which I have not seen, is a booklet, compiled by Ulli Beier, from conversations of Georgina Beier with the artist.

113. Beier and Beier, *Mathias Kauage*, pp. 12, 18.

114. Tröger, "A Short Biography of Georgina Beier," p. 24; also Beier and Beier, *Mathias Kauage*, pp. 33–34.

115. The descriptions of Kauage's work are abbreviated and paraphrased from Beier and Beier, *Mathias Kauage*, p. 3. See the illustrations pp. 7–20.

116. Quotations from ibid., pp. 6, 11.

117. Ibid., pp. 3, 4. The comment on "the rebellious creator of art-for-arts-sake," is from S. Smith, "New Guinea Art Now," a review first published in *The Courier-Mail*, Aug. 1, 1998, posted on the Web site of Grafico Arts (http://www.grafico-qld.com/books/exhibit/ngart.htm). Thanks to my friend Wilfried van Damme, I learned of the struggles of contemporary native artists, in particular, an artist named Wendi Choulai, from Jacquelyn A. Lewis-Harris's then unpublished paper, "The Price of Being Contemporary: Papua New Guinean Art in the 21st Century." Lewis-Harris also tells of a traditional sculptor, Saun Anti, who, driven by his dreams, sculpted in a style different enough from the style that prevailed in his village to appear subversive. The penalty that he paid was to be driven from the village. See also Thomas, *Oceanic Art*, pp. 195–96.

118. The Web biography I consulted (http://lesartisgalleria.com/bio.html) is no longer operative, but Allingam still has a large presence on the Internet.

119. On modern Inuit art, see J. Blodgett, *Kenojuak*, Toronto, 1985; W. W. Fitzhugh and S. A. Kaplan, *Inua: The Spirit World of the Bering Sea Eskimo*, Washington, DC, 1982; I. Hessel, *Inuit Art: An Introduction*, New York, 1998, esp. chap. 5 ("Themes and Subjects in Inuit Art"); J. Houston, *Eskimo Prints*, Barre, MA, 1967; E. Leroux, M. E. Jack-

son, and M. A. Freeman, *Inuit Women Artists: Voices from Cape Dorset,* Vancouver, B.C., 1994; D. H. Eber, *Pitseolak: Voices Out of My Life,* Seattle, 1971(from recorded interviews with the artist Pitseolak Ashoona); G. Swinton, *Sculptures of the Eskimo,* Greenwich, CT, 1972; N. H. H. Graburn, "Eskimo Art," in Graburn, *Ethnic and Tourist Arts,* Berkeley, 1976; R. A. Tulurialik and D. A. Pelly, *Qikaaluktut: Images of Inuit Life,* Toronto, 1986. For a brief but comprehensive description of modern Canadian Inuit life up to about 1980, see F. G. Vallee, D. G. Smith, and J. D. Cooper, "Contemporary Inuit Life," in D. Damas, ed., *Arctic,* vol. 5 of *Handbook of North American Indians,* Washington, DC, 1984, pp. 662–75.

I regret not dealing in my text with modern Native American Art of the United States or with that of the twentieth-century Haidas, a Northwest Coast people of Canada. To make partial amends, I include the following reading list (books that that I am happy to own and to have read): J. C. Berlo, ed., *Plains Indian Drawings, 1865–1935: Pages from a Visual History,* New York, 1996; J. C. Berlo and R. B. Phillips, *Native North American Art,* New York, 1998; P. L. Macnair, A. L. Hoover, and K. Neary, *The Legacy: Tradition and Innovation in Northwest Coast Indian Art,* Vancouver, BC, and Seattle, 1984; L. Mulvay, D. Snauwaert, and M. A. Durant, *Jimmy Durham,* London, 1994; D. Shadbolt, *Bill Reid,* Vancouver and Toronto, 1986.

120. See, e.g., E. Carpenter, "They Became What They Beheld," in M. Casky, ed., *How Did It Feel?* London, 1979; see also Graburn, "Eskimo Art," p. 55.

121. Houston, *Eskimo Prints,* pp. 9.11.

122. Ibid., p. 18.

123. Ibid., pp. 22–24.

124. Hessel, *Inuit Art, pp.* 75–77.

125. From Eber, *Pitseolak,* interviews with the artist recorded by Eber. The book is unpaginated but brief. See also the stylistic description of Pitseolak's work and the reminiscences of her daughter and a friend in Leroux, Jackson, and Freeman, *Inuit Women Artists, pp.* 20–21, 45–46 (the critic's quote is from p. 44).

126. Leroux, Jackson, and Freeman, *Inuit Women Artists,* p. 165; see also pp. 26 (for critical remarks) and 159–88.

127. In Blodgett, *Kenojouak,* pp. 23–24 (p. 24 quoted). On praise for her work, see Leroux, Jackson, and Freeman, *Inuit Women Artists,* pp. 22–24, 93–114 (p. 22 quoted).

128. Hessel, *Inuit Art,* p. 189. My last remarks on Inuit art are heavily influenced by Hessel.

129. I point readers to the following sources on modern Aboriginal art: J. Isaacs, *Australian Aboriginal Art,* New York, 1989; W. Karuana, *Aboriginal Art,* London, 1993; R. Layton, "Traditional and Contemporary Art of Aboriginal Australia: Two Case Studies," in J. Coote and A. Shelton, *Anthropology, Art, and Aesthetics,* New York, 1992; pp. 137–59; three works by H. Morphy, *Aboriginal Art,* London, 1998; *Ancestral Connections,* Chicago, 1991; and "From Dull to Brilliant: The Aesthetics of Spiritual Power among the Yolngu," in Coote and Shelton, *Anthropology, Art, and Aesthetics,* pp. 181–208; S. Kleinert and M. Neale, eds.,

The Oxford Companion to Aboriginal Art and Culture, Melbourne, 2000 (an especially rich source of information); S. McCulloch, *Contemporary Aboriginal Art: A Guide to the Rebirth of an Ancient Culture,* Honolulu, 1989 (organized by art communities); A. Quaill, *Marking Our Times: Selected Works of Art from the Aboriginal and Torres Strait Islander Collection at the National Gallery of Australia,* Canberra, 1996; P. Sutton, ed., *Dreamings: The Art of Aboriginal Australia,* New York, 1988; A Voigt and N. Drury, *Wisdom from the Earth: The Living Legacy of the Aboriginal Dreamtime,* Boston, 1998; Warlukurlangu Artists, *Yuendumu Doors, Kuruwarri,* Canberra, 1987.

130. Caruana, *Aboriginal Art,* pp. 179–83; Kleinert and Neale, *The Oxford Companion to Aboriginal Art and Culture,* pp. 242–43, 633–34, 643, 534–35; Morphy, *Aboriginal Art,* pp. 355–68.

131. J. V. S. Megaw and R. M. Megaw, "Painting Country: The Arrernte Watercolour School Artist of Hermannsburg," in Kleinert and Neale, *The Oxford Companion to Aboriginal Art and Culture,* pp. 197–204; "Namatjira," also in Kleinert and Neale, pp. 655–56; Morphy, *Aboriginal Art,* pp. 264–79. Of the material I found on the Internet, the most helpful was Andrew Mackenzie's "Albert Namatjira: A Biographical Outline," a careful chronology of Namatjira's life along with a bibliography, a map of the sites at which he worked, and an anthology of pictures. The outline can be found at In the Artist's Footsteps (http://www.artistsfootsteps.com).

132. Three Aranda myths that Namatjira related were included in Roland Robinson's book *The Feathered Serpent,* Sydney, 1956. On earlier dismissals of his art and more recent recognition, see Morphy, *Aboriginal Art, pp.* 264–66, 269–70, 272–76.

133. Megaw and Megaw, "Painting Country," p. 204.

134. See T. Bonyhady, "Papunya Aboriginal Art and Artists—Papunya Stories," *Aboriginal Art Online* (http://www.aboriginalartonline.com/forum/articles4.php), first published as "Sacred Sights," *Sydney Morning Herald,* Dec. 9, 2000, Spectrum, pp. 4–5. See also Morphy, *Aboriginal Art,* pp. 264–66.

135. On Papunya, see C. Anderson, "The Papunya Tula Movement," in Kleinert and Neale, *The Oxford Companion to Aboriginal Art and Culture,* pp. 208–20; C. Anderson and F. Dussart, "Dreamings in Acrylic: Western Desert Art," in Sutton, *Dreamings,* pp. 89–142; G. Bardon, "The Papunya Tula Movement," in Kleinert and Neale, *Oxford Companion,* pp. 208–11; T. Bonyhady, "Papunya Aboriginal Art and Artists"; Caruna, *Aboriginal Art,* pp. 97–103, 107–151; V. Johnson, "Desert Art," in Kleinert and Neale, *Oxford Companion,* pp. 211–20; Isaacs, *Australian Aboriginal Paintings, pp.* 9–119; McCulloch, *Contemporary Aboriginal Art,* pp. 26–36, 59–77; C. Mackinolty, "Acrylic Painting," in Kleinert and Neale, *Oxford Companion,* pp. 519–29; Morphy, *Aboriginal Art,* pp. 289–99. C. Nicholls, "Acrylic Painting," in Kleinert and Neale, *Oxford Companion,* pp. 519–20.

136. Bardon, "The Papunya Tula Movement," pp. 208–9.

137. Ibid., pp. 209–10.

138. Ibid., pp. 210–11.

139. McCulloch, *Contemporary Aboriginal Art, pp.* 29–32.

140. Johnson, "Desert Art," p. 212, and "The Papunya Tula Movement," p. 107; C. Mackinolty, "Acrylic Painting," p. 519.

141. See David Langsam, "Aboriginal Art—Australia's $100m Hidden Industry,"). The Aboriginals constitute less than two percent of the Australian population.

142. Johnson, "The Papunya Tula Movement," pp. 133, 139–42.

143. Ibid., p. 214. For a detailed chronology, see Morphy, *Aboriginal Art*, pp. 430–31.

144. This early memory is cited by J. Isaacs, "Anmatyerre Woman," in J. Isaacs et al., *Emily Kame Kngwarreye—Paintings*, Sydney, 1998, p. 13. See also C. Hodges, "Kngwarreye, Emily Kame" and "Utopia Art," both in Kleinert and Neale, *The Oxford Companion to Aboriginal Art and Culture* pp. 619 and 725 respectively; M. Maynard, "Indigenous Dress," in Kleinert and Neale, *Oxford Companion*, pp. 388–89; McCulloch, *Contemporary Aboriginal Art*, pp. 79–87; Morphy, *Aboriginal Art*, pp. 15; M. Neale, "Emily Kame Kngwarreye, *Utopia Panels*, 1996," in Kleinert and Neale, *Oxford Companion*, pp. 220–21. A fair number of Kngwarreye's pictures can be viewed on the Internet.

145. See J. Isaacs, "Anmatyerre Woman," pp. 17–20; McCulloch, *Contemporary Aboriginal Art*, p. 80 (regarding the testimony of the coordinator, Rodney Gooch).

146. Quoted in T. Smith, "Kngwarreye Woman Abstract Painter," in Isaacs et al. *Emily Kame Kngwarreye*, p. 31.

147. Isaacs, "Anmatyerre Woman," p. 12.

148. The artist's ingenuity, which reminds me of the Chinese or Japanese use of the brush, is described by Isaacs (ibid., p. 21).

149. Neale, "Emily Kame Kngwarreye, *Utopia Panels*," p. 220. See also Isaacs "Anmatyerre Woman," pp. 21–22, and "The Artist's Studio," pp. 146–47, as well as T. Smith, "Kngwarreye Woman Abstract Painter," pp. 25–26—all three in Isaacs et al., *Emily Kame Kngwarreye*.

150. J. Holt, "Emily Kngwarreye at Delmore Downs, 1989–1996," in Isaacs in *Emily Kame Kngwarreye*, pp. 155–58.

151. Isaacs, *Australian Aboriginal Paintings*, pp. 121–88; Caruana, *Aboriginal Art*, pp. 21–96; McCulloch, *Contemporary Aboriginal Art*, pp. 141–93; Sutton, *Dreamings*, pp. 38–58, 64–88; L. Taylor, "Bark Painting," pp. 535–37, and "Rock Art as Inspiration in Western Arnhem Land," pp. 109–28, both in Kleinert and Neale, *The Oxford Companion to Aboriginal Art and Culture*.

152. [My footnote cites H. Morphy, "Art and Politics: The Bark Petition and the Barunga Statement," in Kleinert and Neale, *The Oxford Companion to Aboriginal Art and Culture*, pp. 100–2.]

153. Morphy, *Ancestral Connections*, pp. 32–33.

154. See, e.g., Morphy, *Aboriginal Art*, p. 169.

155. Ibid., pp. 193–96; and, in greater detail, Morphy's "From Dull to Brilliant," pp. 181–208.

156. I follow Morphy, *Aboriginal Art*, pp. 148–64, fairly closely. The remarks on body images are from Sutton, "The Morphology of Feeling," in Sutton *Dreamings*, pp. 64ff. The coming clear at the end is from Morphy, "From Dull to Brilliant," p. 205.

157. Morphy, *Ancestral Connections*, pp. 143, 167.

158. See Morphy, *Aboriginal Art*, pp. 204–6, 246–47.

159. Ibid., pp. 33–36, 238.

160. Ibid., p. 37, quoting from the film *Narritjin in Canberra* by Ian Dunlop.

161. Morphy, *Aboriginal Art*, pp. 383–415. See also M. Neale, "Urban Aboriginal Art," pp. 267–78, and R. Sykes, "Aboriginal Protest Art," pp. 278–81, both in *The Oxford Companion to Aboriginal Art and Culture.*

162. M. Neale, "Lin Onus," in Kleinert and Neale, *The Oxford Companion to Aboriginal Art and Culture*, pp. 666–67; M. Neale, ed., *Urban Dingo: The Art and Life of Lin Onus, 1848–1996*, Sydney, 2000. Reproductions of Onus's pictures and short articles on him and his work are widely available on the Internet. U. Beier's *Dream Machine—Machine Time: The Art of Trevor Nickolls*, Bathurst, N.S.W., 1985; and *Quandamooka: The Art of Kath Walker*, Bathurst, N.S.W., 1985, are brief, well-illustrated accounts of two other highly individual urban artists.

163. S. Kleinert, "Onus, Bill," in Neale and Kleinert, *Oxford* Companion, p. 666. Neale's chapter on Onus in *Urban Dingo*, pp. 11–23, is biographical, and the book ends, pp. 116–28, with a detailed chronology of Onus's life.

164. The quotation on Namatjira is from I. McLean, "One Mob, One Voice, One Land: Lin Onus and Indigenous Postmodernism," in Neale, *Urban Dingo, p.* 45. See also Tom Spencer, "Lin Onus, Artist."

165. Quotation from Neale, in *Urban Dingo*, p. 18; see also pp. 19–20.

166. Ibid., pp. 19–20

167. I. McLean, "One Mob, One Voice, One Land: Lin Onus and Indigenous Postmodernism," quoted in Neale, *Urban Dingo*, pp. 41–47, see also 12–13.

168. Ibid., pp. 20–21 and plate 43 (p. 95).

169. Ibid., pp. 20–21 and plate 38 (p. 90).

170. Neale, *Urban Dingo*, p. 128; from the chronology by Jo Onus and Tiriki Onus, Lin's son.

171. For background on this discussion of modern African art, readers may turn first to two bibliographies: J. L Stanley's *Modern African Art: A Basic Reading List, A Work-in-Progress*, National Museum of African Art Library, Smithsonian Institution Libraries, Washington, D.C. (www.sil.si.edu/SILPublications/ModernAfricanArt/modern-african-art .htm), is an especially helpful work with summaries, occasional quotations, and, often, critical remarks. For Nigeria, see B. M. Kelly and J. L. Stanley, *Nigerian Artists: A Who's Who and Bibliography*, 1993. Kelley and Stanley's annotated bibliography contains many relevant citations (I cite this book because of its importance but have not had it at my disposal).

Helpful general literature includes U. Beier, *Contemporary Art in Africa*, London, 1980 (translation of *Neue Kunst in Afrika*, 1980); S. L. Kasfir, *Contemporary Africa Art*, London, 1999 (good on social contexts); A. Magnin, ed., *Contemporary Art of Africa*, New York, 1996; Barthosa Nkrumeh, "20th Century Contemporary African Art," in *Encyclopedia of Sculpture*, Chicago, 2003 (a brief summary, followed by an account of the author's own

work, is posted on the author's Web site, Ulonka, http://afropoets.tripod.com/ulonka/id10.html);. M B. Visonà, R. Poynor, H. M. Cole, and M. D. Harris, *A History of Art in Africa*, New York, 2000; S. Vogel, ed., *Africa Explores: 20th Century African Art*, New York and Munich, 1991. The *Collection UNESCO de l'Histoire générale de l'Afrique* has a group of brief, reliable online sections, by J. Vansina, on the recent visual arts of Africa under the general heading of "L'Afrique depuis 1935." Corrected to the year 2000, this is the online account of earlier printed editions in French and English (www.unesco.org/culture/africa/).

For contemporary African criticism, see K. Adeleke, "Interviewing Nkiru Nzegwu," *This Day*, August 1999 (posted at Africa Resource, http://www.africaresource.com/content/view/57/68/); K. Deepwell, *African Criticism and Africa*, London, 1998; A. Fonda, "Olu Oguibe Interview," March 20–21, 2001 (posted on the media site Ljudmila, http://absoluteone.ljudmila.org/oguibe_en.php); K. Ikwuemesi, "Chinwe Uwatse Evaluates the Nigerian Art Scene," from *Ijele: Art eJournal of the African World* 1.2, 2000, (www.ijele.com/ijele/vol1.2/ikwuemesi.html); N. Nzegwu, "The Africanized Queen: Metonymic Site of Transformation," *African Studies Quarterly* (http://web.africa.ufl.edu/asq/v1/4/4.htm); O. Oguibe and O. Enwezor, eds., *Reading the Contemporary: African Art from Theory to the Marketplace*, London and Cambridge, MA, 1999.

172. See, e.g., C. Beckwith and A. Fisher, *African Ceremonies*, 2 vols., New York, 1999; S. Vogel, "Traditional Art: Elastic Continuum," in Vogel, *Africa Explores*, pp. 38–40.

173. I quote from B. Jewsiewicki, "Painting in Zaire: From the Invention of the West to the Representation of Social Self," in Vogel, *Africa Explores*, pp. 138–39; and H. Cole, "Tourist Art of the Western Sudan," in Visonà et al., *A History of Art in Africa*, p. 153.

174. My account of Onabolu is mostly based on Ola Oloidi's "Artists in Lagos" (see note 106 above).

175. Vogel, "International Art: The Official Story," pp. 178–79.

176. Quoted by O. Oguibe, "Thoughts towards a New Century," in Deepwell, *Art Criticism and Africa*, p. 104 n. i. The preface was to Akin Losekan's *Drawing Made Easy*.

177. See, e.g., Olu Oguibe, "Art Criticism and Africa," keynote speech delivered at the International Association of Art Critics Conference, Courtauld Institute, London, November, 1996 (posted on the Olu Oguibe homepage, http://www.camwood.org/aica.htm); and Vogel, "International Art: The Official Story," in Vogel, *Africa Explores*, p. 178.

178. Vogel, "International Art: The Official Story,"pp. 186, 196 n. 22. See also R. Poynor, "The Yoruba and the Fon," in Visonà et al., *A History of Art in Africa*, pp. 268–72. Kasfir, *Contemporary African Art*, has a number of useful pages. I have drawn on the following material, all available on the Internet: Norbert Aas, "Die Oshogbo-Künstlerbewegung als Renaissance von Yoruba-Kultur," a careful account (posted on the Web site of the Institute for Integrated Studies at Johannes Kepler University, Linz, www.aib.uni-linz.ac.at/AFRICA/katalog/node121.htm); Paul Faber, "The Reality of Myths: The Issue of Identity in African Art," *Africa e Mediterraneo* (www.africaemediterraneo.it/articoli/art_faber_eng_2_3_99.doc)—Faber is curator of the African section at the Tropenmuseum in

Amsterdam; "Georgina Beier and the Mbari Art Club," *This Day Online*, Sept. 30, 2001 (http://www.thisdayonline.com). Some information is also available at on the Web site of the Iwalewa House, Institute for African Studies, University of Bayreuth (http://www .iwalewa.uni-bayreuth.de/).

I owe a particular debt of gratitude to Ulli Beier, who has answered my questions, found errors and misapprehensions in my text, and volunteered information from his personal experience in Nigeria, not to speak of Papua New Guinea and Australia. The surprising range and number of his publications are listed in the third edition, compiled by T. Lipp, of *The Hunter Thinks the Monkey Is Not Wise . . . The Monkey Is Wise, but He Has His Own Logic: A Bibliography of Writings by Ulli Beier*, Bayreuth, 1996. Among Beier's books relevant to the new African art, I have made use of *A Dreaming Life: An Autobiography of Chief Twins Seven-Seven, the Ekerin-Bashorn Atunluto of Ibandanland*, Bayreuth, 1999; *Neue Kunst in Afrika*, Berlin, 1980; and *Thirty Years of Oshogbo Art*, Bayreuth, 1991. On Wenger, see U. Beier, ed., *Susanne Wenger—Grenzüberschreitungen*, a catalog of a retrospective exhibition for the years 1950–1990; and Wenger's own *The Sacred Groves of Oshogbo*, Vienna, 1990 (neither of these two books was at my disposal). J. Jahn writes on Wenger in Beier, *Neue Kunst in Afrika*, pp. 43–53. On Georgina Beier, see Tröger, "A Short Biography of Georgina Beier" (edited from conversations with Georgina), pp. 9–58.

[My footnote cites V. Y. Mudimbe, "'Reprendre': Enunciations and Strategies in Contemporary African Arts," also in Vogel, *Africa Explores*, p. 287 n. 1.]

179. [On the discussion of Wenger in my footnote, see Kasfir, *Contemporary African Art*, p. 53. Wenger's beliefs are presented in quotations posted as "The Work and Thoughts of Susanne Wenger" on the Web site of the Ifa Foundation, www.ifafoundation.org/classroom.html.]

180. Tröger, "A Short Biography of Georgina Beier," pp. 9–13 (p. 9 quoted).

181. See A. Onibonokuta, "My Life in the Duro Ladipo Theatre," in Beier, *Thirty Years of Oshogbo Art*, p. 49.

182. Tröger, "A Short Biography of Georgina Beier," p.15.

183. Beier, *Thirty Years of Oshogbo Art*, p. 63. See also Aas, "Die Oshogbo-Künstlerbewegung als Renaissance von Yoruba-Kultur."

184. M. Oyelami, "Visual Experience," in Beier, *Thirty Years of Oshogbo Art*, p. 11; differently punctuated version, "In Muraina Oyelami's Own Words: My Visual Experience Personality," *This Day Online*, December 30, 2001 (www.thisdayonline.com).

185. I cite R. Ogundele, "Rufus Is Rufus," and G. Beier, "To Organise Is to Destroy," both in U. Beier, *Thirty Years of Oshogbo Art*, pp. 46 and 68, respectively. Some of Rufus Ogundele's remarks and pictures are posted on the Internet.

186. G. Beier, "Oshogbo," in U. Beier, *Neue Kunst in Afrika*, pp. 117–28; U. Beier, *A Dreaming Life*, p. 31.

187. M. Oyelami, "The Creative Process," in Beier, *Thirty Years of Oshogbo Art*, pp. 15–16; see also the information in Georgina Beier's biography in Tröger, "A Short Biography of Georgina Beier."

188. C. O. Adepegba, "Nigerian Art: The Death of Traditions and the Birth of New Forms," *Kurio Africana, Journal of Art and Criticism* 1.1, 1989, pp. 2–14; as reported in J. Stanley, *Modern African Art,* under the general heading of "Western Africa, Nigeria."

189. D. J. Consentino, "Afrokitsch," in Vogel, *Africa Explores,* pp. 248.

190. Much of my account of McEwen is drawn from Kasfir, *Contemporary African Art,* pp. 68–76, who is also very useful on workshops in general (see especially chap. 2, "Transforming the Workshop"). I have also drawn on various Internet articles: The obituary printed in the *Times (London),* Jan. 17, 1994, has been posted on the Adele Art Cafe site (http://www.adeleart.com/McEwen/FrankMcEwen.html), along with other relevant material, including McEwen's "New Art from Rhodesia," from the catalog of the show in the National Gallery of Rhodesia in 1957, when the gallery was inaugurated by Queen Elizabeth, and reviews of the First Congress on African Culture from the *Times (London)* of 1962 and *Time* magazine of Sept. 18, 1962. Also helpful were Joceline Mawdsley, "History of Zimbabwe Stone Sculpture," posted in English by the Bettendorff Gallery (www.bettendorff.de/); and George P. Landow's "History of Contemporary Stone Sculpture in Zimbabwe," posted as part of the Postcolonial Web project, University Scholars Programme, National University of Singapore (http://www.scholars.nus.edu.sg/post/zimbabwe/art/sculptors/history.html).

191. H. Spurling, *The Unknown Matisse,* p. 145; my remarks on Moreau are based on pp. 84–88, 109–113, 144–45.

192. See Mawdsley, "History of Zimbabwe Stone Sculpture."

193. See McEwen's obituary, *Times (London),* of Jan. 17, 1994.

194. Kasfir, *Contemporary African Art,* pp. 71, 127, from a 1966 interview with Mukarobgwa.

195. Ibid., pp. 72–73.

196. Quoted in Mawdsley, "The History of Zimbabwe Stone Sculpture." The source of the quotation is not stated but must be later than 1957.

197. F. McEwen, "Modern African Painting and Sculpture," from a 1966 colloquium, Paris, published in *Présence Africaine,* 1968 (cited in the entry "McEwen, Frank," in Stanley, *Modern African Art,* under the heading "General, Surveys and Critiques"); J. Cousins, "The Making of Zimbabwean Sculpture," *Third text: Third World Perspective on Contemporary Art and Culture* (London), 12, winter 1991, pp. 31–42 (cited under the entry "Southern Africa, Zimbabwe," in Stanley, *Modern African Art*). Cousins is interested in explaining the Zimbabweans' indifference.

198. See Ulli Beier's biography of Twins Seven-Seven, *A Dreaming Life,* and Magnin, *Contemporary Art of Africa,* pp. 61–64 (entry by Jacques Soulillou). The Internet provides a wealth of sites with examples of the work of Twins Seven-Seven.

199. Beier, *A Dreaming Life,* pp. 3–14, 74–80, 86–87, 96, 109–111, 115–19 (on his mother); Twins Seven-Seven, "They Came with Brushes in One Hand and a Bag of Knowledge in the Other," in Beier, *Thirty Years of Painting in Oshogbo,* p. 124.

200. For what Twins feels about his work, see Beier, *A Dreaming Life,* p. 21, 33–34; for the usefulness of his wives, p. 22; for his promotion of his musical career, pp. 65–70; on

his seven wives individually, pp. 147–161, for his status as a chief, pp. 88–91. On his business ventures, see "Chief Councillor Twins Seven-Seven: Musik und Politik," in U. Beier, *Neue Kunst in Afrika, p.* 99–100. On his generosity and zest for life, U. Beier, "1967—a Year in the Life of a Philosopher," in Beier, *Thirty Years of Art in Oshogbo*, p. 28.

201. These details are from a letter by Ulli Beier of December 14, 2003.

202. See Beier's introduction to *A Dreaming Life,* pp. 7–8, and for Twin's quoted remarks on his early art, p. 19; Twins Seven-Seven, "They Came with Brushes in One Hand," p. 18; Magnin, *Contemporary Art of Africa,* p. 61. Twins' more detailed account of his early life is given in *A Dreaming Life, pp.* 13–22, in which he recounts the view I attribute to him just above. See also pp. 29–34.

203. See the illustration in Magnin, *Contemporary Art of Africa,* p. 63. The remark on records is from Beier, *A Dreaming Life,* p. 43.

204. *The Lazy Hunters and the Poisonous Wrestlers, Lizard, Ghost and the Cobra* can be seen in the National Museum of African Art's virtual exhibit "A Concrete Vision: Oshogbo Art from the 1960s," in Contemporary Gallery 2 (http://africa.si.edu/exhibits/index.html). What I say of Twins's dreaming comes from Beier, *A Dreaming Life,* p. 20.

205. On these opera-producers and writers see chap. 5, "Myth and Contemporary African Literature," in I. Okpewho, *Myth in Africa: A Study of Its Aesthetic and Cultural Relevance,* Cambridge, 1983, esp. pp. 175–87 (p. 176 quoted).

206. Ibid., p. 177. For the intuitive likeness between the retiring Tutuola and the social Twins, see Georgina Beier, in U. Beier, *Neue Kunst in Afrika,* p. 36. [My footnote draws on R. M. Dorson, "Africa and the Folklorist," in R. M. Dorson, *African Folklore,* Garden City, 1972, and on the foreword of the anthropologist Geoffrey Parrinder to Amos Tutuola's novel, *My Life in the Bush of Ghosts,* London, [1954] 1964, p. 10 quoted.]

207. See J.-L. Ferrier, *Outsider Art,* Paris, 1998, pp. 25–30, 76–91; J. Maizels, *Raw Creation: Outsider Art and Beyond,* London, 1996, pp. 19, 23–29, 55–58, 60, 93, 155.

208. Ulli Beier speaks of Twins's humorous view of his art in a personal letter. I have read of this tendency in traditional Igbo art and see it attributed to the Oshogbo artists by one of their teachers, Ru van Rossem, in U. Beier, "Ru van Rossem: A Self Effacing Teacher," in Beier, *Thirty Years of Oshogbo Art,* p. 72.

209. For Mukomberanwa's history and some direct quotes, I have drawn largely from his biography on the Art Zimbabwe Web site (http://artzimbabwe.net/).

210. Quoted on Mukomberanwa's page on the on the Art Zimbabwe Web site, citing R. Guthrie, *Prominent Sculptors of Zimbabwe: Nicholas Mukomberanwa,* 1989, p. 19. See also B. Danilowitz's article describing a 1998 New York exhibition, "Nicholas Mukomberanwa," posted by Reece Galleries (www.reecegalleries.com/African_Sculpture/Mukomberanwa _Nicholas/Mukomberanwa_Essay.html); and J. Mawdsley's article "Nicholas Mukomberanwa," adapted from her *Chapungu: The Stone Sculpturers of Zimbabwe,* 1995, for the Postcolonial Web project, University Scholars Programme, National University of Singapore (http://www.scholars.nus.edu.sg/post/zimbabwe/art/sculptors/mukomberanwa/bio .html).

211. Oliver Sultan, in Magnin, *Contemporary Art of Africa,* p. 90.

212. From the notice of an exhibition, from May 21 to July 12, 1998, of the works of Nicholas Mukomberanwa and his family. Some of the family's work is still visible on the Internet. See the English portion of the Bettendorff Gallery Web site, (www.bettendorff.de/).

213. On this African equation of "modern" with "contemporary," see Adeleke, "Interviewing Nkiru Nzegwu." On Senegalese "international art," see Vogel, "International Art: The Official Story," and I. Ebong, "Negritude: Between Mask and Flag, Senegalese Cultural Ideology and the 'School of Dakar,'" both in Vogel, *Africa Explores*, sec. 4. For a brief but comprehensive description of African academic art see "Les arts académiques," in J. Vansina, "Les art et la société depuis 1935," chap. 20 of the *Collection UNESCO de l'Histoire Générale de l'Afrique*.

214. M. Dixon, introduction to Léopold Sédar Senghor, *The Collected Poetry*, Charlottesville, VA, 1991, pp. xxiv–xxix; Ebong, "Negritude: Between Mask and Flag," pp. 198–209—as Ebong says, the term "École de Dakar" refers primarily to the first generation of Senegalese painters, whose exhibit, "Tendences et Confrontations" was part of the first World Festival of Pan-African Arts in Dakar in 1966. See Kasfir, *Contemporary African Art* and Visonà, "Many Worlds and the Upper Niger," in Visonà et al., *A History of Art in Africa*, pp. 126–29 (under the subheading "Art for the International Market").

215. Ebong, "Negritude," pp. 200–201 (from Senghor's address "Picasso en Nigritié," 1977).

216. Ibid., pp. 202–4.

217. Ibid., p. 205.

218. On Lods and his Poto-Poto school, see Joanna Granbski Ochsner, "Envisioning 'Modern' African Art: Expatriates and Painters in Brazzaville, Congo," *Baobab*, March 16, 1997 (http://sdrc.lib.uiowa.edu/ceras/baobab/grabski.html); citing M. W. Mount, *African Art: The Years Since 1920*, Bloomington, 1973, pp. 84–85.

219. See I. Ndiaye, cited in J. Baldwin et al., *Perspectives: Angles on African Art*, New York, 1987, pp. 162–75. Biography and reproductions can be found on the Iba Ndiaye's home page (www.ibandiaye.com). See also Franz Kaiser's preface to *Painters between Continents*, the catalog for a 1966 exhibition at the Museum Paleis Lange Voorhout, in the Hague. Kaiser and O. Enwezor have written a related book, which I have not seen, *Primitive? Says Who? Iba Ndiaye, Painter between Continents*, Paris, 2002. The article "Ibn Ndiayem l'homme qui peint," *Africultures* 46, March 2002 (www.africultures.com), is a brief but useful account with quotations from Ndiaye, the source of which are not given.

220. Baldwin et al., *Perspectives*, p. 163.

221. See, e.g., Iba Ndiaye Diadj, "Mutations disciplinaires dans les arts et champs nouveaux de créativité : Le cas des arts Africains," for the ISEA Symposium in Paris, Dec. 2000, p. 6; posted at Africque Virtuelle (www.olats.org/africa/artsScience/mutations).

222. I. Ndiaye, "Art et Société," 1984, unpublished manuscript; quoted in Vansina, "Les arts académiques."

223. See Baldwin et al., *Perspectives*, pp. 164–73 (pp. 164, 168, 173 quoted).

224. See the annotated anthology of his sculptures and paintings for the retrospective show curated by Nkiru Nzegwu, "Ben Enwonwu: Art from a Sixty-Year Career," *Ijele: Art*

eJournal of the African World 1.2, 2000 (www.africaresource.com/ijele/vol1.2/BEnwonwu .htm). This issue of *Ijele* contains a twenty-two page anthology of Enwonwu's articles and two essays on him: S. O. Ogbechie, "Contested Vision: Ben Enwonwu's Portrait of Queen Elizabeth II," and N. Nzegwu, "The Africanized Queen: Metonymic Site of Transformation" (the latter also available online in the *African Studies Quarterly* (http://web.africa.ufl .edu/asq/v1/4/4.htm). See as well N. Nzegwu, "Art as Time-Lines: Sacral Representation in Family Space," *Ijele: Art eJournal of the African World* 2.1, 2001.

225. See, in the anthology of Enwonwu's articles in *Ijele: Art eJournal of the African World* 1.2, 2000, "Problems of the African Artist Today," p. 3 (first published in *Présence Africaine*, 1956).

226. Ogbechie, "Contested Vision," and Nzegwu, "The Africanized Queen." The two essays have some small factual discrepancies, which I cannot reconcile. In the former account the bust goes to the queen's collection; in the latter, the bust is put "inside the chambers" of the Nigerian House of Representatives. I have therefore made the natural assumption that there were two busts. The former account, but not the latter, speaks of an epoxy copy of the full statue, which is exhibited at the RBA and seen by the queen there (p. 3), though on the previous page it is the bronze statue that is presented to the Queen at the RBA. I thank Nkiru Nzegwu for her comments on the discrepancy.

227. Ogbechie, "Contested Vision," pp. 3, 6 n. 10.

228. See, in *Ijele: Art eJournal of the African World* 1.2, 2000, Enwonwu's "The African View of Art and Some Problems Facing the African Artist," p. 4 (first published in 1968), and "Problems of the African Artist Today," p. 2 (quoted).

229. See, in ibid., Enwonwu, "The Evolution, History and Definition of Fine Art," pp. 6, 4 (no date of original publication provided).

230. Van Damme, *Beauty in Context*, p. 274; based on C. C. Aniakor, "Structuralism in Ikenga: An Ethno-Aesthetic Approach to Traditional Igbo Art," *Conch* 6.4, 1974, pp. 1–14.

231. Enwonwu, "The African View of Art," p. 3.

232. Nzegwu, "Art as Time-Lines," p. 16.

233. Commentaries to reproductions 1 and 2 of the oil *Ogolo* (1989), in the Internet retrospective "Ben Enwonwu: Art from a Sixty-Year Career," *Ijele: Art eJournal of the African World* 1.2, 2000.

234. On popular African artists, see U. Beier, "Populäre Kunst in Afrika," in U. Beier, *Neue Kunst i Afrika*, pp. 69–85; B. Jewsiewicki, *Cheri Samba: The Hybridity of Art*, Westmount, Quebec, 1995, and "Painting in Zaire: From the Invention of West to the Representation of Social Self," in Vogel, *Africa Explores*, 130–52; V. Y. Mudimbe, "Reprendre: Enunciations and Strategies in Contemporary African Art, p. 285, and S. Vogel, "Art of the Here and Now," both in Vogel, *Africa Explores*; Kasfir, *Contemporary African Art*, chap. 1 ("New Genres: Inventing African Popular Culture"); Magnin, *Contemporary Art of Africa*; H. M. Cole, "Akan Worlds," and R. Pynor, "The Western Congo Basin," both in Visonà et al., *A History of Art in Africa*, pp. 225–26 and pp. 408–11 respectively.

235. For illustrations of these artists' work and brief texts on them see especially Magnin, *Contemporary Art of Africa*.

236. In addition to the general works cited in note 171 above, I have used the following Internet sources for facts or illustrations: the pages for Moké and Samba on the Website of the Peter Herrmann Gallery (http://galerie-herrmann.com/arts/moke/ and http://galerie-herrmann.com/arts/samba/) and a page on Samba on the Congonline site (www.congonline.com/Peinture/cheri.htm).

237. Jewsiewicki, "Painting in Zaire," p. 131.

238. The biographical account that follows is almost all from Jewsiewicki, *Cheri Samba*, pp. 34–38.

239. Ibid., p. 40.

240. Ibid., p. 28 (citing the magazine *Kanal* 70, 1989).

241. Quoted in ibid., p.42; see also Vogel, *Africa Explores*, p. 124.

242. Quoted in Jewsiewicki, *Cheri Samba*, p. 42 (in statements made in 1989 and 1990).

243. Illustrated in Kasfir, *Contemporary African Art*, p. 26.

244. Illustrated in Vogel, *Africa Explores*, p. 174. The information on the contract comes from Vogel, p. 129 n. 12. Jewsiewicki, in *Cheri Samba*, p. 40, makes it clear that by 1990, Samba was no longer exhibiting his new pictures in his Kinshasa shop.

245. Jewsiewicki, *Cheri Samba*, p. 84.

246. Quoted in a Josefina Ayerza, "Interview with Cheri Samba," *Lacanian Ink* 1 (http://www.lacan.com/frame18.htm).

247. Ibid., p. 151

248. Most of the immediately following passages are from Deepwell, *Art Criticism and Africa*. See also Oguibe and Enwezor, *Reading the Contemporary*.

249. Deepwell, *Art Criticism and Africa*, p. 70.

250. The description of the triptych, which I have not seen, is based on the brief account in the catalog *Forms of Wonderment: The History and Collections of the Afrika Museum*, Berg en Dal, 2002, p. 184. Olu Oguibe is quoted in from Aurora Fonda, "Olu Oguibe Interview," March 20–21, 2001 (see note 171 above).

251. Adeleke, "Interviewing Nakiru Nzegwu."

252. Deepwell, *Art Criticism and Africa*, p. 64.

253. Ibid., p. 109.

254. Krydz Ikwuemesi, "Chinwe Uwatse Evaluates the Nigerian Art Scene," *Ijele: Art eJournal of the African World* 1.2, 2000 (http://www.africaresource.com/ijele/vol1.2/ikwuemesi.html).

255. C. Okeke, "Beyond Either/Or: Towards an Art Criticism of Accommodation," in Deepwell, *Art Criticism and Africa*, pp. 89–93 (pp. 92–93 quoted).

CHAPTER 5: THE COMMON UNIVERSE OF AESTHETIC DISCOURSE

1. See S. Pinker, *How the Mind Works*, New York, 1997, pp. 268–275. Pinker refers to I. Biedermann, "Visual Object Recognition," in S. M. Kosslyn and D. N. Osherson, eds., *An Invitation to Cognitive Science*, vol. 2, *Visual Cognition*, 2nd ed., Cambridge, MA, 1995.

For a different, more phenomenological account of visual construction, see J. Willats, *Art and Representation*, Princeton, 1997.

2. For an account of the anthropological investigation of color terms, see B. Berlin and P. Kay, *Basic Color Terms: Their Universality and Evolution*, Berkeley, 1969. Berlin and Kay's research led to a series of responses and researches that, as usual, multiplied questions and made clear, definitive answers hard to reach. See, e.g., J. Gage, *Colour and Culture: Practice and Meaning from Antiquity to Abstraction*, London, 1993, chaps. 2 and 7, and his chapter "Colour and Culture," in T. Lamb and J. Bourriau, eds., *Colour: Art and Science*, Cambridge, 1995, pp. 186–93, in which he is rather skeptical of Berlin and Kay (it is not clear to me what is meant by "the assimilation of white to black," the phrase attributed to the anthropologist R. E MacLaury on p. 187). See also R. H. Barnes, "Anthropological Comparison," in L. Holy, ed., *Comparative Anthropology*, Oxford, 1987, pp. 119–26, also highly skeptical of Berlin and Kay. J. Lyons, "Colour in Language," in Lamb and Bourriau, *Colour*, pp. 194–224, is relatively favorable and asks for more careful formulation of the hypothesis (pp. 201, 222). See also G. Lakoff, *Women, Fire, and Dangerous Things: What Categories Reveal about the Human Mind*, Chicago, 1987, pp. 24–38. For an evolutionary hypothesis, see R. N. Shepard, "The Perceptual Organization of Colors: An Adaptation to Regularities of the Terrestrial World?" in J. H. Barkow, L. Cosmides, and J. Tooby, eds., *The Adapted Mind*, New York, 1992, pp. 495–532. D. C. Hoffman, *Visual Intelligence*, New York, 1998, chap. 5, deals with the process of color perception.

3. Two general books on color are Lamb and Bourriau's *Colour* and C. A. Riley II's *Color Codes*, Hanover, NH, 1995. For the history of the use of color in Western painting, Gage's *Colour and Culture* is thoroughgoing, though limited to European art; his *Colour and Meaning: Art, Science and Symbolism*, London, 1999, contains wide-ranging essays. M. Pastoureau, *Blue: The History of a Color*, Princeton and Oxford, 2001, is the social history of the color blue in Europe.

4. On the Lüscher test and the emotional qualities attributed to colors, see the brief account in Gage, "Colour and Culture," pp. 189–91.

5. For sharp, well-informed criticism of the kind of universalizing tendencies I show here, see R. Needham, *Circumstantial Deliveries*, Berkeley, 1981. For Africa in particular, see the essays under the general headings of "Perception," "Cognitive Development," and "Language" in B. Lloyd and J. Gay, eds., *Universals of Thought: Some African Evidence*, Cambridge, 1981.

6. See A. Jacobson-Wedding, *Red-White-Black as a Mode of Thought*, Stockholm, 1979. I owe this reference to Needham, *Circumstantial Deliveries*, p. 47.

7. On white, black and red in European antiquity, see Pastoureau, *Blue*, pp. 14–16, and the entry "colours, sacred," in S. Hornblower an A. Spawforth, *The Oxford Classical Dictionary*, 3rd ed, Oxford and New York, 1996, p. 366 (quoting E. Wunderlich, 1925). In some contradiction to the impression left by Pastoureau, who says that in Europe up to the twelfth century blue was an uncommon color (p. 13), who points out that the Greeks had no simple, unambivalent word for blue, and who notes that Latin authors were indifferent or

hostile to the color blue (p. 26), see Gage, *Colour and Culture,* who points out that blue and yellow were often used in early Greek painting (p. 11), that for Aristotle, deep blue was one of the five unmixed intermediate colors (p. 12), that Lucian speaks of bright blue (p. 14), that Greek painters used blue and green (p. 15), and that mosaics from Pompeii and Herculaneum have vivid blues (p. 16). On the last point, Pastoureau confirms that Latin had eight terms for blues and that the Greeks used bright, saturated blues in their paintings (p. 30; see also pp. 27–29). [My footnote cites Pastoureau, pp. 7, 9, 10 and n. 16.]

8. See C. A. Lutz, *Unnatural Emotions: Everyday Sentiments on a Micronesian Atoll and Their Challenge to Western Theory,* Chicago, 1988, pp. 5, 8. The attitude Lutz objects to is exemplified by the research that I depend on, of Paul Ekman and his associates. See, e.g., P. Ekman, ed., *Emotion in the Human Face,* 2nd ed., Cambridge and Paris, 1982. See also the later summary of his work in the introduction, afterword, and commentaries to his edition of Charles Darwin, *The Expression of the Emotions in Man and Animals,* 3rd ed., London, 1998.

A few, among many, relevant books and articles, include A. J. Fridlund and B. Duchaine's "'Facial Expressions of Emotion' and the Delusion of the Hermetic Self" and P. Heelas's "Emotion Talk across Cultures," both in R. Harré and W. G. Parrott, eds., *The Emotions: Social, Cultural and Biological Dimensions,* London, 1996, pp. 259–84 and 171–99 respectively; A. Kleinman and B. Good, eds., *Culture and Depression Studies in the Anthropology and Cross-Cultural Psychiatry of Affect and Disorder,* Berkeley, 1985; Lakoff, *Women, Fire, and Dangerous Things;* R. S. Lazarus, *Emotion and Adaptation,* New York, 1991; J. Marks and R. T. Ames, eds., *Emotions in Asian Thought,* Albany, 1995.

9. M. J. Weber, ed., *Perspectives: Angles on African Art,* New York, 1987.

10. Hsiang Ta, "European Influences on Chinese Art in the Later Ming and Early Ch'ing Periods," in J. C. Y. Watt, ed., *The Translation of Art: Essays in Chinese Painting and Poetry,* Hong Kong, 1976, p. 176.

11. M. D. McLeod, *The Asante,* London, 1981, p. 18.

12. R. F. Thompson, in J. Fry, ed., *Twenty-Five African Sculptures,* Ottawa, 1978, p. 64.

13. J. Maquet, *The Aesthetic Experience,* New Haven, 1986.

14. Frans de Waal, "How Close to the Apes? Human Behavior and Primate Evolution," the Tanner Lectures on Human Values, delivered at Princeton University, Nov. 19–20, 2003 (lectures 2003–2004, available on the university's Web site, http://lectures.princeton .edu/). Among de Waal's relevant books, the most recent is *Primates and Philosophers: How Morality Evolved,* Princeton, 2007.

15. See, e.g., A. C. Graham, *Chuang Tzu: The Inner Chapters,* London, 1981, p. 600.

16. [The themes outlined in my footnote draw on the following articles from *Empirical Studies of the Arts:* (1) M. S. Lindauer and D. A. Long, "The Criteria Used to Judge Art: Marketplace and Academic Comparisons" 4. 2, 1986; (2) T. Chamorro-Premuzik and A. Furnham, "Art Judgment: A Measure Related to Both Personality and Intelligence" 24.1, 2004–2005; (3) G. J. Feist and T. R. Brady, "Openness to Experience, Non-Conformity, and the Preference for Abstract Art" 22.1, 2004; (4) N. Kettlewell, S. Pipscomb, L. Evans, and K. Rosston, "The Effect of Subject Matter and Degree of Realism on Aesthetic Preferences

for Paintings" 8.1, 1990; (5) "Cross-Cultural Aesthetic Contrasts and Implications for Aesthetic Evolution and Change" 11.1, 1933.]

17. [In my footnote, I cite R. J. Brettell, *Modern Art, 1851–1929*, Oxford and New York, 1999, p. 47. For the various "schools" of twentieth-century art, see also R. Atkins, *Artspeak: A Guide to Contemporary Ideas, Movements, and Buzzwords*, New York, 1990 (ranging from art brut, art informel, and arte povera to situationism, sots art, surrealism, and transavantgarde, or later, neoexpressionism). For a detailed history of the formation of a contemporary "school" of art, see J. Meyer, *Minimalism: Art and Polemics in the Sixties*, New Haven, 2001.

18. Meyer, *Minimalism*, p. 276.

19. W. Camfield, *Marcel Duchamp: Fountain*, Houston, 1989, p. 97.

20. For Mellon and Duveen, see D. Cannadine, *Mellon: An American Life*, New York, 2007.

21. Tobias Meyer, the chief auctioneer and worldwide head of contemporary art at Sotheby's, as quoted in John Colapinto, "The Alchemist: Tobias Meyer and the Art of the Auction," *New Yorker*, March 20, 2006, p. 88.

22. Amy Cappellazzo, the international co-head of postwar and contemporary art, Christie's, New York, quoted in A. Lindemann, ed., *Collecting Contemporary*, Cologne, 2006, p. 221.

23. Ibid., pp. 8–9.

24. Alanna Heiss, founder and director of P.S. 1 Contemporary Art Center, a MoMA affiliate, New York, quoted in Lindemann, *Collecting Contemporary*, pp. 158, 259, 263.

25. Maya van der Eerden, "Quality or Selection?" *CultureGates*, 2003, p. 3. This article was written in anticipation of research on art reviewing commissioned by the Netherlands Theater Institute. It can be downloaded from the CultureGates Web site, at Results: Views of Artists/Experts (www.culturegates.info/).

26. On the distinctions between experts and nonexperts in art I have read, apart from Maya van der Eerden's "Quality or Selection?" M. A. Augustin and H. Leder, "Art Expertise: A Study of Concepts and Conceptual Spaces," *Psychology Science* 48.2, 2006, pp. 135–56; and M. Kaskmann, "Personality, Training in the Visual Arts and Aesthetic Preferences for Line Drawings," a painstaking master's thesis completed for the Department of Psychology of Tartu University, Estonia, 2004 (available from the University of Tartu Library, http://hdl.handle.net/10062/1052). It is from Kaskmann's thesis (p. 14), that I found reference to eye movements, citing C. F. Nodine, P. Locher, and E. A. Krupinsky, "The Role of Formal Art Training on Perception and Aesthetic Judgement of Art Compositions," *Leonardo* 26, 1933, pp. 219–27.

27. G. N. van Wyck, *African Painted Houses: Basotho Dwellings of Southern Africa*, New York, 1998; M. Perrin, *Magnificent Molas: The Art of the Kuna Indians*, Paris, 1999.

28. Van der Eerden, "Quality or Selection?" pp. 4–5, 9, 12. Van der Eerden refers to an article in Dutch, published in 1993, by P. Hekkert and P. C. van Wieringen, a number whose articles have appeared in English, among them "Beauty in the Eye of Expert and Non-Expert Beholders: A Study in the Appraisal of Art," *American Journal of Psychology* 109.3, 1996, pp. 389–40.

29. See Philip Tedlock, *Expert Political Judgment: How Good Is It? How Can We Know?* Princeton, 2005.

30. L. Marshall, "Sharing, Talking, and Giving," in R.B. Lee and I. Devore, eds., *Kalahari Hunter-Gatherers*, Cambridge, MA, 1976, p. 354.

31. D. Zahan, *The Religion, Spirituality, and Thought of Traditional Africa*, Chicago, 1979, pp. 113–14.

32. M. Astrow, *The Winged Serpent: An Anthology of American Indian Prose and Poetry*, New York, 1976, p. 39.

33. J. Chaves, "Some Relations between Poetry and Painting in China," in J. C. Y. Watt, ed., *The Translation of Art: Essays in Chinese Painting and Poetry*, Hong Kong, 1976, p. 86.

34. H. C. Chang, *Chinese Literature*, vol. 2, *Nature Poetry*, Edinburgh, 1977, p. 8.

35. Ibid.

36. E. J. Coleman, *Philosophy of Painting by Shih T'ao*, The Hague, 1978 (p. 115 quoted, from Shih T'ao, chap. 1); reviewed in P. K. K. Tong, *Journal of Aesthetics and Art Criticism*, fall 1977. See also J. Cahill, *The Compelling Image*, Cambridge, MA, 1982, pp. 187ff, 215–19.

37. Shih T'ao, chap. 3, in Coleman, *Philosophy of Painting by Shih T'ao*, p. 118.

38. Shih T'ao, chaps. 1 and 4; in ibid., pp. 115–16. See also P. Ryckmans, *Les "Propos sur la Peinture" de Shitao*, Brussels, 1970, pp. 14–18.

39. Shih T'ao, chap. 1, in Coleman, *Philosophy of Painting by Shih T'ao*, p. 116.

40. Mozart to his father, letter of May 2, 1778, in W. Hildesheimer, *Mozart*, New York, 1982, p. 91.

41. A. Condivi, *The Life of Michelangelo*, trans. A. S. Wohl, Baton Rouge, 1976, p. 105.

42. F. Hartt, *Michelangelo: The Complete Sculptures*, New York, 1968, p. 13.

43. R. S. Liebert, *Michelangelo: A Psychoanalytic Study of His Life and Images*, New Haven, 1983, pp. 49, 93, 412.

44. J. Pope-Hennessy, *Italian High Renaissance and Baroque Sculpture*, 2nd ed., London, 1970, p. 113.

45. A. S. Wylie and A. F. Valenstein, "Between a Hostile World and Me: Organization and Disorganization in Van Gogh's Life and Work," in W. Muensterberger and L. B. Boyer, eds., *The Psychoanalytic Study of the Child*, New Haven, 1979, p. 104 (the words are those of the authors, not of Van Gogh himself).

46. A. J. Lubin, *Stranger on the Earth: A Psychological Biography of Vincent van Gogh*, New York, 1972, p. 11.

47. Ibid., p. 252 n. 15.

48. Van Gogh, letter, The Hague, second half of July, 1882, in *The Letters of Van Gogh*, trans. M. Roskill, London, 1963.

49. A. E. L. Dube-Heyning, *Kirchner: Graphik*, Munich, 1961, p. 15.

50. R. Stang, *Edvard Munch*, New York, 1979, pp.15, 23.

51. Ibid., p. 15.

52. M. Urban, *Emil Nolde: Landscapes*, London, 1970, pp. 29, 30.

53. Nolde in a letter of Oct. 9, 1926, as quoted in ibid., p. 34.

54. L. Simpson, *Three on the Tower: The Lives and Works of Ezra Pound, T. S. Eliot, and William Carlos Williams*, New York, 1975, p. 307, quoting Williams's "I Wanted to Write a Poem."

55. C. Schorske, *Fin-de-siècle Vienna*, New York, 1981, p. 363.

56. On oscillation, see E. Buschor, *On the Meaning of Greek Statues*, Amherst, 1980.

57. H. Himmelheber, *Eskimokünstler*, Eisenach, 1953, pp. 46–48; see also Himmelheber's *Negerkunst und Negerkünstler*, Braunschweig, 1960.

58. E. Eyo and F. Willett, *Treasures of Ancient Nigeria*, New York, 1980, e.g., plates 39, 76, 92; R. Brain, *Art and Society in Africa*, London, 1980, p. 134.

59. B. Holm, *Northwest Coast Indian Art*, Seattle, 1965, p. 11; J. C. H. King, *Portrait Masks from the Northwest Coast of America*, London, 1979, p. 44 (illustration 32), p. 23 (illustration 14).

60. C. Aldred, *Akhenaten and Nefertiti*, New York, 1973, pp. 43–47, 180; and *Egyptian Art*, London, 1980, pp. 69–70.

61. C. Śivaramamurti, *The Painter in Ancient India*, New Delhi, 1978, pp. 15–16, 18.

62. See S. Bush and H. Shih, *Early Chinese Texts on Painting*, Cambridge, MA, pp. 31 (on Yao Tsui), 45–46 (on the care attributed to the painter by Hsieh Ho) and 275–78 (on Li Kan); C. Li, *The Autumn Colors on the Ch'iao and Hua Mountains: A Painting by Chao Meng-fu*, Ascona, 1965, p. 174 (on Huang Kung-wang); R. Barnhart, *Wintry Forests, Old Trees: Some Landscape Themes in Chinese Paintings*, New York, 1972, p. 55 (on Tung Ch'i-ch'ang); O. Siren, *The Chinese on the Art of Painting: Translation and Comments*, [Beijing], 1936, p. 222 (on historical accuracy of dress).

63. On later portraits, see Cahill, *The Compelling Image*, pp. 1–6, 114–16.

64. On portraits of the Zen masters, see J. Kanazawa, *Japanese Ink Painting*, Tokyo, 1979, pp. 25–29. See also H. Mori, *Japanese Portrait Sculpture*, pp. 13, 44, 81 (plate 73), 88, as well as pp. 90–92 on the *nise-e*.

65. J. Hillier, *The Uninhibited Touch*, London, 1974, pp. 20 (Ogata Korin) and 225 (Sosen Mori).

66. L. Hudson, *Bodies of Knowledge*, London, 1982, pp. 28, 41, 44–45.

67. A. A. Wellek, *A History of Modern Criticism, 1750–1950*, vol. 4, repr., Cambridge, 1983, p. 4.

68. M. Bukofzer, *Music in the Baroque Era*, London, 1948, pp. 302–5; M. Solomon, *Beethoven*, New York, 1977, pp. 32–21.

69. W. Fong, "Addenda," in R. Whitfield, *In Pursuit of Antiquity*, Rutland and Tokyo, 1960, p. 185.

70. R. Edwards, *The Art of Wen Cheng-ming* (1470–1559), exhibition catalog, University of Michigan Museum of Art, Ann Arbor, 1976, pp. 120–23, 166–67.

71. J. M. Chernoff, *African Rhythm and African Sensibility*, Chicago, 1979, pp. 50–51, 113–14, 144, 166.

72. F. Willett, *African Art*, rev. ed., London, 1993, pp. 208–22. [For my recommendations in the footnote, see W. van Damme, *A Comparative Analysis concerning Beauty and Ugliness in Sub-Saharan Africa*, Ghent, 1987, pp. 67–68; and *Beauty in Context: Towards an Anthro-*

pological Approach to Aesthetics, Leiden, 1996, pp. 308–9. Van Damme's "World Aesthetics: Biology, Culture, and Reflection" appears in J. Onians, ed., *Compression vs Expression: Containing and Explaining the World's Art*, New Haven, Yale University Press, 2006. See also "Anthropologies of Art," *International Journal of Anthropology* 18.4, October 2003, 231–44; and "Transcultural Aesthetics and the Study of Beauty," in *Frontiers of Transculturality in Contemporary Aesthetics* (proceedings volume of the Intercontinental Conference, University of Bologna, October 2000), ed. G. Marchianò and R. Milani, Turin, 2001 (proceedings papers are available online, http://www3.unibo.it/transculturality/files/proceedings.htm).]

73. M. Leiris and J. Delange, *Afrique noire*, Paris, 1967, pp. 40–45; J. Maquet, "Art by Metamorphosis," *African Arts* 12.4, August 1979.

74. See R. F. Thompson, *African Art in Motion*, Berkeley, 1974, pp. 43–45 (Yoruba); Willett, *African Art*, pp. 211 (Dan), 212–15 (Yoruba), 215 (Gola).

75. M. D. McLeod, *The Asante*, London, 1981, p. 178.

76. H. E. Cole, *Mbari*, Bloomington, 1982, p. 180.

77. This is not a direct quote, but a summary of "The Snow Wife," in K. Seki, *Folktales of Japan*, Chicago, 1963, pp. 81–82.

78. E.g., the *Republic* 424, 596ff., and the *Laws* 656ff., as against the *Symposium*.

79. Plotinus 5.8.1, in *Plotinus*, trans. A. M. Armstrong, London, 1953, p. 149.

80. E.g., Plotinus 6, 7, 22, in ibid., pp. 74–75.

81. Plotinus 6.7.3, in ibid., p. 149.

82. E. Panofsky, *Idea*, Columbia, NC, 1968, pp. 36ff., 49–52, 58–59.

83. E. H. Gombrich, *Symbolic Images*, Oxford, 1972, pp. 172ff.; Panofsky, *Idea*, pp. 53–54. See also A. Chastel, *Art et humanisme à Florence au tempts de Laurent le Magnifique*, Paris, 1959, pp. 102ff.

84. Panofsky, *Idea*, pp. 93–95, 115–16.

85. In addition to Panofsky, *Idea*, see, e.g., M. H. Abrams, *Natural Supernaturalism*, New York, 1971, pp. 27, 29, 31, 169. See also the sources provided in note 88 below.

86. See H. von Glasenapp, *Das Indienbild deutscher Denker*, Stuttgart, 1960; R. Schwab, *La renaissance orientale*, Paris, 1950. Schopenhauer's views can be found, e.g., in *The World as Will and Representation* (1918), para. 34. On the Theosophists, see B. F. Campbell, *Ancient Wisdom Revived: A History of the Theosophical Movement*, Berkeley, 1980, pp. 168–71.

87. See, e.g., P. Vogt, *The Blue Riders*, Woodbury, NY, 1980, pp. 6–7; also B.-A. Scharfstein, *Mystical Experience*, Oxford and New York, 1973; K. Wilbur, *Quantum Questions*, Boulder, 1984.

88. I direct readers to the following general works on mysticism and European abstract painting: A. Besançon, *The Forbidden Image: An Intellectual History of Iconoclasm*, Chicago, 2000 (from roughly Plato to Kandinsky and Malevich); Barasch, *Modern Theories of Art*, vol. 2, *From Impressionism to Kandinsky*, New York, 1998; J. Golding, *Paths to the Absolute*, London, 2000 (on Mondrian, Malevich, Kandinsky, Pollock, Newman, Rothko, and Still); J. Harrison and P. Wood, eds., *Art Theory, 1900–1990: An Anthology of Changing Ideas*, London, 1992 (a number of relevant texts); A. Moszynska, *Abstract Art*, London,

1995 (comprehensive, brief, general); M. Tuchman, ed., *The Spiritual in Art: Abstract Painting, 1890–1985*, Los Angeles and New York, 1986 (from my standpoint, the fullest and most pertinent account).

On Kupka, see V. Spate, "Orphism," in N. Stangos, ed., *Concepts of Modern Art*, rev. ed. London, 1981, pp. 88–89.

On Kandinsky, see R.-C. W. Long, *Kandinsky*, Oxford, 1980; H. K. Roethel, *Kandinsky*, Oxford, 1979; P. Selz, *German Expressionistic Painting*, Berkeley, 1957, pp. 223–24; but see also N. Kandinsky, *Kandinsky et moi*, Paris, 1978, p. 270.

On Malevich, see J. Andrea, ed., *Kazimir Malevich*, Los Angeles, 1990; S. Faucereau, *Kazimir Malévitch*, Paris, 1991.

On Mondrian, see Y.-A. Bois, *Piet Mondrian*, Boston, 1990; F. Elgar, *Mondrian*, London, 1968; the Web page "Mondrian Biography," posted by Nick Blackburn on the Snap Dragon portal (http://www.snap-dragon.com/mondrian_biography.htm); D. Vallier, *L'art abstrait*, Paris, 1967; J. Milner, *Mondrian*, London, 1992; D. Sylvester, "Piet Mondrian (1872–1944)," in D. Sylvester, *About Modern Art: Critical Essays, 1948–1997*, London, 1997 (available online through the Artchive Web site, http://www.artchive.com/artchive/M/mondrian.html); Eiichi Tosaki, "Prelude to Visualized Rhythm: The Work of Piet Mondrian," *Colloquy*, no. 4, *Curious Eyes: Sites and Scenes of Modernism*, 2000 (http://www.colloquy.monash.edu.au/issue004/index.html).

89. On the sequence of styles, see D. Sarabianov, "Kazimir Malevich and his Art, 1900–1930," in Andrea, *Kazimir Malevich*, pp. 164–67 (p. 167 quoted). On the underpainting of the black square, see Faucereau, *Kazimir Malévitch*, pp. 124, 126.

90. K. Malevich, "Futurism-Suprematism," 1921, quoted in Andrea, *Kazimir Malevich*, pp. 177–78.

91. K. Malevich, "Non-Objective Art and Suprematism," in Harrison and Wood, *Art Theory, 1900–1990*, pp. 2291–92.

92. W. Kandinsky, "The Cologne Lecture,' in ibid., p. 94.

93. Long, *Kandinsky*, p. 32.

94. A. Besant, *The Ancient Wisdom: An Outline of Theosophical Teachings*, London, 1987, pp. 146, 185; as quoted in S. Ringbom, "Transcending the Visible: The Generation of the Abstract Pioneers," in Tuchman, *The Spiritual in Art*, pp. 134, 137. Kandinsky owned the book *Thought Forms*, published by Besant and C. W. Leadbeater in 1905. In Tuchman's book, see also J. E. Bowlt, "Esoteric Culture and Russian Society."

95. Roethel, *Kandinsky*, p. 18.

96. Elgar, *Mondrian*, pp. 104–5; N. Stangos, *Concepts of Modern Art*, rev. ed., London, 1981, p. 142; Vallier, *L'art abstrait*, pp. 110–29.

97. S. Ringbom, "Transcending the Visible," in Tuchman, *The Spiritual in Art*, p. 146. See also, in the same book, C. Blotkamp, "Annunciation of the New Mysticism: Dutch Symbolism and Early Abstraction," 89–111.

98. P. Mondrian, "Plastic Art and Pure Plastic Art" (1937) in *Plastic Art and Pure Plastic Art and Other Essays*, New York, 1945, p. 13; Elgar, *Mondrian*, pp. 73–75; M. Seuphor, *Piet Mondrian: Life and Work*, New York, 1955, pp. 117–18.

99. Mondrian, "Plastic Art and Pure Plastic Art," pp. 14–15.

100. From Mondrian, *"Plastic Art and Pure Plastic Art,"* as quoted in Harrison and Wood, *Art Theory, 1900–1990*, pp. 372–73.

101. See D. Shapiro, "Mondrian's Secret," in B. Beckley, with Dr. Shapiro, eds., *Uncontrollable Beauty*, New York, 1998, pp. 317–23, esp. pp. 317–18; and D. Sylvester, "Piet Mondrian."

102. M. Tuchman, "Hidden Meanings in Abstract Art," in Tuchman, *The Spiritual in Art*, p. 49; quoted from a 1971 Museum of Modern Art catalog, *Barnett Newman*, by T. B. Hess.

103. A. Frankenstein, ed., *Karel Appel*, New York, 1980, pp. 14–15.

104. S. Vogel, *Baule: African Art / Western Eyes*, New Haven, 1997. I know Vogel's earlier study, *Beauty in the Eyes of the Baule: Aesthetics and Cultural Values*, Philadelphia, 1980, only from the long summary in W. van Damme, *Beauty in Context*, , pp. 213–42.

105. As summarized in van Damme, *Beauty in Context*, pp. 216–19.

106. Ibid. 221–23. [On spirit wives, see p. 265.]

107. Ibid., pp. 223–29.

108. Vogel, *Baule*, p. 40.

109. Ibid., pp. 90, 270–78 (p. 90 quoted).

110. Ibid., pp. 94–98 (p. 94 quoted).

111. Ibid., pp. 108, 110–11, 127, 190–91, 194.

112. The exhibition catalog was edited by J.-P. Colleyn, *Bamana: The Art of Existence in Mali*, New York, Zurich, and Ghent, 2001. See also M. B. Visonà, "Mande World and the Upper Niger," in M. B. Visonà et al., eds., *A History of Art in Africa*, New York, 2000, pp. 102–24. For a summary following the Griaule school of Bamana (Bambara) mythology, see G. Dieterlin in Y. Bonnefoy, ed., *Mythologies*, vol. 1, Chicago, 1933, pp. 33–49. [My footnote cites Visonà, p. 242.]

113. Colleyn, *Bamana*, p. 122.

114. J.-P. Colleyn, "The Power Associations: The Ci-wara," in ibid., pp. 204–5.

115. See M. J. Arnoldi, "The Sogow: Imagining a Moral Universe through Sogo bò Masquerades," in Colleyn, *Bamana*, pl. 80–81.

116. See the following articles, all in Colleyn, *Bamana*: J. Brink, "Dialectics of Aesthetic Form in Bamana Art," p. 240; S. Malé, "The Initiation as Rite of Passage: The Jo and the Gwan" in Colleyn, Bamana, p. 156 (quoted); also B. Fank, "More than Objects: Bamana Artistry in Iron, Wood, Clay, Leather and Cloth," pp. 45–51.

117. J. Brink, "Dialectics of Aesthetic Form," p. 240.

118. Ibid., pp. 239–40.

119. Ibid., p. 62.

120. Zahan, *The Religion, Spirituality, and Thought of Traditional Africa*, pp. 1, 154, 156. See also, e. g., M. Huet, *The Dance, Art, and Ritual of Africa*, New York, 1978; and Thompson, *African Art in Motion*.

121. Vogel, *Baule*, pp. 288, 292.

122. For background on ancient Indian aesthetics, see the following general works: S. J. N. Banarjea, *The Development of Indian Iconography*, 3rd ed. (from 2nd ed., 1956), New Delhi, 1974; B. N. D. Desai, *Erotic Sculpture of India: A Socio-Cultural Study*, Tata McGraw Hill, New Delhi, 1975; J. Gonda, *Vedic Literature*, , Wiesbaden, 1975, pp. 65–73; J. Masselos, J. Mrnzies, and P. Pasl, *Dancing to the Flute: Music and Dance in Indian Art*, Sydney, 1997; L. Rowell, *Music and Musical Thought in Early India*, Chicago, 1992; N. Ray, *An Approach to Indian Art*, Chandigrah, 1974; C. Śivaramamurti, *The Painter in Ancient India*, New Delhi, 1978, and *The Art of India*, New York, 1977.

On poetics, see S. K. De, *History of Sanskrit Poetics*, repr., 2 vols. in 1, Calcutta, 1977, and *Sanskrit Poetics as a Study of Aesthetics*, Berkeley, 1963; D. H. Ingalls, trans., *An Anthology of Sanskrit Court Poetry*, Cambridge, MA, 1965; D. H. Ingalls, J. M. Masson, and M. V. Patwardhan, *The Dhvanaloka of Ananavardhana, with the Locana of Abhinavagupta*, Cambridge, MA, 1990; J. L. Masson and M. V. Patwardhan, *Santarasa and Abhinavagupta's Philosophy of Aesthetics*, Poona, 1969; K. C. Pandey, *Comparative Aesthetics*, vol. 1, *Indian Aesthetics*, Banaras, 1950; A. K. Ramanujan, "Indian Poetics," in E. C. Dimock Jr., et al., *The Literatures of India*, Chicago, 1974; A. K. Warder, *Indian Kavya Literature*, vol. 1, Delhi, 1972.

On iconography and canons, see T. Bhattacharyya, *The Canons of Indian Art*, 2nd ed., Calcutta, 1963; P. N. Bose, ed., *Silpa-Sastram*, Lahore, 1929.

123. N. Ray, *An Approach to Indian Art*, p. 177.

124. Ibid., pp. 266–67, from the *Vishnudharmmottaram* 3.2.1–9.

125. Warder, *India Kavya Literature*, vol. 1, pp. 32–33.

126. I take the translations of the *raja* pairs from Rowell, *Music and Musical Thought in Early India*, p. 329; see also, for comparison, Bukofzer, *Music in the Baroque Era*, pp. 388–90.

127. Warder, *Indian Kavya Literature*, vol. 1, p. 33, cites ancient discussions of music and paintings in relation to *rasas*.

128. Masson and Patwardhan, *Santarasa and Abhinavagupta's Philosophy of Aesthetics*, p. 9.

129. Warder, *Indian Kavya Literature*, vol. 1, pp. 16, 32–33, 74; Rowell, *Music and Music Thought in Early India*, pp. 96–98, 112.

130. See the Natyasastra 1.113–14, 104–8, and 6.31–32, in A. T. Embree, ed., *Sources of Indian Tradition*, 2nd ed., vol. 1, New York, 1988, pp. 266–68.

131. K. Krishnamoothy, trans., *Anandavardhana's Dhvanyaloka*, Dharwar, 1974, p. xxix. See also Warder, *Indian Kavya Literature*, vol. 1, p. 118. On the language of the *kavya* tradition, see as well, De's *History of Sanskrit Poetics* and *Sanskrit Poetics as a Study of Aesthetics*; Ingalls, *An Anthology of Sanskrit Court Poetry*, pp. 72ff.; Pandey, *Comparative Aesthetics*, vol. 1; Ramanujan, "Indian Poetics."

132. Desai, *Erotic Art of India*, pp. 177–82, 184, 187, 195.

133. See Śivaramamurti, *The Art of India*, e.g., pp. 131–32, 134, 135. Both examples, with associated illustrations, are on p. 132.

134. Anandavardhana's *Light on [the Doctrine of] Suggestion* consists of verses, meant to be memorized, and a prose commentary, which some modern scholars believe is by another, anonymous author. Because there are no marked discrepancies between verses and commentary, I do not distinguish between their different possible authors. For background on Anandavardhana and Abhinavagupta, see R. Gnoli, *The Aesthetic Experience according to Abhinavagupta*, Rome, 1956, pp. 55, 87–96; Ingalls, *An Anthology of Sanskrit Court Poetry*, pp. 13ff.; Ingalls, Masson, and Patwardhan, *The Dhvanyaloka, with the Locana*; Masson and Patwardhan, *Santarasa and Abhinavagupta's Philosophy*, pp. 50–55; Pandey, *Comparative Aesthetics*, vol. 1, p. 21; Ray, *An Approach to Indian Art*, pp. 131ff.

135. Ingalls, *An Anthology of Sanskrit Court Poetry*, pp. 5–6; Ingalls, Masson, and Patwardhan, *The Dhvanyaloka, with the Locana*, pp. 45, 679–89 (*Dhvanyaloka* 4.2).

136. Ingalls, Masson, and Patwardhan, *The Dhvanyaloka, with the Locana*, pp. 47–48, 243 (*Dhvanyaloka* 1.1, 1.1.5), and 721 (*Dhvabyaloka* 4.16); Krishnamoothy, *Anandavardhana's Dhvanyaloka*, p. xxxi.

137. Masson and Patwardhan, *Santarasa and Abhinavagupta's Philosophy*, p. vi, attribute the quoted characterization to "pandits."

138. Gnoli, *The Aesthetic Experience according to Abhinavagupta*, pp. 87–90; Masson and Pawardhan, *Santarasa and Abhinavagupta's Philosophy*, pp. 56–57; Pandey, *Comparative Aesthetics*, vol. 1, p. 144.

139. Ingalls, Masson, and Patwardhan, *The Dhvanyaloka, with the Locana*, pp.114–16; Masson and Patwardhan, *Santarasa and Abhinavagupta's Philosophy*, pp. 46–47, 57–58.

140. Gnoli, *The Aesthetic Experience according to Abhinavagupta*, p. xxii. On *rasapratiti* see Masson and Patwardhan, *Santarasa and Abhinavagupta's Philosophy*, pp. 65–67, 70.

141. Masson and Patwardhan, *Santarasa and Abhinavagupta's Philosophy*, p. 13.

142. Ingalls, Masson, and Patwardhan, *The Dhvanyaloka, with the Locana*, pp. 120–21; Masson and Patwardhan, *Santarasa and Abhinavagupta's Philosophy*, pp. 12 (quoted), 18–19.

143. Ingalls, Masson, and Patwardhan, *The Dhvanyaloka, with the Locana*, pp. 520–26; Masson and Patwardhan, *Santarasa and Abhinavagupta's Philosophy*, pp. vii–viii, 130–59; Pandey, *Comparative Aesthetics*, vol. 1, pp. 196–206.

144. On Abhinavas's philosophy, see K. C. Pandey, *Abhinavagupta: An Historical and Philosophical Study*, repr., Varanasi, 2006, pp. 293ff.

145. Masson and Patwardhan, *Santarasa and Abhinavagupta's Philosophy*, pp. x–xiii, 51–52.

146. B. N. Goswamy, *Pahari Painting of the Nala-Damayanti Theme in the Collection of Dr. Karan Singh*, New Delhi, 1975. See also M. C. Beach, *Mughal and Rajput Painting*, Cambridge, 1992, pp. 174–210.

147. Goswamy, *Pahari Painting*, p. 31.

148. For more reading on Chinese aesthetics, I recommend W. R. B. Acker, ed., *Some T'ang and Pre-T'ang Texts on Chinese Painting*, Leiden, 1954, pp. xxvii–xxviii; Shou Kwan Lui, "The Six Canons of Hsieh Ho," *Oriental Art*, n.s. 17, summer 1971, p. 144; K. Munkata, *ChingHao's "Pi-fa-chi": A Note on the use of the Brush*, Ascona, 1974, pp. 3, 20–21, 24–25. See also O. Siren, *The Chinese on the Art of Painting: Translation and Comments* (sometimes

misleading), [Beijing], 1936; and especially S. Bush, *The Chinese Literati on Painting*, Cambridge, 1971 S. Bush and H. Shih, *Early Chinese Texts on Painting*, Cambridge, MA, 1985; and Lin Yutang, *The Art of Painting*, London, 1967 (knowledgeable but very free).

149. D. Pollard, "Ch'in Literary Theory," in A. A. Rickett, ed., *Chinese Approaches to Literature from Confucius to Liang Ch'i-chao*, Princeton, 1978, pp. 64–65.

150. Acker, *Some T'ang and Pre-T'ang Texts*, p. 4. Acker gives a careful explanation of the terms of the canon on pp. xxi–xliii.

151. From Yang Wei-chen, *Precious Mirror for Examining Painting*, completed in 1365; as quoted in Bush and Shih, *Early Chinese Texts on Painting*, p. 246.

152. See esp. Acker, *Some T'ang and Pre-T'ang Texts*; Shou Kwan Lui, "The Six Canons of Hsieh Ho"; Munkata, *ChingHao's "Pi-fa-ch,"* pp. 20–21 n. 13, 225 n. 21.

153. W. C. Fong, *The Problem of Forgeries in Chinese Painting*, Ascona, 1962; W. C. Fong et al., *Images of the Mind*, Princeton, 1985, p. 171.

154. G. Rowley, *Principles of Chinese Painting*, Princeton, 1959, p. 48.

155. [My footnote draws on B. March, *The Technical Terms of Chinese Paintings*, Baltimore, 1935.]

156. S. Wong, "Ch'ing and Ching in the Critical Writings of Wang Fu-chih," in Rickett, *Chinese Approaches to Literature*, Princeton, 1978, pp. 148–50.

157. J. Ching, *To Acquire Wisdom: The Way of Wang Yang-ming*, New York, 1976, p. 127.

158. Ibid., pp. 142–44.

159. For background on classical ("medieval") Japanese aesthetics, I point readers to the following sources: E. Miner, ed., *Principles of Classical Japanese Literature*, Princeton, 1985; N. G. Hume, ed., *Japanese Aesthetics and Culture: A Reader*, Albany, 1995, chap. 2 (D. Keene, "Japanese Aesthetics") and chap. 3 (W. T. de Bary, "The Vocabulary of Japanese Aesthetics," from *Sources of Japanese Tradition*, New York, 1958); Saburo Ienaga, *Japanese Art: A Cultural Appreciation*, New York, 1978 (sketches changing social backgrounds of art); J. Konishi, *A History of Japanese Literature*, vol. 2, *The Early Middle Ages*, Princeton, 1986; R. Izutsu and F. Izutsu, *The Theory of Beauty in the Classical Aesthetics of Japan*, The Hague, 1981, p. 28; E. Miner, H. Odagiri, and R. E. Morrell, *Companion to Classical Japanese Literature*, Princeton, 1985, esp. the dictionary of literary terms on pp. 270–305; S. Odin, *Artistic Detachment in Japan and the West: Psychic Distance in Comparative Aesthetics*, Honolulu, 2001, pp. 99–169; D. Pollack, *The Fracture of Meaning: Japan's Synthesis of China from the Eighth through the Eighteenth Centuries*, Princeton, 1986; H. Singer, "Ma—the Charged Emptiness and Its Expression in the Japanese Aesthetic," Ph.D. diss., University of Haifa, 1999 (in Hebrew); and J. Stanley-Baker, *Japanese Art*, rev. ed., London, 2000. Stanley-Baker's relevant study (which I have not had the chance to consult) is *The Transmission of Chinese Idealist Painting to Japan: Notes on the Early Phase*, Ann Arbor, 1992. See also M. Ueda, *Literary and Art Theories in Japan*, Cleveland, 1967, chap. 4; Kozo Yamamura, ed., *The Cambridge History of Japan*, vol. 3, *Medieval Japan*, Cambridge, 1990, chap. 10 (H. P. Varly, "Cultural Life in Medieval Japan"); chap. 11 (B. Ruch, "The Other Side of Culture in Medieval Japan").

On modern Japanese aesthetics, see M. Marra, ed., *A History of Modern Japanese Aesthet-*

ics, Honolulu, 2001; and *Modern Japanese Aesthetics: A Reader,* Honolulu, 1999; S. Odin, *Artistic Detachment in Japan and the West,* Honolulu, 2001.

[My footnote draws on Stanley-Baker, *Japanese Art,* p. 10, and on Konishi, *A History of Japanese Literature,* vol. 2, pp. 91–99. For Konishi's periodization, see the chart on p. 66. This chart contradicts the more general chart Konishi provides in the first volume of his history (also p. 66), which ends the Middle Ages in the late fifteenth century. Konishi's comparison of Chinese, Japanese, and Korean literature is taken, with large omissions, from *A History of Japanese Literature,* vol. 1, Princeton, 1984, pp. 21–34.]

160. Mezaki Tokue, "Aesthete-Recluses during the Transition from Ancient to Medieval Japan," in Miner, *Principles of Classical Japanese Literature,* pp. 130–80 (p. 154 quoted).

161. This is the thesis of Pollack in *The Fracture of Meaning.*

162. Summarized in ibid., pp. 43–47.

163. The quotation from the *Kokinsu* is added by me, not Norinaga. See also H. Sato and B. Watson, *From the Country of Eight Islands: An Anthology of Japanese Poetry,* New York, 1987, p. 7.

164. De Bary, "The Vocabulary of Japanese Aesthetics," pp. 44–45; Ueda, *Literary and Art Theories in Japan,* pp. 196–213, esp. pp. 199–202. On Norinaga and the intellectual movement called "national studies," see also T. Najita, "History and Nature in Eighteenth-Century Tokugawa Thought," in J. W. Hall, ed., *The Cambridge History of Japan,* vol. 4, Princeton, 1991, pp. 616–21.

165. De Bary, "The Vocabulary of Japanese Aesthetics," pp. 55–58; Izutsu and Izutsu, *The Theory of Beauty,* pp. 26–44 (esp. p. 33); Pollack, *The Fracture of Meaning,* pp. 40–53, 223–25; Ueda, *Literary and Art Theories in Japan,* pp. 59–66. See also Hall, The Cambridge History of Japan, vol. 4, pp. 616–21. The quotation, from a translation of Zeami's difficult summary of his views, *The Nine Stages of the No in Order,* is found in J. W. de Bary, ed., *Sources of Japanese Tradition,* New York, 1958, p. 293.

166. Varly, "Cultural Life in Medieval Japan," pp. 466–67.

167. Ruch, "The Other Side of Culture in Medieval Japan," esp. pp. 541–43.

168. Odin's *Artistic Detachment in Japan and the West* is a well-researched and well-thought-out exposition of this theme, with examples from modern Western and modern Japanese literature. As is usual, Odin finds the Western origin of the idea in Immanuel Kant, who probably owes the idea to the seventeenth-century empiricists beginning with the Third Earl of Shaftesbury (1671–1713)—"the first thinker to bring the phenomenon of disinterestedness to light and analyzing it"—and continuing with David Hume, Joseph Addison, Edmund Burke, and others (Odin quotes J. Stolnitz, "On the Significance of Lord Shaftesbury in Modern Aesthetic Theory," *Philosophical Quarterly* 2.43, p. 100). I think that it was the work of Edward Bullough that made the "psychical distance" well known.

169. See, e.g., A. Storr, *Solitude: A Return to the Self,* New York, 1988, chap. 8.

170. Han-shan (Hanshan), "Body Asking Shadow," trans. G. Snyder, as cited in J. Minford and J. S. M. Lau, eds., *Classical Chinese Literature: An Anthology of Translations,* vol. 1, *From Antiquity to the Tang Dynasty,* New York and Hong Kong, 2000, p. 979. Translations of the same poems by Han-shan made by different English and French translators are

printed together in J. Pimpineau, *Le clodo dur dharma: 24 poèmes de Han-shan, Calligraphies de Li Kwok-ming*, Paris, 1975. The calligraphic form of the poem is from p. 25; p. 24 has a word-for-word translation. See also B. Watson, *Chinese Lyricism*, New York, 1971, pp. 176–79. Han-shan and his companion Shih-te (Shide; in Japanese, Jittoku), "Foundling," stand out in the Ch'an/Zen tradition of eccentric monks. On their representation in Zen art, see J. Fontein and M. L. Hickman, *Zen Painting and Calligraphy*, Boston, 1970; and S. Addiss, *The Art of Zen*, New York, 1989.

INDEX

'Abd al-Aziz, 202
Abhinanda, 248
Abhinavagupta, 249, 420–21, 516
Abiodun, Roland, 256
Aboriginal art. *See* art, Aboriginal
Aboriginal Arts Board, 325, 327
Aboriginal Land Rights (Northern Territory)
 Act, 322
Aboriginal motifs, 318
abstract expressionism, 298, 320
abstraction, 397, 399, 410; in Inuit art, 312; lyri-
 cal, 290, 320
Abu'l Fazl, 198
Académie des Beaux Arts (Kinshasa), 329n
Accademia del Disegno, 164
Achuar (Ecuador), 79
Ackerman, Diane, 19
acrylics, used by: Aboriginal painters, 312, 315,
 317–19, 321, 326, 357; African painters, 100,
 356; Papuan painters, 307
act of creation, 3

Addison, Joseph, 518
Adnyamathanha, 120
advertising, 56
aesthetic analysis. *See* analysis, of visual art
aesthetic appreciation, 30–31, 60, 123
aesthetic aspect of experience, 66–67, 69–70
aesthetic conventions, local, 68–69
aesthetic dimension of life, 8–10, 15–16
aesthetic experience, 213, 361, 386
aesthetic judgments, 44n
aesthetic pluralism, 367
aesthetic theory, 8–9
aesthetic wealth, 6
aestheticism, 214, 299, 426; religious, 214
aesthetics, 6, 213, 390, 401n, 404, 429, 432,
 434; African, 411–16; Chinese, 134, 422–24,
 516; conception of, 8–9; and ethics, 213n;
 Indian, 122–23, 249, 418–21, 515; Japanese,
 425–28, 517–18; open, 366, 432; terms,
 400, 430; Western (European), 404–5, 410;
 Yoruba, 364

affections, European theory of, 417

African art, 8–9, 100–101, 261n, 283, 453–54; influence on Western art, 279–80

African carver, traditional, 3, 5

African fantasies, 341

afterlife, and Egyptian art, 112

Ahmosé, 187

Akanji, Adebisi, 330n

Akbar, 198–200, 370

Akhenaten (Amenhotep IV), 113, 185–87, 197, 398

Akis, Timothy, 304, 305

Akpan, Sunday Jack, 350, 354

Akurra (Dreamtime Serpent), 116, 119

Ala, Igbo creator-goddess, 260n

Alberti, Leon Battista, 50, 206–7, 391, 405

Alberti, Rafael, 11

al-Bukhari, 475

Alcamenes, 159

alchemy, 440

Alexander the Great, 190

'Ali Asghar, 202

Allingam, "Jodam," 308, 356

al-Nawawi, 196n

Alzheimer's disease, in artists, 223

ambidexterity. See handedness

Amenemhat, 187

Amenhotep III, 185

Ames-Lewis, Frances, 145n

Amun, 187

analysis, of visual art, 91, 144, 155, 167

Anandavardhana, 419–21, 516

anatomy, studied by artists, 139, 205, 234, 287, 405

Andreasen, Nancy C., 224n

angels, 128

animism, Senegalese, 344

anthropologists, French, 96

anthropology, 77–85, 363, 382, 401n, 433, 451; payment for information, 78n; symbolic, 80, 98

anthropomorphism, cosmological, 133

Anti, Saun, 495

Antigonous, 190

Anton's syndrome, 23

apartheid, 353

Apelles, 190

Apollinaire, 281n

Apollo, 115, 127–28, 160

Apollo Belvedere, 128, 162–63, 270–71

Apollodorus, 190

Appel, Karl, 298–99, 410

apprenticeship, 129–30, 239, 364

arabesque (rhythmic design), 196, 201

archaism, 74, 140–41, 144, 149–51, 159

archetypes, 178, 335, 405

architects, 182; in ancient Egypt, 472; in ancient India, 472; in Islamic culture, 472; medieval European, 194, 472

architecture, 91n; African, 401n; Dogon, 132–33; Greek, 137; Hindu, 135; Indian, 109, 135–36, 247, 420, 458; neoclassical, 137; Renaissance, 137, 139; Roman, 137; so-called primitive, 133

Arioi, professional cult, in Polynesia, 251, 279

Aristodemus, 189

Aristotle, 64, 136, 159, 188, 191–92, 218, 508

arithmetic, 43

Arosa, Jean-Dominique, 275–76

art about art, 295–96

art appreciation, 162, 368, 381, 386

art as a source of income, 358; for Aborigines, 316–17, 318n; for Africans, 328, 333; for the Inuit, 309

art auctions, 7 (see also auctioneers)

art criticism, 80, 178–79, 337, 354–55, 375, 500; Chinese, 424n

art dealers, 375–76

art fair, 375–76

art for art's sake, 214, 215n, 216, 308, 431

art historians, 375

art market, 99, 377, 378n; for Chinese art, 239; in South Africa, 353–54; international, 371

art nouveau, 406–7

art production, at a Mughal court, 475

art theory, 404–5; Chinese, 422–23

art therapy, 232

art: as aesthetic activity, 61; belonging to the people, 54; as a body meant to satisfy hunger for direct experience, 60; common measure for, 66, 70; conceptions of, 8, 16, 66, 429; definitions of, 8, 85; differences between

Western and Chinese, 234–35; as an expressive act, 403; functions of, 68; as a ghost, 61, 68; high versus low, 57–58; humanity of, 432; impersonally personal messages, 5–7, 61–65, 68–69, 88, 403; of the insane, 98–99, 371, 396; judgment of, 368–73, 375, 378–80, 382, 386–89, 433; made by animals, 4, 321; for protest, 324; radicalization of, 268; and religion, 179; resisting definition, 60, 69; as a response to the hunger for imagined experience, 3, 5–6, 433; for ritual purpose, 430–31; as a sacred mission, 216; separated from non-art, 8; as a style of living, 297; as a vehicle for social criticism, 353; as a weapon, 16, 280; worth of (market value), 6, 369n, 388

art: abstract, 28, 40, 368n, 406; academic, 369–70; academic, in Africa, 328–29, 334, 344, 348, 358; baroque, 40; Buddhist, 282; classical, 159, 180, 192; conceptual, 302, 374; contemporary, 15–16, 62, 234, 240, 265, 312, 334, 345, 354, 371–73, 375–77, 381, 386; decorative, 383; exotic, 102, 271, 354; figurative, 47, 298, 383; local or private, 384, 386; marginal, 58; medieval, 170, 283; modern: 22, 282, 354, 376, 452; modern European, 446; modern egocentric, 231; early Norman, 284; ornamental, 42; outsider, 58, 99, 308, 342; plastic, 409; pop, 40; popular, 56–57; postmodern, 264, 302; pre-Columbian, 280, 283; primitive, 61n, 108, 308, 358, 371, 411; modern primitive, 304–5, 327; realistic versus unrealistic, 40; Renaissance, 40, 267, 273; Romanesque, 284; traditional, 29, 115, 170, 433; tribal, 80–81; twentieth-century Western, 297, 304, 356, 358–59; universal, 54, 84, 383; verbal, 67; world, 401n

art, Aboriginal, 115, 120–121, 312, 371, 453–454; and cultural identity, 321n; modern, 304–305, 312, 355–358, 496; urban, 324–325, 358

art, African, 327, 346–347, 349, 371, 404, 415–416; from the Congo, 101; modern, 305, 327–329, 334, 337, 349, 354–359, 499; in traditional African kingdoms, 94–95, 456

art, Bavarian, 283

art, British, 335

art, Chinese, 8–9, 163, 282, 284, 289–93, 295, 364, 366, 400, 422–24, 426n, 430, 434; European influence on, 286; histories of, 482; role of imperial court, 164

art, Dutch, of the seventeenth century, 267

art, Egyptian, 185–88, 282–83; of ancient Egypt, 140–41; compared to Mesopotamian, 112

art, Greek and Roman, 162, 180, 188–93, 267, 270, 273, 280, 282

art, Huichol, and the nature of the landscape, 88

art, Indian, 8–9, 109–11, 123, 175–77, 179, 282, 364, 371, 378n, 419, 434

art, Inuit, 454; modern, 304, 308–12, 355–57

art, Italian, 267, 284; early, 270

art, Japanese, 8–9, 170, 280, 284–85, 366, 426n, 427–28, 434; influence on Aboriginal art, 325; modern, 491

art, Korean, 76, 91, 172, 366, 369, 382

art, Maori, 88–89, 98

art, Mexican, 284

art, Native American, 371, 454; modern, 496

art, Oceanic (Polynesian, Melanesian), 9, 280, 284, 371, 454; modern, of Papua New Guinea, 306, 308, 355–57

art, Scythian, 282

art, Senegalese, 345–46

art, Tibetan, 229n, 282

art, Yolngu, and the power of ancestors, 90

art, Zen, 435, 519

artisan-artists, medieval, 195n

artisans, status of, 191–92; versus artists, 9

artist, as hero, 230–32

artistic abandon, in Chinese art, 184

artistic ability, and sexual ability, 210–11

artistic training, academic, 164, 208

artists' cooperatives, 175 (see also guilds)

artists: contemporary, 261; eccentricity of, 204, 219, 239, 260; individuality in Islamic art, 200–202; Italian, as salaried members of aristocratic households, 206; popular, 350, 358; sane, 228; versus craftsmen, 206; as visionaries, 192; Western romantic conceptions, 201; wild Chinese, 184–85, 239–40

arts and crafts, 9–10; in India, 246

Arts and Crafts Movement, 170

Beuys, Joseph, 17, 373–74
Bharata, 417–18, 431
Bhavbhuti, 249, 261
Bhoja, 247
Bible, 210, 326, 352
bibliographies in the endnotes: Aboriginal art,
 452–53, 496–97; Aboriginal myth, 459–60;
 African art, 453–54, 499–500; anthropol-
 ogy of art, 452–54; Apollo figures, 462; Chi-
 nese aesthetics, 516–17; Chinese architec-
 ture, 463; Chinese art, authenticity in, 457;
 Chinese art, symbolism of the old tree and
 the rock, 461; Chinese painting, amateur
 versus professional, 482–83; Chinese paint-
 ing, commentators, 466; Chinese scholarly
 style, 466; color, 507–8; Eastern borrow-
 ing from Western tradition, 491; empathy,
 449; genius, 477–78; Haidas (Northwest
 Coast, Canada), 496; Indian aesthetics, 515;
 Indian art, authenticity in, 458; Indian build-
 ing, 463; Inuit art, 454, 495–96; Japanese
 aesthetics, 517–18; Japanese literature, 465;
 mysticism and European abstract paint-
 ing, 512–13; Native American art, 454, 496;
 Oceanic art, 454; Shiva, 460–61; visual pro-
 cessing and intelligence, 441–42
Biedermann, Irving, 22n
biographers, of artists, 381
bipolar affective disorder, 224n (see also depres-
 sion)
Birdwood, George, 110
birth, as a metaphor for creating art, 3, 5
Bizhad (Bezhad), 197, 201, 203–4
black culture, 344
blacksmiths, African, 350, 414–15
Blake, William, 172, 176, 209, 391
Blavatsky, Helena, 406n
blindness, 22–23; color, 387; emotional, 387;
 face (prosopagnosia), 23–24, 442; motion,
 387
blue landscape, as a universal, 54
body painting, Aboriginal, 315, 318, 320–21
bohemianism, 232–33
Bohr, Niels, 406
Boltanski, Christian, 29–30
Bonaventura, 177

Bonnard, Pierre, 273, 281, 335
boomerangs, 313, 325
boredom, 32
Bose, Nandalal, 111
Botticelli, 128, 270
Bourdieu, Pierre, 265
Brahma, 231, 417–18
brain, 1, 10, 17, 27, 32–36, 440; imperfections,
 illnesses, or injuries, 21, 23; injury and artis-
 tic ability, 222–23; and language, 444; rela-
 tionship between hemispheres, 36, 39–40;
 scanning, 25; extreme specialization of, 23;
 split, 37n; visual, 17, 24, 34
Brancusi, Constantin, 335, 343
Braque, Georges, 280, 335
Brendel, Alfred, 228n
Brereton, Leo, 318
Breton, André, 268
Brettell, Richard R., 370n
bribery, to gain attention, 293
bronzes, South Indian, 106–7
Brooks, James, 226
Brueghel, 331
brushwork (brushstokes): in Chinese art,
 103, 144, 153, 156, 184, 235, 238, 240, 287,
 365–66, 393, 423n, 424, 426n, 498; "one-
 stroke," 393; "scribbling," 184; "splashing,"
 184, 292; "wrinkles," 238, 360, 424n; in
 Greek art, 189
Buddha, 110, 383, 385, 431
Buddhism, 236, 300n, 301n, 303, 406, 426–
 27, 431; Ch'an (Zen), 154, 393, 428; in India,
 246; Tibetan, 229
building: in medieval Europe, 194; in China,
 133–34; in India, 135
Bullough, Edward, 518
Burckhardt, J., 170, 206
Burke, Edmund, 518
Bushmen, 81
Byron, Lord George Gordon, 217, 234

cabinets of curiosity, 86
Cage, John, 32
Cahill, James, 150, 156–57, 242, 245–46, 468
Calame-Griaule, Geneviève, 97
Calcutta School of Art, 111

Calle, Sophie, 28–29

calligraphy: Chinese, 91, 104–5, 143–48, 151–52, 158, 175, 235, 240, 288–90, 370, 380, 384, 393, 400, 422, 429; Muslim, 148n, 196–97, 200–201

camera, effect on painting, 267–68

camera obscura, 267

canon, 140

Canova, Antonio, 270

Canterbury Psalter, 195n

Cappellazzo, Amy, 509

Captain Cook, 99

Caravaggio, 270

cardinal directions, symbolism of, 133, 361

caricature, 202–3

Carlyle, Thomas, 170

Carpenter, Edmund, 308

Carrol, Kevin, 329n

Carroll, Lewis, 72, 211

Carstens, Asmus Jacob, 216

carving: Aboriginal, 321; African, 253–55, 259; Inuit, 310

Cassatt, Mary Stevenson, 273

Castagno, Andrea del, 230

Castelli, Leo, 299

Castiglione, Guiseppe, 287

cathedrals, of medieval Europe, 130, 134n

Catterson, Lynn, 169n

cave art, 398

Central Pende (Zaire), 86, 87n, 101

ceremonies: Aboriginal, 84, 90, 120, 249–50, 313n, 314–15, 369; African, 3, 93–94, 114, 259–60, 327–28, 456; as art, 67, 77, 84–88, 91–92, 249–50; Chinese, 392; Egyptian, 112, 231; of the Elema, 92; Indian, 106, 108, 130, 231, 417; Polynesian, 251; Xavante, 16–17

Césaire, Aimé, 344

Cézanne, Paul, 156, 172, 239, 270, 281, 283, 288, 290, 308; his bathers, 128, 447

Champfleury, 270

Ch'an (Zen) artists, 295, 372

Ch'an (Zen) monks, 181–82, 519

Chang Hung (Zhang Hung), 287

Chang Lu, 240, 242

Chang Yen-yüan (Zhang Yenyuan), 142–44, 152, 235

Chao Meng-fu (Zhao Mengfu), 144

Chao Po-chü, 154

chaos, as metaphor for art, 264–67

Chavanna, 247

Ch'en Hung-shou (Chen Hongshou), 103, 145, 149–51, 370

Chen, Tsing-fang, 288–90

Chernoff, John Miller, 400

ch'i (qi), 133, 235, 422–23

Chia Ping-ch'en (Jia ping-chen), 286

childhood, 29–30

children's art, 98, 266, 283, 303, 321, 335, 356, 358, 366, 371, 384

Chin Nung, 104

Ch'ing (Ching), 183, 262–63

Ch'ing (Qing, or Manchu) dynasty, 240, 286, 291

Ching Hao (Jing Hao), 124

Chopin, Frédéric, 217, 440

Chou Liang-kung (Zhou Liang-gong), 152

Choulai, Wendi, 495

Chöying Gyatsho (Tödrup-gyatso), 229n

Christianity, 108, 199, 221, 285–87, 330n, 338, 357; missionaries to China, 286

Christie's, 377

Christus, Petrus, 11

Chuang Tzu (Zhuangzi), 124, 183, 368

Cicero, 139, 159, 191

Cimabue, Giovanni, 230–31

cinema, 268, 432

Clapp, Anne, 126n

classic, versus classical, 158n

classicism, 74, 139–40, 142, 144, 157, 180, 299; Chinese, 141, 153; European, 140, 153, 159, 167; literary, 154; Renaissance, 166

Claude (Claude Lorrain, Claude Géllee), 153

Close, Chuck, 11, 298

coffins, as art, 350, 354

Cole, H. E., 260, 402

collecting, 54, 97n, 375–76, 439; Chinese, 144, 146, 149, 151–52, 154, 290; Greek and Roman, 192; Indian art, 108–9; for museums, 100–101; of primitive art, 99–100, 102; Roman, 159

collections, imperial, 151–52

Colonna, Vittoria, 169

color, 22, 84–85, 362, 407–8; in Indian arts, 418, 458; in Iranian painting, 196–97, 201; natural, 25, 27; perception (recognition) of, 34, 41, 362, 363n, 442, 448; use by artists with mental illness, 223

color patterns, 31

color preferences, 85, 362; in the United States, 53n

color symbolism, 363n

coloring, in Chinese art, 103, 238, 423n

colors: black, 53n, 363; blue, 52–53, 363, 507–8; red, 53n, 363

commensurability, 137–38

commercialization, of Aboriginal art, 315

communication: essential to art, 63, 69, 432; through art, 7

community: aesthetic, 5; intellectual and artistic, 207n

competition, artistic, in ancient India, 247

computer processing, of images, 31, 48, 269

Condivi, Ascanio, 394

Confucius, 64, 75, 125, 141–42, 393, 427

connoisseurs, 160, 210, 364; *mingei*, 173

connoisseurship, in Chinese culture, 103, 106, 145, 147, 149, 151, 154, 290, 380

conscience, 73–74, 93

consciousness, 10, 18–20, 30, 32, 37n, 58, 441; cosmic, 269; historical, 95; visual, 22

contemplating art, as a response to the hunger for experience, 3, 5

context, essential to understanding, 7, 87, 380–81, 433–34, 440

context, of a work of art, 87, 89

continuity, in Chinese art, 145

conversation, 14

Coomaraswamy, Ananda, 111, 175–79

copying, 160–61, 344; in Chinese art, 104–5, 125, 153, 239–40, 295, 370, 423n; in classical Europe, 166–68, 170; in Egyptian art, 141

Correggio, Antonio Allegri da, 163

costumes, 77, 91; African, 93, 255, 327, 416; Arioi, 251; Chimbu, 307; Iranian, 201

Cotgrave, Randle, 158n

Coulthard, Anne, 119

Coxeter, H. S. M., 42–43

craft villages, 175

craft, and artisanry, in China, 240

craft-ideal, 171, 173

crafts and arts. *See* arts and crafts

crafts: traditional, 76, 131; versus fine arts, 129, 284

craftsmanship, 155, 168, 172, 176, 192, 369n, 371–72, 388; African, 402; New Guinea, 252

craftsmen: anonymous, 170–75; and artists, in India, 247; Egyptian, social standing, 187; Greek, 188–89; medieval European, 194

Cranach, Lucas, 153

creating art, as a response to the hunger for experience, 3, 7

creation, and destruction, universal cycle of, 122–23

creativity, 57, 448, 261n, 357; contemporary research, 477; and mental health, 221, 225; and mental illness, 223–27; statistical evidence, 261

cross-hatching, in Aboriginal art, 322–23

crystallography, 42

Csikszentmilhalyi, Mihalyi, 15, 221, 233

cubism, 40, 279–82, 297, 355, 371n, 407

culture, traditional, 178 (*see also* tradition); transmitted, 74

curiosity, 1–2, 32, 72, 386, 403, 433

da Sangalla, Francesco, 168n

Dadaism, 370, 371n

Dahomey (Africa), 114

Dakar-Djibuti Mission (1932), 97n

Dali, Salvador, 175

Damas, Léon, 344

Damas, Nicholas, 350

Damasio, Antonio, 18n, 21n

Dan (West Africa), 129, 253, 401–2

dance, 13, 45; in African art, 255, 40in, 404, 415; in Indian art, 122–23, 417, 420; traditional, 102

Dandin, 248

Dante Alighieri, 35, 178, 208, 489

Danti, Vincenzo, 164

Danto, Arthur, 55–57

Darwin, Charles, 452

Dasoja, 247

Daswanth (Dasvanth, Dasvanta), 198–99

David, Jacques-Louis, 165
d'Azevedo, W. L., 259
de Kooning, Willem, 226, 245, 296–97, 303, 304n
de Piles, Roger, 164, 370
de Sahagun, Bernardino, 82n
de Stijl, 406
de Sully, Maurice, 194
Degas, Edgar, 164, 272, 293
Deir el-Medina (workers' village), 187–88
Delacroix, 153, 164, 166, 217
Delbanco, Dawn Ho, 157
dementia, 223
democracy, 178
depression, 3, 218–19, 226–27
Derain, André, 268, 279, 328
Derrida, 80, 303
Descola, Philippe, 79
Dharmakirti, 248–49
dichotomies, of art, 65–66, 433
Dickens, Charles, 397
Diderot, Denis, 211
Dieri (South Australia), 116
Dieterlin, Germaine, 93
Dio Chrysostom, 191
Dionysian religion, 217
Dirac, Paul Adrien Maurice, 406
Divine Faith (Indian), 199
Dix, Otto, 357
Dogon (West Africa), 83–84, 92–93, 95–98, 133, 390, 414, 455–56
Donatello, 127–28, 160
Doryphoros (Spearbearer), 138–39, 160, 189
Dostoyevsky, Fyodor, 221
dragon veins, lines of force in Chinese art, 156, 468
drama, Indian, 417–21, 428
draughtsmanship, 134n
drawing, 356; African, modern, 336, 343, 351; in Chinese art, 103; Inuit, 310–12; Papuan, 305–6; as a value in seventeenth-century European painting, 103; Western academic method, 288
drawings: by children, 27 (see also children's art); by de Kooning, 304n

dreams, as source for art, 30, 130, 197, 219–20, 229, 231, 254, 259, 273, 276–78, 318n, 341, 359, 403, 409, 495
Dreamtime, of Australian Aboriginals, 115–17, 119–20, 249, 314, 316, 319, 323, 404, 459
Duchamp, Marcel, 265, 269, 298, 301–2, 324, 373–74, 385
Duff, William, 209
Dufy, Raoul, 173
Dürer, Albrecht, 139, 219, 231, 271
Duris of Samos, 191
Dutch studies, in Japan, 285
Duveen, Joseph, 375

Eadwine, 195n
Eastern art, influenced by Western art, 284, 288–89
eccentricity, in response to tradition, 291
eclecticism, 243, 245, 291, 296
École des Arts du Senegal (Dakar), 346–47
École Nationale des Beaux Arts (Dakar), 345–46
ecological ordering, of art, 380–82
Edwards, Richard, 126n
egalitarianism, as a response to tradition, 291
egocentricity: of African artists, 253, 259–60; of artists, 231–32, 234, 260–61, 397–98; of Chinese artists, 238; of primitive artists, 249; versus tradition, 181–82
egoism, and craft, 171–72
Einstein, Albert, 406
Ekman, Paul, 508
El Greco, 153, 283
Elema (Gulf of Papua), 91–93
Elkins, James, 12
embodied shadow, 3
embryogenesis, 266
emotion(s), 28, 30, 36, 39n, 40–41, 45, 47–48, 84–85, 213, 217, 380, 392, 403; and aesthetic sense, 33; in response to art, 3, 360–63; originating in nonhuman predecessors, 2
emotion in art, 5–6, 10, 13, 15, 62, 68–69; in Indian art, 417–18, 421, 431; in Japanese art, 426n
empathy, 63–65, 379–80, 432, 449

Francesca, Piero della, 271
Frederick II, 194
freedom, 213; artistic, 261, 301, 369; artistic,
 in Egyptian art, 185; of artists, 232–33, 240,
 246, 261; from art's past, 294; from the laws
 of nature, 212; sexual, 278–79
French Academy of Painting and Sculpture,
 164–66
French Academy, in Rome, 165
French Revolution, 165, 265
Freud, Sigmund, 231
Fronto, M. Cornelius, 157
Frost, Robert, 14–15
Fry, Roger, 280, 283, 406
Fu, Shen and Marilyn, 245
Fulbert of Chartres, 194
Fulk Nerra, count of Anjou, 194
fusion, 390–94, 397, 432
futurism, 268–69, 371n, 407

Galen, 138
Gallese, Vittorio, 64n
Gauguin, 175, 272–79, 280, 371
Gautier, Théophile, 214–15
Geertz, Clifford, 79n, 80
Gell, Alfred, 45, 61n, 87, 102, 178n
Gellius, Aulus, 158n
genius, 208–12, 214, 224, 265; and art, 211,
 214; applied to African artists, 261n; as an
 explosive flash, 212; history and nature of,
 477; and madness, 220, 222, 225, 227; and
 madness, in China, 228; natural, 209–
 11, 237; psychological traits, 220–21, 225;
 among the Yoruba, 256n
geomancy, 133–34
geometrical symbols, versus figures, in Aborig-
 inal art, 323–24
geometry, 42, 135–36, 164; in Pueblo pottery,
 44n; of space, 28n
Géricault, Théodore, 164
gesture, 13, 77, 418, 440; indicating emotion, in
 Egyptian art, 187
Getzels, Jacob, 233
Gherardi, Christofano, 205
Ghiberti, Lorenzo, 217, 391

ghostpainters, in Chinese art. *See* substitute
 artists, in Chinese art
Gilson, Etienne, 176
Giotto di Bondone, 230–31
Glassie, Henry, 57
God, relation of true artist to, 208
Goethe, Johann Wolfgang von, 209–11, 270
Gola (Liberia), 253, 259, 401
gold casting, 413
golden rule, 368n
golden section, 91n
Goncourt, Edmond de, 270
good, equated with beautiful, 214
Gorky, Arshile, 226
Gottlieb, Adolph, 226
Goya, Francisco José de, 39, 230, 347, 357
Gozzoli, Benozzo, 217
Grabar, Oleg, 197, 202
grading, of artists or works of art, 164, 370, 470
Grafton, Anthony, 207n
grants, for art, 379n
graphic art, 42
grasping, versus empathy, 65
Graves, Morris, 288n
Greece, ancient, 9, 136–38, 157
Griaule, Marcel, 93, 95–98, 133
Grosz, George, 357
ground painting, Aboriginal, 315, 317
ground sculptures, 317
Grünewald, Matthias, 153
Guebehi, Emile, 350
Guedes, Pancho, 329n
Guenon, René, 176
guilds, 175; court, in African kingdoms, 129; in
 China, 130–31; in Europe, 129, 131, 164; in
 India, 130; in Japan, 131; medieval, 463
Guston, Philip, 226

Hadrian, 192
Haidas (Northwest Coast, Canada), 398
Hamada, Shoji, 171–74
Hamlet, as a symbol of creative discomfort, 219
Hampa, Chikka, 247
Hampâté Bâ, A., 75
handedness, 35–38, 222

Han-shan (Hanshan, Kanzan in Japanese), 435, 518–19
harmony, 137, 139; universal, 197–98
Hartung, Hans, 290
Hasan Baghdadi, 202
Haskell, Francis, 270
Hastings, William, 108
Havell, Ernest, 109–11
Hazlitt, William, 234
head ornament, Marquesan, 99
hedonism, aestheticized, 214–16
Hegel, philosophy of art, 109
Heiss, Alanna, 379
Hekkert, P., 388–89
Hellenism, 160, 398
Heracles, 218
Herder, Johann Gottfried von, 210–11, 422
hero, myth of, 228–230, 246
heroism: in African art, 259–61; of artists, 261; in Chinese art, 182, 241; in Egyptian art, 185; in primitive art, 249, 252
Hesiod, 158
heterodoxy, 240
hieroglyphics, 187
Himmelheber, H., 253–54, 462
Hinduism, 199, 421
Hindus, traditional, and self-abnegation, 181
Hiratsuka, Un'ichi, 310
Hirst, Damien, 373
historical ordering, of art, 380–81
history, general, 162; of African art, 345, 347; of art, 6, 8, 47, 138, 163, 177, 179, 269–70, 283, 297, 388–89, 397–98; of art, and chaos theory, 264–65; of Chinese art, 146, 240; of modern art, 28, 371n
Hoffmann, E. T. A., 391
Hokusai, 272–73, 285, 326
Holbein, Hans, 11, 38
Holm, Bill, 102
Homer, 158, 162, 189, 191, 209–10
Honolulu Academy of Art, 462
Honolulu scroll, 127n
Hopi, 85; (Pueblo) pottery, 44n, 445
Hopper, Edward, 378n
Houston, James, 309–11, 357

Houy, 188
Hrabal, Bohumil, 19
Hsieh An, 146
Hsieh Ho (Xie Ho), 142, 423
Hsün-tzu (Xunzi), 2, 73
Huan Yün, 126n
Huang Kung-wang (Huang Gongwang), 244, 399
Hugo, Victor, 219
Hui Shih (Hui Shi), 124
Huichol (Mexico), 89–91
Hui-tsung (Huizong), 104
human body: Greek devotion to, 127; in Western art, 166, 234
human figure: Egyptian, 186–87, 197; in miniatures, 197; as a subject for art, 112, 128, 364
human remains, Native American, 108n
human societies, number of, 84
Humboldt, Wilhelm von, 210–11
Hume, David, 518
Hyman, John, 26n
hyperbolic (non-Euclidean) space, 43
hypnosis, 301n

i (untrammeled), 242
Ibo (Igbo, eastern Nigeria), 260, 342, 348–49, 355, 402
iconography: African, 255; Indian, 177, 247, 515; of ancient Peru, 277
ideograms, of the Dogon, 95–96
Ife (Nigeria), 398
Igbo (Nigeria), 86, 101, 503
illustrations, ix
imagination, 1, 3, 5, 10, 14–15, 19, 23–24, 60, 193, 210, 212, 214, 262, 432–33
imitation, versus originality, 208–10
immortality, 183, 213, 217
impressionism, 40, 308, 370, 406
Inayat Khan, 200, 476
India, as a symbol of Eastern spirituality, 109
individualism, 207n, 397; of Aboriginal artists, 250; of Egyptian artists, 187; heroic, 185; idealistic, 176
individuality, of the artist, 69, 369, 430

classical, 158; Egyptian, 140; Inuit, 83, 309; Nahuatl, 82n; Native American, 98; Sanskrit, 418–19, 422, 434, 515

Laocoön, 160, 162, 167, 169–70, 271

Lao-tzu (Laozi), 266

Latto, Richard, 26–28

Le Corbusier (Charles-Édouard Jeanneret), 137, 406

Le Nain, 270

Leach, Bernard, 171–74

Lee, Simon, 165

Léger, Fernando, 407

Leiris, Michel, 97n

Lenain, Thierry, 4

Leo X, 231

Leonardo da Vinci, 37–38, 49–50, 64, 128, 134n, 139, 155, 164, 205–8, 296, 373, 431

Lesage, Augustin, 342

Levine, Sherrie, 302–3

li (inherent form), in Chinese art, 237

Li Ch'eng, 154

Li Chih, 154

Li Kan, 399

Li Kung-lin (Li Gonglin), 391

Li Po (Li Bo), 289

Li Yü, 50

Lin Fengmian, 378n

Lipsey, Roger, 176n

Liszt, Franz, 217

literary arts, as a model for aesthetics, 429

literary structure, abstract analysis of, 9n

literati, Chinese, 124, 228, 425, 482

literature: Chinese, 142, 422; classical, 159; of ancient Egypt, 140–41; Greek, 158, 162; Japanese, 142, 425n, 426–27; oral, 81; Roman, 158

Littré, Maximilien-Paul-Émile, 158n

Liu Hsieh (Liu Xie), 142

Livy, 163

Lods, Pierre, 346–47, 357–58; Poto-Poto school, 504

Loehr, Max, 157, 468

Lombroso. Cesare, 220

loneliness, of artists, 232–33, 395, 435

Longinus, 158

Loti, Pierre, 278

love, 394–95, 404–5, 409, 427; ideal, 35, 248; of artists for their materials, 10–11; of musicians for their instruments, 11; romantic, 33

Lowell, Robert, 222

Luba (southeastern Zaire), 95

Lucian of Samosata, 191–92, 508

Ludwig, Arnold, 225

Luke of Tuy (bishop), 195

luminance, 442

Luria, Alexander, 6

Lutz, C. A., 85, 363

Lys, Jan, 205

Machaut, Guillaume de, 391

Machiavelli, 73

madness, in artists, 217–20, 265

magic, natural, 183

Magritte, René, 28

Mahabharata, 199, 419, 421–22

Mahonda, Tony, 354

Makerere School of Art (Uganda), 329n

Malawan, 280

male-beauty contents, in ancient Greece, 127

Malevich, Kazimir, 282, 296, 299–301, 406–8

Mallarmé, Stéphane, 214n

Malliyana, 247

Malraux, André, 279

mandalas: Indian, 135; Tibetan, 86

Mandelbrot set, 31

Manet, Édouard, 153

manic-depression. *See* depression

Mano (Liberia), 94n

Mantegna, Andrea, 131, 145n, 205

manuals: diagnostic, 224n; Indian craft, 106, 370, 416, 419; Japanese, 131

manuscripts, illuminated, 195

Manzoni, Piero, 299–301

Maoris, 61n, 278n

maps, 267

Marc, Franz, 282–83

Maritain, Jacques, 176

market value, of art, 369n

Markus, Mario, 31

Marquesan motifs, 455

Masaccio, 205

masks, 87–88, 94n, 100–101; African, 254–55, 259, 279, 283, 327, 345n, 348–49, 353, 365, 401, 413, 416, 430, 455; for ceremonies, 86–87; Chinese, 283; death, 398; Dogon, 93, 97n; Egyptian, 398; Igbo, 86; Northwest Coast (Canadian), 102; Pende, 86, 455; Yoruba, 114, 365
Maslow, A. H., 221
masons, 131
masquerade theory, for African art, 355, 359
Masson, André, 339
masterpieces, 131–32
materials, for art, 335
mathematics, 42–43, 281; of natural patterning, 446
Matisse, Henri, 266, 279, 283, 288, 290, 335, 337
Maulana Sultan-'Ali, 201
Mayas, 82n
Maybury-Lewis, David, 16–17
Maymura, Banapana, 322, 324
Maymura, Narritjin, 322–24
Mbari Artists and Writers Club, 330
Mbari house (Ibo), 260, 355
Mbari Mbayo Club, 331–32, 337, 339
McCrae, Tommy, 313n
McEwen, Frank, 334–37, 343, 357
measure, 139
measurement, units of, in India, 136
media artists, 379n
Medici, 128, 167; Cosimo de', 158; Ottaviano de', 205
meditative concentration, 301
meditative levels, Buddhist, 408
Meister Eckhart, 176–77
Melamid, Alexander, 52–57, 383
melancholy, 218–20
Melanippus, 189
Mellon, Andrew, 375
memories, 6, 10, 18n, 19–20; false, 36; personal, 29; in works of art, 30, 364; of works of art, 29
memory, 14, 21, 25, 28, 31, 65, 68, 179, 223n; collective, 69, 180, 269; of the community, 29; cultural, 295; metaphors for, 472; and tradition, 94–95; tribal, 96; visual, 105, 297

memory disorder, 24
Mengs, Anton, 163
mental illness, 220–21, 223–27; in scientists versus artists, 225–26
Menuhin, Yehudi, 11
Mery-Re, 188
Meyer, James, 371n
Meyer, Tobias, 509
Mi Fei, 288–89
Mi Fu, 145–49, 370, 376
Michaux, Henri, 290
Michelangelo Buonarroti, 35, 37, 127, 160, 162, 164, 167–71, 175, 206–8, 270–71, 296, 373, 394–95, 399, 405, 431
Mickie, 312n
microscope, 267, 269
Middle Kingdom (Egypt), 188
Mikhalkov, Serge, 56
Mikyo Dorje, 229n
Milarepa (Mila Ras-pa), 229
Millais, John Everett, 231
Millet, Jean-François, 272
Ming period, in Chinese history, 239–40
mingei (folk crafts), 172, 174
Ming-ti (Mingdi), 151
miniatures: medieval, 195–98, 200; Mughal, 271, 421; Persian, 282; Rajput, 421–22
Mir San'i, 203
Miró, 28, 266
mirror images, 37
mirror neurons, 64, 379–80
Mitter, Partha, 178
Mo Ho-chih, 154
Mobutu Sese Seko, 328
Modena Cathedral, 195n
modernism, 297; in art, 40, 261n; in Chinese painting, 157; late, 54
Modigliani, Amedeo, 334
Moeran, Brian, 173
Mona Lisa, 296
Mondrian, 25–28, 384, 406, 409
Monet, Claude, 164, 272, 281, 289, 319, 366, 378n
money, role in art, 293, 376, 379, 382 (see also price, of art)
Montorsoli, 167

Moore, Henry, 283–84, 309, 335–36, 358
morality: and art, 53, 143, 163, 212, 216, 353; and beauty, 479
Moreau, Gustave, 164, 335, 337, 358
Morphy, Howard, 16, 322–23
Morris, Desmond, 4
Morris, William, 109, 479
mortuary displays, New Ireland and the Tiwi, 86
mosaics, 283, 317, 508
Motherwell, Robert, 226
motion, 23, 34, 45
Mowalijarli, David, 250
Mozart, W. A., 180, 394
Muhammed ibn Muqlah, 148n
Mukarobgwa, Thomas, 336–37
Mukomberanwa, Nicholas, 337, 342–44, 356
Munch, Edvard, 232, 394–96
Murakami, Takashi, 377
Murillo, 271
museum professionals, 15, 58, 375
museums, 7, 271, 297, 334; as aesthetic consciences, 371; American, 106; patrons of, 54; role in artistic success, 293, 316, 376
museums: American Museum of Natural History, 100–101, 108n; Archaeological Museum (Florence), 284; Australia Museum, 460; Boston Museum, 176; British Museum, x, 109, 257, 283; Bunkamura Museum (Tokyo), 366; Capital Museum (Beijing), 366; Center for African Art (New York), 86; Institute of Contemporary Arts (London), 317, 337; Isabella Stewart Gardner Museum (Boston), 28; Louvre, x, 164, 166, 289; Metropolitan Museum of Art, x, 11; Musée de l'Homme, 97n, 277, 280; Musée du Quai Branly (Paris), 366; Musée Dynamique, 345; Musée Rodin, 337; Museo Tamayo of Contemporary Art (Mexico City), 366; Museum for African Art (New York), 413; Museum of Modern Art (New York), 28, 337; National Gallery of Art (Washington, D.C.), 308, 375; P. S. 1 Contemporary Art Center (New York), 379; Rhodes National Gallery, 335–36; Royal British Artists galleries, 348; Seoul Museum of South Korea, 366; Tel Aviv Museum of Art, 366; West-

falisches Landesmuseum fur Kunst und Kulturgeschichte (Munster, Germany), 475
music, 26, 33, 36, 45, 281, 303n, 387; African, 252, 255, 338, 356, 400, 415–16; inseparable from dance, in Indian art, 122, 417–18, 420; and speech, 13; as the supreme art, 180
musical harmony, 136; and visual proportion, 139
musicians, black Amerian jazz, 222
Muslim (Islamic) prohibition against images of living things, 195–96, 198–99, 364; love for beautiful books, 195
Muzaffar, 203
Myron, 191
mysticism, 179, 198, 410–11
myths, 96, 277n; Aboriginal, 115n, 117–18, 459; African, 96; of creation, 116–17, 385; of the Dogon, 95–96
mythology, 218; of craft, 130; Indian, 422; Jewish, 266; Mesopotamian, 266

nabis, the, 371n
nakedness, in Greek art, 127
Nalalis, 195n
Namatjira, Albert, 304, 313–15, 318n, 325, 329, 356
narcissism, in the myth of the heroic, romantic, egocentric artist, 231, 233–34, 312
Natanson, Thadée, 277n
Nataraja, 122–23
Native American Graves Protection and Repatriation Act, 108n
Native American tribes, 390
nature, 2, 42, 161, 163, 166–68, 173–74, 208, 210, 212–13, 216, 236–37, 243, 395–96, 405; absent in Indian art, 109–10; in Chinese art, 143, 155–57, 392–93, 399; and the Chinese artist, 182–84; harmony with, 133; as numbers, 137
Nature, 207, 229
nature mysticism, 406 (see also mysticism)
Ndiaye, Iba, 346–47, 356–57, 359
Nebamun, 187
Needham, Joseph, 134n
Nefertiti, 187
negative hands, 38

Plotinus, 178, 193, 404–5, 421
Plutarch, 163
poetry, 12–15, 19, 30, 63, 217–18, 303n, 392,
 411; Chinese, 125, 141–42, 228, 238, 391,
 424; epic, 189; folk, 210; Indian, 271, 417–
 22, 515; Iranian, 204; Japanese, 427; lyric,
 175; related to speech, 14; Sanskrit, 248–49;
 Tibetan, 229
poets: American, 222; American, suicide and
 drug addiction, 221; as heroes, 229; in India,
 representative of mad artist stereotype, 249;
 and mental illness, 225, 227; modern, 239;
 praised in prologues of Indian plays, 486
Poincaré, Henri, 281n
Poiret, Paul, 173
political satire, in art, 340
politics, in art, 353
Pollock, Jackson, 226, 373, 410
Polyclitus, 127, 138–39, 160, 189, 191–92, 464
Polynesians, 81, 91n
Pontormo, Jacopo da, 205
pop art, 57, 359, 374
Pope Julius II, 160
popular culture, 52
porcelain, 271
portrait sculpture, 398
portraits, 112–13; in African art, 254, 329; of
 African royals, 114; for the arrangement of
 marriage in India, 398; Ch'an, 399; Chinese,
 399; funerary, 350; in Indian art, 198, 200,
 202, 204; Japanese, 399; tree, 125
portraiture, 111n, 190, 204, 235, 286, 372; Afri-
 can, 398; Mughal, 422
postimpressionism, 370n
postmodernism, 326, 344, 360
pottery: African, 366; Chinese, 172–75, 372;
 Chinese, Persian influence on, 282; Hopi
 (Pueblo), 44, 445; pre-Columbian, 274–75
Poulenc, Francis, 151
Pound, Ezra, 153–54
Poussin, Nicolas, 153, 160, 162–63, 165, 347, 469
poverty, material versus cultural, 84
power relations, 79–80
powwows, Native American, 102
praise poems (oriki), of the Yoruba, 256–58, 262
Praxiteles, 190–91

preference: aesthetic, 32–33, 35–36, 52, 361, 383;
 aesthetic, American versus Chinese, 53; for
 differentiated pattern, 43; for faces, 47; and
 familiarity, 35, 69; for portraits facing left,
 39–40; psychologists' findings, 443; for the
 right side, 38, 40; for symmetry, 41, 446
preference-for-prototypes, 46
price for art, 7, 105, 160, 293, 376–78; for
 Aboriginal art, 307, 313–14, 317–18, 371
primitive art, 80–81, 86, 273; durability of, 86;
 ethnographic approaches, 86; influence on
 Western art, 279–80
primitive artists, identifying, 101n, 102
primitives, 76–78, 82–84, 86, 280; characteris-
 tics of, 81; versus civilized peoples, 78
primitivism, 261n, 273, 342n
Prince, Richard, 377
Princet, Maurice, 281n
printmaking: Eskimo, 309–10; Western, 357
Prinzhorn, Hans, 396
Prix de Rome, 164–65
processing fluency theory, 59n
proportions, of buildings, based on humans,
 137
Proverbs, 74
psychiatric illness. See mental illness
psychoanalysis, 226, 281
psychology, 49, 382, 445; humoral, 220
public adulation, for musicians, 217
purism, 371n
Pushpadanta, 248
Pythagorean intervals, in music, 136–37

Qazi Ahmad, 203
Queen Elizabeth II, 307, 314, 348–49, 502, 505
Quintilian, 191
quotations, in painting, 295

Radha, 248
Rainbow Snake (rainbow serpent), 115–18, 120–
 21, 126, 250, 459
Rainer, Arnulf, 4
Rajeshekhara, 248
Ramachandran, V. S., 26n
Ramessid period (Egypt), 187
randomness, 19

ranking, of artists, by price, 377n
Raphael, 49–50, 162–64, 206, 215, 219, 231, 271, 280, 299, 373
rasa (aesthetic emotion), 417–21, 431
Rauschenberg, Robert, 299–300, 303–4
Ravel, Maurice, 151
Ray, Niharranjan, 179
Raz, Ram, 458
Read, Herbert, 335
reading and writing, direction of, 38, 39n
readymades, 373–74, 385–86
realism, 28, 53, 128, 155, 286–87, 325, 328, 350, 368n, 370n, 373, 397–99; cubo-futurist, 407; in Indian art, 200; Russian, 406; of some paintings, as a stereotypical story, 231
reality, 212, 214, 436–37; psychic distance of art from, 430–31
Reber, Rolf, 59n
Regius manuscript, 131
Reims Cathedral, 160
Reinhardt, Ad, 226, 293, 296, 300, 410
relativism, 79–80; and absolutism, 47, 440
Rembrandt, 164, 172, 271, 277, 284, 296, 299, 347
remembering, 17, 28, 30
Renaissance, 111, 127, 138, 141, 158, 163, 205, 237, 270, 398, 405, 429; High, 164
Renoir, Auguste, 164
reproductions: photographic, 295; of reproductions, 302; of works of art, 269, 275, 302–3
research, surveys of, 32n
Reynolds, Joshua, 163
rhythm, in art, 41, 45, 243, 288n, 345, 361, 366, 401
Rimbaud, 219
rites of passage (initiation rites), 94n, 414
Riza (Aga Riza, Riza-I Abbasi), 202–4
Rizolatti, 64n
Robinson, Rick, 15
rock paintings, Aboriginal, 118, 321
rocks, in Chinese art, 235
Rodchenko, Aleksandr, 299, 301
Rodin, Auguste, 343
Roethke, Theodore, 222
Romain-Desfosses, 329n
romanticism, 180, 219; European, 217

Rome, ancient, 157, 160
Rosa, Salvator, 206
Rosen, Charles, 11
Rossetti, Dante Gabriel, 391
Rothko, Mark, 226, 294, 410
Rouault, Georges, 334–35
Rouch, Jean, 93
Rousseau, Théodore, 272
royal courts, African, 327
Royal Society of Arts (London), 110
Rubens, Peter Paul, 164, 206, 296, 299, 373
rules: of construction, 132–33, 135–36; dependence of art on, 210–11; for holy images, in India, 136
Ruskin College (Oxford), 348
Ruskin, John, 109, 170, 173, 270
Ryman, Robert, 300

Saatchi, Charles, 373
Sacks, Oliver, 24
Sadiqi (Sadiqi Bek, Sadiqi Bey), 202–4
Sahlins, Marshall, 450
Saila, Pitallousie, 311
Saint-Lambert, Jean-François, 211n
Salmon, 281n
Salons, in the Louvre, 164
Samba, Chéri (Samba wa Mbimaba N'Zinga Nurisami), 350–54, 356, 358–59
sand paintings, Navaho, 86
Sansovino, Andrea, 230
Sarayama, 173–74
Sardanapalus, 215
savanna hypothesis, in evolutionary biology, 54–55, 448
Schäfer, Heinrich, 112
Scharfstein, Ben-Ami, drawing by, 436
Scharfstein, Ghela, photograph by, 2
Schiller, Friedrich von, 210, 213–14
schizophrenia, and schizoaffective disorder, 224n
Schoenberg, Arnold, 394, 396
Schoenmakers, M. H. J., 409
School of Dakar, 345n
schools of art, 370; contemporary, 371n
Schopenhauer, 180, 406
Schrödinger, Erwin, 406

Schwarz, Norbert, 59n
scientific knowledge, and the appreciation of art, 31
scientific method, in anthropology, 82
scrolls, 147n, 148n, 152; portrait, 103
sculpture, 6, 11, 30, 139–39, 159, 356, 369, 392, 429; Aboriginal, 327; African, 253, 280, 345, 347–48, 365, 401n, 402, 414; modern African, 336, 343–44; Baule (African), 411n, 413; Egyptian, 280, 283; Greek, 160, 168, 284, 302, 431; ice or butter, 86; Indian, 106–10, 136, 416–20; Inuit, 309; Malaysian and Easter Island, 283; Papuan, 308; social, 374; Western, 447
seals, 152
seeing, 17–18, 21, 30
self, 18n
self-abnegation, traditional, 181, 295
self-consciousness, 59, 61
self-destruction, 298
self-determination, 213
self-expression, 82, 99, 178, 237, 293, 425
self-portraits, 124, 190, 206, 217, 219, 229n, 275, 407, 489; as an artist's signature, 194, 195n
selling, of art, 293; in China, 238–39
Senghor, Léopold Sédar, 344–46, 358
Sennedjem, tomb of, 474
senses, 85; number of, 21
Senufo (West Africa), 129
Sepik, 86
Setaou, 188
Seung-taek, Lee, 298
Severus Alexander, 192
sex, as a necessity, relative to art, 1
Sexton, Anne, 222
sexuality, 446, 447
Shah Tahmasp, 197
Shakespeare, William, 209–10
shamans, 83, 85, 89, 98, 309–10, 309
shapes, recognition of, 6, 10, 22–30, 36, 42, 44n, 67, 136, 361
Shen Chou (Shen Zhou), 106, 244, 391
Shen Tsung-ch'ien (Shen Zong-jian), 423
Sherman, Cindy, 377
shih (momentum), 155

Shih Chung (Shi Zhong), 184–85
Shih-t'ao (Shitao). See Tao-chi
Shih-te (Shide, Jittoku in Japanese), 435, 519
Shintoism, 426–27
Shipibo-Conibo Indians (eastern Peru), 85
Shire, George, 354
Shiva (Śiva), 247, 417, 421, 431; as Lord of the Dance, 115, 122–23, 126, 383, 404; myths, 461
Shona tradition, 336–37
Shun Chih (Shunzhi), 291
Sigi, ceremony of the Dogon, 93
signatures, on artistic works, 188–89, 194, 195n, 201–2, 256
Sirén, Oswald, 127n
Sisala (northwest Ghana), 253
Sisley, Alfred, 164, 378n
Sitwell, Dame Edith, 20
Śivaramamurti, Calambur, 122–23
Slade School of Fine Arts (University of London), 348
Smikros, 189
Smith, David, 226
snow woman, 402
Socrates, 189, 218
Somanathaprasasti, 122
Someshvara, 247
song/dances, of the Suyá, 92, 390
Songman, 249–50
songs, creation, 117
Sophocles, 189
Sosen Mori, 399
Sotheby's, 509
Soulages, Pierre, 290
Soyinke, Wole, 330
speech, 12–15, 36, 387, 440; musicality of, 440
spirit spouses, of the Baule, 411n
spirit-consonance (ch'i-yün, chi yun), 235
Spivey, Nigel, 189
spontaneity, 14, 208, 308, 397; in Chinese art, 147–48, 154, 175, 182–84, 240–41, 246, 370
Squacione, Francesco, 131
Śri Harsha (Śriharsha), 422
St. Thomas, 177
Staël, Nicholas de, 294
standards, aesthetic, 368, 371–72, 382, 386

Stanley-Baker, Joan, 426n

Starr, Frederick, 100–101

statues: African, 279, 401, 411–13, 430; Egyptian, 141, 186, 188, 231; ancient Greek, 127, 138–39, 159–60, 162–63, 167–69, 171, 190–91, 193, 270; Indian, 106–9, 231, 246–47, 418; Yoruba, 114

status, Muslim, 196

Stein, Leo, 28n

stereotypes, biographical, 230

Stevens, Wallace, 14–15

Stewart, Andrew, 138–39

Stickney-Gibson, Melinda, 30

Still, Clyford, 226, 410

stone rubbings, ancient Chinese, 289

storytelling, African, 252

Strand, Mark, 59

Stravinsky, Igor, 153, 468

Strindberg, August, 232

Strother, Z. S., 87n, 26in

Stuart, Charles, 108–9

Stubbs, Dacre, 120

style, classical Greek, 111–12, 128; hierarchies of, 87–88

Su Shih (Su Shi), 152, 236–38, 391

Su T'ung-p'o (Su Tungpo), 391

substitute artists (substitute brushes), in Chinese art, 103–4, 239

success, of artists, 376

Sulla, 159

Sung dynasty, 370

Sung Tzu-fang, 237

supernatural world, as a source of design, 129, 263

suprematism/constructivism, 371n, 407–8

surrealism, 223, 280, 342, 359, 370, 371n, 406; in Inuit art, 312

surrealists, experiments in automatism, 232

Susu (Guinea), 401

Suyá (southwestern Brazil), 91–93

symbolic meaning, in works of art, 98

symbolism, 275–76, 349, 370n, 387, 397, 407, 432; artist's, 277n, 320; visual, of art, 177

symmetria, 137

symmetry, 42–43, 44n, 138, 361, 445; and asymmetry, in Maori art, 88–89; in African

art, 401–2; in faces, 47–48n, 49; in nature, biological need for response, 445; in textiles, 445

synesthesia, 6, 45, 47n, 408, 439

synthetism, 371n

Tagore, Abanindranath, 111

Tahitian life, 278

Taiga, Ikeno, 293

Taiwo, 258

talking drums, 344

Tall, Papa Ibra, 346

T'an Yin (Dan Yin), 391

T'ang (Tang) Dynasty, 144, 370

T'ang Hou (Tang Hou), 147n

Tantric doctrine, 114

Tantric imagery, 199

Tao (Dao), 266, 423

Tao-chi (Daoji; Shih-t'ao, Shitao), 240, 244–46, 384, 392–93

Taoism, 133, 182–83, 215n, 236, 266–67, 285

Tao-te Ching (Daode Jing), 266

telescope, 267

Temple of Apollo, 137

temples: Greek, 137; Indian, 135–36; mortuary, 187

Teniers, 164

texture, in art, 52, 86, 139, 334, 362

The Blue Rider, 282, 406

The Book of Changes, 289, 393

theology, Islamic, 198

Theosophy, 406n, 408–9

Thomas, Rover, 317, 318n

thought: mythical or magical versus rational, 83; preliterate, 451

Thutmose, 398

Tintoretto, Jacopo Robusti, 270

Titian (Tiziano Vecellio), 163, 206, 270

Tiv (Nigeria), 252

Tjapaltjarri, Clifford Possum, 317, 318n

Tlingit Indian clan (Alaska), 108n

Tobey, Mark, 288n

Tolstoy, 221

tombs, royal, 187

Tomlin, Bradley Walker, 226

Tompieme, 254